THE EARLY ART OF NORFOLK

THE EARLY ART OF NORFOLK

A SUBJECT LIST OF EXTANT AND LOST ART
INCLUDING ITEMS RELEVANT TO EARLY DRAMA

ANN ELJENHOLM NICHOLS

EARLY DRAMA, ART, AND MUSIC
REFERENCE SERIES 7

MEDIEVAL INSTITUTE PUBLICATIONS

WESTERN MICHIGAN UNIVERSITY

KALAMAZOO, MICHIGAN 49008
2002

ISBN 1-58044-034-7

Library of Congress Cataloging-in-Publication Data

Nichols, Ann Eljenholm.
 The early art of Norfolk : a subject list of extant and lost art including items
relevant to early drama / Ann Eljenholm Nichols.
 p. cm. – (Early drama, art, and music reference series ; 7)
 Includes bibliographical references (p.) and index.
 ISBN 1-58044-034-7 (casebound : alk paper)
 1. Christian art and symbolism–England–Norfolk–Catalogs. 2. Church
 buildings–England–Norfolk–Catalogs. 3. Art, Medieval–England–Norfolk–
 Catalogues.
 I. Title. II. Series.

 BV153.G7 N53 2002
 016.2615'7'094261–dc21 2001052115

Cover Illustration by Marianne Cappelletti
after Assumption of the Virgin, East Harling,
Norfolk

Cover Design: Linda Judy

Printed in the United States of America

CONTENTS

ILLUSTRATIONS

Photos are by the author unless otherwise identified in plate captions. Drawings in the Introduction and appendices are by Heidi Bleier and Marianne Cappelletti.

ACKNOWLEDGMENTS

IN ANY PROJECT that stetches over fifteen years, the list of acknowledgements grows long. First, my debt of gratitude is immense to Clifford Davidson, whose vision had made the subject lists possible, and who has been enormously patient throughout the editing process. I need also to thank Barbara Palmer, whose encouragement from the inception of the project has been heartening. Eamon Duffy, Nigel Morgan, and Kathleen Scott have provided information as well as advice and counsel over almost as many years as the project has been in hand. I am particularly grateful to specialists who have graciously shared their expertise with me, David King for painted glass, Pauline Plummer for screens, David Park and Andrea Kirkham for wall paintings, Francis Cheetham for alabasters, Nicholas Rogers for manuscripts and hagiography, Simon Cotton for unpublished information from wills, and Veronica Sekules, whom I have troubled with questions over a wide range of media. Their instruction, some at the beginning of my work, some at the end, has saved me from many a blunder. I take full responsibility for all that remain.

I would also like to thank Stephen Paine and Mark Perry for conservation reports at Potter Heigham and Norwich St. Gregory, respectively, and Birkin Haward for information on the Knapton roof. At the Victoria and Albert Museum, Linda Wooley helped me with costume dating, and Judith Crouch and Martin Durant provided painted glass information. At the Burrell Collection I owe special thanks to Rosemary Watt, who made available copies of the architect cards, and Patricia Collins, who answered a number of specific questions about Norfolk glass in their collection. Their generosity is characteristic of the hours spent by so many people helping me to compile this subject list. Anne van Buren was equally generous in providing a typescript of the glossary in her forthcoming book *Dress and Costume in Late Medieval Art*. Bridget Cherry and Gavin Watson of the Buildings Books Trust made available an early copy of Pevsner's *Norfolk 2: North-West and South*. Philip Broadbent-Yale and Ann den Englese of the National Trust at Great Yarmouth provided inventories of their collections. Edwin J. Rose, Development Control Officer of Norfolk Landscape Archaeology, resolved a number of dating problems.

The keepers of churches deserve special thanks, Colin Bodkin, secretary of the Norwich Redundant Churches Trust, for devoting an entire rainy morning to unlocking Norwich churches; Kate Weaver of the Churches Conservation Trust for the names of key holders and Diana Poole at the central office for courtesies rendered; and Janet Seeley of the Council for the Care of Churches. Too many vicars and churchwardens have answered queries and provided keys to permit individual citation, but extraordinary help was provided by Peter Halls and Anthony Long, vicars of Brooke and Worstead respectively, E. A. Jones of Aylsham, R. V. Bailey and I. Gooch of Bedingham, V. Bothwick of Burnham Deepdale, Thelma Hope of Shottesham All Saints, John Doggett of Pulham St. Mary, J. K. Reynolds of Lessingham, Cynthia Chitsiga of Keswick and Intwood, A. N. G. Duckworth-Chad of Tattersett, Ken Clabbrun of Besthorpe, Ann Meakin of Martham, and Sir Rupert Mann of Thelveton. I wish also to thank churchwardens and incumbent priests for permission to publish photographs of work in their churches.

At my university I wish to thank Carol Slade and Rob Brault for the production of tables, Michael Meeker for computer assistance, and the interlibrary loan staff of Maxwell Library for many services

rendered. I owe special gratitude to the Minnesota Inter-Faculty Organization for travel funds for successive field trips, and Winona State University for grants supporting student research assistants who relieved me of much of the tedious work of compiling lists and entering early field notes into the data base.

Much of the help I received was provided under exceedingly trying situations. After the disastrous fire that destroyed the Norwich Public Library and many of the sources that I had been using in the Local Studies Library, staff were enormously generous in helping me to locate other copies. Manuscripts after conservation were housed in a number of sites, not all in Norfolk; I am particularly grateful to Clive Wilkins-Jones, who arranged for me to see material not locally available. The closure of the Castle Museum for renovations with its art collections temporarily housed at Shire Hall must have tried the souls of its conservators, but they graciously provided me corners to work. The Library has now been rebuilt and the Castle will have reopened before this book is published, but unfortunately the excellent museum at St. Peter Hungate has been closed permanently. Work from redundant churches once readily available to the public will now be put in store, where access will be limited to specialists.

In any long-term project, one comes to treasure congenial and supportive environments in which to work. One is fortunate in Norfolk to have the Norfolk Record Office, the Norfolk and Norwich Archaeological Association library at Garsett House, the various services of the Norfolk Museums Services, and the Dean and Chapter Library. I am grateful to the staff at the Record Office for their courteous help in accessing material and for their prompt replies to requests for posted photocopies. At the Norwich Museums the list is long: John Renton, who unfailingly and cheerfully answered what must have seemed endless questions; Norma Watt, Assistant Keeper, and her staff at the Castle Museum for their permission to view drawings in the Art Collection; Lynda Wix at the Costume and Textile Centre; and Alan West, Assistant Keeper at the Castle Museum. Anyone who has worked at the Dean and Chapter Library understands the debt of gratitude owed the Dean and in particular Tom Mollard, whose wide knowledge of Norfolk history and the Library resources is invaluable. With the assistance of Brenda Lemon he sustains a congenial working environment in which strangers can discover common interests. Finally, for their support of this project, I wish to thank Norfolk colleagues, who have since become friends, Barbara Green, Andrea Kirkham, John Mitchell, Jane and Paul Quail, Pauline Plummer, Martial Rose, and the Carmelite nuns at Quidenham and Langham, who not only provided shelter during successive field trips, but also welcomed me to a community of prayer and work where I felt truly at home.

INTRODUCTION

NORFOLK churches were well served by print in the last century: H. Munro Cautley's survey (1949), the three volumes by D. P. Mortlock and C. V. Roberts (1981–85), the massive anthology published to celebrate the Cathedral's nonecentenary (1996), and more recently Bill Wilson's major revision of Nikolaus Pevsner's two volumes. The Norfolk Subject List serves a very different purpose from the work already published. A subject list of one county enables us to test the hypothesis that there were distinct regional styles and devotional preferences. A superficial comparison with Barbara Palmer's findings in the West Riding of Yorkshire (Early Drama, Art, and Music Reference Series 6) reveals notable contrasts in the range of Old Testament subjects as well as in the number of *pastoralia* compositions, meager in the West Riding but particularly rich in Norfolk. The Creed with four West Riding citations and Works of Mercy with one are also found in York (Reference Series 1), but in Norfolk only two of twenty-three Creed citations are in the cathedral city, and none of the eighteen Works citations can be traced to Norwich. Such differences may be more apparent than real, but they provide suggestive vantage points for future research as other subject lists are completed. Regional preferences seem also to have been at work in manuscripts. Kathleen Scott in treating fifteenth-century East Anglian manuscripts noted instances in which they diverge from the patterns represented in her *Survey* volume. In the Crucifix Trinity (Mercy Seat) the Father commonly supports the cross with both hands (cf. York, Minster Library, MS. Add. 2, Scott [2000] pl. 5), whereas in the East Anglian work the Father holds the bar of the cross with only one hand and blesses with the other. Both types are found in Norfolk parochial art (contrast **FIGS. 1 & 2**), but the blessing model predominates. For the Circumcision Scott cited the unusual features

of bleeding bowl and Child being nursed on Mary's lap rather than placed on the altar. The same nursing scene is represented in woodcarving at Salle and in glass at St. Peter Mancroft. The bleeding bowl figures in two other Norfolk witnesses, providing evidence for classifying a feathered angel holding a bowl in the Erpingham window (Cathedral) as all that remains of a Circumcision scene. Scott also noted that the feast of the Nativity of the Virgin is typically represented by Anne holding the infant, but nursing in the Wollaton Antiphonal (Nottingham MS. 150), a manuscript of East Anglian provenance. The same scene illustrates the feast in the Ranworth Antiphonal. The midwife is presenting the swaddled infant to Anne lying in bed, her naked breasts visible above the sheets (**FIG. 6**).

Subject lists also provide a basis for describing regional devotional life. St. Leonard and St. Stephen are thinly documented in the Yorkshire subject lists, but widely so in Norfolk. St. Faith, unrepresented in the two Yorkshire volumes, probably owed her popularity to the Benedictine Priory at Horsham St. Faith. Some local saints like Walstan and William of Norwich seem to have been largely relegated to screens, whereas SS. Edmund and Etheldreda appear widely in a number of media. The Norfolk List also provides further evidence for the complex relationship between official feasts and popular devotion. Long after the offices of the Transfiguration were being copied into existing choir books and rituals, a young mother's death is recorded as occurring on the feast of a martyr replaced by the new feast. Conversely dateable glass and painted panels witness the popularity of the Visitation a quarter century before the feast was officially promulgated in 1475 and widely accepted elsewhere (Pfaff). Although there are few dates for images of St. Anne, there is evidence for devotion well before her feast

was extended throughout England in 1383. St. Giles Hospital in Norwich had been dedicated to the Virgin and St. Anne by its thirteenth-century founder, Bishop Suffield. In the first quarter of the fourteenth century, a chapel was dedicated to her at the Cathedral (c.1329), and the Joys of St. Anne were added to a Norfolk manuscript (NMS MS. 158.926.4f) shortly after its completion (c.1322), probably for a female owner.

A reasonably comprehensive list of subjects in one county also enables us to test general impressions against the facts insofar as we are able to ascertain them from either artifactual or documentary evidence. Thus the repeated assertion that lay musicians appear rarely and only late is contradicted by the evidence (see XV.1b). Similarly, the impression that the Virgin and Child appeared as a rare subject on Norfolk screens is qualified; when lost work is added to extant there were at least a dozen examples. Also, the common belief that saints loomed large (Wilson's "glut of saints") is also qualified when the "helper" saints are differentiated from the Evangelists, Latin Doctors, and Apostles. A survey of all the media rather than just the screens also helps to correct the impression that scriptural subjects were neglected. In fact, they were probably much more extensive than extant work suggests. Narrative scenes from the Old and New Testaments would have been in the main lights, precisely those most easily destroyed, whereas saints commonly inhabited the tracery, less liable to destruction. Grand theological schemes like those in the Cathedral bosses were epitomized in the porch bosses or painted on the walls of parish churches. There is documentary evidence that parishes other than Little Witchingham and West Somerton had sacred history painted on their walls. In a notice of the 1884 issue of the *Ecclesiologist* the writer expressed dismay over the obliteration of the paintings with whitewash at Bridgham: "We are at a loss to conceive upon what religious

principle a Christian Priest could withdraw from the eyes of his people 'scenes from the life of Our Blessed Saviour'; or upon what canon of taste or morals he prefers whitewash to instructive pictures" (p. 94). Even the Five Joys of Mary, which seem to be Marian, were organized with the Resurrection as the central scene in at least two instances (as it is in five extant alabaster altarpieces cited by Cheetham and a sixth in Denmark), its centrality drawing attention to Christ as the key figure in all five scenes. Passion events also occupy central registers, e.g., at East Harling the Crucifixion and Ascension in the two lowest registers of the central light. This privileging contrasts with the porch bosses, where the Coronation is typically central.

The subject lists also enable us to distinguish standard features from incidental ones, thus providing a norm for correcting earlier subjective identifications, e.g., that a woman in a doorway is a harlot enticing a man (see XIII.5 *Wilton*). The Norfolk List documents the importance of a house or doorway in the Works of Mercy; hence a woman in a doorway may well be Mercy offering hospitality to the pilgrim. A second example concerns the prominence of prayer beads in warnings against gossip. It has been said that the Jangling composition represents women gossiping rather than listening to the priest, but the visual focus on the beads suggests instead neglect of private prayer—these woman have forgotten their beads, which hang slackly in their hands much as they do in the hands of Sloth, and instead have turned their tongues to gossip.

Norfolk is an amazing county, not just for the number of its medieval churches (Cautley counted 659) but also for its preservationists, past and present. If I were to write an *explicit* for this book I would begin with the words "compiled by," for this Subject List of Norfolk has been based on three hundred years of observations by antiquaries, artists, professional conservators, enthusiasts

as well as scholars. My compilation pales in comparison with their achievements. The pre-eminent antiquarian source for Norfolk parishes is *An Essay Towards a Topographical History of the County of Norfolk*, typically referred to as Blomefield, although the work was really a grand collaborative effort of a group of antiquaries ranging over three-quarters of a century, with all the strengths and weaknesses of such projects. If Peter Le Neve provided "the backbone of the history of Norfolk," as the *Dictionary of National Biography* asserts, Blomefield provided the flesh. His volumes are full of fascinating details. A case is point is the statue of the Virgin, removed to "an obscure place" in the monastery of the Blessed Virgin and St. Andrew. At some later time a painter "found a silver plate nailed to the top of the head" with a treasure trove of relics inside (2:117–8). This is the sort of detail that largely disappears in later volumes, perhaps one reason why Dawson Turner ungraciously referred to Charles Parkin as Blomefield's "unequal successor." The documentary sources for the *History* transmitted through a tangled web of marriages and friendships are outlined in a contribution by Barbara Green at the conclusion of the Subject List.

A second major source is found in the visual record created by that indefatigable circle of nineteenth-century artists, conspicuous among them the wives and daughters of local clergymen, who recorded work almost as soon as it was discovered. William Beal, the vicar of Brooke, recorded in 1849 that when scraping away a thick coat of plaster, they found extensive wall paintings, which were immediately copied "ipssimus picta" by his wife, the daughter of Dawson Turner. In the Castle Museum collection there are several thousand prints, drawings, and watercolors—over 1000 by C. J. W. Winter alone. Some of the work was destined to illustrate copies of Blomefield's *History* (see Barbara Green, below). The unbound Todd Blomefield is at the Castle, the Neville-Rolfe bound volumes are in the Local Studies Library, and the Dawson Turner volumes are at the British Museum.

The second and third quarters of the century were busy ones. Until 1848 only the Christopher was visible on the south wall at Brisley, but scraping in preparation for whitening revealed a flanking Bartholomew (church dedication) and Andrew. There were losses as well as gains. The Christopher at Stokesby was destroyed by chipping and scraping in 1858. Sometimes, as at Starston, the colored surface crumbled at the touch, though in this case a colored drawing was made. A drawing of the Three Living and Dead at Ditchingham was reproduced in the *Archaeological Journal* for 1848, and apparently the same one was exhibited at a meeting of the Norfolk and Norwich Archaeological Society. On 3 May 1861 Sir John Boileau exhibited at a meeting of the Archaeological Institute drawings of a martyrdom of Thomas Becket discovered at South Burlingham, evidently made by Mr. Jeckell of Norwich, who had supervised the uncovering of the painting. The soldiers were recoverable, but not Thomas, his figure having been obliterated by a substance other than whitewash. Another martyrdom was reported at Burgh St. Peter by the Rev. W. Boycott in July 1865 and sketched before being obliterated. In 1860 the wall painting David Park calls the best in Norfolk was uncovered at St. Gregory's in Norwich. In 1866 the north half of the screen at St. John de Sepulchre was uncovered. In 1877 tests were made of the colors used on a statue found in a wall of the Shimpling chancel. Ironically, we know more about the colors than the statue. The extracts from meetings of the Norfolk and Norwich Archaeological Society are filled with such notices about new findings, a testament to preservationist zeal of that organization. Wall paintings continue to be found, the spectacular Crucifix Trinity at the dilapidated church at Houghton-on-the Hill, a fine St. Christopher at Cockthorpe,

the Latin Doctors and Annunciation in the south aisle at Norwich St. Gregory, and more recently an as yet unidentified program at Bawburgh. Funds are urgently needed to support conservation of such finds.

As in previous subject lists, the arrangement in this volume is chronological; within centuries media are arranged alphabetically. Blocking within media is designed to draw attention to patterns—e.g., all the entries for tower pinnacles are blocked rather than chronologically dispersed. Lost work without dating evidence is arranged alphabetically at the end of each medium. Traditionally, a variety of terms have designated broad chronological periods for architecture and furnishings, political ones like Norman or Tudor, stylistic ones like Decorated (c. 1300–50) and Perpendicular (1350–1500). Other terms such as International Gothic are typically used for panel painting and painted glass. Most of the extant work cited in this volume is fifteenth-century.

A subject list necessarily deconstructs the arrangement of sacred history once embodied in the parish church. Even for parishes like Great Hockham with relatively few entries, they are spread across four sections of the Subject List, with multiple entries in two. The user must, therefore, use the index to appreciate the relationship of these works: the Epiphany and Last Supper, both on the north wall, and the complex composition, which I have called the Exaltation of the Cross, on the chancel arch.

Because of the geographical focus of the subject lists, provenance is central in determining what to include and what to exclude. I have tended to be conservative. For example, I have disqualified a cope in the Norwich Museums Costumes and Textiles Collection because it came from the collection of Percy Moore Turner, who owned a gallery in London before coming to Norwich. Without some evidence of Norfolk provenance, the cope did not qualify for inclusion. On the other hand, I have sometimes included work without certified Norfolk provenance when its iconographical significance seemed to warrant it. The long-standing practice in Norfolk of making up windows out of glass from a variety of sources makes it very difficult to determine what is of Norfolk provenance and what not. The Erpingham window at the Cathedral is a case in point (King [1996], 419–21). East Anglian manuscripts are particularly problematic because the term 'East Anglian' can extend into three dioceses and four counties, whereas the Subject List is confined to one county (see *Manuscripts*, below).

After provenance, subject identification is crucial. Many of the identifications could not have been made without the gracious help of the experts cited in the acknowledgments. I have not attempted to cite identifications that differ from mine. For example, the figure on Christ's left in the West Somerton Last Judgment has been variously identified as female (L'Estrange) and John the Evangelist (Tristram), but the figure *is* John the Baptist, identifiable by traces of a hair garment. Any attempt to correct wrong identifications would have clogged the Subject List beyond burden. Only where there is legitimate reason for alternative interpretation of evidence have I so stated.

Exclusions

Altar furnishings held by angels (on hammer beams, purlins, wall posts), e.g., chalice, ciborium, candlestick, and liturgical book, and hierarchical symbols of papal tiara, miter, and crown. These objects are commonly combined with the instruments of the Passion.

Animal and face masks, sometimes found on poppy head finials of benches, rarely in painted glass though there is a fine mask at Billingford St. Leonard. An unusual survival is the late fourteenth-century jug with a face mask found at Grimston (*Age of Chivalry*, Catalogue no. 182). Some authors connect the lolling tongue so common in animal

masks with demonic power, but such consideration is beyond the scope of this work. Masks are highly conventional in manuscript decoration (see Nichols *et al.*, *Index of Images*).

Backgrounds in rood screens and painted glass, except where useful for dating, e.g., atmospheric landscapes, which establish a relatively late date for screens.

Coats of arms, other than *Arma Christi*, including arms of saints, e.g., the arms of SS. Peter and Paul held by the delicately carved angels on North Burlingham screen (formerly at Burlingham St. Peter). Attributes of dedicatory saints are common in flushwork, as in the basecourse of shells at Southrepps, crosses saltire at Barton Bendish, and gridiron at Hunworth.

Colors are cited only sporadically. Counterchanged backgrounds often determined color selection on screens, and early conservation/restoration practices have sometimes altered the original colors. Where wax was applied to panel paintings, they have darkened, sometimes as the result of chemical reactions with bat dung and urine. Color photographs are cited where known.

Crosses without corpus, though rare Anglo-Saxon remains are noteworthy (e.g., at Whissonett or Little Dunham), as is the iron cross with trefoil leaves on the south door at Tunstead, a shape also popular for pilgrim badges. Roods are cited only with documentation.

Domestic sites have not been searched but are noted where published information has come to my attention. Inn signs would have borne traditional images. In 1433 the Norwich Guild of St. George purchased oil and pigment for the sign at the George Inn, and similar purchases are recorded in the Thetford Priory records for the Angel (Dymond).

Donor portraits, although important for dating when accompanied with arms, are not cited separately unless costume is significant. Some have minor iconographic interest, e.g., the paired lay figures, one with beads, the other holding a church, over the west door at St. Peter Parmentergate.

Flemish glass unless documented as belonging to a parish in our period. A number of churches have Flemish glass leaded into otherwise clear windows, much of it collected in the eighteenth and nineteenth centuries, eventually entering churches by way of gift or memorial (as at Barningham Winter). It is possible, particularly in the area around King's Lynn, that pre-Reformation Flemish glass was imported by local church guilds or patrons. I have thus tended to be liberal about including Flemish material in marshland parishes. See Cole for Continental roundels at Brockdish, Earsham, Felbrigg Hall, Ketteringham, Langley, Saxlingham Nethergate, Long Stratton, Norwich (Cathedral and St. Mary Magdalene), Newton Flotman, Oxburgh Hall, and Swardeston.

Furnishings except with significant iconographic figuration.

Funerary monuments, although Norfolk churches preserve a fine range of medieval cadaver brasses as well as Elizabethan and Jacobean monuments, some with original coloring. Norfolk has at least eight monuments attributable to Nicholas Stone, the foremost Jacobean sculptor, or his workshop. The student of costume will find post-Reformation monuments rich in detail.

Gargoyles.

Grotesque heads unless they have identifiable demonic characteristics. The twelfth-century corbel head with thick pursed lips, blunt nose and exophthalmic eyes (Borg & Franklin, 23) and a later detached head at Brockdish with its large ears, deep eye sockets, exaggerated nostrils, and open mouth exemplify techniques used by the stone mason to suggest menace. When such compositions are found on the north side of the church, they have traditionally been connected with the devil. Such figures, however, are by no means confined to the north. On the Fincham roof lively figures with grinning mouths and lolling tongues alternate with

traditional angels.

Hybrids, with the exception of a few unusual examples.

Portrait heads, although anyone wishing to study medieval treatment of the human head ignores Norfolk at cost. One particularly fine head (c.1320–40), originally at Norwich Whitefriars, is now in the Magistrates Court. Phillip Lindley (pl. 11) connects it with other contemporary work at the Cathedral. For a primitive thirteenth-century example, see Tracy (1987), pl. 27 (Irstead); for the fourteenth century, pls. 71 (Snettisham), 72a (Cley); for fine fifteenth-century heads, Tracy (1987), pl. 113 (Salle), and L & M, Catalogue no. 85 (Thetford Priory 1). There are also particularly fine heads on the elbow rests at Lynn St. Margaret (c1370–80), and a slightly later one at the Cathedral, for which see Martial Rose (1994), 43.

Proper names unless they clearly refer to saints rather than to donors.

Prophet/Patriarch figures, commonly represented in lateral niches in glass but unidentifiable.

Proverbs or texts unless part of an identifiable composition.

Rebuses, either for place names, e.g., the flaming barrel (ton) at Brinton or the swan and barrel at Swanton, or proper names, such as Bishop Lyhart's self-indulgent Lying-Hart bosses at the Cathedral.

Restoration details, though extensive work is cited. Two painted glass Crucifixions, both restored in the nineteenth century, may serve to exemplify the methodology of the Subject List vis-à-vis restoration. Today both are simple three-figure scenes. At Taverham we know from documentary records that the Crucifixion scene was originally in the east window of the north aisle. Only the loincloth, ground, skulls, and some of the quarries are original. There was similar extensive restoration at Martham. Both subjects are classified as Crucifixion, Type 1 "heavily restored."

Sacred monograms though they provide rich allusions, as in a Coronation at Stody where the monograms decorate the back of the throne on which the Virgin and Christ sit. The crowned M is common in flushwork of churches with Marian dedication. It seems likely that guilds dedicated to the name of Jesus had the name suitably inscribed. As early as 1387 the guild of "Christ Jesus" at Sheringham had a "table on which the name of Jesus is written" (Westlake, no. 323).

Textiles, embroidery and painted cloth, unless they contain iconographic subjects. Such work is a rich source for flora and fauna, the latter ranging from small blue birds to swans, from silver baboons to leopards, as well as fabulous animals like the gryphon. An inventory from St. Leonard's Priory cites a ruby satin frontal and matching riddels with white stags and vines (Bensly, 1895, 212, 214). For more details see Watkin's index (pt. 2). Church inventories from the reign of Edward VI document vestment sets powdered with flowers and lilypots, suggesting Annunciation iconography. Something of the complexity of the embroidery at Thetford Priory is indicated by a payment to John Numan, "broyderer," for twenty-six days of work, apparently for repairing vestments (Dymond 2:576). It is common to find vestments embroidered with the attributes of titular saints.

Unspecified antiquarian citations, such as references to screens or glass "curiously painted and adorned with images" though such passages document how much has been lost. Neither are references to Lady chapels cited, many of which, like those at the Cathedral and Wiveton (Harrod [1487], 117), have long since disappeared. The chapel at Kimberley, measuring 12 yards by 7 and ruined by Blomefield's day (2:535), had been founded before 1370 and was served by a chantry priest.

Woodcarving has been only selectively noticed. Omitted are most flora and fauna, although both deserve attention. Tracy cited "at least ten different sorts of leaves" in the

crockets of the Cathedral choir stalls (1990, 35). The stooling of churches produced a rich menagerie of animals and fanciful hybrids, a very few of which are cited in XV.6. Norfolk woodwork deserves a book of its own.

GUIDE FOR USERS

This guide is designed to provide the principles governing the selection of details and determination of dates in the subject list descriptions; to identify numerical systems for various media used to indicate their location within a church; and to clarify vocabulary and suggest the wealth of detail that has been cut from the data base in order to make this volume manageable.

Alabaster fragments found in isolated churches are now for the most part concentrated in Norwich, the major exception being the fine collection at East Rudham. In addition to *Te Deum* tablets, subjects are concentrated in Parts III and IV, the Nativity and Naming of John the Baptist at Mulbarton, a Nativity at Burnham Deepdale, and the Teaching of the Virgin stolen from East Barsham. Individual tablets may originally have been part of altarpieces. There are also non-specific documentary citations for Great Yarmouth (Manship), the Lady Chapel at Old Buckenham Priory (Bl 1: 389), and an alabaster tablet at the head of the altar at Horstead (Watkin 1:30).

Altars are cited in subsections because they provide evidence for images and vestments. They are not double-listed; if image and altar are cited in the main entry, the altar is not cited below.

Apostles are treated in Parts X and XIII. Generic apostles with teaching gestures, common on bench ends or in gesso designs, are not cited individually in the Subject List. Apostles are best preserved in the painted panels of over three dozen rood screens. With the exception of James Major, the apostles wear long tunics and mantles often lined in contrasting color. The mantles are draped in two distinctive ways, with both sides falling loose from the shoulders or with one side draped across the torso at waist height, a convention established by the end of the thirteenth century (Tristram). The mantle is sometimes turned back at the neckline to form a collar with contrasting color (at Irstead ten of the mantles are so arranged). See also Appendix IV.

Arma Christi technically are the symbols emblazoned on a shield as a coat of arms. Some authors refer to the five sacred wounds as *Arma Christi*, but I distinguish the wounds from the instruments of the Passion, using the term *Arma* as shorthand for the collective representation of the instruments of the Passion whether or not they are represented on a shield. See headnote for VI.3, *Instruments of the Passion*.

Arms of the Trinity comprise a shield with diagonal lines reaching from the angles to a center roundel. When complete, a text distinguishes unity of nature from uniqueness of person. Variously abbreviated, the text reads "DEUS" in the central roundel; in those at the three angles of the shield "PATER, FILIUS, SPIRITUS," joined around the perimeter to read "PATER non est FILIUS non est SPIRITUS non est." The name roundels are connected by "est" to the central "DEUS." The arms are ubiquitous, carved on porch facings and font panels, painted in glass and on the walls, and even on the back of a rood screen facing the altar (Great Cressingham, Blomefield 6:101). It is likely that the words were painted on stone reliefs. Since coats of arms are excluded from this survey, the arms of the Trinity are cited only if they feature in other compositions. It is important, however, to remember that the arms of the Trinity were one of the most

common symbols that Norfolk parishioners saw in their churches. Will evidence and guild records document widespread Trinitarian devotion.

Bells sometimes bear the names of the dedicatory saints, but L'Estrange (1874), noting that inscriptions rarely correspond to church dedications, cited Sperling's suggestion that they reflect instead altar dedication and gild devotion. A bell at Foulsham was funded by the Holy Trinity Guild: "FRATRES: GILDE:SANCTE:TRINITATIS:FECERUNT:ME: FIERI," and the Corpus Christi Guild of Oxborough was responsible for a bell at Salhouse: "ORATE PRO A[N]IMABUS F[ATR]EM & SOROR GILDE CORPIS XPISTI DE OXEBURGH" 1481. Inscriptions are in the first person singular, "VOCOR JOHANNES," or plural "SANCTORUM MERITIS PANGAMUS CANTICA LAUDIS." Inscribed prayers may be directed to a specific saint "QUESUMUS ANDREA FAMULORUM SUSCIPE VOTA" (Burston) or the Deity, "SANCTA TRINITAS SALVA ME" (Gillingham). They are often in formulaic verse. Inscriptions are noticed selectively.

Bench End as a term refers to stalls as well as benches; only rarely are heads, shoulders, or elbow rests specified. Except for the Cathedral there are few specific dates for figured furniture. Costume is sometimes used for dating, as at Wiggenhall St. Mary. Nineteenth-century wood-carvers were particularly skilled at imitating medieval designs, the screen at Ditchingham being an especially good example where bits of medieval carving were incorporated into the new work. Even Gardner (1955) asked forgiveness "if one or two clever fakes" crept into his inventory. Jane Quail, who has studied the arm rests on the stalls at East Harling, notes the skill of repair work let into original woodcarving. She also believes it is possible to distinguish different artists on stylistic grounds.

Bosses in parish churches, when numbered, begin from the east; for Cathedral bosses see Appendix II. The Joys of Mary were a popular subject for late porch bosses, though Walpole St. Peter boasts a particularly magnificent set of animals. When detail is obscured by whitewash, generic descriptions should be used with caution.

Brasses are an invaluable source for costume study, in particular minor detail like metal mounts of belts and cinctures. However, since the subject lists are only incidentally concerned with costume, brasses are usually noticed only for iconographical subject. Date cited is that of death, which does not always coincide with the manufacture of the brass.

Church Dedications are cited where a parish name would otherwise be ambiguous, and for rare saints or ones with relatively little artifactual or documentary citation since every parish was required to have an image of its patron. Otherwise, dedications of hospitals, leprosaria, parochial chapels, or parish dedications are not noticed other than to include figures calculated by Linnell and Bond. Linnell notes that Norfolk has a high concentration of unusual dedications. His citations are cumulative, including ruined and redundant churches (images of churches declared redundant would have been transported when one parish was joined to another; see XII *Olave*). The most common dedication, singly and jointly, was to the Virgin (196); the next seven in popularity were All Saints (153), Andrew (106), Peter (61 or with St. Paul a total of 101), Margaret (58, also the fifth most popular saint in Lincolnshire and Kent), Michael (43), John the Baptist (30), and Nicholas (29). Numbers are suggestive rather than definitive. Wymondham was originally dedicated to SS. Mary and Alban, with Thomas of Canterbury (Thomas Becket) replacing St. Alban. Today, elderly parishioners at Lyng St. Margaret remember the church having been dedicated to St. Michael. Dedications also varied in wills, though Simon Cotton estimates only a 5%

chance of finding a church dedication in a will. Sometimes such variation has artifactual support, e.g., a boss of the martyrdom of St. Andrew at Horsham St. Faith (a 1457 will cites Andrew) or the crowned A in the flushwork at Lopham St. Nichols (a 1479 will cites Andrew). Linnell is skeptical of modern Marian dedications under specific titles.

Clerics are identified by tonsure. Subsets can sometimes be distinguished by clothing (see Costume Glossary): priests by chasuble, deacons by dalmatic (their tonsure is usually prominent as well). Secular clergy are difficult to identify, though Master John Schorne is represented in academic garb. Members of the regular clergy are easier to distinguish because of their habit, though without color it is often impossible to distinguish a monk from a friar. For Benedictines, see XII *Benedict*; for Premonstratensians XIII.6, the Ranworth Antiphoner; for Dominicans XII *Dominic* and *Peter Martyr*. Benedictines appear on a number of Cathedral cloister bosses (Fernie, pl 56) not entered in the Subject List. "Cleric in religious habit" = a tonsured male in a nondescript, sometimes voluminous, garment with hood.

Dates cited for English kings and bishops (and archbishops) are regnal dates and drawn from Fryde *et al.*, *Handbook of British Chronology*; papal reigns from Duffy, *History of the Popes*. Dates for other saints are based on Farmer, *Oxford Dictionary of Saints*. Authority for dating of works is cited in the first entry. The best way to find such information is always to check the first index entry under place name; for example, *Stalham, pwd* where the initial entry cites dating detail. Dating, even when specific, should be taken as approximate; caveats in published surveys of dates apply to this work as well. Building dates can provide a *terminus a quo*, just as a succession of bequests suggests a major campaign, but testamentary dates need to be used with caution since a donor's desires may have been delayed substantially or not met for financial reasons. Stylistic dating can range over three-quarters of a century. I have made no attempt to adjudicate dating disputes as they belong more properly to specialized studies. See also media entries below.

Descriptions generally proceed from left to right (from viewer's perspective). In figure description LH/RH means the figure's left/right hand. For symmetrical compositions description begins with the central figure (C). "Virgin (C) flanked by 2 angels" means there are 2 angels on the right and 2 on the left.

Embroidered vestments that survive probably do so because of thrifty churchwardens. They are all dated stylistically. Post-Reformation inventories provide only a *terminus ad quem* for lost work. Vestments saw long service, a fact attested where more than one inventory exists for the same church.

Fonts with iconographic subjects are all perpendicular in date with the exception of a notable series of Norman fonts. Prior and Gardner (1912) argued that perpendicular fonts moved from simple figures (early) to complex scenes (late), a theory supported by limited documentary evidence, e.g., the Evangelist font at Caistor St. Edmund (gift of Richard Caister † 1420) or the lion font at Topcroft with a bequest in 1435. The Acle font (1410) was highly innovative with its Crucifix Trinity and Pietà. The complex seven-sacrament fonts first appeared mid-century. Arms were common on the bowl faces, the most common being the Trinity, Eucharist, *Arma Christi*, titular saints, donors, and patrons. Blank shields may have been so painted. Figure sculpture within the niches of font stems is often badly disfigured. Unless identification is clear, such work has not been noticed; guesses can already be found aplenty in church guides.

Generic Descriptions of popular subjects are entered at section heads. Unless stated otherwise, the details obtain in each of the citations except fragmentary subjects (so identified), which are described in full.

Guilds and altars are cited for minor saints to provide evidence of devotion that might otherwise go unnoticed. Wealthy guilds would have provided statues for their altars, and even modest ones might have afforded a painted cloth. At Upwell a guild dedicated to the Invention of the Holy Cross had expenses to repair a "picture of the Holy Cross," and one dedicated to the Purification was organized specifically to expend monies for, among other things, an image and ornaments "at the altar" of the Virgin (Westlake, nos. 336–7). No attempt has been made to cite guilds, altars, or chapels for popular saints. Walter Rye calculated no fewer than seventy-five guilds at King's Lynn (see also Farnhill).

Image, a common term in antiquarian sources, is non-specific for medium. Wooden effigies of royalty, some with moveable joints, still preserved in the Westminster Abbey Museum, were variously referred to between 1413 and 1533 as *pycture* or *ymage* (Harvey and Mortimer, 3). Where undated, "images" are block-listed as fifteenth-century work, but the chronological designation is suppositious.

Initial Entries provide information about dating, catalogue references, manuscript provenance, etc. This information will not occur in later entries for the same work. The general index should be used to locate initial entries.

Lights, commonly funded in bequests, are ubiquitous for popular saints; Blomefield recorded nineteen at Fakenham alone. Lights are cited only for less well documented saints.

Manuscripts whose calendars identify them as destined for the Norwich diocese (with diocesan feasts and grading) are now widely scattered, and catalogue citations often lack sufficient detail for classification within the subject list guidelines. Thus this important source remains largely untapped except for fifteenth-century manuscripts presently in Norfolk collections, which have been inventoried because they are part of the Index of Images project in which the compiler of this Subject List is a contributing member. The county Norfolk is here defined by its pre-1835 boundaries; other diocesan manuscripts will be treated in the Suffolk Subject List. I have, however, included two East Anglian manuscripts with Cambridgeshire provenance for their iconographic relevance: Chaucer's *Parson's Tale* with illustrations of sins and virtues (Cambridge University Library Gg.4.27[1]) and the *South English Legendary* (Bodleian Library Tanner 17) because of the text's extraordinary collection of marginal illustrations for the lives of the saints. For East Anglian manuscripts excluded from the Norfolk Subject List, users are referred to volumes 4–6 of *A Survey of Manuscripts Illuminated in the British Isles*, gen. ed. J. J. G. Alexander; catalogue citations are provided only in the initial entry. Unless stated otherwise, it can be assumed that illuminations in liturgical manuscripts are tied to the appropriate feasts or *memoriae*. Manuscripts owned by the Norfolk Museums and Archaeology Services are cited in Ker as Castle Museum but are currently housed in a number of sites.

Painted Cloth, by nature fragile, is documented in inventories, wills, and church accounts. At Tilney All Saints there are regular entries in the early sixteenth century for "berying off banerys to Saynt Lawrence," sometimes cited with similar procession expenses for Rogation days and "Crosse days" (Stallard, 101). Presumably such banners would have been painted or embroidered, though the subjects can only be conjectured. Sepulcher cloths are often noticed as "steyned" but without specification.

Painted Glass is rarely *in situ*. Much has been rearranged relatively recently; e.g., glass Woodforde described in the north aisle at East Harling was moved to the south when an organ was installed blocking the northern window. The archaeology of window glass is exceedingly complex given the history of Victorian releading and the pre-World War II practice of creating patchwork windows from bits of glass, sometimes from a number of sources. The Subject List provides only current location, generally cited by the system used by the Corpus Vitrearum Medii Aevi (see diagrams 1 & 2) but with some variation because the Subject Lists originally used a different system. It has not been possible to recheck early field work when inaccessible vestry windows without representational glass were not counted. Also, non-representational glass in eyelets was not taken into account in tracery lights, in which case A1

designates the first full-size tracery light. Dating of glass is largely based on stylistic analysis except in the rare cases where donors can be identified. Unless stated otherwise, all specific dates are David King's (1974 and personal communication for Old Buckenham, Cley, Field Dalling, Guestwick, Kimberley, and Stratton Strawless). More general dating is based on cumulative evidence. Will evidence for glazing one window may be evidence of a more general campaign, and where style is homogeneous, that date may be extended to a number of windows. Churches sometimes preserve glass from a number of periods (e.g., South Creake and Mileham) or from a number of different places (e.g., the Norwich Guildhall). I have not attempted to date small fragments of subjects more precisely than by century. Full description of painted glass must await David King's Corpus Vitrearum volume for Norfolk.

Painted Wood panels on the dado of screens are described as currently arranged, except Creed screens where the order is demonstrably wrong. Panels are cited left to right, numbered separately for the north (N1, etc.) and south (S1, etc.). Where specific testamentary dates are cited, the source is Simon Cotton (1987). Quarter centuries are based on non-specific bequests or stylistic judgment (Appendix VI). For a description of the physical structure of screens, see Briggs (997–1000).

Pilgrim Badges are difficult to situate because they are usually found some distance from shrines of origin; ascriptions should be used with care. Many badges that Mitchiner ascribed to Walsingham have since been assigned to other shrines by Spencer (1998). Badges are here cited by find spot or museum, not by shrine unless there is good evidence for doing so. Mitchiner (38) has argued that the ampullae found in Norfolk field sites were probably holy water containers used for blessing fields rather

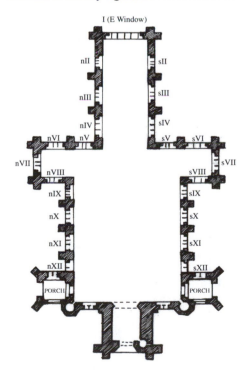

Diagram 1. Arrangement of windows at Salle and CVMA numbering system. NII = clerestory.

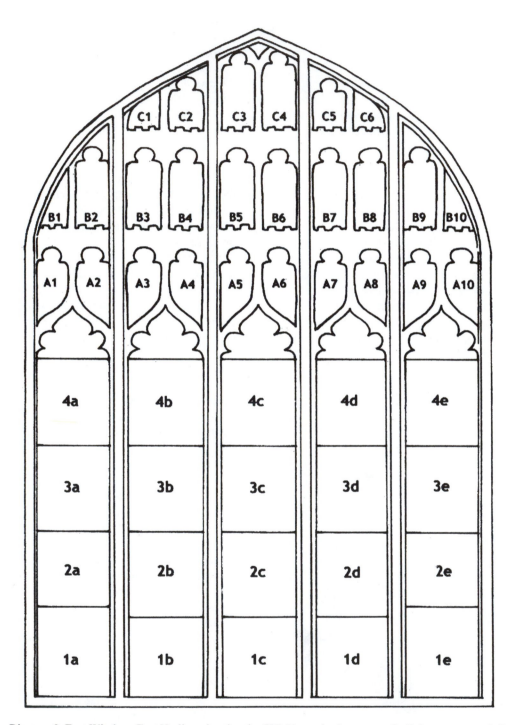

Diagram 2. East Window, East Harling, showing the CVMA numbering system for lights; note especially the manner in which the tracery lights are differentiated.

than related to a shrine. He also notes that Walsingham ampullae are largely confined to East Anglia finds in contrast to other Walsingham badges found over a wide geographic range. Finds in Norfolk indicate that pilgrims returning or passing through had visited widely, Doncaster and Eton (the Virgin), Westminster (Edward the Confessor), and Canterbury (Thomas Becket). Such finds are cited selectively where they reinforce the same devotion within Norfolk.

Place name is normally the parish church. *Ex situ* work is cited by original site if known, with present site noted within the description (e.g., the Trinity glass from Tottington now at the Cathedral). Only the Norwich museums, the Victoria and Albert Museum, and the Burrell Collection have been searched for Norfolk work, though when known other work has been included. Museum holdings are cited by provenance when known, otherwise by museum name. "Provenance Uncertain" means uncertain in Norfolk. Manuscripts with diocesan calendars but with no specific provenance are classified as Diocese. Manuscripts more specifically placed (e.g., Wiggenhall St. Germans) may be assumed to have diocesan features. Walsingham without further specification refers to the shrine proper.

References are kept to a minimum. Page numbers are not normally cited for sources organized alphabetically by place unless references are to introductory sections. Eighteenth-century typographical conventions in Blomefield and other early sources have not been reproduced. Only exceptional critical studies are cited and only in the first entry for place name. Thus the Norton, Park, and Binski study of the Thornham Retable occurs under the first entry for Thetford Priory 2 in Part III.2. Anyone accessing the retable through other subjects (e.g., XII *Dominic*) must check the location entry in the index in order to find the bibliographical reference.

Relics are noticed because acquisition was sometimes related to the promotion of devotion to a new image. Major religious institutions would have had a store of relics displayed only rarely if ever. At the Cathedral we have no record of devotion to SS. Gilbert, Euphemia, Theodore, or Hernolaus, though their relics are recorded (Beeching, 17).

Reproductions are cited selectively on the basis of quality as well as availability of source. Where a composition comprises multiple subjects, reproductions are cited only in the first entry. Sources with multiple reproductions that do not meet criteria for inclusion are indicated in the Bibliography. Where illustrations are small and difficult to locate in long works, page numbers are provided.

Saints with generic attributes have been excluded unless there is other supportive evidence (but see XII *Etheldreda* and *Thomas Becket*). The guidelines for identifying saints provided by Richard Hart (56–57) in the middle of the nineteenth century are still sound ones (though his identifications are sometimes less so)— consider church dedication, local guilds, and regional saints before opting for unusual choices. It is also wise to be chary of unusual identifications provided in the last century unless there is visual evidence, either *in situ* or in the extensive watercolor collections. Spellings are based on David Farmer, *The Oxford Dictionary of Saints* with the exception of Sitha, who is never called Zita in Norfolk, Birgitta, and Lawrence to conform to the spelling of earlier subject lists. Documentary citations for SS. John and Thomas are generally ignored unless further specified. No attempt has been made to distinguish fact from fiction (for which see Farmer and the publications of the Bollandists). Biographical detail has been selected for its pertinence to iconography. Saints are classified liturgically, a distinction also found in common speech (e.g., Anthony Abbot, Edward Martyr, and Edward the Confessor).

The classification sometimes enables identification. Thus Theobald at Hempstead St. Andrew paired with St. Denys is probably the archbishop of Canterbury; both are prelates, the one a confessor, the other a martyr.

Seal citations are drawn from catalogues. Sites may refer to place where a seal-die was found. Single dates refer to date of sealed document. For bishops and priors inclusive dates in parentheses refer to terms of office. Quoted identifications should be used with caution.

Stop is used generically to refer to molding terminals whether hoodmold or label stops.

Texts when they are standard elements of a subject, e.g., the angelic salutation, are provided only in the generic description since variant spellings and abbreviations are immaterial to subjects. EDAM guidelines provide for the expansion of abbreviations in italics with missing letters/words in brackets. The fragmentary condition of much of the surveyed work makes it impossible to hew very carefully to these guidelines. Glass is often dark and deletion symbols difficult to discern. In wall and panel painting, series of minims with only the lower half of the strokes preserved, sometimes a dozen in succession, makes transcription a guessing game. It is useful to remember that what we read today may be based on nineteenth-century guesses, often probably sound ones since the evidence was better then. A case in point is the reading Camm provided for Lazarus at Thornham in the early twentieth century: "Much obliterated but from the Dawson-Turner painting, I found it ran *Per me multi crediderunt in Ihesum*." This is precisely what we read today, clearly written, not "much obliterated," with predictable abbreviation symbols. In many cases, where texts are easily legible, one can suspect restoration.

Wall Paintings when narrative in structure typically read like a book in horizontal registers from left to right. These registers are cited by Arabic numerals and individual scenes by small letters (the same system used for the main lights of windows). Narratives sometimes read top/down (Sporle), sometimes bottom/up (Hemblington). Given the fact that wall paintings are subject to a number of hazards, rising damp, salting, growth of microorganisms such as algae, and the deposition of bat effluvia, it is remarkable that so many have survived, more than in any other county. See the useful survey by David Park in Pevsner and Wilson, 67–68.

ABBREVIATIONS AND TERMS

al	alabaster
Bapt	Baptist
be	benchend
betw	between
Bl	Blomefield, Parkin, *et al.*, see Bibliography
BL	British Library
BM	British Museum
Bod L	Bodleian Library, Oxford
c	*circa*, +/– 15 years
C	center
Cambs	Cambridgeshire
Cat.	Catalogue Number (illustrated)
CB	Cambridge
CCCC	Cambridge, Corpus Christi College
ch(s)	chapel(s)
ClunyM	Musée National du Moyen Age, Paris; formerly Cluny Museum
CUL	Cambridge University Library
CVMA	Corpus Vitrearum Medii Aevi
d	pence
Diocese	MSS. with calendars for the Norwich diocese
DNB	*Dictionary of National Biography*
DP	David Park, in Pevsner & Wilson
DT	Dawson Turner's collections to illustrate Blomefield's *Norfolk*, BL Add. MSS. Add. 23,013–23,062, cited by the last two digits of the MS. number + folio. Thus DT 24:133 means Add. MS. 23,024, f. 133.
E	east
emb	embroidery
Ev	Evangelist
ex situ	not original with church
f/ff	folio/folios
fig(s)	figure(s), used of people without clear gender identification
fig(s)	figure(s), illustration(s)
FIG	in-text figure, or in photo section
fn	footnote or endnote
frag(s)	fragment(s)/fragmentary
Gt	Great
hi	historiated initial

il	illustrated in/on
im	image
incl	including
inscr	inscribed/inscription
in situ	in original site
L	left
LA	left arm
L & M	P. Lasko and N. J. Morgan, *Medieval Art*; see Bibliography
L & P	*Letters and Papers*; see Bibliography
LF	left foot
LH	left hand
LS	left shoulder
Lt	Little
Lynn	King's Lynn
Maj	Major
M & R	D. P. Mortlock and C. V. Roberts, *Norfolk Churches*; see Bibliography
Min	Minor
ms(s)	manuscript illumination(s)
MS(S)	manuscript(s)
N	north
nd	no date
NMR	National Monuments Record
NMS	Norfolk Museums & Archaeology Services
NNAS	Norfolk & Norwich Archaeological Society
NRO	Norfolk Record Office
NRS	Norfolk Record Society
P&W1	Pevsner and Wilson, vol 1; see Bibliography
P&W2	Pevsner and Wilson, vol 2; see Bibliography
p(p)	page(s)
pcl	painted cloth
pg	painted glass
pl(s)	plate(s), illustration(s)
pwd	painted wood, unless stated otherwise on screen dado
R	right
RA	right arm
RCHME	Royal Commission on the Historical Monuments of England
RF	right foot
RH	right hand

RS	right shoulder
S	Saint
S	south
s	shilling
S & N	M . R. James, *Suffolk and Norfolk*; see Bibliography
sc	sculpture
SPH	S Peter Hungate, Norwich
SPM	S Peter Mancroft, Norwich
SS	Saints
Suf	Suffolk

Thetford Priory (1)	Cluniac	
Thetford Priory (2)	Dominican	

U	University
UEA	University of East Anglia

V & A	Victoria and Albert Museum
VCH	*Victoria County History*; see Bibliography

W	west
wdcarv	woodcarving
Wdf	Christopher Woodforde, *The Norwich School of Glass-Painting*; see Bibliography
Wilts	Wiltshire
win	window
wp	wall painting
*	no longer extant
†	died
~	alternates with

?Place name = queried provenance; place names refer to parish churches

Place name? = queried identification of subject at this place

In designations of date by century, superscripts designate quarter century, as in 14^1, 14^2, etc.

I. Representations of God, Angels, Devils

1. Deity

Where it is not possible to distinguish the Father from the Son, such representations are classified as Deity. The cruciform nimbus does not seem to have been used exclusively for the Son. Quoted identifications should be used with caution since terminology is not uniform. All pg frags are heads unless stated otherwise.

Cathedral Priory. ms, Bible, Bod L Auct. D.4.8, hi, f 339v (Ps 109). 1190–1250; 14c Cathedral Priory pressmark. Seated, blessing. Morgan, *Survey* pt 1, Cat. 75. This exceptionally important Bible has historiation at the head of each book; the subjects entered here are selective; for full details, see Morgan.

Cathedral? sc, capital. 12c. Seated fig on ?throne, Borg & Franklin, Cat. 4.

Cathedral Priory. ms, psalter, Lambeth Palace 368, hi, f 97 (Ps 109). c1270–80. God blessing; Morgan, *Survey* pt 2, Cat. 181.

Cathedral Priory. ms, Martinus Polonus, Chronicles of the Roman Emperors and Popes, BL Royal 14.C.I, ff 20–70, hi f 20. 1295–1303. "Lord blessing," Sandler, *Survey* Cat. 48.

Diocese. ms, hours, NMS 158.926.4f, hi, f 44 (Lauds, *memoriae*). c1310–20. Bust. Sandler, *Survey* Cat. 47.

Burlingham S Edmund. pg, sV, upper segment betw 2 lancets. 14c. Bust, cruciform nimbus, forked beard, gown with loose fold at neckline.

Kimberley. pg, sII, set in tracery. 14c. Head, red nimbus.

Ketteringham. pg frag, reset in E win, 2a. 14c. Red nimbus, dark yellow gown, dark mantle, LH raised, ¾ profile.

Gt Massingham. pg, quatrefoil at head of nII. 14c. Bust, full face, cruciform nimbus; characteristic central part of hair, loose fold of gown at neckline.

Mileham. pg, W win, uppermost eye. 14c. Head.

Bridgham? pg frag, nII. Trace of hand and gown.

N Tuddenham. pg, sIV, head of tracery. 14c. Expressive eyes, drooping moustache; flanked by censing angels. Most of the glass is *ex situ* (Wdf 55), probably from a number of sources. The rector Robert Barry was an enthusiastic collector of glass at a time when other churches were remodeling. See also XI.4.

Saxlingham Nethergate. *pg, E win, head of tracery. c1400. Bust, cruciform nimbus, full face, shoulder-length hair; blue gown with coin design, loose fold neckline; DT 23:19.

Crownthorpe? *pg, "upper part" E win. "Father, or our Saviour setting, with a candlestick & golden or yellow candle on each side of him, and a Globe at his feet," blessing and "holding something in LH but broken," NRO, Rye 17, 1:236v.

Castle Acre? pg frag, not *in situ*, sIV.3a. c1400. Head.

Woodton? sc, apex of sIII arch. S aisle added before 1348. Bearded head.

Hemsby. *See* Pity of the Father.

Salle. pg, sXII. c1411 (King). Head of Deity with cruciform nimbus at **A2** and **A4**; at **A2** holding cloak with RH, pointing to text with LH; **A4** (composite) ermine-lined gown, RH at waist, LH raised. "God the Father" (Marks 184), Christ (King 1979). Frag text "relating to the Old Testament scenes given by Thomas Boleyn in c.1411" (King [1979] 333).

Bale. pg, sV.2b. Early 15c. Cruciform nimbus, short beard, perhaps seated; mantle fastened with morse.

Letheringsett. pg frag, quatrefoil tracery, sIII.2a, not *in situ*. c1430–40 (King). Long hair falling on shoulder, short beard.

Swanton Abbot. pg frag, sIV.B3, lower foil of quatrefoil. c1432 (Cotton, 1983). Garment with loose fold at neckline.

Gt Cressingham. pg, nVIII.B3. 15^{1-2}. (Angels below), face faded, RH extended, LH with orb surmounted by cross fleury; radiance, nebuly surround.

Norton Subcourse? pg frag, sVI. 15c. Bearded head in closed crown with peak.

Norwich SPM. pg frag, E win, 3e. Mid 15c. Head in rayed nimbus.

Pulham S Mary. pg, eye of tracery, nVII. c1450. Apostles below.

Norwich SS Simon & Jude. pg, frag, nIV, eye of tracery. Bust, beard and blue gown.

Cawston. pg frag, sX.2a. 15c. Cruciform nimbus, short beard.

Holme Hale. pg, W win, C1. 15c. Bearded fig at

head of tracery.

N Tuddenham. pg, sVI.A2. 15c. Head leaded on bp.

— pg, nVI.A1. 15c. Seated, in white gown with narrow gold braid at neck and wrists.

Warham S Mary Magdalene. pg frag, nIV, head of light a (*ex situ*). ?15c. Closed eyes, moustache.

Ringstead. *pg, belfry win. Drawing of head, NRO, Rye 17, 3:134.

Salle. sc, S porch boss (C). Mid 15c. Head with small beard; feathered angel in prayer.

Heydon. sc, S porch boss (C). 15c. Against mandorla, bearded fig seated fully clothed, hands raised; surrounding bosses with angels in attitude of prayer.

Burnham Market. sc, relief, battlemented parapet, tower. 15ᵉˣ (arms of lord of manor †1500). (Reading clockwise) **N7** against radiance ?crowned fig with orb, turned slightly towards adjacent panel **N8** with kneeling woman (?donor) in attitude of prayer; Wilson (P & W 2) thinks the lord of the manor. On the N, E, and perhaps W faces, the subjects are treated in paired panels. The S is badly eroded.

Lynn All Saints. wdcarv, boss, S aisle. 15c. Crowned, seated fig with nebuly surround.

Outwell. pg, sIII.C3 (Beaupré Ch). 16¹. Deity seated with orb in LH, "in a chair of gold" (Bl 7:471).

Hand of God (Manus Dei)

See also V.2 and XII *Edward the Confessor.*

Cathedral. seal, Thomas de Blundeville (1226–36). Hand issuing from cloud over seated Virgin and Child, *BM Cat. of Seals*, 2022.

Norwich, Carrow Priory. second seal. 13c. "Over the head of the Virgin a hand of blessing," *BM Cat. of Seals*, 2878; see VIII.3 *Virgin Standing.* The Benedictine prior of nuns, originally dedicated to S Mary and S John, moved from Norwich to Carrow suburb c1150.

Beighton. paten. c1350. In sexfoil depression within cruciform nimbus, hand issuing from fold of sleeve. Hope and Fallow (type C); L & M Cat. 36, cited as the earliest surviving paten; on display at the Cathedral. The 4 *Manus Dei* patens are also illustrated in small scale in Manning, facing 89.

Foxley. paten. c1350 (queried by Oman, 51, fn1). Issuing from fold of sleeve; il Hopper (1917) facing 226; on display at the Cathedral.

Paston. paten. c1450. Issuing from fold of sleeve, clouds with 3 stars below; Hope and Fallow (type E) pl 9.1; Manning facing 89; Hopper (1922) facing 10.

Cromer. paten. c1500. Sexfoil depression, hand issuing from fold of sleeve, surrounded by glory. Hope and Fallow (type C); il Manning facing 89.

Irstead. sc, relief, font bowl. 15c (late 14c, Cautley). Against stylized nebuly, hand with depending scroll.

The Father.

See also VIII.1 *Coronation*

?Wiggenhall S Germans. ms, Howard Psalter, BL Arundel 83 I, f 3v. At center of a wheel diagram of the petitions of the *Pater Noster*, Father enthroned, blessing, orb in LH. Sandler, *Survey* Cat. 51, suggests the psalter may have been intended for the Fitton manor chapel at Wiggenhall S Germans.

Lynn. pilgrim badge. After 1420. (Upper register) bust of God the Father with radiance behind head, nebuly below; (lower register) head of Richard of Caister, text surround, "soli deo honor [et amor et gloria]"; Spencer (1980), Cat. 111. In a version found at Salisbury, the Father is cross-nimbed, Spencer (1990).

Foulsham. pg, nII.B1, not *in situ*. 15c. Father crowned, orb in hand, seated above nebuly; tiny composition.

Barton Turf. pg frag, nV.2c, not *in situ*. 15c. Tiara, forked beard, hand on breast just below neckline.

Hoe. *pg, N aisle E win. "On another pane, God the father," NRO, Rye 17, 2:258v. It is unclear whether this subject is part of a larger composition; see II.5

The Son

Isolated figures of Christ may have been part of a larger subject; see IX.

Diocese. ms, Corpus Christi Psalter, CCCC 53, miniature, ff 17v–18. 14¹. Christ in majesty, paired with James Maj and John Bapt; James (1912).

?Cathedral Priory. ms, Gregory the Great, *Moralia in Job*, CB Emmanuel College

112, hi Book 19. c1310–20. RH blessing, tau orb in LH; flanked by tetramorphic symbols; Sandler, *Survey* Cat. 45, il no. 104. This is the classic Majesty composition. Full description of the MS in James (1904). Sandler notes the rarity of illustrated *Moralia*, this being the only known English example.

Cathedral. wp, vault of Ante-Reliquary Ch. c1325. Christ seated on vine in center of vault, surrounded by saints in groups of three; blue drapery, outer gown purple. This work could be classified in a number of ways. David King argues that it is based on John 15:5 (1996, 395). It is also possible to see the program as an extension of the Tree of Jesse motif. The vine motif was particularly popular in the 14c (see VI.2 *Lt Witchingham*).

Kimberley. pg, E win, center of upper tracery. Early 14c (King). Head flanked by sun and moon (with faces); sun and moon more normally flank Crucifixion (below at A1).

S Creake. pg frag, nXI.3b, not in situ. 1330–40. White mantle over green gown.

Bexwell. pg, Norman N win. 15c. A small "head of Christ," P & W 2.

Irstead. See Vernicle.

Norwich SPM. *pcl for Trinity altar. 16[1]. Above "the second person and in ther lower parte o' Lady," Hope (1901) 219.

Norwich. *wdcarv. 1501. Bequest of "a maser w[t] a brode bonde, and a prynt of Jhesus in the botom," Harrod (1847) 121. An interesting example of a secular vessel.

Majesty Seals

Cathedral, Benedictine Priory of the Holy Trinity. seal, second conventual. 1258. Demi-fig on cloud, both hands raised; Annunciation below; *BM Cat. of Seals*, 2093. For discussion see Heslop (1996) 447–50 and fig 165.

— seal, Deanery of the Manors of the Prior and Convent. 1321. The "head of our Lord," *BM Cat. of Seals*, 2082.

— seal, Nicholas Hoo, Prior. 1378. "Our Lord, with cruciform nimbus, seated in a canopied niche . . . ; lifting up the r.h. in benediction, in the l.h. an orb"; *BM Cat. of Seals*, 3765.

— seal, Alexander Tottington, Prior. 1382. The same with the orb topped with a large cross, *BM Cat. of Seals*, 3766.

Cathedral. seal, Walter Suffield (1245–57). Bp blessing, flanked by symbols for Luke and Mark; reverse, "Our Lord in glory, enthroned, lifting up the r.h. in benediction"; "LH pointing to lateral wound" (*Index Monasticus* xxxi); below bishop kneeling, HOC TE TORMENTO : REDIMI WALTERE MEMENTO, *BM Cat. of Seals*, 2024.

— seal, Simon Walton (1258–66). 1258. Reverse "our Saviour on a throne" RH blessing, *Index Monasticus* xxxi.

— seal, Thomas de Skernyng, archdeacon. 1272. In upper register "head of our Lord," *BM Cat. of Seals*, 2106.

— seal (faculty), John Salmon (1299–1325). 1323. "Our Lord seated on a throne," RH blessing; *BM Cat. of Seals*, 2065; see also Hope (1887) 299.

— seal, William Ayermine (1325–36). 1335. "our Lord with nimbus, seated under a gothic canopy, lifting up the r.h. in benediction, in the l.h. a mound [orb]," *BM Cat. of Seals*, 2038; Bayfield (314) cites orb and cross.

— seal, Henry Despenser (1370–1406). In gothic niche "our Lord seated betw. two angels; Trinity below," *BM Cat. of Seals*, 2045; see also Hope (1887) 299.

Norwich. seal. Probate Court. 1403, "on a church-roof, and beneath a trefoiled gothic canopy, our Lord, half-length, lifting up the r.h. in benediction, in the l.h. a cross"; *BM Cat. of Seals*, 2077.

Modney. seal, Benedictine Priory. 15c. "Our Lord, with nimbus, seated . . . ; lifting up the r.h. in benediction, in the l.h. an orb topped with a long cross"; *BM Cat. of Seals*, 3655; Heslop (1996) fig 165.

Dove of the Holy Ghost

A dove descending may be from a number of compositions; occurrences cited here have no evidence for the original scene. The dove also appears as a sign of inspiration; see XII *Gregory*, *Birgitta* (*Bridget of Sweden*), and *Richard Caister*.

Diocese. ms, hours, NMS 158.926.4f, hi, f 43v (Lauds, *memoriae*). c1310–20. Dove of the Holy Spirit.

Ringland. *im. 1467. "a cloth to cover the image of the Holy Spirit," Bl 8:254.

Seething. See IV.2 *Annunciation*.

Suffield. See IV.2 *Annunciation*.

Castle Acre. pg frag, sIV.1b, not *in situ*. Dove descending.

Shipdham. wdcarv, boss, N aisle, E end. 15c. Angels carved on four faces of cube; dove on face parallel to floor.

Elsing. *im. 1503. Bequest "unto Seynte Sprytte l[li] of waxe, to be made of v small tapers, to brenne be for hym," Harrod (1847) 122.

Holy Spirit Guilds

Attleborourgh, *Index Monasticus* 71.
Congham, Watkin 2:130.
Clenchwarton (with Jesus and S Margaret), Westlake no. 228.
Geldeston, *Index Monasticus* 72.
Gressenhall, Bl 9:518.
Roughton S Mary, Bl 8:158.
Scottow, Bl 6:345.
Shipdham, Bl 10:248.
Southburgh, Bl 10:251.
N Walsham, Bl 11:79.
Wells-next-Sea, Bl 9:285.
Wiggenhall S Mary Magdalene, 1368–89, Farnhill.
Wymondham, 1524, Farnhill.
Yarmouth, 1475–6, Morant, 224–5; Bl 11: 366.

Son Seated on the Right Hand of the Father

Cathedral Priory. ms, Ormesby Psalter, Bod L Douce 366, hi, f 147v (Ps 109). 14[1]. Father and Son flanked by angels on wheels, 3 sets of wings, scarves; enemies underfoot ("Sede a dextris meis; donec ponam inimicos tuos scabellum pedum tuorum"); Sandler, *Survey* Cat. 43; il Sandler (1983) fig. 47. Robert Ormesby's gift to Priory for use of sub-prior.

Diocese. ms, psalter, Bod L Liturg. 153, hi, f 102v (Ps 109). 15[1]. Son seated at the right hand of the Father. Scott (*Survey* 1:Table I) cites 20 examples of this subject out of 31 MSS in which Ps 109 is illuminated.

One Figure and Dove

Cathedral. seal, Archdeaconry. 13c, "our Lord, with cruciform nimbus, seated, lifting up the r.h. in benediction, in the l.h., a mound [?orb], over-head, the dove descending on the head of the Saviour." *BM Cat. of Seals*, 2110.

Cathedral. sc, W cloister boss, B7. 1420–1. Enthroned with tau orb surmounted by cross, blessing; dove beside head; flanked by

angels; beneath feet, cross, mitres, tiaras. For the numbering system of the bosses, see diagram in Appendix II.

Pity of the Father

Father and Son as in Crucifix Trinity; no dove; see VI. 3.

2. Trinity

Trinitarian images were sometimes accompanied by texts (see also below 4.a and XII *All Saints*).

Trinity, Three Men

See also below section 3, E Harling. This composition was also used for the Holy Trinity Guild of Wisbech (Ely), *BM Cat. of Seals* 4480.

Lynn S Margaret. brass (Flemish). Robert Braunche (†1364) and wives Letitia and Margaret. Immediately above 3 effigies, 3 bearded, nimbed figs, each seated on a bench with feet on cushion and holding a small (badly worn) soul; each person of the Trinity flanked by 2 angels, the innermost swinging thuribles, outermost with musical instruments; Cameron pl 45a and b (no soul). Similar scene appears on Walsokne brass; see Cameron 154–5. Related to Bosom of Abraham iconography.

Diocese. ms, Wollaton Antiphonal, Nottingham U Library 250, hi, f 246v (Ps 109). c1430. Son displaying wounds, cross hung with crown of thorns; Scott, *Survey* Cat. 69, il no. 276. The MS was designed for a patron in ?Lincoln/ Nottinghamshire, but made in E Anglia; Scott queries Cambridge or King's Lynn.

Cathedral. sc, nave bosses, Bay N. 15[3]. **18** seated, against radiance, Father and Holy Ghost bearded men crowned, Son with crown of thorns, at RH of Father, displaying wounds; **19 & 20** censing angels demi-kneeling, both in copes over figured gowns; **21** Bp Lyhert. Central boss, the Last Judgment. For the numbering system of the bosses, see diagram in Appendix II.

Trinity, Two Men and Dove

This representation was not uncommon in manuscripts (further 15c examples in Nichols *et al.*, *Index of Images*). In Norfolk it seems to have been restricted to illumination and sculpture of the Coronation; see also VIII.1.

?Wiggenhall S Germans. ms, Howard Psalter, BL Arundel 83 I, hi, f 72 (Ps 109). c1310–

20. Father and Son seated on wide bench, each with tau orb; dove betw; grotesque hybrids in bas-de-page; Sandler, *Survey* Cat. 51, il no. 125.

Diocese. ms, Stowe Breviary, BL Stowe 12, hi, f 200v (Ps 109). c1322–25. Father and Son seated on wide bench, Son with book; dove betw with orb in beak. Description of this important breviary in Sandler, *Survey* Cat. 79 and L & M Cat. 26.

— ms, Corpus Christi Psalter, CCCC 53, hi, f 122v (Ps 109). 14¹. Father and Son seated, dove betw. This important Norfolk MS, sometimes called the Psalter of Hugh of Stukeley, passed into Peterborough ownership very early; see Sandler, *Survey* Cat. 66.

Ranworth. ms, Ranworth Antiphonal, S Helen's Church, hi, f 160 (Ps 109). 1460–80. Directly below Dove, bearded Father and Son seated on a throne facing each other, arms raised; Father and Son crowned, wearing ermine-lined red mantles with ermine collars; Son's mantle draped to display lateral wound; wounds on hands visible. Scott (*Survey*, Cat. 121) found no evidence of original ownership, though according to local tradition the antiphonal originally belonged to Langley Abbey ("Extracts" 18: xxxiv–xxxvii).

Crucifix Trinity
(Mercy Seat, Gnadenstuhl)

Father seated, usually crowned, supporting with one or both hands the cross bar of crucifix, his mantle draped over knees; crucifix resting betw knees, ending at an orb. Deterioration sometimes makes it difficult to verify the presence of the dove of the Holy Ghost. Where present, the dove is typically above the head of Christ (in alabasters dowel holes indicate that the dove was a separate piece, Cheetham Cat. 223–5, 227–8, 230–2). This composition was undoubtedly the principal image at the Cathedral, which may account for its widespread use in Norfolk. Relatively well-preserved compositions with no dove are better classified as *Pity of the Father*. A case in point is Bp Alnwick's signet seal in contrast to the great seal (Hayes pls 10–11).

Houghton-on-the-Hill. wp, E wall, largely filling the area above the chancel arch. c1090 (DP in P & W 2). Father seated in lobed mandorla, one arm of crucifix, dove. In 1997 only the N side of the image had been uncovered. This is the earliest known instance of the Crucifix Trinity in England. The painting scheme covered all 4 walls, with at least 2 later programs painted on top of the original scheme. See also *Resurrection of the Dead*.

Norwich, Carrow Priory. ms, Carrow Psalter, Baltimore, Walters Art Gallery W.34, hi, f 200 (Ps 109). 1250–60. Morgan, *Survey* pt 2, Cat. 118. 15c ownership inscr.

W Acre Priory. seal, Austin Canons' Priory of S Mary and All Saints, second seal. 13c. Obverse, in upper register "Trinity, in a vesica, upheld betw. the emblems of the four Evangelists"; (for lower register, see VIII.3); *BM Cat. of Seals*, 4296; *VCH* pl 2, facing 494; Pedrick (1902) 135–6, pl 25, seal 50. Taylor cited the dove at Christ's ear, *Index Monasticus* 28.

Ingham. al, tomb relief, E face of de Bois tomb. Mid 14c. Father on wide bench, defaced and disarmed; remains of damaged small crucifix betw knees, resting on top of orb; flanked by angels at ends of wide bench, holding the souls of Sir Roger and Margaret his wife in cloths draped over arms; traces of color.

— seal, Collegiate Church and Priory of the Order of Holy Trinity for the Redemption of Captives. 14c. Trinity in niche, *BM Cat. of Seals*, 3314.

Cathedral. im silver gilt, S side of high altar. 1347–56. "W. Bateman . . . contulit summo altari Norwycensi imaginem magnam S. Trinitatis in Tabernacula totam de argento et deauratam ad magnum valorem. Item minorem imaginem S. Trinitatis cum reliquiis ponderis xx. lib^m," Bartholomew of Cotton, quoted by Stewart (36). Beeching (23) cites entries for making shoes and cleaning crowns, which suggests a 2- or 3-person image, but Blomefield (who is in error about the site of the image) records a Crucifix Trinity "represented by a weak old man; Blessed Redeemer . . . on the cross betw his knees and the Eternal Spirit, by a dove, on his breast," 4:30. Before Bp Bateman's gifts there was already an unspecified Trinity at the Red Door (Shinners), renewed in 1439 at a cost of 18*s* 8*d* (Beeching 23). Gifts of silver and gold jewelry were provided in 1443 and 1449. There was also an image by S William's altar. It is unclear whether the latter was

Bateman's lesser image ("minorem imaginem") with relics weighing 20 pounds.

Diocese. ms, missal, Bod L Hatton 1, hi, f 119v. 14⁴. With dove; cross resting on tau orb; Scott, *Survey* Cat. 5.

Walsoken, Hospital of the Holy Trinity. seal. ?14c. "God the Father supporting our Saviour on the cross," *Index Monasticus* 61.

Norwich. The seals of Bps Salmon, Wakeryng, Lyhert, Nykke, and Repps (Rugge) il in Goulburn pl 2 betw 530 and 531. Episcopal seals cited in chronological order.

— seal, Roger Skerning (1266–78). The "deity on a throne, holding crucifix," *Index Monasticus* xxxi.

— seal, William Bateman (1344–55). Bp with Trinity above in quatrefoil; in second seal within a niche; *BM Cat. of Seals*, 2040–42. The seal in the Society of Antiquaries "had the matrix in two parts, sliding one within the other, and so . . . the central portion [Trinity] could be used separately as a signet. . . . When the seal is complete this forms part of group with S Thomas of Canterbury and S Katherine on either side, Our Lady and Child above, and the kneeling bp below," Hope (1887) 296. Virgin and Child also appear on seals of Bps Wakeryng, Lyhert, and Nykke, *Index Monasticus* xxxi–xxxii.

— seal, Henry Despenser (1370–1406). 1379. Bp blessing with Trinity in niche above; *BM Cat. of Seals*, 2047–8, il Bayfield, 317. Trinity; in niches above "our Lord seated betw. two angels," at base kneeling bp; *BM Cat. of Seals*, 2045–46.

— seal, Alexander Tottington (1407–13). "Trinity seated under a carved canopy," *BM Cat. of Seals*, 2049.

— seal, William Alnwick (1426–36). "Trinity within a cusped and beaded border," *BM Cat. of Seals*, 2053; Hayes pl 10. Alnwick was also willed "a gold tablet of the Trinity . . . from his predecessor" (cited in Hayes, 12).

— seal, John Wakeryng. 1416, 1418. Trinity, Bayfield, 319.

— seal, Walter Lyhert (1446–72). Trinity, *BM Cat. of Seals*, 2055; see also Bayfield, 320–1.

— seal, James Goldwell (1472–99). Trinity,

Index Monasticus xxxii.

— seal, Thomas Jane (1499–1500). Trinity, flanked by Peter and Paul, Bayfield, 321–2.

— seal, Richard Nykke (1501–35). Trinity flanked by angels; (above) Virgin and Child, Bayfield, 322–3.

— seal, Consistory Court. 15c. Trinity, *BM Cat. of Seals*, 2067.

— seal, Episcopal Consistory, ?Stephen Gardner, Archdeacon. 1529. Trinity, *BM Cat. of Seals*, 2070.

— seal, William Repps (1536–50). In a Renaissance style niche "with shell-shaped back, the Trinity"; *BM Cat. of Seals*, 2057–8; "Father supporting the Son, who is nailed to the cross, with the Holy Ghost descending," *Index Monasticus* xxxii.

— seal. William, Keeper of the Spiritualities of Norwich. nd. Trinity with frag of crucifix; *BM Cat. of Seals*, 2087.

E Rudham. sc, boss, S porch. ?14c, reset in 19c porch. Damaged but once with dove; drawing in Astley pl 1.

Cathedral Priory. ms, Ranulf Higden, *Polychronicon*, hi, Bod L Bodley 316, f 8. c1394–7. Priory press mark, originally made for the College of the Holy Trinity, Pleshey, Essex. Author in margin. Pächt & Alexander Cat. 674, pl LXX.

Diocese. ms, psalter, CB UL Dd.12.67, hi, f 119 (Ps 109). c1400. Flanked by angels.

?Besthorpe. ms addition, Bod L Don. d.85, f 2v, pen drawing flyleaf. 1420–30. RH blessing, LH holding cross resting on orb; Scott, *Survey* Cat. 39; Pächt & Alexander 803, pl LXXVII. Whetehall arms added f 1. Oliver Whetenhall vicar at Besthorpe, 1445–60.

Ranworth. See XII *All Saints*.

Elsing. pg frag, sII.3a, not *in situ*. 14⁴. Upper foil of quatrefoil, cross-nimbed head of deity, short beard, RH supporting crucifix bar in lateral foil.

NMS. al altarpiece. 15c. (Above) 2 angels censing, (below) 4 angels holding chalices to collect blood; Crucifix betw Father's knees; dowel hole above head of Christ for dove; Father with hands extended holding cloth with 5 souls. The central scene of a 7-panel altarpiece. For details see Cheetham (1983) il no. 45 and Cat. 226–9, color pl VI.

Thurton. pg, sV, 2b, not *in situ*. c1450. Against radiance crowned Father enthroned, RH blessing, LH resting on cross bar of cruci-

fix; dove ascending against radiance directly above Christ's head; Christ nimbed, with thin twisted crown of thorns, wearing yellow loincloth, blood flowing from foot wounds; foot of crucifix resting at circumference bar of orb; **FIG 1**. Ascribed to the Passion Master (Marks 196).

Burnham Deepdale. pg, nVIII.3a, roundel. Mid 15c (King). Against radiance Father holding crucifix, nimbed dove directly above cross.

Ringland. pg, NV, 1–3A. 1460–70. Father wearing ermine-lined red mantle, upper head lost; hands raised, not supporting cross; Christ in murrey loin cloth, wounds bleeding; dove ascending above Christ's head; cross resting on tripartite orb (plants and clouds above waters); (below R) kneeling donor with inscr scroll, "Sancta Trinitas," and labels "Orate pro a" and "Gild" (Wdf 71). See Te Deum below.

S Creake. pg, nX, head of tracery. 15³ (1451, 5 marks to glaze a N win, C & C). Largely restored. There was major work throughout the first half of the century, with tower glazing in the 1460s.

— pg frag, nVIII.3b. 15³. Nimbed head with radiance, hands supporting cross bar, label above inscr "spiritum"; heavily restored. Female donor at prayer desk leaded in 1b.

Bale. pg frag, sV.1b. 15c. Small crucifix with bleeding corpus against patterned gown with ermine trim; trace of orb with waters below.

N Tuddenham. pg frag, sVI.A4. 15c. Crucifix and gown of Father.

Yelverton. pg, E win, patchwork tracery. 15c. Remains of crucifix against shaded fabric, no crown of thorns.

Norwich Guildhall. pg frag E win 1a. Father in alb, Dove on breast flying up; no crucifix. The glass currently in the Council Chamber comes in part from the former Ch of S Barbara at the Guildhall (c1450) but also from other sources. Complex provenance, as well as the fragmentary state of subjects, makes them difficult to date. For the history of the glass, see Wdf and Kent.

Bressingham. *pg E win, central light. "God the Father in purple clothing etc. with our Saviour before him on the cross," NRO, Rye 17, 1:150, no dove mentioned (cf Dunston); perhaps better classified as Pity

of the Father (VI.3.b).

Dunston. *pg, N win. "God the Father with the Dove and our Saviour on his cross," NRO, Rye 17, 2:54.

— *pg, E win. NRO, Rye 17, 2:54.

Sharrington. *pg. "In the second window in S. aisle in glass is God the Father with our Saviour before him upon the Cross, both with their feet upon the globe of the world, and under them six saints [?angels] with musical instruments," Dr Newdigate, Frere MSS, NRS 1:36.

Attleborough. pwd, roodscreen bays filled to form reredoses for nave altars. 15³ (donors names inscr; rector-donor †1446; Peter Martin 1458; further bequest for sollar 1465). 3 figs N and S against cloth of honor held by demi angels in ermine tippets. **S2** Father with hands in orans gesture, in red gown and patterned cloak; dove ascending on Father's breast, white cloth hanging over both forearms supporting two souls, faint text on cloth; standing crucifix resting on orb. Although related to the Bosom of Abraham iconography, the design has been adapted to focus on the two donors whose names are inscr below the panel. Barrett's watercolor has no sign of the souls but preserves a partial text, "Juncta utraque . . . ," DT 53:32. For distinction betw Abraham/ deity, see Cameron (1980) 170, Appendix 1. Cumulative East Anglian evidence supports Trinitarian interpretation. See also XIV.1.

Gt Snoring. pwd, screen, 2 panels only. 15c. Father, mantle draped across lap, supporting cross bar with LH, RH blessing, palm out; corpus bleeding, cross ending at central orb band, waters below; no trace of dove but panel defaced above Christ's head; uncovered by Tristram, restored by Anna Hulbert.

Acle. sc, font bowl, E face. Inscr 1410. Father crowned; if holes in cross are original, the fig of Christ was a separate piece; restored dove. Pietà on W face; perhaps better classified as Pity of the Father.

Cathedral. sc, W cloister boss, D6. 1420–1. As above, Father crowned, RH blessing; Dove immediately above cross bar, cross resting on tau orb; flanked by censing angels and donors; Sims 457, fig 172; Goulburn pl 4. Sims (456) argues that this Trinity was "not

unlike" the conjectured Trinity of the Erpingham Gate.

Hemblington. sc, font bowl, W face. 15c. Crowned Father defaced, seated on massive bench, cross ending in orb; dove immediately above cross bar.

Stalham. sc, font bowl. 15^3; variously dated late 14c (Cautley), 15c (Bond), late 15c (Wilson, P & W 1); cf documentary evidence for double-fig font panels at Norwich All Saints (X.1). Crowned Father enthroned, feet bare, supporting tau cross in both hands; dove ascending directly above crucifix and head of Christ and below Father's beard; inner hand raised, outer with scroll; (above) flanked by angels; **FIG 2**. Font restored 1864.

Loddon. sc, statue in niche above S porch entrance. 15c; porch 16^1 (P & W 2). Father's head restored; small mass remaining above head of Christ against upper crossbar, cross resting on orb. Martin noted "This is Trinitas," NRO, Rye 17, 3:34v. Statue fits awkwardly in niche & may predate the porch. The defaced 8th panel of the font bowl may also have been carved with this subject, Nichols (1994) 121.

Wroxham. sc, frag not *in situ*, set in wall of vestry. 15c. Head of Father and arms of crucifix lost; plug hole on shoulder of Father for dove; traces of original polychromy.

Norwich. seal, mayoralty. 1403. Trinity, corpus badly worn; *BM Cat. of Seals*, 5236; Pedrick (1904) 96–8 and pl 36, seal 72. Subject replaced by the Resurrection at Reformation (Bl 4:574–5).

— seal, altered 1573. Center of counterseal, image of Trinity replaced by IMMANVEL in 4 lines. Directive in Mayoralty book ordered that the Mayor's seal "which is now having the picture of the Trynyte, which is not only contrary to God's Word, but to her Magesty's instructions, be altered . . ." (DT 37:70, dated 1568, 22 June). *BM Cat. of Seals*, 5229–30; Hudson & Tingey vol 2, pl facing 278.

Mautby. *seal. nd. Identified as seal of prior of convent (DT 35:12), but no religious house cited in Knowles and Hadcock. For other problems in the labeling of 19c drawings, see Barbara Green, "The Antiquaries," pp 286–8, below.

Cathedral. wp. c1475. "Erpingham reredos"; see VI.3 *Exaltation*.

Hockham. wp, chancel arch. 15c. Atypical since the Father does not hold the cross; see VI.3 *Exaltation*.

Trinity Unspecified

Given the widespread evidence for the Crucifix Trinity, it is likely that some of these entries should be so classified.

Norwich S Michael Coslany. *emb. 14^3. "Item pannus de velwet' cum ymagine de Trinitate desuper brudata rubei coloris," Watkin 1:5.

Briningham. *emb. 14^3. Vestment "cum ymaginibus Sancte Trinitatis de auro," Watkin 1:88.

Lynn All Saints. *im. 1377. Light provided by guild. Many miracles reported before this image, Westlake no. 275.

Ranworth. *?pcl. 14^3. Banner "cum ymagine Sancte Trinitas," Watkin 1:36.

Norwich S John de Sepulchre. *?pcl. 14^3. Banner, Watkin 1:22.

Tottington. pg, now at the Cathedral, nVII (Jesus Ch). c1330–40. **6b** censing angel with scroll reading "s*anctus* sanctus s*anctus*" approaching a throne, and evidently four tracery lights with the tetramorphic symbols, two only extant; **2a** lion with inscr scroll, "ecce s*piritus* s*anctus*," L & M Cat. 34; **2c** Matthew with "ecce Filius"; D King (1996) fig 147. King conjectured that the third and fourth invocations would have been to the Father and Trinity. In Potter's 1819 description of Tottington, the Trinitarian glass was distributed betw tracery in the E win of the N and S aisles.

Horstead. *im. 1416. Bequest of 13*s* 4*d* "to gyldynge of the Trynyte over the perk," Millican 19.

Shipdham. *im. 1459. Burial before, NRO, Rye 134, f 16.

Norwich S Laurence. *im. 1459. Burial in churchyard "before the image of the Trinity," Bl 4:269.

W Tofts. *im. 1484 will requested burial before image, Bl 2:262.

Tilney All Saints. *im and ch (guild 1453). c1492. "Item pro (peyntyng) albacione Sancte Trinitis" (Stallard 74). Perhaps tabernacle expenses related to this im.

Norwich SPM. *im, S end of the perk. 1493.

Bequest "to new gild" an image "and paint the tabernacle it stood in," Bl 4:213–14.

Norwich S Mary Coslany. *im and altar, W end of nave, N side. 15⁴ (nave rebuilt 1477). Bl 4:490.

Norwich S Giles. *im, in niche on W side of steeple. Bl 4:239.

Oxborough. *im, chancel. Bequest for candle "before the image of the Holy Trinity in the chancel," Bl 6:182. There were also requests for burial before the Trinity. A 1513 will implies that the image was on the S since burial was to be before "the image of Trinity where chapel is to be erected" (186).

Poringland. *im. "In the upper part of the east chancel gable in the churchyard, are three niches, in one of them, part of the effigies of the Trinity still remain," Bl 5:442.

Rushall. *im. Ch on N side of nave with "altar, image and gild, held; all in honour of the Holy Trinity," Bl 5:343.

Pulham S Mary? *pg, E win, Father, Son, and Holy Ghost, Bl 5:395; see also VIII.1 *Coronation.*

Sparham? *pg, S win, "good Trinity," NRO, Rye 17, 3:216.

Poringland? *pg, N win, "man and woman praying, and over them 'Sancta Trinitas Unus Deus, miserere Nobis'," Bl 5:442.

N Walsham. *pwd. 1475 (Cotton). Bequest "to paint the tabula of the Trinity altar."

Upwell? *pwd, screen, Bl 7:466.

Norwich SPM? *emb copc. 16¹. Trinity in hood; orphreys with apostles and prophets; second example cited of Trinity in orphreys with apostles and virgins, Hope (1901) 196–7.

Wroxham. *?im. 1516. Bequest to gild Trinity on perk (Cotton).

Shimpling. *im. 1524. Bequest to image in chancel (James Galle, Briggs 179, Cotton personal communication).

Wymondham. *im. 1527. Guild expense for light "cora*m* ymagine*m* Trinitatis in choro," Carthew (1884) 252.

Thetford Priory 1. *pcl. 1532/3. "Thome Bell pro le peyntyng of the clothe ad altare Sancte Trinitatis 10s," Dymond 2:609.

Feltwell S Mary. *sc. 1522. Bequest of £3 6*s* 8*d* to gild Trinity tabernacle (Margaret Rudland, Alblaster 184, Cotton personal communication).

Ellingham. sc. c1530. "I will have a faire stone of marbil with a pyctur of the Holy Trinities, and a preest with a chales in the same stone," Williams (1941) 335.

Fakenham. *?medium. "Trinity on the pillar against our Lady in the wall"; *light before "Trinity of the lower cross in the nave," Bl 7:96.

Holy Trinity Guilds

The existence of a guild does not document an image, but it is likely that guilds in prosperous parishes did fund images (see Ringland, above), and even poorer guilds might have afforded a painted cloth. Chapels were not confined to churches; at Wiveton there was one on the bridge (Harrod [1847] 115). Altars, lights, and chs of the Trinity, which appear frequently in bequests and antiquarian records, have not been cited because they were so common, the guild list serving to indicate the centrality of the Trinity in parish worship.

Ashill, Bl 2:349.
Ashwellthorpe, *Index Monasticus* 7.
Banham, altar, Bl 1:357.
E Barsham, Bl 7:64.
Beeston S Mary, Bl 9:465.
Billingford S Peter, Bl 8:194.
Blofield, 1421 will, Bl 7:211.
Bodham, Bl 9:369.
Bodney, 1499 will, Farnhill; Bl 6:18.
E Bradenham, *Index Monasticus* 71.
Brancaster, 1450–93 wills, Farnhill.
Breccles, Bl 2:272.
Brisley, Bl 9:470.
Briston, Bl 9:377.
Old Buckenham, 1525 will, Farnhill.
Caldecote, 1420 will, Farnhill; Bl 6:59.
Cawston, Bl 6:264.
Congham, Bl 8:389.
S Creake, Bl 7:84.
Cromer, Bl 8:107.
E Dereham, Bl 10:213.
Dersingham, *Index Monasticus* 72.
Little Dunham, Bl 9:481.
Fakenham, Bl 7:96.
Foulden, *Index Monasticus* 72.
Foulsham, Bl 3:208.
Gt Fransham, Bl 9:499.
Garboldisham, 1490 will, Farnhill.
Gooderstone, *Index Monasticus* 72.
Gressenhall, Bl 9:518.
Happisburgh, 1423 will, Bl 4:31–2.
Hardingham, Bl 10:227.
E Harling, 1479 will, Bl 1:332.
W Harling, Bl 1:311.
Hempnall, 1491–9 wills, Farnhill.
Heydon, Bl 6:253.
Hitcham, Bl 10:312.
Holkham, 1389, S Mary and Trinity, Farnhill.

Holme Hale, *Index Monasticus* 72.
Holme next Sea, Bl 10:344.
Hoveton, Bl 11:41.
Ingham, 1470–89, Farnhill.
E Lexham, Bl 10:8.
Lynn All Saints, 1377–1401, Farnhill.
Lynn S James, 1371–89, Farnhill.
Lynn, S Margaret, new ch built c1472, Beloe (1899).
Mattishall, Bl 10:239.
Methwold, *Index Monasticus* 73.
Narborough, 1441–71 wills, Bl 6:167.
Narford, 1465 will, Bl 6:239.
Necton, *Index Monasticus* 73.
W Newton, Bl 9:36.
Northwold, 1489–1517 wills, Bl 2:221.
Norwich, Cathedral, 3 Guilds, 1364–1527, 1366–89, 1375–89, Farnhill.
Norwich, SPM, 1470s, Fishmongers met on 9 Sun after Trinity before an altar so dedicated, Bl 4:205.
Oulton, Bl 6:372.
Oxborough, 1382–1470, Farnhill; Bl 6:192.
S Pickenham, 1498 will, Bl 6:132.
Ringland, NRO, Rye 17, 3.142v.
Ringstead S Peter, Bl 10:345.
Roughton All Saints, with S Mary and All SS, 1371–89, Farnhill.
Runcton, *Index Monasticus* 74.
Rushall, Bl 5:343.
E Ruston, Bl 9:340.
Saham Toney, Bl 2:319.
Salle, Bl 8:276.
Sedgeford, *Index Monasticus* 74.
Setchy Parva, *Index Monasticus* 74.
Shipdham, Rye 134, f 16.
Snetterton, dissolved 1548, Bl 1:422.
Snettisham, Bl 10:379.
Lt Snoring, Bl 7:188.
Sporle, *Index Monasticus* 74.
Swaffham, 1465–1525, Farnhill.
Swanton Morley, Bl 10:57.
Terrington S Clement, 1377–89, Farnhill.
Testerton, Bl 7:200.
Thompson, Bl 2:366.
Thornham, Bl 10:395.
Tilney All Saints, Farnhill; (1453) Stallard.
Toftrees, *Index Monasticus* 74.
Tunstead S Mary, Bl 11:73.
Tunstead, Ch of S Michael, Bl 11:73.
Lt Walsingham, 1540, Bl 11:271 (guild frequently cited in wills, Cotton personal communication).
Walsoken, 1513 will, Bl 9:128; guild & ch *L & P* (1536) 10:634.
Wiggenhall S Germans, 1360–89; 2 other guilds, both ending in 1389, Farnhill.
Wighton, Bl 9:209.
Wretton, 1515 will, Bl 7:510.
Wymondham, 1462–1545, Farnhill.
Yarmouth, 2 guilds, 1363/4–1389, Westlake no. 372–3; Morant 222.
Yaxham, Bl 10:284.

Tetragrammaton

Norwich S Stephen. *pg, E win. 1533. Mackerell cited "in a circle the name of God in Hebrew, Greek, Latin, and English" with a date below; BL Add MS 12525, f 232.

Shipdham. pwd. 1603. Tetragrammaton at apex of Commandment table.

Trinitarian Texts and Angels

In pg where there are angels at the heads of main lights, both Woodforde and David King conjecture lost Trinity compositions below. Inscr scrolls are held by angels or function as prayer scrolls.

3. *Te Deum*

At Oxborough bells inscr "TE PER ORBEM TERRARUM SANCTA CONFITETUR ECCLESIA PATREM IMMENSAE MAJESTATIS 1582" (see XII *Edmund*), "VENERANDUM TUUM VERUM, ET UNICUM FILIUM, 1582," and "O CHRISTE, REX GLORIAE ES TU, 1586" (Bl 6:181). See also Appendix VIII.

Norwich. al. 15[1]. 4 tablets in separate collections: (1) 9 Orders of Angels (**Cathedral**); (2) 9 Female Martyrs and Holy Women (**SPM**); (3) 9 Prophets (**S Stephen**); (4) 4 apostles (**NMS**); Bensly (1892) il facing 353, 355–6. For details, see individual entries, section 4 below, II.6, X.2, and XII (*Barbara, Catherine, Etheldreda, Helen, Margaret, Ursula*; 3 other saints without attributes). See also Nelson (1917) 115–7 and pls 10–11.

Ringland. *pg, E win N aisle. Late 14c (King). Crucifix Trinity, Father supporting cross; in lateral niches angels with thuribles and *Te Deum* scrolls: "Te deum laudam*us* te domin*um* confitem*ur*"; and "Te ete[rn]em *patrem*." Colored drawing, George King Collection, Box 2, NNAS. Martin also recorded donors with scrolls: "S*anc*ta Trinitas, unus Deus, miserere nobis" and "Orate *pro* fratibus et sororibus guilde sancte [Tri]nitatis qui fecer*unt* istam fenestram," NRO, Rye 17, 3:142v. Apparent duplication of texts in two windows (see *Crucifix Trinity*) may stem from formulatic practice or from confused note taking. Martin seems to have been the source for the Bl citation (8:254).

E Harling. pg, E win, 3a. c1470. Angels with frag texts; "Tu pat[ris sempiternus es filius]; Tu de[victo mortis aculeo]; Tu ad

dexteram [dei sedes]; [Iudex c]reder[is] esse uenturus." The Trinity may have been represented by three figs since each person is addressed separately with litany texts: (2a) "Pat[e]r de Celis De[us] Miserere nobis," originally with Anne Harling; "Spi*ritu*s S[ancte deus mis]erere [nobis]" above Magdalene's head; (1a) above Sir Robert Wingfield "Fili redemptor mu*nd*[i deus] miserere nobis" (Crewe fig 20); and (1e) Sir William Chamberlain, "S*anct*a trinitas un*us* de*us* m[iser]ere nob[is]." Wdf (51) conjectured that a frag of bearded nimbed fig (3e) may have come from the *Te Deum* composition.

Glasgow Burrell Collection. pg, 3 elongated quatrefoils set in rectangular panels. 15^{3-4} (Marks). Above rayed cloud angel in appareled alb and amice with hands outstretched, inscr scroll: "Te eternu*m* patre*m* omnis te*rr*a veneratur"; "Tibi om*n*es angeli tibi univ*ers*ale potestates"; "Tibi cherubin & ser[ap]hin i*n*cessabili voce proclama[nt]" (Marks fig 68); Wells (1965) Cat. 128, 205, 123. Probably a transom series; see 4.b Harpley & Oxborough. All the glass cited in the Burrell Collection is Norwich work of uncertain provenance unless stated otherwise.

Caston? pg, nIII.3a, not *in situ*. 15c. "S*anct*us" on roll against rayed background (2 examples). The background of these restored fragments may argue against *Te Deum* classification.

Gt Snoring? pg, sII, head of light b. 15c. Demi-angel in alb and amice, holding ends of "sanctus" scroll.

Salle. pwd, faint remains on cornice of roof, N nave. 15^1. Angels in albs with scrolls inscr "ad dextera*m* dei sedes i*n* gloria p[at]ris. Iudex crederis esse uenturus. Te ergo q[uae]sumus famulis tuis subueni quos [pretioso sanguine] redemisti"; DT 60:7.

Norwich S John Maddermarket. pwd, roof, Jesus Ch (N aisle). c1450. Angels, flanked above and below with ihc within crown of thorns, holding *Te Deum* scrolls. Angel in dalmatic, cross-diadem, LH pointing to scroll below "Te deum laudamus te domi-nu*m* confitemur"; angel with burlet, ermine tippet over feathers, holding scroll, "Cheru-bin et Seraphin incessabili voce pro[clam-ant]"; below a second scroll. NMS. See

also IV.2 *Magnificat*.

Cathedral? sc, Erpingham Gate. c1430 (Sekules 206). Virgin saints, apostles, evangelists. Sims (454–6) argues that the central niche now occupied by a statue of Sir Thomas Erpingham originally held a Trinity; if correct, the gate incorporated all the elements of the al *Te Deum* composition.

Cathedral. wp, N arcade, presbytery. c1475. "Erpingham reredos" (see VI.3 *Exaltation*). Seated Father blessing; 9 angels with inscr scrolls (see Whittingham [1985] 204): "Te decet laus [et honor] et ymp*num* et gloria"; "Te ad[orantes] glori[fi]cant"; "Tibi Gloria in excelsis." Angels in gowns, some with tippets, one in armored collar; Powers with scourge and chained devil, "tettigere P . . ."; Whittingham pls 4–5; Park and Howard fig 144.

Swainsthorpe. wdcarv. 15c. (1) Roof boss, angel in alb with scroll, *"Te deu*m* laudam*us*"; (2) *misericords, lying loose in 1841, angels with scrolls inscr "ad te domine clamam[us]," "misericor[dia tua] domine," "in te domine sper[avi]," "ne co*n*fu*n*dar in eternu[m]," DT 60:233, 235–6.

Ranworth. *wdcarv, misericord. 15c. Feathered angel with scroll, perhaps room for triple sanctus, "Sanctus . . . de[us]," DT 42:70.

Knapton. wdcarv, double hammerbeam roof with polychrome. 15^3 (DeVere/Howard arms, either before 1462 or 1464–73/4; Haward, 1999). Angels with scrolls: Upper rank **S3** "Te de[u]m," **N3** "Laudam*us*"; **N5** "Te Dom[inum]"; **S5** "Confitemur"; **N7** "Et eter-num"; **N11** "Mages[tatis]"; **S10** "Amen Al[leluia]." On the wall posts prophets (**N3** "Elias"; **S3** "Jonas"), apostles, and martyrs/holy church (**N4** Edward; **S4** fig with arrow and **N12** Edmund). Further angels on wall posts, plates, and ridge struts (variously numbered 138/160). For lower rank, see Appendix I.3; for costume Appendix I.2, **Fig. o.** Robinson color il betw 126 & 127. Elizabeth de Vere, Countess of Oxford (née Howard) is represented in glass at Long Melford (Suf); see Wdf 117. Nave roof is often erroneously given the chancel date of 1504, formerly inscr under the chancel roof for the rector donor (Bl 8: 134); in 1511 money left to pin the roof (Cotton personal communication). See Appendix VIII.

4. Angels

Because angels are ubiquitous in Norfolk churches, any attempt to provide a comprehensive list would be necessarily prolix. The following section comprises a sample of representative compositions in a variety of media. Angels are also cited in other subjects (e.g., I.2, IV.2, & VIII). Demi-angels typically rest on nebuly with rays depending. Costume is cited only extraordinarily (but see Appendix I.1). Some multi-winged angels may have been part of an Orders series.

Cathedral. sc frag. Mid 13c. Bowl of thurible; bare foot and part of garment; probably censing angel from tomb of ?Bp Walter Suffield, Borg & Franklin Cat. 30–31.

— wp, W face of E arch, Ante-Reliquary Ch. c1250–60. Censing angels (L, faint), R with smoke rising from thurible, originally flanking altarpiece; Park and Howard 392, fig 140. For a similar use of wp flanking an aisle altar at Eaton, see Boileau (1864a) foldout, 163.

Bromholm Priory. ms, Bromholm Psalter, Bod L Ashmole 1523, hi, f 99 (Ps 80). c1310 (ff 1–168v). (Above) deity seated, RH blessing, book in LH, flanked by censing angels in albs, demi-kneeling; (below) musicians; Sandler, *Survey* Cat. 44; L & M Cat. 22, color il; Pächt & Alexander 537, pl LII. See other 14c glass in VI.1.

Bawburgh. pg, nIV.B3 & 4, not *in situ*. 14^1. Two angels censing, restored.

S Creake. pg, nVI & sV, A1 & 2. 1330–40 (King). Angels censing. Because of major glass rearrangement, "we cannot be sure of the original position of the rather fragmentary remains" (King 10).

Barningham Winter. pg, nIII.A2, not *in situ*, set at head of light. c1360 (King, personal communication). Bust with distinctive hair style, clear part, hair falling in waves therefrom. A similar angel at Matlaske.

Kimberley. pg, E win, 4a, tracery frag. 14^4. Demi-kneeling angel in alb, both hands raised.

Long Stratton. pg, E win 1b, not *in situ*. 14c. 2 angels censing.

W Barsham. pg, formerly in E win. 14c. 2 angels censing.

Castle Acre. pg frag, sIV.1b, not *in situ*. 14c. Thurible.

Attleborough. pg, W win tracery, C2 & 4. 14c. Angels censing; restored.

Elsing. pg, sII.3a. 14c. Angel censing.

Bradfield. wp, chancel arch. 14c. Flanking majesty, (L) censing, (R) angel badly worn, symmetrical pattern likely.

Cathedral. *wdcarv, high altar. c1363–4. £2 6*s* 7*d* to gild 2 archangels, cited by Park and Howard, 402.

Norwich S Laurence. *wdcarv. 14^3. Stock with 4 wooden angels for the paschal candle, Watkin 1:15.

Norwich S Martin-at-Oak (Coslany). *processional cross. 14^3. Two angels at the top, Watkin 1:4.

Cathedral. *im. $15^{1–2}$. 1401, costs for an angel lowered from the roof on the feast of the Trinity, "Item in expensis circa ymagine angeli in tecto corporis ecclesie pro solempnitate in festo sanctae Trinitatis"; 1405 "Ditto pro thurificatione angelo"; 1440 "pro thurificatione angeli in tecto ecclesiae . . . cum sylverfoil" (Sacrist rolls quoted in Goulbrun, 276). See also XIII.6.a.

?Paston. *im, gilt. 1464. "An image of Owr Lady with ij. awngellis sensyng," property of John Paston, Gairdner vol 4, no. 563.

Litcham. pg, sV.A1, 2, & 5. c1412. Pointing with both hands; "high glazing quality," King 33.

Salle? pg, nV.A2 & 5. c1440. Angels censing; probably flanked a Coronation (VIII.1).

Letheringsett. pg, sIII, light a. $15^{3–4}$. Angel with scepter over LS, burlet with cross rising from center.

Field Dalling. pg, xIV.B. 15^2. Censing angels in matching quatrefoil, probably flanking deity (lost, now with modern figure).

E Harling. pg frags, sIV.3d, not *in situ*. $15^{3–4}$. Feathered angel with 2 sets of wings, burlet, ermine tippet closed with circular morse. At heads of lights b and c, angel heads with foliated cross-diadems and twisted collars.

Glasgow Burrell Collection. pg, tracery. 15c. Angel in alb and amice, demi-kneeling with chain (of thurible) in hand; composite surroundings; 45/56, Wells, Cat. 125. There is a second angel from the same set (45/55), kneeling in adoration (Cat. 122).

— pg, quatrefoil. 15c. Bust of feathered angel censing, ending in nebuly; petalled burlet (Appendix I.1). Wells, Cat. 94.

Burnham Deepdale. pg, nVIII, head of win. 15c. Angel with petalled burlet (Appendix I.1).

Banningham. pg, angels censing; see IV.2 *An-*

nunciation.

Burnham Deepdale. pg, W win (tower). 15c. Angel censing.

W Dereham. pg, sIV.B1 & 2. 15c. Two censing angels; see below, section b.

Dersingham. pg frag, sX.A2, not *in situ*. 15c. Angel censing.

Gristson. pg, nIV.A1 & 6 and nV.A1. 15c. Feathered angels censing; originally the same pattern probably at nV.

N Tuddenham. pg, sIV, flanking eye of tracery. 15c. Angels censing.

Warham S Mary Magdalene. pg frag, nIV.4a & c, *ex situ*. 15c. Angel with thurible, **FIG 3**. nIV.A5, feathered angel with arms crossed at breast. This win has dozens of discrete frags leaded separately, incl a number of other angel frags.

S Creake. pg, nVI.3a & c, 4b, frag, not *in situ*. 15³. Demi-angels in ermine tippets, 4b with rolled collar; 3c with tippet over armor.

— pg, nX.A1–6. 15³. Feathered, all with multiple sets of wings; holding scepters; ermine tippets with double slits; each with different diadem; radiance below. The N clerestory also contains a number of demi-angels.

Field Dalling. pg, flanking eye of sIV. 15³. Feathered angels with cross-diadems.

Shimpling. pg, nIV & sIV at heads of two lights. 15c. Demi-angels, feathered with ermine tippets, both hands raised, ending in murrey/blue nebuly. Shimpling is rich in angel frags: **nV.A1** an angel in armor with military belt; **A4** angel with both hands raised. For 19c repairs, see P & W 2. See also Appendix I.3.

Merton. pg frag, sV, tracery. 15c. Feathered angel with multiple sets of wings, hand raised.

Welborne. pg, E porch win, 1a & b. 15c. Identical frags, angel in alb seated on wide bench, both hands raised.

Bale. pg, sV.A5. 15c. Feathered angel, multiple sets of wings, cross-diadem; rolled collar over ermine tippet, low belt; hand resting at breast.

Weasenham S Peter. pg, nV, light a. 15c. Feathered angel, both arms extended, R knee raised, body drawn in motion.

Lt Walsingham. *pg, S chancel. Angels with stigmata (Wdf 14); destroyed in 1961 fire. There was a Franciscan friary at Lt Walsingham after 1347.

Happisburgh. pwd, screen. 15c. Though scenes obliterated, "it still seems possible to discern the outline of angels," DP (P & W 1).

Hethersett. *pwd, screen. 15c. Angels holding cloth of honor; DT 31:153. Demi-angels holding a cloth of honor are not uncommon on screens, sometimes, as at Litcham and Ranworth, feathered with ermine tippet, elsewhere in albs. Normally the cloth honors the represented saint, but only a stenciled design was recorded at Hethersett.

Yelverton. pwd, screen. c1505 (screen inscr for donors 1505, C & C). In uppermost register, demi-angels in albs, hands on breasts; texts inscr in register below angels; rocky landscapes with trees in background; N "Omnes gentes plaudite; Lauda anima mea"; over-restored.

Thurlton. sc, relief, N door. 15c. Censing angels flanking deity; see VI.3 *Pity of the Father*. Keyser (1907a) pl ll.

Salle. sc, relief, spandrels of W door. 15¹ (arms of Henry V as Prince of Wales, 1405–13). Two feathered angels censing (Gardner fig 513).

Sidestrand. sc, set above S door. ?15c. Standing, holding chalice at breast, from E gable of original church (Pevsner 1).

Gt Ellingham. wp frag, S chapel. 15c. In crocketed niche under triple arch tiny angels with cloth of honor for lost statue. DP suggests Virgin and Child (P & W 2).

Cawston. wdcarv, hammerbeam roof. 15c (before 1460). Angels in feathered garments, variously with scalloped tippets, low belts, and multiple sets of wings; hands in variety of postures; demi-angels with shields along wall plates; P & W 1 fig 44; Gardner fig 514. See Appendix I.3.

Necton. wdcarv, hammerbeam roof. c1450 (Haward). Angel censing, Haward (1999) il N7.

Blickling Hall. wdcarv, chimney piece. c1446. Angel supporters for the arms of Sir John Fastolph and Millicent Tiptoft (Wilson, P & W 2), feathered, with tippets and hoods; angels with helm and crest, Pevsner 1 pl 49b. Originally from Caister Castle.

Yarmouth. *?wdcarv. 1465. Sums spent "for mending of angels" on the Easter Sepulcher, Bl 11:36; Galloway and Wasson cite mending for 1463.

Barton Bendish S Mary. wdcarv, 2 matching

spandrel-shaped reliefs, recently hung on E wall. 15c. Demi-kneeling feathered angel with scroll. Perhaps from ruined All Saints.

N Elmham. wdcarv, screen spandrels above N9 (John Ev). 15³. Paired feathered angels, (R) with bells at hip; see X.

V & A. wdcarv, ?from screen. 15c. Demi-fig, feathered, with tippet and attached hood, arms extended; Tracy (1988) Cat. 121, pl 42.

Thornham. wdcarv, be. 15⁴. Angel in alb, kneeling, with scroll.

Trunch. wdcarv, misericords. 15c. Demi-angels.

Walpole S Peter. *emb. 1504. Bequest from the vicar for "a suit of vestments of white damask branched with angels of gold, or lily pots, like the red suit in the said church," Bl 9:120.

Norwich SPM. *plate. 16¹. A "cresmetory silver & passel gilte . . . wᵗ iij angelles beryng it up at ich corner . one gilte . ther wynges a brode," Hope (1901) 210.

S Pickenham. wdcarv, nave. After 1604. Frieze of demi-putti.

Sustead. wdcarv, pulpit. 17c. Carved betw columns of repeated design, angel heads with wings reaching over arched niche. Originally at N Barningham.

a. Angels with Texts

For citation of typical texts at Gt Cressingham without reference to angels, see Bl 6:101; see also VIII.4 *Marian Texts* below and above *Te Deum*.

Da(te) gloriam Deo

A popular text in emb; see below *Angels on Wheels*.

Norwich S Michael Coslany. *emb. "The carpet at the altar formerly belonged to the altar of the north chapel [John Bapt], . . . and there are several angels with labels, on which, 'Da Gloriam Deo . . .'," Bl 4:498.

Banningham. pg, sV.4c. c1450. Demi-angel with inscr scroll; alb ending in nebuly.

Crostwight. *pg. Angel with inscr scroll, apparently part of a series with 2 others playing stringed instruments, DT 54:130.

Martham. *pg, angel with inscr scroll, DT 35:50. This glass was part of a series of tracery lights now mostly lost. Nave rebuilt c1450 (C & C). Watercolors preserve a number of tracery angels and other unidentified figs, now lost.

Deo gratias

Martham. *emb, altar cloth made from more than one vestment. 15c. Demi-angels on nebuly with text scrolls, Winter, *Selection* 2:3. Before the 1856 restoration the cloth was already in poor condition (E S Taylor [1859b] 172). In 1933 a cope/altar frontal was recorded displayed in the church "in the three upper spaces of the pulpit" (NRO DN/TER 101/1); it was probably lost in the 1968 reburbishment. I am grateful to Mrs. Ann Meakin for this information. Drawings suggest that the original cope was produced from the same patterns as those used for the copes once at Gt Bircham and Norwich S James.

Gloria in excelsis Deo

The text may suggest a lost Nativity. For text variation on domestic buildings, see P & W 2, Felbrigg Hall.

Shimpling. pg, nV at head of light a. 15c. Demi-angel in body armor with inscr scroll; same subject probably repeated in the opposite win.

Martham. *pg, angel with scroll, DT 35:48.

Gloria Patri

Demi-angels holding texts. James (*S & N*, 163) also recorded the prayer as well as Ps 150 painted on the cornice on the nave at Salle; no longer decipherable.

Blakeney. pg, nVII.2a, 2d, not *in situ*. 15c. 3 feathered angels with inscr scrolls; label only at 5c. A number of other angel frags appear in this win, at 1a probably with scroll. For details, see A. Rose.

Martham. *pg. c1450, "in omnia secula seculorum amen," DT 35:49.

Buxton. *pg, Bl 6:447; see VIII.1 *Assumption*.

Laus Domine Deo

Martham. *pg. Youthful saint with scroll text, flanked by (R) saint and (L) angel; DT 35:47. Perhaps a composite when drawn.

Nunc dimittis

Norwich SPH. pg, E win at heads of main lights *in situ*. 15³. 3 angels with *Nunc dimittis* scrolls: light a "Nunc dimittis servum tuum domine secundum uerbum"; b "quia viderunt oculi mei salutare tuum; c "quod porasti ante faciem omnium populorum."

Bawburgh. pg, roundels, not *in situ*, nIV.A.1–2, 5–6. 15c. Rolls unwinding vertically with

opening words of each verse of *Nunc dimittis*: "Nunc dimitis seruum tuum domine; Quia viderunt [oc]uli mei salu*tare*; Quod parasti ante faciem om*n*ium; Lumen ad revela*tio*nem gent*ium*."

Salus, honor et virtu omnipotenti Deo

Wighton. pg, nIV & sIV. 1450–60. Demi-angel at head of central light with scroll; restored. Wdf (138) conjectured a Trinity below.

Martham. pg, sV.4b. c1450. 2 angel busts with inscr scrolls.

Salve ?[Domi]nus

Norwich S Andrew. pg, sVIII.2b, not *in situ*. 15c. Feathered angel holding text. New work in the chancel 1500 and 1850 meant that glass was more than usually peripatetic.

*Sit nomen domi*nis *benedictum*

Wimbotsham. wdcarv, nave boss, demi-angel with inscr scroll.

Tibi laus, tibi gloria, tibi gratiarum actio

Old Buckenham. pg, sVI, head of 3 lights, probably *in situ*. 1460–80 (King). 3 demi-angels on nebuly, with scrolls. First responsory, 3 Nocturn, Matins, Trinity Sunday, texts restored, (Wdf 138, King 29). 3 angels without texts, **FIG 31**.

Other

Norwich SPH. pg, nV, head of lights b and d, *in situ*. 15³. Angels with scroll inscr: "[Simil]e est regnu*m* celoru*m*"; "Gaude*n*t i*n* ce[lis]"; see Wdf 139 for liturgical contexts. Lights **a** and **c** have Marian texts (see VIII.1 *Assumption*).

Glasgow Burrell Collection. pg. 15c. Angel busts in tippets holding inscr srolls (undeciphered); Wells (1962) Cat. 60 (composite with 2 angels); roundel, Wells (1965) Cat. 116.

See also below *Angels on Wheels* at Gt Bircham, Lyng, and Norwich All Saints.

b. Nine Orders of Angels

Unless names accompany angels, it is not usually possible to identify individual orders (Appendix I.2). In glass, the medium richest in detail, elaborate costume seems to distinguish the three hierarchies. Sets are listed first in this section, and doubtful examples are classified at the end.

Cathedral. al, part of a *Te Deum* altarpiece, on display in the Visitors' Centre (1999). c1415. 9 angels with red wings in 3 registers; Bensly's identifications in square brackets. (Below) [Virtue] barefoot, in girdled alb, cross-diadem, supporting book on RA with red chalice on cover (shadow only now). [Power] crowned, tippet over voluminous gown, RH raised palm out, scepter in LH. [Dominion] crowned, mantle, scepter in LH, RH pointing thereto. (Mid) Throne, crowned, in alb, holding throne. [Principality] in plate armor with bascinet, spear in LH. [Archangel] feathered, amice, cross-diadem, shield, and sword. [Angel] alb, floral chapelet, roses in RH. (Above) [Cherub] in alb, with thurible/ ?lamp. [Seraph] alb, closed book with cover charged with cross; L & M Cat. 63; Bensly (1892) il facing 353. Cathedral inventory cites as "untraced find."

Narborough. pg, nII (originally in E win, Wdf 132–3). c1430 (King in L & M, p 44). **A1** small angel [Wdf, Thrones]; **A2** Powers, cross-diadem; in armor, belt with bells depending; birch in RH, in LH chain attached to a devil with yellow head, vaned wing; scroll inscr "presu*n*t demones"; **A3** Virtues, angel in purple feathers, long scarf over shoulders, crossed in front, wound around back, ending in looped tie at front of waist; scepter in RH, LH with scroll inscr "Virtutes faciu*n*t mirabilam." In patchwork, frag of angel on ruby glass, ?Seraphim; also text fragment "ne," ?Dominaciones; **A5** ?Cherubim, golden feathers, 3 sets of wings; **A6** Angel (guardian), apparelled alb, LA reaching around three men and resting on head of foremost in black skull cap; scroll inscr ". . . ndt snglei p . . .," which Wdf (133–4) connects with "singularis persone." Some of the glass has been rearranged since Wdf's description.

Salle. pg, E win. c1436–41 (King 1979). **A3** archangel (head new) in alb and ?dalmatic holding and pointing to open book with writing; (below) church; (above) "arch-a*n*gelo"; **A4** (above) "Ordo archa*n*gelo" (below), missing; **A5** & **6**, Principalities in blue robes, tippets and diadems, holding

scepters, kings kneeling at their feet; **A7 &
8** see I.5; **A9 & 10** Powers, wearing armor,
burlet on helmet, holding birch and chain to
which winged devil attached. In 1884,
James recorded the labels "ordo principa-
tus," "ordo potest," and "ordo serap" (cited
in Wdf 136–7). Wdf conjectured that A5
and 8 may have included the Principalities
with their maces laid on the demons. Dup-
lication of each order. Restored 1980.

Banningham. pg, s V. c1440. **A2** murrey feathers,
gold and silvery wings, ermine tippet, floral
morse, both hands raised, scroll inscr
"Seraphin," alien head; **A3** eye-covered
feathers, scepter in LH, RH raised, twisted
white scarf crossed over breast, scroll inscr
"Cerubin." Main light frags, **3a** angel with
open box containing flowers, trace of sash,
label "Arcangeli"; **3c** angel in armor; hand
guard, breast plate with trace of twisted
scarf; label "Angeli."

Gt Cressingham. pg, probably representing the
3 hierarchies. 15^2. **nVII.A1–6** feathered an-
gels with two sets of wings, nimbed with
cross-diadems, members of each pair slight-
ly facing each other, with one-word scrolls
in hands; inscr "Te et fi[lius] et [?illegible]
deus." **nVIII.A1 & A6** feathered, ?2 sets of
wings, swinging thurible, standing on flow-
ery mead; **A2 & 5** in alb, harping, standing
on pavement; **A3 & 4** feathered, 3 sets of
wings, orante position, standing on white
and gold nebuly; deity in quatrefoil above.
In the 18th century the roof was still
painted with stars and the texts "Hosanna in
Altissimis. Gloria in excelsis" (Bl 6:101).

Wiggenhall S Mary Magdalene. pg, nII. c1450
(local tradition, Cotton and Tricker). **A2**
[Cherubim and Seraphim] angel with eye-
covered feathers holding open book with
writing; (below) "Sy . . ."; **A3** angel
holding scales, (below) "Troni"; **B1**
holding spear with pennon attached, wallet
hanging from belt inscr IHC, (below)
"Angeli." Restored 1924–5.

E Harling. pg, not *in situ.* c1470. **E win 3a** angel
with flask, and one with cross-staff; ori-
ginally "in tracery of easternmost win of the
north aisle," Wdf 54; **A5** feathered angel, 2
sets of wings; **A6** angel in gown and tippet,
petalled burlet, with wand; **sIV.3a** frag,
feathered angel, 2 sets of wings, scepter,
wearing barret.

— pg, N clerestory. 20 demi-angels distributed
in tracery of 9 windows; on nebuly (blue,
murrey, red) with radiance below: feathered
with ermine tippets or dressed in armor,
rarely in albs; holding scepters; some
crowned, otherwise with diadems. Two bits
of costume suggest order angels: **NVI.A1**
angel in a flower crown or burlet; and
NIV.A3 angel in alb and black cap. Or-
iginally there would have been 54 angels.

Martham. pg, sV, not *in situ.* 15^3. **4a** feathered
angel (restored) standing on wheel; **3c**
angel in armor, sword in RH over shoulder,
name scroll held vertically in RH, "Prin-
cipatus"; **3a** angel in ermine tippet over
armor, nebuly around hips; one set of
wings; scales in LH, name scroll in RH,
"Troni"; **4c** angel with 3 sets of wings,
feathered with eyes, scepter in LH, name
scroll in RH, "Cherubin"; for Potestates,
see Mulbarton. For the 19c record, see E S
Taylor (1859b) 174.

— pg, sV, tracery remains of second set of or-
der angels. 15^3. **A3** frag of angel with scep-
ter; red feathered arm, and frag of body
(further red feathers in transom of light b)
?Seraphim; an 1840 watercolor shows a
complete tracery angel in red feathers
pointing to a book in his RH, DT 35:44. **C3
& 4** feathered angels, multiple sets of
wings: with mandora/gittern; harpist with
knight's belt at hips. Also a bust of angel
with open box (?chrismatory) at **B1** and
other angel musicians.

Mulbarton. pg, E win 2c, *ex situ* Martham. 15^3.
In crown, armor, standing on devil with
hands bound; birch in one hand, chain in
other to which devil attached; scroll inscr
"Potestates" lying across skirt of armor;
devil, looking up, shaggy body, long talons
on claw-like hands, webbed foot.

Norwich SPH. pg, nII. 153. **A2** 4 wings, burlet
made of feathers with central ouch, in
armor with gold belt, ermine tippet with
suspended jewel; spear in LH (?Princi-
pality, Wdf 135); **A3** 4 wings, feathered,
wearing scarf and belt, hands raised,
standing on axle of pair of wheels; **A4 6**
wings, wearing diadem, scarf, belt; hands
raised, standing as in A3; **A5** frag of
feathered legs and feet on axle with 2
wheels.

W Dereham. pg frags not *in situ.* 15c. **E win 2c,**

head of angel in tiara; **1b** frag, in alb holding a thurible at rest, an uncharacteristic posture for angels, perhaps part of a liturgical scene. Glass in the E win is said to have come from W Dereham Priory. **sIV.C2** Cherubim, feathers covered with eyes, open book in RH, with minim writing; **C3** angel with three sets of wings, scarf crossed over breast; **D1** frag Powers, mailed hand holding chain; **D2** frag Thrones, tiara, hand holding scales.

Emneth. pg, nVI. 15c. Demi-angels on nebuly with radiance, **A1** multiple sets of wings, feathered, split ermine tippet, jewelled burlet, holding scepter; **A4** frag, in white alb and purple dalmatic edged in fur, holding thurible, ?Virtues; Wdf (130–1) cites as part of this series a standing angel at **nVIII.A3** with blue wings, wearing diadem, alb, and holding massive crown, but the style is markedly different from nVI.

Harpley. pg, W win, below transom and above 5 main lights. 15c. Angels in albs unless stated otherwise. 1 Thrones, blindfolded, loose cowl neckline, scales in LH; **2** ?Virtue in hat with brim turned down (cf Barton Turf), scepter in LH (**FIG 42**); **3** angel in ermine tippet over voluminous garment, palm in LH, clasped book in draped RH; **4** ?Angel in belted gown with coin trim, spear in RH; **5 & 6** feathered angel holding open book with minim writing; **7** angel playing harp; **8** ?Virtue in cowled surplice with flask (RH) and scroll (LH); **9** feathered angel with multiple sets of wings, walking, hands extended; **10** feathered angel, multiple sets of wings, standing on wheel. For possible identification, see Wdf 131–2.

Lessingham. pg. 15c. **A3** angel in papal tiara, voluminous gown; **A4** feathered angel on wheel, multiple sets of wings, both hands extended, knight's belt at hips.

Norwich S Stephen. pg, E win, damaged in 17c explosion and WW2. 15c. Frags of angels in B tracery lights. Powers with birch rod and demon attached to chain; *Seraphim of ruby glass; *angel with patriarchal cross; Wdf 135, Bl 4:154–5.

Oxborough. pg, E win tracery below the transom. c1430–40. "9 orders of Angels have been painted, four only of these figures are now left, with their names under them,

angels, archangels, virtues, seraphim, &c," Bl 6:186. Only 2 labels remain, but there are 6 angels, all in albs with long wings; 4 are playing instruments: (light b) 3 bagpipes; 4 "[Arc]hangeli," A. Rose conjectures gittern; (light c) 5 positive organ; 6 "angeli," positive organ; (light d) 7 Gothic harp; 8 psaltery. A. Rose, fig 20. Atypical for an orders set. Restored; photograph at the NMR shows different arrangement.

Gt Snoring. pg. 15c. **sII.2b** "Cherubin" on scroll. **A2** Thrones, feathered, cross-diadem, 2 sets of wings, holding pair of scales. **A3** Powers, frag in armor with surcoat holding chain attached to red demon with bound hands, spatulate fingers with protruding nails. **A4** Dominations, feathered, wearing mantle; scroll below, "*Dominaciones*." It is possible that the feathered angel with multiple sets of wings plucking a gittern in **A1** also belongs to this series. **n.II** at head of light **b**, angel in patterned gown holding horizontal scroll, only R end preserved, "angeli." **nII.A1 & 2** frags, "angeli," head with diadem (Wdf, 131, cited these 2 frags in the E win); **A4** standing feathered angel with 3 sets of blue wings and nebuly skirt, both hands raised. For nII see Appendix I.3.

Barton Turf. pwd, screen. c1440 (Morgan, L & M Cat. 72). Colors of angel wings alternate by panel, pink and blue; feathered bodies; feet and lower legs bare unless in armor; names inscr above. **N3** "Potestates," birch in raised LH, standing on chained devil; in full plate armor, feathered burlet with central ouch worn over helmet; damask mantle caught with double jeweled morse, hip belt; devil with dog-head grimacing, second head in belly, grasping chain with one claw. **N4** "Vertutes," 2 sets of wings, scepter in LH, RH extended at breast toward scepter standing on gold length of cloth depending from shoulders; closed crown rising above barret, white split tippet with rolled collar, twisted sash on hips, with ends depending to floor (Appendix I.1, **FIG m**). **N5** "*Domi*naciones," 2 sets of wings, with scepter in RH, LH extended; chasuble with orphrey, dalmatic; tiara. **N6** "[Se]riphin" 3 sets of wings, thurible in RH, LH extended at breast; elaborate burlet with rays above; ermine tippet with double split over mantle

falling to floor, nebuly at hips ("girdle of fire," James, *S & N*, 151). **S1** "Cerub[in]," 3 sets of wings, standing on mantle depending from shoulders, both hands raised; petalled burlet with gold ornament and rays rising; split ermine tippet, scarf tied at hips in loose central knot; feathers covered with eyes (Appendix I.1, **FIGS j & n**). **S2** "Principatus," standing on mantle, holding partly filled flask in RH, gold palm in LH; closed crown on twisted burlet, figured tippet with lined hood lying on shoulders, large jeweled ornament at neck, belt of bells on hips (Appendix I.1, **FIGS k & l**); Pevsner 1 pl 32a). **S3** "Troni," 3 sets of wings, standing on hem of loose garment, scales in RH, throne on nebuly in LH; burlet covered with large oak leaves; white tippet turned back to create collar, large jeweled ornament at neck, blue loose garment with gold trim at hem lines. **S4** "Archangeli," 2 wings, standing above battlemented towers, in full armor except helmet, belt of bells; mace in RH, LH resting on pommel of sword; burlet with small oak leaves ornamented with three large flowers. **S5** "Angeli," 2 wings, with spear in LH, RH extended at breast; diadem, pinkish alb over feathered tights, slit at side and blouson at waist, low girdle with eliptical purse attached ("alms-box," James, *S & N*, 151); (lower R) 2 souls kneeling on rock; S3–4 il Duffy fig 105, Rickert pl 190; Constable 212–3, figs 2–5. Restored 1978.

Cathedral. sc, ribs of font bowl panels. c1465. 8 standing angels with multiple sets of wings, most disfigured. Identifiable attributes: thurible, ?scourge, organ, and star on breast (see below).

E Dereham. sc, ribs of font bowl panels. 1468. 8 standing angels, badly damaged; 3 with one set of long wings; others with 2 sets; betw Crucifixion and Extreme Unction, angel against a starburst; Gardner fig 525.

Cathedral. wp, N arcade, presbytery. c1475. "Erpingham reredos" (see VI.3 *Exaltation*). Powers with scourge and chained devil, other Order Angels with inscr *Te Deum*, see above I.3.

Irstead. *wp. "N wall of chancel; part of the Heavenly Hierarchy"; jambs of chancel win, 6 angels, Keyser.

Individual Orders

Archangels

For Michael, see IX.3 and XII.

Massingham. *emb. 1368. Set of vestments powdered with archangels and flowers, Watkin 2:16.

Erpingham. pg, sIV.2b, *ex situ*. 15c. Angel with 4 wings; armor, ornamented surcoat with low belt, rolled collar over ermine tippet; jewel hanging from decorated ribbon; with trumpet (frag) in RH, LH raised; modern head; (?Archangel, Wdf 131).

Swanton Abbot. pg, nIV. 15c. Ermine tippet, gauntlets, holding a trumpet with spearhead-shaped mouthpiece (?Archangel, Wdf 137); now missing. I have been unable to trace this glass.

Norwich SPM. *emb. 16¹, "a cope of rede damaske powdered wᵗ archangel*les* of gold"; "a vestment complet wᵗ deacon & subdeacon of purpull vellvet powderd wᵗ archangel*les* of gold," Hope (1901) 197, 202.

Cherubim with Star (on Breast)

At Framingham Earl an inscr bell "O FONS. ENVANGELII.FAC.NOS.CHERUBYN.SOCIARI."

Norwich S Michael-at-Plea. pg, E win, A3. 1460–80. Ornate diadem; feathered, with ermine tippet and rolled collar; star on breast; scroll inscr "Cherubyn" (Wdf 134–5; [1938] 175).

Hindringham. pg, S aisle E win. 15c. Feathered angel in plate armor, star in middle of breast with LH at breast; blue nebuly around hips; ?multiple sets of wings.

Cathedral. sc, font rib betw Penance and Confirmation panels. c1465. Standing angel with star on breast.

Swainsthorpe. *wdcarv, boss, angel holding against breast roundel with eight-pointed star, DT 60:233.

Ketteringham? pg, E win, B2. 15² (King in L & M, 44). 3 sets of wings; amber feathers; hands raised.

Other Higher Order Angels

It is difficult, especially with small figs, to determine whether there are two or three sets of wings.

W Rudham. pg. nV.A1. 15c. Feathered angel with multiple sets wings, RH on breast, wearing twisted scarf over shoulders and

around waist with looped knot.

Glasgow Burrell Collection. pg, quatrefoil. 15c. Feathered angel with 2 sets of wings, arms in *orans* position; nebuly at waist; Wells Cat. 99.

V & A. pg. 15c. Angel with two sets of wings, hands extended, palm out; burlet, collar with oak leaves depending, feathered tights below skirt, low knotted sash around hips; Wdf pl XXXI.

— pg. 15c. 2 feathered angels with 3 sets of wings, central cross rising from ?barret. C.346–7/1937.

Angels Standing on Wheels

Feathered angels, typically with multiple sets of wings; characteristic pattern in embroidery (Alford 376).

Wiggenhall S Germans. ms, Howard Psalter, BL Arundel 83 I, f 5v (full-page miniature). c1310–20. "Cherubim" standing on wheel, 3 sets of wings, 2 covering body.

Southrepps. pg, low win, beneath sV. 14c. Feathered, two sets of wings, both hands raised; knotted scarf at neckline; rich amber color; a wheel leaded separately.

Lyng. emb, vestments converted to altar frontal. c1480. 3 angels with 3 sets of wings; 2 with scrolls reading "Da gloriam deo" (DT 33: 185, unreadable today); spread eagles and fleur-de-lis. Material from 3 silk velvet vestments of differing dates recycled to create the frontal. The angels, spread eagles, and stylized fleur-de-lis are identical in pattern to that in the next two items. Terrier records in 1678 cite "an ancient carpet for the communion table." The Lyng provenance suggests a possible source from the Benedictine nuns at Thetford, for whose connection with Lyng see Knowles and Hadcock. Conserved 1983.

Gt Bircham. emb cope, since converted to altar frontal. c1480, bequeathed to Bircham by Roger Le Strange, 1505. 3 sets of wings, cross-diadem, ermine tippet, knotted sash at waist both hands raised; text scrolls above, "Sanctus," "Da Gloriam Deo"; spread eagle and fleur-de-lis; engraving in DT 53:158; L & M Cat. 100; NMS. See also VIII.1 *Assumption*.

Norwich S James. emb cope. c1480. Angels with 3 sets of wings, heads and bodies unpicked; NMS. See VIII.1 *Assumption*.

Norwich S Stephen. *emb. 15c. multiple sets of wings, holding scrolls, "Da gloriam deo," DT 33:191.

Martham. *emb. 15c. Angels with 3 sets of wings, with scroll above, "Da Gloriam Deo"; Winter (1888) 122.

Norton Subcourse. pg frag, sII. Early 15c. Angel with knotted scarf.

Colby S Giles. pg, E win, 2a & 2c. 15[1–2]. Feathered, triple set of wings, neck scarf tied in loop, both feet on 3-spoked wheel, hands palm out shoulder height, no halo; head missing on N angel; similar scarf. The rector at Colby (1825) gathered a remarkable collection of glass from 5 wins in the E win (Wdf 162).

S Creake. pg, nXI.2b, not *in situ*. 15[3]. Triple set of wings, both hands raised, wheel (14c); frag of 2nd wheel with one foot. This win contains a number of angel frags.

W Dereham. pg, W2.1b. 15c. Multiple sets of wings.

Downham Market. pg, W win, 1b. 15c. Multiple sets of wings; alien head (saint).

Hoveton S John. pg frag, nIII.3b. 15c. 2 feet on wheel; similar wheel in nII.

Cathedral. pg frag, Erpingham Win, nX.2c. 15c. Wheel.

N Tuddenham. pg, sIV.A1 & 4. 15c. Scarf at neck.

Wighton? pg frag, W win (N) A3 & 4. 15c. ?6 wings, restored. But see IX.3.

Norwich, SPH. See above I.4.b.

5. Fall of the Angels

Salle. pg frag, E win, A7 & 8. c1436–41 (King 1979). Crowned demon falling, wearing ?gorget, holding mace; vaned wings, porcine nose, pointed ears, shaggy mane, spatulate fingers, clawed foot; part of Order Angels composition. Wdf's description represents pre-1980 state of glass.

6. Devils

Typically bat-winged with long tails and cloven feet; for a pair of devil's shoes used in a Wymondham play, see Carthew (1884) 146. See also XIII.6 & Index for inclusion in other subjects.

Castle Rising? sc, font bowl. 12c. (E end) 3 "good faces" and (W) 3 "bad ones," Bond (1985) 181; il Bond, 177, Cautley 130.

?Cathedral Priory. ms, Gregory the Great, *Moralia in Job*, CB Emmanuel College 112, historiated initials at heads of books.

c1310–20. (Book 2) "Christ seated, a devil pulling a monk's robe"; "sons of God assembled and Satan among them" (James 1904); (Book 9) "devils falling into Hell mouth." Devils typically blue and bearded. Benedictines figure in a number of the illustrations.

Reedham. sc, NW corner of nave. c1300 (E Rose, NMR report). Demon's head.

Cley? sc, stop, S nave arcade against chancel arch. 14[1] before 1320 (Lindley, 1985). Damaged fig with long curling tail, once with inset eye.

Holme Hale? sc, stop, E end of N arcade. 14c. Snouted creature with protruding tongue.

— sc, set in wall under holy water font. ?14c. Demonic head.

Cockley Cley. sc, stops, either side S door. 14c. Head only, animal ears, grimacing mouth.

Erpingham. sc, corbel, N wall chancel. 14c. Demon's head.

Beachamwell. graffiti, W end S arcade. 14c. Bust of devil, large ears, horns, tongue protruding, with flesh hook in raised LH; woman in wimple.

Lynn S Margaret. wdcarv, elbow of choir stall. c1370. Head with tongue protruding; vaned wings covering head; il Colling 1:86.

Warham S Mary Magdalene. pg frag, nIV.A2 *ex situ.* 15c. Animal face, naked body, protuberant breasts, clawed hands.

Guestwick. pg, sV.1b, tiny frag, not *in situ*. 15[3] (King, personal communication). In red glass, torso with prominent rib cage, upper chest hair-covered, ?hands behind back; also a tiny grotesque face right of the starburst. There are also two animal-like creatures in the same color tones at sV.2b and sVII.2b. Extensive fragments of glass have been assembled in two S wins.

Lt Cressingham. pg, sIV. CVMA records (NMR) cite a demon; missing in May 1997.

Griston. *pg, "devil with cloven feet, ass's ears, sitting on a throne, as a King, with his crown and robes; a vast press of people crowd to make their address to him; there are kings with their crowns on, pressing forward, the little devils with long ears & tails flying over them and this broken label, '. . . Exaltet eum . . . in Ecclesia'," Bl 2:294. It is unclear whether this scene was meant to contrast with a second in which a priest is preaching. See XIII.2.

Cley. wdcarv, be, nave, N side. 15c. Devil seated with open book on lap, ?animal head betw legs. On the S side there is also an angel holding a ?chest.

Holme Hale. wdcarv, be, arm recess. 15c. Seated, vaned wings, bird feet, horns.

E Lexham. wdcarv, misericord. 15c. Bird with very large vaned wings.

Litcham. wdcarv, misericord. Early 15c. Animal head, short horns betw ears.

Paston. wdcarv, be. 15c. Horned devil.

Thurgarton. wdcarv, be. 15c. Wide stole-like garment lying over lap, vaned wings behind. Church guide misidentifies as a priest, a collecting box having obscured the wings.

Wickmere. wdcarv, be. 15c. Animal with face on buttocks.

II. THE OLD TESTAMENT

1. Creation

Cathedral Priory. ms, Bible, Bod L Auct. D.4.8, hi f 17. 1190–1250; 14c Priory pressmark. (Genesis) Creation of firmament, earth, sea, trees, sun, moon, birds, & animals, Eve; God resting; also Expulsion; Crucifixion; Last Judgment. Pächt & Alexander 444, pl XLI.

Norwich, Carrow Priory. ms, Carrow Psalter, Baltimore, Walters Art Gallery W.34, miniatures, f 21v. 1250–60. Creation of Eve; God giving instructions to clothed Adam and Eve.

?Cathedral Priory. ms, Gregory the Great, *Moralia in Job*, CB Emmanuel College 112, hi Book 25. c1310–20. Deity with book, Adam reclining, "Creation of Adam," Sandler, *Survey* Cat. 45.

Bromholm Priory. ms, Bromholm Psalter, Bod L Ashmole 1523, hi, f 116v (Ps 97). c1310. (Above) Creator with compasses flanked by animals; see also XIII.6.d. Sandler, *Survey* Cat. 44, il no. 101.

?Mulbarton. ms, St Omer Psalter, BL Yates Thompson 14, f 7. c.1325–30. Medallion scenes on Beatus page. Creator flanked by angels; (L) hell mouth with souls falling in; (R) creation of Eve. Sandler, *Survey* Cat. 104; Yates Thompson, *Facsimiles* pl 1. Commissioned by a knight of the St Omer family.

Cathedral. sc, nave bosses. 15³. Bay A focuses on Creation: **1** sun face; **4** God blessing, dividers in LH, flanked by unicorn and lion (*900 Years*, color il p 34; Rose [1997] 40); **5 & 6** angel, one feathered, one in alb; **7** hart; **15** swan; **16** eagle; **17** fish in water; **12** creation of Adam: God, holding Adam's R wrist, Adam bearded; **11** creation of Eve: God, RH raised, Eve emerging from chest of Adam. For the Creation play at Norwich, see Lancashire 1227.

Lyng. *pg, S Win. "God yᵉ father wᵗʰ Compasses in his hand, &c—representing yᵉ Creation," NRO, Rye 17, 3:45.

Cawston. *pg, S transept. ?Mid 15c. Windows "adorned with several histories of the Creation, Deluge, Passion, &c.," Bl 6: 266–7; "very old and well done on this window,"

NRO, Rye 17, 1:204. The glass in the transepts had disappeared by 1841.

Martham. *pg, see II.2.

Snetterton. *pg, N aisle. ?15³ (C & C). The "history of the creation . . . with the legends in labels," Bl 1:420. It is unclear whether the labels accompanied the Creation; see V.2.

2. Adam and Eve: Fall and Expulsion

For the Norwich Grocers' play see Lancashire no. 1227.

Norwich, Carrow Priory. ms, Carrow Psalter, Baltimore, Walters Art Gallery W.34, miniatures. 1250–60. Ff 22 (above) temptation of Eve, serpent with female head in tree; (below) expulsion; 22v Angel giving Adam and Eve spade and spindle; Morgan, *Survey* Pt 2, Cat. 118, il nos. 101–2.

Fincham. sc, font, N face. Norman. 3 compartments: Adam resting head on RH; tree with serpent (restored); Eve extending apple in RH; Adam and Eve covering genitals with LH; il Bond (1985) 156. Font *ex* Fincham S Michael (destroyed 1744).

?Cathedral Priory. ms, Gregory the Great, *Moralia in Job*, CB Emmanuel College 112, hi Book 31. c1310–20. Human-headed serpent coiled around tree and offering fruit; flanked by Adam and Eve eating and offering fruit; James (1904).

?Mulbarton. ms, St Omer Psalter, BL Yates Thompson 14, f 7. c.1325–30. 3 medallions. Adam and Eve; tree; God appearing to Adam and Eve holding fig leaves. Adam and Eve kneeling before deity, angel driving them out of Paradise. Adam digging, Eve spinning. Yates Thompson, *Facsimiles* pl 1.

Warham S Mary Magdalene. pg frag, nIV. 14c. **A3** Angel with hand on hilt of sword held point upright; **A4** Adam with bare foot on spade; Eve with distaff.

Martham. pg, originally 6 tracery lights in S aisle. c1460 (King). (*1) God, barefoot, both hands raised; (*2) Eve giving fruit to Adam, serpent with female head in horned headdress with scalloped veil, apple in hand, wing, claw, tail ?winding around tree (temptor preserved at **nIV.C1**); (*3) red

37

angel with raised sword; (4) Adam and Eve naked, holding tri-lobed fig leaves, walking away from angel; Eve with pendulant breasts, looking back over her shoulder; Adam looking straight ahead; (5) Adam delving, in long-sleeved blue gown, R foot on spade held in both hands; (6) **sV.1b** Eve seated in flowery mead spinning. 4 and 5 now at Mulbarton, E Win, 2a & b; E S Taylor (1859b) il facing 173; work of The "Passion Master," King 24.

Cathedral. sc, W cloister boss, A1. 1415–16. Eve (damaged); serpent wound around tree trunk, facing Eve; Adam holding apple; Rose (1997) 28.

— sc, nave boss, A10. 15³. Hybrid serpent in midst of tree laden with fruit, plucking apple, handing apple to Eve; (R) Eve extending apple; (L) Adam holding apple; il Rose (1997) cover. 1545–58, Corpus Christi procession included "the Griffin and a tree of paradise, and an angel," Lancashire 1220. For the props for the Grocers' play of the Fall (incl the creation of Eve and Dolor) see Lancashire 1227.

Burnham Market. sc, relief, tower. 15ᵉˣ. (Reading clockwise) **N3** Eve and **N4** Adam, both naked with hands covering genitals; Adam holding apple; **N5** king with scepter, **N6** death as a skeleton.

Swainsthorpe. *wp, S wall. Demi-figs, Adam and Eve, both with filets in hair and wreath of leaves at waist, looking back over their shoulders; Adam's LA raised, Eve with luxurious hair; angel above (R). "This fresco together with many others, was whited over when the church was repaired in 1849," DT 60:227.

Poringland. ?wdcarv, *screen. 15⁴. (Supposed donor Robert Peresson, rector 1472/3–90.) "On the screens are Adam and Eve plucking the forbidden fruit, and an angel driving them out of Paradise," Bl 5:440. Since the screen was evidently painted with apostles and prophets (XIII.1.b), perhaps spandrel scenes as at Brooke.

Brooke. wdcarv, frag from spandrel of *screen. Late 15c. (L) angel with raised sword; (upper R) serpent twined around tree trunk, upper body female; (below) Adam & Eve leaving the garden, "an old screen, of which we have scarcely any remains," Beal 69; **FIG 4**. A note (1947) displayed in a photo-

graph indicates that the spandrel frag was returned by a grandson of Beal. Cautley cited the frag, but I have not been able to trace it. The NMR photograph was taken in 1938.

Weybridge Priory (Austin Canons). block-printed tinted calendar, NMS 134.944. 1503. In the Ages of Man at bottom, man, woman in veil. This unusual roll calendar cites 6–10 feasts for each month by name and by demi-fig +/– attribute. For provenance, see Wdf 160.

Hunstanton. 12 Jan 1626. Accounts of Sir Hamon and Lady Alice L'Estrange cite 10s "giuen to the men that sshewed the Motion with the gardin of Eden," apparently part of a masque produced by Gray and his company, Galloway and Wasson, 26. The accounts record regular entertainment expenses.

3. Patriarch History

Cain and Abel

?Mulbarton. ms, St Omer Psalter, BL Yates Thompson 14, f 7. c1325–30. 2 medallions. Adam and Eve at work, sacrifice of Abel, Cain murdering Abel. Lamech killing Cain. Yates Thompson, *Facsimiles* pl 1.

Salle. *pg, S aisle. Story of Cain and Abel cited in win with Boleyn inscription (†1411), NRO, Rye 17, 3:170.

Cathedral. sc nave bosses. 15³. Bay A **18** killing of Cain: Lamech in hood holding bow, arrow piercing breast of Cain, tunic stained with blood; (below) bust of boy pointing to Cain; Bay B **1** Man in striped garment holding jawbone of an ass (?Lamech, who kills the boy). For the play at Norwich, see Lancashire 1227.

Noah

See also II.6.

?Mulbarton. ms, St Omer Psalter, BL Yates Thompson 14, f 7. c1325–30. 3 medallions. Building of the ark, variety of tools. Loading the 3-storied ark, man on ladder with sheep on back; windows with sons, wives, & animals; ark floating with drowned bodies below. Drunkenness of Noah, mocked by Ham, 3 women. Yates Thompson, *Facsimiles* pl 1.

N Tuddenham? pg frag, porch W win 4a. Man

with a sheep on his back against ladder or roof.

Cawston. *pg, See II.1.

Salle. *pg, S aisle. Story of Noah's Ark cited in win with Boleyn inscription (†1411), NRO, Rye 17, 3:170.

Cathedral. sc, nave bosses. 15^3. Bay B devoted to Noah: **4** Noah planing plank with broadaxe; (above) ark partially finished, (*900 Years* il p 41; Rose [1997] 41); **8** man carrying spotted ewe and ram (il Rose 45); **10** 2 men and woman (?going to ark); **12** Noah with staff walking with wife; **13** woman carrying chicks in basket on head, skirt caught up as if wading in water; **11** 3-storied ark with castles; in windows (above) 2 monkeys, birds, ?elephant; (middle, 3 windows) birds; Noah, two women, man; unicorn; (below) muzzled bear, horse, ox, cow, lion (Rose 44); **9** raven eating carrion horse; **14** dove with olive branch in beak; **15** woman facing young man (?demi-kneeling) holding staff, hand on his shoulder; **18** Noah planting vine, vines in leaf with grapes (Rose 49); **7** Noah flanked by Ham and Canaan lifting garment. For the Norwich play Noah's Ark, see Lancashire no. 1227.

Newton Flotman. sc, N wall, Blandeville Monument. "Noah's ark with 'Extra Ecclesiam non est Salus'," Bl 5:69.

Wells-next-Sea. *wp, "Over the south door in the church, the history of the flood is painted," Bl 9:286. See below *Jonah*.

Quidenham Hall. plaster ceiling decoration, stairwell. 1619. Angel above; (W) Noah standing in ark, LH raised just below arm of angel, RH holding open book inscr "Peace Plentie thou shalt labor for 1619"; (E) Noah's wife, LH raised, RH against wind-blown skirt; c18" in height. I am grateful to Judith Leckie, ODC, for providing this information.

Moulton S Michael. Commandment tables with ark; see XIII.2.

Weybridge Priory. printed calendar, NMS 134.944. 1503. Ark.

Babel

Cathedral. sc, nave bosses. 15^3. Bay C **1** Stone mason working on stone; square, set of chisels and other tools; **4** fortified gateway.

Abraham and Isaac

Cathedral. sc, nave bosses. 15^3. Bay C largely dedicated to Abraham and Isaac: **7, 11, 12** Entertainment of angels (*900 Years*, color il p 40; Rose [1997] 53); **13** man holding horse by bridle; **8** wood on Isaac's shoulders, Abraham resting RH on Isaac's head, hilt of sword in hand; **10** Isaac with joined hands seated on altar, Abraham lifting massive sword (Rose 52); Bay D **2** angel pointing to **3** ram in thicket. For the play at Norwich, see Lancashire 1227.

Norwich S Andrew. pg frag, sV, light b, originally in E win; moved c1850. 16^1 (1500 license to lengthen chancel, Bl 4: 304; bequests throughout first decade, C & C). Two registers. (Below) Isaac bearing wood on shoulder, led by Abraham with back to viewer, bearing fire in one hand, sword in the other; originally the ram was on the same axis as Abraham's head, only frag remains. (Above, now largely lost) Abraham with arm raised to slay son, angel restraining sword; G King (1914) il facing 286. The win is intact in Winter's 1849 engraving, *Selection* 2:12.

Norwich S Stephen. pg frag, E win, light a. 1533. (R) Two men with laden horses; (L) Isaac with wood on back following Abraham.

Norwich Abraham's Hall? *pwd. Blomefield (4:184) cites the sign of Abraham offering up his son Isaac; in 1619 inn reputed very old.

Southwood. tapestry, Flemish. ?17c. Abraham with scimitar raised, LH on Isaac's head, Isaac kneeling; (far L) ram. Now at Limpenhoe; in all likelihood postdating the subject list.

Wooing of Rebecca

Cathedral. sc, nave bosses. 15^3. Bay C **9** Rebecca drawing water from well; **14** servant with 2 camels.

Salthouse. ivory carving, part of a box, in private possession. ?17^1. 2 camels; Rebecca holding a pitcher to lips of Eliezer demi-kneeling; well. According the family tradition the "Queen's box" came from Anne of Denmark; DT 60:4.

Deception of Isaac

Norwich, Carrow Priory. ms, Carrow Psalter, Baltimore, Walters Art Gallery W.34, hi, f 155 (Ps 80). Wrestling with an angel.

Cathedral. sc, nave bosses. 15³. Bay C **5** Jacob kneeling before Rebecca who extends animal skins to him (*900 Years*, color il p 39); **6** Esau with game over shoulders and box (*900 Years*, color il p 40); **15** Isaac in bed, eyes closed, holding Jacob's hand; (L) Esau with bow walking away (Rose [1997] 56); **16** Esau hunting; **17** Jacob slaughtering kid (Rose [1996] 369, fig 126); **18** Isaac in bed, Esau kneeling beside, bow in LH, RH held by Jacob; hands resting on bedsheet.

Jacob

Norwich Carrow Priory. ms, Carrow Psalter, Baltimore, Walters Art Gallery W.34, hi, f 155 (Ps 80). 1250–60. Wrestling with an angel.

Cathedral. sc, W cloister boss. A3. 1415–16. Wrestling with angel.

— sc, nave bosses. 15³. Bay D devoted to Jacob: **1** Rebecca standing before open door of empty house; **4** Jacob staff in hand (journeying to Paddan-Aram) (Rose [1997] 57); **5** anointing stone; **6** sleeping; **7** wrestling with angel (il Rose 60); **8** removing stone from well, water flowing; **9** Jacob and Rachel embracing, (R) sheep; **11 & 12** marriage to Rachel and Leah (il Rose 65); 10 peeling rods, flanked by sheep (il Rose 61); **13 & 14** sheep and goats feeding; **16** Jacob with camel bearing chest (leaving Paddan-Aram); **17** Rachel and Leah with swaddled infants, riding side-saddle (il Rose 64); **15** 2 angels climbing ladder, nebuly above; **18** covenant betw Jacob and Esau (bearded).

Joseph

Cathedral. sc, nave bosses. 15³. Bay E devoted to Joseph: **1** Joseph kneeling beside seated Jacob; **2 & 3** five brothers each; **4** Joseph with sack on staff and leather bottle; **5** 2 seated brothers; **6** Joseph in stocks; **7** Joseph being stripped of garment; **8** Ishmaelite with pack horse; **9** Ishmaelite holding money sack; **10** brothers (L & R) forcing Joseph into pit (Rose [1997] 68);

15 stripped Joseph being sold to traders; **14** brother killing goat, blood being caught in bowl; **13** brother fingering ornamented gown; (below) pan with blood; **11** Jacob seated, hands clasped, grieving; **12** 3 figs eating, ?brothers/?Joseph, Potiphar and wife; **16** brothers eating; **17** Judah kneeling before Joseph with sack in hand; **18** Pharaoh and Joseph; Bay F **1** Joseph surrounded by sacks of grain (Rose 69); **2 & 3** in each boss 2 brothers with empty sacks over arms.

Tribes of Israel

Walpole S Peter. *wp. "Against the walls of the nave are painted the insignia of the 12 tribes of Israel," Bl 9:114.

W Walton. wp, arcade spandrels, arms of 10 tribes in roundels, perhaps copies of earlier work. Cited by James as 17c (*S & N*); David Park dates as 18/?19c.

Moses

See also section 6, below, and VI.1 & 3, IX.4, and XIII.1b.

Cathedral Priory. ms, Bible, Bod L Auct. D.4.8, hi. 1190–1250; 14c Priory pressmark. Ff 39v (Exodus) Moses set afloat; 61 (Leviticus) Moses sacrificing at an altar; 75v (Numbers) Balaam and ass; Pächt & Alexander 444, pl XL; 96 (Deuteronomy) burial.

?Mulbarton. ms, St Omer Psalter, BL Yates Thompson 14, f 57v. c1325–30. 5 marginal medallions: Moses removing shoes before burning bush, deity above; Moses before Pharaoh. Drowning of Egyptians in sea, Moses and Israelites on shore. (L) Moses receiving the tablets; (C) Israelites worshipping calf; (R) Moses casting down tablets. Moses raising brazen serpent, Israelites, some dead. Building the tabernacle, variety of tools. Sandler, *Survey* Cat. 104, il no. 267; Yates Thompson, *Facsimiles* pl 2.

Cathedral. sc, above Prior's door (R). c1297–1314. (R) bearded and with horns, holding tablets, feet resting on recumbent fig (Ps 109:1); color il *900 Years* 77.

— sc, nave bosses. 15³. Bay F devoted to Moses: **4** woman placing swaddled Moses into basket in river (Rose [1997] 72); **6** Moses seated with crook watching sheep; **7**

horned Moses kneeling before deity (bust) in radiance in midst of bush (Rose [1996] fig 129); **5** Moses removing shoes; **10** Pharaoh, 3 men and chariot in Red Sea (Rose [1997] 84); musicians celebrating with **8** harp and lute, **9** shawm and bent trumpet (Rose [1997] 73); **11** 2 women and **12** man and priest observing; **13** Moses with staff dividing Sea, Israelites behind him; **14** Pharaoh, Moses with horns, Aaron (tonsured, in tippet with hood); **15** 2 priests carrying Ark of the Covenant, **16** 2 men, each with hands joined, walking (following Ark). For the play at Norwich, incl the burning bush as well as "the children of Israel and Pharaoh with his knights," see Lancashire no. 1227.

— pg, Erpingham win, nX.4a, *ex situ*. 1450–60. Head of Moses with "horns" as golden rays coming from ears, King (1996) 419, fig 146; for details on origin of extensive glass now set in the win, see King.

N Tuddenham. pg, nVI.A3. 15³. Moses standing with crook in RH, in white gown and murrey mantle looking up, LH extended; background with flowers; horns, same cartoon as in Erpingham win, Wdf pl XIX.

Norwich S Andrew. pg frag, sV, light c, originally in E win. 16¹. Two registers. (Below lost) men and a woman tormented by serpents; (above) Moses holding tablets of Commandments and pointing to brazen serpent raised on pole, crowd of men looking up; complete design in G King (1914), facing 286.

Norwich S Stephen. pg frag, E win, light e. 1533. People tormented by serpents.

Lyng. *pg, S win, "a fair large figure," NRO, Rye 17, 3:45

Guist. *wp, inner N wall; "a large figure, ?Moses," Keyser with reference to *Gentleman's Magazine* n.s. 5 (1836) 218. Perhaps a Christopher.

Moses and Aaron

The Cathedral's relics (13c) included a piece of Aaron's rod (Beeching 17). See also XIII.2.

Cathedral. *?pwd. Pictures of Moses and Aaron burned in the market, 1647, Bl 3:390.

NMS. 2 2-dimensional painted manikins, 4' high. ?c1630. Moses, holding tablet of law in RH and rod raguly in LH; Aaron appears in mitre, breastplate, tunic with bells, and is

holding thurible; from Gorleston (Suf).

4. Joshua, Judges, Ruth, Kings
Joshua

Cathedral Priory. ms, Bible, Bod L Auct. D.4.8, hi, f 115 (Joshua). 1190–1250; 14c Priory pressmark. Siege of Jericho.

Judges

Cathedral Priory. ms, Bible, Bod L Auct. D.4.8, hi, f 115 (Judges). 1190–1250; 14c Priory pressmark. Destruction of Jerusalem.

Samson

?Mulbarton. ms, St Omer Psalter, BL Yates Thompson 14, f 77v (Ps 52). c.1325–30. 3 medallions. Carrying gates of Gaza, soldier in battlement above. (L) rending lion; (R) Delilah shearing locks, Philistines behind. Philistines feasting, Samson leaning on pillars, roof cracking; Sandler, *Survey* Cat. 104, il no. 267; Yates Thompson, *Facsimiles* pl 2.

Cathedral. sc, W cloister, 1420–21. **D3** rending lion's jaw.

— sc, nave bosses. 15³. Bay **F 17** Manoah and wife kneeling, hands joined; **18** Samson rending lion's jaw. Bay **G 1** carrying the gates of Gaza; **2** sleeping on Delilah's lap, she binding his wrists; **3** similar scene, Delilah in horned headdress cutting a lock of Samson's hair with scissors, his wrists bound, hat on a ledge, Rose (1997) 76.

— wdcarv, misericord, N13. 15¹. Samson dressed as knight, astride lion, rending lion's jaws; supporters (L) crane; (R) owl with mouse in beak; ils in Bond (1910a) 138; Lund 140; Rose (1994).

Ruth

Cathedral Priory. ms, Bible, Bod L Auct. D.4.8, hi f 141v (Ruth). 1190–1250; 14c Priory pressmark. Noami, Elimelech, and sons going to Moab.

Kings
Samuel

Cathedral Priory. ms, Bible, Bod L Auct. D.4.8, hi f 144 (Kings 1). 1190–1250; 14c Priory pressmark. Presentation of Samuel. Morgan, *Survey* pt 1, Cat. 75.

Saul

Norwich, Carrow Priory. ms, Carrow Psalter, Madrid, Biblioteca Nacional 6422, hi, f 62v (Ps 51). 1250–60. Suicide with devil, "misused" for David in the waters; Morgan, *Survey* pt 2, Cat. 120, il no. 109.

— ms, Carrow Psalter, Baltimore, Walters Art Gallery W.34, hi, f 114 (Ps 52). 1250–60. Suicide, ?Saul.

David

See also sections 5 & 6; VI.3 *Exaltation* (Attleborough), & XIII.1.b Thornham. In English psalters representations of David are generally standardized; see Scott, *Survey* Table I.

Cathedral Priory. ms, Bible, Bod L Auct. D.4.8, hi. 1190–1250; 14c Priory pressmark. Ff 163 (Kings 2) Amalakite before David; 315 (Ps 1) harping; 319v (Ps 26) pointing to eyes; 323 (Ps 38) pointing to mouth; 325v (Ps 51) David & Goliath; 333 (Ps 80) playing viol; Morgan *Survey* pt 1, Cat. 75, il nos. 252 (Amalakite) & 253 (Ps 26).

Norwich, Carrow Priory. ms, Carrow Psalter, Madrid, Biblioteca Naçional 6422, hi. 1250–60. Ff 7 (Ps 1) (above) David harping; (below) lay woman with book, lay woman with sword; Morgan queries Mercy & Truth; 96v (Ps 80) David playing bells; Morgan, *Survey* pt 2, Cat. 120, il nos. 108 (Mercy & Truth), 111 (playing bells); see also XV.1.b. Ps 80 is sometimes illustrated with clerics playing bells. Morgan, *Survey* pt 2, Cat. 182, queries a second Mercy and Truth in BL Egerton 1006, a MS with Suffolk provenance.

Cathedral Priory. ms, Ormesby Psalter, Bod L Douce 366, hi. 14[1]. Ff 10 (Ps 1) David harping (L & M 21, color il; Pächt & Alexander 581, pl LX); 38 (Ps 26) Anointing of David (Atherton, color pl IIb); 71v (Ps 51) Doeg and and 3 others slaying 3 priests (L & M Cat. 21, color il); 109 (Ps 80) David playing bells with musicians below; 131 (Ps 101) David praying. Sandler, *Survey* Cat. 43, il no. 98; Pächt & Alexander 536, pl LI.

Diocese. ms, CCCC 53, hi, 14[1]. Ff 19 (Ps 1) David harping, (bas-de-page) David with stones held in hem of garment, sling and one stone in the air, Goliath (Sandler *Survey* Cat. 66, il no. 170); 38v (Ps 26) pointing to eyes; 52 (Ps 38) pointing to

mouth; 64 (Ps 52) with fool eating cake and holding club; 94v (Ps 80) playing bells; James (1912).

Bromholm Priory. ms, Bromholm Psalter, Bod L Ashmole 1523, hi. c1310 (ff 1–168v). Ff 50 (Ps 38).David pointing to mouth, rejects Devil; 65 (Ps 51) murder (?Doeg); Pächt & Alexander, 537, pl LII.

?Wiggenhall S Germans. ms, Howard Psalter, BL Arundel 83 I, hi, f 40 (Ps 51). c1310–20. David about to decapitate Goliath.

W Dereham Priory. ms, psalter, Escorial Library Q II 6, hi. c1320–30. Ff 15 (Ps 1) David harping; 36 (Ps 26) pointing to eyes, Sandler, *Survey* Cat. 80, il no. 205. Secular ownership of ms (?Lincolnshire) before passing to W Dereham Priory in the 15c. Sandler sees similarities betw this ms and the Stowe Breviary (Cat. 79); she conjectures E Anglian origin.

?Diocese. ms, psalter, Oxford, All Souls College 7, hi. c1320–30. Ff 7 (Ps 1) David harping; 38v (Ps 38) pointing to mouth, God above in cloud; 49 (Ps 51) slaying Goliath; Sandler, *Survey* Cat. 82, il nos. 209–10.

— ms, Stowe Breviary, BL Stowe 12, hi. c.1322–25. Ff 171v (Ps 26) David pointing to eyes; 176v (Ps 38) pointing to mouth; 180 (Ps 52) seated, fool with bladder; 190 (Ps 80) playing bells.

?Mulbarton. ms, St Omer Psalter, BL Yates Thompson 14, f 70v (Ps 68). c. 1325–30. 5 medallions. Battle with Philistines, loss of ark of covenant. (L) Goliath with stone in forehead; (C) David cutting off head, Saul observing; (R) David kneeling, presenting head on sword to woman. Battle on Mt Gilboa. (L) David anointed king; (R) David enthroned. David seated, surrounded by soldiers in armor, one kneeling before him. See also Solomon. Yates Thompson, *Facsimiles* pl 3. This MS also contains the following: f 29v (Ps 26) anointing and crowning (miniature); and historiated initials: ff 44 (Ps 38) pointing to tongue, deity above; 57v (Ps 52) seated with fool; 87 (Ps 80) playing bells; see also *Moses* and *Samson*. Sandler, *Survey* Cat. 104, il nos. 266–7 (Psalms 26, 52).

?Thetford Priory 1. ms, Cluniac Psalter, Yale, Beinecke 417, hi, f 7. c1320–30. (Ps 1) David harping; in bas-de-page and margins David and Goliath, Annunciation; Sandler,

Survey Cat. 108, il no. 279.

Diocese. ms, Psalter, CB UL Dd.12.67, hi. c1400. Ff 7 (Ps 1) David seated, harping; kneeling layman supporting harp; 46v (Ps 38) David seated pointing to eyes, flanked by ?fruit trees; 59v (Ps 51) kneeling fig above recumbent devil; hand of God above. Atypical scenes.

— ms, Helmingham Breviary, NMS 1993.196, f 7 (Ps 1). c.1420. David harping, ermine-lined mantle; counterchanged geometric (see Appendix VI, **FIG w**).

?Besthorpe. ms addition, Bod L Don. d.85, hi, f 11 (Ps 1). 1420–30. David with harp, young man kneeling.

Diocese. ms, psalter, Bod L Liturg. 153, hi. 15¹. Ff 25 (Ps 26) David pointing to eyes, Pächt & Alexander 848, pl LXXXI; 37v (Ps 38) David pointing to mouth, ?sword at side; 49v (Ps 52) fool with bladder on stick.

Ranworth. ms, Ranworth Antiphonal, S Helen's Church, hi. 1460–80. Ff 141 (Ps 1) David harping under canopy, 4 attendants; 145 (Ps 26) David kneeling in prayer before Deity in nebuly; 147v (Ps 38) David standing with scepter, city in background; 149v (Ps 52) David with fool; Scott, *Survey* Cat. 121, il no. 446.

Marsham. See XV.6 *Nine Worthies*.

Cathedral. sc, N cloister bosses. 1427–8. **F7** David, crowned, wearing knight's belt over short gown, slaying lion; **F6** similarly dressed with head of Goliath on pole; **F3** king (dressed as at **F7** & **F6**) opposite wild man.

— sc, nave bosses. 15³. Bay **G 4** David attacking armed Goliath with slingshot, stone embedded in Goliath's forehead (Rose [1997] 77); **5** soldier drawing sword; **6** 2 armed soldiers; **7** David decapitating Goliath. Bay **G 10** David holding harp, flanked by counselors placing crown on head; **11** courtier with mace; **12** courtier with sword. For the David & Goliath play at Norwich, see Lancashire 1227.

N Buckenham. sc, corbel 5. ?Victorian restoration. In apostle sequence, bust with harp.

W Dereham Priory. *wp, 2 scenes. 16¹. Arming of David: soldiers with halberds; helmet being put on young man armed with massive sword. David acclaimed by Women of Israel: elaborate city in background; (reading L to R) woman playing stringed instrument; man in helmet holding palm; man in soft hat; man with halberd; ?Saul on horseback; David crowned with leaves holding a head upside down; man in soft hat, with bill; DT 28:189–90. David in procession with Goliath's head appears in Continental psalters illustrating Ps 80.

Yarmouth? *wp frag, N wall N aisle. Goliath with weapons; David before Saul; Israelite soldiers before open building with cross; DT 62:31, identified by Husenbeth. Perhaps the same frag wp reproduced by C Palmer (facing 119), secular figures in armor and a group of soldiers in chainmail hoods beside a church or chapel.

Walsoken. wdcarv, E wall of chancel arch. 17c. Large fig of David seated, harping; paired with Solomon on W wall. Cleaned recently.

David and Abigail

Norwich SPM. plate, high relief on cup and cover. 1633. Around cup, laden horses and camels led by men; Abigail with attendants, kneeling offering bowl of fruit to David, David and men armed. On cover, David sending messengers, their reception by Nabal and return. Hopper (1888) il betw 1–2 & 103.

Solomon

In 1547 the triumph for the Coronation of Edward VI included a pageant of King Solomon, Lancashire 1232.

Cathedral Priory. ms, Bible, Bod L Auct. D.4.8, hi. 1190–1250; 14c Priory pressmark. Ff 178 (Kings 3) Solomon riding on David's mule; 226 (Chronicles 2) directing building of the Temple); 349 (Proverbs) instructing Rahoboam; 360 (Ecclesiastes) teaching; 364v (Song of Songs) Ecclesia & Synagoga before Solomon; 366v (Wisdom) seated; Pächt & Alexander 444, pl XL.

Diocese. ms, Stowe Breviary, BL Stowe 12, hi, f 121. c1322–25. (1st Sun, Aug) instructing a child, Sandler, *Survey* Cat. 79.

?Mulbarton. ms, St Omer Psalter, BL Yates Thompson 14, f 70v (Ps 68). c1325–30. 3 medallions. David in bed blessing young boy presented by Bathsheba. Solomon seated; man with raised sword about to cut infant in two, held with legs apart by woman, second woman holding infant in arms. Building of temple. Yates Thompson, *Facsimiles* pl 3.

Cathedral. sc, nave bosses. 15³. Bay **G 13** ?Nathan with scrolls; **14** ?Adonijah in chaperon; **16** David crowned, holding scroll, Bathsheba behind; **15** Solomon being blessed by dying David (crowned), both holding scepter (Rose [1997] 81); **18** enthroned in ermine collar, with temple on R forearm and (LH) sword, (Rose [1997] 80 & [1996] fig 128). Bay H **1** enthroned, holding scepter, flanked at **2** by prophet with scroll inscr ?"Esaias propheta" and **3** man in turban with scroll (Goulburn identified as Nathan and Zadok; Rose queries).

Mulbarton? pg, see XII *Athelstan.*

Oxborough? pg, roundel, E win, light c, not *in situ.* 15⁴. Bearded king, the same model as at Browne's Hospital; frag sword in RH.

Catfield? pwd, see XII *Athelstan.*

Judgment of Solomon

For the wicked judge Otanes see XV.6.b.

Norwich, Carrow Priory. ms, Carrow Psalter, Madrid, Biblioteca Nacional 6422, hi, f 48v (Ps 38). 1250–60. Judgment; Morgan, *Survey* pt 2, Cat. 120, il no. 110.

Diocese. ms, psalter, CB UL Dd.12.67, hi, f 32v (Ps 26). c1400. Seated with sword; one woman turning away with hands clasped in prayer; second holding naked child by feet.

Norwich Guildhall. *pg, easternmost win, S wall. New Council Chamber completed 1535. Biblical judgment with text "The Trewe and counterfet to trye,/ She had rather lose her Ryght,/ Seying, the soulders ware redy / To clyve, with all ther myght," Bl 4:230. The Guildhall apparently had a number of judgment scenes, including "a King, with a large parcel of armed men, placing a person before him on his knees, and on the other side was a man in his winding sheet, sitting in order to be shot dead with arrow," Bl 4:229. Wdf (198) identified as legendary judgment of 3 brothers competing for inheritance. Kent (n.d.) cited Flemish glass with the judge seated beneath the flayed skin of his father with text (19–20). Blomefield commented on the broken and misplaced glass fragments, some of which had also been "brought from other places," 4:230.

Walsoken. wdcarv and wp, W wall. 17c. Central carved Solomon seated on throne with painted canopy behind and flanking wp; (L) woman standing, woman kneeling; (R) soldier with raised sword with child in LH. Recently cleaned. Paired with David on E wall. There are two other paintings of the judgment of Solomon hung in the chancel, one late 17c.

Elijah

Norwich. ms, Bible, Bod L Auct. D.4.8, hi, f 194 (Kings 4). 1190–1250; 14c Priory pressmark. Ascension of Elijah. Morgan, *Survey* pt 1, Cat. 75.

5. Tree of Jesse and Genealogy of Christ

Isolated king and prophet frags may be evidence for the genealogy or Tree of Jesse.

Cathedral Priory. ms, Ormesby Psalter, Bod L Douce 366, full page Beatus initial, f 9v. 14¹. Page flanked by prophets with scrolls; (below) Jesse lying on bed, head on pillow; 5 registers above: David harping, flanked by Solomon with sword and king with scepter; bp or mitred abbot and monk kneeling in prayer; 2 kings flanked by layman and woman kneeling in prayer; 2 kings flanked by the Annunciation; Coronation flanked by angels in albs playing fiddle and gittern; Pächt & Alexander 536, pl L; Sandler, *Survey* Cat. 43, il no. 96.

Diocese. Corpus Christi Psalter, CCCC 53, f 19. 14¹. Tree of Jesse, Sandler, *Survey* Cat. 66, il no. 170.

?Wiggenhall S Germans. ms, Howard Psalter, BL Arundel 83 I, hi, f 14 (Ps 1). c1310–20. Tree of Jesse, tetramorphic symbols and prophets in margins.

?Mulbarton. ms, St Omer Psalter, BL Yates Thompson 14, f 7. c1325–30. David flanked by ?patriarch and Moses, Solomon by prophets, and Virgin and Child by angels; Yates Thompson, *Facsimiles* pl 1.

Weston Longville. wp, N wall. c1360 (same workshop at Lt Witchingham, DP in P & W 2). Interlaced vine stems with grapes, leaves, and tendrils, originally with 35 compartments; a number of heads of prophets and kings remaining, some conversing, most looking at—and many pointing to—the three central compartments; (uppermost) with Virgin and Child; (middle) enthroned king; (lowest) David harping; pro-

phets clad in long gowns with mantles, soft shoes and hats (one with liripipes at hat and sleeves), all bearing scrolls, lettering illegible; kings cross-legged, some mantles lined with vair. Tristram 262–3, pl 23a & b.

Norwich SPM? pg, E win, originally in sIII (King, forthcoming). Mid-15c. Inscriptions of 3 ancestors of Christ, Asa, Isaac and Jacob in nIII, and unidentified kings and patriarchs (one preserved in the sIV tracery, though King projects as many as 20 or 24 in the original win). Displaced scroll inscr "Assa," Wdf pl I.

Norwich SPH? pg, E win, central tracery lights. King and prophet, both against seaweed screen. Although there is another prophet now in the E win (1a), it is smaller scale.

Cathedral. pg, roundel. c1500. Jesse recumbent; 4 kings; Virgin and Child flanked by 2 ?prophets; in Visitors' Centre; King (1996) 426, fig 150. Uncertain provenance.

Hoe. *pg, E win, N aisle. "Isaie prof: Ecce virgo concipiet & pariet filium. This over the virgin as below. . . . On another pane God the Father, our Saviour & the Virgin with Jesus in her lap, over them St. David & St. Gabriel with Ave gracia. . . ." The description is cramped at the bottom of a page, but a later description cites the Salutation in the same win; NRO, Rye 17, 2:258v, 260.

E Rudham. *pwd, on the screen, ancestors of Christ: "Asa / Abram / [one figure unidentified] Salomd . . [Salmon] / Esau [?Esron] / Isaac/ /Judas [Judah]" NRO, Rye 17, 3:157. The list is curious for a screen. The citation with virgules suggests the panes were cited in sequence, but no pattern emerges.

E Harling. wdcarv, screen, N side (at W end of pews). c1500. Within quatrefoil, crucifix rising from the breast of recumbent Jesse, flanked by Mary and John (anomalous Type 1 Crucifixion); il Cautley 116.

6. Prophet/Patriarch Sets

Two patriarchs figured in a pageant for Elizabeth Woodville's visit to Norwich, Harrod (1859b) 35.

Norwich S Stephen. al, part of *Te Deum* composition. 15[1]. 9 prophets, all except John Bapt wearing elaborate headgear; in 2 irregular registers. (Above) ?David, crowned; 2 prophets in chaperon; ?Isaiah with saw; Moses, horned, with staff in RH

and broken tables of the law in draped LH; (below) holding ?verge; with massive scimitar, holding forked beard (?Gideon, Nelson [1917] 116); holding roll, gown decorated with red quatrefoils (?Jeremiah); John Bapt with Angus Dei on book; Bensly il facing 356. See also Cheetham Cat. 238 where John and Moses occupy the same positions far R and the prophet with the scimitar stands in the lower register (Cheetham suggests Gideon).

Salle. pg, chancel. 1441–50 (Marks 188). Headdress distinguishes prophets from patriarchs with hoods; name scrolls form an arch at heads/shoulders: name + *propheta*/Patr. The N win also includes saints in cardinal costume; see King (1979) 334. **sII.A2** Jonah in white mantle over blue gown; **A5** David, white mantle over blue gown; **nII.A1** Enoch, hood, tippet over mantle, wide sleeves of gown, long forked beard, LH raised; **A2** "Helijeus," cap, flowing beard, teaching gesture; **A3** "*Sanctus. Laurentius, Cardi*"; **A4** "*Sanctus* [Feli]cissim[us]"; **A5** "Helias" in ¾ profile, blue chaperon, roll in RH (Marks fig 157; King pl 8); **A6** Noah in profile in pointed cap over hood, tippet; holding book with ornamented cover, double clasp; **B3** Jacob, hood topped with cap, long flowing beard, LH raised, double clasped book in RH; LH raised; **B4** "*Sanctus* Austerius, cardin"; restored.

Stody. pg, nVI. 1440–50 (King personal communciation). "Series of kings and prophets or patriarchs" (King 6); elaborate prophet hats, turban; prophet with cowl-like hood (cf Bale and Salle) pointing to S Edmund (see also XII).

Griston. pg. c1450 (new work in process or planned c1435, NCC Surflete 186). Names and text forming arch over prophet heads, each gesturing to scroll. **sIV.A2** Ieremiah in ?turban, "Verba Ieremie . . ."; **A4** Isaiah in ?turban, "Ecce Virgo concipiet et pariet filium"; **A5** David in saffron hat "Quia filius meus es tu ego hodie genui te"; **sV.A2** Noah "Ecce adducam aquas dilu[vii] super terram." See Appendix IV.2.

Prophet Sets

It is possible that some of the prophets were originally paired with the Apostles and the articles of the Creed;

see also XIII.1.a and Appendix IV.2.

Houghton-on-the-Hill? wp. c1090. E wall, above chancel arch directly below Crucifix Trinity; in roundels busts holding scrolls. Restoration in progress.

Bale. pg, sV.2b. 14³⁻⁴. 2 prophets with texts: (L) bearded with gold mantle over head and shoulders, LH raised, R index finger pointing to text, "ascendit rept*ans* m*anibus* et pedib*us*" (1Sam 14:13); (R) Daniel, in dark gown, unbearded, with text "post ebdominad' sep*tuaginta* d*uas* occidet[ur]" (Dan. 9:26); **FIG 5**. See Appendix IV.2.

Narborough. *pg, E win. ?15c. "Prophets; the effigies of Isaias, Elias, and Jeremias are still to be seen," Bl 6:164.

Cley. *pg. "There are several saints and prophets on the windows, viz. Sts. Mathew, Gregory, Ambrose and Malachias[,] Joel, Aggeus, Daniel, prophets and several others"—all this on a large sheet of paper c1735; Frere MSS, NRS 1:15.

Thornham. pwd, screen. 15⁴ (before 1488, donor †1488 named on screen but no bequest in will). 12 prophets & 4 saints, (see X *Paul* and XII *Barbara, Lazarus,* and *Mary Magdalene*). All prophets in mantles over damask gowns, elaborate hats (Appendix IV.3, **FIGS p–s**); none heavily bearded; names + *propheta* inscr in bottom register; rubricated texts in lateral scrolls. Panels cited in order of texts. **N8** Jeremiah with teaching gesture, "P[at]rem i*n*vocab*is* q[u]i fec[i]t t[er]ra*m* & co*n*did[i]t celos" (3: 19/32:17); **N7** David crowned, with harp on RA, ermine-lined mantle and collar, "D*omin*us dix[i]t ad me fili[us] m[e]u*s* es tu" (Ps 2.7); **N6** Isaiah both hands raised, "Ecce ui[r]go co*n*cipiet & p*a*riet filiu*m*" (7:14); **N5** Zachariah with scroll in LH, RH raised, "Aspicie*n*t ad me que*m* confixer[unt]" (12:10); **N4** "Osee" beardless, with teaching gesture, "O mors ero mors tuo" (13: 14); **N3** Amos with teaching gesture, "Qui edificat in celo asce*nc*[i]o*nem* [suam]" (9: 6); **S1** "Sophonias" LH hitched in belt, "Ascenda*m* ad uos i*n* iudi[ci]o & [ero te]sti [velox]" (Malachi 3:5); **S2** Joel holding mantle with RH, LH raised "Efunda*m* [d]e sp[irit]u meo s[upe]r o*mn*em carn[em]" (2:28); **S3** Micah both hands raised, "I*n*uocabu*nt* o[mn]es n[ome]n d*omini* & ser-[v]ient ei" (Sophonias 3:9); **S4** "Mala-

ch[iah]. . ." holding mantle with LH, RH raised, text largely lost "[depo]net d[omi]-nus o[mnes iniquitates nostras]" (Micah 7:19); **S5** Daniel LH raised, "Educa*m* uos de sepulcro p*o*[pu]l[us] meus" (Ezekiel 37:12); **S6** Ezekiel pointing to scroll with RH, "Euigilabu*nt* o[mn]es alii ad vita*m* alii in [opproprium]" (Daniel 12:2). Restored. The position of Jeremiah may have been influenced by the parallel position of Peter in apostle screens at the door of the screen; however in Creed screens his normal position was N1 with the text reading L to R. Restored 1970s by Eve Baker. Anderson (1971, 261 fn8) knew only that the paintings might "have represented the prophets." See Appendix IV.2.

Harpley? pwd, medieval screen, panels painted 1865, perhaps replacing an original prophet set. Zechariah, Isaiah, Amos, Micah, Obadiah, Daniel, Jonah, Jeremiah, Joel, Hosea, Ezekiel, Malachi. Doors: Virgin and Child, SS Lawrence, Joachim with name scrolls, and Virgin teaching Mary to read.

Old Buckenham. wdcarv, be. 15c. Paired bearded men, some with hats; seated, commonly with open book/scroll on lap; ?Isaiah standing next to vase (a similar decapitated fig at N Lopham); perhaps an apostle/prophet set, see X.4 *James Min.*

7. Prophetic Books

Cathedral Priory. ms, Bible, Bod L Auct. D.4.8, hi. 1190–1250; 14c Priory pressmark. Ff 397 (Isaiah) martyrdom; 424v (Jeremiah) God speaking to Jeremiah; 454 (Lamentations) Jeremiah lamenting; 457 (Baruch) Jeremiah dictating to Baruch; 460v (Ezekiel) seated; 487v (Daniel) in lion's den; 498 (Osee) God speaking to; 502 (Joel) teaching; 503v (Amos) with flocks; 506 (Abdias) prophets eating bread; 506v (Jonah) emerging from whale; 507v (Micah) prophesying before Hezekiah; 510 (Nahum) prophesying before Nineveh; 511 (Habakkuk) God speaking to; 512v (Sophonias) God speaking to; 513v (Aggeus) instructing building of temple; 514v (Zachariah) prophesying; 519 (Malachi) prophesying.

Isaiah (Isaias)

Cathedral Priory. ms, psalter, Lambeth Palace

368, hi, f 128v. c1270–80. (Confitebor) ?Isaiah standing by lectern with open book.

?Cathedral Priory. ms, Gregory the Great, *Moralia in Job*, CB Emmanuel College 112, hi Book 16. c1310–20. Isaiah standing over Hezekiah (in bed).

Ezekiel (Ezechiel)

Diocese. ms, Stowe Breviary, BL Stowe 12, hi, f 136. c1322–25. (lst Sun, Nov.) in apostle garment, book in RH, LH raised; Sandler, *Survey* Cat. 79, il no. 201.

Daniel

See above, Bale, Thornham.

Norwich S Michael-at-Plea? *pg, frag text suggests Dan 5:1–2. E win. 15c. Wdf (196–7, pl XLIII) conjectured Belshazzar's feast.

Susanna (Dan 13:1–64)

Melton Constable. pg, nII, not *in situ*. Mid 16c. Susanna in garden, wall in foreground, with a flower; 2 companions; Wdf conjectured that a second text now leaded above may have accompanied the execution of the elders: "Synne and iniquite / Bryng them to mysere / Thys ys nott to leer"; Flemish work, probably from Norwich, Wdf 198–9.

Jonah (Jonas)

See also above, Salle.

Norwich, Carrow Priory. ms, Carrow Psalter, Madrid, Biblioteca Nacional 6422, hi, f 77v (Ps 68). 1250–60. (Above) bust of diety; (below) Jonah emerging from whale.

— Carrow Psalter, Baltimore, Walters Art Gallery W.34, f 131 (Ps 68). 1250–60. Being thrown into sea; emerging from whale.

Cathedral Priory. ms, psalter, Lambeth Palace 368, hi, f 51 (Ps 68). c1270–80. Jonah thrown to whale; Jonah rising from whale.

— ms, Ormesby Psalter, Bod L Douce 366, hi, f 89 (Ps 68). 14[1]. Jonah thrown overboard and saved.

Diocese. ms, Corpus Christi Psalter, CCCC 53, hi, f 76v (Ps 68). 14[1]. Deity above, Jonah "perhaps emerging from mouth of large fish," James (1912).

?Wiggenhall S Germans. ms, Howard Psalter, BL Arundel 83 I, hi, f 47 (Ps 68). c1310–20. (Below) saved from whale, Nineveh in

background; (above) deity blessing, tau orb in hand; hybrids in bas-de-page; Sandler, *Survey* Cat. 51, il no. 123.

?Diocese. ms, psalter, Oxford, All Souls College 7, hi, f 61 (Ps 68). c1320–30. Saved from whale, Deity blessing above; Sandler, *Survey* Cat. 82.

?Mulbarton. ms, St Omer Psalter, BL Yates Thompson 14, hi, f 70v (Ps 68). c1325–30. 2 registers, (above) thrown overboard; (below) saved; hand of deity, Nineveh in background; Yates Thompson, *Facsimiles* pl 3.

Diocese. ms, Stowe Breviary, BL Stowe 12, hi, f 184v (Ps 68). c1322–25. Jonah in shirt, emerging from mouth of whale; Sandler, *Survey* Cat. 79, il no. 202.

W Dereham Priory. ms, psalter, Escorial Library Q II 6, hi, f 75v (Ps 68). c1320–30. Emerging from mouth of whale, one leg free; Sandler, *Survey* Cat. 80, il no. 204.

Diocese. ms, psalter, CB UL Dd.12.67, hi, f 73 (Ps 68). c1400. Emerging from mouth of whale.

Ranworth. ms, Ranworth Antiphonal, S Helen's Church, hi, f 152 (Ps 68). 1460–80. Emerging from mouth of pike-like whale; deity in nebuly above; Nineveh in background. Scott, *Survey* Cat. 121, il no. 447; L & M Cat. 69, color il p 59.

Wells-next-Sea. *wp "Over the north door [history] of Jonas," Bl 9:286; "a large painting . . . of Jonas's voyage to Ninevy with the benefactors names in 1660," NRO, Rye 17, 4:89v.

8. Other Old Testament Books

Esther

Cathedral Priory. ms, Bible, Bod L Auct. D.4.8, hi f 293 (Esther). 1190–1250; 14c Priory pressmark. Assuerus and Esther.

Job

Cathedral Priory. ms, Bible, Bod L Auct. D.4.8, hi f 300v (Job). 1190–1250; 14c Priory pressmark. Job on dungheap.

?Cathedral Priory. ms, Gregory the Great, *Moralia in Job*, CB Emmanuel College 112, hi Book 14. c1310–20. (L) Hook-nosed blue devil with birch, (R) Job; *manus dei* above; James (1904).

Diocese. ms, Stowe Breviary, BL Stowe 12, hi, f

125v. c1322–25. (1st Sun, Sept) Job disputing with friends.

9. Old Testament Apocrypha
Tobias

Cathedral Priory. ms, Bible, Bod L Auct. D.4.8, hi f 280v. 1190–1250; 14c Priory pressmark. (Tobit) Tobit giving Tobias the debt of Gabael.

Diocese. ms, Stowe Breviary, BL Stowe 12, hi, f 128. c1322–25. (3rd Sun, Sept) Tobias reclining, angel resting hand on head.

Judith

The civic pageant for Elizabeth I's entry in 1578 at Norwich included Judith, Deborah, Esther, and Queen Martia, Lancashire 1236.

Cathedral Priory. ms, Bible, Bod L Auct. D.4.8, hi f 286. 1190–1250; 14c Priory pressmark. (Judith) Beheading Holofernes.

Diocese. ms, Stowe Breviary, BL Stowe 12, hi, f 130. c1322–25. (Last Sun, Sept) Holofernes reclining, Judith in veil, raising sword above his head.

Elsing? pwd, screen, N1 & 2. 16[1-2]. Two women in non-English costume, parted overskirt, low neckline; Flemish headdress (Plummer, personal communication, has found similar headdress in Flemish work). **N1** Holding falchion in LH, platter with severed head in RH; no halo. **N2** Holding basket in relaxed LH. These panels are by a second hand; they are faint and difficult to view because of obstructing church furniture. Identifica-

tion suggested by John Mitchell (personal communication). James and others have identified as Catherine and Dorothy.

Babingley. *pwd, screen. c1500/?1553–58. Nimbed, white veil, red mantle, holding male head by long hair in LH, massive ?palm in RH; the watercolorist may have misinterpreted the remains of a sword, DT 53:63. The history of this screen is exceedingly complex, but there were 2 artists, the second perhaps Marian. By 1850 "the pannels . . . were lying broken and disfigured in a pile of rubbish"; by 1854 "they were entirely gone and . . . broken up for firewood" (DT 53:67, 64).

Wiggenhall S Mary? wdcarv, be, nave N6. 16[1]. Woman seated, grounded sword. Bullmore thought S Paul, but the fig is female, paired with woman on the other shoulder.

Norwich. Moulded brick (4" x 6"). c1530. Tent with flaps drawn back to reveal woman severing head of man in elaborate bed; il Borg and Franklin Cat. 56.

Maccabees

Cathedral Priory. ms, Bible, Bod L Auct. D.4.8, hi 520v, 537v. 1190–1250; 14c Priory pressmark. (Macc 1) death of Alexander; (Macc 2) battle scene.

Diocese. ms, Stowe Breviary, BL Stowe 12, hi, f 131. c1322–25. (1st Sun, Oct) Jews being slain by Antiochus.

Marsham. See XV.6 *Nine Worthies*.

1. Early Life of Mary

Diocese. ms, Stowe Breviary, BL Stowe 12, hi, f 288 (Feast of Conception). c1322–25. Joachim and Anne embracing at the Golden Gate; Sandler, *Survey* Cat. 79.

Potter Heigham. wp, N aisle. 14c. Uppermost of 3-register composition: **3a** Appearance of Angel to Joachim: angel emerging from clouds to kneeling man in headdress of OT priest. **3b** Joachim and Anne at the Golden Gate: fig facing E (destroyed by roof truss) joining his RH with LH of woman wearing red gown and white mantle with RH on breast. **3c** Virgin leaving home: Anne, nimbed veiled, LH raised, holding hand of Virgin in doorway; hair over shoulders, holding mantle with LH. **3d** Presentation in the Temple (partially destroyed by win): (above) bearded priest in conical tiara with two others in soft caps; (below) veiled female head; (lower L) similar smaller head; Tristram. Many details no longer distinguishable.

Norwich S Stephen. *pg, E win, Lady ch. 1461 (King). Window "very fine containing the whole history of the Virgin's life, with many labels and inscriptions as 'Salve Regina Mater miserecordie. Ave Regina celorum, ave Domina'," Bl 4:154–5. Repaired 1522 (154). Perhaps better classified as a Joys sequence.

Oxborough. *pg, ?E win, N aisle. Angel appearing to Joachim: elderly man with purse, flanked by figs, incl (R) "a shepherd in a russet coat . . . near him are sheep feeding, and a dog couchant; and on a label, '__ad ___cam Porta et Sacrifica'," Bl 6:184. James (*S & N* 192–3) so interpreted and also cited birth of Virgin.

Guild of Conception of the Virgin at Lynn S Margaret (Westlake no. 240).

Nativity of the Virgin

Diocese. ms, Stowe Breviary, BL Stowe 12, hi, f 296. Crowned, veiled head. Cf IV.2 *Annunciation* NMS MS 158.926.4f.

Hingham. *im and ch dedication; Hingham had ch dedications to the Virgin under at least 3 titles; see VI.3 *Pietà* & VIII.1 *Assumption*; Bl 2:423.

Reepham? *im, "a famous image of the Virgin Mary"; church dedicated to S Mary's Nativity, Bl 8:248.

Tottington? *im. Guild dedicated to Nativity of Our Lady, "kept at her altar in the church, before whose image there was a light continually burning in service time," Bl 2:355. If the prescribed Marian altar of the church, rather than a guild altar, the image would not have been of the Nativity.

Diocese. ms, Wollaton Antiphonal, Nottingham U Library 250, hi, f 375v. c1430. Anne nursing infant; Scott (*Survey* Cat. 69) cites as atypical iconography, Anne holding the infant being the norm, but see the next entry.

Ranworth. ms, Ranworth Antiphonal, S Helen's Church, hi, f 257. 1460–80. Anne in nightcap, bare-breasted, in canopied bed; maiden presenting swaddled infant; **FIG 6**.

Thetford Priory 1. *im. 1537/8. "pro x yardes & iij quarterys of holond pro le tabernakyl Nativitatis Sancte Marie 5s. 4½d." Dymond 2:591.

It is possible that some churches with generic dedications once held this title; cf Beeston S Mary "founded in memory of the Nativity of the blessed Virgin," Bl 9:465. At Carrow the nuns held a fair on the vigil of the feast and the two following days (Gilchrist & Oliva 28). Guilds at Lynn (Owen 325), Thetford (3 chaplains supported by the guild, Firth 199), Walsoken (Bl 9:128), Wiggenhall S Mary (Farnhill), Wymondham (1415–64, Farnhill).

2. S Anne Teaching Virgin to Read

See also the next section.

Thetford Priory 2. pwd, retable. c1335. Virgin standing before lectern on which rests open book inscr "Audi fi*l*ia quia . . . & inclina aure*m* tuam"; Virgin with filet in hair, holding lower edge of open book; Anne in widow's garb standing behind, LH resting on Virgin's arm, RH reaching behind Virgin and pointing to words; ClunyM; *Age of Chivalry* Cat. 564, fig 132. For details of this remarkable retable, see Norton, Park, & Binski. The Dominican Priory was founded on the former Cluniac site, 1335.

E Barsham. *al frag. ?15c. Torso of Anne laying R fingers against book on lectern; Virgin

beside, L fingers resting on book, RH holding a pointer; recovered from nearby 15c barn; at one time on chancel win sill; W Martin, il facing 258; whereabouts unknown. Cheetham (55) records 17 alabasters of this subject. Astley (19) conjectured the alabaster frags might have come from Walsingham when the shrine was dismantled.

Norwich SPM. pg E win. Mid 15c. **E4** Anne in wimple; **E5** Virgin in ?sideless surcoat; holding open book.

Mulbarton. pg frag, sIII.2a. 15c. Anne with prophet head holding book at bottom with LH, pointing to frag text ("Domine labia mea aperies, et os meum annuntiabit laudem tuam"); Virgin with golden hair, bare neck, trace of gown; DT 56:195.

Fersfield? *pg, E win, S aisle. "The Blessed Virgin, and St Anne, her Mother," Bl 1:105.

Mileham. *pg, SE win of chancel. "The Virgin teaching the child Jesus to read," Bl 10:23, surely a misidentification here and at Outwell.

Outwell. *pg, N ch. "Virgin teaching the child Jesus," Bl 7:473.

Houghton S Giles. pwd, screen, N6. 15[4]. Anne standing, looking down, RH on Mary's shoulder, LH holding corner of book; Virgin wearing chapelet of cinqfoils, holding open book with rubricated writing, clasps depending, looking up at Anne; Anne in mauve peaked hat over white veil (Costume Glossary, **FIG a**), belted gown with embroidered cuffs, white-lined red mantle; Virgin in ermine sideless surcoat, skirt with wide ermine hem. Inscr above on frame "S*anct*a Emaria"; Camm [Ingleby] recorded Emadia/Emotia. The iconography is clear, so the name is in error.

Elsing. pwd, screen, N4. Late 15c. (L) Anne, LA ?behind Virgin, RH extended; veil,wimple gathered under chin, gown with tight sleeves; (R) Virgin with open book in RH, with LH supporting; minim writing; burlet in hair, ermine-trimmed gown. All the paintings on this screen are difficult to read because of abrading and general deterioration.

Provenance unknown. pwd, screen panel. c1500. Virgin holding book with writing, Anne pointing with LH; from unidentified screen. Heavily restored; now at Rainthorpe

Hall; photograph at NMR.

Sparham? *pwd, screen. "Anna mater Marie"; the Virgin was on the next panel; NRO, Rye 17, 3:214.

Taverham. sc, font stem. 15c. 8 saints cited in the 18c (NRO, Rye 17, 4:12v), but the stem figs seem heavily restored if not Victorian replacements. Williamson (1961) also thought "panels and figures must have been recut in recent years." However, Cautley, Pevsner, and Wilson cite the font without comment.

Walsoken. wdcarv, Flemish. Late 15c. Seated, .Anne's RH missing, probably held book.

Hunworth. *al. 1506. "I will that myn executors purvey a table of Alabastr of the story of our lady and sent Anne her moder," Harrod (1847) 123; probably teaching the Virgin to read.

Babingley? *pwd, screen. ?1553–58. Anne in white wimple and veil under crown; red mantle over purple gown, with open book in both hands; below small fig in demi-profile both hands extended, long hair; DT 53:59. This is an atypical composition because of the diminutive size of the Virgin. The watercolor is labeled "Anne or Emona," probably the same name recorded at Houghton S Giles.

3. Holy Kinship

According to Rushforth (199–200), the subject became popular in the second half of the 15c. The screens at Houghton S Giles and Ranworth vary in the identification of the fourth son of Mary Cleophas, James Justus at Ranworth and Philip at Houghton, the latter found also at Gt Malvern and at Hesset (Suf).

Norwich SPM. pg, E win, E3. Mid 15c. John and James as children; John holding eagle and palm; James a scallop shell (Wdf 21).

Norwich All Saints? pg, nII.A3. Late 15c. "Maria Cleoph*ae*" standing with arms crossed at breast. The fig does not conform to the Holy Kindred scenes preserved elsewhere in Norfolk, but the label seems to belong with the female; perhaps originally in a crucifixion scene; Wdf (1938b) il facing 173.

Fincham. *pg, E win, N aisle, "Mary Salome . . . with her two little children by her side, St John and St James; John in a blue gown, bearing in his hand a cup with a dragon issuing out of it; and James in a green gown

and a escollop shell in his hand," Bl 7:356.

Swannington. *pg, N win. "Two large figures of women are one on each side of the blessed virgin with our saviour in her arms," inscr "Maria . . .haph' and Maria Salome," NRO, Rye 17, 3:240v.

Ranworth. pwd, retable, S aisle. c1479 (bequest). 4 scenes against cloth of honor held by demi-angels; women in damask gowns; children in belted gowns, barefoot: **S1** Mary Salome white veil hanging loosely from head and on shoulders, red mantle; RH extended, palm out; John seated on her lap with eagle in extended LH; James standing at her feet with scallop shell in RH, LH extended. **S2** Virgin crowned, blue mantle; supporting naked Infant on lap with RH, extending breast with LH; gown with front opening; Infant with both hands raised towards breast. **S3** Mary Cleophas, costumed like Mary Salome, with Simon and Jude on her lap; Simon with tiny fish in RH, Jude with unrigged boat on L forearm; James Min and Joseph Justus standing at her feet, James Min with windmill, blowing bubbles. **S4** Margaret. Winter (1867) figs 23–5; Duffy fig 74. For details of the retable, parclose, and rood screens, see Plummer (1979).

Houghton S Giles. pwd, screen. 15⁴. Six mothers standing with children at sides, names inscr on sill above; at **N1 5 & 6** wearing identical Jewish hats with hooked peak over white veil (Costume glossary, **FIG a**), wimples, belted gowns, and white-lined mantles; **2 &**

4 are similarly dressed but without hats. **N1** nimbed child in mantle over gown standing before woman, inscr above "*Sancta* Anna"; lower section damaged. **N2** Mary Salome, holding cloak with LH, RH raised, palm out; at her feet, John with palm and chalice with serpent, James Maj with palmer's staff/?toy sword. **N3** Virgin in crown fleury, blue ermine-lined mantle over red gown with gold belt; with naked Child on L forearm. **N4** Mary Cleophas, holding mantle with RH, LH raised; (below, damaged) 4 children holding respectively palm, loaves of bread, ?boat,?fish. **N5** Elizabeth in ermine-lined red mantle, RH on breast, John holding her LH, tiny lamb on palm of his RH. **N6** Anne teaching the Virgin to read. The apparent duplication of scenes at N1 and N6 has provoked a variety of interpretations of N1, the most ingenious being SS Monica and Augustine (Cox). Camm suggested that N6 originally stood at N1, later being moved to N6, without a corresponding correction of the names inscr above. James found the name at N1 "hardly legible," yet he identified Emeria, the sister of Anne, mother of Elizabeth, and ancestor of S Servatius "probably the boy here" (*S & N* 177). The sibling relationships are cited by Robert Reynes (Louis, 191, 195, 200 [Ismary]).

Docking. See XIII.6.d *Upton.*

Norwich S Gregory? *im. In a list of images and lights, "St. Elizabeth St. John" without comment; Bl 4:274.

IV. EARLY LIFE OF CHRIST

1. Parliament in Heaven (Daughters of God; Ps 84:11)

See also II *David*, Carrow Priory.

Salle. pg, nVI. c1441. **A1** Mercy, nimbed woman, mantle over square-necked ruby gown, Johannine hair, ornament with cross at center part of hair; "mīa" inscr on gown; pointing to Veritas; restored scroll above "Misericordia & Veritas." **A2** Truth, new except for frag of ruby gown. **A5** Justice with "iusticia" inscr on gown, scroll above inscr "Justicia & pax"; **FIG 7**. **A6** Peace largely new, frag of original gown, scroll above inscr "*oscul*atae sunt." Heavily restored 1912.

2. Individual Subjects

Isolated representations are surveyed first, with sequences treated more summarily in later sections. The transept bosses at the Cathedral, which also form a sequence, are treated here because of the unusual amount of detail. It is, of course, possible that some of the work below originally formed part of a sequence (see Sections 3 and 4).

Annunciation

Unless stated otherwise, the Virgin is standing. Ermine often lines her mantle or trims her gown. Not uncommonly only Gabriel remains as evidence for the scene. In glass the standard texts, "Ave gratia plena" and "Ecce ancilla domini," are abbreviated to meet the demands of space. The angelic salutation also appeared on frontals and corporal cases (Bensly [1895] 212). An Annunciation scene seems to have figured in a pageant for Elizabeth Woodville's visit to Norwich; Gabriel was played by a friar (Harrod [1859b] 35). Where only Gabriel or the Virgin remains, it is usually easy to determine the position of the other from posture. Both Gabriel and Virgin are cited if the scene is complete; frag = partial figs, furniture, or inscr only.

Binham Priory. seal, Benedictine Priory of St. Mary. 12c. Gabriel, RH raised; Virgin seated on dais, book held upright on L knee; dove descending to Virgin's nimbed head, *BM Cat. of Seals*, 2642.

Cathedral Priory. seal. 1258. Reverse, Annunciation within doorway of church; removed 1544 with heads remaining, later converted into Tudor roses; *BM Cat. of Seals*, 2093, 2102.

Cathedral Priory. ms, psalter, Lambeth Palace 368, miniature, f 10. c1270–80. Morgan, *Survey* pt 2, Cat. 181.

Shouldham Priory. seal, Gilbertine Priory of the Holy Cross and Virgin Mary. ?13c. Taylor queries Annunciation, *Index Monasticus* 34.

Lynn/Norwich/London/Salisbury. pilgrim badges from Walsingham. Virgin (typically L) and Gabriel commonly flank lily pot, some with inscr; Spencer (1998, 141) dates trade from c1320–30. Mitchiner Cat. 38. In addition to the Annunciation, Spencer (1980) queried hunting horns for Gabriel (Cat. 31–2): those found in London inscr "Ave Maria," Mitchiner (Cat. 25–27). Mitchiner noted failure of later evidence. (For a differently shaped horn used for SS Giles & Hubert, see Mitchiner Cat. 624–7 & Bruna Cat. 217.) 14c. Mitchiner Cat. 222–5; Spencer (1980) Cat. 16, 26; *Age of Chivalry* Cat. 73–5. 15c. Spencer (1980) Cat. 17–25, 27, 28 (inscr "Wallsygam"), 29; mould with scene within 6-pointed star found near Lt Walsingham, Cat. 30. Mitchiner Cat. 529–32. 14/15/16c Spencer (1998) Cat. 142–51, 146a with God the Father above. Circular badges popular from late 15c; Virgin sometimes with book (Cat. 151b & c), or beads (Cat. 151b). Spencer (1990) Cat. 50. 16c. Mitchiner Cat. 894–8.

Walsingham. tablets. 14c. Bequests to ch: the Salutation with precious stones (c400 marks); silver and gilt tablet of Salutation and a painted im; Waterton 2:190. Spencer without documentation (1998 Cat. 139) assigns an Annunciation to the Holy House from the 13c and "others bestowed on it during the 14th century."

Walsingham Priory. *reredos. c1480. "Gabriel gretyn Our Lady; in the myddes of the tabyll at the auter stante Our Lady, on eche syde of her stante an angell, Seynt Edward, Seynt Kateryne on the ryght hande, Seynt Edmond, Seynt Margarete on the left hande; all clene gold,"cited by Robert Reynes (Louis 116). Frags of 2 angels with angelic salutation found in priory ruins, Warner 125.

Terrington S Clement. *emb. 14³. Vestment of

blue cloth and white baudekyn with leopards and white serpents with orphreys of red cloth of gold "cum Salutacione angelica," Watkin 2:127.

Diocese. ms, hours, NMS 158.926.4f, hi, f 52v (Lauds, *memoriae*). c1310–20. Heavily veiled Virgin with wimple historiates Annunciation prayer.

— ms, missal, Bod L Hatton 1, hi, f 151v. 14[4]. Gabriel kneeling, staff in LH, gesturing with RH; Virgin standing; lily pot. Pächt & Alexander, 713, pl LXXI.

Heydon. *plate. 14[3]. "Item j scutum ad modum tabule cum salutacione Gabrielis." Watkin suggests a tray (1:54; 2:xcvii).

Cathedral. sc, S cloister boss, I4. 1327–29. Gabriel standing with scroll depending; lily pot; Virgin standing; Lindley (1987) pl 23. Visitation at J4.

Attleborough. pg, W win tracery. Mid 14c. **G1** Gabriel with scroll ("Maria gracia") in RH, LH raised; **G2** nebuly above with dove descending; lily pot in the L foil; Virgin, clasped book in LH and RH outstretched; **G3** angel in attitude of prayer. Restored.

Seething. pg frag, nII, tracery. ?Late 14c. Dove descending. Probably the Annunciation in the 2-light window below.

Frettenham. pg, sII.A2. 14c. Gabriel standing, text scroll in LH, RH pointing.

Fring. wp, E wall, S of chancel arch next to carved niche. c1330 (Tristram). Faint traces of veiled Virgin with RH raised (?seated); vertical scroll; nimbed head and wings of angel, wearing mantle, probably feathered. The painting has faded since Tristram described it.

Lt Melton. wp, flanking E win. 14c. (L) Gabriel, scroll in LH, right extended with index finger pointing; (R) Virgin, RH extended, traces of dove above and lily pot below, partly hidden by prayer board.

E Rudham. al frag. 15c. Virgin (head and RA missing) kneeling at desk with open book, LA raised; lily pot; a second frag, probably Gabriel. In 1876 a series of frags of varying subjects were found in a wall cavity during reconstruction. It has generally been assumed that the E Rudham frags came from an altarpiece; frags incl Nativity, Crucifixion, Coronation, John Bapt Reproving, Martyrdom of John Ev, S Antony.

Lyng. emb. c1480. DT 33:192.

Gt Witchingham. *emb. ?15c. "Our Lady and Holy Ghost in a cope," Bl 8:310. A comparison of Marian with Edwardian inventories (L Bolingbroke) reveals an amazingly prompt reappearance of vestments, strong evidence for local sequestering rather than sale.

Lynn St James, Guild of SS Giles & Julian. *emb. Late 15c. "A stained altar cloth with the Salutation of our Lady" (Richards 433). Town records cite a 1445/6 *ludus* for Christmas including 20*d* for teaching "le Mary & Gabriel cantare in *dicto* ludo," Galloway and Wasson 48; Lancashire 811.

Swaffham. *im, Bl 6:217 fn 4.

Diocese. ms, Wollaton Antiphonal, Nottingham U Library 250, hi, f 331. c1430.

W Rudham. pg, nIV.A5. 1430–40 (King 35). Angel with double set of wings, in alb with blue cloak, RH on breast, LH extended. nIII, eye of tracery. lily pot, 5 flowers on one stalk in bulbous vase.

Colby. pg frag, E win, 1b, not *in situ*. 15[1–2] (King). Virgin, RH raised in greeting, LH on breast; (L) trace of prayer desk; unusual lily pot, single flower rising from elevated vase attached by legs to a large decorated bowl supported on a stand.

Salle. pg frag, sVI (with alien glass). c1444. **B1** Virgin seated (?from a Coronation), lily pot at feet; scroll inscr "ecce . . fiad mihi secundum verbum"; **B4** Gabriel, upper body, feathered, scepter in RH; LH extended, with inscr scroll.

— pg, sVII.D1. c1466. Gabriel demi-kneeling in dalmatic, facing empty light.

Stratton Strawless. pg, nIII. 1445–55 (King personal communication). **A5** Gabriel with cross-diadem, feathered with mantle (restored), scepter in LH, RH outstretched with rising scroll inscr "Ave Maria / Alleluia" (perhaps from different win); **A6** Virgin, burlet with ouch, both hands outstretched to Gabriel, scroll inscr "ancilla dom*ini*."

Norwich SPM. pg E win G3. c1450. Gabriel, feathered in mantle, demi-kneeling, "*Sanctus* Gabr."

Banningham. pg, nV.B2 & 3. c1450. Largely restored except for B3, Gabriel demi-kneeling, in alb with amice, leaf chapelet,

scroll inscr "Ave Maria plena D*ominus* te"; C1 & 2, censing angels.

Bale. pg, 5 scenes & frags leaded in sV. 1450–80 (King). **1a** Virgin kneeling before draped table with open book (minim writing); in white gown with gold band at sleeve hem and square neck, mantle turned back at shoulder to create collar, trimmed with gold coin design; RH at breast, LH extended; nimbed dove descending in rays to Virgin's head; "ancilla d*omini*" in scroll above; lily pot below, 3 blooms; *900 Years*, color il p 72. **3c** Identical with 1a. **3a** Gabriel in cross-diadem, alb, amice, and dalmatic, demi-kneeing, L index finger pointing to vertical scroll inscr "gracia plena," RH with scepter; in ¾ profile facing Virgin. **3b** Virgin standing, facing forward; supporting open book on palm of RH, LH riffling the pages (minim writing); nimbed dove descending in rays at L of Virgin's luxurious hair; in hair, chapelet with single small flower at hairline in center of brow; diaphanous shift at neckline, ermine-lined mantle worn low on shoulders, double morse; ermine skirt with wide scarlet band with stylized lily pots, chain ceinture; (above) scroll inscr "Ecce ancilla fiad michi"; Wdf pl XXIX. **A1** Virgin with hands crossed at breast, (above) "*ancilla* d*omini*"; **A2** Gabriel standing, cope nearly covering feathered body, ermine tippet; scrolls inscr "ave maria" and "gracia plena" forming an X; figs facing each other. **B1** Virgin kneeling at draped reading desk, open book with tasseled chemise binding; nimbed dove at her ear. **B2** feathered Gabriel wearing toga-style mantle, knees flexed, scepter in LH, RH raised; (above) inscr "ecce ancila d*omini*" and "Ave gr*aci*a plena d*omini*." The provenance of this extensive Norwich glass is uncertain, though it is likely that some of it was originally at Bale.

E Harling. pg, E win. 1463–80 (King). See IV.4.

Bawburgh. pg, 2 compositions. c1463–80 (King). sIV.A2 bust of Gabriel with scepter, feathered arms. sV.A3 crowned Virgin from second composition, prayer desk, lily pot, open book with minim writing and book marker; scroll inscr "Ecce ancilla domini fiat"; dove flying across scroll.

Ringland. pg, NVI. c1466 (King). **1a** Virgin kneeling at desk, RH resting on open book with minim writing, LH on breast, lily pot below; white gown, ermine-lined red mantle with ornamented yellow hem; dove descending blocking out part of frag scroll inscr "d*omini*." **1b** Gabriel feathered with 2 sets of wings (blue and purple), in ermine tippet and skirt, belt; scepter, RH extended; frag scroll inscr "gr*aci*a plen*a*"; see Wdf 71 for reference to G King drawing.

— *pg, Wdf (69) cites a copy of a head of Gabriel "remarkably like the heads of Gabriel at Bale and St. Peter Hungate." G King labeled his drawing "Ringland Ch. Norfolk."

Norwich SPH. pg frag, E win, 4b. 153. G King (1907) identified the lovely angel head as Gabriel; he projected that the fig would have been c 2'6" high; il facing 212.

Shelton. pg, nII, remains of 3 Annunciations. 15[4]. **A2** Virgin facing L, lily pot; **A3** Virgin ?kneeling/seated, facing L, arms crossed on breast; rays depending from nebuly; nimbed dove at Virgin's R ear; lily pot (L); **A4** Gabriel in ?alb and mantle, demi-kneeling, facing L; pure profile; scepter in LH, RH extended, mouth open as if speaking words on inscr. scroll; **FIG 8**.

— pg, E win. c1500. **3a** Virgin both hands raised; head and upper body turned toward Gabriel; **3c** Gabriel nimbed, demi-kneeling. Today the Virgin's gown has a fragment of different fabric design with label inscr "[?]M Mater"; in an 1850 watercolor there is no text, only a blank band; DT 60:67–8. King notes that the Shelton glass has been subject to rearrangement.

Besthorpe. pg frag, leaded in S5. 15c. "Ecce ancela d*omini* fiat m*ihi* cecund*um*." N chapel dedicated to the Annunciation (Bl 1:493).

Emneth. pg, nIV.A2. 15c. Draped desk, open book with minim writing, lily pot before desk; Virgin turning away from desk toward **A3**, ruby gown, ermine-lined mantle fastened with double morse, both hands extended; (upper R) tiny nebuly with dove proceeding in rays to Virgin's head; in looped scroll "ecce ancilla domini

fiat. . . ." A restored king now occupies **A3**. Demi-angels on nebuly at **A1** with lute & at **A4** with harp.

Glasgow Burrell Collection. pg frag. 15c. (Upper L) bust of Father pointing to center of composition, rays depending. The frag has been set with a number of unrelated frags; Wells, Cat. 122. Norfolk provenance unknown.

Harpley. pg, W win. 15c. **C3** Gabriel, restored; **C4** covered desk with open book, lily pot below; Virgin, LH raised, RH at breast.

Ketteringham. pg, E win. 15c. **A4** Virgin standing with back tilted as if drawing back, both hands raised; three-headed lily in pot; scroll with "ancilla do*mini*"; **A5** Gabriel winged, in white, scepter in LH, RH raised in greeting, (above) "ave maria plena."

Poringland. pg, set in E win, light a. Gabriel demi-kneeling, mantle falling over shoulder, inscr scroll. In the 18c this "very perfect" glass was in a S chancel win, "in one pane the Blessed Virgin, in the other an Angel meeting her," Bl 5:442.

Heydon. pg frag, sIII.A4. 15c. Head of nimbed Virgin with dove at edge of halo.

Norwich S Michael-at-Plea. pg frag, E win, A4. 15c. Virgin, hands raised, rays at head; with text.

Warham S Mary Magdalene. pg frags, nIV *ex situ*. 15c. **1a** Virgin's head with nimbed dove at temple; **2** segments from scrolls inscr "la do*mini*", "Av[e]" & "ecce"; **1c** angel head with cross-diadem, scroll inscr "plena do*minus*"; virgin's head, scroll inscr "ecce a*n*cilla"; P & W 1 fig 54.

Suffield. pg frags, nVI. 15c. **A2** feathered angel frag; **A3** nimbed dove against radiance.

Cawston. pg frag, sX.2b. 15c. Nimbed dove flying.

Narborough. pg frag, nII.A3. Inscr ["Gracia"].

N Tuddenham. pg frag, N porch W win. Text "la do*mi*ni" with other minims, Wdf 66.

Wiggenhall S Mary. *pg. 15c. "The windows over the arches of this nave . . . curiously painted. In that over fifth arch on the south side, is the salutation of the blessed Virgin"; opposite "the figure of our Saviour" on the N; Bl 9:180.

Caston. *pg. Barnes (3) cites a report from G King citing "Ave Maria gracia plena. . . ."

Hoe. *pg, E win N aisle. "Salutation," NRO,

Rye 17, 2:258v, 260.

Kirby Bedon. *pg. "In a window, Ave Maria Gratia plena, Dominus tecum," Bl 5:482.

Marsham. *pg, N win, chancel. "Virgin with Ave: Gra: Dns: Tecum," Bl 6:287.

Northwold. *pg, E win, N aisle. The "history of the Salutation painted, Ave Maria Gracia Plena, being now seen in a label," Bl 2: 216.

Norwich S Martin-at-Palace. *pg, roundel. Dove at Virgin's head, Virgin and Gabriel kneeling; sketch in G King Collection, Box 2, NNAS.

S Pickenham. *pg, N side, "fragments of the Salutation," Bl 6:74.

Aylsham. *pg, S transept. 1516. New stone and glass, "a neat painting of the Salutation," Bl 6:277. Repeated 15[4] bequests made to the Lady chapel at the E end (Harrod [1847] 114).

Norwich S Michael-at-Plea. pwd, retable panels, 1958 reset in new retable, S Saviour's Chapel, Cathedral. c1420–40 (King [1996] 415). Gabriel, nimbed, burlet, dalmatic, ?kneeling; LH raised, scepter in RH; Virgin with veil at back of head, wearing ermine-lined mantle; kneeling before desk, LH at pages of book, RH raised, turning head toward Gabriel; dove descending from rays, directly above the part in Virgin's hair; elaborate interior, win, detailed desk; (upper L) Visitation; L & M Cat. 56; color il of entire altarpiece, *900 Years* 48. All pwd panels cited at S Michael-at-Plea were recorded there in the 18c, Bl 4:321; for the complex history of the screen panels in this church, see L & M.

N Walsham. pwd, screen. c1470. (1472–8 documentary evidence for decoration of side altars, which would have followed work on rood screen.) **N3** Virgin standing, crowned, hands joined; elaborate lily pot with two handles (perhaps influenced by Walsingham pilgrimage badges, see Spencer [1990] fig 71); ermine collar and lined mantle over blue gown; **N4** Gabriel, kneeling, scepter in RH, LH raised; elaborate dalmatic, thighs feathered; rolled burlet with rising cross.

Thetford S Mary the Less? *pwd. "On the north side of the skreen were eight saints painted, but now defaced; and over them

'Ave Maria : : Grac. virgines sancte dei orate'," perhaps the Annunciation as well as virgin saints; Martin (1779) 73; see also Bl 2:67.

Norwich S Michael Coslany. sc, 2 statues. c1400. Virgin standing by lectern with elaborately carved open book, lily pot (**FIG 9**); Gabriel in alb and cope, RH raised, scepter in LH; L & M Cat. 64. Now NMS.

Lt Walsingham. sc, statue, N chapel. c1400. Demi-kneeling feathered angel, cross-diadem, RH raised in salutation; mantle draped over knee; Cotman engraving (1838, 2nd series) 44. In 1540 the guild of Our Lady was united with two others, thereafter known as the guild of the Annunciation, S Anne, and S George, Galloway and Wasson 76.

E Rudham? sc, statue. c1400. Seated in alb and cope, scroll in hands, ?angel of the Annunciation. Perhaps from external niche (P & W 2).

Hingham. sc, Morley Monument (Easter sepulcher), N wall chancel. 15^{2-3} (†1435, painted c1462, Fawcett [1996] 223). At the top of the responds, (L) Gabriel; (R) Virgin, facing chancel rather than Gabriel; Pevsner 2 pl 43; P & W 2 fig 30. Fawcett 224, fig 109. For detailed description, see Sheingorn 246.

Mattishall. sc, relief, N porch spandrels, worn. c1445–53 (C & C). (L) Gabriel, holding lily; (R) Virgin with curling hair, holding object; trace of thurible. Ch appropriated to the College of the Annunciation (Cambridge, 1394).

Wymondham. sc, relief, N porch spandrels. c1450. (R) damaged Gabriel with scroll in apex angle; lily pot; tall lectern with open book, Virgin with RH on book; (L) a second angel with diadem and enormous wings, probably censing; remains of broken scroll.

S Walsham. sc, relief, S porch spandrels. c1454 (C & C). (L) lily pot, Virgin at reading desk; with Trinity, in nebuly 2 busts in garments with radiance extending to Virgin; ? dove; (R) Gabriel, feathered, scepter in LH, scroll. Coronation in niche above. Bench ends inside the church carved with texts from the *Ave Maria*.

Pulham S Mary. sc, relief, S porch spandrels.

15^4. (L) Gabriel in armor with scepter in RH, scroll in L (recorded with *Ave Maria* in 18c); (R) lily pot, lectern, Virgin with both hands raised, seated, facing out; flanked in horizontal register of niches by 4 standing angels playing stringed instruments (Bl, 2 lutes, 2 fiddles) and 4 playing wind instruments (2 shawms, 2 long trumpets); in horizontal register above the doorway, 2 angels holding (L) arms of Passion (R) arms of Trinity. It has been conjectured that the porch was built about the same time that John Morton reglazed the church windows (Bl 5:395).

E Tuddenham. sc, relief, S porch spandrels. 15^4. (L) Virgin, hands raised; lily pot; dove of Holy Spirit proceeding in radiance; (R) Gabriel, feathered, scepter in LH, holding long scroll with RH.

E Dereham. sc, relief, S porch spandrels. c1500. (L) lily pot, kneeling Virgin, flanked by large rose-like flowers; dove of Holy Spirit at head of Virgin proceeding from radiance of rays, scroll below; in upper angle a tiny bust in alb, RH raised, LH on breast. (R) Full-sized Gabriel, feathered, 2 sets of wings, in armor, arm extended, long scroll.

Gt Witchingham. sc, relief, S porch spandrels. 15c. (L) Virgin kneeling before open book on lectern; lily pot, scroll; (R) Gabriel in armor, scepter, scroll. Smaller than usual because of frieze, immediately above, with crowned M's.

Cathedral? sc, W facade. 15^2. Virgin; before reconstruction there was a second niche paired with the Virgin; Sekules 203.

Burnham Market. sc, relief, tower. 15^{ex}. (Reading clockwise) **E1** Virgin; **E2** Gabriel. The E face is devoted to 4 scenes from the life of Christ, each comprising 2 panels, no discernible pattern; see also below *Visitation*, *Flight into Egypt*, and VII.1 *Incredulity of Thomas*.

Erpingham. sc, relief, in small niches of frieze above base course flanking W door. c1484–5. Figs worn, (L) standing, (R) with scroll; flanked by crowned M and lily pot.

Gt Hockham. wp, flanking chancel arch. 15c (DP; Caiger-Smith thought early). (L) Nimbed Virgin standing, in frontal pose but with head turned toward Gabriel; RH

raised, LH holding lined mantle, gown with wide ermine border; open book on carved table to her R; (above) scroll inscr "[E]cce ancilla domini fiat mihi . . ."; the dove of the Holy Ghost at end of scroll, beak at edge of halo; (R) Gabriel winged, in alb, demi-kneeling; RH raised as if holding scroll inscr "plena dominu[s]," Caiger-Smith pl 14. See also VI.3 *Exaltation*.

Norwich S Gregory. wp, S aisle, above sIV. Late 15c (DP). Gabriel, with elaborate wing, kneeling, blue-lined red cloak billowing from shoulders, inscr scroll; lily pot, Virgin hands raised, open book with minim writing on lectern, dove at edge of halo; (R) scroll inscr "fiat mihi secundum verbum tuum"; (above C) bust of deity. Uncovered in 1999.

Attleborough. wp, E wall. 15³. Above string course, fragmentary Annunciation, (R) Gabriel, staff in RH, scroll with traces of text in LH; (C) clouds and crowned deity in ermine collar; remains of angels at the extremes. Part of a complex design, see VI.3 *Exaltation*.

Norwich S Etheldreda? *wp, betw windows on N wide. Angel only, N Bolingbroke, 344–5.

Outwell. *wp, S wall of Lynn ch in N aisle. Salutation, Bl 7:472.

Upwell. wdcarv, spandrel. 15c. Dove, scroll depending and looping over lectern, Virgin with RH resting on scroll; NMS. The missing spandrel would have accommodated Gabriel.

Mattishall. wdcarv, screen spandrel S2. c1453 (Cotton). (L) Virgin before open book, pages differentiated from cover, hands joined; lily pot; (R) Gabriel; (below) James Maj and John, Creed texts 3 & 4; Duffy pls 31–2.

Wiggenhall S Mary. wdcarv, be shoulder, nave S2. 15c. (L) Virgin before desk with open book; (R) angel demi-kneeling; lily pot carved on face of benchend.

Norwich SPM. *emb cope hood. 16¹ inventory, "the salutacion," Hope (1901) 196.

— *hanging, "for sent John is aulter a wight after damaske worke wᵗ the salutation of oʳ lady," Hope (1901) 218.

— *pall, "a pale the ground blew silke & powdered wᵗ golde ymages of the saluta-

cion & sent pole & nycolas," Hope (1901) 193.

W Dereham Priory. *im, 1500. Will of Helene Gawsell, "John, Abbot . . . [to have] a Image of the salutacion of oure ladi wᵗ a vernakill," Dashwood (1859) 285.

Norwich SPM. *ms, antiphonal, hi. 16¹ inventory. "ij leife begynnyth *Dominica prima adventus* wᵗ the salutacion of oʳ lady in the first letter"; "an other antiphenarum . . whos beygynnyng is *Dominica prima adventus* wᵗ the salutacion ut supra in iij leife," Hope (1901) 188.

Sandringham. *pg frag, sII.A6. 16¹ (Keyser 1917). "AVE."

Tacolneston. pwd, screen, 2 panels only. c1510–20 (copied from the monogrammist FVB, John Mitchell). Virgin kneeling at foot of bed, hands at breast; Gabriel in alb, deacon's stole and cope; elaborate interior, win, chest with 2 ewers and prayer roll depending; bed with red tester and coverlet, Agnus Dei roundel at bed head. Figs badly damaged; see Mitchell's description in Moore, Cat. 2a, color pl 5.

Cathedral. sc, N transept bosses. 16¹. **C4, E5** God in nebuly commissioning Gabriel; **W5** Gabriel in gateway of fortified wall (of heaven); **W3** Virgin at reading desk; **W4** open book on Virgin's lap; deity in nebuly above Gabriel; in each boss massive lily pot dividing scene. For the numbering of the bosses, see Appendix II.2.

Norwich S George Colegate. sc, R spandrel S porch. 16¹. Gabriel in alb kneeling; lily pot; Virgin kneeling before open book on prayer desk.

Thetford. seal, Guild of S Mary. 16c. *BM Cat. of Seals* 4476–7. See also *Index Monasticus* 50.

N Creake Priory/Abbey. seal, Augustinian Canons (see XII, *Bartholomew*). nd. Gabriel, RH raised in greeting; lily pot; Virgin standing holding heart in LH; ?forgery (Carthew, 1872, 168).

Norwich S Peter Parmentergate? *pcl. 1552–3, "twoo Steyned Clothes, of our Lady, & an Aungell iiijs," Harrod (1859a) 118.

Guilds at Heydon (Bl 6:253), Lynn (1371, Owen, 326), Norwich S Mary-in-the Fields ("time without memory," Farnhill), Lt Walsingham (Farnhill), Wormegay (Farnhill). S Creake had an altar dedicated

to the Salutation (Linnell 1955). L'Estrange (1874, 120) cites an inscr bell at Cromer, "MISSUS VERO PIE GABRIEL FERT LETA MARIE."

The Lily Pot

A favored motif in embroidery (Alford). Also a pilgrim badge; Spencer and Mitchiner connect the pot, as well as fleur-de-lis, with Walsingham; for lily pots see Mitchiner Cat. 533–38; Spencer (1990) figs 70–71 and (1998) Cat. 149.

Walsingham. 14². Henry, Duke of Lancaster, left to the ch "a vase with handles" costing c400 marks (Waterton 2:190), perhaps related to the lily pot pilgrimage badge with two handles; see Spencer [1990] fig 71.

Wickmere. wdcarv.15c. On face of benchend with inscr below.

Trial/Marriage of Mary and Joseph

Cathedral. sc, nave boss, H5. 15³. Marriage: Joseph and Mary link right hands.

Cathedral. sc, N transept bosses. 16¹. **W1** Gabriel appears to sleeping Joseph; **W6** Joseph and pregnant Mary, deity above; **W7** Mary and Joseph flanking doorway; **C7** Joseph kneeling before Mary—?reconciliation; **E8** Joseph resting hand on Virgin's abdomen; **W10** in 2 vertical registers, (L) Virgin seated with book; (R) Gabriel addressing Joseph, Joseph with head on hand; Anderson (1971) pl 88, described as Gabriel leaving and Joseph advancing; **W12** angel with scroll inscr "ihc maria"; Joseph with scroll inscr "I thanc god," above star with 3 rays against nebuly.

Visitation

July 2 (instituted 1389; generally recognized in England after 1475). Feast recorded at S Albans 1392 (motherhouse of Wymondham Priory), which had an altar jointly dedicated to the Visitation and Transfiguration by 1430 (Pfaff 46–8). The 1469 pageant honoring Elizabeth Woodville in Norwich included the Salutation of Mary and Elizabeth (Harrod [1859b] 35). In 1487 5s 3d expended for service book of Visitation at Tilney All Saints (Stallard 64). Dateable pg and pwd indicate the popularity of the subject in Norfolk a quarter century before the feast was widely accepted elsewhere.

Cathedral Priory. ms, Psalter, Lambeth Palace 368, miniature, f 10v. c1270–80.

Cathedral. sc. S cloister boss, J4. 1327–29.

Elizabeth resting LH on Virgin's shoulder and RH on Virgin's abdomen; Virgin with book.

Norwich SPM. pg E win. c1445–55. **G7** Virgin; **G8** Elizabeth in maternity gown; names inscr. Marks fig 166.

E Barsham. pg, nIII, central tracery. 15³ (Marks 198). Both women in ¾ profile facing each other, with hands extended in greeting. **A2** Virgin in blue gown with mantle draped over crook of RA, transparent veil; **A3** Elizabeth in ruby gown with folds over abdomen and LH resting thereon; white mantle drawn across and below to emphasize pregnancy; scene flanked by feathered angels (2 sets of wings) with (L) shawm and (R) harp. A free-standing ch dedicated to the Greeting of S Savior, *Index Monasticus* 67.

Cley? pg frag, sIX.A2. 1450–60. Hand holding clasped book against thigh; on white skirt, shaded to suggest swollen abdomen, 3 crosses. (For a non-English example of a cross marking the Virgin's womb, see Gibson fig 6.13.) Sometimes identified as Sitha, but there are neither beads nor keys, and the 3 crosses disallow the apron. If from a Visitation, alien to the virgin martyr set in this win.

E Harling. pg frag, E win, 3e. 15⁴. Laced maternity gown, from large fig; distinct from Joys sequence.

S Creake. pg frag, nVIII.2b. ?15³. Inscr scrolls held by angels (Wdf 139): "iam e*ni*m hyems," "veni co[olumba mea]," Song of Songs 2:11, 13b–14, chapter at Sext and Nones respectively, Visitation.

Norwich, Blackfriars? *pg. 1452. Bequest for burial before the win with "the story of the Psalm Magnificat"; Harrod (1857) 83–4; see also below *Magnificat* (Mattishall).

Narborough. *pg, S aisle, "remains of the Virgin Mary and of Elizabeth . . . with label over 'Unde hoc Michi ut veniat Mater Domini ad me'," Bl 6:160.

Haveringland? *pwd, screen, N3 & 4. "S*an*cta Maria ora / S*an*cta elyzabeth ora"; cited without comment, NRO, Rye 17, 2:205.

Norwich S Michael-at-Plea. pwd, retable panel. c1420–40 (King 1996). Elizabeth, in white veil and wimple, embracing Virgin; resting her LH on Virgin's abdomen; upper L in Annunciation panel; L & M Cat. 56.

Gateley. pwd, screen. 15⁴ (1485 bequest to paint roodloft, Cotton). **N2** Elizabeth, arms crossed at breast, facing **N3**; black veil, wimple; mantle over gown; name below; **N5** Virgin, RH across breast resting at mantle edge, LH at waist; blue-lined pink mantle over head, gold gown, "Sancta Maria" below. Flanked by nuns regarding the central scene, see XII *Etheldreda* and *Puella Ridibowne* (?Christina of Markyate). All figs on the screen stand on pedestals. Names retouched before 19c drawings made (DT 55:108–19); James (*S & N*) commented on state of the names.

Elsing. pwd, screen, N3. Late 15c. (L) Virgin, burlet, faint traces of lacing for ermine-trimmed maternity gown; RA extended across body towards Elizabeth; (R) Elizabeth, black mantle draped over head, wimple, well-defined maternity gown with lacing; LH raised.

Sparham. *pwd, screen. 15c. (L) Virgin, crown set on burlet, hair falling to calf of legs; ermine-lined and hemmed mantle; square-necked maternity gown with central lacing, swelling slightly less prominent than on Elizabeth; (R) Elizabeth in veil, fur-lined and hemmed mantle (?vair) over gown; prominent opening of central seam of laced maternity gown; both hands raised; DT 44:119–20.

Burnham Market. sc, relief, tower. 15ᵉˣ. **E5** Elizabeth & **E6** Virgin, both with postures of greeting.

Cathedral. sc, N transept bosses. 16¹. **W2, C3,** & **?E4** Virgin & Elizabeth in each boss, tree(s) betw in **C3**; Rose suggests a sequence of stages with actual greeting only in **W2** where Elizabeth lays her hand on Mary's abdomen. **E4** in 2 registers; both figs wear hats; (L) ?Elizabeth standing in doorway; (R) Virgin framed in large branch, ?grapes below.

Norwich, S Andrew. *sc, im with tabernacle, Bl 4:305.

Terrington S John Baptist? wdcarv. c1500, ?Flemish. Young woman, traditionally said to be an angel of the Annunciation, but figure in secular dress; resembles Continental free standing Virgin of Annunciation or Visitation; Guild of S John Bapt.

The Magnificat

See also below above *Visitation* & VII.4 *Marian Texts*.

Mattishall. pwd, 2 ceiling panels, N side of ridge pole. 15³⁻⁴. King in red gown and ?ermine collar; "Depos*uit* potentes desede et exultavit humiles." Massive angel, alb creating a sort of nebuly, ". . . est ad [patres nostros] Abraham et semini ei*us*." 3 paired panels on each side of the ridge pole, each with inner frame marked at the corners with quatrefoils; perhaps other scenes planned but not executed. The work certainly postdated mid-century work in the nave (1445–58); it is tempting to connect the painting with the 40-mark bequest to the Lady Ch in S aisle (1508). (Wilson's 1617 date is for 4 new tie beams, not the ceiling, Edwin Rose, personal communication.)

Nativity/Naming of John the Baptist

Guilds were sometimes dedicated to the Nativity, as at Lynn (T. Smith 58, 71). The inscription on the porch at Garboldesham reads "Christe, Sancte Johannes Baptista, Zacharie, Elizabeth." For John in wall paintings, see Tristram.

Mulbarton. al, 2 lateral registers. 15c. (L) Annunciation frag: bearded Zachariah at the altar of incense; under embattled canopy an angel desending with a scroll depending, altar below; Zachariah in cope and red stole, raising object in both hands (altar and gesture modeled on lateral consecration scenes); (R) Naming (3 horizontal registers): Elizabeth in bed, covers in LH; (background) 3 figs (L) holding John in swaddling clothes; (C) hands joined; (R) with LH raised, LH holding long scroll extending along the bed; (foreground) Zachariah seated on low stool writing on a scroll; except for Zachariah writing, all figs are decapitated. Found in church wall ("Extracts" 8:339). Cheetham (304) notes that the subject is comparatively rare.

Cathedral. sc, roof boss, N transept. 16¹. **W1** Zachariah chosen by lot: 11 figs, one in red gown; **C1** Zachariah officiating, dressed as priest and pointing to open book; flanked by 3 people and cleric holding open book; **E1** Zachariah in Holy of Holies, appearance of angel; **C2** (L) crowd of men, (R) Zachariah emerging from

Holy of Holies; **E2** Zachariah in ogival
doorway; pregnant Elizabeth; **C5** Eliza-
beth in square doorway, Zachariah holding
her by hand; **E7** birth of John, Elizabeth in
bed, midwife holding swaddled infant,
other figures, winged angel; **E6** similar to
C1, ?Naming of John; **C6** Circumcision of
John (same pattern as Circumcision of
Jesus). The Cathedral's store of relics
(13c) included one of Zachariah (Beeching
17).

Guilds at Hunstanton (church booklet); Lynn S Mar-
garet (1362–89, T Smith, 58, 71), Salle (Farnhill). The
Lynn guild was begun in 1362 by young merchants to
repair N side of church (Westlake [1919] 101).

Nativity of Jesus

3 types: (1) manger scene; (2) Virgin lying in bed with
Infant; and (3) Virgin +/-Joseph adoring Infant lying
on ground usually against a radiance (here cited as the
Brigittine Nativity). See also I.4.a.

Thetford Priory 1. 12/13c. Relics of the man-
ger, Bl 2:118.

Fincham. Norman font. S face. In separate
niches, man standing with staff in RH and
?book in LH (?Joseph/shepherd); fig
standing (?Virgin); manger with Infant,
heads of 2 animals, star; Bond (1985) il p
156.

?Cathedral Priory. ms, Gregory the Great,
Moralia in Job, CB Emmanuel College
112, hi Book 24. c1310–20. Virgin in bed,
Joseph seated, swaddled Infant in manger,
ox and ass; James (1904).

Diocese. ms, Stowe Breviary, BL Stowe 12, hi,
f 16v. c1322–25. Virgin reclining, Joseph
with cane seated, pointing to manger with
Infant; ox and ass; Sandler, *Survey* Cat.
79, il no. 200.

Thetford Priory 2. pwd, retable. c1335. (L)
Virgin seated in bed nursing naked Infant;
Joseph in pointed hat seated at end of bed;
head resting on RH, LH resting on stick; 2
animals seated on floor beside bed;
ClunyM; *Age of Chivalry* Cat. 564 & il p
448.

E Rudham. al, frag. 15c. Bed, with draped feet
(of Virgin); at foot of bed, frag Joseph
with hand on cane; small ?midwife behind
bed to Joseph's R; see Cheetham, Cat. 104
for identical modeling of the bed.

Burnham Deepdale. al frag attached to interior
wall of tower. 15c. Brigittine Nativity:
kneeling fig with hands joined; kneeling

Virgin, *orans* posture; large Infant lying
against an elipse; cf Cheetham Cat. 105–6,
who identifies one fig as midwife (person-
al communication).

Cawston. ?emb *frontal. 14³. Blue buckram
with the nativity of the Lord; Watkin 1:53.

Diocese. ms, missal, Bod L Hatton 1, hi, f 20v.
14⁴. Virgin in canopied bed holding swad-
dled Infant; (R) Joseph in cap, seated; (L)
ox and ass. Scott, *Survey* Cat. 5, il no. 1.

?Norwich. ms, Matthew Paris, *Flores Histori-
arum*, BL Cotton Claudius E.VIII, f 39.
c1400. Nativity, L & M Cat. 41. Owned
by Henry Despenser; incl coronations, Al-
fred through Robert Bruce.

Diocese. ms, Wollaton Antiphonal, Nottingham
U Library 250, hi, f 34. c1430. Virgin in
bed, midwife presenting swaddled Infant;
Joseph seated, head on hand, with cane;
ass and ox; Scott *Survey* Cat. 69, il no.
277.

Barton Turf. pg, nV.2b, frag, *ex situ* (Wdf 25).
15c. 2 angels against the framework of the
stable roof (L) ¾ fig with bundle of thatch
in hands; (R) head only, bundle of thatch
over shoulder.

Hindringham. pg frag, sIII. L eye above light a.
Nimbed Infant against radiance.

Guestwick. pg frag, see *Circumcision*.

Provenance unknown. *pg. 15c. Brigittine
Nativity. Stable, ox, ass; ?Joseph demi-
kneeling, with purse, hat on ground, Infant
against radiance lying on Virgin's mantle,
she with arms crossed; sketch in G King
collection, Box 2, NNAS.

Provenance unknown. ivory pax. ?Early 15c.
Brigittine nativity: Virgin kneeling; Infant;
(above) head of God with rays descending;
Joseph with wallet on belt, cane in LH,
candle in RH. NMS.

Outwell. pg frag, sIII.A4. 16¹. Virgin seated.

Foulsham. pg frag. ?English, sIV.B2. 16c. Vir-
gin in stable both hands extended, looking
down, rays from above, stable win to rear.

Cathedral. sc, N transept bosses. 16¹. **W9**
Joseph leading ox and ass, at L of door-
way, Virgin following; **C13** Virgin stand-
ing in doorway; Joseph with cane. **C9**
(above) ?midwife, Infant in manger, ox
and ass; (below) Virgin, Joseph; **C10** in 3
vertical registers: ox and ass; Brigittine
nativity; Joseph; **C11** Virgin in bed with
Infant, 2 ?midwives beside, Joseph at foot

of bed with cane.

Norwich S Michael Coslany. ?*medium. 16¹.
Gregory Clerk bequeathed "the tables that
I have of doctour Treman that one of the
passion of Crist and that also of the byrth
of our Lorde" to the chantry chapel
founded by his family, Ward 304, fn 61.

Weybridge Priory. printed calendar, NMS
134.944. 1503. Crib with swaddled Infant.
A swaddled Infant also marks the entry for
the Incarnation at the bottom of the calen-
dar.

Lights before at Hingham (Bl 2:423), Walsoken (1507,
Williams [1941] 339).

Guilds at Swaffham (1404, Farnhill), Thetford (Ch of
the Nativity, 1289–1389, Farnhill).

Adoration of the Shepherds

Cathedral. wp, S aisle, 4th bay. 12⁴. Adoration
of Shepherds and Magi. Tristram (1944)
138, pls 84–5, supplementary pl *5b* & *c*.
"The bay may have had as many as 20
scenes," Park and Howard 379–80.

Shelfanger. wp, SE end of chancel and part of S
wall, discovered 1965. Mid 13c (DP in P
& W 2). (C) Virgin crowned but without
halo, red gown and white mantle; seated
on wide cushioned bench, holding Child
on lap with LH; crowned unnimbed Child
in white tunic with outer garment draped
like mantle of judgment scenes, RH raised
in blessing, apple in LH (Baker); (R)
angel, one hand raised towards Virgin and
Child, drawing shepherd toward them;
traces of 2 shepherds on adjoining wall,
foremost with LH on stick, RH pointing;
second walking and pointing with RH, LH
on walking staff; to L of seated Virgin and
Child, Adoration of Magi. Baker, il facing
90; "of superb quality," DP.

Catfield? *wp, S wall arcade. 14c. Turner
(1847c) 138; so little remains that his
identification is difficult to accept. See XII
Catherine for David Park's dating of the
wp scheme.

Ranworth. ms, Antiphonal, S Helen's Church,
hi, f 22. 1460–80. Brigittine Nativity with
3 shepherds, 2 wearing hats; Scott, *Survey*
Cat. 121, il no. 445.

Yelverton? pwd, screen. c1505. Immediately
below demi-angels, donor text with gar-
bled Latin: "Thomas hotte and Betres ys
wify: gloria in excels deo: at in terro pax

hoib bone boluntatis randum [laudum]";
the garbling may be result of amateur
restoration. Below text, rocky landscape
with trees (Williamson [1957] palms).

Cathedral. sc, bosses, N transept. 16¹. **W8**
Angel next to open door; **C8, C12, & E10**
angels appearing to shepherds with sheep;
W13 3 shepherds looking up; **E13** 3
shepherds with sheep, lantern, and star;
C14 3 shepherds presenting gifts (basket,
?leather bottle, ?pipe); Virgin seated,
holding Infant on lap, Joseph leaning on
staff; (C above) manger animals, thatched
roof with star; *?manus dei* "right hand . . .
carved betw the 2 ribs above thatched
roof" (Rose, typescript); **C15** same scene
from different perspective, 3 shepherds
leaving thatched house with star above;
C18 3 shepherds approaching walled city
(Bethlehem), one playing bagpipes; good
shoe and clothing detail (Rose [1997]
120); **C19** shepherds singing.

Circumcision

Diocese. ms, missal, Bod L Hatton 1, hi, f 24v.
14⁴. Virgin, with averted eyes, holding
Child on lap of bearded priest with knife;
small angel holding bleeding bowl beneath
Child's hand; Pächt & Alexander 713, pl
LXXII; Scott, *Survey* Cat. 5, il no. 21.
Scott notes the unusual features of bleed-
ing bowl and Child on lap rather than
altar, but see below Cathedral?, Wey-
bridge Priory, and the Virgin nursing
Child at Salle and Norwich SPM (IV.4).

E Anglia. ms, *The South English Legendary*,
Bod L Tanner 17, marginal drawing, f 1v.
15¹. Priest with knife, Virgin holding
Infant on altar; behind Virgin, youngish
man in chaperon; Pächt & Alexander 861,
pl LXXXII.

Cathedral? pg frag, nX.2c. A feathered angel
holding a bowl.

Guestwick. *pg, originally in N aisle, "a repre-
sentation of the circumcision," Bl 8:219.
King (23) conjectures a series of the life of
Christ, with only the frag of Child against
rays remaining.

Cathedral. sc, transept bosses. 16¹. **NE16** Vir-
gin supporting Child on altar (C); priest
holding knife; 4 attendants, one with open
book; Joseph with purse at waist, staff in
hands; **SW7** (L) ?Joseph with ermine

tippet; Virgin with joined hands; Child on altar held by high priest; ?knife on altar.

Weybridge Priory. printed calendar, NMS 134.944.1503. Bleeding bowl.

Adoration of the Magi

The 3 Magi sometimes represent the 3 ages of man, one king usually bearded. In the N transept bosses at the Cathedral the kings are dressed to represent different ages. If Magi are cited as kings, they are wearing crowns. Virgin seated with Child on lap.

Sculthorpe. sc, font relief. 12c. L to R in five separate niches, each fig carved full face: 3 Magi demi-kneeling, each with gift; Virgin, crowned and seated, with Child seated on lap; bearded fig seated in chair with spindle risers, RH raised, ?Joseph; for ils, see Jones (1872) facing 338; Bond (1985) 197. Bond (191) calls this font and those at Shernborne, Toftrees, and S Wootton "the finest in design" of all Norman fonts, "work of a great, unknown, original genius." Pevsner was less enthusiastic, "much recut" (Pevsner 2).

Fincham. sc, relief. Norman font, E face. 3 Kings in separate niches, bearing gifts; il Bond (1985) 156; Cautley 133.

Norwich S Cuthbert & Mary the Less. ?emb *vestment. 14³. New vestment set "cum toto aparatu de Historia Epiphanie Domini," Watkin 1:26.

Diocese. ms, Stowe Breviary, BL Stowe 12, hi, f 40. c1322–25. Kings with gifts, foremost without crown extending ciborium with gold.

— ms, missal, Bod L Hatton 1, hi, f 25v. 14⁴. Virgin seated, Child standing on lap; kings with gifts, one kneeling, 2 standing, one with arm raised, as if to remove crown.

Costessey. *pg, roundel. 14c. Foremost king kneeling, crown on ground, offering ciborium; 2 kings standing behind with ciboria, (C) pointing up; all wearing long pointed shoes, DT 28:72, published in *Gentlemen's Magazine*, 18 Nov. 1842.

Thetford Priory 2. pwd, retable. c1335. Crowned Virgin seated, holding gold piece in RH to which Child reaches with RH; Child seated on Virgin's L knee, LH touching open vessel presented by demi-kneeling white-haired king; gift proffered in RH, crown depending at L wrist; 2 crowned kings standing, probably repre-

senting youth and middle age, RHs raised, gifts in LHs; ClunyM; *Age of Chivalry* Cat. 564, fig 132 (color).

Shelfanger. wp, SE end of chancel. c1325. To L of seated Virgin and Child, 3 kings, foremost kneeling with extended twisted gold ring; (background) 2 kings holding covered ciboria; Baker il facing 90.

Hockham. wp, N wall. Mid 14c (DP in P & W 2). Virgin seated but largely obliterated, flowing red skirt; Child in yellow tunic, seated on Virgin's lap, head missing, arms extended; Joseph facing child, bearded with long hair, in pointed hat, RH raised, palm out; kneeling king (balding, no crown) with arms extended; 2 standing kings: in short, low-belted gown, holding flat dish in LH, pointing with RH; in short gown walking; **FIG 10**.

Castle Acre Priory? wp, Prior's ch. 14c. E end (S soffit) frags of crowned figs, above them a star, probably "an Adoration of the Magi," Tristram 149; (N) fig in a mandorla; on E win splays, 2 bps or abbots. Very little is discernible today, but what remains indicates that the ch was extensively decorated. See also XII *Eustace*.

Heydon. wp, S aisle, frag. Late 14c. 2 standing kings in ermine-lined mantles over short belted tunics, both holding stemmed covered vessels; central king pointing up; 3rd king without crown, elderly, demi-kneeling.

Ringstead? al frag. 15c. Horse's head, stable, ?groom; now NMS. While there are no instances in Cheetham's catalogue of horses in Magi scenes, they are common in other media. In MS Bodley 264 a squire holds the horses (f 223v), in the E win at SPM (2e) 3 attendants are on horseback, and on a pilgrim badge found at Lynn a groom holds 3 horses (IV.4).

Ranworth. ms, Ranworth Antiphonal, S Helen's Church, hi, f 42v. 1460–80. None of the kings is pointing, all of them are wearing crowns; Virgin is depicted seated under a canopy.

Cawston. pg frag, sX.2c. 15c. Frag of hand holding vessel of shape typical in Magi scenes.

Garveston. *pg, "the 3 wise men offering (I believe)," NRO, Rye 17, 2:38.

Pulham S Mary. *pg, E win. The 18c descrip-

tion is not entirely clear, but it would seem that the scene was situated beneath the Trinity and Virgin with child, "at their feet the wise men offering their censers, &c.," Bl 5:395. Perhaps this was originally part of a Joys sequence.

Aylsham. *pg frag. Unnimbed, crowned fig with white beard, demi-kneeling with both hands raised, palms out; DT 53:51.

Cathedral. sc, N cloister boss K5. 1425–30. (L) Virgin in bed holding Child, pillow supported by angel; (above) manger, animal and angels; (below) Joseph seated with cane; ?midwife holding cloth; (R) star and bearded Magi, foremost kneeling, other two standing, crowned.

— im. N side of high altar. Offerings from 1440; 1513 ladder provided for clothing kings (Beeching 23).

Denver. *wp; drawing, NMS 76.94.

Weybridge Priory. printed calendar, NMS 134.944. 1503. Crowns.

Cathedral. sc, N transept bosses. 16¹. **E12**, **W15**, Herod and counselor(s), Anderson (1971) pl 89; Herod cross-legged in **W15**. **W17**, **W18** Kings with gifts before Herod. **W14** Kings leaving Herod's palace, passing through gateway; Herod looking troubled. **E15** Herod with councillors, devil in crown, open book on lap. **C17** Kings riding with gifts; star above roof of house. **E17** Kings mounted with gift. **E18** Kings walking with books, 3rd with open book with minim writing. **E19** Kings mounted with gifts. **C16** Joseph seated with cane, Virgin holding Infant on lap; kings all standing. **W16** Same scene, first king kneeling, crown on ground, offering gift; 2nd king with gift pointing to star above stable roof; 3rd king with gift; ox and ass above; Atherton, color pl IIIc. **W19** (L) Kings leaving stable, one with book; (R) stable scene similar to **W/C16**.

Norwich SPM. *emb cope hood. 16¹, "iij kynges off coleyne," Hope (1901) 199.

Outwell. *pg, nV.2b. 16¹. Large king holding covered cup in LH, originally "figures of the wise men, with their offerings almost as large as in life," Bl 7:473.

Yarmouth. 1465, 1506, 1512. Funds spent for making and "leading the star, 3d. on the twelfth day"; "hanging and scouring the star; a new balk line, and rysing the star,

8d"; and "a nine thread line to lead the star, &c"; Bl 11:366. Galloway and Wasson also cite the making of a new star in 1462. Lancashire (no. 689) conjectures a liturgical play.

Guild at Lynn, 1371 (Owen, 325).

Presentation of Christ in Temple/ Purification of the Virgin

February 2. The (high) priest was traditionally identified as Simeon.

Diocese. ms, Stowe Breviary, BL Stowe 12, hi, f 242v. c1322–25. Joseph with lighted candle and basket with 3 birds; Virgin and Child; Simeon nimbed, dressed in white, extending veiled arms.

— ms, hours, NMS 158.926.4f, hi, f 53v (Prime). c1310–20. Joseph with basket of birds and candle; Virgin with clothed Child reaching RH to her face, apple in LH; priest behind altar extending veiled arms; Sandler, *Survey* Cat. 47, il no. 109.

— ms, missal, Bod L Hatton 1, hi, f 148v. 14⁴. Virgin presenting clothed Child to bearded priest; Joseph with basket.

N Lynn. *im. Candles to burn on festivals, Westlake no. 280.

Diocese. ms, Wollaton Antiphonal, Nottingham U Library 250, hi, f 331. c1430.

Bawburgh. pg, roundels, nIV. *Nunc dimittis* inscr on rolls. Perhaps the Compline text once accompanied a Presentation scene.

Cathedral. sc, S transept bosses. 16¹. **E1** Joseph leading ass through city gates with Mary riding sidesaddle holding swaddled Infant; **C1** Joseph, Mary holding Infant, standing with backs to dressed altar; **C7** as in C1 facing high priest (mitre) with book standing before altar, blessing; **E7** as in C7, facing altar with high priest behind, Virgin offering doves to priest. **W1** Angel with teaching gesture speaking to Joseph. **W1** and **E1** have also been interpreted as the Flight to Egypt. For the numbering system of the bosses, see Appendix II.2.

Norwich SPM. See IV.4.

Weybridge Priory. printed calendar, NMS 134.944. 1503. Candle.

Guilds at Hempstead S Andrew (*Index Monasticus* 72), Lynn (T. Smith, 64, 108; Farnhill; for Tylers Guild, 1329 articles in French, Owen 319–20), Outwell (Farnhill), Gt and Lt Walsingham (Bl 9:271), Upwell (Farnhill).

Light at Walsoken, 1507 (Williams [1941] 339).

Flight into Egypt (and Return)

Burnham Market. sc relief, tower. 15ex. **E7** Joseph with huge bag on shoulder pole (?adze) leading ass. **E8** Virgin and Child riding.

Cathedral. sc, N transept bosses. 16^1. **E20** Joseph leading ass; Virgin riding with Infant on lap; **C23** angel resting hand on Joseph; Joseph before gateway, pointing. **E24** Joseph and Virgin outside fortified wall; **W25** Joseph leading ass with Virgin and Child into gateway (moving R). In Egypt and Return: **C20** Family in Egypt Virgin and Child seated on ass; Joseph speaking to man in short gown; second man ?Pharaoh; walled city in background; **C21** Joseph leading ass; **W24**, **C25** angel appearing to sleeping Joseph; **E25** Joseph leading ass, Virgin and Child sidesaddle.

Massacre of Innocents

Childermas (28 December); see also IV.3 Lynn. The Cathedral owned 2 relics of the Innocents in the 13c (Beeching 17). Guild records at Swaffham indicate some sort of play on Childermas day 1508–15 (Galloway and Wasson 99–100).

Norwich. stone mould frag. 1245–57. Herod seated with crossed knee; soldier in mail and bucket helm piercing infant with sword; second soldier attacking a child; il *Age of Chivalry* Cat. 447. Found in London Street.

Diocese. ms, Stowe Breviary, BL Stowe 12, hi, f 25v. c1322–25. Herod seated; soldier holding up head of slain infant; mother kneeling and holding arms of child being cut in two by second soldier.

Potter Heigham. wp frag, N aisle. 14c. Part of 3-register series: (lowest) female in white gown, black shoes; behind her a male in parti-colored gown and hose; a second male in parti-color, both with maces hanging from belts. Tristram (237) queries identification. He included a representation of a king from the register above, but the remains today bear none of the characteristics associated with Herod. Eve Baker in 1965 cited merely a king and a head of a king. (I am grateful to Stephen Paine for photographs and information on the wall paintings.)

Norwich SPM. pg, see IV.4.

Cathedral. sc, N transept bosses. 16^1. **W23** 3 soldiers leaving Herod. **W20**, **W21**, **E22** massacre. **C22** souls of 3 children escorted by 2 angels in albs; 5 figs in hats, one in ermine tippet playing lute. Rose (1997, 125–6) thinks angels are welcoming souls in heaven; Remnant (1999, 173) interpreted the lute-player as a self-accompanied singer. **E21** Herod being restrained by flanking counsellors; **E23** Herod writhing; **W22** death of Herod in bed; 3 mourners (Rose 121); **C24** massive devil taking Herod's soul coming from mouth; 2 other demons, one with beak; Anderson (1963) pl 11.

Foulsham. *?medium. 1509. Alice Bateman left 40*s* to gild the tabernacle of the Holy Innocents in the chancel (37 Gloys, Cotton, personal communication); church dedication.

Weybridge Priory. printed calendar, NMS 134.944. 1503. Nimbed beardless fig with sword impaled in breast.

Church dedication to Innocents at Foulsham; Bond (1914) cited 5 dedications for England.

Christ Among the Doctors

Cathedral. sc, S transept bosses. 16^1. **C2** Child seated in high-backed chair, open book on lap; flanked by doctors holding books (*900 Years* color il p 42); **E2** (C) ?high priest, Child seen from back (facing priest); flanked by 2 doctors on either side; **E3**, **W4**, **W6**, **E6** Virgin and Joseph seeking Jesus, **E3** flanked by woman and man in ermine tippet; **W4** Joseph leaning on cane; Virgin addressing 2 men, 2 other figs; **W6** Virgin addressing man in tippet and chaperon; Joseph in ermine tippet leaning on cane; **W2**, **C4**, **C6** Virgin and Joseph finding Jesus; **C6** similar to **C2** with Virgin and Joseph (R); **W2** Virgin holding hands of Jesus; Joseph; **C4** Virgin; Child facing Joseph; directly behind Child, doctor; 4 other figs, incl 2 women; **W5** Child with orb, Virgin, Joseph entering doorway.

3. Joys of Mary

Five (Annunciation, Nativity, Resurrection, Ascension, and Assumption/Coronation) or fifteen (see also next section). See generic descriptions above for the

Annunciation and Nativity; post-Infancy events are cited here without description, for which see subject headings in VI–VIII. See also Appendix VII.

W Dereham Priory. ms, Anglo-French poem on the 15 Joys, Escorial Library Q II 6, column miniatures. c1320–30. Ff 3 Meeting at the Golden Gate, Education of Virgin; 3v Suitors of Virgin, Annunciation; 4 Visitation, Angel and Joseph; 4v Nativity: Virgin reclining, Joseph with cane seated, pointing to manger with Infant above, ox and ass (Sandler, *Survey* Cat. 80, il no. 207); 4v Adoration of Magi (R), Virgin and Child seated, (L) kneeling king opening vessel, 2 kings above with gifts, one pointing to star (Sandler, *Survey* il no. 206); 5 Presentation, Christ among the Doctors; 5v Marriage Feast at Cana, Resurrection; 6 Ascension, Assumption; 6v Coronation. Sandler notes that this is an "exceptionally early example" of an illustrated Joys.

?Thetford Priory 1. Cluniac Psalter, Yale, Beinecke 417, hi. c1320–30. Ff 23 (Ps 26) Annunciation; 33v (Ps 38) Nativity; 42v (Ps 51) Adoration of Magi; 43 (Ps 52) Presentation; 52v (Ps 68) Assumption; 64v (Ps 80) Coronation, Sandler, *Survey* Cat. 108, il no. 281. Sandler notes the unusual substitution of the Marian subjects for the more typical psalter illustrations.

Elsing. pg, E win. c1350. *Annunciation (originally in light a). Nativity (b) now A2, frag of head of ass with mane and halter. *Crucifixion Type 1 (originally in light c). *Assumption (originally in light e) with the Coronation in tracery; see also VIII.1 *Coronation*. Win diagram in NRO Rye 17, 6:40–41.

?Norfolk. pcl, oil and tempera on linen. ?1465–70. 6 scenes. Annunciation: Gabriel kneeling with "Ave Maria" scroll; ?in alb and cope; lily pot with 3 lilies; Virgin, open book with writing on reading desk; no sign of Dove, but photograph unclear. Adoration of Magi: 2 kings standing, each holding a ciborium-shaped vessel; third king, crown at feet, kneeling, touching Child's feet; Virgin holding gift; very large Child; Joseph with gray beard. Massacre of the Innocents: Herod; 4 soldiers, one presenting child on spear to Herod; ?2 females. Flight into Egypt. Miracle of the Corn:

man in short coat and hat, looking back over shoulder, holding sheaf of wheat in LH and sickle in RH; Virgin and Child on ass, wallet depending; Joseph holding staff and leading ass by halter. Assumption/ Coronation. All il in Denys Sutton. Although the work was found in Norfolk, Sutton argues for a Suffolk site, the dating reflecting the belief that the paintings replaced dorsaria at Bury S Edmund lost in the 1465 fire.

Saxlingham Nethergate. pg. 1390–1413 (King). Five scenes distributed in 2 windows, 2 scenes not *in situ*: **sIV** Nativity originally in tracery of sII, Virgin holding nimbed Infant, Joseph in soft cap with hands on stick; (above) ox and ass and six-pointed star. **sIV** Resurrection. Descriptions based on Winter watercolors (DT 60: 32, 33); glass now very dark and hard to read. E win tracery, *in situ*, patched with alien glass; **A5** Ascension; **A1** Pentecost; **A3 & A4** Coronation.

Lynn. ?pilgrim badge, lead triptych frag. ?14[1–2]. Upper register (L) Annunciation: Gabriel kneeling (C) vertical scroll and ?lily pot; Virgin; (R) Visitation. Middle register Adoration of the Magi: (L) groom with 3 horses, (R) 2 kings standing, one kneeling. Bottom register Massacre of the Innocents: (L) Herod seeking advice from ?scholar; (R) soldier cutting a child in two, other infant(s) on ground. When complete, there would have been 3 more scenes. Spencer (1980) Cat. 120.

Seething. wp, N wall. Late 14c. Faint remains. Annunciation, trace of lily in pot, kneeling fig; Nativity (faint), Virgin reclining with Child, Joseph seated with staff, crude shed to rear with animal (Bardswell misidentified as the Crucifixion); Resurrection; Ascension; Coronation; 1938 wp "recently uncovered"; Bardswell, il facing 339.

Buxton. *pg, N ch. 15c. Annunciation, Nativity, Assumption, Coronation. Although Bl's description is a bit confusing, the extensive texts cited help identify the subjects of this win; "Angel with label 'Ave Maria gratia plena Dominus tecum'." "Our Saviour in his swaddling clothes by the Virgin"; Assumption; Bl 6:447. The win also included "Justice with her equal balanced scales." It is not immediately clear how the

text "Religio Mundi et immaculata" (James 1:27) figured in the composition. See VIII.4 *Marian Texts*; Wdf (140) identifies the quotations.

Oxborough. *pg, E win, "history of our Saviour's birth, and the Wisemen worshipping him, and their offerings, his resurrection &c.," Bl 6:186.

Attleborough. sc, bosses, N porch. 15². Worn, heavily whitewashed. Annunciation worn 2-fig scene. Nativity prominent horizontal remains. Resurrection, Ascension, Coronation.

Wymondham. sc, bosses, N porch. c1450. Heavily whitewashed and eroded. Annunciation: angel; vertical mass, rather large for lily pot, perhaps lectern stem; Virgin. Brigittine Nativity, multi-figured: (foreground) Child lying in ovoid radiance; (behind) 3 kneeling figs with hands joined in prayer, ?Joseph, Virgin, (far R) ?donor; scene flanked with angels. Resurrection, Ascension, Coronation.

Denton. sc, bosses, N porch. Mid 15c. Annunciation: Gabriel kneeling, dove descending above scroll, lily pot below; Virgin with orante gesture. Nativity: Virgin sitting up in bed, Child on lap; Joseph standing behind bed, leaning on crutch; angel to rear; animals below the bed looking up (Ingleby, drawing, 52). Resurrection, Ascension, Coronation.

Hethersett. sc, bosses, S porch, some badly eroded. 15c. Annunciation: Gabriel, lily pot, Virgin; Nativity: Virgin in bed with figs at rear and one in font. Resurrection, Ascension, Coronation.

Hemsby. sc, bosses, S porch. 15c. Annunciation: book on lectern, Virgin, lily pot, Gabriel in armor. Nativity: Virgin in bed, book lying open, Infant above. Resurrection, Ascension, Assumption, Virgin against rayed backgound. All bosses situated to be viewed leaving church.

Norwich S Helen. sc, boss, S aisle chapel. c1480. **8** Annunciation: Gabriel; lily pot with scroll wrapped around stalk, full bloom above; Virgin in frontal position at desk with open book; dove. **2** Nativity: (L) Virgin in bed holding naked Infant's elbow; (R) Joseph with cane; (C) woman in white veil and wimple, holding blanket in both hands (?midwife, Rawcliffe [130]

suggests S Anne); (above R) wattles, 2 animals. Resurrection, Ascension, Coronation. General view P & W 1 fig 43, and Rawcliffe fig 15 (color). The same model was used in the Cathedral cloister, N walk boss K5. See Appendix VII.

W Harling. 15³. Wm Berdewell left 10*s* to "feywe Joys afore our Lady" probably in the Lady Ch, Bl 1:303. A bell inscr "VIRGO CORONATA DUC NOS AD REGNA BEATA."

Norwich, Carrow Priory. *emb. 1533. Bequest of "a cloth of tapestry work with the stories of the Nativity, Resurrection and Epiphany"; also a cloth with the "three Kings of Colyn" to the prioress; Rye (1889) xxix.

Norwich SPM. *pcl. 16¹, "a hangyng of wight sarent wᵗ the v iois of oʳ lady & other ymagery steyned in gold for up*per* parte of the high aulter," Hope (1901) 219.

— *pcl. 16¹, "a cloith steyned wᵗ v iois of oʳ lady for oʳ lady aulter," Hope (1901) 219.

Norwich S Mary Coslany? *pcl. 1534. Bequest of 5 marks for painting "stories of our blessed Ladie." The choice of stories was left to the executors in conjunction with "the most honest of the . . . the parishe"; cited in Duffy (1997)

Loddon. pwd, screen, many panes with underpainting only, atypically large compositions, some with landscapes. 16¹. **N2** Annunciation: (L) Gabriel in alb and cope, scepter in RH, vertical scroll; (C above) Father in nebuly with rays depending (below) lily pot; (R) Virgin kneeling before desk with RH near open book, turning towards Gabriel with LH raised, diagonal scroll with trace of lettering; il Cautley 12, Briggs 1014. **N3** Brigittine Nativity: in shed, Joseph holding candle in LH, shading it with RH; (LC) Virgin with hands joined; (R) Child lying against auriole. (Winter commented that the panel was well preserved "with the exception of the faces of Joseph and Mary, which are wholly destroyed. This panel I took in hand to restore, and lay bare the freshness of the original colouring, which is rich and deep in tone and masterly handled," *Selection* 1:6, p 17; faces are still defaced, though others have been retouched. **N4** Circumcision: (L) lateral altar within arch,

high priest; (C) Virgin (no halo) handing Child to high priest; Child with gesso halo turning to Virgin; (R) female, male in Tudor bonnet, and Joseph leaning on cane. **N5** Adoration of Magi: (L) 3 kings in red gowns with wide collars, one kneeling with hands joined and crown on ground; one doffing crown and holding chalice; one crowned holding vase; (C above) a gesso star; (R) Virgin, gesso halo, holding Child on lap. **N6** Presentation, only one-third of panel preserved: (L) priest, with gesso detail on mitre, holding Child; fig holding open book, free-standing candle. **S7** Ascension.

Garboldisham. 1531 bequest for "v. Gawdyes brennyng before our Ladye," Bl 1:182. Waterton noted that lights in honor of the five joys were called gawdys.

Outwell. Five lamps to be burned in honor of the 5 Joys, Firth, 173.

Guild to the 5 Joys at Binham (*Index Monasticus* 3).

4. Joys and Passion Sequences

For description of public life and Passion, etc., see separate entries in VI, VII, & VIII; see also Appendix VII.

Norwich, Carrow Priory. ms, Carrow Psalter, Baltimore, Walters Art Gallery W.34, miniatures. 1250–60. Ff 23 Annunciation, Visitation, Nativity, Annunciation to Shepherds; 24v Journey of Magi, Magi before Herod, Dream of Magi, Adoration of Magi; 25 (Morgan, *Survey* pt 2, Cat. 118, il no. 103) (above) Flight into Egypt, Massacre of the Innocents; (below) Presentation, Baptism; 26v Temptation, Entry into Jerusalem, Washing of Feet; 27 Betrayal, Flagellation, Way of the Cross, Crucifixion; 28v Deposition, 3 Marys, Harrowing of Hell, Resurrection; 29 *Noli me tangere*, Incredulity of Thomas, Ascension, Pentecost, Crucifix Tinity; 30v Last Judgment; Morgan, *Survey* pt 2, il no. 104.

Diocese. ms, Corpus Christi Psalter, CCCC 53, miniatures. 14¹. Ff 7v–8 Annunciation and Nativity; 9v–10 Resurrection and Ascension; 11v–12 Coronation and Betrayal (Malchus screaming as Peter cuts off top of head); 13v–14 Flagellation and Carrying of Cross (Christ covered with wounds, executioner leading, Virgin and John following; 15v Crucifixion Type 1 (paired

with Virgin and Child); James (1912).

Norwich SPM. pg, E win. Mid 15c. **2a** Annunciation: angel kneeling, scepter; crowned Virgin kneeling at desk with open book; lily pot, inscr scroll; (above) in radiance, nimbed Dove and tiny Child carrying cross. **2b** Visitation: Virgin with scroll inscr "Magnificat a*n*ima mea domi-n*u*m"; Elizabeth in veil, wimple, laced maternity gown, scroll inscr "Unde hoc m*ihi* ut veniat ad me"; attendant behind with fur-lined garment over arm; in background, loggia, town, tree with bird, Wdf conjectured *cedrus exaltata*; Wdf pl II; Marks fig 166. **2c** Nativity/Adoration of Shepherds: within stable Virgin in bed, holding Child; Joseph bearded, seated in chair; woman warming swaddling clothes at fire; behind bed 2 angels adoring; (R) 3 shepherds playing pipes (A. Rose identifies as recorders); (background) ox and ass eating hay at manger, 2 angels making hole in thatched roof for star to shine through; Wdf frontispiece. **3a** Circumcision: priest seated on canopied throne, holding knife; Virgin seated on stool nursing Child; behind, Joseph leaning on cane; other figs; cf wdcarv at Salle. **2e–2f** Adoration of the Magi: 3 kings, foremost bearded, crown beside, kneeling, removing lid of cup to reveal coins marked with cross; 3 attendants on horseback; Virgin in bed holding Child extending hands to foremost king; Wdf (1935a) il facing p 24. (Felbrigg Hall) Presentation in the Temple: within temple Joseph with lighted candle and basket containing 2 birds; Virgin standing before altar, priest behind holding Child. [Flight into Egypt: copy at Felbrigg Hall.] **2g** Massacre of the Innocents: 2 registers, (above) Herod in loggia, cutting infant in two with sword, attendant behind; soldier with infant impaled on sword being attacked by woman; (below) woman and man with outstretched hand; soldier impaling infant above cot, Wdf pl III. [Last Supper], Crowning with Thorns, Stripping, Crucifixion and Entombment, [Resurrection, Ascension] [Dixon copies]; see also VIII.5. For full description, see David King, forthcoming.

E Harling. pg, E win. 1463–80 (King). 15 scenes. **4a** Annunciation: crowned Virgin,

eyes downcast, arms crossed on breast, head turned towards Gabriel; lily pot beside desk covered with white patterned cloth, on cushion open book with minim writing; against Virgin's halo, nimbed dove descending from rayed murrey cloud; Gabriel kneeling wearing cross-diadem and fringed purple dalmatic, scepter in LH, RH raised in salutation; above heads inscr scrolls, "Ecce a*n*cilla dom*i*ni" and "Ave gratia plena"; at top of panel "[Sa]lutac*i*o be*ata* Mar*ia*"; Crewe fig 44. **4b** Visitation: crowned Virgin with orante gesture; ermine-lined mantle; vertical scroll inscr "Magnificat a*nim*a mea"; Elizabeth in pointed black hood (cf Houghton S Giles), veil, wimple fitted over her chin; LH raised, RH touching Virgin's side; mantle over maternity gown; vertical scroll inscr "Unde hoc m*ihi* ut veniat"; scene set before door of house; above "[Collocutio Mariae] cu*m* Elizabeth"; Wdf pl X. **4c** Brigittine Nativity: (L) Virgin kneeling, hands raised; 2 midwives in white veils with hands raised; (C) manger filled with straw, murrey drape; Child lying on gold rayed mandorla; (L) ox feeding from manger; in front of manger ass; star with beams above; (R) Joseph (headless) with staff. **4d** Adoration of Shepherds: low stool with porringer and spoon; Virgin seated on chair with elaborate back, seat draped in murrey; naked Child standing on her lap; (above C) 5-pointed star; (above R) manger with ass and ox; (below R) 3 shepherds, one with sheep, one blowing pipe; foremost in ruby gown and blue hood kneeling, holding staff and hat in hand; Wdf pl XI. **4e** Adoration of the Magi: (L) 2 kings standing, one in murrey gown with hands tucked in gold belt, the other in fur-trimmed patterned white gown holding ciborium-shaped vessel; foremost kneeling with crown in hand, extending vessel heaped with gold coins (marked with crosses); (R) Virgin (alien head) and Child as in 4c; (above) 5-pointed star, "[E]piphia d[omini]." **3b** Presentation in the Temple: Joseph with lit taper in LH, basket with 2 birds in RH; (C) Virgin, hands parallel against breast; priest in cope and appareled alb, white drape covering his hands, holding Child above altar;

scene set against cutaway temple; Duffy fig 2. **3c** Christ & the Doctors: (L below) Virgin swathed and veiled in blue, ermine-lined mantle, hands extended; (L above) 3 heads, 2 in elaborate hats; (C) above, Child, barefoot, in purple gown, seated on massive cathedra; opposite, doctor in black cap holding roll, ruby gown with purse and fur-lined hood; (R) 2 doctors, one in elaborate hat with teaching gesture; foremost seated on bench, LH holding roll, RH raised; (far R) 2 additional heads; in band above, "Docebat ih*esus*"; Wdf pl XIII. Marriage Feast at Cana; Betrayal; Crucifixion; Deposition; Resurrection; Ascension; Pentecost; Assumption/Coronation. Quoted texts follow Wdf. The subtle variations in details of the Virgin's dress are remarkable.

Martham. pg frag, nIV.1b. c1450. Annunciation: Gabriel feathered with mantle; Virgin; (above L) dove with rays descending to nimbus of Virgin; *Nativity: perhaps the feathered angel with scroll inscr "Gloria in Excelsis Deo" was part of this scene (DT 35:48). *Adoration of Shepherds; *Magi; *Circumcision (56:49), Crowning with Thorns, Crucifixion, Resurrection; Ascension. Win heavily restored, J. Dixon. Taylor (1859b) recorded the Joys in the E win of the S aisle.

Booton. *pg. Annunciation: Salutation with texts incl "supveniet in te virtus." Flight: Joseph and Mary fleeing to Egypt. Baptism: history of the baptism. Entry into Jerusalem: Christ riding to Jerusalem, "Ozana fili david"; for the distribution of these subjects see NRO, Rye 17, 1:132v–134r.

Blofield. sc, font bowl, badly defaced. 15[1]. Reading clockwise: Nativity: (R) Virgin seated in bed, Infant in arms; (far L) Joseph in chair; manger above with huge animal heads; il Cautley 132. Flight: Joseph, huge bag on shoulder pole, leading ass by rope; Virgin and Child seated on ass; grass-like incising below. Christ before Pilate, Crowning with Thorns, Flagellation, Crucifixion Type 1, Resurrection and Ascension. Cautley (21) dated the font 14c, but it is more likely 15c; church dedication in 1427.

Cathedral. sc, nave bosses, **Bay H.** 15[3]. **4**

Annunciation: Gabriel feathered, ermine tippet; scroll around lily pot; Virgin, open book with minim writing. Marriage of the Virgin: **6** angel resting hand on shoulder of Joseph, with staff; **5** Virgin and Joseph, with staff, linking right hands. Visitation: **13** Virgin (no wimple) with staff in hand; **15** Elizabeth in veil and wimple placing hand on Virgin's abdomen; Virgin resting hands on Elizabeth's shoulders. Nativity: **9** angel with scroll inscr "Gloria in . . ."; **10** nimbed nude Infant in manger, (above) 2 animals; Joseph with cane; Virgin; neither Joseph nor Virgin looking at the Infant (Rose [1997] 89). **14** Adoration of the Shepherds: one with crook, one playing pipe; sheep (Rose 85). Adoration of the Magi (flanking 10): **11** king with gift and doffed crown; **12** 2 kings with gifts. (For the Nativity play at Norwich with shepherds and the kings of Cologne, see Lancashire no. 1227.) Presentation in the Temple: **7** Virgin holding Child on altar, facing priest (Rose 88); **8** Joseph carrying basket with 2 doves. Massacre: **18** Herod with crossed leg, flanked by soldier with drawn sword; **16** soldier impaling infant; **17** mother holding infant being impaled by soldier. **Bay I**, Flight: **1** Virgin riding sidesaddle, holding swaddled Infant; **2** angel; **3** Joseph holding staff and stick with "pleated bag" over shoulder. Christ among the Doctors: **4** Child seated, holding closed book, 3 doctors (2 flanking, one below) with open books (2 with minim writing); (R) doctor pointing to book with blank pages (Rose 92); **5 & 6** Joseph and Virgin, each with inscr scroll. Marriage Feast at Cana: **7** Christ and Virgin seated before table with bread and chicken thereon, Christ resting hand on her wrist; before table 3 water jars (Rose 93); **8** servant filling water jars; **9** servant carrying wine goblet. Baptism of Christ, Temptation, Raising of Lazarus, Passion in Bays J, K, & L; Resurrection. Ascension, Pentecost in Bay M.

Salle. wdcarv, false bosses along ridge of chancel roof, originally painted. Mid 15c (15[4] Cave). Reading W to E, 9 scenes. Annunciation: Gabriel demi-kneeling with scroll; lily pot; Virgin standing, RH on breast, LH raised. Adoration of Shepherds: Virgin seated in bed, holding naked Child on lap; 4 shepherds adoring, one in hat, one playing pipe; in background wattle hording and manger with 2 animals, one feeding. Circumcision: Priest seated holding knife, tippet over voluminous gown, two-horned hat (OT mitre); Virgin seated (C) nursing Child; behind Virgin ?Joseph with RH on breast and LH raised, palm out; (far R) 2 men in pointed hood and cap, respectively, both with hand extended to the central scene (Anderson [1971] pl 38). Adoration of the Magi: Virgin crowned, seated with Child on lap, RH raised, palm out; Child reaching both hands into cup borne by kneeling bareheaded Magus; other 2 crowned, one with covered cup in LH; youthful king pointing (to star); all 3 with RH raised. Entry into Jerusalem, Last Supper, Crucifixion, Resurrection, Ascension. Parsons il betw vi & vii; Cave (1935) reproduces the entire set. Excellent black and white photographs displayed in the church.

V. LIFE OF CHRIST: MINISTRY

1. John the Baptist Preaching

E Rudham. al, frag of bust. 15c. RH against breast with pointing gesture; camelskin of tunic contrasting with mantle. ?John reproving; see Cheetham, Cat. 46.

Cathedral. sc, S transept boss. 16[1]. **C3** In camelskin robe, flanked by trees and wild animals. **E4** holding book, facing tree. **C9** John preaching from pulpit. **C12** John in camelskin garment in pulpit; surrounded by men, incl priest with OT mitre, 2 men consulting books with minim writing, 2 in ermine tippets (one in hat with depending lappets ending in tassles, one in chaperon); Rose (1997) 124 & (1996) color pl III.c. **W13** John preaching to Sadducees and Pharisees. **E11** John flanked by Sadducees and Pharisees with open books.

2. Baptism of Christ

Unless stated otherwise, Christ (C) is standing in water of the River Jordan typically thigh-deep; flanked by (L) angel and (R) John baptizing.

Fincham. sc, Norman font, W face. In separate niches, standing fig with crozier in RH and closed book in LH; Christ standing in a ?tub, dove descending; John, book in LH, RH extended.

Norwich. seal, Friars Preachers of S John the Bapt. 13c. "Dove of the Holy Spirit descending on the head of our Lord; a wavy sun on the l., and a crescent on the r. in the field. The names IHC XPC on the l. near the figure of our Lord, and IO . . . BA . . . on the r. near that of St John, across the field"; *BM Cat. of Seals*, 3772.

Norwich Martin-at-Oak (Coslany). al frag. 15c. Kneeling leg, large fish below; camel's hoof; garment (?angel holding); found 1954, now NMS. There are a number of payments for the rebuilding and furnishing of the chancel 1441–54 and a bequest for emendation of the nave in 1457 (personal communication, Cotton).

Cathedral. pg frag, Erpingham Win, nX.2b. 15c. Christ in water. Origin uncertain.

Cawston. *pg, transept. "Saviours baptism," NRO, Rye 17, 1:204; see also VI.

Marsham. *pg. "Christ's Baptism in the Jordan," Bl 6:287.

Snetterton. *pg, N aisle. ?15[3]. Baptism "with legends in labels," Bl 1:420.

Cathedral. sc, nave bosses, Bay I. 15[3]. **10** Christ in heap of waters; John in long gown, demi-kneeling, pouring water on head from footed vase held at throat; scroll; **11** angel holding garment; **12** angel holding length of cloth (Rose, towel; Goulburn, amice; perhaps an anointing cloth, Nichols [1994] 318–9). For the Baptism play at Norwich, see Lancashire no. 1227.

Cley? sc, font bowl. c1460. Nearly obliterated. 8th scene of a 7-Sacrament font.

Binham. sc, font bowl. c1470. Upper section destroyed, but trace of crown with hair in center of frame; angel holding garment; Christ in loin cloth, hands at breast; John in shaggy tunic and mantle. 8th scene of a 7-Sacrament font.

Seething. sc, font bowl. c1473. Angel in alb holding length of cloth draped over folded arms; Christ in loin cloth, hands at breast; John in belted gown, RH raised, water cascading from inverted shallow vessel. 8th scene of a 7-Sacrament font.

Sloley. sc, font bowl. c1480. Angel in alb holding length of cloth draped over folded arms; Christ in loin cloth, hands at breast; John, rope belt at waist; RH raised, water cascading. Nichols (1994) pl 97. 8th scene of a 7-Sacrament font; same model at Seething.

Stalham. sc, font bowl. 15[3]. Angel in alb holding gown; dove descending; Christ with RH on breast, LH raised; fish in water; John in shaggy garment, his LH on breast, RH pouring water over head of Christ from pinched-lipped vessel; Bond (1985) il p 2.

Gresham. sc, font bowl. c1500. (Upper L) Father crowned, dove proceeding to head of Christ; (lower L) on rock angel in alb, no wings, holding length of cloth draped over folded arms; Christ in loin cloth, hands at breast; John in belted gown, pouring water from pinched-lipped vessel, held by handle; Bond (1985) dust cover il. 8th scene of a 7-Sacrament font.

Wendling. sc, font bowl. 16c, before 1536. (L) John, L knee against gown tucked up to thighs, staff in LH; (R) Christ in mound of waters, hands joined; inverted vessel above

70

his head; figs defaced. Atypical scene. 8th scene of a 7-Sacrament font.

Cathedral. sc, S transept bosses. 16[1]. **C5** (L) 2 men, one removing hose; Christ naked in water; John inverting pitcher of water on Christ's head; angel (no wings) holding garment (Rose [1997] 128); **E10** Christ with orb and John Bapt, 5 other figs; **E12** Christ flanked by trees, (above) dove; **C13** Christ flanked by (L) angel holding gown, (R) John emptying pitcher of water above head; (above) Father and frag of Dove; **E13** Christ flanked by angel and John Bapt.

Crostwight. *wp. Angel flanked by 2 angels above; fish in water, DT 54:121.

Terrington S Clement. pwd, inside of font cover. 17[1] (Bond). Baptism with crowd of people, flanked by 2 temptation scenes (see below), 4 evangelists in background. Texts: "Qui crediderit et baptiza feruit salus erit; Vocem pater natus corpore flamen ave; Christum induistis quot quot baptizat estis," Seccombe, 8. M & R suggest that an earlier font cover was redesigned to accommodate foreign work (3:129–30); Pevsner thought "probably Laudian Gothic," Wilson adding "early C17, and of unusual interest." P & W 2 fig 45 (cover closed); Pevsner 2 pl 29, cover open.

Foulsham? *pwd, font cover. When open, showing Our Saviour and four Evangelists, NRO, Rye 17, 2:115. Martin does not mention Christ's baptism, but it is tempting to see a parallel with the Terrington font cover.

3. Temptation

Cathedral Priory. ms, Ormesby Psalter, Bod L Douce 366, hi, f 72 (Ps 52). 14[1]. Temptation of Christ.

Sparham. *pg, N win. "Saviour and the Devil and labels, '[omn]ia tibi dabo [s]i . . . cadens adoravi*s*. . . . Si filiu*s* Dei es dic ut lapides isti pane*s*. No*n in* sola pane vivit ho[mo]'," NRO, Rye 17, 3:216.

Cathedral. sc, nave bosses, Bay I. 15[3]. **13** Satan, winged, horned, huge ears, claws, tail, hooves, body covered in feathers; holding five stones, scroll inscr "panis . . . lap"; **14** Christ, inscr scroll illegible except "am."

— sc, S transept bosses. 16[1]. **E8** devil in lay clothes holding stone; **W10** treasure chest, one locked, other open with coins; Christ;

devil dressed as in lay clothing, split short tunic edged with fur, claws, cloven feet; table with ewer; **W12** Christ and devil on turret; devil in lay clothing, thick lips; **W8** devil with long tail fleeing from Christ; **C11** Christ flanked by 2 angels.

Terrington S Clement. pwd. 17[1]. Inside of font cover, Christ on mountain, Satan as king; Christ seated surrounded by stones, Satan as king holding stone and arrow.

4. Public Life
Calling the Disciples

The Apostles are identified by their attributes.

Norwich SPM. See X.4 *Peter, Narrative*.

Cathedral. sc, S transept bosses. 16[1]. **C10** Christ on shore; Peter and Andrew at sea, holding net with fish against side of boat (Rose [1997] 133); **W11** boat with stays and furled sail; Christ leading Peter and Andrew away; **E9** Andrew facing Christ, pointing to Peter; **W9** John Bapt with book walking away; Andrew facing Christ; **C8** man in chaperon in boat, holding net in sea; on shore John and James Maj following Christ (Rose 129).

Marriage Feast at Cana

E Harling. pg, E win, 3d. 1463–80 (King). Horizontal table, with 3 chargers holding fowl and meat, divides scene into 2 registers: (above) bearded bridegroom in ruby hat, bride wearing burlet with ouch in front, furlined red gown, hands resting at waist; Christ in murrey mantle, with LH raised palm out; (below) nimbed youthful steward in fur-lined gown, towel over RS, palm in RH, LH extended with covered cup, identified in the Middle Ages as S Architriclinus (Wfd 47–8); small fig pouring water into 6 water jars; crowned Virgin, RH pointing down to jars, LH at breast; Wdf pl XII. Joys/Passion sequence.

Cathedral. sc, S transept bosses. 16[1]. **C14** Christ, Virgin, 18 other figs, seated at table set with plates and bread; **W16** 12 figs, incl Virgin; 6 men carrying flagons; **E16** 12 at table, incl Virgin, table set with plates and chalice, 3 men pouring wine from flagons to cups; **C16** 15 at table, bride in pediment headdress; chicken, flagon, bread, salt cellar; guests on cushioned benches; **W15**

typological reference to Last Supper, 12 at table, some with hands joined in prayer; chalice and bread. (Cave [1933] suggested meal at Matthew's house); **E19** feast, incl women.

Sermon on Mount

Cathedral. sc, S transept bosses. 16[1]. **W21** Christ preaching under canopy to 4 people, one with back turned; **E21** Christ on rock, surrounded by 8 people, incl woman; **W25** Christ with orb and RH blessing; 5 disciples.

Miracles
Multiplication of Loaves

Cathedral. sc, nave bosses, Bay J. 15[3]. **11** Apostle betw 2 baskets, emptying large dish into into basket; **12** apostle emptying dish with bread scraps into one of 3 baskets; **13** ?Christ with long inscr scroll (Goulbrun conjectured Bread of Life text); **14** profile bearded man with beads; profile youth carrying basket of loaves.

Calming of Sea

Diocese. ms, missal, Bod L Hatton 1, hi, f 142. 14[4]. Christ walking on water; Andrew and Peter in wooden boat with prow; Peter stepping from boat with hand outstretched to Christ. Pächt & Alexander 713, pl LXXII.

Cathedral. sc, S transept bosses. 16[1]. **W20** Christ asleep on boat with 12 disciples; **C20** Same but Christ being awakened by John (placing hand on the arm of Christ); **C23** Same but Christ awake with RH on breast.

Healing Miracles

Cathedral. sc, S transept bosses. 16[1]. Lame: **E5** Christ as youth flanked by man with crutches and one with wooden leg; **C22** Christ blessing, surrounded by 10 people, one man with wooden leg, one with crutch (Rose [1997] 132); **W24** Christ blessing, man in oriental hat looking at Christ, pointing to man with crutch and bandaged L leg; **C24** Christ with orb surrounded by sick, (L) man on pallet raising hands; (C) man with distended belly and bandaged head, raising hands; (R) man pushing invalid in wheelbarrow. **E25** Christ raising ?woman

in laced gown from seated (?recumbent) position, second woman (Cave [1933] raising of widow's son; ?Jairus' daughter). Peter's Mother-in-Law: **E22** Woman in bed, small fig kneeling beside, female attendant; Christ with orb in hand; **W22** Peter with key, mother-in-law in bed, Christ, orb in LH, RH on her wrist, raising her to seated position (Rose 136); **C21** Christ, Peter with key at one side of table, man on opposite side and mother-in-law serving. Casting out devils: **W23** Christ facing young man with devil in hood at his back; **C25** Christ, young man kneeling with devil issuing from mouth. Centurion's Son (Cave): **E20** Man in hat holding staff, flanked by ?man and woman, facing man in brimmed hat and short gown (?sending servant to Christ); **E24** man in long gown and elaborate hat and staff facing man in short gown (servant of Centurion); **E23** Christ, man kneeling with hands joined.

Raising of Lazarus
See also XII.

Letheringsett? pg frag, sIII.2b. 15c. Hand removing wrapping from head, one band falling loose.

Cathedral. sc, nave bosses, Bay I. 15[3]. Resurrection: **15** Lazarus in gaping shroud, Christ raising him by hand to seated position; **16** 2 men in oriental hats (?Pharisees) observing the miracle; **17** Mary and Martha, RH raised.

Transfiguration
1487 feast assigned 9 lessons; listed in red in the Bromholm Psalter, initial unexecuted (Pfaff).

Norwich S Austin. *im. 1473. Bequest for "a new tabernacle for the image of the Transfiguration of our Saviour, commonly called St. Saviour's Image," Bl 4:476. Thomas Gyllyng's will is very difficult to read, NRO, NCC Paynot 30.

Norwich SPM. *emb cope hood. 16[1], "the transfiguracion," Hope (1901) 197.

Thuxton. *pg, 1504. Contract betw Thomas Sharington of Cranworth and Heyward of Norwich "to glaze a window in this church, at 7s. 3d. farthing per foot, which was to be painted with the history of the Transfiguration of our Lord"; also donors, their arms and those of their parents, Bl 10:254–5.

Foulsham. 1504. "Edmund Ryx willed that "the boke of the service of the transfiguration of Christ be bought," Bl 8:208.

Parables
Prodigal Son

Brooke? *wp, S wall. Large building, outside open door a figure "with arms partly extended, and in a stooping posture; evidently receiving with welcome a tattered, bare-legged, disconsolate-looking individual, who, half bent towards the ground, seemed to implore help," 3rd well dressed fig walking away; "In the distance, within what appeared to be some kind of inclosure, were swine," Beal 65–6. Except for the swine, Beal's description of the mural located directly above the 7 deadly sins sounds very much like one of the Works of Mercy.

Norwich. seal, John Parkhurst. 1559. Prodigal "returning to his father, a herd of swine in background," below "Periit:et:inventus: est," *Index Monasticus* xxxii.

Unjust Steward

N Tuddenham. pg, sVI.A3. 15c. Man in red and white garments, blue hat, holding ?gold coins in hand; before him man kneeling at desk holding open book; in background boy; possibly parable of unjust steward; Wdf (63–4) identified the subject tentatively; the light belongs with glass at nV.A2 and nIV.A4.

Wise Virgins

Thornham. wdcarv, be, hand rest, S aisle. 15c. Female fig rising above ?nebuly, holding lighted lamp in RH. See XIII.3 for the deadly sins on other bench ends.

Ditchingham. pg sV A2 & 3. 15c. Paired virgins in identical dress, holding book in one hand and atypical light in the other. A3 is a copy of A2 (King, personal communication).

Dives and Lazarus

?Cathedral Priory. ms, Gregory the Great, *Moralia in Job*, CB Emmanuel College 112, hi Book 5. c1310–20. Abraham cross-nimbed; soul of Lazarus standing on lap; Dives below in cauldron; Gregory quotes Luke 16:24. James (1904).

Christ and the Samaritan Woman

N Tuddenham. pg, nIV.A4. 15c. (R) Christ (profile) in white gown and purple cloak sitting on the edge of a well, one hand raised, nimbed head may be alien; woman in white veil and blue gown, with pitcher in RH raising her L; Wdf pl XX. Wdf at one time conjectured the scene represented Rebecca and Eleazar (1935c, 223).

Catfield? *wp frag, N wall above arcade. 14³⁻⁴. Barefoot fig seated beside well; pitcher; fig standing; DT 29:159.

Christ and Nicodemus

N Tuddenham. pg, nV.A2. 15c. (L) Christ standing, white gown and purple mantle, one hand extended, with rising scroll inscr "Spirit' ubi vult spet Ioh 3"; Nicodemus seated, in blue gown and yellow cuffs, alien head, but low-crowned hat *in situ*; Wdf pl XX.

Feast at Bethany

Cathedral. sc, nave boss 18, Bay I. 15³. Christ seated at table set with bread, chicken on platter, and knife; (L) Martha offering chalice; (below) Mary with covered flagon (ointment jar), kissing his feet, Rose (1997) 96.

Subject Unknown

Thetford S Cuthbert. *wp, "On the north wall of the chancel were many historical scenes out of the New Testament, but they also are whited over," Bl 2:65.

Bridgham. *wp, walls were painted with "scenes from the life of our saviour," Keyser (*Ecclesiologist* 2:94).

5. John the Baptist, Execution

Feast of Decollation, 29 Aug. The 15c pulpit at Burlingham S Edmund is inscr "Inter natos mulieri*bus* non surrexit maior Johane Baptista" (Matt 11:11), Colling 2:102 (1 & 4).

Cathedral. sc, S cloister boss, G4. 1327–29. Executioner with sword raised, holding John by hair, pulling his head out of prison win, *900 Years*, color il p 39.

Elsing. *wp, SE wall. 14c. Formerly a "history" of S John Bapt, incl (1) Dance of Salome, body bent in the customary bow, "her auburn hair" reaching the ground; (2) John in

blue mantle preaching before Herod and Herodias; (3) Herodias, guard, and disfigured saint before prison gate with portcullis; (4) soldier forcing John to block, executioner with scimitar raised. Tristram's description seems to be based on notes by Sam Southern, who made tracings of 2–4; his description of Salome's dance came from the rector, the scene having disappeared by the time Southern saw the paintings in 1860. I am grateful to Barbara Green for this reference. I have been unable to locate Southern's work.

Heydon. wp, N wall, ch dedicated to John Bapt. Late 14c (DP). 6 scenes in 2 registers reading respectively L to R and R to L; largely destroyed above leg level and overlaid with later memorial. (Above) ?John reproving, 2 figs facing each other, R with crossed legs. ?John under arrest, in camel-hair gown flanked by 2 figures. (Below) Dance of Salome, king and queen behind table; arch of Salome's body in dance well preserved. Beheading (C) sword held high, (R) ?Herodias. Traces of battlemented city. In bottom register traces of later representation of dance of Salome.

Catfield? *wp, S wall above arcade, 14³⁻⁴. Seated king; nimbed fig with 2 lambs beside; executioner holding sword; Turner (1847c) interpreted execution scene, paired with execution of John Ev; DT 27:168.

Salle. *pg, E win S aisle. c1420–30 (King 1979). Life and martyrdom.

Norwich S Clement at Fye Bridge. *pg. 1448. Bequest for story of John Bapt (Tanner 129). The [hi]story may, of course, have included other events than execution.

Cathedral. sc, N cloister boss G5. 15². (C) dressed table, Herod and Herodias behind, with other guests and servant; 2 devils leering; Salome dancing before; (lower rim of boss) John held by warder; Salome with head on platter, headless body below; Gardner fig 504.

Burnham Market. sc, relief, N and W faces of tower battlement. 15ᵉˣ. (Reading counterclockwise) **N7** executioner with sword in LH, John's head in R; **N8** John, headless, kneeling before prison door; **W1** attendant with John's head; **W2** Herod and Herodias seated behind table, Salome dancing before.

Cathedral. sc, S transept bosses. 16¹. **W14** Doorway with 2 figs entering, Herod in oriental hat, Herodias in conical headdress, holding his arm; other figs at rear; **C15** Herod holding hand of Herodias in crown and gown with laced bodice and wide pendant sleeves; female attendant; **C18** illicit marriage of Herod and Herodias, bishop link their R and L hands; attendants; **E14** Herodias holding Herod's arm, Herod pointing to her; John; **C17** Herod, Herodias and others seated at table; ?Salome with back presented, V-shaped back to gown; **W19** Herod and Herodias, ?13 other men, incl 3 with backs presented in elaborate lay clothes, one with chain of office; **C19** Salome dancing before feast, sword held by RH under body; an exceptional scene with four men at table turned sideways to watch the dance (Rose [1995] figs 1–3); **W18** Herod and John; hatless man with axe at side; **E18** John headless; man with scimitar placing head on platter held by attendant; **E15** man in extravagant hat presenting platter with head of John to Salome; **W17** Salome handing platter to Herodias; **E17** burial of headless body in camelskin garment in tomb with foramina.

Norwich SPM. *banner. 16¹. A "cloith steyned of the lyfe of sent John baptiste garnyshid wt wight grene yelow red & blew silke. and sent Margaret. James & Willam in pendans peynted," Hope (1901) 221. We do not know what aspect of his life was represented.

Head of John the Baptist

Norwich. al. ?Late 14c. Scar above L eye. NMS, no provenance.

Lynn S Margaret? 1361. *im. Guild of the Beheading of John Bapt provided candle.

Barney. im, terra-cotta plaque. 1496, new Ch of John Bapt, S transept. No scar on forehead, forked beard; found in 1958 in cottage wall; Cheetham, Cat. fig 30, p 50. NMS. Terra-cotta tablets were produced "in large numbers at Lyons" in the last quarter 15c, Hope (1890) 676.

Irstead. sc, font bowl. 15c. Head against charger, forked beard.

Norwich. al. 15ᵉˣ–16¹. Head on charger, flanked by Peter and Thomas Becket; (above) 2 angels with soul in cloth, against mandorla;

Pity below. NMS, provenance uncertain, but see the next item.

Norwich. *al. 1518. Inventory of John Baker, Tanner 239.

Wighton? sc, keystone, E win, S porch. Set upside down. Perhaps a halo rather than a charger.

Lynn Greyfriars, S Francis Guild. *wdcarv. c.1454. Bequest of mazer with print of S John's head in the bottom (Richards 475). A similar vessel in the 1454 inventory of the priory at S Margaret's (Owen 122).

Trimingham. wdcarv, screen spandrel above N4. c1500. Charger with head, shaggy beard and long moustaches. "In this church was (as pretended) a famous relick in times of popery, the head of St. John the Baptist, to which pilgrimages, great worship, and offerings were made," Bl 8:179. Duffy (1992, 167) suggests that the 1478 bequest for pilgrimage "to St. John hys hede" was to an image rather than to a relic.

Light to at Horstead (Millican 20).

Norwich S George Colegate. *pcl. 14³, "j pannus lineus depictus cum passione Christi," Watkin 1:6.

Norwich S James. *pcl. 14³, "pannum de Christi Pascione," Watkin 1:8. Watkin suggests that the subject of these stained rood cloths may have been the Instruments of the Passion (2:lxxvi, n2), a subject more in keeping with Lenten austerity than a graphic representation. The inventories also cited "j pannnus pro magno crucifixo cooperiendo steyned" at All Saints and "unum pannum pro crucifixo depictum" at S John Timberhill (1:21).

Norwich SPM. *emb orphreys, set of vestments. 14³. Red cloth of gold, "unum vestimentum de panno rubeo aureo de Ciprys cum orfreys de passione Domini," Watkin 1:1.

— *emb cope orphreys. 16¹ "a cope of red damask . . . orpheras brodered of the passion," Hope (1901) 197. Perhaps the same as preceding entry since the set originally included a cope as well as a chasuble and 2 tunicles.

Norwich S Giles. *pg, W win. History of the Passion, Bl 4:239.

Ashwellthorpe. *pg E win, 2b. Window diagram in NRO, Rye 17, 1:20.

Norwich SS Simon & Jude. *pwd, screen. 15c. "Assumption . . . , the Passion of our Saviour, divers Evangelists," Bl 4:356.

Thetford S Cuthbert. *pwd. "On the screens, there were painted several saints and the history of our Saviour's passion, . . . now much defaced," Bl 2:65; and "Upon the screen between the south aile and chapel, and also on various parts of the wall, several scripture histories, but . . . now whitened over," Martin (1779) 83.

Norwich S Michael Coslany. See IV.2 *Nativity*.

1. Individual Subjects

See also section 2 *Passion Sequences*.

Last Supper

?Cathedral Priory. ms, Gregory the Great, *Moralia in Job*, CB Emmanuel College 112, hi Book 22. c1310–20. Christ with towel wrapped around waist washing Peter's feet, Peter with head on RH; other apostles in background; Sandler, *Survey*

Cat. 45, il no. 105.

Yarmouth Greyfriars. sc, cloister boss, 2nd bay from S. ?Late 14c. Perhaps a series of scenes on the central axis as at the Cathedral; Bately 31. Still recognizable in 1925 ("Report" 109). The range of bays illustrated by Bately has since been reduced.

Hockham. wp, N wall. Mid 14c. Nimbed figs seated at table.

Garden of Gethsemane

Keswick. *pg. Christ kneeling, chalice above; gate and fence, 3 apostles sleeping below; 1886 sketch in G King Collection, Box 2, NNAS. See also VII.1 *Resurrection*, perhaps originally a Passion/Resurrection sequence.

Flagellation

Christ flanked by tormentors with characteristic contorted posture of arms and legs suggesting force of the blows.

Bedingham. sc, detached bosses. 15c. Christ in loin cloth, hands tied behind back; flanked by tormentors in profile; bearded fig in central niche behind Christ; badly disfigured. Provenance unknown, apparently not integral to the church. In 2000 the three bosses were reported missing; see also section 3 *Pity* and XVI.

Crowning with Thorns

Thetford Priory 1. 12c or 13c. Relic of the purple robe of Christ, Bl 2:18.

Yarmouth. 1495. Relic "of the Holy Thorn, in silver," Bl 11:367; C Palmer 116.

Christ before Pilate

Cathedral Priory. ms, Ormesby Psalter, Bod L Douce 366, hi, f 55 (Ps 38). 14¹. Trial before Pilate.

Ecce Homo

Banningham. pg frag, sV.3b, not *in situ*. 15c. Demi-fig on nebuly, murrey mantle over LS, twisted crown of thorns, blood on brow, hands bound.

Carrying of the Cross

?Cathedral Priory. ms, Gregory the Great, *Moralia in Job*, CB Emmanuel College 112, li Book 13. c1310–20. Christ with garment only about middle, 2 men behind, one in front; tau cross; James (1904).

Dickleburgh. *wp, N wall chancel, "antient Painting . . . half of which hath been lately renewed, viz. Christ bearing his cross," Bl 1:200. See also VII.1 *Resurrection*.

Norwich? seal, Bp Freake. 1579. *Index Monasticus* xxxii.

Crucifixion

?Wiggenhall S Germans. ms, Howard Psalter, BL Arundel 83 I, full page illumination, f 13. Tree of Life: Christ crucified; (head of cross) pelican in piety; (above cross bar) Good Thief, Centurion; (foot of the Cross) Paul, Jeremiah, Moses, John, Daniel, Ezechiel, Peter. Some unusual combinations of prophets and apostles in other media may reflect the typology of this table.

Type 1

Three-Person Scene, Christ on cross flanked by Virgin (L) and John (R) commonly resting head on hand. Only significant variations will be noted except for frags, which are described inclusively. A number of small single figs are thought to have come from processional crosses. To the meager list below must be added one large-scale rood in each church, some very grand. That in Yarmouth S Nicholas, erected in 1370, was described as "opus pretiosum," and was reputed to be "decorated with devices, &c." (Bl 11:365). The roods were sometimes accompanied by other figs, e.g., angels with texts at Ashby: "on the rood beam: . . celi . . / n celsi . . . angels on the rood loft," loose paper, NRO, Frere MSS C. 3.8.

Cathedral Priory. ms, psalter, Lambeth Palace 368, miniature, f 11v. c1270–80. Morgan, *Survey* pt. 2, Cat. 181, il no. 389.

Horsham S Faith Priory. wp, E wall, refectory; figs twice life size. c1250. Virgin holding clasped book and mantle edge in RH, resting head on LH; Christ in elaborately draped loincloth reaching to mid calf, lateral wound and 3 streams of blood flowing from feet; John, hands clasped at breast, holding small clasped book in crook of LA; *John's head, *upper torso of Christ, *upper part of Virgin's head; Tristram (1950) pls 205–7; Tristram (1926) color il facing 256; for placement vis-à-vis the other paintings, see Purcell pl 1.

Booton. processional cross frag. 13[1]. John, book in LH, RH raised. NMS.

Norwich, Carrow Priory. seal. ?13c. Reverse; *BM Cat. of Seals*, 2879; Bl identified this seal as that of the abbess.

Castle Rising. *wp, N side of W tower arch. 13c (Tristram). Partial texts above each fig; DT 42:201; badly deteriorated when drawing made in 1845.

S Creake. pg frag, nVI, light b. 1330–40. Head inclined on R shoulder, crown of thorns made of reeds bound together. The 14c head and arms now incorporated in new composition (King 11). In 1400 there was a papal indulgence to conserve the altar of the Holy Cross on the N (Cotton, 1987b).

Elsing. *pg. c1350. Central light of a 5-light win, diagram in NRO, Rye 17, 6:41.

Rougham. *pg E win. ?14c. Below "a crucifix with the Virgin and S John the Evangelist . . . a woman on her knees, 'Pries pur L'ame . . .'," Bl 10:37–8.

Thetford Priory 2. pwd, retable. c1335. John with book in LH. Now at Thornham Parva, Suf; *Age of Chivalry*, Cat. 564.

Norwich S Martin-in-the-Bailey. *pax. 14[3]. In inventory from S Michael-at-Thorn, Watkin 1:xvi and 23.

Beeston. *pyx. 14[3], "silver gilt with the Crucifix, Mary and John on top," Watkin 2:105.

Norwich All Saints. *processional cross. 14[3]. Cross with images of Mary and John, Watkin 1:22.

Wormegay. sc, relief. ?14c (Perp, P & W 2). Said to have come from the Augustinian Priory of Our Lady, Holy Cross, and S John the Evangelist.

Starston. *wp, N wall, tomb recess. Early 14c. In funeral scene (XIII.6) a tablet of Crucifixion beside bier; Tristram 252, pl 56a.

Norwich, S John de Sepulchre. *?wdcarv. 14[3]. Watkin hypothesized that the "tunica pro crucifix' de blew tartarine embroud' cum stellis aureis et ij nouchis" might have been a set of clothes for the rood figure (1:22, 2: lxxvi).

Lyng. emb orphrey frag. c1480. John with joined hands; incorporated into altar frontal as part of border; DT 33:185.

Norwich S Michael Coslany. *emb. "The carpet at the altar formerly belonged to the altar of the north chapel [John Bapt], and had a crucifix, and Mary and John on it, though

now picked out," Bl 4:498.

?Norwich. ms, missal, London Guildhall Library, Muniment Room MS 515, full page miniature, f 108v. c1420–30. With bones, tau cross in roundel below; Scott, *Survey* Cat. 46, il no. 190. Three offices cited as "non sarum sed sinodal' dioc' norwic."

Diocese. ms, missal, Bod L Hatton 1, hi, f 111v. 14[4].

Cley. pg frag, nII, light b. 1450–60. Head of Virgin swathed in blue veil; arm of crucifix, small scale composition; these may not have been part of the same scene.

Taverham. pg, nV.2a–2c (originally in E win of S aisle). 1460–70. 2 skulls and bones below cross; donor figs. (1a–1c) with prayer scrolls, "In tua passio sit salus et proteccio," restored as (1a) "O Domine tua passio" (1b) "et mort vita mea" (1c) "Et Proteccio"; heavily restored.

Ringland. *pg, E win S aisle. 15[3]. "Saviour crucify'd and St. Mary and St. John on either side," NRO, Rye 17, 3:143.

Ashwellthorpe. *pg, E win. Martin's win diagram shows the crucifix at 2b with "saint" cited at 2a and c, perhaps Mary and John, NRO, Rye 17, 1:20.

Chedgrave. *pg, E win. 3-light composition, NRO, Rye 17, 1:211.

Norwich S Michael-at-Plea. pwd, retable panel. c1420–40 (King 1996). Virgin with downcast eyes; John in profile looking up at Christ; L & M Cat. 56.

Norwich S Mary the Less. ?processional cross. 1474. Bequest of "silver cross with a Mary and a John," valued at £10, Bl 4:119.

Lynn S Margaret. processional cross. 1476. Cross "Silver Gilte, with Mary and John, with a Baner Cloth [and] a Staff of Silver and Gilt," Beloe (1899) 201.

Attlebridge. *processional cross head. nd. Double cross bars, second broken L with standing fig R, probably John; DT 24:81.

The following 5 small metal figs (NMS) are accompanied by rivets or tangs, hence probably attached to processional crosses. Virgin or John is evidence for Type 1.

Costessey? 15c. John, RH raised to halo, holding narrow clasped book in LH.

Diss. 15c. John.

Gt Melton. 15c. Virgin.

Quidenham. 15c. Virgin.

Provenance Unknown. 15c. Virgin, one hand on breast.

Wickhampton. sc, S porch. Date not known. Figs eroded, back rounded, so probably not *in situ*. Manning (1872b); DT 48:45; DT 61:179.

Reepham. sc, ?boundary cross. ?14c or 15c. Relief on both sides of 10" cross. On reverse Andrew and Michael.

— *sc on a buttress at the NE corner of the chancel, NRO Rye 17, 3:125v.

Burnham Norton. wp frag, E respond of N arcade. ?15.

Stow Bardolph. *wp, over N door. 15c. Virgin, arms crossed on breast; John with hand to head and book in arm; remains of mound for crucifix; Dashwood (1852) il betw 138 & 139.

Norwich Guildhall. *wdcarv. 15[3–4]. Pax for swearing oaths "made of Wainscotte and gravyn with Trymyng of the Crucifyx and Glasse, & for the said Crucifyx and Glasse and for wryghting of St. John's Gospell thereon, &c. for Horn to cover the Swearing Bred &c," anciently in Alderman's chamber, Bl 4:328 fn 9.

Crostwight. ?*wdcarv. 1478. Alice Cook of Horstead provided for a pilgrimage to the "holy Rode of Crostewheyt" (Bl 10:445).

N Elmham. *?wdcarv. Silver "shews whych wer upon yt brown rodes fete" (Cox, 1913, 140).

Norwich SPM. *wdcarv. 1493. Bequest to new gild the im of the Virgin on the perke; 1504 bequest to gild rood loft, Bl 4:213, 214.

Trunch. *wdcarv. c1500. Figs originally attached with pegs to the green faces of the font canopy, only the outlines remaining today; Bond (1985) il p 293.

Norwich S George Colegate. *im. 1514. Bequest to make "2 images of St. Mary and John, to be made to the cross which he did make for his friends," Bl 4:471.

Acle. *im. 1555. "Item payed . . . for peyntyn of Mary and John," the context suggesting the painting of new rood figs, NRO, Rye 17, 1:10.

Norwich SPM. pyx. 16[1]. "Itm. a pixe all gilte of silver wt a crucifixe mary and John in toppe and iiij red roses a bought the glase on boith sides"; second pyx cited, Hope (1901) 210.

— metal work. 16[1]. Enameled cross, with foot weighing 166 ounces. "Itm. a crose wt the

crucifix or lady & sent John" with arms terminating in medallions with evangelists, lower arm with with second medallion with 12 apostles; octagonal foot with 4 evangelists alternating with 3 prophets and seated S Peter; staff for processional use decorated with 6 apostles under canopies; Hope (1901) 163, 207.

Norwich S Mary Coslany. metal work. 1547 inventory, "crosse of silver and gilt with Mary and John, conteyning liiij once," Boileau (1864b) 367.

Weybridge Priory. printed calendar, NMS 134.944. 1503. Center of calendar disk.

Type 1 crucifixions are also represented on the eighth face of seven-sacrament fonts at Alderford, Brooke, Earsham, Norwich (Cathedral), S Creake, Lt Walsingham, and Walsoken, and on other fonts, e.g., at Blofield, Colney, Great Dunham, Hindolveston, Ketteringham.

Type 2

Type 1 with additional figs, in particular Longinus and the Centurion with scroll inscr "ecce vere filius dei"; sometimes sun and moon. In the life of Longinus in the *South English Legendary* (Bod L Tanner 17, f 30) he wears an exotic hat & wide belt; his eyes are closed & he holds a spear.

Kimberley. pg frag, E win, tracery. Early 14c. Sun and moon flanking head of Christ; usually at either side of the crucifix.

Burnham Deepdale. pg frag, S porch, W win. 15c. Sun and moon with faces; King assumes from a crucifixion scene.

Grimston. *wp frag, E wall, S transept. Early 14c. Cruciform nimbus and upper part of cross with label & traces of letter; (L) blue nimbus and "indications of . . . Longinus with the Spear," Tristram 175. Tristram noted the large scale, "originally a work of fine quality."

E Rudham. al frag. 15c. Green cross, (L) angel in alb holding chalice beneath Christ's feet; remains of corpus from chest up and RH, red halo; (R) fig wearing long pointed shoes, holding lance point down; probably from an altarpiece; Astley, drawing pl 2.

Ingham. ms, Michael de Massa, *On the Passion of Our Lord*, Bod L Bodley 758, miniature, f 1. 1405. Corpus covered with wounds; (L) 6 figs incl Virgin supported by woman and John, Mary Magdalene embracing legs of Christ; (R) 3 figs, incl centurion with inscr scroll and ?author seated at lectern desk

with scroll inscr "Angeli pacis"; (above) 3 demi-angels in attitudes of prayer; Scott, *Survey* Cat. 17, il no. 108; Pächt & Alexander 794, pl LXXVI. Thomas Drew, a chaplain at Salle, left Lady Ela Brewes a copy of the work described in his will as a book of devotions with images once belonging to her father (Parsons 84). A copy of this MS was made for the rector of Salle (King 1979).

Diocese. ms, hours, CB Fitzwilliam Museum 55, f 136. c1480.

Norwich S Stephen. pg E win, lights b & d. 1533. Frags, incl soldier on horseback. Originally in the central light.

Runcton Holme. gilt latten pax. 15c. Sun and moon above, bones at base of cross; found embedded in wall; now NMS; Layard, il facing 123; DT 43:58.

E Dereham. sc, font bowl. 15^3. Massive cross on mound, flanked by 3 figs; John supporting head and holding ?book. 8th scene of a 7-Sacrament font.

Salle. sc, font bowl. 15^{3-4}. Cross flanked by 3 figs, (L) incl John supporting Virgin; (R) incl one with RH raised; Nichols (1994) pl 94. 8th scene of a 7-Sacrament font. See also Ingham, above.

Sidestrand? sc, over S door. 15c. Large winged angel with chalice; from E gable of original church, perhaps part of a lost Crucifixion.

Norwich SPM. *paxes. 16^1. "ij. paxes wt the crucifixe mary & John sone & monne over their heedes in blew amell," Hope (1901) 209.

Ludham. pwd, chancel tympanum. 1553–8. Against blue ground, central crucifix with tetramorphic symbols distributed at the ends of cross bars; Christ with head leaning R; flanked by feathered angels with 2 sets of wings, (L) holding 3 nails and (R) probably an instrument of Passion but badly worn; (L) Virgin with huge halo, Longinus with spear tip close to lateral wound; (R) Centurion with RA raised, ?John. Longinus and Centurion dressed in mantles with large collars; Duffy fig 137. The 2 outermost figs are faint and have been variously interpreted. Camm (251) thought the tympanum Marian work since it would have been unlikely for the pre-Reformation parish to have merely a painted rood when it had such an elaborate rood screen.

Crucifix (or Corpus) Only, Miscellaneous or Unspecified

Crucifixes were common in churchyards, that at the Benedictine Priory in Lynn known for its offerings (*Index Monasticus* 5). Documentary citations of "crucifix" may have been Type 1 or 2. Antiquarian references do not always provide enough detail for sure classification.

Weston Longville. sc. ?Saxon. Set in platform of font.

Lynn. sc. 11c (P & W 2). Cross from Blackfriars cemetery, now in Greyfriars' Tower. Crucifix on one side, Michael and dragon below; seated Christ (?Majesty) on opposite side; drawings in Beloe.

Buckenham S Nicholas. copper alloy. 13c. Double cross bar with holes for stones or relics; corpus, crown, enamelled perizonium; Turner (1847b) il facing 300; found under floor of chancel 1829. NMS.

Brundall. lead font bowl. 13c. Nine repeats alternating with stylized fleurs-de-lis.

Norwich Castle. sc, Ch Royal wall. ?13c. Woodward pl 13.

Downham Market. sc, relief set in exterior S wall of chancel. ?13c. Corpus in perizonium; DT 29:57.

Swanton Abbot. al. 14³. "Item j tabula de alabaustr' de ymagine cum cruce de eode," Watkin 1:61.

Norwich Holy Cross. bronze corpus. Early 14c. NMS. The 1368 inventory cites 2 portable crosses, Watkin 1:13.

— *pcl. 14³. "ij vexilla cum Cruxifix," Watkin 1:13.

Rougham. sc, above W door. 14¹⁻². Crucifix with ?donor kneeling L, flanked by small statues of Margaret and Catherine.

Hevingham. sc, hexagonal font (defaced). 14c. Crucifix; (R) veiled fig, gown with voluminous sleeves ?donor.

Lynn. pilgrim badges. ?15c. Spencer (1980) Cat. 94, 97 (INRI inscr).

The following 3 examples (NMS) may have come from processional crosses.

Norwich, Carrow Priory. Lower legs and arms broken off.

E Ruston. Gilded copper alloy, corpus with inset glass eyes.

Sustead. Corpus.

Matlaske. reliquary, gold with black enamel. Late 15c. Crucifix with INRI, flanked by John Bapt (L) and bishop (R); Young pl 3.

Alby. pg, E win, small scale.

Banningham. pg frag, sV.2b. 15c. Legs against cross; small scale composition.

Foulsham. pg, sIII.A1. 15c. Tiny frag, feet pierced with single nail, 3 drops of blood on upper foot; perhaps part of a Crucifix Trinity. Set upside-down against a nimbed queen in veil, enthroned.

Threxton. pg. 15c. Frag of large scale crucifix.

Ashwellthorpe. *pg, E win 3b, win diagram in NRO, Rye 17, 1:20.

Hoe. *pg, N aisle, E win. "Saviour on the Cross surrounded with angels (with lilies over his head)"; *orate* text at feet; NRO, Rye 17, 2:258. Bl (10:50) cites merely "the crucifixion" in this aisle; perhaps a lily crucifix.

Loddon. *pg, E win; NRO, Rye 17, 3:36.

Martham. *pg, Christ on Cross, flanked by lay suppliants, (L) touching his leg, DT 35:43, perhaps the same glass classified in VI.2.

Attleborough. seal, College dedicated to the Exaltation of the Holy Cross. Early 15c. *BM Cat. of Seals*, 2573.

Aylsham. sc, font bowl relief. 15c. Bond (1985) il p 250.

Burnham Market. sc, relief, S face tower. 15ᵉˣ. Crucifix against radiance, crouching fig R, with head on hand.

Sculthorpe. *sc, perhaps part of a market cross. "This Stone lies at the South Entrance for a threshold," NRO, Rye 17, 3:195v.

Norwich S Laurence. *emb. 1501. Bequest of altar cloth to the holy rood altar, "IHS in the sun beams, with a crucifix in the midst," Bl 4:269.

Norwich S John Maddermarket. *metal work. 1524. John Terry bequeathed 40 marks for a silver and gilt cross; Tanner 244–5.

Weybourne Priory. *metal work. 1536. Inventory, "copper gilt cross with silver image of Christ (3s. 4d.)," *L & P* (1536) 11:593.

Lynn S Nicholas. *metal work. 1543 inventory. "Itm one picture of Christ crucified, al gilt, 3¾ ounces," Beloe (1899) 157.

Stylized Crosses

Attleborough. pwd, 2 patched panels beneath John and Thomas Becket, images and faint Latin inscr with black-letter English overpainting. **1** Cross with crown of thorns and 3 impaled nails, (below) shrouded Adam; text flanking cross: "quanta pertulit / pro

peccatis nostris / Christus ..bis. ?salu[s]"
and below Adam "[Ibi Adam] sepultus /
[Ibi Christus cruc]ifi[xus]," with text par-
tially preserved in DT 24:91 and 53:35. **2**
Cross with crown of thorns, INRI, 2 nails,
and probably lance and sponge saltire; first
two texts repeated, "Si co[mpatimur co]n-
regnabimus / Qui . . . / ?lade...." These two
panels must be remains of a structure in the
churchyard in 1631: "on the top side
towards the church 'Crux Christi, Salus
Mundi.' On the standing part, 'Christus pro
Nobis passus.' On the transverse, a
wounded heart, and hands wounded with
the nails, 'Ecce! Quanta pro Te pertulit.'
On the back side towards the east, 'In
Christo Spero.' On the standing part, 'Si
compatimur, conregnabimus.' Then on the
transverse, 'Reliquit nobis Exemplum' The
globe was set up to signify the heavens,
coloured with blue, with stars and clouds.
On the equator circle 'Aspiremus perman-
sura Æterna.' The lower part coloured
green, to signify the earth, with trees and
flowers, on it, 'Quid tumultuamur? Peritua
possidemus'," Bl 1:535.

Deposition

Beachamwell. *al. "effigies of 2 persons taking
down our Saviour from the cross, that of
the Virgin and S John standing by the
cross," Bl 7:297. Turner (1847a) 250.

Lt Walsingham. sc frag. ?15c. (L) fig supporting
the weight of Christ's body as it is removed
from the cross; (R) fig ?removing nail from
Christ's hand still attached to cross.
Sketched by Cotman when still fixed in a
wall of a house in town. In 1996 displayed
in S aisle niche.

Entombment

East Anglia. pwd, altarpiece panel. 1390–1400.
Nicodemus and Joseph of Arimathea
lowering Christ into the tomb; Virgin hold-
ing Christ's hand to her face; John behind
Mary; man holding an anointing vessel.
Heavy gesso work, undefaced; now Ipswich
Museums but possibly Norfolk work; *Age
of Chivalry* Cat. 712.

2. Passion Sequences: Palm Sunday–Good Friday

Resurrection and post-Resurrection events are described
in VII.

?Wiggenhall S Germans. ms, Howard Psalter,
BL Arundel 83 I, ¾ page, f 12v. c1310–20.
Table of the 7 Acts of the Passion: Christ
before Pilate, Scourging, Carrying the
Cross, Nailing to the Cross, Death (Cruci-
fixion Type 1), Deposition, Entombment.
Miniatures, Hours of the Passion, ff 113v
(Matins) Betrayal and Blindfolding; 115
(Prime) Before Pilate; 115v (Terce)
Carrying of the Cross, Sandler, *Survey* Cat.
51, il no. 124; 116 (Sext) Nailing to the
Cross; 116v (None) Crucifixion Type 2;
116v (Vespers) Deposition.

Diocese. ms, hours, NMS 158.926.4f, hi. c1310–
20. Hours of the Cross, ff 11v (Lauds) Jew
lying on ground; 13v (Prime) Jews con-
ferring; 16 (Terce) Christ, 2 Accusers; 18
(Sext) Crucifixion Type 1; 20v (None) De-
position: man removing Christ from the
cross, flanked by Mary and John; 22v (Ves-
pers) Anointing: man anointing Christ lying
in tomb; 24v (Compline) Marys at Tomb.
Sandler notes the atypical illustration,
Survey Cat. 47.

Diocese. ms, psalter, Escorial Library MS Q II 6,
miniatures, Office of the Cross. c1320–30.
Ff 13v (Matins) Betrayal; (Prime) Flagell-
ation; 14 (Terce) Carrying of the Cross;
(Sext) Crucifixion betw thieves; (None)
Crucifixion with Longinus; 14v (Vespers)
Deposition; (Compline) Entombment; at
explicit Resurrection, Crucifixion, Austin
friar at foot of Cross; Sandler, *Survey* Cat.
80.

?Mulbarton. ms, St Omer Psalter, BL Yates
Thompson 14, f 120. c1325–30. 9 marginal
medallions: Betrayal, Flagellation, Carrying
of the Cross, Crucifixion Type 2, Entomb-
ment, Resurrection (atypical), 3 Marys
(*Visitatio*), Ascension, and Pentecost;
Sandler, *Survey* Cat. 104; L & M Cat. 2;
Marks and Morgan color pl 21.

Cathedral. pwd, retable, originally for high altar.
c1382 (King [1996] 414). Despenser
Retable, 5 scenes. Flagellation: Christ in
loincloth, wrists bound above his head to
pillar, waist and legs just below knees
bound to pillar, tips of toes on ground; (L)
fig with long moustache, wearing hat with

turned up fur brim, short tunic, LH resting on low belt; grimacing fig in ¾ profile wearing calf-height buskins, R leg raised, scourge in both hands; (R) fig with profile partly hidden by raised arm, 3-tailed scourge with knots; building in background; L & M Cat. 51, color il p 39. Carrying of the Cross: (L) 3 figs, 2 on horseback; Christ in loincloth, cross beam resting on RS and behind his head, supported with LH; (R) fig in padded tunic and gloves, holding rope wrapped around Christ. Crucifixion Type 2: (L) John supporting Virgin; Arabic lettering on his gown; (R) turning toward 2 men, centurion in fur-lined mantle over short tunic, RH raised, in LH scroll inscr "Vere filius dei erat iste"; head and arms of Christ painted by Pauline Plummer (for account see 1959). Resurrection. Ascension. Color ils in *Age of Chivalry* Cat. 711 and *900 Years* 48. For physical description of the retable, see Rickert, 246 n54; for a discussion of date, see King (1996) 410–3.

Norwich S Michael-at-Plea. pwd, retable. c1380–90 (King [1996] 414). Betrayal: (L) Peter drawing sword from scabbard; soldier in helmet; (C) Christ in ¾ profile, RH touching ear of Malchus, book in LH; (R) Judas, LH against Christ's breast, leaning head toward Christ; to rear helmeted soldiers; c 8" missing from the bottom of panel; L & M Cat. 52, color il p 39. (Now in pulpitum ch, dedicated in 1997 to victims of persecution.) Crucifixion Type 1: with 2 donors; Virgin, fingers interlaced, looking up at Christ; John, ¾ profile, closed book in LH, looking down; seraph (red) and cherub (blue) receiving blood from wounds; (now in S Andrew's Ch, Cathedral); il *900 Years* 49. These 2 scenes were at S Michael-at-Plea in the 18c (Bl 4:321). For the complex history of these panels, see L & M, Cat. 56. For early photographs with particularly good reproduction of gesso detail, see Hope (1897) pls 8–9. The two scenes probably came from a 5-panel Passion retable, perhaps including the "Virgin of Pity, surveying her son's dead body," Bl 4:321.

Norwich ?S Saviour. pwd, 3 scenes in 2 panels of a retable. c1400–10 (Martindale). **1** (above) Christ before Herod: (L) Christ in

crown of thorns; 3 heads to rear, hand resting on Christ's shoulder; (C) man in pileus and doctor's robe pointing to Christ; head of small fig facing scene; (R) Herod crowned, in ermine-lined houpelande with voluminous bell sleeves, leaning towards and pointing at Christ, leg in characteristic pose crossed over knee (Museum notes identify as Pilate); Rickert pl 157B. (Below uppermost section of *Ecce Homo*), frag of Christ's head; 2 scrolls inscr "Crucifige, Crucifige" with head and hand raised betw them. **2** Carrying the Cross: (above) frags of 5 men harassing Christ, 3 gloved; man immediately behind Christ in armor over loose gown; (far R) man aiming a truncheon at Christ's head; (below L) 2 nimbed women (of Jerusalem); L & M Cat. 54. Frags found when cottage demolished in S Saviour's parish; now in the Fitzwilliam Museum, Cambridge. The sequence of scenes in 2 horizontal registers (see also IV.2 *Annunciation*, Cathedral) contrasts with other retables where the rule is one scene per panel, a pattern that becomes the norm in later rood screens.

Hempstead All Saints. *pwd. "Six painted panels within the altar, (1) the scourging, (2) angel taking 3 persons out of a tomb, (3) the last supper, (4) defaced, (5) men in armour sleeping names with 'Sce' over them much defaced, (6) Judas with Saviour in the garden. In the parting of the church from the chancel are pretty good paintings of 14 saints large on wooden panels." Although Dr. Newdigate's description is not altogether clear, the panels must have originally comprised a Passion altarpiece; Frere MSS, NRS 1:19.

Ringland. *pwd. "Last Supper, Crucifixion, and Ascension," (drawn below) IHS and heart in radiance with angel busts flanking; NRO, Rye 17, 3:142v. Unlike Martin, Goddard Johnson specifies medium: "At the back of the screen a painting reaching from North to South in which is represented the Last Supper, the Crucifixion and the Ascension," vol 2, no. 47. See also XIII.

Cathedral. sc, E cloister bosses. 1327–29. **E5** Flagellation set against a vine with bunches of grapes (*900 Years* color il p 37). **D5** Carrying of the Cross, (L) executioner holding 3 nails; (R) Christ in loincloth bearing

cross (Rose [1997] 12). **C5** Crucifixion (Type 1) Gardner fig 388. **B5** Resurrection. **A5** Harrowing of Hell.

Lt Witchingham. wp, N wall. c1360 (DP). Alternating red and light background, originally 13 scenes in one register reading W to E. Constituent scene illegible. Flagellation well preserved with the characteristic leg posture of L scourger; **FIG 11**. Before ?Pilate (L) Christ, guard in helmet, priest in mitre, man in hat with turned up brim, man in pointed hat. 2 scenes illegible. Deposition, ladder against cross. Scene illegible. Entombment, ghosts of figs. Scene illegible. Harrowing of Hell. *Noli me tangere.* Doubting Thomas. ?Ascension. A very elaborate scheme with grape vines below.

W Somerton. wp, N wall. 14c. Figs (3'–4' high); reading W of the N door (principal entrance) to E before the last win in the nave. Entry to Jerusalem: Christ riding eastward on the ass, in green cloak, RH raised in blessing, orb in L; (R) 2 or 3 raised hands. Mocking: Christ seated with bowed head and hands crossed. Flagellation: Christ standing, in green loin-cloth, arms above head and head bent, flanked by tormenters. Resurrection. Last Judgment (S Wall). Large segments have been lost, and some details described by Tristram (248) are no longer visible.

Crostwight. wp, N wall. Late 14c (DP). Reading W to E, 3 registers; insufficient evidence to determine whether column A was part of the series or contained other subjects; sequence begins in middle register. **2b** Entry into Jerusalem: Christ riding on an ass, figs in trees above; fig with arms extended as if laying out cloak. **2c** Last Supper: Christ's head leaning R; heads of apostles. **2d** Washing of Feet: Christ bending towards Peter; other apostles behind Peter. Win splay, Agony in Garden: 3 apostles with eyes closed; Christ kneeeling. **3b** Before Pilate: Christ standing bound, held by man in short dagged gown; Pilate on throne. **3c** Christ Bound, Carrying Cross: Christ's hands tied, fig behind; largely defaced. **3d** 1 (above) Flagellation; (below) Crowning with Thorns, 2 tormentors placing crown of thorns on Christ's head. 2 Crucifixion Type 2: 2 thieves, Longinus thrusting spear into Christ's side and Stephaton holding sponge

on reed; Virgin in fainting attitude; Mary Magdalene at foot of cross. 3 Deposition: Christ's body laid out, Mary Magdalene laying head at his feet. **1c** Ascension. Tristram 161; DT 54:118, watercolor 1847; Turner (1849) il betw 252–3.

Norwich SPM. pg, E win. Mid 15c. **3b** Crowning with Thorns: 2 registers, (above) Christ flanked by 2 soldiers placing crown on head, (below) 3 laymen forcing crown with hooked sticks; (R) high priest, pointing to Christ, extending RH to hand of man in skull cap with scroll in LH; Wdf (1935a) il facing 29. **3c** Stripping: 2 registers, (above) Christ in loin cloth, body marked with flagellation; man with Christ's robe; man with 2 nails; (below) man in chaperon casting 3 dice; man with dagger attacking man on ground with face wounded. **1e** Crucifixion and Entombment: 2 registers, (above) frags of Crucifixion Type 2 incl Longinus; (below) Christ, body marked with wounds, laid in tomb by Virgin holding his RH, John; at either end of tomb Joseph of Arimathea and Nicodemus, neither nimbed.

E Harling. pg, E win. 1463–80 (King). **2b** Betrayal: Christ, barefoot, RA extended to embrace Judas; Judas embracing, ¾ profile with heads touching; (background) 9 soldiers with halberds and spears, foremost in armor, (C) with cresset; (R) Peter with upraised sword in RH, LH holding Malchus' servant by the shoulder; servant with purse and misericord at belt, holding lantern by chain in RH, LH raised; (above) label inscr "Cap*tus* es[t] . . . ," Wdf pl XIV. **2c** Crucifixion Type 2: tau cross, upper fig of Christ restored; Virgin supported by John in ruby cloak; directly behind Virgin trace of nimbed female head; behind John, Longinus pointing to eye; (R) 2 soldiers on horseback, centurion raising RH in gauntlet; scroll inscr "Vere filu' dei erat." **2d** Deposition/Pietà: Virgin holding recumbent body, LH raised; (L) Mary Magdalene, RH supporting Christ's head, LH raised; (R) John hands joined; tau cross with nails at either end; symmetrically arranged, 2 scourges depending from arms, crossed spear and sponge, above "inri" affixed to tau cross with socket. See also IV.4 and Appendix VII.

Martham. pg, nIV. c1450 (C & C). **3b** Crowning

with Thorns: Christ seated, flanked by men tightening crown with rods, one at L jeering, demi-kneeling. **4b** Crucifixion Type 1: tau cross with label, skulls beneath. John RH to head, clasped book in LH; restoration incorporates medieval frags. Perhaps the instruments of the Passion (DT 35:50) were part of this composition. Window heavily restored, J. Dixon. An 1851 drawing of a tracery light shows Christ crucified flanked by lay suppliants, DT 35:43. Joys/Passion sequence.

Cawston. *pg, transept. History of the Passion, Bl 6:266–7; specified by Martin as "our Saviours baptism, scourging, crucifixion, etc.," NRO, Rye 17, 1:204.

Upwell. *pwd, screen, "our Saviour bearing his Cross, his ascension, the descent of the Holy Ghost upon the Apostles, the Trinity, . . . also several female saints now obscure," Bl 7:466; removed c1820 (Keyser).

Cathedral. sc, nave bosses, Bays J, K, L, & M. 15³. **Bay J: 1** Entry into Jerusalem: Christ riding on ass, flanked at **2** by 2 bearded men in long robes holding scrolls and at **3** by bearded man and youth strewing flowers from a basket. Last Supper: **8** Christ addressing Peter (with key); **9** disciple with hand on shoulder of man with pitcher; **10** on table bread and platter with 2 fish, Christ resting LA on John's shoulders (head on table), LH on platter; 7 other apostles, incl Bartholomew, James Maj and Philip (Rose [1997] 97). (It is unclear whether the men variously costumed in bosses 5–7 are meant to be observing the angelic appearance in the roof at 4 [see XIII.6 *Eucharist*] or, as Goulbrun conjectured, apostles on mission.) **11–14** See V.4. Washing of Feet: **15** Christ pointing to feet of Peter; Peter beginning to remove red hose (Rose 100); **18** Christ washing Peter's feet in large basin; second apostle. **16–17** Bearded man with inscr scroll. **Bay K** Agony in Garden: **1** garden with paling; Christ kneeling before chalice surmounted by host flanked at **2 & 3** by 2 men with hands joined. **18** Betrayal: Judas in long patterned gown, Christ with hand on chest of Judas surrounded by soldiers. Arrest: **5** ?Judas and official; **6** man with club and lantern; **7** Christ held by 2 men; **8**

2 men with scourges; **9** 2 men with swords; **11** 2 soldiers in armor with weapons, one with spear; **12** 3 men, one with sealed warrant for arrest; **17** Peter severing ear of Malchus (ear on sword), lantern betw; Christ behind (Rose 104). **15** Buffeting: Christ blindfolded on bench; flanked by 2 tormentors, hands resting on shoulders, other hands raised to strike (Rose 105). Christ before Pilate: **10** multi-fig scene, Christ standing before (far R) Pilate wearing hat with ermine brim, seated on canopied bench; tiny man seems to be eavesdropping (Rose 101). **13** 2 men with birches. **14** 2 men with battle axes. **4** Crowning with Thorns: Christ blindfolded, flanked by tormentors tightening crown with rods. **16** ?Pilate's wife pleading: Pilate and fig with ?barb under chin (if a chaperon then a 2nd man). **Bay L 1** Christ led by men holding his arms, tower of keep in background, flanked at **2** by 2 bearded men in high crowned hats observing and **3** 2 executioners with hammer and 3 nails. Nailing to Cross: **4** 3 men binding Christ to cross with massive ropes, 4th nailing one bound hand, 5th ready with hammer and nail; **5** man drinking from flagon; **6** 2 soldiers with swords; **7** 2 men dicing for garment (Rose 108); **8** man (R) mixing gall in mortar with pestle; man (L) about to dip sponge therein (Rose 109); **9 & 11** 2 soldiers with weapons, incl spear and halberd. **10** Crucifixion Type 2 (10 figs around cross): (L) Longinus with spear (broken) pointing to eyes; (R) Stephaton holding up sponge on pole (Rose 112). Entombment: **15** Joseph of Arimathea & Nicodemus laying Christ in tomb; **16** seated barefoot tonsured man, both hands raised, ?Peter; **17** John comforting Virgin. For completion of sequence, see VII.2–4.

Blofield. sc font bowl, badly defaced. 15¹. Christ before Pilate: seated fig with LH raised, Christ, with hands crossed (?bound), held by fig behind; 2 prisoners kneeling; 2 other figs at rear. Crowning with Thorns: (C) Christ seated, facing out, flanked by figs in short coats; (L) 2 figs, one kneeling; (R) 2 figs, one with arms extended to Christ, ?holding rod for tightening crown of thorns; all defaced and disfigured. Flagellation: (C) Christ, arms tied, facing forward, flanked by

tormentors with characteristic body contortion. Crucifixion Type 1. See also VII.1 & 3.

Salle. wdcarv, ridge of chancel roof. Mid 15c (15⁴ Cave). 9 scenes. Entry into Jerusalem: trees on knoll, 4 figs; (C) Christ riding ass with halter, no bridle; gateway with a fig in each of 2 turrets in crenellated parapet; (far R) 2 figs. Last Supper table central, 4 apostles below; 7 above, John resting head on breast of Christ (C); foremost apostle with one hand extended; ?bread on table, Cave conjectured that a separate chalice was once fitted into a hole in the boss. Crucifixion Type 2: (L) Virgin swooning, supported by John; a soldier and a man in a high-crowned hat, both looking at Christ; (R) 2 men in high-crowned hats, one pointing to Christ; foremost with halberd; ?soldiers. Cave (1935) ils betw 368 & 369. See also VII.1 & 3.

3. Passion-Related Images
a. Our Lady of Pity (Pietà)

Cathedral. *im. 1386. New image of Our Lady of Pity in Bauchun Chapel, "sancta maria de compassione," Shinners, 138. 1423 bequest for "a light burning before the image of the Blessed Virgin of Pite here, which was an effigies of the Virgin sometimes in tears, sometimes in a most melancholy posture, surveying the wounds and dead bodies of our Blessed Saviour," Bl 4:31–2. Shinners notes that while this image is well represented by donations in the sacrist's rolls, 2 other new Marian images, one at the Precentor's Altar and a new image in the Lady Chapel (c1390), were less popular.

— sc, corbel, Bauchun Chapel, above the original altar. ?14c. Virgin with Christ on her lap; James (1908) pl 4.E. A relic of the blood of the Virgin was kept either in this chapel or in the ante-choir, *Index Monasticus* 66.

E Barsham. *al frag. ?15c. Christ's body lying diagonally on lap of Virgin; arms crossed at wrists; wounds visible, drops of blood on leg; W Martin il facing 257.

S Creake. *im. c1415. Tanner (1977) 90.

Swaffham. *im. 1422 will (Williams [1941] 338–9); Bl 6:217 fn 4.

Norwich S Mary Coslany. *im in Our Lady's ch

on S side. 1464. Burial before Virgin of Pity; 1465, bequest for a candle before "the 'Pyte'," Bl 4:489–90.

Norwich Austin Friars. *im, N aisle. 1480. Burial before, Bl 4:89.

Norwich SPM. *im. 1494. Bl 4:214.

Beeston Priory. *im. Legacies left to our Lady of Pity, *Index Monasticus* 21; Augustinian Priory of S Mary the Virgin.

Emneth. *im. Dugdale 6:25.

Fakenham. *im. *Index Monasticus* 72.

Hingham. *im and ch. Bl 2:423.

Norwich Greyfriars. *im. *Index Monasticus* 40; 1505, Kirkpatrick (1845) 126.

Norwich S Giles. *im. Bl 2:657 (folio ed).

Norwich S Laurence. *im and tabernacle. "St. Mary of Pity," Bl 4:263.

Norwich S Martin-at-Oak (Coslany). *im. Bl 4:485.

Norwich S Stephen. *im, N chapel. Bl 4:162.

Shipdham. *im. Bl 10:248.

Heydon? *pg. A major composition with young men swearing (see XIII.3) surrounding central fig with textual lamentation (Bl 6:253). We do not know the identity of the central fig, but since the speaker is the Virgin, and since the Pietà figures in analogous wall painting at Broughton (Bucks.) and Corby (Lincs.), the Pietà is a reasonable candidate. It may be that Martin's connection of the lament with "the Figure of our Saviour speaking to sinners" provided a distinction between Mary speaking the first part of the poem ("Alas my chyld . . .") and the words Martin records above Christ as if spoken by him, "ȝe þat othys grevye ðe world/ ðou grevist up . . . ," NRO Rye 17, 2:210v.

Acle. sc, font bowl, W face. 1410. Virgin seated on bench, Christ lying on lap; restored.

Walpole S Peter. sc, S porch, NW corner niche. c1435 (Pevsner 2). Christ lying on Virgin's lap; paired with seated Virgin and Child in NE corner.

Walsingham Priory. *im. 1531. Cited by John Benett of Raunds (Northamptonshire) as one of the key devotional sites. Spencer (1998) cites a large number of pilgrim badges (Cat. 153), one found at E Harling (late 15c), another at Lynn (Spencer [1980] Cat. 53).

Thetford S Peter. *im. 1503. Bequest of 26s 8d "for a tabernacle and an Image of our Lady of Pity, on the south side of St. Catherine's

Chapel," Bl 2:62.

Elsing. *im. 1503. Bequest "unto our Lady of Pety lli of waxe, to be made of v small tapers, to brenne by for hyr," Harrod (1847) 122.

Cawston. *im. 1504. Burial before "image of oure Lady of Pity, in the Chapel of Our Lady," Bl 6:264.

Norwich S Mary-in-the-Fields. *im. 1513. Burial before image, S side of church, Bl 4:180.

Norwich, Carrow Priory. 1531. Burial "between the high-altar, and the image of our Lady of Pity," Bl 4:526.

Burlingham S Andrew. *im. 1540. Bequest to gild image; cited in Duffy (1997).

Horstead. Bequest for pilgrimage to "our Lady of Pity of Horsted," Bl 10:445. Some believe the statue stood in the niche on the W wall of the tower, where there are remains of hinges for a grill (Millican 19).

Guilds at Outwell (Farnhill); Shipdham (Rye 134, f 5). Altars at Norwich S Giles (altar of the Virgin of Pity, Bl 4:239). Chs at Wood Dalling (N aisle Bl 8:324); 2 at Cathedral (antechoir under pulpitum, 1510, Bl 4:29). Lights before at Ashill (1505 Bl 2:349), Deopham (1504 Bl 2:494); Fakenham (Bl 7:96); Heydon (Bl 6:249); Hockham (1532 Bl 1:461); Marsham (Bl 6:287), Norwich S George Tombland (Waterton 2:110); Outwell (Bl 7:473), Potter Heigham (Waterton 2:50); Ranworth (1507 Morant & L'Estrange, 191); Swaffham (Bl 6:217, fn 4); Upwell (Bl 7:470).

b. Pity of the Father

The Father holding the crucifix; distinguished from Crucifix Trinity because only the Father and Son are represented.

Thurlton. sc, boss at head of north door arch. ?14c. Father crowned, flanked by scrolls; cross bar beneath; below (and carved on the under side of the stone) a demi-fig of the Pity, arms crossed at waist, ending in nebuly; censing angels in door spandrels. 15c frame provided for the older doorway (see also I.4).

Hemsby? sc, S porch boss. Mid 14c. Seated, trace of ?cross betw legs; "God the Father," (Wilson, P & W 1). Badly worn, directly above door; antedates new set of bosses.

Norwich S Etheldreda? *wp. 14c. "Our Father of Pity, on the E. side," Harrod (1859a) 120. Harrod may have meant a Crucifix Trinity.

Diocese. ms, Wollaton Antiphonal, Nottingham U Library 250, hi, f 166. c1430. No dove.

W Dereham Abbey. *ms, roll announcing death of abbot. In uppermost of 3 registers (L) throng of monks, Abbot John Lyn with prayer scroll, "O deitas trina . . ."; Father supporting crucifix, no dove; Assumption and entombment of abbot below; DT 28: 191–2. The copy, if accurate, shows only 2 Persons of the Trinity, despite the verbal focus of the prayer scroll.

Downham Market? *pg. "God the Father & Son broken on his knees in small figures," NRO, Rye 17, 2:37. This would appear to be the variation sometimes called Corpus Christi.

Sparham? *pg, N win. "Effig: of God with our Savior," NRO, Rye 17, 3:216. Perhaps a Crucifix Trinity.

Bridgham. sc, font bowl. 15c. Father crowned, seated on bench; tau crucifix betw knees; no dove. In the 18c the font was described as whited over, NRO, Rye 17, 1:142.

W Lynn. sc, font panel. 15^3. Father seated on elaborate throne holding crucifix; no dove.

Cathedral. sc, presbytery boss, P65. 15^4. Against nebuly and radiance, Father supporting both arms of the crucifix; vulneral wound; no dove; Goulburn pl 3. Coronation at P83. These are the only storied bosses in the presbytery, otherwise decorated with Bp Goldwell's rebus.

c. Cross of Bromholm

Relics of the true cross were claimed by a number of Norfolk churches in the Norwich Archdeaconry inventory of 1368 (Watkin 2:247–8), and in 1491 Agnes Petyte gave "a little tablet with pearles, and a piece of the holy cross therein," to S Stephen Norwich (Bl 4:162). The Abbey of Wendling and Priory of Old Buckenham also had relics (*VHC* 422, 376), and at Yarmouth in 1495 a goldsmith was paid to mend "the cross, that the piece of holy cross was in," C Palmer 116. The most famous relic was acquired c1220 by the Priory of Bromholm, where it was enshrined in a patriarchal cross. According to Matthew of Paris, the relic in the form of a cross was about the width of a man's hand.

Bromholm Priory. *metal. 13c. Patriarchal cross. Marginal drawing in CCCC 16, f 59; Wormald pl 6c.

— seal, Cluniac Priory of S Andrew. 13c. Patriarchal cross held in Andrew's RH; Pedrick (1902) 36–7, pl 27, seal 54; *BM Cat. of Seals* 2736; Wormald pl 6a. For patriarchal processional crosses, see Watkin, index.

London. pilgrim badges. Mid 13c. Ampulla shaped like a patriarchal cross. Christ crucified with 3 patriarchal crosses in background; (reverse) Cross of Bromholm supported by winged angels (Exaltation), Mitchiner Cat. 39; Spencer (1998) Cat. 178. A second example with son and moon, and angels replaced by monk and ship (silver replica of Henry II's great ship offered as *ex voto*), Spencer (1998) Cat. 179. 14c. Small patriarchal cross, Mitchiner Cat. 242. See also *Age of Chivalry* Cat. 76–7, and Spencer (1998) Cat. 180.

Diocese. ms, hours, Fitzwilliam Museum 55, full page miniature, f 57v. c1480. Patriarchal cross with corpus on base surrounded by text. For text see Wormald 33–4; Minns 43, fn 1; Scott, *Survey* Cat. 135, il no. 490.

Provenance uncertain. ms leaf, Lambeth Palace 545, f 186. 15c. Patriarchal crucifix at the center of heart with 3 flowers rising above the image; Wormald pl 7b. Probably a pilgrim memento later sewn into the ms. This image, like that in the preceding entry is surrounded by text. Wormald queries whether the fig of Christ was added for devotional purposes or whether a corpus had actually been added to the Bromholm reliquary at some time.

London/Lynn/Norwich. pilgrim badges. 14c. Cross rising out of heart, Mitchiner Cat. 244. 15c. Ampulla with heart and flowers surmounted with a cross, Mitchiner Cat 405–6. Cross within a heart "with 3 flowers issuing from the top," sometimes held by a gloved hand, Spencer (1980) Cat. 104–7. Mitchiner notes the conflation of rood/sacred heart imagery, with the heart growing in popularity in the 15c; see Cat. 553–63.

d. Exaltation of the Holy Cross

A complex composition centered on the Cross but incorporating other elements of salvation history. 3 May (Invention of the Cross); 14 Sept (Exaltation of the Cross); for Cathedral ceremony for the feast, see Chadd 321–2. Bromholm held an annual fair on Holy Rood day.

Cathedral. wp, N arcade, presbytery. c1475. "Erpingham Reredos" in 2 registers: (above) God the Father seated and blessing, ?2 censing angels; dove below; flanked by angels (I.4.b) with scrolls inscr with Trinitarian texts; (below) Crucifixion Type 1 (with sun and moon); solid cross originally attached; Evangelists above cross bar (see XI.2); Virgin and John flanked by Latin Doctors below cross bar (XI.3). Erpingham left 300 marks for a chantry at the Holy Cross altar. For detailed treatment of the wp see Whittingham (1985); Park and Howard 405–8, fig 144. The separation of the elements of the Crucifix Trinity into distinct registers and the addition of subjects not common to that composition justifies special classification.

Attleborough. wp, E chancel wall. 15^3. (Above string course) frag Annunciation; (below) a massive foliated cross with arms of Trinity directly above; ?eagle in rhombus at the top of the cross bar (see XI.1); section destroyed when blocked windows opened in 1845. (Above the cross beam L) Moses and David (crowned and bearded), (R) Jeremiah (in prophet hat and dalmatic) and an unidentified fig (Camm conjectured Ezekiel), scrolls above their heads, no discernible writing, but traces of texts on robes; flanked by angels holding (L) ?birch and (R) pillar. (Below cross beam) sun and ?moon, (L) Virgin in ermine-lined mantle, nimbed, ?crowned; (R) John with scroll above his head; register flanked by feathered angel censing. Originally the entire scene was bordered by a series of niches holding figs, only traces of L series remaining. Description based on 1844 watercolor (DT 53:29). General views in Duffy (1997) fig 8.1; Cautley p 110; Long, facing 161. See also the 1848 copy of lost 1841 painting by Ninham before the the arms of the cross were destroyed, Camm [Ingleby] pl 53. This ambitious work reflects the dedication of the college (licensed 1405) to the "Exaltation of the Holy Cross."

Hockham. wp, chancel arch. 15^4. Flanked by Annunciation (far L and R). Father, seated on rainbow, both hands raised; wearing voluminous alb, crossed stole, red mantle; dove of the Holy Spirit descending (depicted against the red mantle); flanked by angels, by a kneeling man and woman each with a scroll (?donors) and by the arms of the Trinity and Passion. (Below) outline of double armed cross with long horizontal label (inscr illegible). The Annunciation suggests a parallel with the Attleborough

wp. Hockham dedication, Trinity.

Linnell cites 4 churches dedicated to Holy Cross. The Norwich church dedicated to the Invention of the Cross (S Crouch) was a property of S Giles Hospital, whose ch is dedicated to S Helen.

16 Holy Cross guilds; at Lynn one for the Exaltation of the Cross, and at Wormegay one for the Invention of the Holy Cross (joint dedication). Two Thetford fairs owned by Augustinian canons occurred on the feasts of the Invention and Exaltation, Dymond 1:45 with citations for 1528/9 and 1525/6 respectively. Altars in the nave in front of the pulpitum were commonly designated "Holy Cross," as at the Cathedral, probably because of the rood above.

e. S Savior

No one has satisfactorily attached the label to a specific image. For one theory, see Linnell.

Cathedral. 1278. The ch of S Stephen and All Martyrs, rededicated to S Saviour and All Saints (Shinners fn 5).

Norwich S Andrew. *im with tabernacle, Bl 4: 304–5.

Norwich S Austin. See V.4 *Transfiguration*.

Linnell cites dedications at Norwich and *Surlingham; Bond 9. It seems to have been a popular dedication for hospitals.

Guilds at Burnham Westgate (Bl 7:38), Freethorpe (Bl 7:232), Necton (*Index Monasticus* 73), and *Surlingham, where the guild provided a win, subject unspecified (Bl 5:467; *Index Monasticus* 74).

f. Pity, *Imago Pietatis*, Man of Sorrows

An image without identifiable narrative components in which Christ displays his wounds, typically a demi-fig rising from the tomb or against radiance, but also full figure.

Thurlton. sc. ?14c. Against nebuly, a demi-fig of Christ with arms crossed at waist; worn; see also above *Pity of the Father* Thurlton.

Diocese. ms, Psalter, NMS 158.926.4c, f 1v, page inserted (recto blank). Mid 15c. Christ, cross nimbed, crowned with thorns, demi-fig in tomb, LH extended, RH against breast just below lateral wound; body covered with wounds, all wounds bleeding; framed in architectural niche; **FIG 12**.

W Rudham. pg, nV.A3. 1430–40 (King). Against a radiance, Christ displaying 5 wounds; 2-strand crown of thorns, locks of hair falling over shoulders; mantle draped over L forearm and lower body; L & M Cat. 76, color il p 60; Marks fig 153.

Cley. pg, eye of tracery, sXI.c2. 1450–60. Demi-fig in tomb, wearing loincloth; crown of thorns, locks of hair falling over shoulder; RA held against breast obscuring lateral wound, though drops of blood visible; blood flowing from hand wounds.

Norwich SPM. pg frag, E win B9. Mid 15c. Radiance behind, both arms raised, seated, LH with wound; so identified by Wdf (23). See King, forthcoming.

Poringland. pg, E win, light b, not *in situ*. 15c. Christ standing, crown of thorns; long mantle held by central morse; forearms raised, all wounds displayed. In the 18c a woman kneeling below with text "Ut indendas et defendas Morte tristi"; the glass was then in a N win (Bl 5:442). Winter's watercolor shows the fig standing within a niche, the body covered with wounds (NMS B326.235.951). In 1995 the glass was removed for conservation.

W Runton. pg frag, sV. 15c. A4 Head of suffering Christ, against horizontal ?cross bar (with illegible writing); LH extended as in Pity. Win comprised of frags from a number of scenes; A3 apostle.

Gt Cressingham. pg, nVI.B3, quatrefoil, head of tracery. 15c. Tomb in lower foil; hands and lateral wound flowing blood; ruby robe falling from shoulders and providing surround for lower torso; restored head.

— pg, nIX.B4, quatrefoil, head of tracery. 15c. Hand and lateral wounds bleeding; ruby mantle on shoulders and at waist; radiance in lower foil.

Blakeney. pg, nVII.2c, not *in situ*. 15c. Nimbed, crown of thorns, standing in tomb against radiance; holding lateral wound with RH, LH raised with blood flowing down arm; **FIG 13**.

Norwich All Saints. pg, nIII, eye of tracery. Late 15c. Standing fig, "blue mantle thrown back and the arms are outstretched," Wdf (1939) 174. Rays in lateral lobes.

Bedingham. sc, detached bosses. 15c. Against nebuly demi-fig with both forearms raised, mantle turned back over upper arm; wound in side; head lost. In 2000 reported missing.

Cathedral. *sc. Roger Bigod memorial; renewed 1443–4 (*Communar Rolls*, 43). Standing, crown of thorns, in typical posture, but no wounds shown in drawing, NRO, Rye 17, 7:40. Browne (*Repertorium*, 10) refers to 2 persons kneeling in prayer.

Drayton. *wp, side chancel arch. In mandorla

Christ seated, displaying hands; robe wrapped around waist and over lap; DT 54:214.

Norwich. al. 15^{ex}–16¹. Demi-fig in tomb, LH raised RH resting near lateral wound; part of John's Head composition; NMS.

Wiggenhall S Germans. wdcarv, be, S1 in niche. c1500. Demi-fig, prominent rib cage; badly deteriorated; Duffy fig 47.

Wellingham. pwd, screen (S2) and retable for altar. 1532 (inscr). Double pane, ¾ fig of Christ in loincloth standing in open tomb, cross bar behind head; torso covered with bloody wounds, arms streaked with streams of blood from hands; LH outstretched toward instruments of Passion, RH resting below lateral wound; surrounded by instruments of the Passion (see below); Duffy fig 50.

Norwich SPM? *pyx. 16¹, "a pixe all gillt for the sacrament beryng w^t ij Angel*es* a bought the barrall & Jhc*sus* in his Sepulcre bi them / o^r lady sent peter & pale ov*er* the birrall & the Trynyte in a pavilion in the tope," Hope (1901) 212.

— *monstrance. 16¹. "Itm. an ymage of silv*er* of o^r Savio^r w^t hys wound*es* bledyng his vesture gilte w^t a little pixe for the sacrament uppon the breste and a diadem silver & gilte . . . , " Hope (1901) 209.

g. Sacred Wounds

For the technical descriptions of the Wounds as the Arms, see Poringland and Martham. Christ's wounds also figure prominently in the Instruments of the Passion, Resurrection, and Last Judgment. Sir John Wodehouse (1421) was granted a charter to establish a chantry in the Carnary Ch in honor of the five wounds (Sims, 455). The wounds as Arma Christi also figured in domestic glass, e.g., in John Marsham's house (Norwich mayor 1518), Bl 4:290.

Poringland. pg, E win, light b. 15c. Heart flanked by hands (above) and feet (below); a short ruby stream radiating from hands and feet; heavily restored but corresponding to the 18c description: "Holy Wounds Arg. a cross az. on which a wounded heart gul. in chief 2 hands, in base 2 feet, all cooped and wounded gul. and under it Jesu Christe," Bl 5:442.

Stockton. pg sIII, tracery. 15c. Shield, central heart lost, hands and feet with traces of wounds; crowned angel in eye of tracery.

Easton. *pg. 5 wounds, Bl 2:397; arms of Eucharist cited in a different win.

Hoe. *pg, upper S win. Central heart flanked by wounds, drawing in NRO, Rye 17, 2:259v; location cited 260v.

Martham. *pg, leaded separately. "The quinque vulnera, viz. Azure a heart gules between a dexter & sinister hand in chief & a dexter & sinister foot in base proper," NRO, Rye 3, 1:293; DT 35:50. See also below *Instruments of Passion*.

Mattishall. *pg, S aisle, Bl 10:237.

Norwich S John Maddermarket. *pg, "shield of the five wounds with Jesus est Amor Deum," Bl 4:290.

Sparham. *pg, "two hands, and two feet, in saltire, and an heart between, proper & wounded," Bl 8:261.

Ickburgh. *pwd, screen, perhaps on coving. "Gul. an heart between a dexter and sinister hand, and a dexter and sinister foot couped. . . . We see this shield in many old churches, joined, as here, to that of the Holy Trinity, and that of the Holy Cross," Bl 2:237.

Cathedral. sc, relief, main arch, Erpingham Gate. c1430 (Sekules 206). With some original color. Sims (455) argues connection with Sir John Wodehouse and augmentation of honor of goutee de sang.

Norwich. bone heart-shaped pendant (excavated S Laurence's Lane). Late 15c or early 16c (Margeson). Horizontal wound with incised depending streams of blood; *East Anglian Archaeology* 26:56, fig 38.

Outwell. pg, sIII.C5. 16¹. Shield with heart flanked by hands and feet.

Norwich S Andrew. *sc. 1522. Goldsmith buried under a marble with "name, a roll, scripture and heart of Jesus," Bl 4:304.

— *sc. 1541. Tomb stone of suffragan bp of Norwich "having had a cross, with a heart in the midst, and the hands and feet of our Saviour saltier wise," Bl 4:306.

Terrington S Clement. sc, relief, tower battlement. 16¹. Shield of 5 wounds (2 examples), Seccombe 12.

Ashmanhaugh. wdcarv, back of pew. 1531. 5 shields, pierced heart flanked by pierced feet, and hands; Duffy fig 98.

L'Estrange (1874, 106) cites an inscr bell at Breccles "SALVENT TUA VULNERA XPE."

h. Instruments of the Passion, *Arma Christi*

See also above *Pity* and IX. The instruments are not always emblazoned on a shield. (See Manual for Users for variations in the use of the term *arma*.) The most common elements in Norfolk are a Roman cross with the crown of thorns at intersection of cross bars with spear & sponge (head on pole) saltire (*Arma* 1). The following list is not exhaustive, but cites representative examples in all media. Individual examples are excluded in favor of sets. All roofs are perpendicular in date. Fonts are block classified at the end of section.

Woodton. pg, sIII.B1. 14c. *Arma* 1, nails embedded in cross, flanked below by scourges.

Poringland. pg, 2 quatrefoils set in E win tracery. ?14c. Cross with INRI, sponge and spear parallel to vertical cross bar, 3 nails embedded, cross flanked by scourges. Christ's robe surrounded with pieces of silver; M & R 2 also cite ladder and dice; heavily restored.

Cathedral. *sc, Ethelbert Gate. 1316–7 (Borg & Franklin). Flanked by 2 niches, ?angels with instruments of Passion.

Aldeby. sc, N porch spandrel. 14c. *Arma* 1, perhaps with other instruments; covered with lichen.

Marsham. wdcarv, angel corbel. 14c. Crown of thorns, wood incised diagonally to look like twisted strands.

Diocese. ms, psalter, NMS 158.926.4c, added miniature f 130. Mid 15c (Psalter). *Arma* above text of indulgence: green cross with INRI scroll and 3 nails impaled, bleeding: (above cross bar) club and sword saltire, pincers, chalice, pelican in piety (at head of cross), vernicle, scourge, and birch saltire; (immediately below cross bar) flanking in registers: (L) mortar and pestle, bucket, purse, bloody spear; (R) sponge, cock on pillar with cord, lantern; (L) towel on bar, ewer and basin, ladder; (R) ?torch, cresset, open hand (slapping), hand with index finger against thumb; hand pulling hair; (L) hammer, gown with 3 dice; (R) flowering heart. Flanking shield below, head in Jewish hat, head in crown (Herod and Pilate); 2 mitred heads (Annas and Caiphas). On vertical cross bar, heart within lateral wound of Christ, "Vera mensura vulneris domini nostri ihesu cristi latere suo non dubitetur"; **FIG 14**.

— ms, hours, Fitzwilliam Museum 55, mini-ature, f 92. c1480. 3 registers: crown, sword, rope. 2 knives, ?cup. Tau-cross, pillar and 2 scourges, 3 dice, ladder, reed, sponge, drops of blood, tomb, mound. Pincer, 3 nails, hammer; James (1895).

Acle. ms, Bod L Tanner 407, drawing f 51. Nail drawn below an indulgence for devotion to the 3 nails, in Robert Reynes's commonplace book; Linnell (1959) pl 1, facing 112.

Swaffham. pg frag, sV.B5. 15³. Angel with hammer. See wdcarv, below.

Glasgow Burrell Collection. pg quatrefoil. 15c. Bust of feathered angel holding column with radiance below; Wells (1965) Cat. 95.

Broome. pg roundel, sV.A4, not *in situ*. ?15c. Angel with *Arma* 1 flanked by scourges below. Paired with arms of the Eucharist. The angel wings frame the edge of the roundels.

Martham. *pg, leaded separately. 15c. Sponge (head only), basket of nails, crown of thorns, scroll with "gloria deo," DT 35:50; angel holding roundel with crown of thorns inscr IHS (f 42). See also above *Wounds*.

Gt Witchingham Hall. pg. 15c. *Arma* 1 flanked by (L) scourges saltire, pincers; (R) dice, hammer, pillar, and cord, sketch in G King Collection, Box 2, NNAS.

Alderford. *pg. Kneeling figs flanking pillar with scourges saltire, NRO, Rye 17, 1:14.

Hoe. *pg, N aisle. *Arma* 1 flanked by ?scourge and 3 nails, NRO, Rye 17, 2:259, 260v.

Norwich S Andrew. *pg, E win. Angels with falchion, pillar, cross, reed, spear, G King (1914) 288.

Wood Dalling. *pg, W win N aisle. NRO, Rye 17, 2:17.

Salle. sc, relief, W door. 15¹. Series of shields flanking central empty niche: cross flanked by hammer and pincers; *Arma* 1 flanked by scourges, 3 nails below; censing angels in spandrels of door below.

Cathedral. sc. c1425. Weepers on tomb of Bp Wakering (d 1425), untonsured figs in albs holding mortar and pestle; lantern and sword; pillar and cord; club and ?birches; hammer and bucket; crown of thorns and staff; sponge and scourge. The last 3 weepers hold crozier, mitre and book. Angels holding individual arms also were used on the unfinished tomb (1555) for Henry Howard, Earl of Surrey, at the Cluniac Priory at Thetford (frag with crown of

thorns, NMS).

Lynn S Nicholas. sc, S porch, N spandrel. 15[1]. *Arma* 1, cross fleury.

Cley. sc, E spandrel, S porch. 15[1] (after 1405, arms of France new style). *Arma* 1 flanked by (L) nails, scourges, hammer, pincers; (R) pillar & cord, ?cock, dice.

Provenance uncertain. sc, corbel. 15c. Angel with shield, *Arma* 1 flanked by birch and scourge; NMS.

Westwick. sc, relief, base course of tower. 15[3] (C & C). Heart encircled with crown of thorns.

Ditchingham. sc, relief, base course of tower. 15[4]. Heart encircled with crown of thorns.

Saham Toney. sc, base course tower. 15[4]. Heart encircled with crown of thorns.

Pulham S Mary. sc, relief porch façade. 15[4]. *Arma* 1 flanked by (L) pincers, scourge, and (R) hammer and scourge; paired with arms of the Trinity.

Erpingham. sc, relief, tower battlements. 15[4]. Pevsner (1) cited "Instruments of Passion," but the only identifiable relief on the W face represents pincers saltire, an unusual configuration.

Tivetshall S Margaret. sc, relief, S porch, door spandrel. 15c. *Arma* 1, 3 nails impaled, cross flanked with scourges; paired with arms of Trinity.

Terrington S Clement. sc, relief, N aisle battlements. ?15c. "Cross, crown of thorns and nails. Shield of the Passion"; "pillar between whip and spear in pale." Tower battlement. 16[1], "shield of the Five Wounds," "shield of the Passion," Seccombe 12.

Broome. sc, W door spandrel (R). 15c. *Arma* 1 flanked below with hammer and scourge; paired (L) with arms of Trinity.

Fakenham. sc, W door spandrel. 15c. *Arma* 1 with knife and scourge.

Geldeston. sc, S porch spandrel. 15c. *Arma* 1 with 3 nails 2 scourges.

Wymondham. sc, nave corbels, angels with shields. Late 15c. **S7** ladder flanked by spear and sponge; **S8** ?2 wounds and 2 scourges below.

Wheatacre. sc, altar tomb with angels holding instruments, NRO, Rye 17, 4:103v. Surface now largely illegible.

Stow Bardolph. *wp, chancel arch. 15[2]. Demi-angels holding shield with cross, crown of thorns, 3 nails, spear and sponge, DT 60: 177; Dashwood (1852) il betw 138 & 139.

Hockham. wp. 15c. Arms paired with arms of the Trinity, flanking God the Father in the upper register: Cross with crown of thorns, ?ladder, hand extended, hand holding ?scourge.

Attleborough. wp. ?15c. (L) angel holding scourge; (R) angel (shown with sponge in parish drawing).

Lynn S Nicholas. wdcarv, tie-beam roof, angels with spread wings. 15[1]. **N5** hammer and 3 nails; **N6** 2 scourges; **S4** broken crown of thorns. See also Appendix I.3.

S Creake. wdcarv, hammerbeam and arch braced roof. 15[1] (1412 bequest to cover roof). Angels in albs holding **S4** crown of thorns; **S5** pillar with cord; **S7** hammer and 3 nails; **S10** heart; **N4** pincers; **N5** 3 nails; **N6** cross; **N7** short spear; *900 Years* il color p 68. Extensive restoration 1957; wings largely replaced; for earlier state see **FIG 41**.

Methwold. wdcarv, hammerbeam roof. c1440 (C & C). **N1** and **S1** angels in albs holding crown of thorns and 3 nails, respectively; **N2** angel with crown.

Ranworth. *wdcarv, screen spandrel. c1450. Spear and sponge saltire, 2 nails saltire above and 2 separate below, basket; second spandrel, crown of thorns, DT 42:62.

Norwich SPH. wdcarv, hammerbeam roof. c1460 (1457, 6*s* 8*d* to emend the nave, NCC Brosyard 53 [personal communication, Cotton]). Angels in albs: (counting from the crossing) **N4** pincers and ?nails; **N5** ?hammer; **S2** crown of thorns. A typical roof with mixed symbolism; angels also hold blank shields, a massive ?liturgical book, and a mitre (S transept); other angels modeled to have held objects, perhaps other instruments. Restored.

Knapton. wdcarv, double hammerbeam roof. 15[3]. Lower rank, demi-angels on nebuly (painted) holding: **N3** ladder; **N4** green cross; **N7** crown of thorns; **S3** 3 nails and hammer; **S4** lantern; **S5** mortar and pestle; **S6** ?sepulcher lid; **S7** scourges; **S10** pillar and cord; Haward (1999), figs 116, 118–19. New demi-angels at base of wallposts also hold instruments.

Swaffham. wdcarv, double hammerbeam roof, nave. c1475 (Haward 1999). Lower rank, demi-angels in ?barrets (brim with crown-like indentations), tippets or wide collars over gowns with wide sleeves, ending in

nebuly; holding shields with **N2** tau cross, **N3** robe, **N4** spear, **N5** pincers and hammer, **N6** lantern, **N8** ladder; **S2** crown of thorns, **S3** dice, **S4** sponge and bucket, **S5** 3 nails, **S6** 2 scourges, **S8** pillar; Haward (1999) il p 147. Swaffham church-warden accounts record payment in 1516 for a "wyppe Corde for the Angell*es*," presumably part of the Corpus Christi procession; Galloway and Wasson 100; Lancashire no. 1429. At Yarmouth as late as 1540 Easter Sepulcher costs incl payment for "berying the whip," C Palmer, 118.

Trunch. wdcarv, hammerbeam angels. 1486 (ceiling new). Demi-angels on nebuly holding **N2** crown of thorns, **N3** mitre, **N4** crown; typical ceiling with no apparent pattern, though one may have been obscured by restoration in 1897 and 1976–84. On the S angels either fold hands or hold scrolls.

N Creake. wdcarv, hammerbeam angels (wings lost) in amiced albs holding instruments; paired N with S. c1490 (Compton, 206–7). **4** scourge with pillar and cord, **5** cross with crown of thorns, **6** pincers with hammer and 3 nails. Other figs holding altar furnishings, as well as papal tiara, mitre, and crown. The rector in the 1880's noted the wing loss (207).

Banningham. wdcarv, hammerbeam angels with shields. Late 15c. **N4** heart, **N5** crown of thorns, **N7** scourge; **S3** chalice with host, **S4** ?cord, **S6** open book; restored.

W Walton. wdcarv, hammerbeam angels with shields, 2 angels per bay. Late 15c (Wilson, P & W 2). **S2** heart, **S3** cross, **S4** sponge and spear saltire, **S5** nails, **S6** hammer, **S7** pincers, **S8** sword, **S9** club, **S10** scourges saltire, **S11** robe; **N4** ladder, **N5** coins, **N6** cross, **N9** crown of thorns, **N10** rod for tightening crown, **N11** clubs saltire, **N12** kiss of Judas.

Fincham. wdcarv, arch brace angels. 15c (?1488, C & C). Largely worn but at **N1** holding pincers and nails.

Carbrooke. wdcarv, frieze of rood screen. 15c. Arms: 3 nails, hammer with pincers, 2 scourges, ladder, robe, dice.

Emneth. wdcarv, arch braces, N4 & S4. 15c. Matching pair of feathered angels with pillar.

W Lynn. wdcarv, hammerbeam ceiling, demi-angels on nebuly. 15c. **N1** cross and crown, **S1** ladder and spear; the other angels paired N and S hold a variety of objects difficult to identify except for arms of Peter and Paul and perhaps pillar and scourges. There are 4 small angels and 2 large figs in the Lynn Museum believed to have come from the chancel roof.

Stody. wdcarv, wall posts, angels with hands joined in prayer and spread wings alternate with arms. 15c. Paired NE ?lily with SE pincers and hammer saltire; NW pillar and cord with SW scourge. Chancel: **N1** vessel for vinegar and/or gall, cock and robe; **N2** ladder spear and sponge; **S1** wounds and heart in center; **S2** 3 nails and crown of thorns.

Upwell. wdcarv, nave hammerbeam angels. 15c. **S1** angel with hands raised, **S2** spear, **S3** sponge and bucket, **S4** scourges, **S5** hammer and nails; **N1 & N2** duplicates of S1 & 2, **N3** sponge, **N4** pincers, **N5** crown of thorns. Nave restored 1836–8.

Swainsthorpe. wdcarv, angels with shields at base of principals. ?15c. Spear and sponge saltire, ?4 nails; wounded hands; wounded feet; DT 60:231; "roof to the nave has been so restored that I am doubtful if there is much old," Cautley. The day I visited lack of interior light made it very difficult to discern details.

Billingford S Peter. *wdcarv, a seat in the S aisle, NRO, Rye 17, 1:111.

Scoulton. *?wdcarv. "On the screens . . . in different shields, as the hammer, scourge, crown of thorns, spear and sponge, heart pierced, the nails, the five wounds, and the cross, and the name Jesus," Bl 2:345.

Wellingham. pwd, screen, S2. 1532. Surrounding the Image of Pity (see above), 17 instruments. Cross bar with bloody nail holes at either end; (R) sword, ladder, halberd, collecting shoe with coins (3 rows of 8), lantern with light inside, spear, scourges saltire, 3 nails with bloody ends. (L) hammer and pincers saltire, sponge, 3 dice, hand pouring water over hands held over bason held by 3rd pair of hands, cock on top of pillar with cord attached, awl; (above cross bar) head of Pilate and head of Herod flanking the head of Christ.

Outwell. wdcarv, wall posts, Lynn Ch. 16[1]. Angels holding shields with cross, crown of

thorns surrounding heart, spear and sponge saltire, 3 nails.

Norwich SPM. *pcl. 16¹. "ij° Curtens of Steyned Clothe white wᵗ Crowncs of Thorne and **Jhus** Wretyn in them in red and *salve* for lente / to hang in the Quere," Hope (1901) 216.

— *pcl. 16¹. "ij. baner cloithis paynted wᵗ droipis of rede And the passione of crist*es* armes & grene wrethis," Hope (1901) 222.

— *pcl. 16¹. White with red drops and silver spear heads, Hope (1901) 222.

Fonts

Unless stated otherwise, the reliefs are on the font bowls. 3 nails are the norm, one at each end of the cross bar, and one at foot level. Only variations are noted. On most of the fonts the Instruments are presented as arms—i.e., on a shield. The other faces of octagonal fonts typically bear the tetramorphic symbols (XI.1) or other arms, the most common of which are the Trinity and Eucharist, and less common those of the diocese, saints, or donors. All fonts are 15c except the first (14c) and last two (c1535 and 1544). Periods mark the division betw font panels.

Gt Dunham. Type 1 Crucifixion (frag, Virgin, base of cross). Cross with crown of thorns. Pillar flanked by ?scourges. Fourth panel ?; all badly damaged.

Acle. *Arma* 1 flanked by scourges, 3 nails in cross.

Aylsham. Crucifix. 2 scourges. Sponge and spear saltire with bucket. Pillar with cords; Tomlinson il p 200; Bond (1985) 250; Pevsner (1) thought the font "much retooled in 1852," but an earlier watercolor shows essentially what we see today, the corpus having been repaired. Bl cites essentially the same subjects.

Bale. *Arma* 1 with nails embedded in cross bar, flanked by money bag and scourge; "all severely recut," Pevsner 1.

Blakeney. Arma 1 flanked by (L) 3 nails, (R) ladder. Heart in radiance, flanked (above) by hands (below) by feet. Bill and ?spear saltire flanked by (L) sword with ear and (R) torch; pole for sponge standing in bucket. Pillar with cords, flanked by birches and scourges (worn). Drawings, Williamson (1961) pl III.

Bergh Apton. Damaged feathered angels, one holding crown of thorns, alternate with tetramorphic figs. Angels feathered, one wearing drape at waist.

Caistor S Edmund. *Arma* 1 with 2 nails, flanked by scourges.

Claxton. *Arma* 1, with 3 nails, flanked by scourges.

Cockthorpe. Cross bar with crown of thorns, flanked by (above) 3 nails, 3 dice; (below L) hammer and ladder and (R) spear, sponge, and pincers.

Crostwick. Figs on pedestal with pincers, pillar, tau cross, reed and sponge, 3 nails, scourge, torch, hammer; apostles on the bowl. Cautley thought "a fine 15c font," but Edwin Rose calls it a "19th century naive copy of perpendicular," probably made during the 1842 renovation (personal communication). Perhaps a copy of the replaced font.

Dickleburgh. *Arma* 1 with nails in cross bar, flanked by scourges. Instruments, as well as arms of saints, also in windows, Bl 1:197.

Downham Market. *Arma* 1 with 3 nails, drawing in NRO, Rye 17, 2:37v. Stem 1855. Though the bowl panel matches the 18c description, the angels holding apostolic arms look suspiciously modern.

Fakenham. *Arma* 1 with 3 nails, flanked by scourges, diagonal sword at foot of cross.

Framingham Earl. *Arma* 1 flanked by scourges (spear and sponge not saltire), 2 nails.

Field Dalling. *Arma* 1 with 2 nails in crossbar. Cross with crown above, 3 nails below; "drastically recut," P & W 1

Guestwick. (Above) cross bar (L) hammer and (R) 2 nails, (below L) scourge, sponge, (R) spear, ladder.

Hempnall. *Arma* 1, flanked by ?scourges.

Hindringham. Crucifix. Cross with central crown of thorns, 3 nails impaled; (above L) 3 dice; (flanking below) (L) birches saltire, scourge, spear; (R) sponge, pincers, ladder reaching above cross bar.

Kelling. Cross with crown of thorns; (above L) lantern and second object, (R) cock and ?broken sword; (flanking below L) hammer & pincers, 2 scourges; (R) ladder, pillar & cord, spear, sponge.

Lakenham. Crucifixion Type 1, cross flanked on adjacent panels by Virgin and John. 4th panel: (C) vertical spear, sponge, and pillar with twisted cord, massive pincers below; flanking (far L) and (far R) busts of tormentors, heads in pointed caps, reading from top to bottom (L) with crown of thorns; high priest; hand holding scourge;

(R) hand holding 3 nails; hand holding hammer; hand holding birch. Atypical font, originally at Knettishall, Cautley, *Suffolk Churches*. For prominence of hand see also Hockham and **FIG 14**.

Norwich S Peter Southgate. Demolished 1887. Cock on pillar. Crown of thorns, scourges, rods. Shield of 5 wounds. Shield of instruments of Passion, Bl 4:68.

Salthouse. Cross with nails above cross bar (one/two) (flanked below) by scourges (**FIG 15**). Spear and sponge saltire, crown of thorns above, base of pillar below, flanked by hammer and pincers.

Saxlingham Nethergate. Arma 1 with 2 nails, flanked below by scourges.

Shelton. *Arma* 1 with 3 nails embedded, flanked below by scourges.

Shimpling. 4 demi-angels in albs ending in nebuly holding instruments. Crown of thorns. Spear. Ladder. 4th angel with forearms raised, instruments missing.

Shotesham All Saints. *Arma* 1.

Surlingham. *Arma* 1, 2 nails in cross bar, flanked by scourges below.

Thornham. A rare example of painted shields. *Arma* 1. Scourges and birches at cardinal points.

Thorpe Abbots. Cross with 3 nails, ?originally with spear and sponge saltire; drawing in Tomlinson 229. Font plastered until 1840.

Trowse. *Arma* 1 flanked by scourges and birches.

Wheatacre. *Arma* 1, 2 nails in cross bar, flanked by scourges below; also cited in NRO, Rye 17, 4:103.

Wiggenhall S Peter. Church in ruins; instruments "on the font," NRO, Rye 17, 4:166.

Wighton. Cross (above crossbar L) 3 nails (R) 3 dice; (below L) hammer, ladder (R) sponge, spear, pincers.

Suffield. On chamfer. 1535 ("40s to reparation of the font," Cotton). Sword with ear of Malchus. ?Hammer. Cross. Heart. 3 nails. Crown of thorns.

Walsoken. Font base. 1544. Spear and sponge saltire. Cross with crown of thorns. Hammer and pincers. 3 nails. Club, ladder and sword. Robe and dice. Pillar, cord and 2 birches. 2 scourges; Nichols (1994) pl 2.

It is also possible that the instruments on recut Victorian fonts and new chancel roofs reproduce damaged medieval work.

i. Vernicle (Veronica)

The term is used both for the face of Christ imprinted on Veronica's veil (XII *Veronica*) and representations of that image (frontal view of head, neck and shoulders, typically with cruciform nimbus).

Cathedral Priory. ms, Psalter, Lambeth Palace 368, miniature 95v. c1270–80. Cruciform nimbus, head and neck only. Morgan, *Survey* pt. 2, Cat. 181, il no. 391. Morgan notes that this image tends to appear in Benedictine manuscripts.

Irstead. sc, font relief. 15c. Drooping moustache and beard, cross nimbed, against stylized nebuly background; Bond (1985) il 251; original copper-blue color on nimbus (DP in P & W 1).

Beeston Regis. paten. c1450. In sexfoil depression, head of Christ with cruciform nimbus, straight hair on shoulders, mantle fastened with cruciform morse, forked beard; Hope & Fallow (type D, "the boldest and best designed of the Vernicles," 157); L & M Cat. 82; Oman pl 35c; Manning (1895) il facing 92.

Lyng. paten. ?mid 15c. Short beard, curled hair; Hopper (1917) il facing 229.

Saham Toney. paten. c1480 (Oman). Bust, pointed beard, foliated cruciform nimbus; shoulders in loose garment; Hope & Fallow, (type D); Oman pl 35d; Manning (1895) il facing 96.

Suffield. paten. c1480. Face, circular nimbus (on separate inserted plate) Manning (1895) il facing 98; Hopper (1926) facing 327; on display at the Cathedral.

Costessey. paten. 1496–7. In sexfoil depression; curled lock in center of forehead; Hope & Fallow (type D); L & M Cat. 104.

Hanworth. paten. c1500. Foliated cruciform nimbus; Hope and Fallow (type D); Oman pl 35a; Manning (1895) il facing 96.

Happisburgh. paten. 1504–5. Bust, cruciform nimbus, beard slightly forked, shoulders in tunic; formerly enamelled; Hope & Fallow (type D), Manning (1895) il facing 92.

Hockham. paten. 1509–10. Cruciform rays; Hope & Fallow (type D); Manning (1895) il facing 96; on display at the Cathedral.

Gissing. paten. 1514. Cruciform nimbus, beard forked and curled; Hope & Fallow (type D); Manning (1895) il facing 95.

Banningham. paten. c1520. No beard, cruciform nimbus; Hope & Fallow (type D); Manning

(1895) il facing 92; on display at the Cathedral.

Brancaster. paten. c1520. Sexfoil depression in an ellipse, cruciform nimbus, long forked beard, shoulders in mantle; L & M Cat. 105; Manning (1895) il facing 92; on display at the Cathedral.

Beachamwell. paten. c1520. Bust, cruciform nimbus, shoulders and chest in tunic, forked beard; Hope & Fallow (type D); Manning (1895) il facing 92.

Caston. paten. c1520. Bust, pointed beard, cruciform nimbus, Hope & Fallow (type D); Manning (1895) il facing 94.

Colby. paten. c1520. Bust, cruciform nimbus, forked beard, mantle fastened with morse; Hope & Fallow (type D); Manning (1895) il facing 94.

Hockering. paten. c1520. Bust, cruciform nimbus, hair curled at ends, forked beard; Hope & Fallow (type D); Manning (1895) il facing 96.

Holkham. paten. c1520. Bust with long wavy hair, shoulders in tunic; Hope & Fallow (type D); Manning (1895) il facing 96.

Lessingham. paten. c1520. Bust, cruciform nimbus, hair curled at ends, forked beard; Hope & Fallow (type D); Manning (1898) il facing 233.

Narford. paten. c1520. Face, long hair, long forked beard. Hope & Fallow (type D); Manning (1898) il facing 233; Hopper (1929) facing 325.

Shernborne. paten. c1520. Bust, cruciform nimbus; straight hair, forked beard, shoulders in mantle fastened with cruciform morse; Hope & Fallow (type D); Manning (1895) il facing 98.

Thurgarton. paten. ?c1520. Cruciform nimbus, wavy hair, curled lock in center of forehead, center of beard curled in lock; Hope

& Fallow (type D); Manning (1895) il facing 98; Hopper (1926) facing 329.

N Tuddenham. paten. ?1520. Bust, cruciform nimbus, no beard; Hope & Fallow (type D); Manning (1895) il facing 98; on display at the Cathedral.

Wymondham. paten. c1520. Bust, cruciform nimbus, blunt forked beard; Hope & Fallow (type D); Manning (1895) il facing 98.

Oulton. paten. c1525. Cruciform nimbus, beard blunt, crowned with thorns; Hope & Fallow (type D, "unconventional"); Manning (1895) il facing 94.

Tittleshall. paten. c1525. Bust, cruciform nimbus, forked beard, shoulders bare; Hope & Fallow (type D); Manning (1895) il facing 98; Hopper (1929) facing 27.

Mundham. paten. c1530. Cruciform nimbus, hair twisted and curled, forked beard; Hope & Fallow (type D, "unusual design"); Manning (1895) il facing 96; Hopper (1929) facing 42.

Norwich SPM. paten. 16¹. Half the patens cited in the inventory were engraved with the vernicle, some with unusual details: "the vernecle hed wᵗ the holy gost cummyng ought of his mowith"; "a vernacle stondying in blew amell wᵗ sone bemys gilte"; Hope (1901) 206, 212.

— ?emb. 16¹. "A vernacle off [sic] made in lawnde & ye passion off Cryst wᵗ petyr & powle," Hope (1901) 218.

W Dereham. im. c1500. "John, Abbot . . . [to have] a Image of the salutacion of oure ladi wᵗ a vernakill," will of Helene Gawsell, Dashwood (1859) 285.

Saham Toney. communion cup. 1568. "Silver Cup, with our Saviours head engraved thereon," Bl 2:32; see above for medieval paten.

VII. LIFE OF CHRIST: RESURRECTION—PENTECOST

1. Individual Subjects

Isolated scenes may be evidence for a lost sequence; see also Section 2.

Harrowing of Hell

Christ holding cross-staff in one hand standing before hellmouth filled with souls, sometimes holding foremost by hand. The Harrowing of Hell is sequenced 2 different ways at the Cathedral: in the E cloister it culminates a short series of 5 Passion/Resurrection scenes; in the nave it appears in Bay L preceding the Resurrection sequence in Bay M. See *Resurrection Sequences* below.

Warham S Mary Magdalene? pg frag, nIV.2b *ex situ*. 15c. One hand (yellow stain) on staff, second hand holding white hand as if in lifting gesture; small scale, ?Flemish.

Sepulcher

Sheingorn cites a number of inventory entries for stained Easter Sepulcher cloths; the images can only be inferred. Her catalog (1987) includes the texts for the Cathedral *Depositio*, *Elevatio*, and *Visitatio* (249–50).

Thetford Priory 1. 12/13c. Relics of the rock of Calvary and sepulcher, Bl 2:118.

Resurrection

Christ, stepping from the tomb, holds a cross-staff with pennon sometimes bearing a red cross (cited as resurrection staff). The same staff is typically held by the Agnus Dei.

Cathedral Priory. seal, conventual. 1125–40, probably in use until 1258. Demi-fig of Christ above ecclesiastical building, scepter in RH, LH raised, palm out (not blessing gesture); *BM Cat. of Seals*, 2091–2; for identification, see Heslop (1996), 444–6, fig 162. c1260, 3 Marys at Easter Matins, Lancashire no. 1218.

Thetford. seal, Priory of the Holy Sepulchre. 13c. "Our Lord, with nimbus, rising from the sepulchre," blessing; "in the l.h. a long cross. . . . In the base, 2 sleeping soldiers; at the head of the sepulchre an angel"; *BM Cat. of Seals*, 4161; seal *ad causas*, 1457, "risen Saviour, standing, lifting up r.h. in benediction in the l.h. a long cross," *BM Cat. of Seals*, 4162. Both seals in Bl 2:98, though the common seal shows Christ flanked by censing angels, ?soldiers below.

Cathedral Priory. ms, psalter, Lambeth Palace MS 368, miniature, f 12. c1270–80. Betw censing angels; Morgan, *Survey* pt 2, Cat. 181.

Diocese. ms, Stowe Breviary, BL Stowe 12, hi, f 87. c1322–25.

Diocese. ms, missal, Bod L Hatton 1, hi, 100v. 14⁴. Crowned with thorns, stepping from tomb, displaying wounds; 3 sleeping soldiers, one observing scene. Pächt & Alexander 713, pl LXXII.

Diocese. ms, Wollaton Antiphonal, Nottingham U Library 250, hi, f 135. c1430. Stepping from tomb, displaying wounds; 3 soldiers; Scott, *Survey* Cat. 69, il no. 275.

Cathedral. pwd, retable, originally for high altar. 1382–3 (King [1996] 414). Despenser Retable. Christ, crowned with thorns, blue lined mantle draped over LS; stepping from diagonal tomb, resurrection staff in LH, RH raised to display wound; L knee and leg draped with garment, foot resting on recumbent sleeping soldier; second soldier awake; at the rear of tomb sleeping bearded soldier with halbert; *900 Years* color il p 48.

W Somerton. wp, N wall. 14c. Christ in green mantle over LS, stepping out of tomb, resurrection staff in LH, RH blessing; soldier's bill on ground (L'Estrange, 1872). Some details noted in Tristram (248) are no longer visible.

Seething. wp, N wall. Late 14c. Christ with resurrection staff stepping out of tomb; soldiers in foreground; scene flanked by angels. Joys sequence.

Dickleburgh. *wp, N wall. "I take to be Christ rising from his sepulchre," Bl 1:200; see also VI.1 *Carrying the Cross*; part of a lost sequence.

Norwich S Martin-at-Oak (Coslany). al frag. 1450–75. Corner of tomb and 2 soldiers sleeping, one with dagged sleeves; now NMS.

Ringstead. al frag. 15c. Sleeping soldier, now NMS.

?Paston. *im, gilt. 1464. "Savyowr, gilt, with His crosse, His diademe, and His fane," property of John Paston, Gairdner vol 4, no, 563.

Norwich S Leonard's Priory. *pcl. 1452–3. In-

ventory. "Item diversi panni pro sepulcro steyned cum hystoria Resurrectionis," Bensly (1895) 220.

Saxlingham Nethergate. pg, sIV.2a, not *in situ* (King 25). c1400. Flanked by soldiers, Christ stepping out of sepulcher, staff in LH, RH blessing; wounds displayed; mantle blowing behind; R foot on recumbent soldier, second soldier asleep at head of tomb, helmet of third just visible on far side. Description based on Winter watercolor, DT 60:33.

Besthorpe. pg, sV, not *in situ*. 15[1] (Dennis King notes). Nimbed, twisted 2-color crown of thorns, R shoulder bare, lock of hair falling over L shoulder, resurrection staff in LH, RH immediately above side wound; all 5 wounds visible. **FIG 19**.

E Harling. pg, E win, 1b. 1463–80 (King). Christ stepping out of diagonal tomb, radiance emanating from inside tomb; resurrection staff in LH, RH blessing; crown of thorns, robe parted to show lateral wound, blood design on arm from hand wound, sunburst wound on LF; 4 soldiers, one bareheaded; 3 with halberds, one with sword, detailed military costume. Joys/Passion sequence.

Martham. pg, nIV.2c. c1450. Christ stepping from tomb, resurrection staff in LH, RH blessing, crown of thorns made of twisted strands with thorns protruding; all wounds bleeding; 3 reclining soldiers, all with eyes open. Joys/Passion sequence.

Colkirk. pg frag in S chancel patchwork win. ?15c. Soldier in chain mail sleeping. Also two tiny ugly faces, perhaps from a Passion scene.

Poringland. pg, set in E win, light c. 15c. Resurrection staff in RH, LH raised, wounds displayed.

Keswick. *pg frag. ?15c. Soldier sleeping; head of Christ, sketch in G King Collection, Box 2, NNAS.

Ashwellthorpe. *pg, E win, 4b. No specification, win map in NRO, Rye 17, 1:20.

Dunston. *pg roundels, N win. "Our Saviours Resurrection & ascension painted," NRO, Rye 17, 2:53. ?Joys sequence.

Oxborough. *pg, E win. Lower panel, Bl 6:186.

Swannington. *pg, N East win, "our Sav[ior's] Resurrection and ascension," NRO, Rye 17, 3:240v. ?Joys sequence.

Norwich S Michael-at-Plea. pwd, retable panel. 1450–60 (King [1996] 415). Christ in long mantle, blessing, (L) 2 soldiers, one asleep, one in hooded garment over armor; directly below Christ, sleeping soldiers with halberd, hooded garment over armor, (R) soldier with halberd looking up at Christ. Morgan observed influence of N German models, L & M Cat. 56.

Stalham. *pwd, screen, 5 panels extant. Late 15c. 2-strand crown of thorns, green mantle fastened with morse; cross-staff held diagonally in LH; RH blessing, wound visible; lateral wound with blood depending, no foot wounds; DT 44:163. In the watercolor the Resurrection is paired with S Roche; it seems to have disappeared before 1949, for Cautley (246) knew of only five panels: "I understand that somewhere there are 5 painted panels, one of the rather rare S. Roche." The combination of the Resurrection with saints is unusual, but see Binham.

Binham. pwd, screen panel, dislocated, probably from the missing side of the screen. c1500. Crowned with thorns, RH raised in blessing; double cross-staff in LH, no sign of banner; vulneral wound and blood flowing down arm and leg. Overpainted with black letter 1Tim. 6:10–12. The S side is devoted to saints.

Norwich SPM. pwd, Flemish. c1520. In vestry, "a curious old board picture of our Saviour's resurrection, which is also represented on the tapestry," Bl 4:210. Flemish tapestries (1573) include appearance as gardener to Mary Magdalene and appearance to the Virgin within a house.

Hingham. *plate. 1464. Bequest of "a tablet of gold garnished with perle, containing certain relicks, with a beril in the same tablet, with two images, one of the resurrection, and the other of our Lady," Bl 2:430. Sheingorn queries use for the Easter Sepulcher services.

Attleborough. sc, boss, N porch. 15[2]. Eroded, heavily whitewashed. Christ rising from tomb; Joys sequence.

Wymondham. sc, boss, N porch. c1450. Eroded, heavily whitewashed; Joys sequence.

Denton. sc, boss, N porch. Mid 15c. Christ standing in tomb, mantle on shoulder, bare torso, no obvious wounds; flanked by soldiers in armor; Joys sequence.

Hethersett. sc, boss, S porch. 15c. Christ stepping from tomb; (L) 2 soldiers; badly eroded. Joys sequence.

Hemsby. sc, boss, S porch (W). 15c. Christ with resurrection staff stepping from grave, sleeping soldier; Joys sequence.

Norwich S Helen. sc, boss, S aisle chapel (4). c1480. Christ with resurrection staff, (L & R) soldier(s); Joys sequence; Rawcliffe, il on title page.

Blofield. sc, font bowl. 15¹. Christ stepping out of tomb, resurrection staff in RH; (L) 2 soldiers, one with pike; (R) soldier facing away from the tomb; Joys/Passion sequence.

Northwold. sc, Easter sepulcher, relief on tomb, N wall of chancel. Late 15c. 4 soldiers in armor separated by trees; niche for deposition of Host; Gardner fig 343; Sheingorn fig 46. According to Martin there was "another such in the Neighbouring church of . . ."; he did not complete the phrase; NRO, Rye 17, 3:95v.

E Raynham? sc. c1499. Will for monument before the im of the Virgin "cunningly graven a Sepulchre for Easter Day" (Sheingorn 245). There remain today 2 donor figs at prayer and one fig with cloak fixed with double morse and elaborate belt; 5 pedestals, 2 empty.

Salle. wdcarv, ridge of chancel roof. Mid 15c (15⁴ Cave). Christ, RH raised, lateral wound visible, stepping from tomb, RF on recumbent sleeping soldier; at rear flanked by (L) 2 soldiers, one observing and (R) opening visor and looking at Christ; Cave (1935) il betw 368 & 369. Joys/Passion sequence.

Narborough. brass. c1545. (Above) Christ stepping out of tomb, in loincloth and mantle fastened with morse; lateral wound with drops of blood, RH blessing, resurrection staff in LH; flanked by soldiers in armor with halberds and staves: (upper L) asleep, in hat with giant feather; (lower L) looking up and pointing to Christ; (upper R) looking at Christ; (lower R) asleep. (Below) Sir John Spelman (in coif and legal robes as Justice of the King's Bench) and wife with prayer scrolls: "Jesu fili Dei miserere mei," and "Salvator [Mundi] memento mei."

Shelton. pg, nII.2b. 16¹. Christ with resurrection staff in LH, RH raised, L foot on edge of sepulcher; soldier in armor in foreground looking up, hand to head; (above L) angel, (R) city; "done in England by, or under the strong infuence of, North European glass painters," King 27.

Norwich. seal, mayoralty. Resurrection replaced the Trinity; see above I.2.

Guilds at Burnham Ulph (Bl 7:32), Litcham (Puddy 49), Lynn (Owen 329), Rougham (Bl 10:36), S Creake (Bl 7:84). Honing (1492 Ch in churchyard, *Index Monasticus* 68).

Agnus Dei

Symbol of Resurrection: Agnus Dei, Lamb with head turned back over shoulder, standing or seated on book; resurrection standard set at diagonal angle; sometimes with text "Agnus Dei qui tollis peccata mundi."

Norwich. seal, Bp John de Gray (1200–14). Reverse, Agnus Dei with AGN*VS*:DEI:QVI: TOLLIS:PECCA*TA*:M; *BM Cat. of Seals*, 2019.

Norwich. ?Prior's seal, Friars Preachers of S John the Bapt. 14c. "Agnus Dei on plaque" in LH; *BM Cat. of Seals*, 3775; see also 3776.

Norwich, Hospital of S Christopher. seal. 14c. *Index Monasticus* 59.

Castle Acre. pg frag, not *in situ*, sIV.1c, ?14c. Standing, characteristic leg posture; no book.

Cathedral. wp, presbytery aisle, crown of vaulting. 14c. Standing, "black on a yellow ground," Tristram 229.

Norwich S Cuthbert. *wax tablet. 14³. A "paschal lamb," Watkin 1:26, II:xcix.

Lynn S James, Guild of SS Giles & Julian. *emb. Late 15c. Pillow with "Holy Lamb and Hart," Richards 433.

Holme Hale. pg, sV.B1, roundel. 15c. Standing, no book.

Cawston. pg frag, sX.2b. 15c. Matching nimbed lambs atop pedestals.

Gt Massingham. pg, tracery eye, sIII. c1450. Standing, one foot over cross-staff; radiance behind.

Norwich SPH. pg frag, nIV, tracery eye.

Plumstead S Michael. pg, E Win, quatrefoil set at head of light b, *ex situ*. 15c.

E Dereham. pwd, S chapel. Late 15c. Wainscot ceiling restored but cited in NRO, Rye 17, 2:17; *VCH* vol 2 frontispiece.

Merton. paten. ?14c design (Oman, 51); c1470 (Manning [1895] 89). Standing, no book; Manning il facing 89.

Cley. sc, relief, S porch. 15[1].

Irstead. sc, font relief. 15c. Lamb charged on circular disk, no book; stylized nebuly above; see V.5.

Hulme, S Benet's Abbey? *sc, in roundel on abbatial tomb slab. 15[4]. See XI.1.

Kelling. sc, font bowl, shield font. 15c.

Barney. sc, font bowl. 15c. With cross and sealed book (Apocalypse, see Oman, 51); S John Bapt chapel in S transept new in 1496 (C & C).

Sporle. seal, Alien Benedictine Priory of S Mary. Late 15c. Agnus Dei with pennon charged with cross; *BM Cat.of Seals*, 4070.

Norwich. tile, found on site of Shire Hall, 1905. ?15c. Now NMS.

Swainsthorpe. *wp, DT 60:228.

Saxthorpe. wdcarv, be. 15c. Traces of red on book cover and pennon (with cross), clasp gold; Cautley thought the color original.

Mattishall. wdcarv, boss N aisle. Mid 15c.

Trimingham. wdcarv, screen spandrel above S1. c1500. Paired with fire-breathing dragon.

Provenance uncertain. wdcarv, aumbry door. 15c. No book. NMS.

Norwich SPM. *emb chasuble. 16[1], "an awbe w[t] blew cheessabelle garnishid w[t] crownes of gold & a lambe uppon a boke of gold & it s'vyth to bere the oile and cr*is*me at ester," Hope (1901) 204.

— *?pcl 16[1]. "2 litell cloithes w[t] lambes & frengid with thred for shreyene on pame sonday," Hope (1901) 217.

— *paten. 16[1], "in the midd*es* a lambe beryng a crose w[t] a pendant," Hope (1901) 211.

— *wax tablet ?pax. 16[1], "a round Agnus Dey w[t] holy waxe . w[t] ij birdd*es* in blew amiel in the mydes," Hope (1901) 206.

Noli Me Tangere

Pentney. seal, Austin Canons' Priory of the Trinity, S Mary, and S Mary Magdalene. 13c. Christ "with cruciform nimbus and long cross, lifting up the right hand before S Mary Magdalene who is kneeling before him, with hands lifted up in adoration. Over her . . . : NOLI.ME.TANGERE. Betw. the figures a tree; over our Lord's head a crescent moon; on the l. an estoile"; *BM Cat. of Seals*, 3820.

Drayton. *wp, E end N side. Christ crowned with thorns, mantle draped on bare chest, holding tau cross in LH; Magdalene demi-

kneeling, jar in RH; DT 54:215-16.

Incredulity of Thomas

Burnham Market. sc, relief, tower. 15[ex]. N3 Christ with resurrection staff in LH, holding vulneral wound with RH; N4 Thomas facing Christ.

Wighton. *wp, ?15c. Christ, resurrection staff in LH, brown mantle secured at neck, wounds in feet, holding RH of Thomas in his RH, placing 2 fingers into the lateral wound, drops of blood flowing; Thomas kneeling, LH outstretched; water color, F. Sandys, 1838, NMS 122.B91.235.951.

Denver. *wp, NMS 76.94.

2. Resurrection Sequences

Diocese. ms, hours, NMS 158.926.4f, hi. c1310–20. Ff 58 (Terce) Resurrection; 61 (Sext) Harrowing of Hell: Christ, Adam and Eve foremost of souls in hellmouth framed in building; 63v (None) Ascension; 70v (Compline) Death of Virgin.

Lt Witchingham. wp. c1360 (DP) N wall. Harrowing of Hell Christ holding resurrection staff facing figs at R within hellmouth; **FIG 16**. *Noli me Tangere* (faint) Magdalene; Christ. Incredulity, Thomas holding ?book in LH; Christ with resurrection staff, placing hand in lateral wound.

Cathedral. sc, E cloister bosses. 1327–29. B5 Resurrection: Christ flanked by angels, 3 soldiers, 2 asleep; (below) 2 wildmen. A5 Harrowing of Hell: Christ, wounds displayed, holding hand of Adam; Eve and 3 others; Satan below pierced by cross-staff, hands bound by chain. A5 also links with the contiguous central boss of the N walk (Sealing of the Tomb).

— sc, N cloister bosses. 1427–28. A5 Sealing of the Tomb: (C) tomb with lock, lid decorated with cross fleury, flanked (L) by officials in ¾ length gowns, low belts and misericords, 2 in chaperons, foremost in hat, holding staff; guard in armor, and ?workmen; (R) men in doctors' robes, incl foremost with bag in LH, behind him, doctor sealing tomb with [ring] on RH, gloves in LH; **FIG 17**. For color il, see Rose (1997, p 25), who identifies the figs on the basis of the N-Town play. A2 *Visitatio*: Angel lifting lid of tomb; 3 Marys ap-

proach; 4 soldiers with weapons, one resting head on hand (not visible in **FIG 18**); Finch (484) notes the archaic style of tomb. **A8** *Noli me Tangere*: Mary; Christ in long gown with spade (damaged) and pruning knife hanging from girdle; **B1** Christ in resurrection garment, revealing lateral wound, Mary kneeling at Christ's feet, attempting to wipe wounded feet with hair. **B2** Incredulity: Thomas kneeling, Christ guiding his hand to lateral wound; Rose (1997) 32. **B8** Emmaus: Christ flanked by two disciples; **B5** (2-register scene) (L) outside building Christ in long gown and baldric with 2 men; (R) inside, before ringed curtain, Christ seated breaking bread with 2 disciples; (above on building parapet) angels. **C1** Christ Appears to the 11: Christ in resurrection garment, seated at dressed table with apostles on each side, incl John and Virgin. Next 3 bays have Ascension, Pentecost, and Coronation.

— sc, nave bosses. 15³. **Bay L 12** *Noli me Tangere*: Mary kneeling, hands joined, Christ partially turned from her, holding resurrection staff, pennon with white cross on red ground. **13** 2 women, each with hands joined, against garden background. **14** Mary Magdalene holding jar, name on scroll. **18** Harrowing of Hell: Christ holding Adam by hand, 7 other figs. **Bay M 1** Resurrection: soldier with spear guarding tomb, flanked by 2 armed soldiers in bosses **2 &3**; **4** Christ stepping from tomb with resurrection staff, flanked by 2 soldiers, one sleeping, *900 Years* color il p 41. (For the play at Norwich, see Lancashire no. 1227.) **5** Incredulity: Thomas kneeling, hand held by Christ with resurrection staff. **6** ?Appearance to Virgin: Christ and woman with hands extended.

3. Ascension

In the upper register Christ ascending into a nebuly or cloud, sometimes with radiance, feet or lower gown visible; apostles and Virgin below. Only variations cited.

?Cathedral Priory. ms, Gregory the Great, *Moralia in Job*, CB Emmanuel College 112, hi, Book 23. c1310–20. Robin in border; James (1904).

Diocese. ms, missal, Bod L Hatton 1, hi, f 111v. 14⁴.

Cathedral. pwd, retable, originally for high altar. 1382–3 (King [1996] 414). Despenser Retable. (C) Virgin and John kneeling, facing each other, surrounded by 11 apostles; above in a golden mandorla, Christ ascending. The upper segment of the painting is lost. See VI.2 for reproductions.

Seething. wp, N wall. Late 14c. Apostles with hands lifted, gazing up. Joys sequence.

Diocese. ms, Wollaton Antiphonal, Nottingham U Library 250, hi, f 155. c1430.

Ranworth. ms, Ranworth Antiphonal, S Helen's Church, hi f 98. 1460–80. Virgin and 12 apostles, 2 tonsured; footprints on rock.

E Harling. pg, E win, 1c. 1463–80 (King). (C above) Feet with sunburst wounds, surrounded with rays; flanked by angels in nebuly; footprints with nail marks on saffron field; (C below) Virgin both hands raised looking up; flanked by apostles, John immediately to Virgin's L, in pure profile looking at Virgin; above "Asensio ih*esu*s," Wdf pl XV; Cowen color il 33. Joys/Passion sequence.

Martham. pg, nIV.2a. c1450. 12 figures looking up to ascending feet; in an 1851 drawing Virgin at L; DT 56:149. Joys/Passion sequence.

Saxlingham Nethergate. pg, E win, A5. 1390–1413 (King). Virgin and 5 apostles with hands lifted, looking up; traces of uplfited heads behind Virgin; DT 60:22. Joys sequence.

Dunston. *pg, see VII.1 *Resurrection*.

Swannington. *pg, see VII.1 *Resurrection*.

Cathedral. sc, N cloister boss, C5. 1427–8. Christ ascending from mountain flanked by Virgin and apostles; footprints on top of mountain. Resurrection-Pentecost sequence.

Blofield. sc, font bowl. 15¹. (C) double nebuly with gown below, area below filed smooth; flanked by 6 figs, foremost kneeling. Joys/Passion sequence.

Attleborough. sc, boss, N porch. 15². Worn, heavily whitewashed. (C) group of figs with hands joined in prayer; clouds above and remains of ascending fig. Joys sequence.

Wymondham. sc, boss, N porch. c1450. Heavily whitewashed and worn. (C) ?Virgin with figs L and R; remains of garment above; Joys sequence.

Denton. sc, boss, N porch. Mid 15c. Multiple

nebuly; Virgin and apostles kneeling below in 2 ranks, each of them with hands joined; Joys sequence. 1850 line drawing shows 11 apostles (drawing, Ingleby, 57).

Hethersett. sc, boss, S porch. 15c. Feet visible below nebuly; Virgin flanked by apostles; badly eroded. Joys sequence.

Hemsby. sc, boss, S porch. 15c. (C) Christ with hands joined, nebuly across waist; figs L and R. Joys sequence.

Cathedral. sc, nave bosses, Bay M. 15³. **10** Feet rising above rock; **7, 8, 9, 13, & 14** 12 apostles arranged severally, kneeling in prayer, observing; **11 & 12** angel in golden suit (?feathers) observing.

Norwich S Helen. sc, boss, S aisle chapel (6). c1480. Joys sequence; Rawcliffe fig 41.

Brisley. *wp, over S door; Keyser.

Salle. wdcarv, ridge of chancel roof. Mid 15c (15⁴ Cave). (C) Virgin flanked by apostles, all looking up; Cave (1935) il betw 368 & 369; Joys/Passion sequence.

Norwich SPM. *emb cope hood. 16¹, "thassencion," Hope (1901), 199.

— *pcl. 16¹, "for sent Nycholas aulter . . . wᵗ thadscension in the mydd*es*," Hope (1901) 218.

Loddon. pwd, screen, S7. 16¹. (Above) mountain; (L) 6 figs; (C) headless Virgin in white; (R) 6 apostles looking up or with uplifted hands. Joys sequence.

Upwell. *pwd, screen. Bl 7:466.

Guilds at Lynn (Owen 325); Norwich S Mary-in-the-Fields (1350 Westlake no. 398); Swaffham (1341–1547, Farnhill), Yarmouth (Morant 224).

4. Pentecost

Virgin flanked by apostles; dove of the Holy Spirit descending.

Diocese. ms, missal, Bod L Hatton 1, hi, f 114v.

14⁴. Rays emanating from mouth of the dove of Holy Spirit to Virgin and apostles below; footprints of Ascension visible on rock.

— ms, Wollaton Antiphonal, Nottingham U Library 250, hi, f 160v. c1430. Scott *Survey* Cat. 69, il no. 278.

Ranworth. ms, Ranworth Antiphonal, S Helen's Church, hi, f 101. 1460–80. Dove in radiance.

Saxlingham Nethergate. pg, E win, A2. 1390–1413 (King). (C) Dove and radiance; (below) Virgin and apostles but Winter depicted the central fig with a male head, and rear head (R) in veil (DT 60:23). Joys sequence.

E Harling. pg, E win, 1d. 1463–80 (King). Dove with radiance descending from red nebuly; semicircle of tongues of fire. Joys/Passion sequence.

Garveston? *pg, E win S aisle. "Group of 10 or 11 persons kneeling surrounded with a Glory," NRO, Rye 17, 2:138.

Cathedral. sc, N cloister boss, D5. 1427–8. (C) Virgin (headless) flanked by apostles; nebuly above with dove descending.

— sc, nave bosses, Bay M. 15³. **18** Against radiance massive dove descending directly above head of Virgin (C), flanked by 3 apostles, incl Peter & John; **16 & 17** 2 apostles kneeling in prayer. **15** Virgin kneeling before inscr book on desk. It is difficult to tell whether this boss should be linked to the Ascension or Pentecost; perhaps it is one of the typical linking scenes. For the play at Norwich, see Lancashire no. 1227.

Upwell. *pwd, screen, Bl 7:466.

VIII. CONCLUSION OF THE LIFE OF THE VIRGIN AND DEVOTIONAL IMAGES

1. Individual Subjects

Dormition

See also VIII.2.

Diocese. ms, hours, NMS 158.926.4f, hi, f 70v. 1310–20. Apostles laying out body in tomb; (above) Virgin lifted in cloth by angels into nebuly, *manus dei* above.

Thetford Priory 2. pwd, retable. c1335. 6 apostles seated on the floor beside the deathbed; (C) Christ standing, RA extended to Virgin, LA holding her soul; (far R) 6 demi-fig apostles; scenes flanked above with 2 angels; ClunyM; *Age of Chivalry* Cat. 564, fig 131.

Lynn. ivory tablet, probably French. c1400. Virgin in bed, Christ standing (C) with soul, flanked by apostles with open books. Said to have been found at S Nicholas, Lynn. My notes date from a visit to the Lynn museum 12 years ago; presently the tablet is untraceable. The ivory exemplifies the importance of Lynn as a center of continental imports.

Hoe. *pg, N win, "the Virgin Mary dead & several mourners about her," NRO, Rye 17, 2:259v.

Cathedral. sc, N cloister boss. 1427–8. Virgin, in wimple, lying in bed; John with palm kneeling at bedside; (above) angels with her soul in a cloth.

Burgh S Peter. *wp, S wall of nave. Keyser.

Assumption

Virgin in mandorla or radiance borne aloft by angels, typically 2 on each side. David King (33) conjectures that the Assumption may have been the subject in a number of main lights where there is evidence of the Coronation in the tracery. The general destruction of main lights accounts for the rarity of this subject in contrast to the Coronation. In a few instances the crown is suspended above the Virgin, creating a composite Assumption/Coronation.

Thetford Priory 1. 12/13c. Relics of the girdle and sepulcher of the Virgin, Bl 2:118.

Gt Walsingham All Saints. *pcl. 14[3], "j de panno lineo cum ymagine Beate Marie de Assumpcione diversis coloribus depicta et in parte deaurata," Watkin 1:92. See also *Coronation*.

Diocese. ms, missal, Bod L Hatton 1, hi, f 169. 14[4]. Virgin in cloud mandorla, 4 angels.

S Acre. *pg nIII.N3. c1383. Assumption Ch, with donors, Bl 6:78. See also *Coronation* in the same chapel.

Thurgarton. al frags. 15c. 2 angels at side of mandorla, Thomas kneeling with Virgin's girdle; frag. of Virgin; NMS.

Gt Bircham. emb cope, converted to altar fontal. c1480. In radiance Virgin wearing ermine-trimmed sideless surcoat, surrounded by 5 demi-angels on nebuly; dove resting on crown above; L & M, Cat. 100; NMS. See also I.4.b.

Norwich S James. emb cope. c1480. Virgin in radiance flanked by angels, all unpicked but vivid color against faded fabric. NMS. See also I.4.b.

Hingham. *im and ch, Bl 2:423.

Norwich S Gregory. *im, W end chapel. Dedicated to Assumption "in which was her altar and image with a light always burning before it; and Jesus mass . . . celebrated," Bl 4:273.

Diocese. ms, Helmingham Breviary, NMS 1993.196, f 119v. c1420. Virgin against radiance within nebuly, supported by 2 angels. (Below L) bust of cleric in blue tippet and hood with inscr scroll "Mater divina sis Roberto medicina."

— ms, Wollaton Antiphonal, Nottingham U Library 250, hi, f 369. c1430.

Ranworth. ms, Ranworth Antiphonal, S Helen's Church, hi, f 251v. 1460–80. 4 angels lifting Virgin, trace of radiance behind.

?Norfolk. pcl, oil and tempera on linen. ?1465–70. 2 scenes: Assumption/Coronation Virgin crowned, hands joined, flanked by 2 supporting angels. Christ in voluminous garments, LH relaxed, RH blessing; flanked by angels, Denys Sutton pls 7–8. Joys sequence. Sutton classifies Christ as a Majesty (pl 7), but the 2 scenes are similar in design and perhaps should be treated as a unit.

W Dereham Priory. *ms. (Middle of 3 registers) Virgin in mandorla, surrounded by angels; DT 28:191–2. Priory dedicated to the Assumption.

Lynn? pilgrim badge. 15c. Against radiance, ¾ Virgin in girdled gown standing on crescent moon within radiance; Spencer (1980 Cat. 55) conjectures connection with the feast of the Assumption at Walsingham. (The Virgin on a crescent also figured in badges for Our Lady of Eton, Spencer [1998] Cat. 154 a & b.) Spencer also connects buckle ends with the aprocryphal story of Thomas ([1980] Cat. 60–5 and [1998] Cat. 154d).

E Harling. pg, E win, 2e. 1463–80 (King). Virgin in radiant mandorla held by 4 demi-angels in nebuly; crown suspended over head; Gibson fig 6.21. Joys/Passion sequence.

Norwich SPH. pg, nV, head of light c. 15c. Demi-angel holding text "[M]aria *in* celu*m*" and "ang[eli]" [Assumpta est Maria in caelum, gaudent angeli laudantes benedicunt Dominum], antiphon for feast; Wdf 139. See also section 4, below.

Norwich Guildhall. pg frag, sII. 15c. Nimbed head, angels flanking hair; additional angel frags in this win. Frag of lower gown against radiance in nII.

Norwich S Laurence. pg frag, nII, head of patchwork light b. 15c. Small angel with arm raised against radiance. Bl cited an im and tabernacle (4:263).

Buxton. *pg E win, N chantry ch (dedicated to Assumption). 15c. "In middle pane of the east window the Assumption of the Virgin with many praying to her, saying, 'Virgo singularis inter omnes mitis, nos Culpis solutis, mites Fac et custos'; another with, 'Sancta Regina Celorum'; another with, 'Gloria Patri et Filio et Spiritui Sancto'," Bl 6:447. Perhaps an Assumption/Coronation scene with the Trinity. Joys sequence.

Norwich SS Simon & Jude. *pwd, screen. 15c. Bl 4:356.

Langley Abbey. seal, Premonstratensian Abbey of S Mary. Abbot's seal. 15c. "Virgin in pointed oval vesica of clouds, upheld by 2 angels," *BM Cat. of Seals*, 3403; Erwood, fig 3.2.

Castle Acre Priory. seal (second), Cluniac Priory of S Mary. 1446. "Virgin, full-length, in radiance, enclosed within a vesica-shaped cloud, upheld by 4 angels"; *BM Cat. of Seals*, 2886.

Cley. sc, central boss, S porch. 15¹. Standing in radiance; badly worn.

Cathedral. sc, bosses, Bauchun Chapel. c1470. **12** Crowned against radiance; **1, 16, 32, 34, 40** angel busts with scrolls inscr "Gaudent angeli" (antiphon for the Assumption); **8, 9, 15** angel busts in various attitudes of prayer; see also *Coronation* and Appendix I.3.

Gt Witchingham. sc, font relief, polychromed. 15⁴. Virgin in red gown, hands folded, standing against gold-rayed green mandorla held by 2 demi-angels above; (below) 2 kneeling figs in prayer (?donors). 8th scene of a 7-Sacrament font.

Bridgham. sc, font relief. 15c. Virgin, probably with hands joined, in 3-dimensional nebuly (inner face painted red) held by 4 angels. Surface worn.

Hemsby. sc, boss, S porch. 15c. Virgin against rayed backgound. At the apex of entry arch (?predating porch) a ?Majesty, with hands raised, flanked by angels and donors. Joys sequence.

Walpole S Peter. sc, boss, S porch. c1435. (Above) head of deity, both hands raised; Virgin crowned in rayed mandorla held by 3 angels, 2 (R), 1 (upper L); (below) Thomas with girdle.

Brisley. *wp, "faintly an Assumption," *Ecclesiologist's Guide to the Deaneries of Brisley*, 21.

Norwich S Mary Coslany. wdcarv, nave boss. 15³. Virgin in nebuly surround against radiance; angels at intersection of purlins.

Long Stratton. *im. 1522. Bequest to make new tabernacle in honor of the Assumption (John Kryson, Alblaster 21, Cotton personal communication).

Norwich SPM. *pcl. 16¹, "a baner cloith paynted of thassumpcion of o͏ʳ lady no gold in it fregid w͏ᵗ thred wight rede & gren," Hope (1901) 221.

Thetford Priory 1. *pcl. 1537/8. "pro xvj yardes of holond pro le tabernakyl Assumpcionis Sancte Marie 8s.," Dymond 2:591.

Gt Witchingham. *pcl. 1558. Inventory, "a stayned cloth before the altar painted of the assumption of our Lady, also painted cloths to hang before other saints," Bl 8:310.

Church dedications at Attleborough, W Barsham, E Bradenham (NCC Surflete 148), S Creake (NCC Aleyn 74), Gillingham (NCC Popy 287), Gressenhall (NCC Doke 159, Gloys 250), *Hautbois, Marlingford, Redenhall, Saxlingham Thorpe (NCC Paynot 64) [will cita-

tions, Cotton, personal communication]. Ch dedications also provide evidence for, e.g., at Norwich S James, as are bequests for lights, e.g., at Norwich S Laurence (Waterton 111–2).

Guilds at Attleborough (Bl 1:523), Bacton (Bl 11:21), Deopham (Assumption Ch, E end of S aisle Bl 2:494), Haddiscoe (Farnhill), Marlingford (Bl 2:457), Salle (Farnhill), Shipdham (Bl 10:248), Stoke Ferry & Stradsett (Farnhill), Walsoken (Bl 10:128), W Lynn, Wheatacre & Wiggenhall (Farnhill).

Coronation of the Virgin

Virgin and Christ are seated on bench/chair with elaborate arms (cited as throne). Unless stated otherwise the Virgin is at Christ's right, with his RH blessing. Christ's LH commonly holds a tau orb, sometimes with a rising cross. A frag of an orb alone, however, does not document a Coronation, for it also appears at the foot of the cross in the Crucifix Trinity or may be held by a Christ in a judgment scene. A minor variant includes the Father and/or Holy Ghost. The model found on the Walsingham ampulla and common in 14c MSS and in the Elsing brass, in which the Virgin is being actually crowned, was not common in Norfolk. Instead the seated Virgin is already crowned.

Walsingham. pilgrim ampullae. 13^{1-2}; c1270. Inscr ampullae in shape of church; Virgin inclined toward Christ, both seated on a bench, Son placing crown on Virgin's head; reverse, Virgin and Child; Spencer (1998) Cat. 152–52a; *Age of Chivalry* Cat. 71. Spencer suggests that the inscr (*Ecce Sua Dextra Matrem Devs Ipse Coronat*, "Behold God himself crowns his mother with his right hand") draws attention to the relatively new Coronation iconography.

Horsham S Faith Priory. chapter seal, Benedictine Abbey of S Mary. 1301. Reverse, Virgin and Christ seated on wide bench under matching trefoil arches, both crowned; Christ resting LH against breast, RH touching crown on Virgin's head; far (R) head of monk; reverse, S Faith; *BM Cat. of Seals* 3292–3; Pedrick (1902) 90–1, pl 18, seal 36.

Cathedral Priory. ms, Ormesby Psalter, Bod L Douce 366, f 9v. 14^1. At the head of a Jesse Tree composition; Christ crowning, Virgin's hands joined; Sandler, *Survey* Cat. 43, il no. 96.

Diocese. ms, hours, NMS 158.926.4f, hi, f 76 Penitential Psalms). c1310–20. Virgin and the Son seated on wide bench; Virgin with her hands joined; Christ crowning her with RH, holding orb in LH; Sandler, *Survey*

Cat. 47, il no. 111.

?Thetford Priory 1. ms, Cluniac Psalter, Yale, Beinecke 417, f 64v (Ps 80). c1320–30. Virgin and Christ seated, his hand on crown; Sandler, *Survey* Cat. 108, il no. 281.

Elsing. brass of Sir Hugh Hastings. c1347. Virgin and Christ seated on identical elaborate high-backed thrones; (far L) angel censing, (L) Virgin in profile, her hands joined, angel descending, placing crown on her head; (R) Christ crowned, LH on lap, RH blessing; (far R) indent for matching angel with thurible; Manning (1864a) il betw 202 & 203; Binski (1985) 4; *Age of Chivary* Cat. 678. Badham draws attention to resurrection symbolism evoked by the image. See also XIV.1.

— pg, sII.4a. Mid 14c. Virgin enthroned on cushion, alien head; originally in tracery of E win. Joys sequence.

Gt Walsingham. pg, nII. c1340. **B1** nebuly above; Virgin, crown over veil, ¾ profile, with hands joined and extended; **B2** nebuly above, Christ crowned, frontal pose, clasped book in LH, RH blessing. Quatrefoil above, centered betw 1 & 2, frag God the Father, lower part of bearded face and upper gown.

Pulham S Mary. pg, nV (discounting vestry windows). Early 14c (P & W 2). **A1** censing angel; **A2** frag of blue gown; **A3** Christ crowned, seated on cushioned bench, LH resting on orb on knee, RH blessing; **A4** censing angel. Originally situated below the Trinity in the E win, "J. C. and Virgin and players [?musicians] on each side," NRO, Rye 123, p 34.

S Acre. pg, nIII. c1383. **A1** angel censing; ***A2** leading suggests that Virgin sat inclined towards Christ; **A3** Christ seated on bench, bare feet; RH blesssing, LH holding orb on lap; orb marked with waters; ***A4** censing angel in L eyelet.

Swardeston. pg, sIII, eye of 2-light win. 14c. Virgin crowned, hands joined, facing Christ; Christ blessing; bare torso and feet, may be displaying wounds (glass very dirty).

Blakeney? pg frag, quatrefoil, nVII.C1 and 3 ?14c. 3 tiny angels above a crown. The shape is restrictive, but perhaps the missing figs in the bottom lobes represented Virgin and Christ; cf Gt Walsingham.

Wilton. pg, sIII.A1. 14c. Crowned Virgin, facing R, hands extended in prayer.

Wicklewood. pg, nIII.2c, not *in situ*. 14c. Christ crowned, seated on bench, RH blessing, LH with tau orb surmounted by cross.

Saxlingham Nethergate. pg, E Win. 1390–1413. A3 Christ crowned, seated against ruby cloth of honor, LH resting on orb on lap, RH blessing; A4 Virgin crowned, turned toward Christ, folded hands raised; *deity in eye of tracery above, DT 60:19-21. Joys sequence.

Diss? pg frag, sX.5b, not *in situ*. 14c. Torso with frontal modeling, white mantle over gold gown, RH blessing, tau orb held on lap with LH.

Gt Walsingham All Saints. *pcl. 14³. White silk "depicta et deaurata corona auri," Watkin 1:92.

N Elmham. sc, boss, center W porch. Late 14c. Virgin and Christ (both decapitated) seated on same bench, radiance behind; Virgin with hands joined; Christ, orb on L knee, RA raised for blessing.

Seething. wp, N wall. Late 14c. Virgin and Christ seated on bench; Virgin with hands joined; (L) traces of dove above; Christ, ?crowned, orb in LH, placing crown on Virgin's head; Bardswell (1926) il facing 339. Joys sequence.

E Rudham. al. 15c. (Upper L and R) demi-angel with scroll; Virgin and Christ seated on one bench, on separate cushions; Virgin, hands folded over breast, mantle fastened with double morse, turned towards Christ; (C above) demi-angel with open book; Christ (head and RH missing) with mantle draped over his LS and R lap, LH on orb. Cheetham notes "at least eleven recorded examples" of this seating arrangement (Cat. 135) though he does not cite E Rudham. In none of the V & A alabasters are the Virgin's hands in this position, and in only two (Cat. 143 & 144) are there angels, in each case with musicians beneath the scene.

— al frag. 15c. Lower body of Virgin; Christ in voluminous mantle, LH resting on orb on bench (head and RA missing). It is unlikely there would have been 2 Coronation scenes in the presumed altarpiece (see IV.2 *Annunciation*). Perhaps the larger of the two scenes was a separate devotional image.

Litcham? pg frag, nV. c1412. Twin tracery eyelets with angels, 3 looking up and one down; King (33) suggested there may have been an Assumption in the main light below, and a Coronation in the tracery.

Salle. pg frag, nVI.A3 & 4. c1420–30 (King [1979] 333). Formerly traces of crown over Virgin; now restored as Annunciation.

— pg, sVI. c1444. B2 Crowned Virgin enthroned, hands crossed at breast, inclining towards next light. B3 frag fig, crowned, enthroned, RH blessing.

— pg, sVI.B1. Seated fig, alien in Annunciation frag.

W Rudham. pg frags, nIV. 1420–40 (King). A3 Composite fig, crowned white-bearded deity, ¾ profile, ermine collar over red gown, RH holding cross orb, supported by LH; A4 Virgin crowned, ¾ profile facing left, RH raised, LH on breast, eyes downcast.

Colby. pg, E win, tracery frag set in 1b. 15¹⁻². Christ, ¾ profile, crowned, facing L; RH raised in benediction, LH missing; damask gown; cross orb with resurrection staff.

E Harling. pg, see above *Assumption*.

Stody. pg, nV. c1440–50 (King, personal communication). A4 Virgin crowned, throne decorated with her monogram; demiprofile, both hands extended, palms out; A5 frag, Christ, throne decorated with monogram, orb with very tall double-cross-staff.

W Tofts. pg. 1450–60. Christ crowned; RH raised in 3-finger benediction; tau orb with tall cross fleury with pennon; orb with tripartite division, hand obscuring third segment; now NMS. L'Estrange (1874) cites a bell inscr "VIRGO CORONATA DUC NOS AD REGNA BEATA."

Norwich S Michael-at-Plea. pg, E win, A2. 1460–80. Virgin crowned, arms crossed at breast with head inclined to her L; ermine collar; Wdf (1938b) il facing 174.

Ketteringham. pg, E win tracery. 15³⁻⁴. On simple bench, each fig in white robe with gold trim; C1 Virgin crowned, hands joined, ¾ profile, facing Christ; C2 Christ RH raised, LH holding orb on knee; B1 & 4, angels with harp/stringed instrument.

Stratton Strawless. pg, nIII. 1445–55. A3 Virgin crowned, damask gown (good sleeve detail) and mantle, RH outstretched toward Christ, LH on breast; A4 Christ blessing, tau orb

on L knee supported by LH, cross rising with pennon; orb with tripartite division.

Norwich SPM. pg frag E win G4. Mid 15c. Deity with tau orb.

— pg E win. Mid 15c. **7b** Virgin; **7f** Deity; both enthroned with aurole behind; see also Appendix I.3.

Bawburgh. pg, nIV, lights a & c. 15⁴. Crowned king, luxurious beard; crowned queen; both heads large; perhaps "from a large Coronation of the Virgin," King 19.

Denton. pg roundel, E win, 4e (6" diameter, Ingleby, 65). 15². Virgin, nimbed and crowned, long hair over shoulders, enthroned, facing R; hands joined and raised; ermine collar, white mantle over yellow gown. E win arranged by Joshua Price (1716–9) with fragments of glass originally elsewhere in the church (King 26). Rearranged 19c.

Norwich SPH. pg, W win. 1450–60 (King; 1431 bequest for tower, C & C). **A3** Virgin crowned, head inclined towards Christ; **A4** frag, Christ blessing, LH holding orb with tall cross and pennon (frag of censing angel above); scene flanked by feathered angel musicians, **A2** in tippet, playing bagpipe; **A5** wearing knight's belt, playing fiddle; Remnant (1986) pl 125.

N Tuddenham. pg, sIV.A2. 15c. Christ in white gown and blue mantle, in RH orb (sea and clouds) with tall double cross; LH extended and raised; Wdf 64.

Long Stratton. pg frag, E win. 15c. **A2** censing angel; **B1** Virgin enthroned, legs turned in direction of Christ; **B2** Christ enthroned, RH blessing; **A3** censing angel.

Guestwick? pg frag, sV.1b. 15³. Hand on orb, probably tri-partite; **FIG 20**.

Mileham? pg frag, W win, 2a, 15c. Part of Barbara's tower replaced by hand holding tau orb with staff, tri-partite division; nimbed head of deity at head of tracery. The entire W win was in conservation in 2000.

Cawston? pg, tiny frag sX. Hand on crown.

Diss? pg frag, nXI. Shoulder, LH holding tau orb.

Worstead. sc, boss, S porch. c1400. Son and Father seated on triple-backed throne, blessing, both in tiaras, Father with orb; central throne partially damaged, ?originally with Dove; (C below) headless Virgin seated; originally flanked (above) by angel musicians; ?donors (below); **FIG 21**.

Lynn S Nicholas. sc, S porch, 3 bosses. 15¹. (C) Deity in tiara holding orb in LH, RH blessing. Surrounding bosses with angels and other figs: (W) queen, (E) head of deity, flowing hair and beard; Beloe (1899) pl 33. Cave (1948) identifies C as Father.

Cathedral. sc, N cloister bosses. 1427–8. E5 (Above) dove in radiance; Son and Father seated on throne; (below C) seated Virgin; 4 angel musicians. ?W4 2 seated figs under an arch, badly worn.

— sc, W cloister boss, M8. 1425–30. In 3 vertical registers with angels surrounding boss: angel holding tiara; Son, and Father on throne, Dove; crowned Virgin seated.

Walpole S Peter. sc, see above *Assumption*.

Salle. sc, central boss, N parvise chapel. 15². In multiple nebuly surround, Virgin with hands joined; Christ's arms missing; both figs decapitated. On surrounding bosses, foliage, green men and angel musicians. Restored by Tristram. See diagram, Appendix I.3.

Attleborough. sc, boss, N porch. 15². Virgin and Christ on long bench; Christ crowned and leaning toward Virgin; eroded, heavily whitewashed. Joys sequence.

Wymondham. sc, boss, N porch. c1450. (Above) seated on elaborate throne (L) ?Father and (R) Christ, ?bare chest; mass above, betw Father and Christ ?Dove; (below C) Virgin. Boss eroded and heavily whitewashed. Joys sequence.

Denton. sc, boss, N porch. Mid 15c. Virgin and Christ seated on throne; Virgin with long hair (no crown), forearms bent at elbow; Christ crowned, holding orb on lap with both hands; flanked by angels playing stringed instruments, incl mandora/gittern; one angel above; nebuly surround; James *S & N* il p 27. Joys sequence.

Norwich S Helen. sc, boss 1, S transept chapel. 1480. Virgin crowned; Christ blessing; (below) angels playing instruments; (above) angels singing, (C) with open book, others with scrolls; Joys sequence; Rawcliffe fig 10 (color).

Hethersett. sc, central boss, N porch. 15c. (C above) angel; crowned Virgin and Christ seated on throne; Virgin's arms crossed on breast; Christ, LH holding orb on knees, RH blessing; flanked by angels with

stringed instruments, one identified by Montagu as lute. At the rib ends of the vaulting, tiny angels with stringed instruments, lute and mandora/gittern. Joys sequence.

S Walsham. sc, statue, S porch niche. c1454 (C & C). (Above L & R) Son and Father seated; dove betw them at apex; (below C) Virgin seated, flanked by angels; a rare survival of statuary, eroded but perfectly legible. Annunciation in spandrels below.

E Tuddenham? *sc. flushwork in the register immediately above S doorway arch, "Gloria Tibi M R." The architecture of the porch façade is nearly identical to that at S Walsham suggesting that the empty pedestal betw 2 (blocked up) windows originally held a Coronation.

Cathedral. sc, bosses Bauchun Chapel. c1470. 36 (above C) Dove with wings spread and beak touching cross on Virgin's crown; Virgin on bench flanked by Father (R) and Christ (L), both touching crown; Christ displaying wounds. **27, 38, 39, 45** angel musicians; **34, 47** angels in various attitudes of prayer. See diagram in Appendix II.3.

— sc, presbytery boss, P83. 15⁴. Virgin crowned in red gown, gold mantle; in radiance, rays ending at roses, ribs painted with red buds in leaf; Pity of the Father at P65. For the Coronation with the Crucifix Trinity, see Morgan (1994) 227–8.

Norwich SPM. emb cope hood. 16¹, "in the cape the coronation of or lady"; apostles and virgins on the orphreys, Hope (1901) 198.

— *pcl. 16¹, "cloith of red with the coronation of oʳ lady for the upper parte of oʳ lady aulter," Hope (1901) 220.

— *pcl. 16¹, "wight for sent Nicholas aulter wᵗ coronation of oʳ lady & other seynttes marters," Hope (1901) 220.

— *pcl. 16¹, "for the Trinite aulter a wight steyed hangyng wᵗ the coronation of oʳ lady in the upper parte," Hope (1901) 218; see also XII Anne.

Queen of Heaven

The title is here reserved for images of the Virgin crowned but not part of a Coronation; no Child. See below *Marian Texts* and, above, Assumption/Coronation entries.

Weybourne Priory. seal, Austin Canons' Priory of S Mary and All Saints. Late 12c–13c.

Crowned Virgin standing, book in RH, fleur-de-lis in L; in field L, a crescent, *BM Cat. of Seals*, 4277; another from 13c, 4278. The priory was dependent on W Acre.

W Acre Priory. seal. 1231–36 (first seal). "Virgin, with a crown of archaic form, seated, in the r.h. a sceptre fleur-de-lizé, the l.h. broken away," *BM Cat. of Seals*, 4294.

Melton Constable? pg, W win, not *in situ*. 15c. Large head of queen, luxuriant hair; Wdf 198 identifies as the Virgin. M & R 1 cite the Virgin crowned on one of the roof corbels.

Poringland. *pg, S win, "fine bust of the Holy Virgin crowned," Bl 5:442.

Babingley. *pwd, screen. ?1553–58. Crowned, long hair; ermine collar, belted gown; standing, hands joined; at feet vase of tall quatrefoils; DT 53:62.

Necton. wdcarv, wall post, S4. c1450 (Haward, 1999). Crowned, arms at sides, hands raised palms out; Haward pl 4S. Situated opposite Christ, barefoot; perhaps a Coronation variant. Recent repainting leaves Christ a startling blond; hair originally gilt (Bl 6:49). Perhaps Carbrooke's roof "adorned with images of our Saviour and his Apostles" (Bl 2:336) was similar.

Tharston. wdcarv, be. 15c. Crowned Virgin in radiance, drawing in NRO, Rye 17, 4:118. L'Estrange (1874, 107) cites 4 bells invoking the Virgin as queen with the petition, "VIRGO CORONATA DUC NOS AD REGNA BEATA" and 5 with "CELI REGINA LANGUENTIBUS MICHI SEMPER SIT MEDICINA."

2. Sequence

Norwich SPM. pg, scenes distributed betw Felbrigg Hall (FH), the E win SPM, and Burrell Collection. Mid 15c. John given Palm: (FH) Virgin seated on elaborate bed ("canopied throne," Wdf), giving palm to John (L); (R) another apostle; 5 apostles in background, one probably Peter. Miraculous Assembly (FH when described by Wdf, now at SPM): 5 demi-apostles rising in a cloud above barren landscape; angel in cloud; **3f** John Foretells Death: (L) John facing 11 apostles and one hooded man listening to John; demi-angel in cloud. **3g** Arrested Funeral: (C) diagonal bier draped with crimson pall ornamented with lilies and M; 9 apostles at rear of bier, John with

palm; in front (L) apostle with joined hands, (R) 2 apostles; in foreground one knight and halberd lying on ground; second knight kneeling with hands affixed to bier; Wdf pl IV. Conversion of Arresting Jew (Burrell Collection, Wells [1965] Cat. 117): (C) Knight kneeling before John and Peter with key, receiving palm from John; Virgin's coffin draped with cloth bearing "M," 2 other apostles behind; city in background. For details see King, forthcoming.

3. Devotional Images

Where the Virgin was titular patron, her image would have been on the N side of the high altar; elsewhere it would have been in the enjoined position to the S. Surprisingly, the Norfolk inventories of 1368 do not cite images of the Virgin, a failure Watkin attributed to their being permanent fixtures of the church. In addition to her enjoined image, there would have been others both inside and out. Bequests for burial in churchyards sometimes specified before the image of Virgin. At Norwich SS Simon & Jude there was an image in the alley of the churchyard (Bl 4:356). Some chapels, like Our Lady on the Mount at Lynn, were themselves sites of pilgrimage. Marian gilds would have had their own altars with separate images. There, as elsewhere, the Virgin's image would have been honored by "our Lady's Light," a lamp burning before it. Wealthy gilds would have had their own vestments, embroidered with Marian subjects, and women left clothing and beads for the Virgin's image, e.g., "a pair of beads of coral with the gaudeys of silver and gilt to the intent that the image of our Lady in the mid-altar of the north side shall be adorned with them at her feast and the church wardens to have the supervision of them perpetually to the same intent" (Newton-by-Castle Acre, quoted by Linnell in church booklet). Religious houses would also have had images of the Virgin; there was one one at the dortor door at the Cathedral Priory (Stewart 174). By multiplying Marian devotion at least once for every church, chapel, and religious house, we have some idea of the ubiquity of the Virgin's image.

Virgin Seated with Child

Nimbed Virgin holding the Child typically in or against her LA, and commonly with scepter or branch in RH. For this image at Walsingham, see below.

Carleton Rode? pg frag, sIII, tracery trefoil. 13[4] (Pevsner 2). Crowned, seated fig, harp in discrete segment; A. Rose thinks an angel.

Castle Acre Priory. seal. c1200. Virgin seated, Child on lap with scroll in LH; *BM Cat. of Seals*, 2884-5.

Norwich, Carrow Priory. seal. 12c. "Virgin, in profile to the r., with crown of three points,

and hair confined in a net, seated on a chair, the Child on the l. knee, in the r.h. a sceptre fleur-de-lizé," *BM Cat. of Seals*, 2877; Fitch, il facing 252. 13c. Seated Virgin nimbed, holding nimbed Child on L knee; (L) prioress kneeling with scroll inscr MATER D' MEM [Meurs]'; above the scroll, crescent and star, and overhead a hand of blessing, *BM Cat. of Seals*, 2878-81, 2879 with Crucifixion on reverse & 2881 with scepter fleury.

Wymondham Priory. seal, Benedictine Priory of S Mary. 12c. Crowned Virgin, Child on L knee, scepter fleury in RH, *BM Cat. of Seals*, 4380; 14c seal, same scene, elaborate throne, flanked by censing angels, 4381; *VCH* pl 1, facing 326.

W Acre Priory. seal. 13c (second seal). In lower register, Virgin crowned and ?nimbed, seated on bench, feet resting on wyvern, apple held in RH, LA supporting standing Child; unnimbed Child with orb in RH, fleur-de-lis in LH; *BM Cat. of Seals*, 4296; *VCH* pl 2, facing 494; Pedrick (1902) 136, pl 25, seal 50.

Norwich. seal, Bp Thomas de Blundeville (1226–36). Obverse, (R) Virgin on throne; Child held on knees; (L) bp with scroll inscr "Ave"; *BM Cat. of Seals*, 2022; "Extracts" no. 18, fig 6 facing ii.

— seal, Bp John Salmon (1299–1325). Virgin with Child; "at the r. of the seat, a sceptre; and in the field on the r., a candlestick and candle. In base, under a triple arch or arcade, a priest kneeling before an altar, with a chalice on it. MATER : DEI : MEMENTO : MEI," *BM Cat. of Seals*, 2036; "Extracts" no. 18, fig 5 facing ii.

Langley Abbey. seals. 1267. Reverse, Virgin on elaborate throne; Child on L knee; flanked by hand and arm holding candle in candlestick, inscr "VIRGO FLOS FLORUM: PIA TUTRIX SIS MISERORUM"; *BM Cat. of Seals*, 3398-9. Erwood fig 3.4. 14c. In canopied niche holding scepter fleury, *BM Cat. of Seals* 3400-1; Erwood fig 3.3.

Hulme, S Benet's Abbey. seal, Benedictine Abbey. 1275-1302. Reverse, half-length Virgin; Child on LA; in field 2 stars; (below R) abbot in prayer; SALVE REGINA MISERICORDIE; *BM Cat. of Seals*, 3300-3.

Horsham, Priory of S Faith. seal (Prior's seal). 1281-93. In the upper register, the Virgin

is seated, with Child on L, (RH) scepter fleury; *BM Cat. of Seals*, 3294–5. See also XII *Faith*.

Bromholm Priory. seal. 13c. In church win above S Andrew in doorway, Virgin (half-length) with Child in RH; *BM Cat. of Seals*, 2736; Pedrick (1902) pl 27, seal 54; see also *Cross of Bromholm*.

W Dereham Priory. seal, Premonstratensian Canons of S Mary (second seal). 13c. Within niche, Virgin, feet on wyvern; Child on LA; flanked by censing angels; *BM Cat. of Seals*, 3051. 1236, NMS. c1429. Virgin under arch, Child in arms, star over head, flanked by angel with palm branch, *Index Monasticus* 30.

Hickling Priory. seal, Austin Priory of S Mary, S Austin, and All Saints. 13c. Virgin seated on throne; Child (cruciform nimbus) on L knee; "on each side three cherubs," *BM Cat. of Seals*, 3279.

Thetford Priory 1. seal, Cluniac Priory of S Mary. 13c. "Virgin, with large nimbus, seated on a carved throne, holding the Child . . . on the l. knee, in the r.h. a flower"; Child blessing, book in LH; *BM Cat. of Seals*, 4157. In Bl 2:127 the flower looks like a palm branch.

Norwich Castle. sc, Ch Royal, ?part of altar-piece, E side. ?13c. Infant on RA, dove beside (cf bird as toy below); Woodward pl 13.

Diocese. ms, hours (Matins), NMS 158.926.4f, hi, f 27 (Matins). c1310–20. On cushioned bench, Virgin holding flower with prominent sepals; Child holding bird. In niches in border, bp, Etheldreda (book and crozier), and Edward the Confessor (with ring); Sandler, *Survey* Cat. 47, il no. 110.

Cathedral Priory. ms, Ormesby Psalter, Bod L Douce 366, hi, f 29. 14[1]. Virgin with branch in RH; Child, RH extended to branch, book in LH; Sandler, *Survey* Cat. 43, il no. 97; Pächt & Alexander 499, pl XLVIII.

N Elmham. pg, nVII, tracery. 14c. Virgin in short white veil under crown, no halo, on scarlet cushion on throne; green gown and voluminous mantle lying over lap and LA on which Child sits; tip of ?scepter betw thumb and index finger; Child blessing, ?apple in LH.

Foulsham. pg frag, sII.D3. ?14c. Tiny Child,

probably seated, holding ?apple.

Billingford, Hospital of S Thomas the Martyr. seal. 14c. Crowned Virgin within canopied niche, Child on L knee, *BM Cat. of Seals*, 2625.

Booton. sc frag statue, in N porch. 14c. Headless Virgin seated with Child on L. Life-sized frag found in wall of former church.

Lynn S James, Guild of SS Giles & Julian. emb. Late 15c. "An altar cloth with our Lady and her child on her knee," Richards 433.

Ringland. pg, now in Cathedral, sVI. c1460–70. Virgin, crowned, seated against radiance, scepter in RH, ermine-lined mantle, hair falling on shoulders; Child lost except for RA holding string with bird depending; Wdf pl XXI. The bird over the Virgin's womb looks remarkably like the Dove of the Holy Ghost. The Child once held a orb and cross in his hand, NRO, Rye 17, 3: 142v.

Bressingham. pg frags, E win. 15c (donations span a century, with clerestory completed 1527). Light a, hand on staff against flowing hair; light b, Virgin's head, crowned, flowing hair; originally in light c, "Virgin with our Saviour in her right arm and a sceptre in her left hand," NRO, Rye 17, 1: 150. On removal from the church the glass was preserved at the Hall and replaced in the 18c.

Norwich SPM. pg, E win 7b. Mid 15c. Small scale.

Diss. pg frag, sX.2a. 15c. Virgin with scepter; Child nimbed, holding object.

Themelthorpe. *pg, S chancel, "Virgin sitting with our Saviour in her arms holding his RH upon his Mother's L breast and his L upon a bird in her lap," NRO, Rye 17, 4:22.

Norwich. seal, Bp John Wakeryng (1416–25). 1424. Crowned Virgin in canopied niche, holding Child with LH, scepter in RH; *BM Cat. of Seals*, 2051–2. Bayfield (319) also cites angels.

— seal, Bp Walter Lyhert (1446–72). Trinity; (above) Virgin on throne, "our Saviour in one hand and a sceptre in the other," Bayfield, 321.

Cokesford. seal, Austin Priory of S Mary. 15c. Crowned Virgin, in RH scepter fleury; Child on L knee; *BM Cat. of Seals*, 2977.

Colby. sc, face of font bowl. 15c. Virgin on wide

throne; holding object in LH; Child standing on her lap.

Gayton Thorpe. sc, face of font bowl. 15c. Virgin on wide bench; (L) Child standing; disfigured. 8th scene of a 7-Sacrament font. (Marian dedication.)

Cathedral. wdcarv, misericord, N3. 15[1]. Virgin holding Child's R foot; Child holding bird; two angels holding crown above Virgin's head; Rose (1994).

Hemsby. *?wdcarv, roof boss. 15c. Crowned Virgin, nimbed Child seated, resting against her RA; DT 31:115, drawing made in 1840. This boss, together with three others now missing, are identified as being on the roof of the S porch, perhaps in the upper chamber now remodeled.

Ranworth. *wdcarv, misericord. Uncrowned Virgin, (L) naked Child seated; DT 42:68.

S Acre. brass. 16[2]. (Below) Thomas Leman, rector, †1534, in surplice and ?humeral veil, hands joined, kneeling with prayer scroll; (above) crowned Virgin on wide bench, Child seated on her lap; two windows at either side; very worn; DT 44:111.

Walsingham

For seals representing the priory church, see *BM Cat. of Seals*, 4247, 2448. Mitchiner notes the growing popularity of the shrine, with recovery rate for its badges exceeding those for Canterbury after 1500 (Cat. 221), but see *Ara Coeli*. The best succinct treatment of Walsingham images is by Spencer (1998). Map of precincts in P & W 1.

a. Holy House

?1061 (Gillett 1961), under the protection of the Austin Canons from 12[3]. In the 15c William of Worcester measured the internal dimensions of the Holy House as 23' 6" x 12' 10" (Green and Whittingham). Supposedly a replica of the house where the Annunciation occurred, the wooden house was enclosed in an outer structure known as the new work in the 15c. Glazing of the windows was in part financed by Henry VIII (*L & P* 2:1451, 1458). See also IV.2 *Annunciation*.

Lynn/Salisbury/London. pilgrim badges. 13–14c. Holy House, consistently represented with "A roof with three crosses on its ridge and a 'clerestory' of three windows beneath it . . . perched on the gable-ends of an upper storey. In the middle of this floor stands either the statue of Our Lady or a scene of the Annunciation. Under the eaves, a lower storey has a central doorway flanked by windows," Spencer (1980) p 11, Cat. 8–15; Spencer (1990) Cat. 67–8 and (1998) Cat. 138d–141; see also *Age of Chivalry* Cat. 73

and Mitchiner Cat. 229–31, who notes this badge is rare after 1400, replaced by sturdier designs. The earliest example is Spencer (1998) Cat. 140.

b. Cult Image. *wdcarv. Virgin seated on a cushioned bench, scepter fleury or branch of flowers in RH, Child on L side. Henry III commissioned a gold crown for the image in 1246. *Valor Ecclesiasticus* reported offerings of £25 1s. The wooden im, described by Erasmus as "imaguncula, nec magnitudine, nec materia, nec opere praecellens" (quoted in Gillett [1950] 25, "not much of an image in size, material or workmanship"), stood at the N of the shrine altar; it was removed to Lambeth on 18 June 1538 and burned in July.

Walsingham Priory. seal, Austin Canons' Priory of S Mary. 13c. Reverse, Virgin, crowned and nimbed, "Seated in a chair-like throne, with tall finials; the Child, with nimbus, on the l. knee; in the r.h. a sceptre fleur-de-lizé. Overhead and at the sides two curtains," with the text "AVE : MARII[A : G]RAC[IA :] PLENA : DOMINVS : TECVM"; obverse, priory church, worshippers within, *BM Cat. of Seals*, 4248; *VCH* pl 2, facing 394; Hart (1864) facing 293; Warner, facing 126. In some of the reproductions the Child seems to hold a book.

Lynn/London/Salisbury. pilgrim badges. c1400. Under a crocketed canopy, Virgin and Child both crowned; Child standing/sitting in LA, Spencer (1980) Cat. 1–6. Nimbed variant found in London, *Age of Chivalry* Cat. 72. See also Mitchiner Cat. 232–33; Spencer (1990) fig 66 and (1998) Cat. 137b–138. Spencer (1990) notes that after the middle of the 15c, the predominant badge is the Annunciation rather than the cult image.

East Anglia. pilgrim ampullae. 14–15c. Spencer and Mitchiner cite a wide variety of ampullae (some with suspensory rings) with scallop shell design, initials, many with "W," the long arrow of Walsingham, or other symbols suggesting the shrine, probably used for water from the holy well (earliest reference to the well of the Virgin, late 14c); Spencer (1980) Cat. 38–41, Mitchiner Cat. 221, 397–403; Hart (1864) fig 294. Spencer (1980) cites an Annunciation mold found near the parish church at Lt Walsing-

ham with broad arrow on the reverse (34–5).

Walsingham. *im. 1439. The Countess of Warwick bequeathed "her tablet with the image of our Lady, to the church of Walsingham, which had a glass over it; also to the Lady there, her gown of alyz cloth of gold, with wide sleeves, and a tabernacle of silver like in the timbre, to that of our Lady of Caversham," Bl 9:279. Waterton (2:189–95) records a number of other bequests of clothing and fine jewels. The nature of the im is unknown, perhaps the Annunciation (see IV.2).

c. Holy Milk.
An important relic kept on the R side of the high altar of the priory church. *Valor Ecclesiasticus* reported offerings of 42*s* 3*d*. The earliest mention is an offering by Edward I (Spencer [1998] Cat. 153).

Lynn/W Lynn. pilgrim badge frag. 15c. Spencer (1980) Cat. 33; complete badge of reliquary enclosing vial, with text "lac marie" found in London, Spencer (1998) Cat. 153a.

d. Miracle of the Knight's Gate.
Recorded by Robert Reynes of Acle in his commonplace book (Louis 322).

Lynn/London. pilgrim badges. c1330. Knight, hands joined, riding through small wicket gate over chained posts, Spencer (1980) Cat. 36–7; Spencer (1998) 153; Mitchiner Cat. 235. Erasmus cited a plaque next to the gate commemorating the miracle.

Virgin Nursing, *Maria lactans*

See also III.3, Ranworth, & IV.2 & 4 *Nativity & Circumcision.*

Brampton. brass. 1468. (Above) Crowned Virgin with nursing Infant; (below) shrouded figs of Robert and Isabella Brampton; prayer scrolls, "mater [magnifica] miseris miserere maria; virgo deo digna p[ec]catibus esto benigna"; Badham (1996) fig 27.

W Dereham Priory. seal, Abbot William de Norwich. 1519. Virgin seated, nursing Infant in LA; DT 28:197–8.

Bromholm. 1536. "They say they have the girdle and milk of St. Mary," *L & P* (1536) 10:143.

Virgin Standing with Child

Cathedral. wp, ante-reliquary ch, E bay. 1300. Crowned, apple in RH, supporting Child on LA; blue mantle over white gown; Child

extending LH towards apple, caressing Virgin's face with RH; flanked by Margaret and Catherine; Park and Howard 395, fig 142; Atherton color pl Va.

Diocese. ms, Corpus Christi Psalter, CCCC 53, f 16, miniature. 14[1]. Virgin standing with Child, holding respectively flower and fruit; James (1912).

Lynn Whitefriars. seal. 14c. Crowned Virgin in niche, Child on LA; Margaret (R); *BM Cat. of Seals*, 3585; DT 56:77.

Norwich, Hospital of S Giles. seal (?master). 14c. Crowned Virgin "full length" with Child on LA; *BM Cat. of Seals*, 3781.

Norwich, S Mary-in-the-Fields. collegiate seal. 14c. Crowned Virgin; Child on LA; *BM Cat. of Seals*, 3785–86.

Norwich, Carrow Priory. 2 seals reproduced in frontispiece pastedown in Frank Sayer's copy of Blomefield (vol 1), nos. 191–2. The seals are described in 4:571–8, but the engravings are not found in all printings.

Yarmouth Blackfriars. seal. 14c. Crowned Virgin flanked by (L) Dominic and (R) bp ?Nicholas; *BM Cat. of Seals*, 4382; *VCH* pl 2, facing 436. *Index Monasticus* (39) cites a 15c seal with Virgin and Child flanked by bp and prior; Manship pl 2.5.

Provenance Unknown. seal. nd. Virgin with child in arms; kneeling fig; inscr "Mater Dei Memento Me"; found at Yarmouth. Manship pl 2.6.

Lynn/London. pilgrim badge. 15c. Virgin (headless) with scepter, Child on LA holding bird in L; Spencer (1980) Cat. 54.

Ringland. pg, NV.1–3b. 1460–70. Crowned Virgin, ermine-lined mantle; naked Child holding apple, resting face against Virgin's; both nimbed; female donor below.

Shelton. pg frag, nII.1b. Late 15c. Virgin with scepter in RH; Child on LA holding bird, DT 60:84.

— pg, E win, c1504. Virgin on pedestal; largely reconstructed 19c.

Stockton. pg, set in sII, light a. 15c (Cautley). Crowned, hair falling over RS/A, holding Child in LA; Child clutching edge of Virgin's mantle with RH, object (?bird) in LH; yellow stain faded; Keyser (1907a) pl 21.

Attleborough. pwd, retable, N2. 15[3]. Against cloth of honor, Virgin crowned, ermine sideless surcoat, mantle fastened with ties;

scepter in LH; Child seated on her draped RA, barefoot, ermine collar. In Miss Barrett's watercolor, the Virgin is not crowned and there is a donor in lower L corner; DT 53:37.

Horsham S Faith. pwd, pulpit, pane 1. c1480. Virgin crowned, holding Child in crook of LA, ?apple in RH; Child in long gown, clasped book in RH; Benedictine below with scroll, "Mercyful lady qwene of hevyn. Kepe me fro þe dedly synys sevyn," text cited in NRO, Rye 17, 2:266 and recently renewed on the pulpit.

Gt Snoring. pwd, screen panel. 15c. Virgin crowned, with three roses in extended LH; ermine-lined mantle with large foliate design; nimbed Child resting in crook of RH, his hand touching morse on Virgin's mantle.

W Somerton. *pwd, ?screen panel. 15c. Virgin crowned, Child holding book. Bensly ("Extracts" 8:336) reported that the painting was "on a narrow thick piece of deal," suggesting a screen panel; oak was more normal for screens. Stolen.

Norwich S James. sc, font stem. 15³. Child holding bird ?on string. Font now at S Mary Magadalene.

Stalham. sc, font stem. 15³. Child on LA.

Hockering. sc, font stem. 15c. Child on LA. 19c bowl.

Ditchingham. sc, statue, N niche of W door. ?15⁴. Largely reconstructed; Virgin crowned, holding Child in LA; a 1926 photo shows the Virgin with damaged face and no infant.

Welborne. sc, frag. A modern statue of the Virgin stands in the churchyard with a lichen-covered child seated on her RA; a fragment of an older supporting hand remains, date uncertain.

Happisburgh? *sc, statue. Date uncertain. Virgin veiled holding Child on LA; according to church notes, the present image replicates a statue destroyed in WWII.

Walpole S Peter. pwd, screen, N2. 16¹. Virgin crowned, ermine-trimmed gown, holding Child in RA; Child nimbed, ermine collar, extending RA and touching object in Virgin's hand; a 19c drawing shows an orb in his LH and the Virgin holding an ?apple; DT 43:27; Briggs il p 1013.

Wiggenhall S Mary. pwd, 8-fig screen, S3. 16¹

(donors inscr, C & C). Crowned Virgin, holding naked Child (unnimbed) seated on LA, holding foot with RH; John Bapt with Agnus Dei on LA at S4. A shoulder-high brick wall as background for the scenes.

Beeston S Mary. pwd, screen, N6. 16¹. Standing woman with ermine hem on mantle; badly disfigured but fig in LA (adzed away) conforms to the shape of a Child.

Virgin With Child
Frag or no details of posture.

Cathedral Priory. ms, psalter, Lambeth Palace 368, miniature, f 11. c1270–80. Virgin and Child censed by angels; Morgan, *Survey* pt 2, Cat. 181.

Cathedral. pg frag, nVII.1b, Jesus Ch. 14c. Virgin crowned. Origin unknown, King (1996) 422.

Norwich, S Leonard's Priory. *im. 1422/1452–3. Child wearing silver and gilt crown; around the neck of the Virgin, an Agnus Dei with clasp, sapphire ring on middle finger, Bensly (1895) 200, 216. At the feet of the image of S Leonard an ivory pyx containing a girdle of the Virgin (198); in the 1452–3 inventory a green girdle accompanies a "veste purpurea aurea" (214).

Ashwellthorpe.*pg, E win 2b. Virgin with the Savior in her arms, win diagram in Rye 17, 1: 20, 24v.

Cringleford. *pg, "Virgin Mary with our Saviour in her arms and a star over his head"; donor priest with label "Mater Dei Memento Mei," Bl 5:38; "Virgin with our Saviour in arms but broken," NRO, Rye 17, 1:229v. See also XII *Margaret*.

Didlington. *pg, E win S aisle, "broken remains of the Virgin with child Jesus in her arms," Bl 6:90.

Dunston. *pg, E win. "The Virgin & our Saviour broken," NRO, Rye 17, 2:53.

Ickburgh. *pg, N side, Bl 2:237; Virgin with Savior; NRO, Rye 17, 3:5.

Pulham S Mary. *pg, E win. Beneath the Trinity "the blessed Virgin with our Saviour in her arms and a lily by her," Bl 5:395. The description of this win suggests that other subjects intervened betw the Trinity and the Marian scene. There were also donors with prayer scrolls beneath; NRO, Rye 123, p 34.

Oxborough. *pg, "effigies of Virgin with the

child Jesus," Bl 6:182.

Tilney All Saints. *pg, N. aisle. "Virgin Mary; with the child Jesus"; a second image in the S aisle, Bl 9:80–1.

Burnham Norton. *pwd, screen. c1458. Inscr "above the head of the Virgin Mary—'Nos cum prole pia benedicat Virgo Maria,'" Bl 7:17.

Sparham. *pwd, screen, "Virgo M. ut [et] puto," NRO, Rye 17, 3:214.

Weybourne. finger ring. 15c. On hexagonal bezel; site 19097; *NA* 41 (1993): 521.

Norwich Whitefriars. seal. nd. With Savior in arms, *Index Monasticus* 42. Flanked by friars, reproduced in frontispiece pastedown in Frank Sayer's copy of Blomefield (vol 1), no. 181.

Norwich, Hospital of S Mary Magdalene. seal. nd. With Savior in arms, *Index Monasticus* 57. Reproduced in frontispiece pastedown in Frank Sayer's copy of Blomefield (vol 1), no. 168.

Cathedral. sc, vestry arch apex. 15[1]. Virgin against radiance, damaged.

Walpole S Peter. *wp. Above the door to the roodloft, "an old piece of painting of the Virgin and the child Jesus," with text of patron's prayer, Bl 9:114.

Shimpling. *wdcarv. 15c. Virgin and Child, colored and gilt; found in chancel wall in a hole, reported in "Extracts" 8:337.

Walpole S Peter. *im. 1504. "I geve to bye a kyrtill and a cote of velvet to our lady and hir son in the parclose of the church, to be worn every good day, xiijs. iiijd.," Williams (1941) 338.

Virgin (No Child Cited)

Thetford Priory 1. *pwd? 12[1]. A "famous picture of the Blessed Virgin," in the refectory, purchased by lady Maud de Samundeham, "a lay sister and great friend of the house," Bl 2:118.

— *wdcarv. 13c. A miraculous image containing a large number of relics. The monks found a treasure trove inside the head of a statue of the Virgin, all wrapped in lead and labeled. The relics were replaced and the statue set in a new "tabernacle adorned with small images, painting, gold, and precious Stones," Bl 1:450 (1739); 2:117–8 (1805–10). The Cluniac Priory, originally at site of former Cathedral (S side of river); moved to new site N of river in 1114. According to John Brame, the find, which occasioned pilgrimages, occurred in the 13c (Dymond 1:3), but the statue was much older.

Horsham S Faith Priory. seal. 1281–93. Obverse, upper register, Virgin in canopied niche, (RH) scepter fleury, (LH) book; flanked by censing angel and kneeling fig; *BM Cat. of Seals*, 3294–5. See also XII *Faith*.

Norwich S Stephen. *im, ch in N aisle. 1315. Bequest for "a wax candle lighted before the Virgin's image." 1509. Beatrix Krikemer left her "best beads to hang about her neck," Bl 4:153.

Banham. *im. 1362, 1437. Candles before im (Westlake no. 219); burial before, Bl 1:357.

Clippesby. *im. 14[3], "an image of Saint Mary," Watkin 1:50.

Hellesdon. *im. 14[3], "an image of Blessed Mary in the chancel," Watkin 1:27.

Weasenham S Peter. *im. 14[3], "an image of Blessed Mary in the nave"; also a chalice for her altar; Watkin 2:112.

Norwich SS Simon and Jude. *im. 14[3], "a cloth for the image of Blessed Mary," Watkin 1:10.

Norwich, Carrow Priory. *im. 1385. Saddlers' and Spurriers' guild met "a-forn ye ymage of oure lady at ye heye auter in ye chirche of nunnes in ye nunrye of Carrowe," T Smith, 42; floor plan of priory, Gilchrist and Oliva fig 5.

Norwich S Martin-at-Oak (Coslany). *im. 14c. Famous image of Our Lady in the Oak, in churchyard. "What particular virtue this good lady had, I do not know, but certain it is, she was much visited by the populace, who left many gifts in their wills to dress, paint, and repair her; at the coming of Edw. VI. to the crown, she was dismounted, and I am apt to believe the poor oak, also cut down . . . ," Bl 4:484.

Norwich S George Colegate. *pcl. 14[3]. Linen cloth painted with Virgin, Katherine, and Margaret, Watkin 1:6.

Norwich S Stephen. *im. 1460. Bequest for painting, Bl 4:153. Guild of Virgin at the Dissolution valued at £5 6s.

?Paston *im, gilt. 1464. "Our Lady, gilthe, with a crowne and a lely," property of John Paston, Gairdner vol 4, no. 563.

Upton. *im. 1488. "My body to be buryed befor

the pyktur of our lady in the south syde of the cherche," cited in Hill 115.

Lynn Blackfriars. *im. 1497. Virgin in the body of the church, *Index Monasticus* 37.

Norwich S Mary-in-the-Fields. *im. Mass said daily by the first prebend before painted image at S James's altar, Bl 4:171, 179.

Alburgh. *im, chancel, Bl 5:354.

Gooderstone. *im, Bl 6:63.

Mautby. *im. Margaret Paston to be buried before im, M & R 1.

Trowse Newton. *im. Our Lady's image, Bl 5: 462.

Fersfield. *pg, E win, S aisle, Bl 1:105.

Hockwold? *pg, E end S aisle, "suppliant praying to Virgin Mary or some other female Saint," NRO, Rye 17, 2:241.

Lyng? *pg, "in every pane of the windows is or has been some figure of the blessed Virgin," NRO, Rye 17, 3:45.

Oxborough. *pg frag, E win. Crown and gown with M engraved, "it is plain the Virgin Mary was here figured," Bl 6:186.

Sparham. *pg, S win. "Sca Maria," upper fig lost, NRO, Rye 17, 3:216.

Watlington. *pg, N aisle. With donor, Bl 7:483.

Wiggenhall S Mary. wdcarv, be nave S. 15c (P & W 2). A number of niches marked VB (*Virgo beata*) with Virgin within radiance, hands joined; Bullmore fig 1. P & W date the S benches to early 15c, but Batcock (78–9) suggests that they may appear earlier than those on the N because the workmanship is cruder. He also comments on the Marian theme of the S side (see IV.2 *Annunciation*).

Lt Walsingham. *altar table, ?al. 16¹. "John Mathu, graver in part payment for making an altar table of the Blessed Virgin Mary," Firth, 179.

Norwich SPM. *emb cope. 16¹. Hood with image of Our Lady, Hope (1901) 199.

Cranworth. *pg. 1509–10, new win N aisle. A "picture of the Blessed Virgin," Bl 10:203.

4. Special Titles and Marian Texts

Titles such as "Our Lady of the West" for the statue on the W front at Salle or "Our Lady of the Mount" at Lynn are best classified as local idiolects. For Our Lady of Eton, see above section 1 *Assumption*.

The Virgin of Ardenbourg

Yarmouth. *altar and ch dedicated to "S Mary de Arnburgh." 14⁴. Edward III went on pilgrimage to a famous church at Ardenbourg, Flanders, after battle of Sluys, 1340. Collections in 1484–5 amounted to £10 5s 7¼d; Morant (1872) 223. Perhaps located in a separate building (243). Bequest for pilgrimage (Tanner 85); guild (Westlake no. 377).

The Virgin of Mercy

Under this title the standing Virgin shelters a group of people (originally Cistercians) within her mantle.

S Creake. 1491. Bequest to the light of "Mary of Mercy," Robert Norton, Norf Arch Book 1 f 173 (Cotton personal communication).

Our Lady of Grace

There were well known images at Ipswich and Cambridge.

Norwich S Andrew. *im. 1510. Bequest to paint, Bl 4:304; ch of our Lady of Grace under the steeple; also a guild. See Waterton (108) for a list of bequests.

Beeston Priory. Regular Canons of S Augustine. Bequests left to our Lady of Grace, *Index Monasticus* 21.

Potter Heigham. Light, Waterton 2:50.

Our Lady of Milan

Norwich SPM. *im, Lady ch. 1497. "10 marks given to paint our Lady's tabernacle and image in this chapel, and keep a continual light before it"; her image there "called our Lady of Millain," Bl 4:206. There was a famous statue of the Virgin at Milan.

Our Lady of Peace

Winfarthing. *im. 1548. Light before the "image of Our Lady of Peace," Bl 1:181. Virgin crowned with scepter in RH and Child in LA, standing on dove. Mitchiner connected 15c badges found in London (Cat. 544–50) with Walsingham, Spencer (1998) with a London shrine. Perhaps Winfarthing should be considered.

Ara Coeli

Demi-fig/bust of Virgin and Child in aureole on crescent moon; cult image at Rome. Mitchiner connected the many London finds of these badges (which he calls the Assumption) with Walsingham, but Spencer is less positive (1998, 148). He argues that badges without aureole are from Our Lady of Willesden (Cat. 59). For similar badges found in France, see Bruna Cat. 146 (with scepter) 143–45, 147 (without scepter). I am grateful to Nigel Morgan for identifying this image.

Lynn. pilgrim badges. 15–16c. Virgin (demi-fig) with scepter fleury; Spencer (1980) Cat. 56, 57, 59. For London finds, Mitchiner Cat. 540–43 and Spencer (1998) Cat. 154.

Lynn S Nicholas. wdcarv, roundel on poppy head. c1419. Against radiance (¾) Virgin seated, Child (disfigured) on RA; reverse, an atypical John Bapt.

Marian Texts

The following texts must have been orginally connected with suitable images of the Virgin.

Old Buckenham. pg, sV, heads of lights a, b, & c, probably *in situ*.1460–80 (King). Angels in belted gowns with cuffs, **b** with original head, all holding scrolls horizontally in outstretched hands; **a** "Salve regina mater misericordie"; **b** "Beata dei genetrix maria," antiphon for Sunday Vespers; **c** "Ave regina celor*um*, ave d*omi*na," antiphon for feast of Purification; texts restored; Wdf 138–40. Perhaps the Purification was originally below in light c.

Norwich SPH. pg, nV, head of lights a and c. 15³. Angels with scrolls inscr: **a** "Letabu*nd*ʒ exultet fidelis chor*us*," incipit of the sequence of Mass of the Blessed Virgin, Wdf 139.

Buxton. *pg, part of a Joys win (see above, IV.3). 15c. "Ave maris Stella Dei mater Alma/ . . . Virgo felix, Celi porta./ Monstra te esse Matrem,/ Sumat per te precem qui pro uobis natus,/ Tuli esse tuos"; "Sancta Regina Celorum"; Bl 6:447.

Norwich S John Maddermarket. pwd, ceiling (faded), S aisle Lady Ch. c1450. Angels with scrolls reading "Ave Maria gracia plena Dominu*s* tecum, Virgo serena. &c. And the cipher of the word MARIA crowned, is scattered all over it," Bl 4:295. In watercolors in the G King Collection, the scrolls are inscr "Ave Maria gra*tia* plena d*omi*nus tecu*m* . . . ," "Te benedictus fructus uentris tui," "Qui inhe*n*des . . . fecit per gram," and "Benedicta tu in mulieribus qui peperisti . . ." (NNAS Boxes 2 & 4) For angel headdress see Wdf 148 (for his "turban" read burlet). Hart (1844, 63) cited "the blessed Virgin painted on the roof," now lost.

5. Miracles and Symbols
Miracles of the Virgin
Accused Empress

Cathedral. sc, 47 bosses incl Assumption, Coronation, and Angel Musicians, Bauchun Ch. c1460. Emperor and Empress identified by imperial crowns. For numbering system, see Appendix II. **2** Court scene with Emperor, Empress, and attendants, incl jester; Thurlow (1966) il facing 6. **3** Attempted seduction of Empress. **4, 11** Empress on horseback, with suppliants and male/female attendants. **5** Deathbed of Empress, tiara on pillow; (R) Virgin flanked by angels; (L) physician with jordan (Barasch fig 3). **6** Empress flanked by 2 men, one with sword; tree. **7** Empress, flanked by Virgin and angel, kneeling, plucking herb to put in glove held in LH. **10** Empress praying, flanked by praying man and woman; Virgin touching Empress. **13** Parley betw mounted Emperor and brother. **14** Prayer scene: woman and kneeling child; 3 other figs (boss damaged). **17** Marriage of Emperor and Empress: bp with hand on wrist of Emperor; attendants; cleric with open book. **18** Empress kneeling in prayer by tree; (L) 2 men with weapons. **19** Departing Emperor on horseback holding hand of standing Empress. **20** Accusation: Emperor and Empress seated, courtiers conversing, Empress with RH raised in consternation. **21** 2 men attacking Empress on throne, 3rd in background. **22** Empress sleeping in bed; wicked brother placing dagger into hand of sleeping Empress; (below) slain youth in coif; **FIG 22**; Thurlow (1966) il facing 7. **23** Interior scene, kneeling Empress, ?healing woman touching her crown. **24** Empress on horseback, extending hand to woman. **26** Emperor mounted with sword; Empress sidesaddle, scourge in LH; 2 mounted female attendants, one with orb (*900 Years* color il p 41; Barasch fig 2). **25, 33** Empress holding bundled infant; attendant women; in **25** woman holding cloth as if further to wrap infant. **28** (C) Empress kneeling in prayer; (L) Virgin placing arm around Empress; (above) angel and (R) attendant. **29** Empress in

prayer; (L) man in boat. **30** Emperor with RH in crook of Empress's arm, Empress with clasped hands; (L) attendant and tree(s). **31** Emperor holding Empress by hand, flanked by attendants. **37** Emperor in court scene, receiving scroll from kneeling man. **41** Empress flanked by men. **42** Arraignment: Empress standing before seated man, hands crossed below waist; attendants. **43** Arrest: Empress, hands clasped at waist; (R) man with staff laying hand on Empress. **44** Empress on gangplank, extending hand to woman on board; mariner aboard. **46** Reconciliation: Emperor enthroned, RH raised, LH touching crown of kneeling Empress.

Jew of Bourges

Cathedral. sc, N cloister boss F5. 1427–8. (C) priest, with his back to dressed altar, giving communion to kneeling boys; (L) father taking son away and casting into oven; (R) 2 feet coming out of oven, 2 observers. The boss is more detailed than the illustration of this miracle in the Vernon Manuscript (Bod L, English Poetry a.1). Anderson (1964) pl 7.

Basil of Caesarea

Mercurius, killed by Julian the Apostate, is miraculously raised from dead through the power of the Virgin.

Cathedral. sc, W cloister bosses, 1425–30. **E7** Basil offering bread to Julian the Apostate; attendants (L & R); **F7** Basil lying prone, vision of crowned Virgin in radiance, seated with Infant on lap, flanked by angels; **G7** (bottom) empty tomb; 2 vertical reg (L) angels; (R above) Virgin enthroned and angel, (R below) Mercurius with horse; **H7** (above) angel and devil; (below) mounted Mercurius attacking Julian, who is thrown from his horse.

The Merchant (Christian) of Constantinople

Cathedral. sc, W cloister bosses. 1425–30. **17** Money-Pledge: (below) Jew sending heap of gold coins by servant to Merchant; (above) attendant; statue of Virgin on pedestal (surety); **J7** (above) on shipboard, Merchant and men leaning over to put casket in sea; (below) Jew taking casket from sea; Rose (1997) 29; **K7** (C) statue of Virgin on pedestal (accusing Jew of lying), (L) Merchant, (R) Jew, attendants in prayer. The same scenes are illustrated in the Vernon Manuscript (Bod L, English Poetry a.1).

Theophilus

Cathedral. sc, N & W cloister bosses. 1425–30. North Cloister, Devil forced to relinquish bond: **K8** (C) Crowned Virgin, standing; (L) kneeling fig and angel musicians (fiddle and ?mandora/gittern); (R) two devils; **K2** (L) 2 devils, one with talons; (C) Virgin seated with Child, below her feet devil holding bond; (R) damaged fig, ?Theophilus, man smiling. West Cloister **M4** (adjacent): flanked by angel musicians (above with plucked instruments), below L with psaltery), Virgin, breasts bared, seated with Child on RA, LH extended to scroll held by kneeling cleric; beneath Virgin, angel bust; entire scene demarcated by nebuly; cleric outside nebuly. Other damaged or unidentified bosses may also belong to the miracle set: N bosses **G4** woman in wimple and veil and man seated, man extending arm towards woman; **H4** 2 defaced figs. For Theophilus at Bury S Edmund's, see Tristram (1950) 515.

Other

Cathedral. sc, W cloister bosses. 1425–30. **E6** (C) monk with book flanked by other monks. Tristram (1936, 15) suggested a Marian miracle; James, a miracle of S Benedict. **G1** Central ?Virgin flanked by figs, one crowned; woman with child; (above) rocks and clouds. Tristram (1936, 18) interpreted the miracle of the woman giving birth on pilgrimage to Mont S Michel, protected by Virgin from tide.

Norwich. pilgrim badge, copper alloy (excavated S Laurence's Lane). Late 15c/early 16c (Margeson). Crowned Virgin seated holding Infant on R knee, ?extending breast; (R) robe on horizontal hanger with SR (*Sancta Roba*) above; *East Anglian Archaeology* 26:56. Spencer (1998 Cat. 239b) suggests Chartres as the origin (city saved in 911 when tunic was

carried by the defenders), though the shift at Aachen was equally popular in the 15c (Spencer, Cat. 254l & 255b). Perhaps the holy robe represented Christ's *sainte tunique* at Argenteuil (Bruna Cat. 24-6; I thank Gail Gibson for this reference). For a similar juxtaposition of Child and holy robe, see Master Bertram's altarpeice, Gibson fig 6.8.

Symbols

Lynn. pilgrim badge. ?Late 15c. Virgin seated with Child, flanked by ?rose bushes; Spencer (1980) Cat. 52. Spencer (1998) cites a bracteate badge with Virgin holding a long-stemmed rose (Cat. 138c) as having "possible iconographical links" with Walsingham.

Cathedral. sc, N cloister boss B3. 1427–8. Virgin and unicorn.

Norwich S Peter Parmentergate. *wdcarv, misericord, Virgin and unicorn, Bond (1910a) 52.

Cathedral. wdcarv, misericord, N26. 15^4. Fortified town/castle, double ward, gateway with doors and portculis. Grössinger interpreted as Marian symbol; Anderson (1955) pl 23. Rose (1994) compares with the common seal of Norwich.

Cathedral. sc, N transept boss. 16^1. **E11** man standing in doorway of fortified wall, holding book with seal, in context of Nativity bosses. **E4** Virgin surrounded by fruitful vine. See also IV.2 *Visitation*.

E Harling. wdcarv, screen. c1500. Within a quatrefoil, sacred monogram entwined with rose branches.

Norwich. "In 1739, in digging in a garden, was found a piece of silver . . . on which is the Salutation on one side, and a burning bush on the other, in which is an image of the Virgin crowned, with a sceptre in one hand, and our Saviour in the other and round it 'S. Maria in. Loo. Bosch'," Bl 4:182.

IX. END TIMES

1. Christ Enthroned, Displaying Wounds

Cathedral Priory. ms, Psalter, Lambeth Palace 368, miniature, f 12v. c1270–80. Christ blessing, open book, seated betw sun and moon, feet resting on tau orb upper half inscr "hevrope," Morgan, *Survey* pt 2, Cat. 181, il no. 390.

Diocese. ms, hours, NMS 158.926.4f, hi, f 95 (Gradual Psalms). c1310–20. Seated, blessing, holding garment open with LH; flanked by angels with instruments of Passion, (L) cross and crown of thorns, (R) spear and ?nails); Sandler, *Survey* Cat. 47, il no. 112.

Gt Walsingham. pg, nIV, central quatrefoil in tracery. c1340. Cross nimbed, tress over each shoulder; seated on cushioned throne; dressed in belted yellow gown with fitted sleeves; gown slit to reveal lateral wound; both forearms raised with blood flowing from wounds; lower foil lost. Cf next entry.

Kimberley. pg, E win, A3. Mid 14c (King 28). On wide throne; wearing dark gown with lighter mantle; wounded LH drawing aside slit in gown to reveal lateral wound; petal wound on foot.

Lt Witchingham. wp above tower arch. c1360 (DP). Bust of Christ displaying wounds, lateral wound well preserved; flanked by censing angels and kneeling figs.

W Rudham. pg, nIV eye of tracery. c1430–40 (King). Seated, crowned with thorns, both hands raised; atypical.

Norwich S Michael-at-Plea? pg frag, E win, A1. 15c. Christ with bare torso and lateral wound, cross frag against L side; Wfd (1938b, 174) thought a representation of the Trinity.

Cathedral. sc, above Prior's Door. c1297–1314. Christ displaying wounds flanked by angels with frag instruments of the Passion (L) ?crown of thorns and cross and (R) spear and sudarium; remains of fig beneath Christ's feet; Sekules (1996) fig 96. For the symbolism of this doorway, see Fernie 175 and pl 55.

Hingham. sc, Morley Monument. 15^{2-3}. At apex of massive monument, Christ seated, flanked by kneeling donors; Pevsner 2 pl 43; P & W 2 fig 30. When painted the wounds would have been readily visible.

2. Christ Seated on a Rainbow

Norwich, Carrow Priory. ms, Carrow Psalter, Madrid, Biblioteca Nacional 6422, hi, f 132 (Ps 109). 1250–60. Opening garment to point reveal lateral wound; 3 Benedictine nuns and chaplain; Morgan, *Survey* pt 2, Cat. 120, il no. 112.

Diocese. ms, missal, Bod L Hatton 1, hi 8v. 14^4. Crowned with thorns, displaying wounds.

Bradfield. wp, faint. 14c. Displaying wounds; mantle draped over arms and on lap; flanked by angels (L with thurible).

Saxlingham Nethergate. *pg, originally in N nave (King 25). 15c. Crowned with thorns, long lock of hair on RS; blood flowing from feet and from raised hands down arms, lateral wound; flanked by censing angels and angels with instruments of Passion: (L) pincers and hammer, (R) scourges and 3 nails; copy of Winter drawing in Wdf (1934) 167. Frags remaining in nIV: 3a angel with 3 nails and scourges; 3b censing angels.

Salle. sc, central boss, N porch. 15^2. Crowned with thorns, flanked by angels and instruments of Passion, incl pillar and cords, cross, spear, sponge on reed, ladder and hammer; Cave (1935) 37; Parsons, facing 28. Details difficult to discern.

Erpingham. sc, font bowl. 15c. Fig on rainbow remodeled as woman. Font originally at Norwich S Benedict, damaged during WWII and drastically recut.

N Creake. wp frag, chancel arch. Mid 15c. Christ flanked by figs R and L. In poor condition.

3. Last Judgment Resurrection of the Dead

See also XIII.5.

Houghton-on-the-Hill. wp. c1090. E wall, N spandrel of chancel arch. Souls rising with hands joined; angels, one blowing trumpet. In 1997 the work was not yet fully revealed. Preliminary tests show an angel to the S of arch and a devil and hell scene on the W

wall, with devil grasping an ?ankle.

Norwich, Carrow Priory. ms, Carrow Psalter, Baltimore, Walters Art Gallery W.34, miniatures f 30v. 1250–60. Christ displaying wounds, flanked by angels with trumpets and instruments of the Passion; (below) the blessed with S Michael and damned with devils; Morgan, *Survey* pt 2, Cat. 118 il no. 104.

?Mulbarton. ms, St Omer Psalter, BL Yates Thompson 14, hi f 120. c1325–30. (Psalm 109) Christ displaying wounds, seated on rainbow; (above) 2 angels with trumpets; (below) dead rising. L & M Cat. 28. For medallions, see VI.2.

Gooderstone. pg, sV (E win, S aisle). 14c. **A1 & 4** angels with trumpets; **A2 & 3** souls in shrouds with hands joined rising from graves; **B1 & 2** angels with thurible chains; **C1** bust of Christ, brown mantle over green gown. Note the precision of the 18c description: "Bust of our Saviour, under that Angels sounding the last trump and dead arising out of their graves," Bl 6:62.

W Somerton. wp. S wall, main figs life-size, badly damaged. 14c. (C) Christ destroyed except for rainbow and orb directly below feet; flanked by (L) kneeling Virgin exposing one breast (**FIG 23**) and (R) frag John Bapt in camelskin garment, both presented by angels; below (L & R) angels in albs blowing trumpets; heads and hands of male and female resurrected, incl bishop, 2 kings, tonsured cleric, ?pope, 2 knights; (far R) a tonsured naked cleric who seems to be supporting with one hand the coffin above. Some details have been lost since Winter's copy, for which see L'Estrange (1872) il facing 256; Tristram 248. Winter's drawing shows Christ flanked by 2 females.

Hales. wp, spandrels of nave arch. 14c. Angels "blowing last trump, doubtless the remains of a Last Judgment," DP (P & W 2).

Paston. wp frag. 14c. Above chancel arch, "a pair of feet," Tristram 234.

E Harling. wp, N wall, faint. ?14c (DP in P & W 2). King, hand to mouth, being led toward hellmouth; traces of animal legs below; (far R) top of building.

Wiggenhall S Mary Magdalene. *wp, chancel arch. 14c. Souls rising from graves, jaws of Leviathan (cited in Tristram's iconographic

list, no detail). Spotted demons, one with scourge, one with fig on his back and driving another toward hellmouth; "perhaps part of a large red bat-shaped wing, but this is somewhat hazy," Keyser (1907b) 308; whitewashed sometime in 1906–7.

Ditchingham. *wp. 14c. Cited without description in notice of "archaeological intelligence," *Arch J* 5 (1848) 69; see also XIV.4.

Diocese. ms, hours, NMS 158.926.4f, hi, f 105v (Placebo). c1310–20. 4 bodies rising from graves; deity above.

Brandiston. *pg, S win next to porch. "Venite benedicti patris mei p[oss]i[de]te pa[rat]us regnum mᵗxxuᵒ; / Discedite a me maledicti in ignem et[er]num mᵗxxuᵒ"; NRO, Rye 17, 3:118; see XIII.5.

Lammas. *pg. "In a north window is painted the last judgement, the blessed standing under the judgement-seat on the right hand, with this over their heads: 'Venite Benedicti Patris mei.' Over the wicked, on the left hand: 'Qui faciunt ista, non percipiunt Regna Celestia. Ite Maledicti in Ignem Eternum'," Bl 6:291–2; see see XIII.5.

Walpole S Peter? *pg, S aisle. In one of upper windows "a profane representation of the Supreme Being, habited in a loose purple gown, with a long beard, resting his right hand on a staff of gold, and crowned with glory; pointing out the fore finger of his left hand, as dictating to the Virgin Mary, who is seated before him, with a pen in her hand, and a paper on a desk before her. The deity stands at the door, or entrance of a castle, embattled, and with turrets, surrounded by a wall embattled; within this wall is the Virgin, and many angels are looking down from the tower, &c. there has been a legend, and the word—Convertit—is now legible," Bl 9:114; a curious description.

— sc, boss, S porch, central boss. c1435. Christ, both hands raised, bare chest, flanked by (L above) decapitated fig with soul, (below) shrouded fig and (R) yawning hellmouth with chained soul being dragged in by 2 devils.

W Walton. porch boss, cited by Anderson (1971) without specification.

Cathedral. sc, nave bosses Bay N. 15³. **1** apostle casting demon out of man's mouth, demon (naked body) shaking fist; **2** apostle holding dragon (demon) upside down by wing,

scourging; **3** apostle scourging dragon (demon); **4** hellmouth, devil with spotted body and bat ears holding club, standing in mouth opening, 3 souls within; mouth with 4 huge incisors and row of teeth; **5** feathered devil with hooked nose and claws carrying one soul over shoulder, another upside down, bodies marked with red scratches; **6** red-faced devil, cloven hands and feet, leading 3 souls bound by rope in his RH and over shoulder with LH; **7** devil pushing one soul in wheelbarrow and carrying on his shoulder a woman with pitcher (see XIII.3 *Fraudulent Alewife*) (a hell cart was provided for the Pentecost plays in Norwich, Lancashire no. 1227); **8 & 13** souls rising from the dead, some from coffins; **9** angel leading a female and 2 male souls; **11 & 12** kneeling angel with trumpet; **10** Christ on rainbow, crescent moon below, displaying wounds; flanked by angels blowing trumpets; (below) rising from graves, king and pope (Rose [1997] 117); **15** Peter holding 2 keys; **16** angel leading 2 souls (Rose 116); **17** 3 souls looking up.

Norwich SPH. sc, boss, transept crossing. c1460. Christ flanked by Virgin and John Bapt (no hair garment), each with joined hands; (below) souls rising from graves; devil in hellmouth ?holding one soul.

Marsham. sc, font bowl. c1470. Christ, wearing crown of thorns, on rainbow, displaying wounds; flanked by Virgin and John and 2 descending angels; (below) shrouded bodies emerging from angular sepulchers, one with hands joined, another with hand resting on edge of sepulcher; Nichols (1994) pl 82. 8th scene of a 7-Sacrament font.

Martham. sc, font bowl. c1470. Christ on rainbow displaying wounds; flanked by angels wearing diadems and holding shawms; traces of 3 resurrected below. 8th scene of a 7–Sacrament font.

Barton Turf. *wp, spandrel, N side of nave. 15c. Hellmouth at throat of spandrel, within mouth a male and female head surrounded by flames; devil approaching with fig on his back; devil poking falling fig with fork into flames, head submerged; above (L) devil holding fig by hand, DT 25:14.

Garboldisham S John Baptist. *wp. "In the vestry, under the east window was an old

altar standing, over which, on the wall, I saw a rude painting of the Last Judgment," Bl 1:267.

Martham *wp. Over chancel arch, angels on each side, "one with spear," Taylor (1859b) 17[1]. Probably part of a Doom.

Sloley. *wp. 15c. N side chancel, "a man, naked except a girdle round his waist with a staff in his hand"; E wall S aisle, 3 souls standing in flames "apparently walking forward with what may be the fragment of a wheel behind," Spurdens 89; DT 44:55.

Snetterton. *wp. "Over the rood is a defaced painting of the last day, on the top our Saviour sitting on the judgement-seat, saying to the blessed on his right-hand, 'Come ye Blessed of my Father, inherit the Kingdom prepared for you' and to the cursed on his left, 'Depart from me ye Cursed into everlasting Fire'," Bl 1:419.

Stow Bardolph? *wp, chancel arch. (L) remains of skull and bones; (R) 2 panels, one with fig "blessing suppliants; the other apparently the contrary . . . which I have supposed . . . the Last Judgment," Dashwood (1852) 139 See also VI.3 *Instruments of the Passion*.

Wolferton. *wp, chancel arch. After 1486 (Goldwell license to collect alms for rebuilding after severe fire). Doom discovered c1886 (P & W 2), replaced by Christ in glory with angels, those below with instruments of Passion on banners.

Wymondham. *wp, eastern arch. "Day of Judgement, destroyed," Keyser. N aisle over door, a fragment "representing naked people in a boat in great danger, and several others suffering for righteousness sake, on the right-hand; and on the left, the devils, some offering a can of drink, others a purse of money, encouraging sinners to their own destruction," Bl 2:528.

Horning. wdcarv, be, niche relief. ?16c (see XII *Benedict*). Devil pushing woman into flames of hellmouth, her hands held to head in terror; Gardner (1955) pl 16.3.

Resurrection of the Dead

Fragmentary remains probably part of a Last Judgment.

Diocese. ms, hours (Matins), NMS 158.926.4f, hi, f 105v (Placebo). c1310–20. Bodies ?rising from graves; deity above.

Bressingham. pg frag, E win, light b. Soul being

lifted by hands.

W Dereham. pg, W2, 3a and b. 15c. Good souls, male and female, hands raised, looking up; preceded by ?angel in 3b.

Downham Market. pg frag, W win. 15c. **3a** 6 souls (incl woman) with hands raised, looking up; **3b** 2 angels, 2 souls.

Wighton? pg, W1. 15c. What appear to be angels on wheels actually have nude torsos and rib cages like those in mortuary scenes and breast line with nipple; restored. Perhaps a conflation of two scenes.

Attleborough. *wp. 2 rows of 4 coffins with lids tipped up, (L) king, laymen, 2 missing; (R) 2 laymen, bishop, and layman; Walter Hagreen watercolor, NMS, B415.235.951.

Norwich Blackfriars. *emb. 4 Ed 6. "Item . . . three pecys of hangyngs of black worsted imbrodrd with dede bodys, rysyng owt of graves," Kirkpatrick (1845) 60–1.

Merton. pg, sIV. ?17c. 2 angels with trumpets, scrolls, **A1** "Repent"; **A2** "The kingdom is at hand."

Michael Weighing Souls

Paston? wp. c1370. N wall, below 3 Living & Dead, nude fig and hind quarter of beast (Bardswell 191); "frag of ?a large figure, and a small nude soul; perhaps originally a St. Michael Weighing Souls," Tristram 234.

Martham. pg, sV, E win S aisle. c1440. Mantle over feathered tights; holding balance scale in LH, 3 souls in R pan, 2 green devils sitting in L pan pulling on the cords and one falling (now badly restored); Wdf (1933b) il facing p 8. In the 19c Michael was against a cloth of honor held by a demi-angel, and there were 6 souls in the L pan (E S Taylor, 1859b).

Belaugh. *pg, N chancel. Michael "holding a sceptre and sword, and a pair of scales, a man in one scale, and the Bible in the other, and under him a great number of men, women, and children, and over them 'Michael Archangele celi veni in auxilium Populi'," Bl 6:314.

Aslacton. *pg, S chancel win. Broken scales with a book in the L pan and the devil in the R; NRO, Rye 17, 1:33v.

Ormesby S Michael. *pg, N win. Saint "with scales," NRO, Rye 17, 3:104v. 1486 request for burial "under the Image of St.

Michael," Norris, NRO, Rye 3, 1:162.

Filby. pwd, screen, 8 figs symmetrically arranged. c1471 (William Tebbe "leaves to church a pulpitum," Cotton). On counterchanged pavement: **S3** Cross-diadem in hair, feathered with wide ermine collar, red body armor with white cross, at hips twisted sash with single knot; soul in lower of scale pans; devil, pulling at cords. Symmetrically paired with George.

Wellingham. pwd, screen, S1. c1532. Michael, bare legs and feet, feathers depending from thighs and arms; wide ermine collar, red jupon (?armor) with white cross, low hip belt, sword grounded in RH; scales in LH, pan (R) with 2 tiny devils pulling down on the strings, 3rd devil below touching bottom of pan; pan (L) holding 2 souls kneeling with arms raised; (far L) angel in alb and stole, Virgin placing 2 sets of red beads on the beam of the scales; (below) scroll inscr "Anime Probantur"; Duffy fig 122.

Norwich S Michael Coslany. sc, statue, damaged. c1400. Michael in armor with cross, standing on devil; (lower L) tiny devil with curled tail, hair garment, RH against grounded sword; remains of scale and soul; "probably" from chantry ch, L & M Cat. 64. Now NMS.

Tharston. wdcarv on face of be, N side. c1500. Angel weighing soul and devil; see also VIII.1 *Queen of Heaven*. Restored 1928.

Weybridge Priory. printed calendar, NMS 134.944. 1503. Scales.

4. Apocalypse

See Appendix III.

Norwich Public Library. ms, Berengaudus, *In Apocalypsin*, TC 27/1, column miniatures unless stated otherwise. 13[3–4]. Ff 6 Angel Orders Letters: John seated, writing at desk, knife in LH. **7v** Row of Churches. **8** Vision of Christ with Sword: Christ flanked by candlesticks, sword in mouth, holding stars. **9v** 2 keys. **10** 7 stars. **10v** Stylized tree. **11v** White stone. **12v** Rod. **14** Key. **15v** Door opened. **16** 4 Elders. **18** Tetramorphic symbols. **19v** Christ and the Book: Christ in mandorla, book sealed. **20a** Angel; **20b** Nimbed Lamb with 7 horns. **21v** First Seal: rider with bow. **24v** 2nd Seal: rider with sword. **27v** (half page) 3rd Seal: rider with

scales. **35** (full page, 3 registers): Angel Censing Altar; Angel and book: one foot on land, one in sea. John Measures Temple. **35v** Woman Clothed in the Sun: seated, feet on crescent moon, dragon below, tail dragging stars. **54** (full page, 3 regs) Harlot on Beast: holding cup; angel flying down, flanked by trumpets; Angel and Millstone: angel casting into sea; **54v** John Kneels to Angel; Armies of Heaven: Christ on white horse, robe spotted with blood; angel summons birds. **74** (full page, 3 registers) John and Angel; same; John vested before altar. **74v** Altar above, John in sarcophagus. Provenance uncertain, 1618 gift of Norwich merchant.

East Anglia. ms, Dublin Apocalypse, Trinity College 4 (K.4.31), 73 large miniatures. 1310–20. Pp **3** Christ and 24 Elders: (C) in mandorla Christ seated on rainbow, holding book, flanked by 7 lamps; central scene flanked by tetramorphic symbols and 24 Elders. **4** Christ and the Book: Christ in mandorla, holding sealed book, blessing; flanked by Elders doffing crowns. **5** John Weeps. **6** Lamb Takes the Book: Lamb with seven horns taking open book from Christ; scene flanked by tetramorphic symbols; (below) elders making music. **7** First Seal: crowned rider with bow, on white horse; (above) angel (Matthew). **8** 2nd Seal: rider in mail armor, (above) lion. **9** 3rd Seal: rider holding scales; (above) ox. **10** 4th Seal: rider coming out of hellmouth; (above) eagle. **11** 5th Seal: souls under altar, deity above (L & M Cat. 23). **12** 6th Seal: 8 stars falling from cloud; (lower R) massed figs in caves, incl a king, monk, and bishop. **13** 4 Winds: 4 angels with 4 winds. **14** Multitude Adore God and Lamb: (above) Deity and Lamb, flanked by angels; (below) Elders, one pointing to multitude with palms and addressing John. **15** 7th Seal and Distribution of Trumpets. **16** Angel censing altar; Deity above. **17** Incense Cast on Earth. **18** first Trumpet: Angel descending with trumpet; (L & R below) trees. **19** 2nd Trumpet: one boat sinking, men drowning. **20** 3rd Trumpet: star Wormwood falling and in water; 2 men with bowls, one drinking; others dying. **21** 4th Trumpet: sun, moon, and stars partially darkened. **22** Voice of Eagle: angel with trumpet; eagle rising (Sandler, *Survey* Cat. 46, il no. 107). **23** 5th Trumpet and Locusts: falling star, king of locusts as hybrid in chain mail emerging from hellmouth, mouth open, ridden by Abbadon. **24** 6th Trumpet: (above L) angel sounding, (R) angel beside altar; (below) 4 armed angels in Euphrates. **25** Army of Horsemen riding animals, lion heads, serpent tails; people in distress. **26** Angel and Book, and John takes Book: (L) John seated; (C) angel with open book, one foot on land, one in sea; (R) John taking book; above rainbow, thunder faces (Sandler, *Survey* il no. 108). **27** John Measures Temple: (L) John seated with measuring rod; angel pointing to temple (R). **28** 2 Witnesses: (C) 2 barefoot men in long mantles flanked by crowds. **29** Death of Witnesses: (below) hybrid (as on p 23) trampling on witnesses holding weapons; (above) 2 groups of men pointing below. **30** Ascension of Witnesses: 2 ascending in cloud; buildings falling on men below. **31** 7th Trumpet: (above) bust of Deity; (L) angel sounding; (below) 2 groups of Elders. **32** Woman Clothed in Sun: (L) temple in Heaven with thunder heads below; (R) Woman seated against sun, feet on crescent moon; mass of stars above crown. **33** Dragon and Woman: (above) angel taking child to heaven; dragon, tail dragging down stars. **34** War in Heaven: 3 armed angels standing on dragon. **35** Dragon casting water & Woman with Wings: dragon with water pouring from mouths into hole in earth; tree; woman with wings of eagle. **36** Worship of Beast: 5 men marked with sign of beast worshipping beast with 2 feet on sea, 2 on land. **37** War of Beast and Saints. **38** False Prophet: beast, false prophet as horned animal, fire descending from heaven. **39** Mark of the Beast: (L) men worshipping (C) beast on pedestal and false prophet, (R) merchant scene, all marked with sign of beast. **40** Lamb on Mt. Sion. **41** First and 2nd Angel: angels with scroll and book descending on falling towers of Babylon. **42** Son of Man Reaping: (above) reaper seated with sickle, facing angel before temple; (below) John in doorway, reaper reaping. **43** Vintage 1: (above) angel with pruning knife leaning to angel (below) pointing to grape vines. **44** Vintage 2: wine-

press. **45** 7 Angels and Harpers on Sea of Glass and Fire. **46** Temple opened and Distribution of Vials: angel in temple; lion handing vial to one angel, others holding vials. **47** First and 2nd Vials: angel pouring on earth; seated men with heads on hands; angel pouring into sea (with fish). **48** 3rd Vial and Praise: angel pouring into well head; Deity above. **49** 4th and 5th Vials: (L) angel pouring on sun; (C) distressed people seated; (R) angel pouring on chair of beast, (below) men, one gnawing tongue and plucking at garment. **50** 6th Vial and Frogs: angel pouring on earth, pointing to dragon, beast and false prophet, all vomiting frogs. **51** 7th Vial, Earthquake, and Hail: (above) angel gesturing to thunder heads; (below L) angel pouring vial into clouds, rain and hail falling; (below C & R) citizens dying under falling towers. **52** Harlot on Waters. **53** Harlot on Beast holding raised chalice. **54** Fall of Babylon: (above) angel with scroll; (R) Babylon fallen with large devil gloating in ruins. **55** Lament of Kings. **56** Lament of Sailors. **57** Angel and Millstone: angel casting millstone into sea. **58** Triumph in Heaven and Bride: Deity in mandorla flanked by tetramorphic symbols; Elders adoring; (far R) bride; no lamb. **59** John Bidden to Write. **60** Armies of Heaven: rider with sword in mouth, robe spotted with blood, other horsemen following. **61** Angel Summons Birds. **62** Battle with Beast: beast and knights confront heavenly army. **63** Defeat: beast, and false prophet cast into hellmouth by angels, rider trampling soldiers on whom vultures feed. **64** Satan Bound: chained devil creeps into hellmouth. **65** First Resurrection: saints judging. **66** Loosing of Satan. **67** Siege of Holy City: miners undercutting walls. **68** Satan Cast Down: angel thrusts Satan into hellmouth holding beast and prophet. **69** Last Judgment: Deity in mandorla holding open book, flanked below by (L) souls in river and (R) souls in hellmouth. **70** Casting into Hell: 2 angels thrust souls into hellmouth. **71** New Jerusalem. **72** Angel and Vials. **73** Holy City. **74** River of Life. **75** John and Angel. Sandler, *Survey* Cat. 46; James, 1932 facsimile. (I have converted the MS pagination from roman to arabic).

?E Anglia. ms, Apocalypse, BL Royal 19.B.XV, 73 miniatures. c1310–25. Morgan queried origin in E Anglia and cited a relationship to the Cathedral bosses (see Appendix III). When two miniatures appear on a page, I have identified them as (a) and (b). John and the angel figure regularly in the miniatures. Ff **1v** John Preaching: holding palm, preaching to large group of men in Jewish hats. **2** Vision of Christ with Sword: Christ standing with tau cross and crown of stars in hand, sword in mouth, flanked by candlesticks. **2v** John on Patmos: asleep, angel touching his shoulder. **3** Angel Orders Letters: seated, writing at pedestal desk, angel dictating; Sandler Cat. 61, il no. 163. **2** Vision of Christ with sword. **5v** Door Opened in Heaven: angel above assisting John climbing ladder to opened doors. **6** Christ and 24 Elders: (above) John, angel, Christ enthroned displaying wounds, blessing, orb in LH, flanked by tetramorphic symbols (all with angel bodies); (below) crowned elders. **7v** Christ and the Book: (a) (above) Christ enthroned in mandorla holding book, flanked by tetramorphic symbols (all with angel bodies); (b) Christ in mandorla, in RH open book with 7 seals depending, LH pointing to book; angel, John ?disputing with prophet. **8** Lamb takes Book: (above) Lamb taking book from Christ; (below) Elders with harps and vials, entire scene flanked by tetramorphic symbols. **9** Adoration of the Lamb: Christ enthroned in mandorla, flanked by angels and Elders below. **9v** (a) First Seal: (above) angel (Matthew); crowned rider with bow on white horse; (b) 2nd Seal: (above) lion; crowned rider on red horse with raised sword, bloody battle (L & M Cat. 15). **10** 3rd Seal: (above) ox; crowned rider on black horse holding scales and arrow. **10v** 4th Seal: (above) nimbed eagle; on pale horse rider in elaborately tied head scarf coming out of hellmouth. **11** 5th Seal [souls under altar]: 5 naked, 2 being clothed. **11v** 6th Seal [earthquake]: sun and moon, falling towers, men in caves. **12** 4 Winds: rigged ship at sea with 4 winds, scene flanked by John and angel. **12v** Multitude Adore Christ and Lamb: Christ and Lamb in mandorla, multitudes in 4 registers, 4th

dressed as deacons holding palms. **13** John and an Elder. **13v** Censing Altar, Casting Incense on Earth and Distribution of Trumpets: 2 vertical registers (L) deity and angel censing altar; (R) above, 7 angels with trumpets; below, angel casting incense on earth, men in caves. **14** First Trumpet: tongues of fire and 3 live oak trees. **14v** 2nd Trumpet: 6 dead trees, (L) upturned boat with men drowning; (R) boat afloat with men praying or sleeping. **15** (a) 3rd Trumpet: star falling into water; (b) 4th Trumpet and Voice of Eagle: sun and moon darkened, eagle rising. **15v** 5th Trumpet and Locusts: (above) star at end of trumpet; (below) locusts with crowned human heads, bodies of mail; king emerging from hellmouth riding hybrid horse, others all breathing fire. **16** 6th Trumpet: (above) deity and altar; (below) angel unloosing 4 chained angels in Euphrates. **16v** Army of Horsemen: riding animals with lion heads and serpent tails breathing fire, trampling men below. **17** Angel and Book: nimbed fig in white holding open book, seated on spheres of the elements, one foot on land, one on sea (Sandler, *Survey* il no. 161). **17v** John takes Book: John seated, writing, looking up; thunder head above (Sandler, *Survey* il no. 164); **18** (L) angel, (R) John with book, both holding long-stemmed flower betw them. **18v** John Measures Temple: John given rod. **19** Witnesses: 2 scholars disputing with seated king and soldier. **20** 7th Trumpet and Death of Witnesses: Angel with trumpet outside miniature frame; 3 witnesses dead beneath king's feet, 4th about to be executed, all blindfolded; tonsured fig kneeling in supplication in doorway. **20v** Woman Clothed in Sun: wearing a crown of stars. **21** Dragon and Woman: (upper R) woman in bed with child taken up by angel; (below) dragon menacing, tail dragging down stars. **21v** War in Heaven: 4 angels attacking dragon. **22** Angel Proclaims Salvation: angel indicating healthy plant; angel indicating dying plant. **22v** Woman Given Wings and Dragon Casting Water: (above) woman with wings; (below) crowned 7-headed dragon ?casting water, soldiers attacking. **23** Beast from the Sea: 7-headed beast on

the sea. **23v** Worship of Beast and War of Beast and Saints: men adoring beast, 5 dead soldiers below. **24v** False Prophet Calls down Fire: (L) beast on altar, men adoring; (R) false prophet (horned animal), fire, soldier killing 2 men. **25** Lamb on Mt. Sion: Lamb flanked by adoring men; Sandler il no. 162. **26** Angel and Everlasting Gospel: men below looking up at angel holding open book. **26v** Angel Predicting Fall of Babylon and Lamb on Mt Sion: 2 vertical registers, (L) angel above indicating fallen towers; (R) angel indicating and men observing Lamb on Mt Sion with altar below, chalice surrounded with fire. **27** Son of Man Reaping: (above) in nebuly crowned man with sickle; (below) same reaping; angel in doorway of temple. **27v** Vintage 1 and 2: angel cutting grapes; vat with men treading and horses at river of blood. **28** 7 Angels and Harpers: (above) 7 angels with vials; (below) harpers on sea of glass and fire. **28v** Temple in Heaven and Distribution of Vials: angel with vial, 7 angels with crossed stoles holding vials; angel in temple doorway. **29** First Vial: angel pouring vial on earth. **29v** 2nd and 3rd Vials: (L) pouring vial into sea with men and fish; (R) pouring vial into apertures, both with streams flowing therefrom. **30** (a) 4th Vial: pouring vial on sun, distressed men below; (b) 5th and 6th Vials: (L) pouring vial on seat of beast; (R) pouring on ?earth. **30v** Frogs: coming from mouths of dragon, beast, and men. **31v** 7th Vial, Earthquake, and Hail: (L) angel pouring vial, earthquake; (C) above, angel in temple; below, fallen town, (R) thunder heads with hail falling on citizens below. **32** Harlot on Waters: (L) Beast with mirror seated by water; (R) harlot on beast holding chalice. **32v** Harlot Drunk: seated by water, chalice in one hand, resting head on the other. **34** Fall of Babylon 1: 3 vultures above fallen buildings; beast, upside down devil. **34v** Fall of Babylon 2: 4 men, 2 in coifs, all with gloves, rightmost pointing to door (?gateway). **35v** Angel and Millstone: angel in sea with millstone. **36** Triumph in Heaven: (above) Christ and Lamb enthroned, flanked by kneeling, adoring men. **37** Armies of Heaven: Christ with sword in

mouth, open book, leading army. **37v** Angel Summons Birds: tree with birds; (below) birds, incl heron, parrot, egret and a rabbit in warren. **38** Battle with the Army of the Beast: angel above army; false prophet, angel decapitating enemy, vultures on body below; partial fig of Christ as horseman. **38v** Dragon Bound: angel holding chain fastened to collar, putting key into prison lock. **39** First Resurrection: angels taking souls from bodies of 2 decapitated bodies; men observing. **40** Last Judgment: Christ enthroned with books, blessing, flanked by saints in white; souls emerging from hellmouth below. L & M Cat 15; for other scenes at beginning and end of MS, see Sandler, *Survey* Cat. 61 and Table pp 182–7.

Cathedral. sc, S cloister bosses. 14¹. **A5** Angel standing. **B2** John Preaching: John with scroll; 5 men, one in peaked hat. **B3** Angel (shod) with Trumpet. **B5** Vision of Christ with Sword: Christ enthroned, frag of sword in mouth, flanked (L) by 3 candlesticks and 6 stars (?one lost) and (R) 4 candlesticks; Gardner fig 390; Anderson (1955) pl 1; *900 Years* color il p 37. **B8** John on Patmos: John asleep, cross nimbed Deity against nebuly. **C1** Angel Orders Letters to the Seven Churches: angel; John seated before pedestal writing desk with open book. **C2** Door Opened & John Climbs Ladder: (L) John climbing ladder; (R) angel pointing up; both standing before open door of building; nebuly surround. **C5** Christ and 24 Elders: (C) Christ in mandorla, open book beside, flanked by tetramorphic symbols (above and below) and (L & R) 24 crowned elders, each with hands joined; above their heads 7 lamps (1 missing) (Lindley [1987] pl 22). **D1** Lamb and 24 Elders: boss flanked by tetramorphic symbols; (above) in mandorla Lamb with resurrection staff, flanked by Elders, crowns betw 2 groups of 12. **D2** Christ and the Book: (C) Christ in mandorla blessing, book beside; (L) John led by crowned fig holding his hand; (R) angel. **D5** Lamb takes the Book: Lamb, in shield-shaped mandorla with open book, seven horns on head; (below) 24 crowned Elders playing harps and fiddles, originally flanked by tetra-

morphic symbols. **E1** Adoration of the Lamb: flanked by tetramorphic symbols; 2 registers (above) Lamb (as in D1) flanked by 8 angels perpendicular to scene; (below) 24 elders, hands joined. **E2** First Seal: Lamb (as in D1) in shield-shaped mandorla; (L) winged lion with scroll; John; crowned rider with bow, on white horse. **E5** 2nd Seal: (L) angel (Matthew) with scroll; rider on red horse. **E8** 3rd Seal: (L) eagle with scroll; rider on black horse holding scales (frag). **F1** 4th Seal: (above) winged calf with scroll; crowned rider on pale horse riding out of hellmouth. **F2** 5th Seal: altar flanked by angels, 4 headless figs below against nebuly (souls of slain). **F5** 6th Seal: sun and moon faces, 8 stars falling from cloud; (below) massed figs, incl a king, in distress. **G1** Four Winds: 4 angels with 4 winds as heads of 4 beasts. **G2** Angel with Seal: angel standing RH raised, staff in LH. **G5** Multitude adore God and Lamb: in mandorla seated Deity, orb held on knee; Lamb beneath; flanked by angels; (below) 6 priests (crossed stoles over albs), one with palm. **G8** John and an Elder: (L) John addressed by (R) Elder. **H1** Distribution of Trumpets and Censing: in mandorla, Deity blessing, LH on book; (L) altar with chalice covered by corporal; partial surround of 7 angels, (upper R) with trumpet, (lower L) ?originally with thurible. **H2** First Trumpet: (above, angel with trumpet held horizontally; (below L) 2 men; trees occupy half of the boss. **H5** 2nd Trumpet: angel blowing trumpet, mountain being cast into sea (now blue, but originally red); (below) 2 boats with people, one sinking; Gardner fig 391; Anderson (1955) pl 17. **H8** 3rd Trumpet: angel blowing trumpet, vertically bifurcating scene; coming from trumpet mouth a star; flanked by men with vessels (poisonous water), 3rd man recumbent. **I1** 4th Trumpet and Voice of Eagle: (above) eagle with scroll, sun and moon faces; (below) angel blowing trumpet, stars fallen to earth beneath trumpet. **I2** 5th Trumpet and Locusts: (below) star, cloud of smoke rising from building below and surrounding sun face (above), (L) 7 locusts, (R) king of locusts (crowned hybrid) in chain mail; no trumpet. **I5** 6th Trumpet:

(above) deity in mandorla, feet on orb; dressed altar, angel beside; (below) 4 angels in Euphrates being loosed from rope by angel. **I8** Angel and Book: angel, one foot on land, one in sea, book in hand, beneath golden arch (rainbow); (L) thunder heads. **J2** John Takes the Book: John and angel (damaged). **J5** Army of Horsemen: (above) 3 horsemen, serpent beneath one, confronting a 4th; (below) people in distress. **J8** John Measures Temple: John standing at doorway measuring temple; within are 6 figs. **K1** 2 Witnesses: (L) 2 barefoot men in long mantles; (R) crowd. **K2** Death and Ascension of Witnesses: (L) dragon with mouth on head of one witness; (R) ascension of witness; crowd of fearful figs. **K5** 7th Trumpet: (L) angel blowing trumpet; Christ in mandorla flanked by 24 elders praying. **K8** Woman Clothed in the Sun: (L) clouds; (C) woman in headdress of stars standing on moon face; sun face below her waist; (R) doorway with angel. **L1** Dragon and Woman: woman in bed with infant, hovering above her a dragon with 7 crowned heads and crowned tail dragging down stars. **L5** War in Heaven: (above) 6 feathered angels with swords fighting 6 devils; (below) Michael impaling mouth of dragon with spear.

— W cloister bosses. 15[1]. **A4** Dragon Cast Out: face of beast in nebuly surround, incisors, huge ears; flanked by 4 horned devils. **A5** Dragon Casting Water and Woman with Wings: dragon with water pouring from mouth into hole; tree; woman with wings of eagle. **B1** Beast from the Sea: beast with 7 crowned heads standing in sea. **B2** Beast like a Leopard: horselike beast. **B5** Worship of the Beast: leopardlike beast worshipped by crowd, incl monks and woman. **C1** False Prophet Calls Down Fire: 15 men and women praying around central fire. **C5** First Angel and the Everlasting Gospel: (above) seated Deity in radiance, orb in LH; (L) angel; (below) 19 men and women adoring. **D1** 2nd Angel Predicting Fall of Babylon: (L) angel resting hand on head of John beneath; (R) turreted city. **D5** Son of Man Reaping: (R) reaper enthroned, crowned, holding sickle (frag); (below) field of grain; (L) angel before temple. (**D7**

Open door [3:8] directly above the refectory door.) **E1** Vintage 1 & 2: horses in tide of blood; angels gathering grapes into baskets. **E2** Angels: 4 angels, 2 with vials. **E3** Fear of the Lord: 8 people praying, incl a woman. **E5** Harpers on Sea of Glass and Fire: (above) Christ blessing, seated against radiance, flanked by two figs, each with joined hands; (below) John with palm, 3 men harping, 2 kings, one harping, standing on sea. **E6** Song of Moses: against waves, 4 men and Moses with horns, scroll in LH. **E8** Temple Opened in Heaven and Distribution of Vials: 7 angels with vials; (far R) angel in doorway of temple. **F1** First Vial: John; angel pouring 3 streams over heads of men beneath incl one king. **F2** 2nd Vial: John seated; angel pouring streams over prostrate monk on sea. 3rd Vial: **F5** (L) ?John; (above) 2 angels with wings spread over 2 wells (fountains) of blood; 3 figs kneeling in river of blood. **F8** John; angel inverting vial of blood into well head. **F6** Judgment of God Praised: (L) seated bearded man, attendant behind; 4 naked men (prophets) on bloody ground. **F3** 4rd Vial: angel extending (vial) towards starlike sun, 5 figs, one hooded, in consternation. **G1** 5th Vial: (L) angel emptying vial over (C) seat of beast; (above R) winged, horned devil; (below) 7 men, incl 2 plucking garments (because of sores). **G2** 6th Vial: (R) angel, streams flowing to river (Euphrates); (C) ?woman; (L) other figs. **G5** Frogs: (far L) John with palm; (above) dragon with 7 heads menacing (C) 2 kings, one with scepter; false prophet immediately beneath dragon; (below) beast with frog coming from mouth menacing one of the kings. **G3** Gathering of Forces: (above) devil with bat wings overshadowing (below) king flanked by counselors in tippets. **G6** Armageddon: (above) devil with bat wings; (below) 9 kings in armor. **G8** 7th Vial: (L above) John with palm; angel emptying vial into clouds; (R) Christ enthroned on pedestal against radiance; (C) 4 men; **H1** Earthquake: (above) lightning, (below) walls of city broken (C register) distressed male and female citizens; (L) finely dressed woman and man with misericord at belt; (C) 2 men shaking hands, one

in beaver hat and dagged sleeves; (R) 2 figs before counter with pile of coins, the man in beaver hat. **H2** Plague of Hail: large hail stones falling from clouds on people displaying gestures of fear; **H3** ?*Beatus qui vigilat*: 10 figs, male and female, some with books and beads; peaceful gestures contrast with terror of people at H2. (Rose interpreted as representation of 17:16; if so belongs with Harlot and Beast). **H5** Harlot on Beast: (L above) John, (L below) angel showing vision to a small John with palm; (R above) scarlet woman riding beast with 7 heads; (R below) 4 men in scalloped collars, 2 crowned. **H6** 10 Kings (with whom the Harlot fornicated). **H8** Harlot Drunk: (L) John with palm; scarlet woman drinking from bowl in one hand, second bowl in other; man kneeling in prayer before her; (above and R) 3 men with scrolls and king, crossed legs, with sword. **I1** Mystery of Woman: (L) John with palm, angel in alb and amice; (R) scarlet woman riding 7-headed beast, neck and heads occupying C of boss, kneeling fig below. **I2** Beast Emerges from Sea: winged beast emerging from the sea flanked by John with palm beneath tree and angel. **I3** Names not in Book of Life: (below) Christ with cruciform nimbus, LH on head of man kneeling in prayer; grotesque devil (large horns, ears, misshapen body, face in belly) touching man far R; (above) men (?17:8b); **I5** Beast That Was and Is Not: winged beast surrounded by 11 kings (?17:11–2); **I6** Beast goes to Perdition: (below) massive hellmouth, into which beast falls head-first from clouds; scene flanked by 2 men (17:17:11b). **I8** Kings Fallen: (above C) enthroned fig, flanked by numerous figs; (below) kings fallen (17:10). **J1** 10 Kings: (upper R quadrant) seven-headed beast; (other quadrants) 10 kings with scepters, dagged collars and belts (17:12–3). **J2** Fall of Babylon: (above) horizontal angel; (below) parapet with 3 men, tile-roofed buildings, man in chaperon within. **J5** Lament of Kings: 4 buildings with tiled roofs at quadrant points, with 7 citizens ranged among them, incl a king; **J6** Lament of Merchants: merchants beneath groined roof, 5 merchants before table with drink-

ing vessels, some in stylish hats; **J3** Lament of Shipmasters: 9 shipmasters in a variety of stylish hats. **J8** Angel and Millstone: (above) angel casting millstone into the sea, (L) walls of Babylon; (C) sea with fish; (R) John with book. **K1** Blood of the Prophets: angels surrounding expanse of blood; (R) John with palm. **K2** Judgment of the Harlot: Christ in resurrection garment seated against radiance, flanked by angels; (L & R) flanked by figs with book; (at base) hellmouth with 2 devils dragging in woman (harlot). **K3** John Bidden to Write: deity, seated, flanked by angels, incl musicians; (below) John kneeling with palm and angel with prominent scroll. **K5** Triumph in Heaven: deity seated in radiance, flanked (above) by eagle and lion (?tetramorphic set), surrounded by 24 Elders. **K6** ?Great Voice: Deity in radiance; angels, one of them blowing trumpet; John with palm. **K8** John Kneels before Angel: Deity blessing, seated in radiance, flanked by angel musicians; (below) John prostrate with palm and angel. **L1** Armies of Heaven: (L) John with palm; (R) Christ on horseback with tiara ("many crowns") and in red gown ("vesture dipped in blood") followed by other horsemen. **L2** Angel summons Birds: angel, tree with bird(s); John with palm. **L5** Battle with Beast: 7-headed beast with armed men at his back. **L3** Defeat: vultures feeding on 9 men in armor. **L6** Prophet and Beast: angel; in massive hellmouth, beast and prophet. **L8** Dragon Bound and Imprisoned: angel (originally with ?key and chain); winged beast with curled tail, chain at neck (broken) standing at fortified gate, portcullis up, above gateway 2 grimacing devils; (R) John with palm. **L4** ?First Resurrection: 7–8 damaged figs, some nude. **M1** Loosing of Satan: crowned devil with bat-ears, second face in belly, in doorway of fortified gate, tiny devils above; angel and John with palm. **M2** Siege of Holy City: John; city with gateway, towers, people within; animal on hind legs before walls. **M5** Last Judgment 1: (above) Christ seated on rainbow, flanked by angels; (below) souls (awaiting judgment). **M3** Last Judgment 2: crowd of naked souls; (far L) ladder. **M6** Casting into Hell: souls cast

into hellmouth. Descriptions ignore background detail; nebuly are common. John is easily identified by his palm, but many figs are damaged, bosses L4, M3, and I6 badly so. Full illustration in Rose 1999; bosses C2, F1, and I5 are also reproduced in Rose 1997 (pp 20, 21, 24), for which compare color differences.

Snetterton? *pg. ?15[3]. "The Windows contain the History of the Revelations," Bl 1:420.

Four Last Things
See XI.2 Gt Snoring.

X. APOSTLES

Mission of the Apostles

Cathedral. sc, N cloister bosses. 1427–8. Apostles Preaching: **C2** apostles flanking tree (C) preaching to 3 men at **C8**; Tristram conjectured 3 converts; Rose (typescript) suggested scenes from Acts. Perhaps the following bosses reflect the trials of the apostles: **D1** 5 apostles flanked by dragon and ?panther (James, ?legend of James Maj); **D2** martyrdom scene. The bosses are on the same axis as the martyrdom of the apostles at bosses **1**, **2**, and **8** in bay E. James interpreted the sequence as the legend of Hermogenes, rejected by Tristram (1936) 7.

1. Apostle Sets

Apostle sets were common in Norfolk, some churches having more than one. Where only 6 apostles remain, there may be reason to posit a complete set, but it must be remembered that apostles could serve individually in their intercessory role. Paul is often included as one of the twelve, probably because of his pride of place in the canon of the Mass. Less often John Bapt replaces an apostle; he is more common in 16-pane screens, where more than 12 saints are needed, or on double-fig fonts. The apostles are bearded, barefoot, and wear a loose mantle over gown. They typically carry books (often clasped). The hand holding the book is commonly draped with the mantle, the cloth serving a semi-liturgical purpose of honoring the sacred text (cited as "draped hand"). Sometimes the attribute of martyrdom is also so honored. Unless stated otherwise, generic descriptions apply. Only unusual features are cited except for frags, which are described completely. Apostles were more common in glass than the following inventory suggests since it does not include unidentifiable frags like the large bare foot on a counterchanged pavement at Norwich S Laurence. See also XIII.1 and Appendix IV. The 12 apostles also figured in a pageant for Elizabeth Woodville's visit to Norwich, Harrod (1859b) 35.

Peter: full tonsure, short beard, key(s) with wards pointing up.

Andrew: cross saltire in a variety of sizes.

John: unbearded, hair with stylized curls; chalice with dragon/serpent rising, held in palm of LH, RH blessing or pointing; sometimes palm in RH. Cf distinction of attributes at Norwich All Saints; for the palm in alabasters, see Cheetham Cat. 50–52.

James Major: the apostle with the most detailed costume, which will regularly be described.

Thomas: spear, held vertically or diagonally with point up.

James Minor: fuller's bat, curved end resting on the ground.

Philip: loaves of bread usually in a woven basket (see Appendix IV.4, **FIG u**); for cross also see Appendix IV.4.

Bartholomew: flaying knife held vertically or diagonally with point shoulder-height (but see Norwich All Saints).

Matthew: halberd, blade upwards (identified on basis of order of the Creed clauses; money bag (6 times, incl 2 at N Walsham); see Appendix IV.4.

Simon: fish(es) held in a variety of positions; see Appendix IV.4.

Jude: unrigged boat; see Appendix IV.4.

Matthias: carpenter's square, right angle or T square (held differently from a tau cross); see Appendix IV.4.

Paul: bald, holding sword by hilt, usually with point downwards (grounded).

John Baptist: holding Agnus Dei; barefoot, dressed in skins.

Norwich, Carrow Priory. ms, Carrow Psalter, Baltimore, Walters Art Gallery W.34, miniatures. 1250–60. 12 in pairs incl Paul, Barnabas, and John Bapt (James Min, Philip, Matthias absent); Morgan, *Survey* pt 2, Cat. 118.

Cathedral. wp, Ante-Reliquary Ch, soffit of W transverse arch. c1300. 12 apostles in pairs, barefoot "on grassy ground . . . holding, alternately, a book or a scroll," gowns and mantles of varying colors, incl red, green, purple/blue, purple; Tristram 230; Caiger-Smith pl IX. The Cathedral's store of relics (13c) included ones of Bartholomew and Philip.

Lt Witchingham. wp, N wall. c1360. Park (P & W 1) identified a row of standing apostles in the upper register; only Andrew's cross well preserved.

Lynn S Nicholas. *brass, William de Bittering and wife. ?14³, "embellished with figures of yᵉ 12 apostles and many other saints etc," quoted in Cameron 154–5.

Hellesdon. *emb. 14³. Vestment with orphreys "de rubea velvett cum ymaginibus apostolorum de auro," Watkin 1:27–8.

Wramplingham. *pg. 14c (Wdf 7). "There were six regular windows on each side, and in

each of them one of the twelve Apostles," Bl 2:498. Only canopies remain.

Diocese. ms, hours, Fitzwilliam Museum 55, miniatures. c1480. All apostles with books unless stated otherwise: ff 128 Peter; 128v Paul; 129 Andrew; 129v James Maj with "club, and pilgrim's hat"; 130 John with chalice; 131 Philip with halberd (Scott, *Survey* Cat. 135, il no. 493); 131v James Maj "with pilgrim's hat, and stick with scallop shell"; 132 Thomas with spear; 132v Simon; 133 Jude with boat and oar; 133v Matthias with long axe; Scott notes that the set may not derive from one source; James (1895) suggested a rood screen. Note in particular the confusion of the two Jameses.

Pulham S Mary. pg, nVII, complete set with attributes. c1450. **A1** Philip, woven basket with 5 loaves; **A2** ?Bartholomew, clasped book in RH, frag of knife handle in LH; **A3** Matthias, T square over RS, book in draped LH; **A4** Jude; **A5** Simon; **A6** Matthew, ?halberd in LH, and clasped book in draped RH; **B1** James Maj, shell on brim of hat, staff in RH, in draped LH closed book with shell on top; **B2** John; **B3** Peter, 2 keys and open book on draped LH; **B4** Andrew with small cross in RH; **B5** Thomas, clasped book in RH, spear in LH; **B6** James Min, clasped book in RH, bat in LH; restored. Marks attributes work to the Passion Master (196).

— pg, sIII. 15c. **A1** Peter, 2 large keys in RH, clasped book in draped LH; **A2** frag, Andrew; **A3** James Maj, frag of head, staff and shell in a LH; **A4** ?John, hair only; **A6** ?James Min, frag of curved short staff in LH.

Fersfield. *pg, S aisle. "The windows of the isle . . . formerly beautifully adorned with paintings on glass, of the twelve Apostles," Bl 1:105.

Foulden. *pg, chancel. 12 apostles, 3 to a win "standing on pedestals," John with palm and chalice "the most entire," others "generally bearing the instruments of their martyrdom," Bl 6:32.

Garboldisham All Saints. *pg, church delapidated in 18c. 12 Apostles with other saints and confessors; "the windows both of the nave and isle, were chiefly painted glass, and very well done but were all broken to

pieces," Bl 1:268.

Lyng. *pg, S win. "St. Peter & the other Apostles in order," NRO Rye 17, 3:45.

Swardeston. *pg. There "were the effigies of 12 apostles and some of which still remain," Bl 5:54.

Wiggenhall S Mary. *pg, N clerestory. ?16[1] (Batcock). Apostles in sets of 3; work cited as broken in 1730; (above 4th arch) Simon, Jude, and Matthias; (3rd) Philip, Bartholomew, and Matthew; (2nd) John, Thomas, and James Maj; (1st) Peter and Andrew; "in the upper window over the fifth arch, on the N side is the figure of our Saviour, &c." (Bl 9:180). Perhaps James Min was mistaken for James Maj, who could have been in the first win with Peter and Andrew. At NII a 16c youthful head, thought by Batcock to be a remaining apostle.

Norwich All Saints. sc, font bowl. 1458. "Bequest to emendation" (C & C). On each face paired apostles, book in one hand, attribute in other. Reading counter-clockwise: Peter and Paul; John Bapt and John Ev with palm; James Maj and apostle with ?saw; Andrew and John with chalice; Thomas and Bartholomew with sword; Jude (holding boat vertically with the keel against his body) and Simon (oar); Philip with tau cross and Matthew; Michael and George; Spencer and Kent il p 33; Gardner fig 524. On stem pedestals 8 standing figs of such regularity as to cast doubt on their origin; Williamson (1961) identified symbols but commented "There has clearly been some restoration of the figs and bases of pedestals." Now at S Julian. In addition to the bowl figs, Bl noted "many saints and confessors carved on it . . . , " Bl 4:133. For differing identifications, see Appendix IV.4.

Norwich S James. sc, font bowl. 15[3] (from the same workshop as font at All Saints). On each face paired apostles, book in one hand, attribute in other. Reading clockwise from the N face: Peter and Paul; James Maj with fur gown and James Min; John Bapt and John Ev (chalice missing); Andrew and Philip with tau cross; Leonard and ?William; Matthias and Matthew (sword and halberd); Bartholomew and Thomas; Simon and Jude (boat held vertically). Now at S Mary Magdalene. See Appendix IV.4. Fur

coats were worn by pilgrims (Piponnier and Mane fig 2).

Stalham. sc, font bowl. 15³. 2 apostles on each of 6 faces of the bowl, each in buttoned tunic with mantle, holding a long vertical scroll. Reading clockwise Peter and Andrew; James Maj and John with palm; Thomas and James Min; Baptism of Christ; Bartholomew and Matthias (square); Simon and ?Matthew with sword; Jude with oar and apostle with forked stick; Trinity; Cautley il p 131.

Watlington. sc, font bowl. 15³ (Cautley, 14c; Pevsner early 16c). 2 figs on each panel, apostles with ?doctors. Peter and ?Paul (titular saints); Matthew (halberd) and James Maj (staff and chemise-sac); ?Bartholomew and apostle; John and James Min; Simon (with huge fish) and Jude; apostle and Andrew. Double figs seem to have been popular in 15³.The shape of the font bowl is unique in Norfolk, Cautley il p 126.

Norwich S Helen. sc, bosses, S transept. c1480. Outer ring of bosses, 12 apostles incl Paul with attributes and name scrolls (flowers at 14 & 22). **11** Andrew, **12** Peter, **13** Paul, **15** James Maj, **16** John, **17** Thomas, **19** Matthew, attribute lost, **20** Bartholomew, attribute lost, **21** James Min, **23** Simon with boat, **24** Matthias with fish, **25** Philip with tau cross. See Appendix IV.4.

Cathedral. *sc, flying buttress supports, presbytery. c1472. 19c copies, Sekules (1996) 208.

Necton. wdcarv, clerestory wall posts. c1450 (Haward 1999). 18 canopied figs. **N1** Bartholomew clasped book in RH, with knife in LH; **N2** Simon with fish in both hands; **N3** James Maj with book on palm on LH, wallet hanging from staff (Haward il N3); **N4** Christ, divided beard, tau orb with rising cross in LH, RH blessing; **N5** Peter; **N6** Philip, RH blessing, basket with loaves in LH; **N7** Thomas; **S1** Andrew with small cross; **S2** Jude, unrigged boat in both hands, RH; **S3** John; **S4** Virgin; **S5** Paul, sword in LH; **S6** James Min, bat in RH, book held by spine; **S7** Matthew. **N8–9** and **S8–9** identical, bp in full pontificals and a fig with a hat and scroll (?prophet). Recent repainting leaves Christ a startling blond; hair originally gilt (Bl 6:49). Cf the Car-

brooke roof.

Tilney All Saints. wdcarv, nave wall posts, worn. 15c. **N1** Peter, **N2** Andrew, **N3** James Maj, **N4** James Min, **N5** Jude, **N6** ?Bartholomew; **S1** Paul, **S3** Philip, loaves on draped hand, **S4** Simon, **S5** apostle holding book.

Swaffham. wdcarv, double hammerbeam roof. c1475 (Haward 1999). Lower rank, angels bearing arms: **N7** swords saltire, **N9** scallop shell, **N10** knife, **N11** cross saltire, **N12** basket, **N13** boat, **N14** fish; **S7** keys saltire, **S9** fuller's bat, **S10** spears saltire, **S11** chalice, **S12** axe, **S13** T square. Haward il pp 146–77. Restored but angels largely original. In S porch angels bear arms of Peter, Paul, Andrew, and George.

Emneth. wdcarv, wall posts, ?11 apostles. 15c. **N2** Peter with 2 keys; **N3** Andrew; **N4** James Maj, staff with spiked end; **N5** John; **N6** Jude; **N7** ?fish; **S2** Philip with 3 loaves; **S3** Bartholomew; **S5** Matthew, small halberd and book on draped RH; **S6** James Min; **S7** ?John Bapt; **S4** Michael; **S1** Edmund (dedication); **N1** illegible.

Gissing. wdcarv, wall posts, nave. ?15³ (Haward). The 14 wall post figs are much worn today, and at some time were truncated for win enlargement, but it seems likely that the 12 apostles were represented, and the restorers clearly so interpreted the figs; **S5** holds a fish. The lower bank of restored angels have elaborate shields (restored) with typical attributes for apostles, incl crossed keys, staff and wallet, cross saltire, knife, basket; spears saltire, serpent in cup, halberds saltire, money bag, swords saltire.

W Lynn. wdcarv. wall posts, 14 figs, angels above. 15c. **S1** ?Peter, **S2** Paul (angel with crossed swords), **S3** John, **S4** Philip with loaves on arm, **S5** Jude, **S6** Andrew, **S7** indecipherable, **N1** apostle with saw, **N2** Peter (angel with crossed keys above), **N3** James Maj, **N4** James Min, **N5** Simon, **N6** Matthew holding money bag, **N7** ?Thomas.

Walsoken. wdcarv. wall posts, polychromed. 15c. Probably a full set with king and lay fig to complete the remaining wall posts. Except for Jude, James Maj, John, and Philip with loaves stacked in his LH (**N2, N5, S3, S7**), distinctive attributes are missing or difficult to interpret unequivocally; most with book.

Wolferton? wdcarv, wallpost figs under cano-

pies, 6 apostles on either side of nave. ?15c (new chancel roof following 1486 fire). ?Peter as pope in NE corner; James Maj the only other clear attribute. All deteriorated; roof replaced 19c; so heavily restored "it is difficult to say what is original," Cautley.

Carbrooke. *wdcarv. 15c. Roof "adorned with images of our Saviour and his Apostles, all of which were demolished in the time of the Usurpation," Bl 2:336. Angels remain on false hammerbeam roof.

Norwich SPM. *altar cloth 16¹, "wt dy*verse* seyn*ttes* gold and in the frontell the xij appostell*es* hedd*es* And longith to or lady auter," Hope (1901) 220.

— *processional cross. 16¹. 2 blue enamel crosses with 12 apostles below, Hope (1901) 207.

N Buckenham. sc, nave corbels. ?1524/8 (donations, C & C). 10 apostles with attributes, David and angels. **N2** Matthew, **N3** Jude with rigged boat, **N4** Simon with fish, **N6** apostle with closed book, hand blessing, **N7** James Min, ?upper end of fuller's bat; **N8** apostle with cross; **S2** Peter with 2 keys, **S3** John, **S4** Andrew, **S5** David, **S6** Thomas, **S7** James Maj, **S8** angel writing in book. Major restoration 1879; Wilson (P & W 2) labels the 1968 restoration "inexpert."

Apostle Screens

Partial sets are included. See also XIII.1.

Edingthorpe. Early 15c (Wilson, P & W 1). 6 apostles. **N1** Bartholomew; **N2** Andrew, small cross, ?book in RH; **N3** Peter, uncrossed keys, book in draped LH; **S1** Paul, grounded sword, clasped book in RH; **S2** John, palm in LH, clasped book in RH; **S3** James Maj, scallop shell held vertically at tip of fingers, hat against shoulders, tie over chest, wallet and staff in LH. Width of chancel opening allows for only 6 panes; *900 Years* color il p 69.

Castle Acre. c1440 (DP, P & W 2; formerly dated 1410–20 [L & M 39–40]). 12 apostles standing on greensward, mantles typically envelop bodies; except James Maj, all apostles with attributes hold them in LH. **N1** Philip demi-profile, light beard, 3 loaves on draped LH, RH pointing toward next apostle; **N2** James Min in demi-profile, closed book in draped RH, bat in LH, curved end up; **N3** Matthew beardless, RH

pointing to halberd in LH; **N4** Jude/?Simon, profile, facing and pointing to **N3**; **N5** John; **N6** James Maj, massive staff in RH, wearing hat with scallop shell on turned-back brim; **S1** Peter, crossed keys, closed book in draped RH, L fore-leg bare, mantle turned back over RS to create collar; **S2** Andrew short cross saltire, RH blessing; **S3** Bartholomew; **S4** Thomas; **S5** Matthias, beardless youth, RH pointing to massive grounded sword held by LH; **S6** Simon/?Jude, clasped book in draped LH, RH blessing, defaced.

Swafield. 1454 bequest to emend perke (Cotton). 8 apostles. **N1** Andrew, clasped book in LH; **N2** Peter, church with central tower in draped RH, key in LH; **N3** Jude, boat in both hands; **N4** Simon, 2 fish in RH; **S1** James Maj, staff over RS, wallet hung from LS; book against breast, no hat; **S2** John; **S3** Thomas, clasped book in LH; **S4** James Min, clasped book in RH.

Ranworth. 15³. 12 apostles incl Paul; counterchanged pavement; names in vocative case below; elaborate damask gowns with pomegranate and animal design based on Italian design (Plummer, 1979); mantles turned back to form collars at N1, 3, 6 and S4, 6. **N1** Simon, LH pointing to fish in draped RH; **N2** Thomas; **N3** Bartholomew, clasped book with gold cover in LH; **N4** James Maj, staff in RH, eyelets on wallet belt, scallop shell on tasseled wallet flap and gown, clasped book in LH; **N5** Andrew, purse at belt, large cross saltire; **N6** Peter, 2 keys, open book with minim writing in draped LH; **S1** Paul, bald, sword in RH, held diagonally over book and against LS, closed book in draped LH; **S2** John; **S3** Philip, woven basket with 3 loaves, RH blessing; mantle turned back over head; **S4** James Min; **S5** Jude, boat in both hands, LH draped, RH supporting prow; **S6** S*ancte* mathee (vocative), broad sword in LH. N side, Duffy fig 56; Winter drawings in Bond (1914); partial view, P & W 1 fig 52. Wide range in modeling of hands not holding attribute. Restored 1965–69, Pauline Plummer. For dating, see Appendix VI.

Hunstanton. 15³. 12 apostles incl Paul; all in elaborate gold damask gowns, counterchanged pavement; wide range of haloes; names in nominative case on register below, some

defaced on N side. **N1** Jude, unrigged boat in RH, closed book in L; **N2** ?Simon, both hands together, attribute now obliterated; **S3** James Min, clasped book in RH, LH with bat held diagonally; **N4**, "Mathias" with grounded sword, holding mantle with LH; **N5** Bartholomew; **N6** Peter, key in RH, open unclasped book in draped LH, leaves riffled; **S1** Paul, sword resting on clasped book in draped LH; **S2** John, massive chalice resting on L palm, eagle in damask design of gown at breast level; **S3** James Maj, staff in LH, 4 scallop shells on wallet hanging over LS, no hat; **S4** Andrew, waist-high cross; **S5** Philip, LH holding tiered, woven basket with 3 loaves, open book in RH supported on palm with fingers over edges; **S6** Thomas, clasped book on palm of RH. Screen removed 1857, returned 1892.

Pulham S Mary. Mid 15c (Wilson, P & W 2). 10 Apostles. **N1** barefoot fig; **N2** barefoot fig; **N3** Jude, boat in both hands; **N4** Simon, fish in LH; **N5** James Maj, staff in LH, shell in RH, hat on shoulders; **N6** Peter, clasped book in LH; **S1** Andrew, small cross, clasped book in draped LH; **S2** John; **S3** barefoot fig; **S4** James Min, bat in both hands, club end at shoulder height; other panes illegible. Poor condition but Wilson noted "quite good" quality.

Lessingham. ?15³. Originally 12 apostles. Section **A 2** Matthew with halberd in RH; **3** Simon, fish in palm of RH, LH blessing; **4** James Maj, staff and wallet in LH; **5** Andrew, large cross, RH holding open book with clasp, **FIG 24**. Section **B 4** Philip, bread in RH; **5** Jude, boat in both hands; **6** James Min; L & M Cat. 92. The screen has been variously dated; King (L & M 45) conjectured an early date, but there are strong similarities to the Pulham screen. The quality of the apostles is markedly superior to that of the virgin saints on the doors (see XII *Apollonia*). Now NMS. See also XI.3.

N Walsham. c1470. 12 apostles incl Paul (18 panes, see also IV.2 *Annunciation* and XII). **N5** Jude; **N6** Simon, open book in LH; **N7** Philip, RH pointing to woven basket in LH, multiple loaves of bread; purse hanging from belt; **N8** Thomas; **N9** James Maj, staff in RH, holding wallet with scallop shell in

LH; **N10** Peter, nearly obliterated; in spandrels above 2 tiny mitred heads; **S1** Paul, LH with grounded sword, book in draped RH; **S2** Andrew, thigh-high cross; book supported by both hands; **S3** John (palm and chalice); **S4** Matthew, money bag in raised LH; **S5** Bartholomew, holding cloak with RH; **S6** James Min, RH raised, curved end of bat over shoulder.

Swanton Abbot. 15³, restored initials of incumbent (1433–77). Panels facing the east (described L to R), with Andrew and Peter out of order; "shocking restoration" (Cautley). 12 apostles. **S1** Andrew; **S2** Peter with church supported on palm of LH, key(s) in RH; **S3** John; **S4** James Maj, wallet strap wound on staff, shell on wallet, large hat on back; **S5** Jude; **S6** Simon, 3 fish in LH supported on R forearm; **N1** Bartholomew; **N2** Matthew, halberd in RH; **N3** James Min; **N4** Philip, flat bottomed woven basket with loaves in RH; **N5** Matthias, long square held by LH, clasped book in draped RH; **N6** Thomas.

Carleton Rode. 15³⁻⁴ (bequest to roodloft 1476). 12 apostles incl Paul; all bearded except Peter and John; all with books except Jude, John, Paul, James Min. **N1** Simon, with fish; **N2** Jude, boat resting on draped LH, prow supported by RH; **N3** Thomas; **N4** Bartholomew, knife with gold fittings; **N5** John; **N6** Paul, sword held vertically against RS, book on draped LH; **S1** Peter, crossed keys in RH, clasped red book in LH; **S2** Andrew, waist-high cross; **S3** James Maj, long staff in RH, wallet (shell partially visible) hung diagonally from RS, tie for hat; **S4** James Min, bat held diagonally in LH, RH raised; **S5** Philip, LH holding woven stemmed basket with loaves of bread, clasped book in RH; **S6** Matthew, broad grounded sword in LH, clasped book in RH; screen restored by Tristram 1937; Duffy fig 57.

Westwick. ?15³ (extensive gifts to tower). 12 apostles incl Paul. **N1** Jude, holding mantle with LH; mantle turned back to create collar; **N2** Simon, fish in RH, LH elevated; **N3** Matthew, halberd in RH, LH at breast; **N4** James Maj, pointed staff in LH, clasped book in RH; wallet with shell on flap hung from LS; furry hat at back; **N5** John, mantle folded back to create collar; **N6** Paul,

clasped book in RH; sword in LH, thumb in foremost position; **S1** Peter, no beard, usual hair style, youthful face; 2 keys uncrossed in LH; open book with writing in draped RH; **S2** Andrew, mantle folded to create collar; **S3** Thomas, spear held diagonally in RH, clasped book in LH; **S4** James Min, bat in RH, mantle folded to create collar; **S5** Philip, in RH woven basket containing ?4 loaves, LH elevated; **S6** Bartholomew. Screen over-restored.

Middleton. ?15^{3-4}. 1463 bequest for partition at Trinity altar (C & C). Section of screen in chancel; overpainted with remains of original (Plummer): Jude, James Maj, Matthias with T square; Thomas.

Tunstead. 15^4 (perke new in 1470; bequests 1470–90, Cotton). 16 figs: Latin Doctors & 12 apostles incl Paul; minor defacement, names in vocative case inscr below; doctors flanking at **N1–2** and **S7–8**. **N3** "Mathiee" with halberd (Appendix IV.4); **N4** Bartholomew; **N5** Simon, RH holding 2 fish by tails, their heads resting on draped LH; **N6** Jude, boat with castle on R forearm, steadied with LH; **N7** Thomas, spear steadied with R wrist, open book in draped LH; **N8** Paul, sword over RS, LH securing mantle against waist; **S1** Peter, RH holding key horizontally, wards pointed towards Andrew, open book held against chest with LH; **S2** Andrew, small cross saltire; **S3** James Maj, short staff in LH over LS, scallop shell hanging by cord from knob of staff, no wallet; at RS hat with scallop shell, knotted tie in front; fur-lined mantle caught at RS with large morse; **S4** John, LH blessing; **S5** Philip, RH holding woven basket with lipped base containing 3 (?4) loaves, LH raised, third finger touching the thumb; **S6** James Min.

Cawston. N1–8. 1490 (Bl 6:266); further bequests 1492–1504 (Cotton). 16 figs against cloth of honor with gesso band incl 12 apostles + Paul in gold damask gowns and 3 saints. **N1** Agnes; **N2** Helen; **N3** Thomas, clasped book in LH; **N4** John (palm and chalice); **N5** James Maj, gray hair & beard; small purse with scallop shell tied to massive staff in RH, large scallop shell in draped LH; fur-lined mantle; **N6** Andrew, clasped book in RH, small cross; **N7** Paul, RH holding hilt of massive grounded

sword, clasped book held against breast by LH (Rickert pl 191); **N8** Peter, full tonsure, in draped RH open book inscr "Quod habeo hoc tibi do," 2 keys in LH; **S1** James Min, resting both hands on short bat; **S2** Bartholomew, LH holding scroll with dot writing, mantle draped over head; **S3** Philip, body in full profile, head turned to face spectator, small red book with minim writing in LH, tips of R fingers touching one lobe of a three-lobed bread (Rickert pl 191); **S4** Jude, head in nearly perfect profile; boat on LA, supported by both hands (Strange, color pl of **S3** and **4** facing p 81); **S5** Simon, partially open book on L forearm, oar in RH; **S6** Matthew, ¾ profile, adjusting spectacles with RH, holding open book in LH, hollow barrel-shaped collecting pot with chain at his feet; **S7** Matthias, clasped book held by spine in palm of RH, halberd in LH; **S8** John Schorne. Three artists: N1–8 and S1–2; doors (see XI.3); S3–S8 (see also Joan Evans in "Report 1949" 100). Screen cleaned and restored 1952. I am grateful to Tony Sims for confirming that Matthew's attribute is not an ape's clog; he cites a letter from the Norfolk Herald Extraordinary, College of Arms.

Belaugh. Late 15c. 12 figs incl John Bapt and Paul in ermine-lined mantles. **N1** James Min; **N2** Philip, 3 loaves in woven basket with twisted handle, LH raised; **N3** Thomas; **N4** Bartholomew; **N5** John Bapt, apostle gown, ermine-lined mantle, LH pointing to nimbed Agnus Dei, no pennon; **N6** Peter, draped LH holding open book; key in RH; **S1** Paul, RH holding grounded sword by hilt, LH supporting clasped book (good binding detail) resting on draped forearm; **S2** John; **S3** Andrew, chest-high cross (raguly) in RH; **S4** James Maj, scallop shell held aloft in RH, LH holding staff with wallet attached, hat at back against RS, ermine-lined mantle; **S5** Simon with 2 fish in draped RH; **S6** Jude, boat in both hands. Generally defaced; Cautley thought the color untouched.

Blofield. Late 15c. 12 apostles. **N1** Matthias with short-handled axe held in RH; **N2** James Min, curved end of bat over shoulder, book; **N3** Thomas; **N4** John; **N5** James Maj, closed book on R palm, wallet with

scallop shell depending from staff; **N6** Andrew, short cross, closed book; **S1** Peter, 2 keys in LH, in RH open book with writing ?with chemise binding; **S2** Philip, closed book in LH, in RH stemmed woven basket with 3 loaves; **S3** Bartholomew, knife in RH, closed book on draped LH, mantle closed with tie; **S4** Matthew, halberd held diagonally in LH, closed book on palm of RH; **S5** Jude, rigged boat on R palm, supported by LH; **S6** Simon holding fish vertically in both hands, mantle closed with a tie; heavily restored 19c; DT 53:174 (Peter), 175 (Bartholomew); 176 (apostle with halberd); 177 (Andrew).

Irstead. Late 15c. 12 apostles grouped in threes. **N1** James Min, RH pointing to bat; Thomas, clasped book in RH; James Maj, clasped book in draped LH, fur hat at back of shoulders; wallet, with large scallop shell on the front, wound on staff held in LH; in 1856 "Scs Jacobus" written on staff (DT 56:10); **N2** John; Andrew with waist-high cross; Peter, clasped book in draped LH, 2 keys held diagonally over shoulder; **S1** Philip, round basket in LH, RH pointing toward Bartholomew; Bartholomew, clasped book in draped LH; Matthew with halberd in LH, RH pointing thereto; **S2**, Jude, clasped book in LH; Simon, fish in draped RH, LH raised palm out; Matthias, damaged, book in RH, T-square in LH (DT 56:21). Atypical stenciled background; mantles typically folded back to create collars.

Lynn All Saints. Late 15c. 6 apostles. **N1** Bartholomew; **N2** Matthew with halberd; **N3** Philip, 3 loaves, each marked with 3 red lines; **N4** Thomas; **N5** James Maj staff in LH, holding open book, rubricated capitals, minim writing, hat on RS with cord and tassel on breast, mantle with scallop shells; **N6** Peter. All standing on pedestals. The other apostles were recorded in the 19c, incl Matthias with T square; "in 1847 entirely gone," DT 56:109.

Redenhall. 15c. 12 apostles incl Paul, all on pedestals, hexfoil raised design on mantle borders and hems. **N1** Simon ?oar in RH, clasped book in LH; **N2** Matthew with halberd; **N3** Philip, 3 loaves in palm in LH; **N4** Thomas; **N5** James Maj, no shell visible, closed book on R palm, staff in LH; **N6**

John; **S1** James Min; **S2** Andrew, large cross, supported by both hands; **S3** Paul, grounded sword held diagonally by LH; **S4** Bartholomew, on LH open book with minim writing, chemise binding with tassels; **S5** Jude; **S6** Peter, large key held upright in RH with smaller key depending, closed book in LH. Overpainted.

Walpole S Peter. 16[1]. 6 apostles incl Paul flanked by virgin saints. **N4** John, RH blessing; **N5** James Maj, clasped book in draped LH, staff in RH; small wallet with shell hanging from strap; belted fur gown, brimmed hat with shell on crown; **N6** Thomas in profile; **S1** Peter, crossed keys in LH, clasped book in crook of RA; ?second book beneath keys; **S2** Paul, raised sword in RH, book on draped LH; **S3** Andrew, large cross in both hands. Standing on counterchanged pavement.

Aylsham. Against cloth of honor held by demi-angels; gesso decoration, 16 figs incl John Bapt, Paul, and 2 donors. N 5–8, S1–2, late 15c; N1–4, S3–8 painted on parchment, early 16c (DP in P & W 1); screen gilded before 1507 (donor inscription). **N1** donor, layman wearing ?chaperon, in contrapposto; **N2** Thomas; **N3** donor wearing ?chaperon, roll in RH; **N4** James Min, leaning on bat; **N5** apostle with unusual beard, book in LH, staff in RH ?Matthias; **N6** James Maj, plain staff in LH, small purse with shell, hat with turned-back brim decorated with shell; **N7** John Bapt, damask gown, pink-lined mantle; with nimbed Agnus Dei (no cross-staff); **N8** Peter, clasped book in palm of RH, 2 large keys held at waist with wards at shoulder height; **S1** Paul, sheathed sword in LH with tip resting at shoulder; **S2** disfigured apostle ?John; **S3** Andrew, in demi-profile, cross held at crossing with both hands; **S4** Philip with tau cross; **S5** Simon, demi-profile, fish in both hands; **S6** Jude, profile, oar with wide blade up (cf Cawston); **S7** Matthew, in profile with halberd; **S8** Bartholomew, open book in LH. Extensive defacement. Constable (147 fn) noted the position of S Thomas next to his donor namesake, Thomas Wymer. "The paintings are by at least two hands, and the most accomplished are very Flemish in style," David Park in P & W 1.

Trunch. 1502 inscr. 12 apostles incl Paul against cloth of honor (3-dimensional at S1–2); general defacement. **N1** Thomas, clasped book; **N2** Philip, 3 round loaves in LH; **N3** James Min, open book in LH; **N4** Matthew with halberd; **N5** James Maj, scallop shell in LH, RH holding mantle with RH, no other attributes; **N6** Peter, 2 keys held diagonally in RH, open book with red margins and first clause of the Creed; **S1** Paul, chest-high grounded sword, book in clasped case in draped RH; **S2** Andrew, hip-high cross; **S3** John (palm and chalice); **S4** Jude, boat on palm of LH, supported with RH; **S5** Simon, spine of closed book held horizontally in RH, LH holding fish by tail, fish resting against upper fore edge of leaves; **S6** Bartholomew, clasped book in crook of LA.

Marsham. 1503–9 (bequests to paint and gild, Cotton). 16 panes: 12 apostles incl Paul against cloth of honor with gesso band. **N1** constituent scene missing; **N2** Faith; **N3** James Min, resting both hands on bat; **N4** Thomas; **N5** James Maj, staff in RH, LH holding mantle, no other typical attributes; **N6** John; **N7** Andrew holding one bar of large cross with both hands; **N8** Peter, 2 crossed keys in RH, open book held on L forearm, full head of gray hair; **S1** Paul, open book on palm of LH, RH modeled to have held hilt of sword; **S2** Philip, wicker basket in RH, no discernible loaves; **S3** apostle with closed book under LA, enormous sleeve with no hand visible, RH in holding gesture; **S4** Matthew in profile holding open book in both hands (cf Cawston); **S5** apostle holding mantle with LH, RH clenched and extended; **S6** LH extended toward S5, RH clenched and extended; **S7** bp in cope and open book with minim writing (?Latin Doctor); **S8** constituent scene missing. Restored 1939. If Creed order is applicable, S3 would be Bartholomew, with Matthew following as at Mattishall; S5 & 6 would have been Simon and Jude or vice versa.

Worstead. Against cloth of honor with gesso band and elaborate diaper work; 16 figs by 5 different hands (see also XII); 12 apostles. 1512 inscr. N1–2 19c. **N3** James Min, beardless; **N4** Philip, beardless, open book with pages riffled in LH, miniature basket in LH; **N5** Simon, holding fish in RH against book held by LH (copied from Lucas van Leyden model, John Mitchell in Moore, Cat. 2); **N6** Jude, LH holding boat with castle; **N7** Matthew holding money bag in RH, LH raised; **N8** John; **S1** Andrew, profile, holding open book by both hands; unusual position of cross behind Andrew resting under LA with one piece rising behind head; also unusual dress, coat with sleeve hole, ?chaperon on back; **S2** Peter, open book held in both hands, one key resting vertically against book betw fingers of LH; **S3** James Maj holding shell upright in LH, staff in RH; hat at back but attached by thong to staff, wallet hanging diagonally from shoulder; **S4** Thomas, spear in crook of LA; mantle turned back to create collar; book resting against RA held open by both hands, inscr with rubrics and black letters; "Beat*us* non vider*unt* et qui [cre]diderunt"; **S5** Bartholomew, open book with minim writing in RH; **S6** apostle, in contrapposto, holding open book and cross-staff ("Jerome" inscr below); **S7** William; **S8** Uncumber. (Below) names crudely entered, probably during one of the radical 19c restorations. For the complicated history of this screen, see Camm 273–4 and Mitchell 377–80.

Beeston Regis. 16[1] (bequest for rood renewal 1519). 12 apostles. **N1** Simon, saw in LH, clasped book in RH; **N2** apostle with grounded sword in RH; **N3** James Min, clasped book on draped LH; **N4** Jude, boat held in both hands; **N5** James Maj, shell on brim of hat, buckled wallet attached to L-shaped handle on staff; shoes, traces of fur on belted gown; **N6** Andrew, large cross, clasped book; **S1** Peter, one key, open book with writing in draped LH; **S2** John, chalice on clasped book in LH; **S3** Bartholomew, clasped book in draped LH; **S4** apostle with short halberd held diagonally in LH; **S5** Philip, 3 loaves in LH, RH raised; **S6** Thomas in profile. Over restored.

Beighton. *pwd, screen. "Rood screen with panel paintings of Saints and Apostles. Removed," Keyser.

Deopham. *pwd, screen. "*Sancte* tadee *Sancte* Toma *Sancte* Iuda. *Sancte* Iacobe *Sancte* Johes. *Sancte* Andrea / *Sancte* petre *Sancte* Iabcobe *Sancte* philippe *Sancte* Symon.

Sancte Bartholomee *Sancte* mathee," NRO, Rye 17, 2:13. Curious duplication of Jude Thadeus, perhaps mistranscribed, but see Appendix IV.4.

Kenninghall. *pwd, screen. "Paintings of the Apostles on the panels," Keyser. Bl recorded a number of donor portraits on the chancel and chantry screens, 1:242.

Neatishead. *pwd, screen. "On the screens are painted the apostles," Bl 11:51. Probably destroyed when nave demolished in 1790.

Acle. ?screen. 1555. "Item payed . . . for payntyn . . . the xii apostylls," NRO, Rye 17, 1:10. The entry follows payments for restoration of perke with rood figures.

Hope (1895a, 106) records an altar of the Apostles at Castle Acre Priory.

2. Partial Sets

Unless stated otherwise, generic descriptions apply.

Cathedral. pg, nVII, lights a and c. c1300. Matthew and Thomas (with 15c heads), each with name scroll. See also XII *Barnabas*. Original provenance uncertain.

Kimberley. pg, E win, tracery lights not *in situ*. 14^4. **3a** John; **3b** Andrew; ?John Bapt; **3c** apostle with cross; **3d** Bartholomew; a larger apostle, ?John with ?palm. The glass is dark and difficult to read.

Fring. wp frag. c1330. S wall adjacent to E wall, saint with palm and book; on splays of adjacent win "slight remains of similar figures within niches," one with bare foot and portion of staff, "probably . . . an Apostle," Tristram 174. Wilson (P & W 2) identified fig with a palm as John Ev, Tristram thought a female.

Rougham. wdcarv, set against S chancel wall (not *in situ*). 14c. Frieze, 6 apostles incl James Maj and John alternate with smaller angels. Pevsner (2) queried whether part of a reredos.

Norwich. al, part of *Te Deum* composition. 15c. Peter with book and key; Paul with book and grounded sword; Andrew with tall cross saltire; John with palm and book on draped RH; Bensly, 357–8; Nelson (1917) 116; L & M Cat. 86. NMS; for provenance, see Appendix VIII.

Lyng. emb orphreys. c1480. Apostles/prophets in arcades; used as borders in altar frontal, incl Paul with sword over shoulder and John with chalice; DT 33:185.

Gt Bircham. emb orphreys. c1480. Orphreys cut down the middle and used to form 2 borders of an altar fontal. The half-figures match with some loss; Paul's sword preserved, other apostles with books. NMS.

Colby. pg, E win, 2 sets (frag, not *in situ*, leaded 1825). 15^{1-2} (King 17). Main lights, large figs, against cloth of honor with floral design: **1a** James Maj (?alien head, no hat), wallet hanging below hips by long strap, staff in LH, garment with fur design; **2b** Peter, key in LH, clasped book in R; **1c** John, palm in LH, chalice and serpent on palm of RH. Tracery set, against cloth of honor with coin design at base. **A1** Peter, 2 keys in LH; **A2** John; **A3** frag, Simon, vertical fish in LH; **A4** Andrew, large cross in LH, RH with clasped book; **A5** Thomas, spear in RH, book in LH.

Gt Massingham. pg, against a 3-dimensional screen. c1450. **sII.A1** Peter with 2 keys and book; **A2** apostle with ?chemise-sac; **A3** James Min; **A4** Bartholomew, knife in RH, book in LH; **nIII.A1** Matthew with halberd; **A2** Simon, fish held on top of book in draped hand; **A3** Jude; **A4** Matthias with long square; A3 & 4, Wdf pl XXXIX. Bodies well preserved, some destruction to heads.

Norwich Guildhall. pg, E win. c1450. Against 3-quarter, 3-dimensional screen; **4a** Bartholomew; **4b** Thomas; **4c** Philip; **4d** apostle; Kent (n.d.) il facing 18; same screen design at Gt Massingham.

Wiggenhall S Mary Magdalene. pg, nIV, names. c1450. **A1** *Sanctus* paulus (composite with bald head, tippet and hood over patterned gown, holding ?cane), Keyser (1907b), pl 12; **A2** *Sanctus* petrus; **A3** *Sanctus* iohs; *Sanctus* t[homas]. No trace of apostle figs whose names are attached to ecclesiastics; glass restored 1924–5 (Cotton and Tricker).

Stody. pg, nV. 1440–50 (King personal communication). Standing on counterchanged pavement, set against 3-dimensional screens. **A1** Philip, woven basket with 3 loaves; **A2** Bartholomew, knife held in RH, clasped book in LH; **A3** Matthew with halberd, LH raised, palm out; **A4–5** Coronation; **A6** Simon, fish in LH, its head resting on top of closed book in draped RH; **A7** Jude; **A8** Matthias with T square. The

matching win opposite probably held the other 6 apostles. See XIII *Edmund* for a matching set of kings and prophet/patriarchs.

Weston Longville. pg, sV. c1460. **A3** James Maj with staff and fur garment decorated with whelks. (King [20] cites same model at Norwich SPH; whelks are also found in alabasters, Cheetham Cat. 32 & 34–36.) **A4** Philip with basket of loaves in LH and large "Olaf" loaves in RH. **A6** John, restored (King thinks properly so).

Wighton. pg, nIV. 1460–80. **A1** Peter, full tonsure, key, closed book in draped hand; **A2** Andrew, small cross saltire, bald head from another composition; **A3** Bartholomew (heavily restored); **A4** apostle with closed book in RH, LH with palm out, pointing down ("St. Paul?" King 13). Restored.

Field Dalling. pg, sV. 15³. Names below in scrolls: **A1** Andrew; **A2** Thomas; **A4** bare feet; **A5** Jude, boat on L forearm, supported with RH; **A6** Philip with woven basket in LH, RH raised; **A7** Bartholomew, knife in LH, closed book in R; **A8** Paul, LH on hilt of grounded sword, book in RH. Mantles of Thomas and Peter decorated with their initials in yellow stain.

Norwich SPH. pg, E win, not *in situ*. 15³ **1a** apostle; prophet or patriarch. **2a** James Maj (bald) hat hung on back by cord, wallet hung from shoulder, shaggy fur garment with long slit sleeves, whelks on gown; Simon; **1c** virgin; apostle. **2c** apostle; Bartholomew.

Guestwick. pg frags in sV and sVII. 15³. Apostle mantles above bare feet; hands with teaching gesture.

Long Stratton. pg, E win, evidence of 2 sets, one larger scale than the other. 15c. **5a** frag James Maj, hand with finger intertwined with cords (of wallet/hat); shell, probably on wallet; **A4** Philip's body, holding basket with multiple loaves, leaded into Coronation scene; **4c** ?John's head; there are other frag bodies and hands with books. Restored 1929.

Shelton. pg frags, sII. **A1** hand with key, patched into angel; **A2** ?John's head patched on bp.

Thuxton. *pg, cited by Wdf (172) without comment; no apostle glass in 1999.

Old Buckenham. *pg."Several broken Saints, Angels, Apostles &c about the windows,"

NRO, Rye 17, 1:167v.

Cawston. *pg, N aisle "had apostles painted, not broken," NRO, Rye 17, 1:204. When Winter drew Thomas (1848), the glass was recorded in the S aisle (NMS B65.235. 951).

Heydon. *pg, N win, "many saints, confessors, martyrs, &c. . . . Peter, Bartholomew, Matthew, Simon, Jude and Ozias," Bl 6:253.

Ormesby S Michael. *pg N win. S Peter, S John. NRO, Rye 17, 3:104v.

Oxborough. *pg, E win, N aisle, "on the summit here have been the effigies of the Apostles. . . . St. Peter, and John the Baptist, are still remaining," Bl 6:183.

E Rudham. *pg, E win. Peter with book and keys; Andrew with green cross, John Ev with Agnus Dei, "on the screen chapel East Window," NRO, Rye 17, 3:157.

N Elmham. pwd. 15³ (1457, major bequest for pulpitum before roodloft, Cotton). 6 apostles incl Paul, in elaborate gold damask gowns with animal patterns, **N3** blank; **N4** Thomas; **N5** Matthew, RH holding grounded sword; **N6** Jude, boat with castles in draped LH, supported by RH; **N7** James Min, open book in LH; **N8** Philip, rectangular woven stemmed basket with multiple loaves; **N9** John holding chalice by base; **N10** Paul, RH holding sword by hilt, blade over shoulder, LH hitched in belt. In the 18c all 12 apostles were cited: "On the skreen dividing the Church from the Chancel are 12 apostles well painted with divers odd figures carved over them," NRO, Rye 17, 2:65v. See XI.3. The panels were once used as flooring, which probably accounts for the loss of the other apostles. For the history of rearrangement, see XII *Agnes*.

Worstead. pwd, screen S aisle 1 and 2. 15³ (early 15c, Camm). Peter, holding 2 uncrossed keys in RH, clasped book in LH; Paul, RH holding sword diagonally across book in LH; at present paired with John Bapt and Stephen on the other side of opening. N aisle 1 and 2. Bartholomew, knife in LH, clasped book in draped RH; Philip, woven basket with stand in RH; multiple loaves of bread; at present paired with Lawrence and bp on N side. Pauline Plummer believes these panels were part of the original rood screen. Extensive rebuilding of the chancel and aisle chapels in the fourth quarter of

the century precipitated a new rood screen, with the old being relegated to the aisles.

Horsham S Faith. pwd, pulpit. 1480. Reading counterclockwise: **5** Andrew, clasped book in LH; waist-high cross resting on floor, held with RH. **6** John Ev, RH blessing, not pointing towards serpent. **7** John Bapt, Agnus Dei supported on forearm, R forelegs raised, unusually large cross-staff; gown hem ending in jagged edge; white-lined mantle.

Repps. *pwd, screen panel. ?1553–8. Thomas, holding sword over shoulder; Andrew; John Ev, chalice and palm; Bartholomew; John Bapt in fur garment, holding full-length resurrection banner, no lamb; DT 59:204–05, 209, 216–17. The watercolors record names below, but script questionable. A comparison of other work done by this watercolorist with extant screens indicates typical difficulty with attributes, often problems with size. The watercolors documented 14 saints, "painted over" by 1854 (59:204). Although North and South Repps are distingished in DT 42, these watercolors are identified only as Repps.

Alderford. sc, font stem. 15¹. Andrew, James Maj, ?Philip, John alternating with female saints.

Binham. sc, font stem. 15³. 8 apostles, all with books: Peter, Andrew, James Min, and John with attributes.

E Dereham. sc, font stem. 15³. ?Andrew, Bartholomew, James Maj, Thomas, James Min, Philip (basket), apostle with short halberd, apostle with roll.

Martham. sc, font stem. c1470. 8 apostles with books: Thomas, ?Paul (sword), Andrew, ?James Maj; a drawing suggests also Peter and John, DT 35:31.

Gt Witchingham. sc, font stem. 15⁴. Perhaps 6 apostles, though only 3 identifiable: Andrew crucified, James Maj, Peter; also arch-bp and Catherine.

Burston. sc, font stem. 15c. Andrew and 4 other figs in apostle mantles alternate with Latin Doctors (Williamson [1961] queried James Min).

Erpingham. sc, font bowl. 15c. Peter with key and book; James with wallet attached to staff; heavily remodeled, but it is likely that at least some of the other figs were originally apostles.

Hockering. sc, font stem. 15c. Peter, Andrew, John Bapt (tail of animal skin betw legs), and 5 other saints. Bowl modern.

Buckenham S Nicholas? sc, font bowl, recut. Peter, Thomas, Erasmus, bp, ?Leonard, Simon, James Min, Bartholomew. Although the general iconography seems medieval, the set is idiosyncratic. Cautley dated the font 14c; Pevsner (1) as "Perp . . . well preserved," and Batcock as a "good 15c font" (50, pl 49). The stemwork, however, is Victorian and the bowl is suspect as well. White's *Directory* (1854) cites a complete renovation of the church, and according to the *Norwich Mercury* (463 [1907] 28) the font was "reworked." Until recently there was a shield font in the Old Rectory garden (removed by a previous owner). I suspect this was the original font.

Burnham Market. sc, relief, tower, W face. 15ᵉˣ. (Reading counterclockwise 3–6) Peter, Andrew, John, James Maj.

N Walsham. wdcarv, screen, N parclose. 15c ("obviously c14" Pevsner 1; "possibly early c15," P & W 1). Small apostles with name scrolls paired in spandrels of screen panels: **N1** Peter and Andrew; **N2** John (palm and chalice) and Matthew with money bag on palm of LH; **N3** Paul and Jude (boat on palm on RH).

Forncett S Peter. wdcarv, be. 15c. Simon and Philip (with basket). Inscription on parapet to SS Peter and Paul.

Gt Walsingham. wdcarv, be, N aisle. Late 15c. Andrew; apostle with saw in both hands; John, James Min; ?Paul; Bartholomew.

Wiggenhall S Germans. wdcarv, nave, figs in be niches. c1500. S2–7 Peter, John, Jude, Andrew (Gardner [1951] fig 12), Simon, and Philip holding 3 round loaves. The facing benchends on the N are uncarved; perhaps a complete set had been planned but not completed. On the L shoulders of the N3–6 are seated figs in apostle mantles with scroll in hand, each paired with an animal. See XIII.3 for shoulder carving above the apostles.

Norwich SPM. *processional cross. 16¹. Staff "in the tope vj apostellis graven & tabernacled," Hope (1901) 210.

Walsoken. sc, font stem. 1544. Peter, John Bapt, ?Paul, and other saints.

3. Paired Apostles

Unless stated otherwise, generic descriptions apply.

James and John

Saxlingham Nethergate. pg, roundel, sII.2a, not
 in situ. Mid 13c. Seated, turned towards
 each other, each holding book up in outer
 hands, inner hands in teaching gesture;
 unnimbed; names in scroll. Perhaps from
 Saxlingham Thorpe; King 15.

Harpley. pg, W win. 15c. **A4** James, wallet with
 shell on flap, hanging from staff in LH; fur
 gown; **A7** John.

Loddon. *reliquary. On front of small wooden
 box, James Maj with scallop shell on turned
 up brim, staff in RH, closed book on
 draped LH; John, chalice in draped RH,
 closed book in LH. Found in a cottage wall
 1839, DT 56:58; origin uncertain.

James Major and James Minor

Norwich S James. *im and guild; double dedica-
 tion cited for S James (Pockthorpe), Bl
 4:423–4.

John the Evangelist
and John the Baptist

See also section 1 *Apostle Screens*. Pairing may reflect
a donor so named.

Weston Longville. wp, flanking chancel arch,
 both standing on pedestals. 14c. (N) John
 Bapt, camelskin garment, with Agnus Dei.
 (S) composite fig, head of Paul, but holding
 John's chalice in RH. A 1979 church guide
 cites the southern fig as "indistinct," so re-
 storation is recent.

?Paston. *im, gilt. 1464. "Sent Jon Vangelist"
 and "Sent Jon Baptist . . . with Lamb,"
 property of John Paston, Gairdner vol 4,
 no. 563.

Boughton. *pg, N aisle. 15c. John Ev; John Bapt,
 shaggy garment beneath; lamb on book in
 draped RH, "ecce Agnus Dei" scroll above;
 male and female donors below, DT 26:75,
 watercolor 1705/6.

Guestwick. *pg, S aisle, Bl 8:219; NRO, Rye 17,
 2:150v. King (23) conjectures a donor so
 named.

Attleborough. pwd, retable. 15³. Against cloth of
 honor, **N1** Nimbed lamb seated on palm of
 LH (no book) looking up into John's face;
 rope belt on camelskin garment; damask
 mantle; **N2** Virgin and Child; **N3** John Ev.

Similar hair style on both Johns. John Rous
left 4 marks to the rood sollar in 1465 (Cot-
ton).

Oxborough. pwd. 15⁴. **N2** RH raised, eagle on L
 shoulder (Oxborough dedicated to S John);
 N3 John Bapt pointing to Agnus Dei; book
 closed with a seal. Screen now at E Dere-
 ham.

Elsing. pwd, screen. Late 15c. **S3** John Ev; **S4**
 John Bapt, Agnus Dei resting on book held
 on LA; red mantle, scroll above (L); both
 panels difficult to read.

Wilton S James. *pwd, screen. "the figure of S
 John the Evangelist, with the Cup, and a
 Dragon issuing out of it and on a Label, 'In
 principio erat Verbum,' under him the
 Pourtraiture of a Man kneeling, and this
 Label, 'Ora pro nobis beate Jacobe'; on a
 third pannel the figure of S John Baptist,
 with a Lamb, &c. and a Label, 'Ecce Agnus
 Dei,' under him the Portraiture of a
 Woman, bidding her Beads, and this Label,
 'Omnes Sancti Apostoli orate pro nobis',"
 Bl 2:175. Blomefield described these pan-
 els as part of "an old Wainscot Partition"
 running the width of the chancel behind the
 communion table. There was another panel
 with 2 priests kneeling at an altar. Although
 the text beneath John suggests an evangelist
 set, the petition from the Litany supports
 the possibility of an apostle screen.

Eaton. *wp, chancel, John Bapt (S wall) opposite
 John Ev (N wall). "Book and cross,"
 probably an Agnus Dei; Boileau, 164,
 drawing betw 162 & 163. See also Keyser.

Catfield? *wp, S wall above arcades, W end,
 martydom scenes; see separate entries.

Lyng. *wdcarv? "old stand for book (broken)
 with St. Johns eagle and Agnus Dei," NRO,
 Rye, 17, 3:44v.

Norwich SPM. *?emb. 16¹, "a nether cloith of
 grene bawdkyn wᵗ ij ymag*es* of sent John
 baptist and John evangelist longyng to Sent
 John is aulter," Hope (1901) 219.

— *pl. 16¹. Bason "wᵗ Crosses in the bottem in
 sone bemies" with John Bapt and John the
 Evangelist, Hope (1901) 213.

Cley. *pg, S aisle. 1502. Bequest for win of the
 John Ev and John Bapt, John Symondes
 requested burial before im and left money
 for a win of the John Ev and John Bapt.
 Perhaps not paired; see XII *Agnes*. (NCC
 Popy 135; I am grateful to Simon Cotton

and Eamon Duffy for this information.)

Peter and Paul

Shared feast 29 June. Paired on either side of the doorway in 11 of the rood screens cited above. Paired attributes are commonplace in titular churches, e.g., the keys saltire and sword in a tile at East Harling (DT 55:212), on the rood screen frieze at Carbrooke, or in the flint flushwork at Griston. The delicately carved angels holding the arms of Peter and Paul formerly at Burlingham S Peter support a joint dedication there.

Diocese. ms, Stowe Breviary, BL Stowe 12, hi, f 261v. c1322–25. With attributes, Peter as pope, Paul in apostle robe.

Thetford Priory 2. pwd, retable. c1335. Flanking Crucifixion, each with RH extended; (L) Peter holding 2 keys in LH; (R) Paul, resting LH on hilt of sword; now at Thornham Parva, Suf; *Age of Chivalry*, Cat. 564.

Gt Walsingham. pg, sII. 14c. Demi-profile heads paired, facing each other; Peter titular saint.

Bergh Apton. al. c1400. Damaged, book on palm of RH, grounded sword; polychrome traces; L & M Cat. 62. Found walled up in a cottage near church dedicated to Peter and Paul; NMS. Cheetham (1970) conjectured that a frag found with Paul was Peter. Church bell inscr "PETRUS AD ETERNE DUCAT NOS PASCUA VITE," L'Estrange (1874) 110.

Sustead. *im. Cited in will, Tanner 86.

Salle. *pg, chancel. 1441. Scenes from life of S Paul & S Peter, N & S sides respectively, King (1979) 335. See section 4

Swaffham. *pcl. 1454 inventory. Frontal for high altar, Peter and Paul flanking the Pietà; Rix 12.

Dickleburgh. *pg, NRO, Rye 17, 2:26.

Filby. pwd, screen. c1471. **N4**, Peter crossed keys in RH, open book with minim writing in LH; mantle folded back to create soft collar; **S1** Paul, sword in LH lying across partially open book in draped RH; book unclasped, nice detail of clasp; dog and goose design on damask gown, same cartoon at Ranworth.

Norwich SPM. sc, bosses S porch. Mid 15c, before 1461 (arms of Henry VI on S porch). Peter in tiara and chasuble, seated on elaborate chair, blessing, LH damaged, flanked by angels. N porch, Paul in chasuble, seated, sword in raised LH, RH blessing.

— *sc. High altar flanked with tabernacles with images, Bl 4:213, 215.

Fakenham. *sc, empty niches (c5' high) either side of W door; titular saints.

Norwich. seal, Walter Lyhert. 1445. Trinity flanked by Peter and Paul, *Index Monasticus* xxxii.

Norwich SPM. *pcl, banners. 16[1], "an old wight baner cloith peynted w[t] sent polle frengid w[t] thred, an other of the same facion of sent peter," Hope (1901) 222; perhaps one of these the "fine silk banner" beqeathed in 1502 (Bl 4:221).

— plate, silver bason, 44 oz. 16[1]. Parcel-gilt "in the myddis of the rose . . . sent petir & polle stondyng graven," Hope (1901) 208.

— pyx. 16[1], "o[r] lady sent peter & pole over the birral," Hope (1901) 212.

Norwich S Peter Parmentergate. *pcl. Inventory, 1552–3, "a lectern cloth of lynen peynted with pet*er* & Poull," Harrod, (1859a) 117.

Linnell cites 40 church dedications; Bond (1914) cited 283 respectively for England. 7 guilds, though some cited as Peter may have had joint dedication, particularly in churches so named.

Philip and James Minor

Shared feast 1 May.

Saxlingham Nethergate. pg, sIII, main lights. 1350–90 (King 15). Light a, Philip, basket in LH, ¾ profile looking towards James; b, James Min, bat in RH. Perhaps from Saxlingham Thorpe, King 25.

Suffield? *pwd, screen (12 panes). c1524 (bequest, Cotton). Philip with 3 loaves in LH; James Maj, shell on hat, staff in RH; Winter's watercolor numbered 1 & 2, NMS 1227.76.94. See also XI.4. Perhaps another instance of the confusion of the 2 Jameses.

Weybridge Priory. printed calendar, NMS 134. 944. 1503. James Min in pilgrim hat; Philip with cross.

Simon and Jude (Thaddeus)

Shared feast 28 October.

Norwich SS Simon & Jude. ?sc over vestry door. (L) fish and ?snake; (R) man rowing in boat, identified as S Simon, Bl 4:356. Cautley thought there were 3 fish entwined as a Trinity symbol, but the reproduction in Muskett (pl 11) does not support that interpretation; sc inaccessible in 1999. Sole Norfolk dedication.

Fritton. pwd, screen, 8 figs incl 2 donors. 16[1] (donor died 1511; bequest to gild perke, 1528, Cotton). **S1** Simon, holding large fish in both hands, S*an*cte Simon behind head; **S2** Jude with unrigged boat.

Wiggenhall S Mary. wdcarv, be, N aisle. 16[1]. **S5** Simon and Jude. At **S6** apostles with saw and axe. There are other apostle figs, but they seem not to form a set (see below Andrew, James Major).

Weybridge Priory. printed calendar, NMS 134.944. 1503. Boat.

Norwich S Andrew. *im. 1528 bequest for tabernacle, Bl 4:305.

In addition to the Norwich parish, there was once a free standing ch (Rawcliffe Map 2), disused c1400 (*Index Monasticus* 70).

4. Individual Apostles

Unless stated otherwise, generic descriptions apply. It is possible that individual apostles are the sole survivors of apostle sets.

Andrew

30 Nov. The cross saltire was used decoratively in churches with his dedication—e.g., at Blo Norton where it is carved on the face of the baptismal font. The Priory at W Acre had a piece of his finger in a silver reliquary, which they at one time pawned for £40 (Bl 9:161).

Martyrdom

Diocese. ms, Wollaton Antiphonal, Nottingham U Library 250, hi, f 303. c1450.

Ranworth. ms, Ranworth Antiphonal, S Helen's Church, hi, f 193v. 1460–80. Martyrdom.

London. pilgrim ampulla. Martyrdom on reverse of ampula, Spencer (1998) Cat. 180.

Horsham S Faith. sc boss, S porch. 15c. Tied to cross, remains of binding on one wrist; 1457 will cites church dedication to S Andrew (Linnell).

Individual

Diocese. ms, hours, NMS 158.926.4f, hi, f 46 (Lauds, *memoriae*). c1310–20.

Horsham S Faith. gilt silver cross ?with relic of cross of S Andrew. 14[3]. An erroneous entry under Horstead cites the relic (struck through), but the parallel entry at Horsham says "ad modum crucis Sancti Andree," not "cum parte crucis," Watkin 1:30.

Bromholm. seal, Priory of S Andrew. Matrix probably 13c. Seated under an arch, holding cross of Bromholm aloft in RH; em-

broidered vestments; (above) a bust of the Virgin with Child in arms; *BM Cat. of Seals*, 2736–39; Wormald pl 6a.

Cathedral. wp, W bay, Ante-Reliquary Ch. c1300. Paired with Paul flanking Peter. Bearded, small cross; blue drapery; Tristram 230.

Brisley. wp, S wall. c1360. Paired with Barthomew (titular saint) flanking larger Christopher, (R) Andrew with small cross and book; DT 53:202.

Themelthorpe. *pg, N chancel. Small fig, NRO, Rye 17, 4:22.

Wellingham. *pg, N win nave, "headless figure of St. Andrew," Carthew 3:432.

Stalham. pwd, screen. Late 15c. Waist-high cross, clasped book. In a 19c watercolor (DT 44:161, 162) Edward and Edmund precede Andrew and a paired archbp; the restoration reverses the order of the 2 pairs. Restored 1961, hung on S chancel wall.

Barton Bendish S Andrew. sc, relief, niche above S porch entry. 15c. Wearing ?mitre, eroded cross saltire in hand; 1539 "painted of St Andrew," John Bishop, NCC Godsalve 220 (Cotton, personal communication).

Brinton. sc, statue. ?15c. Discovered 1871 in plastered exterior niche.

Reepham. sc, head of ?churchyard cross. Paired with Michael.

Fersfield. *wp. Andrew "painted on the wall over north door, though now whited over," Bl 1:102; titular saint.

Harpley. wdcarv, arm rest, 18" high, N aisle. ?Late 15c. Short cross in RH, clasped book in palm of LH. Unusual style. There are 3 such arm rests, one a bp (with restored head); see also James Maj.

Wiggenhall S Mary. wdcarv, be, nave S4. 15c. Paired with a woman holding a ciborium, Bullmore thought Mary Magdalene.

Tottington. *im. 1502. Burial "before the image of St. Andrew," Bl 2:356.

Trowse. *im. c1521. Set in niche at E gable of chancel, Bl 5:460. An earlier im in the churchyard was destroyed by Lollards in 1427 (Hudson, 166, fn 296).

Norwich S Andrew. *im. 1521, 1522. Bequests for new tabernacle, Bl 4:304.

An enormously popular saint in Norfolk. Linnell cites 106 church dedications; Bond (1914) 637 dedications for England. The Norfolk figures do not include re-

ligious houses—e.g., a hospital at Boycodeswade (c1186–1536) or significant chs like the one on the "great road leading from Shelfhanger to Winfarthing" (Bl 1:116), at E Walton (belonging to West Acre Priory (P & W 2), or at Wymondham, where a new roodloft was provided for his ch in 1497 (Bl 2:523).

28 guilds (about half of which are at dedicatory churches); an altar at Poringland (Bl 5:442). Lights at Fakenham (Bl 7:96) and Heigham S Bartholomew (Bl 4:507).

Bartholomew

24 Aug. In 1489 an elaborate play took place at Gt Yarmouth at "Bartlemewtide, all chargis borne, 50s," C Palmer 118.

Brisley. wp, S wall. c1360. Paired with Andrew flanking larger Christopher, (L) Bartholomew (titular saint); DT 53:202.

Attleborough. pwd, retable, S3. 15^3. Against cloth of honor; knife held aloft in RH; gazing toward the adjacent Trinity.

Gt Plumstead. pg frag, E win. Vertical flaying knife; glass moved from Catton Hall.

Linnell cites 5 church dedications; hospital so dedicated at N Creake eventually became the abbey.

Guilds at Heigham S Bartholomew, Bl 4:507; Westlake (no. 293) cites Bartholomew and All Saints.

James Major

25 July. Decorative use of the scallop shell common in titular churches and chapels—e.g., on the base course of the tower at Southrepps and the S transept chapel at Salle.

Narrative

Cathedral. sc, N cloister bosses. 1427–8. **E8** James with wallet and wearing pileus, standing before Herod and counselors; **F1** martyrdom, James decapitated, lying beneath enthroned fig (Herod), flanked by figs, some praying. Tristram ([1936] 16) conjectured that a man kneeling on a rock was Josias, martyred with James.

Guestwick? *pg, n aisle. ?16^1. "A boat by the sea shore; a man lying dead on the shore, a king and several persons viewing the body, with a woman in a red habit, and underneath, 'Hic jacet corpus Jacobi, Sup. Collem'; a benefactor to, or a builder of this isle, as I take it," Bl 8:219. King (23) conjectures a scene connected with posthumous events in the life of the apostle, and/or a reference to James At Hill, whose 1520 brass is in the church.

Individual

Old Buckenham, Austin Canons' Priory of S James. seal. 13^{ex}. In flat cap standing in niche, bird on RS; *BM Cat. of Seals*, 2748. A drawing shows James standing with extended arms, staff in RH, ?chemise-sac in LH; shell on hat; ?wearing shoes.

Diocese. ms, Stowe Breviary, BL Stowe 12, hi, f 279v. c1322–25. Large pilgrim hat, 3 shells on wallet.

Lynn Ch of S James. *im. "A long time before the great pestilence," light before im, Westlake no. 251.

Hales. wp, E splay of Win S4. Probably early 14c. Dressed as pilgrim with large wallet on L hip, hat slung on back, bare feet, staff in RH, illegible inscr scroll in LH.

?Paston. *im, gilt. 1464. "Sent Jamis with his staff," property of John Paston, Gairdner vol 4, no. 563.

Tilney All Saints. *im. 1477. "Item solutum pro veccione imaginis Sancti Jacobi et iijm torc: iid"; Stallard 49.

Carrow S James. *im. Light before image during "divine service," Bl 4:524.

N Lynn. *im. 3 candles before, Westlake no. 282.

Norwich S Edmund. *im, Bl 4:405.

Sedgeford. *im. "North alley," Bl 10:389.

Swaffham. *im, Bl 6:217 fn.

Martham. pg, sV.a2. c1450. Hat with shell, staff in LH held diagonally, in RH four-decade tasselled beads; Duffy fig 63.

Walpole S Peter.*pg, E win of S aisle, chantry of S James. 15^4. Suppliant kneeling with label, "'Tu sis memor mej, Jacobe'; . . . In the said window, no doubt, was the figure of St. James," Bl 9:113.

Rougham. pg, sIV.A3. 15c. Forked beard, staff in LH, wallet attached thereto; scallop shell in center of crown of hat, cord around base of crown.

Trimingham. pwd, screen, 8 figs. c1500 (Pevsner 1). **N4** clasped book in LH, bare feet; mantle with tippet over gown; at center of breast, 2 tasseled cords; R side missing, where staff and wallet might have been. Traditionally misidentified as John Bapt, in part on the basis of the beard and bare feet (both apostolic characteristics); the costume is atypical for the Baptist. Restored 1855.

Castle Acre. *sc. 1438. Bequest of 23s to the im in the chancel new sculpted by Robert Rose, sculptor of Brandon Ferry (John Stegges, NCC Doke 77; Cotton, personal communication).

Salle? sc, statue. 15c. In niche at corner of S James's ch (S transept). Decapitated and disarmed; cord hanging diagonally from LS to under RA; no sign of wallet or other impedimenta. We know from guild records there was an im in 1358 (Westlake no. 321) though the existing statue is certainly later.

Erpingham. sc, font bowl. ?Mid 15c. Church notes identify as Benedict. The font has been drastically recut; see above, section 2.

Harpley. wdcarv, be, arm rest nave, 18" high. ?Late 15c. Staff in RH, wallet over RS under LA, holding clasped book in palm of LH.

Wiggenhall S Mary? wdcarv, be, nave S8. Early 15c. So queried by Bullmore.

Norwich SPM. *pcl. 16[1]. Banner, Hope (1901) 221.

Linnell cites 12 dedications (a lower percentage in Norfolk than elsewhere in England); Bond (1914) cited 414 dedications for England.

Ch at N Elmham, repaired, 1538–9, Cox (1913) 8; Pulham S Mary (rebuilt 1401, *Index Monasticus* 68). Chantry ch at Wapole S Peter licensed in 1344; later chantry jointly dedicated to SS Mary and James (Ward 291, 297, 305 fn 830). Altar cited at Cley (1512, Duffy personal communication).

Light at Stratton Strawless, Harrod (1847) 117.

James Minor

1 May; feast shared with Philip.

Cathedral? sc, N cloister boss J1. 1425–30. Martyrdom. (above) 2 devils, (L) king enthroned (R) fig in gold belt standing at parapet; (below) figs (L & R), one with sword; (C below) bearded saint blindfolded falling, his gown swept up as from the wind.

Taverham? sc, font stem. 15c (?Victorian). Cautley identified James without comment. The fig does not hold the typical bat.

Old Buckenham. wdcarv, choir stall finial. 15c. Seated with scroll across lap, fuller's bat in LH.

Wiggenhall S Mary. wdcarv, be nave, N2. 16[1]. Paired with damaged fig; ?generic apostles on other bench shoulders.

John Evangelist

26 Dec and 6 May (at the Latin Gate). See also IX.4.

Narrative

Cathedral Priory. ms, Bible, Bod L Auct. D.4.8, hi. 1190–1250; 14c Priory pressmark. Ff 631v (1 John) in cauldron of oil; 633 (2 John) drinking from poisoned cup; 663v (3 John) seated in tomb.

Thetford Priory 1. 12/13c. Earth from his sepulcher, Bl 2:118.

W Acre. sc, perhaps from voussoirs of an arch, set in porch wall, reputedly from Augustinian Priory. 13c. John writing to the Churches: seated beside ?desk, RH raised; (lower L) ?stool; (foreground) fig with 2 legs, ?eagle. For similar model in Cathedral cloister, see IX.4 Cathedral, S Cloister C1.

?Cathedral Priory. ms, Gregory the Great, *Moralia in Job*, CB Emmanuel College 112, hi, Book 19. c1310–20. Preaching, a primer text on scroll, listener seated on ground; James (1904).

Catfield? *wp. S wall, W end. 14[3–4]. King seated with crossed knee, holding sword; nimbed fig being thrown into barrel; DT 27: 168.

E Rudham. al frag. 15c. Naked fig, hands joined, standing in cauldron over flames; Astley, drawing p 18; Eve wrongly identified as Faith, il p 12.

Norwich SPM. pg, E win, all fragmentary. 15[4]. **6f** John (with palm) baptizing. **6g** John (with palm) ?converting 2 men. **6b** Arrest of John, guarded by 4 soldiers with spears, one with mace. **6c** (above) island in distance, 4 golden candlesticks, 2 jailers; (below) John writing, 4 golden candlesticks. Wdf notes frags from the John series in 6d (34). As in the cloister bosses, John's palm easily identifies him. For the original site of these windows and the political satire, see King, forthcoming.

Norwich S Clement. *pg. 1448. Bequest to glaze win with story of John Ev (C & C).

Cathedral. sc, N cloister bosses. 1427–8. **D8** with cup of poison; 2 naked men (killed by poison) restored to life by touching John's garment held by Aristodemus; other men in background. **E1** boiling in cauldron of oil, surrounded by men, some in chaperons, (L) one ladling oil, one stoking fire, (R) one using bellows. **E2** assumption of John, bearded and naked, being lifted horizontally by angels; lid of empty tomb raised by disciples; Tristram (1936, 14) identified manna in tomb.

Individual

For representation of John as evangelist, see XI.2. John's eagle figures in 13c seals, e.g., one for the Crabhouse Nunnery of the Virgin & S John the Evan-

gelist (eagle displayed; "SANCTI . JOHA*N*MIS . EWAN-GELISTE"; *BM Cat. of Seals*, 3012) and for Lynn (nimbed eagle "rising reguardant contourné," in talons a scroll inscribed "IN PRINCIPIO ERAT" *BM Cat. of Seals*, 5149; reverse S Margaret; Pedrick (1904) pl I.

Diocese. ms, hours, NMS 158.926.4f, hi, f 46v (Lauds, *memoriae*). c1310–20.

Diocese. ms, Stowe Breviary, BL Stowe 12, hi. c1322–5. Ff 23v & 247. Holding palm; eagle with scroll, inscr with name at 23v.

Upwell. *im. 1328. Guild (1328–89) founded to "repair, paint and adorn with ornaments and lights a chapel on the north side of the church"; also "purchased an image of St. John," Westlake no. 342.

Wiggenhall. *im and *pcl. 1387. 3 candles before image. Guild "apud Cranbone in vila de Wyggenhale," dedicated to "Johan the Ewangelist," T. Smith 114–5.

Cawston. *pcl for lectern. 14³. Green buckram with image depicted; altar, Watkin 1:53; see also XII *Agnes* and *Paul*.

Rushforth Collegiate Church of S John the Evangelist. seal. After 1342. Standing, palm in RH, book in LH; *BM Cat. of Seals*, 3938.

Norwich S Mary-in-the-Fields. *im. 1434, burial before image, Bl 4:179.

Cathedral. *im erected and painted, Chapter House, 1444. "Extracts from Account Rolls," 20.

Blackborough Priory of the Virgin and S Catherine. *im, *Index Monasticus* 11; picture, Bl 8:33.

Breccles. *im, light before, Bl 2:272 fn 5.

Hingham. *im, light before, Bl 2:423.

Norwich S Gregory. *im, Bl 4:274.

Norwich S Laurence. *im and tabernacle. 1493 (Bl 4:263). Bequest to new perke before image (Cotton).

Walpole S Peter. *pg, N chancel. 1423/25 (Bl 9:117). Also John of Beverley; perhaps a donor named John.

Norwich SPM. pg frag, E win. Mid 15c. Not part of Evangelist win, Wdf 37.

Glasgow Burrell Collection. pg. 15c. "St. Joha*n*nis" inscr above; perhaps from an apostle set; Wells (1965) Cat. 70.

Besthorpe. pg frag, sVI, central light. 15c. Chalice and serpent on palm of RH.

Hoveton S John. pg frag, nIII.2b. 15c. Chalice in draped RH; golden palm in LH; white gown with apparel at the neckline; "S*ancte*

Joha*nne*" inscr below.

Barningham Winter? pg frag, nII, not *in situ*. At head of light a youthful saint in white with palm in RH.

Mileham. pg, W win 2b, tracery light not *in situ*. Apostle fig, head looks Johannine.

Bressingham. *pg, E win. Central light below S Margaret "with cup and serpent in his right hand and a palm branch in his left," NRO, Rye 17, 1:150.

Garveston. *pg, "S John with the cup etc.," NRO, Rye 17, 2:138.

Wood Dalling. *pg, ?N aisle, NRO, Rye 17, 2:17.

Tilney All Saints. *pg, N aisle," Bl 9:81.

Watlington. *pg, N aisle. The lowest rank of this win also contained John Bapt, and "our Saviour," all decapitated; Bl 7:483.

Hingham. sc, Morley Monument, L respond. 15²⁻³. James queried identification, *S & N* 141.

Caistor S Edmund. wp, L of chancel arch. Cup on palm of LH, very faint; Bardswell (1926) il facing 340.

Walpole S Peter. *wp, Bl 9:114.

Thornham. wdcarv, be. 15c. With "poisoned cup," Gardner (1955) 36.

Norwich S Andrew. *im. 15c. Bequests for tabernacle, Bl 4:305.

Linnell cites only 3 church dedications (see also 10 fn 20); Bond (1914) 181 dedications for England. John appears more commonly as joint dedicatee, but carnary chs were dedicated to him at Lynn S Margaret and the Cathedral (license granted 1316, Woodman, 178).

Guilds at S Creake (1491, Norf. Arch Bk 1 f 173); Norwich Greyfriars (Tanner 208). Altar at Norwich S Stephen (1498), bequest of 20s to altar of Mary Magdalene and John Ev (Bl 4:153).

Jude

28 Oct.

Denton? pwd, mounted on chest, **2** (scenes reading L to R). 16¹. Unrigged boat on palm of RH; on palm of LH open book with squiggle writing and rubrication. These small scenes may have come from a spandrel set like those on the N screen at N Walsham; they were found loose in the porch chamber and made into a chest. The backgrounds vary from simple stencil to elaborate gesso work. All figures are defaced and costuming is idiosyncratic; the neckline of Jude's gown is heart-shaped. Winter painted a female face with long hair

and identified Magdalene (*Selection* 2:7). For dating, see XII *Agnes*.

Matthew
21 Sept.

Glasgow Burrell Collection? pg. c1320. Standing apostle, clasped book against draped LA, RH blessing. From Costessey Hall, cited as Matthew in inventory but no distinctive attribute. Probably from an unidentified set of apostles, stylistically similar to Mary Magdalene at the V & A, dated c1320 and cited as coming from Norwich or neighborhood; 45/24, Wells (1965) Cat. 46.

Dedication at Norwich, in ruins by 1360; see *Matthias*. L'Estrange (1874, 121) cites an inscr bell at Denton, "O MATHEE ME ADIUVA MENTE ABIMIS SULLEVA."

Matthias
24 Feb.

E Anglia. ms, *The South English Legendary*, Bod L Tanner 17, marginal drawing, f 25. 15[1]. Beardless youth, holding clasped book; Scott, *Survey* Cat 45, il no. 184; Pächt & Alexander 861, pl LXXXII. Matthias is also a youth on the Castle Acre screen.

Church dedication at Thorpe-by-Haddiscoe, Matthew in 1459 will, Linnell thought probably Matthias the original dedication.

Paul
25 Jan, Conversion.

Narrative
Cathedral Priory. ms, Bible, Bod L Auct. D.4.8, hi. 1190–1250; 14c Priory pressmark. 14 initials at heads of epistles, incl ff 640v (1 Cor) falling from horse, 657 (Col) being let down in basket, 661 (1 Tim) blessing Timothy as bp, and 665 (Heb.) being beheaded; see Morgan *Survey* pt 1, Cat. 75 for complete listing.

Diocese. ms, Stowe Breviary, BL Stowe 12, hi, f 232. c1322–5. Conversion, Sandler, *Survey* Cat. 79.

Saxlingham Nethergate? pg, roundel, Sii.2b, not *in situ*. Mid 13c. (L) executioner raising sword in RH, (R) kneeling fig with hands joined. Very dark and difficult to decipher, but Winter (*Selection* 2:9) shows the executioner with LH on head of kneeling man. The roundel apparently comes from a set (see also above *James and John*). Winter

identified Paul; King cites "unknown saint."

?Cathedral Priory. ms, Gregory the Great, *Moralia in Job*, CB Emmanuel College 112, hi Book 30. c1310–20. Kneeling, sword beside; demi-fig of Christ on cloud; scrolls inscr with Acts (9:4–5); James (1904).

Salle. *pg, nIII. "nonne hic est est [*sic*] qui expugnabat eos qui invocabant Nomen Jesus," spread over 3 lights (diagram in Parsons 63). Acts 9:21. NRO, Rye 17 3:174.

Cathedral? sc, N cloister boss J8. 1425–30. In armor falling from horse; 2 other soldiers.

Norwich SPM. pwd. Early 17c. Bl (4:210) cited in the vestry "a good old painting," devil placing thorn in Paul's thigh; a glory inscr "My Grace is sufficient for Thee," overpainting a previous Crucifix Trinity.

Individual
Norwich, Hospital of S Paul. seal of Master. 13c. Half length, sword in RH, book in LH; *BM Cat. of Seals*, 3782.

Cathedral. wp, W Bay, Ante-Reliquary Ch. c1300. Paired with Andrew, flanking Peter. Bald, bearded, sword in RH; Tristram 230.

Cawston. *pcl. 14[3]. Green buckram with image depicted; Watkin 1:53.

Oxborough. *im. 1470, burial before im; Bl 6:192.

Thetford S Peter. *im. 1483–1503. Bequest to paint S Paul's tabernacle; burial "before the image of St. Paul (viz. St. Catherine's Chapel)," Bl 2:62.

W Harling? pg frag, nIV.A1. Alien head on body of Margaret, typical bald pate, sword blade at side of head.

Watlington. *pg, N aisle, Bl 7:483.

Hoe. *pg, with sword, NRO, Frere C.3.9.

Thornham. pwd, screen, N2. 15[3–4] (before 1488). In striped mantle, open book in LH, sword in RH with blade lying along open edge of book; scroll with "Predico vobis ihesum Ch[ristu]m"; Camm color pl LXIV.

Walsoken. sc, font stem. 1544.

Norwich SPM. *emb pall. 16[1]. Hope (1901) 193; see IV.2 *Annunciation*.

Guild at Salle, which seems regularly to have been called S Paul's rather than Peter and Paul (Parsons, 26–7). Light before at Fakenham (Bl 7:96). Ch at Foulsham (1516, Ralph Leke, Gloys 185, Cotton personal communication); Weasenham "in town" (Carthew 1879 3:444).

Peter

1 Aug, S Peter in Chains. The shrine at Walsingham had a joint from Peter's finger (*Index Monasticus* xix).

Narrative

Cathedral Priory. ms, Bible, Bod L Auct. D.4.8, hi. 1190–1250; 14c Priory pressmark. Ff 628v (1 Peter) in prison in conversation with man; 630v (2 Peter) seated.

Diocese. ms, Stowe Breviary, BL Stowe 12, hi, f 285. c1322–5. S Peter as pope, holding chains, Sandler, *Survey* Cat. 79.

Wells. *im. 1495. Bequest for light before, Harrod (1847) 119.

Norwich SPM. pg, E win. Mid 15c. **4a** Christ standing by water; Peter, garment girded, walking on water; single-masted ship with 3 apostles; Wdf pl V & (1935a) frontispiece. **5g** frag, Christ and Peter; **4b** 4 apostles, Peter addressing one, foot on gang plank, ship with furled sail; sailor grasping rigging, mast with flying pennon with cross; Wfd pl VI. **4c** Peter preaching from pulpit, male audience. **4e** Peter baptizing Cornelius from jug held by neck; 4 other men, some ?alien. **4g** Peter looking at Simon Magus dressed in academic gown, walking away. **4f** Peter, hands in teaching gesture, held by 2 soldiers before Nero; emperor clutching beard, wand in LH, striking Peter, R leg extended as if to kick him; Crewe fig 53. For the original site of these windows, see King, forthcoming.

Norwich SPH. pg, nIII, central tracery. 15⁴. Bust of Christ and scroll inscr, "Et tu es petrus"; Peter and scroll inscr "Filius dei viventis"; very small work, c8" in diameter. G King (1907) conjectured a series on life of Peter.

Salle. *pg, chancel. Delivery from prison. "I believe his picture was on most of the chancel windows," NRO Rye 17, 3:174v. "Nunc scio vere quia misit dominus anglum sic s[uum]."

Cathedral. sc, N cloister boss D7. 1427–8. 2 men binding Peter upside down to cross; emperor and man observing; Peter beardless, mouth open.

Norwich S Peter Southgate. *sc, font. Martyrdom, "on cross with head downwards," Bl 4:68.

Norwich SPM. *pcl. 16¹, "a baner cloith steyned of the lyfe of sent peter," Hope (1901) 221.

— *reliquary, 32 oz. 16¹, "a pix of silver all gilt for sent peters cheyne . wᵗ a Cruciffixe

in the tope & sen peter croned"; the chain was wrapped in a plain towel 3 yards long and 3 quarters wide; Hope (1901) 213, 225. Guild dedicated to Peter's Chains at Besthorpe (Farnhill).

Individual

Cathedral. sc, above Prior's door (L). c1297–1314. Peter in chasuble with pallium, tiara; (LH) remains of ?keys and (LH) model church; feet resting on recumbent fig; Fernie pl 55.

— wp, W bay, Ante-Reliquary Ch. c1300. Flanked by Andrew and Paul. Papal vestments, key in draped RH, cross-staff in LH, indecipherable inscription above; yellow lining of blue drapery; Tristram 230.

Diocese. ms, Hours, NMS 158.926.4f, hi, f 45v (Lauds, *memoriae*). c1310–20. As pope, with keys.

Lynn S James. *im. 1329. Light before image, T Smith 62.

Tuttington. *im 1381–2. Guild provided 4 candles before im, Westlake no. 335.

Norwich S Peter Southgate. *pcl. 14³. Processional banner "steyned cum ymagine Sancti Petri," Watkin 1:23.

Norwich Blackfriars, New House. *im. 14⁴. *Index Monasticus* 38.

Beachamwell. *al. "St. Peter with a key and a book in his hand," Bl 7:297, Turner (1847a) 250.

Swaffham. *im. 1457. 7 marks for "peyntyng of seynt Petris tabernaky[le]," Rix 19. 1474, burial before, Bl 6:216.

Ellingham Parva. *im. 1497. Bequest "to the peyntyng of the Tabernakyll of Seynt Petry, xxd," Harrod (1847) 120.

Caston? *im, cited by Barnes (20) with unsubstantiated Bl reference.

Hingham. *im, light before, Bl 2:423.

Fakenham. ?im, "St. Peter in the Upper Cross," Bl 7:96.

Watlington. *im. Guild and light before S Peter's image, Westlake no. 348.

Wiggenhall ?S Peter. *im, "a taper for to bren be-for sent Petur," T Smith 117.

Martham. pg, sV.2c. c1450. Peter's head, ?alien body in chasuble over alb, clasped book in LH.

Pulham S Mary. *pg, E win. ?1476. "St. Peter, as patron of the church universal," Bl 5:395; underneath the Trinity, NRO, Rye 123, p 34.

Cathedral. *pg, S transept. nd. "Under St. Peter's picture was painted the sea, with a ship, and fishermen catching abundance of fishes, and this distich, "Ecclesiam pro Nave rego, michi Climata Mundi / Sunt mare, Scripture, Retia, Piscis, Homo," Bl 4:20.

— pg frag, Erpingham Win, nX.2b. 15c. Head (Baron Ash Collection).

Downham Market? pg, W win, A1. 15c. Head only, characteristic hair style.

Caston. *pg, S win, NRO, Rye 123, p 18.

Edgefield. *pg, N chancel, Bl 9:387.

Taverham. *pg, N chancel win. "St. Peter, blue garment, Gold book and silver chain and Pastoral staff gold," NRO Rye 17, 4:11v.

Barnham Broom? pwd, screen N3. 15⁴. Pope, no key; Pope Clement at N4.

Riddlesworth. pwd set in modern reredos. ?15. From Knettishall, Suf; "so thoroughly repainted that no one would identify . . . as medieval," M & R 3. See also XII *Edmund*.

Walsoken. sc, font stem. 1544. With key.

Brooke. sc, font stem. 15³. With key. Titular saint.

Beeston S Mary. wdcarv, wallposts. 15¹. S3 Peter with keys, donor below; paired at N3 with ?prophet with roll, donor below; flanked by doctors and evangelists. Carthew (2:381) reported woodwork "mutilated and defaced."

Tottington. *im. 1502, bequest to repair S Peter's tabernacle, Bl 2:356.

Norwich S George Colegate. *im. 15¹ (aisle new in 1513). Bequest for burial before im, Bl 4:471.

Norwich SPM. *?pcl/emb. 16¹, "a baner cloith for the crose of grene sarsnet wᵗ sent peter gilte sittyng in a troune frengid wᵗ silke of of [sic] dyverse coloʳs," Hope (1901) 221.

Thetford Priory 1. *pcl. 1531/2. "Thome Bell pro le peyntyng le clothys altar' Virginis & Sancti Petri 3s." Separate altars, "probably in the priory church," Dymond 2:590.

Other

Lynn S Nicholas. *pwd. Bp in episcopal Mass vestments, key in LH, RH raised; scroll reading "aperite michi portas justitie, et confitebor Domino" (Ps 117.19). "Door . . . in vestry, . . . had been whitewashed, but was cleaned," DT 34:62, 63.

Fakenham. *brass. 1428. Roundel at corner of stone at center of chancel, "2 keys in saltire, round which, *Aperite mihi portas justitie*'," Bl 7:96.

Linnell cites 61 church dedications; Bond (1914) 1129 for England. There were some 68 guilds, often in churches so dedicated. That at Norwich S Peter Southgate was known as the Fishermen's Guild (Bl 4:67); a bequest was left in 1505 at Upton "on condition that the brethren and sistern will begin the guild and uphold it," Hill 55; Bl 11:134.

Altars at Salthouse 14³ (Watkin 1:81) and Yarmouth (guild 1388–95, Morant [1872] 224, 229). L'Estrange (1874, 13, 98, 110) cites c20 inscr bells, the popular "PETRUS AD ETERNE DUCAT NOS PASCUA VITE," as well as "A TEMPESTATE PROTEGAS NOS PETRE BEATE." Lights at Fakenham (Bl 7:96), S Creake 1451 (John Norton, NCC Aleyn f 74), 1491 (Robert Norton, Norf Arch. Bk 1 f 173).

Philip

1 May. His arm was preserved at Castle Acre Priory; 1516 bequest for pilgrimage to Philip's arm (Gregory Clerk, PCC Holder 28); 1534–5 Valor 10s offering. The relic and perhaps its tabernacle were moved to Thetford in 1537 ("pro makyng a place pro braggio Sancti Philippi 1s 8dᵗ"), Dymond, 2:695, 745–6, with discussion 1:56 and 2:690n.

Letheringsett. pg frag, sIII.2a. c1450. Hand holding stemmed woven basket with multiple loaves.

Walsoken. sc, font stem. 1544.

Thomas

21 Dec.

Bayfield. tablet. 1510. "Saint Thomas of Ynde, which I have caused to be made; I will have it stand in Bayfield church, Norfolk," Ord 94.

Weybridge Priory. printed calendar, NMS 134.944. 1503. Hand blessing.

Church dedication at *Thorpland (Fakenham); Foxley so cited in 1462 will (Linnell); Bond (1914) cited 46 dedications for England.

Light at Horstead (Millican 20).

1. Tetramorphic Symbols

Tetramorphic symbols are ubiquitous. One well-preserved fig may be taken as presumptive evidence for a set of 4 (but see *Single Figures* below). Matthew as a seated angel (winged man) holds a scroll; the Lucan ox and Marcan lion, both winged, hold scrolls in either mouth or feet; the Johannine eagle in beak or claws. In glass the scrolls commonly bear the names of the evangelists and sometimes primer texts. On brasses the figs occur in roundels at the 4 corners; only a few representative examples are cited (see also Farrer 1890). Mortlock and Roberts commonly cite figs at corners of tower battlements. Detail is hard to discern, but identification seems reasonable where there are 3 animals and a human fig. Bench ends may have been more widely carved with the symbols than the list below suggests. Individual birds and lions are not uncommon, but without specifying detail, they have not been cited. The symbols may also be combined with figural representation of the evangelists (see below section 2). The eagle commonly appeared on lecterns (Manning, 1872a), which Pevsner (2) thought were produced in E Anglia for export c1500.

W Acre Priory. seal, Austin Canons, Priory of S Mary and All Saints. 13c. Symbols flanking Trinity in vesica, *BM Cat. of Seals*, 4296.

Carleton Rode. pg (trefoil) 13^4. nII.A1 winged ox with scroll in mouth, "LUCAS BOS"; sII.A1 eagle with scroll in talons, green halo, "JOHAN [AQ]VIL[A]."

Lynn S Margaret. brass, Flemish. c1349/1364. In corner quadrilobes, badly worn.

Elsing. brass. c1350. Originally framed by "either symbols or figures or both," Binski (1985) 1.

?E Anglia. ms, Apocalypse, BL Royal 19.B XV. 1310–25. Ff 6, 7v, all as angels, 3 sets of wings, knotted scarves at shoulders, heads only distinguished. All other instances in this MS are the typical symbols, as they are in the other illustrations of the Apocalypse (see Index).

Attleborough. pg, 2 tracery sets in W win, D1–4; F1–4. Mid 14c. Each fig with name scroll; restored.

Tottington. pg. 14c. See I.2.

Norwich S Stephen. sc, bosses, N porch. Mid-14c.

Lt Witchingham. wp, spandrels of S aisle. c1360. In cusped roundels (c4 feet in diameter) with name scrolls, John, Mark, Matthew. No room for Luke at E respond. Park (P & W 1) notes that the surrounding vine scroll is almost identical to that at Weston Longville; he attributes the paintings to the same workshop.

Dersingham. wdcarv, chest. 1360 (inventory). On the face of chest huge figs, each with name scroll; inscr on cover, "Jesus Nazarenus Crucifixus Rex Judaeorum" (R side restored); Pevsner 2 pl 34; P & W fig 40; M & R il 3:28.

Erpingham. brass, Sir John de Erpingham. 15^2. Eagle and angel in upper corners.

Norwich S Michael Coslany. brass. 15c. In roundels at corners of ledger.

Salle. Hagham brass. 15c. In roundels at 4 corners, no scrolls, DT 60:9. Probably the brass mentioned by Martin with symbols at the four corners (NRO, Rye 17, 3:172), though there are also roundel indents on the Rose stone in the N transept.

Norwich S Michael-at-Plea. pg frag set in head of light a of E win. 1460–80. Nimbed lion with scroll inscr "Marcus."

Barnham Broom. pg, nVI, tracery quatrefoil. 15c. Eagle with "in princ[ipio] erat"; trace of winged ox in patchwork; ?Matthew, barefoot fig in alb, LH holding tip of scroll.

Blakeney. pg, nVII. 15c. A7 frag Matthew in alb, "cum nat*us* est i[e]hs[us]"; C2 eagle with "in principio erat v[erbum]"; 4d frag winged ox; 5c Luke's text "[mi]ssus est a*n*gel[us]."

Cathedral. pg, roundels, remains of 3 sets, Erpingham win, nX. 15c. 1a Matthew, angel with name scroll, originally in bishop's palace; 1b lion with name scroll (Baron Ash Collection); *drawing of eagle with name scroll, G King Collection, Box 3, NNAS.

Denton. pg, E win, light c, not *in situ*. 15c. Against golden rays, nimbed eagle with name scroll; *Matthew, angel kneeling, wearing alb and amice, scroll inscr "S Mathe*us*," Ingleby pl XI.

Dersingham. pg frag set in W win of S aisle, sX.6. 15c. Eagle with remains of scroll in mouth, "es."

Fersfield. pg, set in E win. 15c. Eagle with scroll, "Joha*nn*es." Perhaps an evangelist/doctor set; see section 3.

Kirby Bedon. pg frag, nIV.2a, *ex situ.* 15c. Nimbed man with wings, holding tools (for ?writing/painting). Usually identified as Matthew but the working surface looks more like a pedimented panel than a book; see section 2 (Stratton Strawless). Church restored 1876–85.

Norwich Guildhall. pg frag, sII, "Lucas" in label.

Mileham. pg frag, W win quarries. 15c. **1a** eagle; **2a** ox; **3a** lion.

Seething. pg, sV, 2 roundels. 15c. Winged lion and ox; scrolls inscr with names + "euangelista."

Ringland. pg, roundels, not *in situ.* 15c. NIV Luke; NVI, Mark and John; Matthew lost. Drawings of this set and another *complete set in the G King Collection, Box 3, NNAS.

Saxlingham Nethergate. pg, roundels, E win 1c. 15c. Matthew with name scroll in RH; bird at 1; Wdf (1934, 165) cites John.

Cringleford. *pg, S win, "the four Evangelists," perhaps figs instead of symbols, in which case this citation should be classified below; Bl 5:38.

Downham Market. *pg, roundels, "only Johannes (an eagle) and Lucas (a bull) remaining," NRO, Rye 17, 2:17.

Dunston. *pg, roundel with "Matheus"; possibly a second set; NRO Rye 17, 2:54.

Marsham. *pg, N aisle, E widow. At the base of a Crucifixion "in four Ovals the Emblems of the four Evangelists," Bl 6:287; loose note cites "In prinipio erat verbum" with John, NRO, Frere MS C.3.9.

Sparham. *pg, S chancel. 4 Evangelists, NRO, Rye 17, 3:214.

Wiggenhall S Mary Magdalene. pwd, screen doors detached, W end. c1500. Angel seated, with scroll in alb holding scroll inscr "Matheas"; name scrolls with 3 animals, all nimbed, with very large wings; "crudely painted," Cautley; Keyser (1907b) pl 4. Bullmore (319 fn) argues that the screens served the aisles, a calculation supported by an 18c description when the figs were "on both sides of the Screen," NRO, Rye 17, 3:55.

Attlebridge. *processional cross head. ?15c. At terminal points of crucifix, eagle, angel; second cross bar (R) standing fig; (L) broken off; DT 24:81.

Norwich S James. sc relief, frags of square "shaft ring." 15c. Each with quotation scrolls with

frag Lombardic letters. Found in 1979 excavation within core of wall. An unusual survival; perhaps "from a tomb or pulpit/lectern base dating to the ?15 century," Woodman, *East Anglian Archaeology Report* no. 15:26, fig 17.

— *sc, "the emblems of the four Evangelists carved in stone lately stood, one at each corner [of the tower]," Bl 4:424. The upper tower was rebuilt in 1743. An 1828 engraving shows no figs on the tower, though there are 3 standing human figs on the pediment of the porch, *East Anglian Archaeology Report* no.15, pl 9.

Lynn S Nicholas. sc, S porch roof corners. 15[1]. Lion and eagle. Perhaps the other 2 figs were once on the N Porch.

Cathedral. *sc, gable roof, Erpingham gate. c1430 (Sekules 206).

Ridlington. sc, tower pinnacles. 1422 (tower bequest, C & C). Headless seated figs "said to represent" the evangelists," *East Anglian Archaeology* 18:99.

Tibenham. sc, tower pinnacles. c1437.

Attleborough. sc, 2 atop N porch buttresses, 2 on porch pinnacles. 15[2]. Christ seated at apex.

Barnham Broom. sc, tower pinnacles. 15c.

Thetford S Mary the Less. *sc. "On the corner of the steeple were placed the symbols of the Evangelists in freestone; but, being thought too heavy for the building, they were taken down," Martin (1779) 70–1.

Northwold. sc, wall post stops. 15c. Set on the N face, a second set S: Mark, Matthew, Luke, John.

Taverham. sc, font chamfer. 15c. In 18c font cited with 4 evangelists and saints; NRO, Rye 17, 4:12v.

Norwich S Helen. sc, bosses. c1480. Atypical set: all evangelists are represented as angels; tiny symbols beside Mark (27), Luke (31), and John (35).

Pulham S Mary. sc, boss in porch chamber, an eagle, NRO, Rye 123, p 31. I have not seen the chamber.

Worstead. sc, bosses, S porch. 15c. Central boss, Coronation of Virgin.

S Walsham. sc, frag table tomb for Abbot of S Benet's (Robert of S Walsham). c1439. Matthew at the Cathedral; probably ox and lion in S Walsham (Norris identified Agnus Dei); Thurlow and Whittingham 503.

Thetford S Peter. *sc, ledger stone, formerly in

the chancel (Martin [1779] 64). c1499. "Emblems of the four Evangelists at each corner," Bl 2:61.

Langley Common. *sc, at top of shaft for cross, DT 33:152, pastedown from *Gentleman's Magazine*, Jan. 1804.

Starston. sc, porch stops, with scrolls. Victorian restoration.

Attleborough. *wp, E wall, nave. 15³. Bird in rhombus at the top of the massive foliated cross, probably a tetramorphic set at the 4 points; 1844 watercolor, DT 53:29.

Aylsham. wdcarv, screen. Late 15c. Winged ox and eagle in spandrels above James Maj.

Cathedral. wdcarv, misericords. 15⁴. S15 Crowned angel seated on bench, academic costume, remains of scroll in hands; S23, Mark; S24, Luke; Rose (1994).

Norwich SPH. wdcarv, porch bosses (very small). 1497.

W Lynn? wdcarv, misericord. 15c, "clerical figures" flanked by an angel and "head of an ox," G L Remnant 113.

Norwich S Gregory. wdcarv, misericords. 15c. Lion standing on scroll (G L Remnant 103, pl 3a); angel holding scroll (misidentified by Remnant as S Luke); 4 seats with carvings cited in "Extracts," *NA* 18:xiii.

Swaffham. wdcarv, be. 15c. With name scrolls; Matthew in storage.

Walsoken. wdcarv, stalls. 15c, "small signs of the Evangelists etc. against the buttresses of the end," Pevsner 2.

Norwich S Helen. wdcarv, be. c1520–30. Partial set; S Luke opposite S Margaret; second bench with paired Matthew and Mark. Bl cited John (4:379; Rawcliffe pl 34 [Matthew]).

Norwich S Peter Parmentergate. ?wdcarv, boss. In 1831 in shed of church, angel with scroll inscr "In princip[io]," drawing in DT 16:92.

Norwich SPM. *processional cross. 16¹, "a grene crose wᵗ iiij evᵃngelistes gilte for ester morow," Hope (1901) 227.

Weybridge Priory. printed calendar, NMS 134.944. 1503. Flanking central calendar disk at head of roll; the feast days are also marked by the symbols.

Oxnead. sc, "probably Jacobean," Pevsner 1. Now NMS.

Fonts

When the tetramorphic symbols decorate an octagonal baptismal bowl, they typically alternate (abbreviated ~) with angels carrying shields charged with a variety of arms (VI.3 *Instruments of the Passion*). Unless stated otherwise, the symbols are carved in relief on the faces of the bowl. Generic descriptions apply; only significant variations are cited. All fonts are perpendicular in date unless stated otherwise. See below section 4 for Evangelist/Doctor fonts.

Ovington. 14c. On upper stem, original base missing; unusual design; from Watton; Cautley il p 126.

Acle. 1410 (inscr). With scrolls, traces of writing for Matthew and Luke; ~ arms of the Trinity, Crucifix Trinity, Our Lady of Pity, and Instruments of the Passion.

Alderford. On chamfer ~ angel heads.

Aylsham. Standing angel with book; unusually spirited animals—eagle standing on one foot, ox on hind legs, roaring lion with shaggy mane; no scrolls; ~ instruments of Passion. Angel and lion repaired; Bond (1985) il 250.

Bacton. With scrolls ~ angels with shields.

Bedingham. Lion with scroll; bird and ox without scroll. 2 angels, one with shield, one with stringed instrument, atypical for set.

Bergh Apton. Angel seated, animals on nebuly, all with scrolls ~ angels with instrument(s) of Passion. Stem, ?John Bapt beneath Luke, prophet fig beneath John, apostle fig beneath Mark; 4th fig badly damaged (M & R 2 conjectured wodewose).

Billingford S Leonard. ~ angels with shields; name scrolls cited in NRO, Rye 17, 1:104, drawn in 6:5.

Caister-on-Sea. ~ roses.

Caistor S Edmund. Angel on bench with scroll across lap; ox, lion, and eagle with scroll in mouths; inscr for guild of S John Bapt; ~ angels with arms incl instruments of Passion. Tetramorphic symbols also on font stem; P & W 2 fig 41. Gift of Richard Caister while vicar of Norwich S Stephen (1402–19), P & W 2.

Colby. ~ saints.

Colney. ~ Type 1 Crucifixion on E face, roses, S Sebastian.

Dickleburgh. With scrolls ~ angels with arms of Eucharist, Trinity, and instruments of the Passion; M & R il 2:30.

Gt Dunham. ~ instruments of Passion.

Dunston. Conflicting descriptions: "several roses, blank escotcheons, and emblems of evangelists," NRO, Rye 17, 2:53; there are no em-

blems on the bowl today but 4 roses, 2 lions, and 2 angels with blank shields. (I am grateful to Michael Ranson for confirming the font description.)

Fakenham. Matthew with huge wings and diagonal scroll across face of panel; animals with scrolls; arms of Trinity, royal arms instruments of Passion; no alternating pattern.

Framingham Earl. ~ angel with shields.

Haddiscoe. ~ angel musicians, Williamson (1961) pl 3.

Happisburgh. With scrolls, ~ angel musicians; Bond (1985) color pl 7.

Hardley. ~ demi-fig angels.

Hemsby. ~ shields.

Hindolveston. All winged ~ arms of Trinity, of George, tau cross, *Arma* 1 with other feathers worn smooth; font from former church.

Hindringham. ~ instruments of the Passion, arms of Trinity, crucifix, royal arms.

Ketteringham. With scrolls ~ Type 1 Crucifixion, roses, and fig on throne with diagonal staff.

Lakenham. With scrolls, ~ Passion subjects; atypical font, originally at Knettishall (Suf).

Ludham. With scrolls ~ lions. Unusual double chamfer with angel musicians and tiny figs difficult to identify.

Needham. Angel seated with scroll in hands ~ roses; Tomlinson pl XLVIII.

Norwich S John de Sepulchre. ~ angels.

Poringland. Ox, 2 lions, eagle ~ roses and angels with shields; probably a mistake or one of the angels meant to be Matthew.

Pulham S Mary. In 1885–6 during restoration "fragments of Evangelist symbols were discovered under the plaster. From these fragments were modelled the existing modern symbols," Ingleby note to Tomlinson (223); for 1848 plastered state, see pl XLIV.

Redenhall? 19c perhaps a copy of the 16[1] font.

Ringland. No scrolls, ~ flowers and angels with shields.

E Ruston. A 19c watercolor shows tetramorphic figs holding scrolls ~ angels with scrolls. Recut in 1882, angels replaced by new reliefs.

Salthouse. ~ 2 Tudor roses and instruments of Passion.

Shelton. ~ angels with arms, incl instruments of Passion.

Shimpling. Angel seated with scroll spread like rainbow; animals with scrolls ~ instruments of Passion.

Stockton. Angel without scroll; atypical figs project out from panels. 14c (Cautley).

Stoke Holy Cross. Font now outside.

Surlingham. ~ instruments of Passion, arms incl Trinity and Eucharist.

Swanton Novers. ~ W surrounded with crown of thorns; same motif on piscina; see M & R 1. Bl thought a rebus for Wil. Garland, Frere MSS NRS 1:38.

Taversham. Chamfer.

Thorpe Abbots. ~ instruments of Passion; Tomlinson 228–29, pl XLVII.

Toft Monks. Against nebuly ~ angels; Keyser (1907a) pl VI.

Upton. All with scrolls ~ angel musicians.

Wacton. ~ demi-angels with shields.

Wells. At angles of font.

Wymondham. All with scrolls, eagle holding in talons ~ arms incl Trinity, Eucharist.

2. Four Evangelists

The evangelists represented as barefoot men are distinguished by their symbols. Unless stated otherwise, they stand. Matthew is beardless in contrast to his representation in apostle sets. Sometimes primer texts accompany the evangelists (the opening of John's gospel also appears on a lectern at Ranworth [c1450]). Church guides often identify 4 seated figs at the corners of porches or towers as evangelists, but without close observation it is difficult to distinguish medieval from late work. Cautley, for example, cited the Honingham pinnacles, since identified by Wilson (P & W 2) as 19c. See XII for Evangelists not in sets.

Cathedral Priory. ms, Bible, Bod L Auct. D.4.8, hi. 1190–1250; 14c Priory pressmark. At heads of each gospel, seated, writing, with symbols; Morgan *Survey* pt 1, Cat. 75.

Breccles? sc, font bowl. Norman. E face, 4 standing men, one with palms held out, one with arms extended; "probably intended for the Evangelists," Cautley, il p 129.

Cathedral. sc, E cloister bosses. 1327–29. Seated with scrolls and symbols, all bearded; **B7** Mark; **C7** Matthew (Lindley [1987] pl 18); **D7** Luke (Pevsner 1 pl 24; P & W fig 20); **E7** bearded John, eagle with scroll in mouth.

W Rudham. pg, nIII.A1. 1430–40 (Marks). Bearded fig in blue mantle, holding name scroll "Marcus"; (below R) lion.

Ashill. pg, nII (tracery, not *in situ*). 1460–80

(King). **2a** John (alien female head), book spine resting RH, LA relaxed, eagle at feet; **2c** Matthew (modern head) holding in LH open book (with dot writing), (below) trace of wing from his angel; see also section 3.

Banningham. pg, sV "probably *in situ*" (King 18). 1460–80. **A5** John; same cartoon at Ashill; **A4** beardless fig with corkscrew curls holding clasped book in crook of LA, ?John from a second set.

Stratton Strawless. pg, nII. 1445–55. All winged and seated. **A1** Mark, mantle turned back to create collar, LH holding name scroll on lap, pen in RH resting on scroll; shaggy lion; **A2** Matthew; **A3** Luke as artist, brush raised in RH, pallet in LH, seated ox; King fig 5. **A4** John, winged, seated, palm in LH, RH relaxed, palm out; (L) eagle standing on floor of platform, name scroll. In 1995 A2 & 3 were in restoration; description based on King 15.

Wighton. pg frag. 15c. Mark; identified by Richard Green; found 10 May 2000, no details available. I am grateful to Judith Leckie, ODC, for drawing my attention to the report in the Gaven Valley Newsletter.

Norwich S Etheldreda. pg, now at Cathedral, sXVII, light c. 15c. Head of John with eagle (atypical small bird).

Norwich S Peter Parmentergate. *pg, Bl 4:96.

Tilney All Saints. *pg, E win S aisle. "St. John the Evangelist, and — 'In principio erat verbum,' &c.," Bl 9:81. Perhaps part of a set.

Suffield. See section 4, *Evangelist/Doctor Sets*.

Crostwight. *pwd, screen. Evangelists with primer texts: Matthew with "Liber generationis Jchr"; Mark with long beard and "recumbentibus undecim"; "destroyed when church repaired," DT 54:122.

Norwich. *?pwd. Pictures of evangelists from the Cathedral and SPM burned in market 1647, Bl 3:390.

Horning. sc, statues. ?15c. Seated at pinnacles of the tower. With symbols.

Necton. sc, statues, chancel arch (blocked win). ?c1450 (nave roof). On pedestals with symbols at feet: (L) John with scroll, eagle; Matthew with large codex, angel; (R) evangelist with scroll and animal with large wings; evangelist with codex and scroll, damaged fig at feet. These small figs flank a large central pedestal, now vacant.

Cathedral. wp, N arcade, presbytery. c1475. "Erpingham reredos" (see VI.3 *Exaltation of the Cross*). Above cross bar; all bearded with moustaches, evangelists with primer texts: (RC) Matthew, small angel descending, "Cum natus est IHS"; (R) Mark with winged lion, "quia nimia altitudo terrene . . ." (Mark 4:5); (LC) John with ghost of eagle; (L) Luke (ox missing) with "In principio erat sermo ille" (John's text); for details see Whittingham (1985) 204, pls 1 & 3. See also section 3, below.

Scarning? sc, pinnacles of tower. 16². "Two Evangelist statues survive," P & W 2.

S Lopham? sc, pinnacles of tower. c1526 (bequest to steeple). 3 standing figs with staves; atypical for evangelists; Cotman (1838) pl XV.

Terrington S Clement. pwd, inside of font cover. 17¹. Evangelists dressed in antique garments, seated and writing, symbols beside; (background) Baptism of Christ; Jenkins color il p 476.

Gt Snoring. pwd, Commandment board. 1640 (DP). Commandments flanked by evangelists seated at tables writing; in contemporary dress rather than traditional costume; see XIII.2.

3. Latin Doctors of the Church

Doctors are identifiable by two types of costume: liturgical (cope over almuce, or chasuble over dalmatic, tunicle, appareled alb and amice; mitre [Ambrose and Augustine], tiara and double/triple cross-staff [Gregory], cardinal's hat and cappa clausa [Jerome]); or less commonly academic (tippet over gown and, unless decapitated, a pileus). Only exceptional examples of gloves and vestments are cited. Clothing is often obscured by the desks at which the doctors sit or stand. Although the sequence of doctors in screens has sometimes been obscured by restoration, the pattern observed by Alexander at Burnham Norton (bishops flanking Gregory and Jerome) does not seem to have been common. See also *Evangelist/Doctor Sets* below and XII for Doctors not in sets.

Thetford Priory 1. 12/13c. Unspecified relics of Gregory and Jerome; Bl 2:118.

E Harling. pg frag, E Win, 3e. 15³. Head of Gregory, dove at ear; G King (1907) thought the fig from the same workshop as that at SPH.

Ashill. pg, tracery, not *in situ*. 1460–80 (King 31). All with alien heads; all seated at characteristic writing desks with writing imple-

ments and scrolls inscr with names. **nII.2c** Gregory holding knife in RH, LH on scroll, lid of inkpot depending from desk; **nIII.3b** Jerome, scroll in RH; **nIV.2b** Augustine, posed from rear, seated on elegant chair, inkpot depending from desk, scroll secured by LH on top of desk, pen in RH. The same sort of ink vessel hangs from the belt of the notary William Curteys (1499), Necton. For a brass rubbing that shows how the lid was attached to the vessel, see Evans (1971) fig 1.

Bawburgh. pg, 2 frags, nIV.2b. 15c. Head in doctor's hat; "S. gregor."

W Dereham. pg frag. 15c. E win 1b "augustin"; sIV.D1 "Doct." Glass said to have come from Dereham Abbey.

Fersfield. pg, E win, not in situ. 15c. Gregory at desk with depending scroll.

Saxlingham Nethergate. pg frag, nIV, not *in situ*. 15c (King 25). **1a** "S*anctus*: Ieroni-mu*s*" inscr on depending scroll; seated at writing desk; cope over alb, cardinal's hat obscuring eyes; inkhorn hanging from desk, RH resting on scroll; **FIG 25**. **1b** seated on wide backed bench; desk with inkpot depending on a cord next to scroll inscr "S*anctus*:ambrosiu*s*"; **FIG 26**. **2a** frag of desk and name scroll for Augustine. **2b** frag of desk and scroll. Set complete when Winter recorded it: all in copes before desks, names of depending scrolls, *Selection* 1:3; Wdf (1934) 166.

Sparham. *pg, N win. "S. Gregori[us] . . . large fine figure," NRO, Rye 17, 3:216.

Norwich, Bishop's Ch. *pg. Bp Hall recounted that he removed the heads of "St. Ambrose, St. Austin, &c" in 1647 to avoid loss of the entire figs, quoted in Wdf 209.

Castle Acre. pwd, pulpit. c1440 (Alexander). Doctors (all defaced) seated on benches with text scrolls above. Augustine seated on cushion in voluminous red doctor's robe, black doctor's cap, LH holding open book with writing (undecipherable), R fingers interleaving. Gregory in appareled alb and amice, figured garment, voluminous cope over all, mitre with double cross above; holding clasped book on L knee. Jerome in cardinal's robes holding closed book in LH, cross-staff in RH with scroll rising above. Ambrose, in green robe with academic hood turned back to form cowl neck, flat hat,

pointing to scroll with LH. Texts transcribed by Alexander (1994, 200): Augustine, 'Impleti spiritu sancto predicant veritatem"; Gregory, "Gloria predicantium est profectus audientium"; Jerome, "Ne te decipiat sermonis pulcritudo"; Ambrose, "Evangelium mentes omnium rigat." Alexander figs 44–45; Duffy fig 17. Apostle screen.

Burnham Norton. pwd, pulpit. 1450. All seated at elaborate desk-chairs with finials; names inscr in arch above. Ambrose, mitred, in cappa clausa and tippet; holding rubricated scroll in both hands as if reading. Gregory, tiara defaced, in cope over alb; writing on extended scroll with pen, LH with knife; inkpot and penner suspended from desk by tape threaded through the loops of leather at the top of penner. Jerome, in cardinal's robe and hat, white tippet; long scroll depending from desk; ?mending his pen. Augustine, mitred, cope over alb; knife in LH, RH holding pen up; scroll extended on desk. Alexander figs 44 and 45; Pevsner 2, pl 31b. Donors John and Katherine Goldalle also represented. Alexander (199) says there was an apostle screen, but in the 18c there were 8 saints including Ethelbert and Virgin (Bl 7:17); see XII *Ethelbert* for current evidence.

S Creake. pwd, pulpit. ?c1450. Underdrawing for 4 typical desks. Wilson notes that "most of the colour [was] stripped off by a bad restorer in 1927" (P & W 2).

Salle. pwd, screen doors. 15³. Originally with names; all except Jerome in cope over dalmatic Augustine, crozier in LH, gloved RH blessing; Jerome, book with minim writing in RH, fingers on margin of book (name above); Gregory, triple cross-staff in RH, open book with minim writing in LH; Ambrose, crozier in RH, clasped book held on LA (name above); il Parsons, facing 58. See XIII.1.a.

N Elmham. *pwd, screen doors. 15³. "On the pannels of the chancel door have been painted the 4 doctors of the church," Bl 9:494. Martin (NRO, Rye 117, 2:65v) cited doctors in list of male saints "On the Skreen in the upper end of the North Isle." Apostles on the N side.

Norwich S James. *pwd, screen doors. 15³. "There used to be the four Doctors . . . but

they have disappeared," Camm 270.

Gressenhall. pwd, screen, 4 figs, panels currently in S aisle, originally N side of screen. 15³⁻⁴. 2 doctors wearing cope over dalmatic; Augustine, largely obliterated, mitre, double cross-staff, ?scroll in RH; (below) "*Sanctus*: Augustin*us*"; Gregory, defaced, ?mitre rather than tiara; tip of double cross-staff in RH, LH raised; (below) "*Sanctus Gregorius.*" Originally 4 doctors paired N and S, NRO, Rye 17, 2:173.

Foxley. pwd, screen doors. c1485 (Baymont bequest of 4 marks to paint screen). Augustine in alb, almuce, damask cope; mitre with infula depending; gloves; crozier in LH, RH blessing; Gregory, pallium, mitre; dove whispering in R ear; double cross-staff; Jerome in fur-lined, patterned red cappa clausa, red-lined tippet of white fur, unusual hat; LH holding open music book with staves and writing; Alice Baymont below (*Orate* scroll); Ambrose, tasseled gloves; cross-staff in LH, RH extended, 2 fingers lying across prayer scroll of John Baymont below; Duffy fig 124. The rest of the screen is painted brown; ?an apostle screen.

Ludham. pwd, screen, 12 figs symmetrically arranged, Doctors flanking doorway. c1493 (screen inscription). Augustine and Ambrose against cloth of honor; names inscr below. **N5** Augustine in mitre, cope over fringed dalmatic, appareled alb and amice; crozier in LH, open book held against chest by RH (3 rings), gloves with tassels; "*Sancte Augustinu[s]*"; **N6** Ambrose in mitre, cope over fringed dalmatic; appareled alb and amice; crozier in RH, clasped book in LH; rings on both hands, "*Sancte Ambrosius*"; **S1** Gregory with tiara, gloves, cross-staff and tiara defaced, "*Sanctus Gregorius*"; **S2** (defaced) Jerome in cardinal's robe and hat, RH raised, "*Sanctus Ieronimus.*" S1 and 2 are by a different hand than the one responsible for the N screen (no cloth of honor, names in white without rubrication); Constable, il p 214.

Tunstead. pwd, screen. 15⁴. 16 figs, doctors flanking apostles; names inscr below, 2 mislabeled. **N1** Augustine, cope over dalmatic, crozier in RH, open book in draped LH; **N2** Jerome, in RH open book with pages and writing visible; lion resting fore-legs against Jerome's legs; "*Sanctus* [A]mbrosius [sic]*"; **S7** Gregory in mitre, tunicle, dalmatic and cope; dove at ear; double cross-staff steadied by R wrist, open book supported with RH and held in draped LH; **S8** Ambrose in chasuble with crozier steadied by L wrist, LH pointing to RH holding open book (pages ruled, bar writing), "*Sancte Ireonimus.*" S7 & 8, Constable, il p 219. Note a similar name error at Weasenham All Saints.

Gateley. pwd, screen, 8 figs, incl 2 doctors. 15⁴. **S1** Gregory, RH with cross-staff, LH holding top of chemise-sac; cope with large morse over Mass vestments; tiara and triple cross scraped away, pedestal damaged. **S3** Bp with crozier in RH, closed oblong black book held against body with LH; cope, almuce, glove; "*Sanctus*" in red, name lost. This is a narrow church with room for only four figures to a side, 2 doctors being upstaged by 2 English saints. For a similar break in pattern, see Potter Heigham where Eligius replaced one of the evangelists.

Houghton S Giles. pwd, screen, 12 figs. Late 15c. Names + titles on sill, "papa" scratched out; scrolls with minim writing hanging over lecterns: **S1** Gregory standing, writing at lectern; cope over alb; **S2** Jerome, cross-staff over L shoulder, pointing with RH to scroll hanging over lectern, penner in LH; red cappa clausa; **S3** Ambrose, crozier in crook on LA, LH on scroll resting on lectern, RH pointing; **S4** Augustine, RH pointing to scroll hanging over lectern; dark cappa clausa with tippet; **S5 & 6** Sylvester and Clement. All defaced.

Cawston. pwd, screen doors. c1500 (bequests). Gregory, defaced; cope over full Mass vestments, tasseled gloves, clasped thick book held against chest with RH; Jerome, white fur tippet, holding 3 clasped books in LH, RH supporting topmost book; lion resting forelegs against legs; Ambrose, cope over appareled alb, crossed stole, tasseled gloves; clasped book held by spine in RH, archiepiscopal cross in LH; Augustine, cope over alb, almuce, tasseled gloves; closed book in LH, crozier in RH; Duffy fig 33. Screen cleaned and restored 1952. The doctors were done by a third artist, whom Plummer has identified with the one who worked at Binham. Apostle screen.

Litcham. pwd, screen doors (6 figs). c1500 (1492, 20*s* to making pulpitum). Largely obliterated except for vestments: **1** appareled alb, crozier base; **2** mitre; **3** appareled alb; **4** ?apostle mantle; **5** cope over appareled alb; **6** Jerome, tasseled ends of hat cord. Carthew's 1430 date (repeated in Cox and P & W 2) must be rejected for the painted panels; see XII *Armel*. White (1904) cites 1903 renovation.

Gooderstone. pwd, screen doors. c1490–1520 (King in L & M, 58). Jerome, well preserved cardinal's garb, hands at waistline; Gregory, double cross-staff, cope over dalmatic and tunicle; bp, cope over dalmatic and tunicle, LH blessing; fig with hands above depending scroll with minim writing. In contrast to the well preserved screen proper, the paintings on the doors are in very poor condition. See also XIII.1.a.

Upton. pwd, screen, 8 figs. c1500 (donor inscription, 1505; no citation in will). **N1** Augustine in cope over alb; clasped book in LH; **N2** Jerome, LH holding cord of hat, clasped book in RH, ?lion lower L; **N3** Gregory, cope over alb, holding open book with minim writing, no staff; **N4** Ambrose clasped book in LH; pallium. The lower portions of N1 & 2 are partially obscured by church furniture.

Fritton. pwd, screen. 16[1]. All defaced; names on horizontal white band, nimbed heads projecting above band. (N1–2 donors); **N3** Augustine, book in RH, closed with thumb inter-leaved; unusual almuce over dark cope; **N4** Jerome, open book, foliated cross-staff (very faint); **N5** Gregory, tiara defaced, clasped book in RH; **N6** Ambrose, almuce, like Augustine's, over cope; single cross-staff in LH, clasped book in RH. Winter (Hart 1872) showed a lion with Jerome; little discernible today. A number of other details recorded in the 19c, particularly in clothing, are no longer visible, DT 55:91–4.

Lessingham. paper pasted on screen. ?1553–8 restoration. All seated on similar benches with names in white bands at the head of cloth of honor; Section **A1** S Roche; **6** Jerome with cross-staff, open book in RH, with writing; perhaps lion originally with at feet; **FIG 24**. Section **B1** Gregory, papal cross; **S2** Augustine, cope over alb; **S3** Anselm. NMS. Order conjectural with doctors

flanking doors (virgin saints); the doctors replaced defaced apostles, whose heads can still be seen.

Wickmere? pwd, screen. S1 On the second board in this pane there is an episcopal staff (Williamson [1957] identified an archbp); see XIII.1.a.

Haveringland. *pwd, screen. "S*an*cte Augustine, S*an*cte Grego[ri]e"; names are hidden on the right side of the screen," NRO, Rye 17, 2:205. In all likelihood the other 2 doctors flanked the door with 4 other saints to balance Margaret, Faith, Mary and Elizabeth.

Norwich S John de Sepulchre. pwd, screen, 6 figs. ?15[3–4]. **N1** Gregory, tiara, double cross-staff, roll in raised RH; cope over mass vestments; **N6** Jerome, no ties for hat; fur tippet, holding book with minim writing. Because of church reconfiguration, difficult to view; descriptions based on Winter's drawings, *Selection* 1:6. The N side of this monochrome screen was discovered in 1866. Williamson (1957) cites 2 modern panels.

E Wretham. *pwd, screen. "There are divers Saints painted on the Screens, as St. Augustine, St. Ambrose, &c," Bl 1:468.

Hevingham. sc. 14c (Cautley). Mutilated figs in academic dress; hexagonal font with Crucifix on W face.

Watlington. sc, font bowl. Mid 15c. Decapitated statues, 2 in chasubles, one with wide scroll depending, one with staff; one in cope and almuce (?Jerome), one obliterated (?Gregory). These four figs completed a set of 12 apostles.

Brooke. sc, font stem. 15c. Standing, in academic costume, decapitated. Pattern is not entirely clear, but probably the doctors & other saints, only Peter and Edmund recognizable.

Burston. sc, font stem. 15c. 4 standing figs in tippets with scrolls; 4 apostles.

Erpingham. sc. 15c. 4 large headless statues, formerly pinnacles on the tower; badly disfigured, but costume consistent with doctor identification.

Bacton. sc. 15c Large fig, supposedly from tower niche, in pileus, holding scroll; probably part of set.

Halvergate? *sc, pinnacles for tower. "Four Latin Doctors on the corner pinnacles until C19" (M & R 1). The replacement figs were

not copies of the Doctors; they wear apostle robes; see also P & W 1.

Norwich S Gregory. wp, bay 1, S aisle, spandrels above sIV and on opposing wall. Late 15c (DP). Seated in desk chairs with text scrolls above and frag names below. (NW) Jerome, depicted with back to viewer (cf Ashill), text undecipherred. (SW) Augustine lost except for traces of scroll. (SE) Ambrose in mitre and cope, text "Vera penite*n*cia est a peccato. . . ." (NE) Gregory in tiara with ?trace of dove wing at R ear, cope over fringed tunicle and apparelled alb and amice, text ". . . tilla i*n* medio . . : hic [?sic] om*n*is malicia ad" Gregory's chair is draped with decorated cloth hung over the arms supporting the writing desk, with the effect of enclosing the chair on both sides; Ambrose's seems not to be draped but painted; Jerome's chair is made of turned spindles.

Cathedral. wp, N arcade, presbytery, c1475. "Erpingham reredos" (see VI.3 *Exaltation of the Cross*). In poor condition, but frag texts. Flanking Mary and John, Gregory; Augustine, Ambrose; "elargatus voce"; Jerome, "tumultus vite confunditur"; Whittingham (1985) 204. See also section 2.

Blofield? wdcarv, be. 15c. Seated, ?cardinal's hat, holding scroll; at opposite end of bench, seated bp with open book.

Harpley? wdcarv, be. 15c. Series of seated figs, most with books: 2 decapitated with books, 2 in tippets, one in cope, doctor with scroll.

Cawston. *wdcarv, "an old reading-desk, having the four doctors of the church carved on it," with the effigy of the donors, Bl 6:267.

Weybridge Priory. printed calendar, NMS 134.944. 1503. The doctor busts are identified by tiara, cardinal's hat, mitre, with Augustine's mitre topped with a heart.

4. Evangelist/Doctor Sets

Fonts are block classified at the end of this section.

Norwich SPH. pg, E win 3b. 15³. Head of Gregory, mitre rising above coronet, with dove at his ear; G King (1907) il facing 211. In the 18c the doctors were in a N win. "S Jerome, S Austin, &c." and paired with evangelists to the S with symbols (Bl 4:330); "curiously stained, one in each pane & very perfect," (Kirkpatrick, quoted in King [1907] 206). The large evangelists

now in the E win may be a replacement in the new style for an earlier set of evangelists. c1535. **3–4a** John with the cup; **5–6a, 4c, & 6c** other evangelist heads; King cited traces of ox (at feet of Mark) and lion.

Cley. *pg. "There are several saints and prophets on the windows, *viz.* Sts. Mathew [sic], Gregory, Ambrose . . .": perhaps an evangelist/doctor set; Frere MSS, NRS 1:15.

Morston. pwd, screen, 8 figs. c1480 (cited in church notes as gift of rector). Symbols below; Matthew, Mark, and Luke hold books with dot and line writing. **N1** John as apostle; **N2** Matthew, open book; **N3** Luke with partially open book; **N4** Mark, open book in draped RH, L index finger pointing. **S1** Gregory, tiara largely destroyed, RH holding triple cross-staff with infula, open book on palm of LH; cope with morse over chasuble and dalmatic; **S2** Jerome, chemise-sac in LH; **S3** bp, elaborate crozier with infula in LH, RH pointing, jeweled mitre, double morse on cope over chasuble, fringed dalmatic; **S4** bp holding open book on palm of RH, morse on cope over chasuble and fringed dalmatic; restored 1988. Curious wdcarv subjects in spandrels, see XVI.

Foulden. pwd, screen doors. c1484 (roodloft "newly made"). Seated, in belted gowns with mantles draped over laps; primer texts; names rubricated. Mark bearded, holding scroll with LH, pointing thereto with RH; "S MAR[C]*US* In illo t*empore* Cum Egressus set [est] i*hesus*"; lion lower L. (This text occurs in primers for the opening of John's gospel, Hoskins 118.) Matthew, clean shaven, crowned angel upper L pointing to scroll; "S*anctus* MAT*HEUS* In illo tempore Cu*m* venisset [?natus est] ihc." Luke largely disfigured; traces of scroll. John, open book on lap with pen poised above, "In principio" barely legible; eagle below. Screen: **S1** bp in cope, probably over dalmatic and tunicle; **S2** Jerome, cardinal's hat, holding open book; other 2 doctors probably at **N5 & 6** (cf Ludham) since S3–6 occupied by other saints. The damaged N side is now painted over.

E Ruston. pwd, screen, 8 figs. Late 15c. **N1** Matthew, winged, cross filet on head, in ermine tippet; RH pointing to open book in LH

with margins and minim writing; below just above hemline, scroll inscr (L) "S*anctus*" and (R) "Matheu*s*"; N2 Mark pointing LH to clasped book in draped RH; nimbed lion; (L) lateral scroll inscr "S*anctus* Marcus"; N3 Luke, in doctor's cap, pointing with RH to open book on palm of LH; nimbed ox; (L) lateral scroll inscr "S*anctus* Lucas"; N4 John as apostle; nimbed eagle; (L) lateral scroll inscr "S*anctus* Joh*anne*s." Except for Jerome, all doctors dressed in full Mass vestments; names inscr in horizontal scrolls behind heads; standing on geometric pavement in recessed niches. S1 Gregory, tasseled gloves, RH (4 rings), "Sanctus Gregori*us*"; S2 "S*anctus* Agustinu*s*"; S3 "Sanc.tuc Ambrocu*s*"; S4 Jerome, small roll in LH, "Sanc.tus Ieronim*us*."

N Tuddenham. pwd, screen frag, W end. Late 15c. Names below. **1** Matthew as angel "S*anctus* Mathias" [sic]; **2** Mark with scroll in LH, bearded, "S*anctus* Marcus," ox lower L; **3** bp, cope over alb and crossed stole, "S*anctus* augustinus"; **4** cross on elaborate mitre, double cross-staff, Mass vestments, "S*anctus* gregorius." The panes are very dark. Originally a full set (background colors do not counterchange); provenance uncertain, given to rector "by a friend who bought them from a lumber shop after they had been discarded from some Church unknown."

Weasenham All Saints. pwd, screen, 8 figs. 15[4]. Doctors, all standing before tall writing desks/lecterns, each with structural variations; identified by name + "Doctor". N1 Ambrose, scroll depending with traces of black letter writing; N2 Augustine, RH on breast, L at book with minim writing; N3 Jerome, almuce, tie of hat, LH raised, RH on open book, lectern with device for raising and lowering; N4 Gregory, inkpot in RH, penner depending, pen in raised LH, scroll over desk inscr "felix culpa"; **FIG 27** (name in error; see also Tunstead). Evangelists badly damaged, all with looped scrolls above with traces of primer texts, and 2 with smaller scrolls at hand; at their feet winged tetramorphic figs. S1 John bearded, eagle below; text begins with rubricated "I[n principio]"; scroll at hand with frag inscr "sup*er*"; S2 Mark, ?lion, rubricated "D[icipulis recumbentibus]";

Luke obliterated; S4 Matthew, text begins with rubricated "C[um natus est]."

Potter Heigham. pwd, screen, 8 figs (3 evangelists). c1500 (bequests 1494 and 1501 for new perke, Cotton). Names below; evangelists with primer texts. N1 Mark with winged lion in RH and scroll in LH reading "recumbentibus undecim discip[ulis]" (Mark 16:14); N2 Augustine, Mass vestments and pallium; clasped book in RH; N3 John, head and chest largely disfigured, but hands consonant with holding chalice; N4 Gregory, cope over dalmatic, book in LA; S1 Jerome holding open book; S2 Eligius; S3 Luke, ox lower left, scroll in LH, "Gabriell angellus." S4 Ambrose in doctor's robes, cap, tippet and gown with sleeves turned back to reveal fur lining; scroll in LH. Screen very dark and damaged by bat urine. The order is curious, alternating evangelists and doctors on the N, and flanking doctors on the S.

Suffield. pwd, screen. c1524. Except for Jerome, all wear copes over dalmatics: N3 Ambrose, clasped book in RH, tasseled gloves; N4 Augustine, heart in RH; N5 Gregory, head obliterated, double cross-staff; N6 Jerome, head largely obliterated, cross-staff, lion below. S1 Luke, winged bearded man, RH pointing up, ox lower L; S2 John, winged, apostle fig, eagle lower L. Although difficult to reconstruct the original order ("restored, William White 1883"), it probably included the other 2 evangelists.

Whitwell. *pwd, screen. (N) 4 saints, one with crozier, one with papal cross; (S) 4 winged evangelists, primer text; name beginning with M; John and "Missus est Angel" (Luke's text), NRO, Rye 17, 3:129v.

Norwich SPH. sc, wall post stops. c1460. At transept crossing, winged figs; except Matthew, standing on their symbols: SE John, SW Mark; NW Luke, NE Matthew. Nave, facing each other (N and S), doctors, in tippets, seated on benches before ringed curtains, open books on laps.

Harpley. wdcarv, S porch door. Early 15c. (L reading from bottom) bp; Jerome; John holding eagle in hands; ?Luke with animal at feet, LH raised ?with scroll; (R) doctor with roll, Gregory; Matthew, book in RH, tiny angel at feet; ?Mark, book and scroll, animal at feet; size and weathering make

animals difficult to distinguish.

Beeston S Mary. wdcarv, wall posts. 15[1]. (Evangelists flanking) **N1** Matthew, **N2** Doctor, **N3** ?prophet with roll, donor below, **N4** doctor, **N5** Mark. **S1** Luke, **S2** doctor, **S3** Peter, **S4** doctor, **S5** John.

Evangelist/Doctor Fonts

The Latin Doctors typically alternate with (~) tetramorphic symbols, less commonly the 4 Evangelists. Academic costume predominates. For a typical font at Monks Soham (Suf), see Nichols (1994) pl 3. All fonts are perpendicular in date. Many of the figs have been radically damaged.

Blakeney. bowl. Tetramorphs ~ doctors in academic costume on wide benches, 3 with scrolls, teaching gestures, one with open book on lectern. Doctor betw Mark and John with penner and ink pot hanging from back of chair. Prior & Gardner date this type of font c1400.

Burgh-next-Aylsham. base; stem. Tetramorphs; standing doctors in academic costume.

E Dereham. base. Tetramorphs ~ seated doctors in academic costumes; il Gardner fig 525; Cautley 134.

Docking. bowl. Evangelists with symbols beneath on chamfer ~ doctors; all seated on wide benches holding open books. (Reading clockwise) Jerome; John represented as apostle; bp; Matthew in cope; ?Gregory; Mark with ?stole; bp in chasuble; Luke in alb and ?stole. Second set of symbols at corners of base, largely disfigured.

Earsham. base disfigured, but originally 8 figures; similar disfigurement at Binham, Cley and Norwich SPM.

Gunthorpe. bowl. Tetramorphs (lion with foot on orb) ~ seated doctors in academic costume. Vestiges of animal feet at base of pedestal.

Hempnall. base. Tetramorphs (Matthew with book) ~ seated doctors in academic costume with books on laps; Tomlinson pl XLIX.

Marsham. stem. Tetramorphs ~ seated doctors in academic costume with books; il Cautley 134.

Martham. stem. Tetramorphs at ribs of stem ~

doctors largely disfigured.

Morston. bowl. Tetramorphs ~ seated doctors in copes, 2 with pileus, 2 with mitres.

Cathedral. base. Tetramorphs ~ seated doctors in academic costume, one with open book (**FIG 28**), others with teaching gestures.

Raveningham. bowl. Tetramorphs on nebuly ~ doctors holding open books seated in elaborate chairs with animal masks on finials, nebuly above. The doctors all wear copes; heads damaged, one mitre, one pileus. Williamson (1961, 257) cites one such font at Rackheath, of which I can find no trace. The font at All Saints dates from 1639 (decorated with arms, Mackerell BL Add MS 12256, f 125) and that at the new church of Holy Trinity is modern. Perhaps the citation is in error for Raveningham.

Reymerston? bowl. Tetramorphs ~ seated men, some with books; one in pileus; elaborate hair styles; "possibly recut," Williamson (1961).

Salle. base. 8 figs originally on stools, a common pattern with 7-sacrament fonts.

Seething. base/stem. Tetramorphs at base ~ standing doctors (book/roll); Cautley il p 136.

Sloley. base/stem. Tetramorphs ~ standing doctors in academic costumes, holding rolls; Bond (1985) color pl 8.

Thelveton? stem. Evangelists as angels with books ~ 3 standing bps with scrolls, ?Jerome in hat.

Trowse S Andrew. stem. Tetramorphs ~ seated doctors in academic costume. 1503 (6s 8d bequest to gild font, C & C). Tomlinson pl L.

Lt Walsingham. stem. Seated Evangelists pointing to open books/scrolls on laps, symbols at their feet ~ standing doctors in copes, holding scrolls; Jerome with ?lion at feet; Bond (1985) color pl 5.

Gt Witchingham. chamfer. Tetramorphs with name scrolls (**FIG 29**) ~ angel busts with names of doctors on scrolls.

All saints are nimbate and are standing, unless stated otherwise. All virgins have long hair, sometimes luxuriant. A generic description is provided at the head of each entry for popular subjects. The features of this description should be presumed present unless the subject is identified as fragmentary (in which case full information is provided) or unless stated otherwise. Uncanonized saints lack feast citation, though some may have enjoyed local celebration. Dates for kings, popes, and English archbishops and bishops are regnal years as in *Handbook of British Chronology* and Duffy, *Saints and Sinners: A History of the Popes.*

Agatha

Virgin martyr (nd). 5 Feb. Agatha's severed breast, one of the tortures, figures in fewer than half the witnesses. See also *Sitha* Docking. For painted glass, see Appendix V.2.

Norwich, Carrow Priory. ms, Carrow Psalter, Baltimore, Walters Art Gallery W.34, hi, f 19v. 1250–60. Martyrdom; mistakenly labeled Cecilia. Morgan, *Survey* pt 2 Cat. 118.

E Anglia. ms, *The South English Legendary*, Bod L Tanner 17, marginal drawing, f 19. 15^1. "Agace" praying; ?divine hand above (cropped); Scott, *Survey* Cat. 45. This Cambridgeshire MS is cited for saints with documented Norfolk devotion.

Cley. pg, sIX.A1. 1450–60. 4-fingered fleshhook held vertically in LH; clasped book in RH at waist; breasts prominent above slit ruby gown; **FIG 30**. Appendix V.1.

Mileham. pg, tracery light. c1450. Crowned, in blue mantle over white gown powdered with gold flowers; breast in LH; (below) S*anct*a Agatha; Wdf (1938b), 172. Glass removed from E win, in storage.

Wighton. pg, sIV.A4. 15^3 (see, however, Marks 198, and King). 3-fingered fleshhook fitted on wooden staff in LH; clasped book in RH; bare breasted; King fig 4. Appendix V.1.

Norwich SPH. pg frag, not *in situ*, E win 1b. 15^3. Fleshhook in LH, book in RH, breast-line prominent above ruby gown; same cartoon as at Cley. Set against a seaweed screen as are the apostle/prophet figs at 1a, suggesting coordinated sets.

S Creake. pg, nVIII.3c, not *in situ*. Mid 15c.In LH forceps with breast; closed book with decorated binding under RA; background

detail suggests she came from the same win as Helen (see below).

Norwich All Saints. pg frag, nII.A5. Late 15c. Name on scroll; Wdf (1938b) 172–3.

Marsham. *pg, N aisle, Bl 6:287.

Martham. *pg, with flesh hook, Husenbeth (1882) 4.

Upton. pwd, screen panel, S4. c1500 (screen inscr for donors, †1505 without bequest in wills; wills transcribed in Hill). In LH forceps with bleeding breast, clasped book in RH; ermine collar; lower R side of this panel cut away to fit molding.

Norwich S John Maddermarket? pwd, screen panel, originally in Lady Ch (gift of Ralf Segrym [†1472], his initials and device painted at top of panes); now at V & A. 15^3. RH holding ermine-lined mantle, green gown; LH holding forceps with bloody breast; L & M Cat. 74; "much repainted," Rickert 250 fn 17; Tracy (1988) Cat. 101, color pl 5. 19c repainting has caused a number of interpretive problems for the Maddermarket screen. This saint has generally been identified as Agatha, but the bleeding wound is not original, and the bloody breast in the forceps is atypically small. See also *William of Norwich*, where the "restorer" showed a similar predilection for blood.

Wiggenhall S Mary Magdalene? *pwd, screen pane. "Faint traces of figs, one said to be St. Agatha," Keyser (1907b) 309. When photographed (pl 3) the screen was across the W aisle.

Hemblington. sc, font relief, N face. 15c. Seated on wide bench, both breasts bare, ?trace of sword above; book in LH, RH raised; polychrome restored by Tristram.

Wiggenhall S Mary. wdcarv, be niche, nave N6. 16^1. Bare breasts, knife lying atop R breast; LH raised; looped sash; M & R 3:162; Duffy fig 69.

Weybridge Priory. printed calendar, NMS 134.944. 1503. Holding breast aloft.

Agnes

Virgin martyr (†c350). 21 Jan. Lamb with forelegs resting against saint or held in arm. The instrument of martyrdom (knife/dagger) figures in only one-third of the

witnesses. The Stowe Breviary historiates the opening initial for the feasts of highly graded saints, incl Agnes, with generic female heads, some in veils. For painted glass, see Appendix V.1.

Thetford Priory 1. 12/13c. Relic of hair, Bl 2: 118.

Cawston. *pcl. 14c. Green buckram with image depicted, Watkin 1:53. Church dedication.

Norwich Blackfriars, New House. *im. 14[4]. *Index Monasticus* 38.

East Anglia. *The South English Legendary*, Bod L Tanner 17, marginal drawing, f 7. 15[1]. Kneeling in prayer against radiance, voluminous white gown, luxurious hair.

Field Dalling. pg, sIV.A6. 15[3]. Yellow-handled dagger plunged in base of throat; lamb held on book in draped LH; RH extended to lamb.

Martham. pg, nIV.3c. 15c. Closed book in LH; RH extended to lamb below. The glass at Martham was extensively restored by Dixon.

Plumstead S Michael. pg, originally from Catton Hall, now set in E win 1b. 15c. Yellow-handled dagger plunged in breast; in RH closed book; LH relaxed at waistline; lamb below.

Stockton. pg frag, leaded in border of S2. Lamb with forefeet raised against a carpeted step.

Norwich S John Maddermarket? pwd, screen panel; now in V & A. 15[3]. Wearing burlet with ouch, vair-lined red mantle; sword held by hilt in outstretched RH; Rickert pl 189. Identified as Agnes (?Catherine) by Tracy (Cat. 100, color pl 6) but queried as Catherine by Morgan (L & M Cat. 74) and Nicholas Rogers, who so argued because the same headdress is also worn by Catherine at Walpole S Peter (cited in Tracy 79). The burlet, however, is not uncommon for virgin martyrs. Although the donor's wife's name was Agnes, there is only one unequivocal example of Agnes holding a sword (see Denton). The absence of lamb is also troubling, but the lower section of this panel where one would expect to find it has been repainted with hummocks.

N Elmham. pwd, screen panel, S7. 15[3]. Nimbed lamb on palm of RH, LH holding mantle; large gold dagger plunged in throat; damask gown, mantle with distinctive gold braid and clasp at neckline; (below) "San*cta* agnes." It is clear from antiquarian descriptions that the panels of this screen have been rearranged a number of times. Carthew cited the virgin saints on "a parclose screen of a chapel in the south aisle," listing the saints in their present order, but Martin cited them in a different order.

Norwich S James. pwd, screen panel. c1479 (bequest to paint screen "particus," NCC Gelour 230). Clasped book in RH; lamb below. "San*cta* [?]auguste" inscr below may reflect variant "Agace/Agasse" for Agatha, but there is no other evidence for Agatha at S James. The screen panels, which have undergone extensive restoration, are now hung separately along the S wall at S Mary Magdalene.

Cawston. pwd, screen panel, N1. 1490. Crowned; dagger plunged in base of throat with blood surrounding; LH holding fold of mantle below waistline, RH holding clasped book against RS; lamb below; wide gold braid at neckline fastened with double clasps, damask gown; Strange, color pl facing p 84.

Litcham. pwd, screen panel, N5. c1500. Long dagger in RH, point up, lamb on LA; mantle over ?damask gown; chapelet in hair. Frame repainted 1901–3.

N Tuddenham. pwd, screen panel, N3. 1499–1504 (bequests, Cotton). Knife at throat, lamb below; chemise-sac in LH; chapelet in hair.

Taverham. sc, font stem. 15c (?Victorian). Crowned, sword in LH, book and ?lamb on RH. The 8 figs on the stem may be reproductions of the damaged figs cited in the 18c. The attributes are typical for Edmund, Giles, Leonard, and Margaret; see also below *Lambert*, and X.4 *James Minor*.

Cawston. wp, E wall S transept, faint. 15c. Within architectural setting, Agnes seated on dais against cloth of honor, crowned, RH raised toward dove with ring in beak; (below) 2 donors kneeling with English prayer scrolls (Park). Very faint; the subject was formerly identified as the Virgin enthroned. Description based on a watercolor by Sandys (NMS B18.235.951).

Wiggenhall S Mary? wdcarv, be nave, S9. Early 15c. Bullmore cited lamb at feet.

Cawston. wdcarv, statue against N chancel wall, not *in situ*. ?Late 15c. Veiled, palm in RH, lamb on LA; overskirt shorter than gown (cf below Denton).

Sandringham. pg, sII.A2. 16[1]. Dagger plunged in

throat horizontally; chapelet, lamb on palm of RH, LH holding cloak; "Sancta Agnes"; Keyser (1917) fig 9B. In opposing N and S wins, 6 tracery lights each with 2 saints turned slightly to face each other; horizontal name labels across center of body. For general views of windows, see Keyser figs 4 & 5.

Cley. *pg. 1502. Bequest for win, John Symondes' will (Duffy, personal commuication).

Garboldisham. pwd, screen panel, N4. c1500 (donor inscr, 1504). Palm in LH over shoulder; ?lamb at feet; label at either side of head, (L) Sancta, (R) ?ag. From delapidated church of All Saints (Bl 1:286).

Beeston S Mary. pwd, screen panel, N3. 16[1] (Cotton). Lamb in characteristic position below; otherwise largely disfigured.

Denton. pwd, mounted on chest, 1 (reading L to R). 16[1] (based on costume). Sword in LH pointing diagonally across body; short-sleeved, ¾ length tunic with tasseled hem over long gown with voluminous sleeves. For further detail, see X.4 *Jude*.

Dersingham? See Withburga.

Babingley. *pwd, screen panel. c1500. Barb, no veil, curious headdress; looking at open book in LH; large palm in RH; (L) white lamb at feet, DT 53:70.

Repps. *pwd, screen panel. ?1553–8. No headdress, hands joined, gazing up; (L) white lamb at feet. All but one of the panes had the name of the saint below, but in atypical script, DT 59:213. The painter also worked at Babingley.

Weybridge Priory. printed calendar, NMS 134.944. 1503. With palm.

Norwich. seal, Archdeaconry. 16 or 17c. "St. Agnes, carrying a lamb in her arms. On a scroll overhead, the inscription: HVMILITAS ANIMI SVBLIMITAS CHRISTIANI"; *BM Cat. of Seals*, 2109.

Church dedication at Cawston; Bond (1914) 5 for England.

Guilds at Cawston (Bl 6:264) & Lynn (*Index Monasticus* 73).

Ailred (Aelred, Ethelred)

Abbot of the Cistercian abbey at Rievaulx, Yorkshire (1110–67). 12 Jan.

Marsham. *pg, N aisle, E win, Bl 6:287, cited as Ethelred. See Appendix V.5.

Alban

Proto-martyr of England, soldier (3c). 20 June (22 June in Anglo-Saxon calendars). Shrine with his relics at St. Albans.

Walpole S Peter. *pg, S chancel. 1423/25. Bl 9: 117.

Wiggenhall S Mary Magdalene. pg, nV.A6. c1450. Archbp with separate inscr scroll "Sanctus albin'." Discrepencies betw representations and name scrolls are common in this interesting series of unusual saints, probably traceable to 1924–5 restoration; Keyser (1907b) full view, figs 5–10. Wdf identified 3 distinct styles (1933). Appendix V.5.

Norwich SPM. pg E win E2. Mid 15c. With scepter, name inscr. David King (forthcoming) notes that Alban is often represented as a prince in late medieval work. Appendix V.5.

Binham. pwd, screen panel, S14. c1500. Upper section of double cross-staff, the uppermost cross encircled in a disk (identified by James, *S & N* 171). Screen overpainted with New Testament passages; although little can be seen of the saints beneath, what remains indicates that it must have been a particularly fine screen.

Binham Priory. seal. nd. Reverse, soldier with massive sword, S Alban kneeling, raised hands, head falling at feet of soldier, extending LH to receive his eyes, which were supposed to have dropped from his head; obverse, Virgin and Child in niche of shrine; Harrod (1857) 209.

Original dedication at Wymondham (SS Mary and Alban); guild at Binham (Bl 9:212). Both Binham and Wymondham were founded from S Albans.

Aldhelm

Abbot of Malmesbury and Bp of Sherborne c705–9. 25 May. Perhaps in pg set at Blythburgh (Suf), Wdf 180–1.

E Anglia. ms, *The South English Legendary*, Bod L Tanner 17, marginal drawing, f 110. 15[1]. In episcopal Mass vestments with mitre and crozier.

Wiggenhall S Mary Magdalene. pg, nVII.A2. c1450. Bp, seated, crozier in LH, RH blessing; chasuble, gloves; "Sanctus Aldelm'"; Keyser (1907b), pl XI. Appendix V.5.

All Saints

Manuscript entries are for the feast. 1 Nov.

Cathedral. *Altar in former Martyrs Ch, rededicated to S Saviour and All Saints, 1278.

Diocese. ms, hours, NMS 158.926.4f, hi, f 51v (Lauds, *memoriae*). c1310–20. Saints, incl king, bp, cleric, and ?virgin; bust of the deity above.

— ms, missal, Bod L Hatton 1, hi, f 181v. 14[4]. Christ seated, holding orb and blessing; surrounded by saints. Scott, *Survey* Cat. 5 il no. 18.

Cathedral. *wp, E wall, Bauchun Ch. c1330. 4 saints (Tristram 230); ch originally dedicated to Virgin and All Saints, Dodwell (1975) 112.

Poringland. *im, tabernacle, Bl 5:442; church dedication.

Hethel. *im and a guild kept before it, Bl 5:108.

?Diocese. ms, Wollaton Antiphonal, Nottingham U Library 250, hi, f 393. c1430. Virgin flanked by Christ with wounds and Father; (below) saints.

Ranworth. ms, Ranworth Antiphonal, S Helen's Church, hi, f 271v. 1460–80. 4 angels in albs; Father blessing and supporting crucifix with L hand, cross ending in orb; no Dove; saints representing estates enfolded in Father's ermine-lined mantle; "possibly the only such [Schutzmantel] in English book illustration," Scott, *Survey* Cat. 121.

Tilney All Saints. *im. c1500 (dedication). Churchwarden accounts: "pro pictac*ione* Imag*inis* Omnium Sanctorum xv*d*"; "pro ern wark ad tabernac[u]lum Omnium Sanctorum iij*s* iij*d*"; "Item solutum pro expensis Ricardi Skynner et aliis adiuvantibus sibi circa pend. le corten coram Imagine Omnium Sanctorum iiij*d*."; "Item pro le Bukkram empt pro Altare Omnium Sanctorum Beate Marie et Sancti Edmundi & factura" 5*s* 6*d*; Stallard 83–84, 90.

Norwich S George Colegate. *im. 1511. "Will. Birde Gravour, buried before All-Hallows Image . . . and gave a pair of chalices to the altar, a vestment of black worsted, and a cope; and ordered the image, of All-Hallows and the tabernacle belonging to it, to be painted like St. George's tabernacle," Bl 4:470.

Shipdham. *im. 1557. In addition to expenses for new rood figures (20*s*) and painting thereof (4*s*), "payde for making þe Image of al hallowne & þe payntin xxxvj s iiij d" and for "for making a base to set on al hallows, xx d," Galloway 83. Church dedication.

Weybridge Priory. printed calendar, NMS 134.944. 1503. 1–2 Nov. Building (heaven —all saints); souls in flames (purgatory —all souls).

Linnell cites 153 churches in Norfolk with this dedication; Bond (1914) 1255 for England (probably all joint). Opening statements of guild certificates often include "alle halwen" even when the guild is specifically devoted to one saint. The dedication was also conjoined with the Trinity, e.g., in the flush work above the S porch at Winterton, "In honore sante Trinitatis et omnium sanctorum" (Cautley, now difficult to decipher), and a bequest was made to Holy Trinity and All Saints of Lynn (Tanner 86).

L'Estrange (1874) cites 12 bells, with inscrs: "ISTA CAMPANA FACTA EST IN ONORE OMNIUM SANCTORUM" (Rockland All Saints), "SANCTORUM MERITIS PANGAMUS CANTICA LAUDIS" (Gt Plumstead), and elsewhere "HEC FIT SANCTORUM CAMPANA LAUDE BONORUM."

Chantry in Gissing churchyard (Bl 1:164); ch in W Rudham churchyard (Bl 7:161).

Lights at Lessingham (Bl 9:329) & Marsham (Bl 6:287).

Alphege (Ælfheah)

Archbp of Canterbury 1005–12 and martyr. 19 April.

E Anglia. ms, *The South English Legendary*, Bod L Tanner 17, marginal drawing, f 89. 15[1]. In Benedictine habit, holding large bloodied axe and stones; tonsured head wounded and bleeding.

Salle. *pg, sIV.light a. c1440. Part of a set of 18 standing figs with labels and dates, one per light in 3 3-light windows N and S. For a schematic representation of this elaborate set of popes, kings, and bishops together with notes from M R James, see Parsons 62–4. The scheme has been further elucidated by King (1979) 335. Appendix V.5.

Weybridge Priory. printed calendar, NMS 134.944. 1503. Bp.

Ambrose

Bp of Milan and doctor (339–97). 7 Dec. See also XI.3.

Wiggenhall S Mary? wdcarv, be shoulder, nave N3. 16[1]. Holding ?beehives (Bullmore). The fig in the niche below is writing with a quill. The objects may be loaves of bread, in which case probably Philip.

Anastasia

See Appendix V.1.

Anne

Mother of the Virgin Mary. 25 July. Her feast was celebrated as early as 1360 in the Norwich Archdeaconry (Watkin 2:xxxix), although it was only extended throughout England in 1383. S Giles Hospital in Norwich had been dedicated to the Virgin and S Anne by its 13c founder, Bp Suffield. The Joys of S Anne were added to a Norfolk manuscript (NMS MS 158.926.4f) shortly after it was completed (c1322), probably for a female owner. See also III.2.

Cathedral. *ch/im. c1329 (ch constructed, Dodwell [1975] 112). 1330, offerings at altars and shrines totaled with those to SS Hippolytus and William, 15s 2½d (Shinners 138). 1374, request for burial there (Bl 4: 38).

Norwich Whitefriars. *im in ch of Holy Cross, *Index Monasticus* 42; 1440, burial before, Bl 4:417.

Norwich SPM. *im. 15³. In ch, where guild met, chief altar "where now the new vestry is," Bl 4:207.

Norwich S Helen. *im in chancel. 15c. Rawcliffe 125.

Yarmouth. *im. 1484–5. "De pixide beate Anne iijs"; perhaps in ch of S Mary of Arnburgh; Morant (1872) 232.

N Barningham. *im, Bl 8:96.

Fersfield. *im, S aisle, in her ch "a famous image standing . . . , and a large gild kept to her honour, to which most that died, in this and the adjacent towns, generally gave something, and often left money to find wax candle[s], and lights, continually burning before it," Bl 1:105.

Norwich Berstreet-Gates. *im in tabernacle in nave, Bl 4:141.

Norwich S Edmund. *im, Bl 4:405.

Norwich S Gregory. *im, niche of S aisle wall, ch dedicated to Thomas Becket, Bl 4:273.

Norwich S Michael-at-Plea. *im, Bl 4:325.

Norwich SPH. *im, light before, Bl 4:325.

Oxborough. *im, "her image is said to be on the N side of the church," Bl 6:183.

Poringland. *im, altar dedication, Bl 5:442.

Fersfield. *pg, S aisle ?E win. "Blessed Virgin and St. Anne her mother, to whom the c[h]apel was dedicated, Bl 1:105.

Norwich SPM. *emb. 16¹, "a single vestment of wight damaske wᵗ orpheras rede damaske wᵗ a ymage of sent Anne uppon the bake / belongyng to sent Anne is gilde," Hope (1901) 204.

— *emb cope hood. 16¹, "in the cape sent Anne," Hope (1901) 197.

— *pcl. 16¹, "a hangyng whight for oʳ lady aulter steyned after the bawdkyn wᵗ roses And an ymage of sent Anne & oʳ lady in the mydds," Hope (1901) 218. Perhaps teaching the Virgin to read.

— *pcl. 16¹, "for the Trinite aulter a wight steyned hangyng wᵗ the coronation of oʳ lady in the upper parte & sent Anne in the nether parte," Hope (1901) 218.

Norwich SPM? *pcl. 16¹, "baner cloith of sent Anne litel gold in it frengid wᵗ threde wight red & grene," Hope (1901) 221.

Thetford S Peter. *im. 1503. 13s 4d bequest for "a new tabernacle of St. Anne" in her ch (E end of N aisle), Bl 2:62.

Norwich All Saints. *im, N aisle, small ch dedicated to S Anne. 1523. Alice Carr bequeathed "a small pair of coral beads to be daily about this image," and "her best coral beads to be used on the feast of St. Anne only," Bl 4:163. This best pair of beads saw wide service, also decking the images of the Virgin and SS Catherine and Margaret on their feasts, Bl 4:154.

Lt Walsingham. *im, probably at the guild altar in N transept, Bl 9:271. 1526 request for burial before, John Harte, *Reg. Palgrave* f 43 (Cotton, personal communication).

Norwich SS Simon & Jude. *im, light before. 1531. Bl 4:356.

N Wootton. *im. 1534. Bequest for tabernacle of S Anne, Bl 9:203.

Loddon. pwd, screen door to Lady Ch. 16¹. Anne in veil and wimple, rose mantle over gown, being handed Infant; the other door is missing, probably with Virgin. Elsewhere in Norfolk this subject seems to have been confined to Flemish roundels, e.g., at Saxlingham Nethergate (sIV) and Ketteringham (E win, 3e); see Cole. Of two panels to the N, one is blank, the other with traces of polychrome.

Weybridge Priory. printed calendar, NMS 134.944. 1503. Anne veiled, Infant (naked with cross nimbus), Virgin; all busts. There was also a guild of S Anne in the Priory.

Guilds at Acle Priory (*Index Monasticus* 71); N Barningham (Bl 8:96); Blakeney Whitefriars, 1518 (Bl

9:455); Congham (*Index Monasticus* 72); S Creake (Bl 6:84, also an altar [Linnell 1955]); Cromer (Bl 8:107); E Dereham 1474 (Bl 10:321); Fakenham (Bl 7:96); Fersfield, 1326–1506 (Bl 1:105); Gt Fransham (Bl 9:499); Happisburgh (Bl 9:301); Hickling (Bl 9:307); Horsey (*Index Monasticus* 72); Lynn (Farnhill); Litcham (Puddy 49); Norwich: S Martin-at-Bailey, 1373, and S Martin-at-Palace, 1505–6 (Farnhill), S Martin-at-Plain (Bl 4:369), SPM 1479–1529 (Bl 4:207); Poringland (Bl 5:442); Shipdham (Rye 134 f 5), Snettesham (Bl 10:379); Stratton S Michael (*Index Monasticus* 74); Swanton Morley (Bl 10:57); Thetford S Peter 1483–1547 (Bl 2:62); Lt Walsingham (mentioned in 1495 and 1501 wills, Cotton personal communication & Bl 9:271); N Wootton (Bl 9:203). L'Estrange (1874, 13) cites 6 inscr bells with evenly divided texts: "Sancta Anna Ora Pro Nobis" and "Celesti Manna Tua Prole Nos Cibet Anna."

Chs at E Harling, N aisle (Bl 1:330, founded by Anne Harling); Hunworth (1506 Harrod [1847] 123); Norwich: Carrow Priory (Rye [1899] xlviii); Conisford, demolished c1370 (*Index Monasticus* 70); S Andrew, E end S aisle 1467, 1502, bequests for vestments (Bl 4:303, 315); Greyfriars (Kirkpatrick [1845] 126); S Margaret, E end S aisle (Bl 3:257); S Stephen (Bl 4:150, 163); ch of ease for S Clement in Conisford demolished 1370 (Bl 4:78).

Altars at Gt Fransham, 1358 (Watkin 2:105) and Norwich: S Mary Coslany (Bl 4:489) and S Gregory (Bl 4:273). Service books cited at Bawsey, Norwich S Saviour, Gt Ryburgh, Thetford S Mary (Watkin 2:130, 1:8, 2:102, 2:145).

Lights at Fakenham (Bl 7:96), Marsham (Bl 6:287), Norwich, S Michael Coslany (Bl 4:499), Outwell (1514, Williams [1941] 339), Stratton Strawless (1490, Harrod [1847] 117).

Antony of Egypt

Abbot, the desert father (251–356). 17 Jan. The temptations of are represented only in the late screen at Tacolneston. Patron of English merchants at Alexandria.

Fincham S Michael. *im. 1375. Candles provided by guild, Westlake no. 232.

Cathedral. *im. 1390, sacrist's roll, Shinners, 139.

S Acre. *pg, N clerestory. ?14$^{3–4}$. "S[an]c[t]us Antonius," Bl 6:81.

Potter Heigham. wp, N aisle, betw westernmost win and N door, *circa* 7' high. 14c. In RH crozier with infula; round object in LH, tau staff below; reported to have at feet a pig with bell, now obscured by a vestry.

E Rudham. al, frag (waist down). 15c. Staff in RH; profile pig at feet with bell on collar. Winter pencil drawings, NMS 1210.76.94.

Swainsthorpe S Mary. *im given to church, 1435. Bl 5:61. Church decayed 16c.

Lynn S Margaret. *im, guild candle burning "be-forn þe ymage of seynt Antony," on feast days "thorow-out þe yere," T Smith 45; Westlake no. 245.

Hingham. *im, light before, Bl 2:423.

Norwich S Leonard's Priory. *im, Bl 4:427.

Norwich S Martin-at-Oak (Coslany). *im, Bl 4:485.

Eccles. *pg, N chancel. "St. Anthony" and below "Beate Antoni, ora pro nobis," Bl 1:410. Same invocation on one of the bells (L'Estrange [1874] 15). See Benedict and Germanus, & Appendix V.5.

Sparham. *pg. "Carrying a bell," Nelson (1913) 154.

Provenance unknown. *pg, roundel. Ch in trees, Antony with beads in RH, L-shaped staff in LH, boar at feet, unidentified sketch in King Collection, NNAS, Box 2.

Weasenham All Saints. *pg, N win, "a saint with a bell . . . , and on a label, 'P. sonitum hujus campanae hostes tui confugiunt'," Bl 10:81.

Gressenhall. *pwd, screen panel. 15$^{3–4}$. Originally S4 symmetrically paired with Leonard at N1, "*Sanctus* Antonius," NRO, Rye 17, 2:173. See also XI.3.

Smallburgh. pwd, screen panel, N1. 15^4. In monastic habit, tau staff in RH, bell on red band hung over LH; white pig with red collar.

Wicklewood? *pwd, screen panel, "a saints bell by the pulpit on the rood loft," NRO, Rye 17, 4:109.

Outwell. *pg, Beaupré Ch. 16^1. Bl 7:471.

Tacolneston. pwd, screen panel, in N aisle. 1510–20 (church rebuilt 1503), based on 1509 engraving by Lucas van Leyden. At rear city and tree; (L) Antony, barefoot, in black, RH raised, LH on open book on red stand before him; (R) standing temptress, extending closed vase to him, wearing exotic headdress, full sleeves with tight cuffs, and green soft girdle with looped tie below waistline, ending in red tassel. See John Mitchell's description in Moore, Cat. 2b and fig 7, color pl 5.

Wellingham. *pwd, screen panel. c1532. On the "first pane . . . a St. with a Bell and [tau cross] on his R shoulder and book in one hand," NRO, Rye 17, 4:83; paired with S Roch. The only blank pane today is on the S side. The diminutive nave makes it difficult to project return screens.

Weybridge Priory. printed calendar, NMS 134.944. 1503. Crozier and pig.

Lights at Marsham (Bl 6:287), Horstead (Millican 20), S Creake 1451 (John Norton, NCC Aleyn f 74), 1491 (Robert Norton, Norf Arch Bk 1, f 173).

Bell inscr "AD LAUDEM SANCTI ANTONII" at Norwich S Lawrence, L'Estrange (1874) 54.

Apollonia

Virgin martyr at Alexandria (†c249). 9 Feb. Invoked against toothache and headache. Uniformly represented with a tooth clasped in the teeth of forceps held in LH vertically, unless stated otherwise.

Hingham. *im, light before, Bl 2:423.

Cley. pg, sIX.A7. 1450–60. Book in RH; ruby gown, gold-trimmed white mantle. Appendix V.1.

Sharrington. *pg, N win. "Upon middle window of N. side are six female saints Cecilia, Appollonia, Katharine, Margaret, Petronilla, and Seytha," Frere MSS, NRS 1:37. Appendix V.1.

Barton Turf. pwd, screen panel, N1. c1440 (L & M Cat. 72). Clasped book in draped RH; ermine-lined red mantle with double clasp over damask gown with pineapple design; (above) "Sancta apilonia"; paired with S Sitha; Constable il p 211; Duffy fig 60; detail in Tracy (1988) fig 28.

Norwich S Augustine. pwd, screen panel. 15³. Single panel with painted design to simulate woodwork tracery. Whenever the tracery was painted, it extended to a second subject since the cut lines run through the design.

Ludham. pwd, screen panel, S6. c1493. All saints on N side against cloth of honor. Forceps in RH, palm and mantle in LH; white-lined red mantle fastened with double clasp over gold gown; same costume used for paired Mary Magdalene (N1); "Sancta Apollonia"; Duffy fig 73.

Lessingham. pwd, screen door (loose). c1500. Closed book in LH, forceps in RH; ermine trimmed gown and mantle, ermine partlet and collar closed with morse, headdress (Costume Glossary, **FIG b**). The female saints on the doors were not painted by the artist responsible for the apostles; I have assigned them to the cluster of bequests c1500 (Cotton). In 1845 the doors were "lying loose in the tower" (DT 33:164) and included Margaret as well as the 3 extant saints. When Cautley saw the screen, he cited very faint names. Catherine and Mary

Magdalene are dressed like Apollonia; NMS. See also X & XI.

Haddiscoe. *pwd, screen panel. Drawing of forceps and tooth, NRO, Rye 17, 2:181. Four saints on the S side.

Sandringham. pg, sII.A6. 16¹. Chapelet on brow; in RH huge forceps with tooth; closed book in LH; "Sancta Appollenia"; Keyser (1917) fig 11B.

Binham. pwd, frag screen panel, S13. 16¹. Part of face and body remains; name preserved below.

Dersingham. pwd, screen, 6 figs, females alternate with males. 16¹ (c1530, Whittingham, church booklet). N1 massive white burlet; dark mantle over red gown.

Horsham S Faith. pwd, screen panel, S3. 1528. Open book in crook of RA. Screen originally had names below, some remain.

Babingley. *pwd, screen panel. ?1553–8. Chapelet in hair, palm in RH; large tooth in draped LH, DT 53:71.

Apollonius

Roman martyr (†183). 23 July.

Lynn. Guild. 1371. Owen 326.

Armel

Abbot (†c552). 16 Aug; feast entered Sarum calendar 1498; Welsh monk who carried his mission to Brittany, Normandy, etc.; his *cultus* was promoted by Henry VII.

Litcham. pwd, screen panel, S3. c1500. Wearing short red chasuble with elaborate orphrey over armor; RH holding book in chemise binding, LA holding devil by decorated lead. The same iconography is found in France and in other representations of Armel in England; see A Green.

Asterius

Martyr priest (†223). 21 Oct. Buried Pope Callistus.

Salle. pg, nII.B4. c1440. "Sanctus Austerius, cardinal," holding book open with both hands. See *Lawrence* and Appendix V.5.

Athelstan

King of West Saxons 924–39, direct rule over Danes of York 927.

Norwich SPM. pg E win C4. Mid 15c. King with church, "Alderstan." King (forthcoming) notes that this spelling is reflected in Capgrave's "Ældestan."

Mulbarton? pg, sIII.2b. 15c. Unnimbed, scepter

in LH, church resting on R forearm; ermine collar and yellow patterned white gown with fur hem, tassels hanging from tight cuff of bag sleeve; "possibly King Solomon, from a genealogy of Christ," King 24.

Catfield? pwd, screen panel, N3. 15[4] (chancel rebuilt by rector, 1460–71; screen woodwork similar to Happisburgh ?1422). Unnimbed, scepter in RH, holding a church in LH. 16 kings, with scepters; in each set of two the kings turn slightly towards each other (cf the composition in the pg set at SPM).

Augustine of Canterbury

Archbp of Canterbury (597–c604) and confessor. 26 May. Sent by Pope Gregory to head British mission.

Diocese. ms, Stowe Breviary, BL Stowe 12, hi, f 250. c1322–5. Bp in chasuble, one of many generic representations in the *sanctorale*.

E Anglia. ms, *The South English Legendary*, Bod L Tanner 17, marginal drawing, f 111. 15[1]. In archiepiscopal Mass vestments, mitre, with single cross-staff, beside baptismal font with font cover on ground.

Salle. *pg, nIII, light c. c1440. Appendix V.5.

Beachamwell. *pg, S win, "figures of St. Augustine, and St. Dunstan, the archbishops," Bl 7:296.

Norwich S Michael-at-Plea. *pwd, screen panel, "St. Benedict and St. Austin," Bl 4:321.

Weybridge Priory. printed calendar, NMS 134.944. 1503. Heart on mitre. The same symbol is used for Augustine of Hippo.

Guild at Norwich S Augustine, Poor men's guild of "seyn Austyn, anglorum Episcopi," 1380 (T Smith 40).

Augustine of Hippo

Bp and Doctor. 354–430. 28 Aug. See XI.3.

Norwich Austin Friars. *im, *Index Monasticus* 43.

Weybridge Priory. printed calendar, NMS 134.944. 1503. Heart on mitre. The same symbol is used for Augustine of Canterbury.

Guilds at Norwich Austin Friars (Bl 4:90) & S Michael-at-Thorn (Tanner 209).

Barbara

Virgin martyr (nd; allegedly put to death in the persecution of Maximian). 4 Dec. One of the 10 saints cited by Lydgate as special helpers. Typically repre-

sented holding a tower (rarely with Trinitarian symbolism). See also XIII.4 N Creake, where Fortitude is based on the Barbara model. Frags of a foreign glass series of her life remain at Norwich S Stephen and Warham S Mary Magdalene (King 11).

Thetford Priory 1. 12/13c. Relic, Bl 2:118.

Norwich Whitefriars? sc, image in niche. c1330. With ?tower. The damaged object might have been an ointment jar, but since there was a guild of S Barbara at Whitefriars, the tower identification is attractive. See Lindley for discussion of the Arminghall Arch, now reconstructed at Magistrates Court, Norwich; figs 1–6, 10–12. It is likely that the paired woman (now without attribute) was also a saint. In the niches above 2 kings with crossed knees. Engraving in Cotman (1818) pl 21.

— *im and light, Kirkpatrick 38, 176.

Lynn & Sheringham. pilgrim badges. 15c. Standing beside tower with palm in hand, Spencer (1980) Cat. 112. There may be a third badge in private hands. A 14c ampulla with Virgin and Child on the obverse found in London; Mitchiner (Cat. 246) speculates from an E Anglian shrine. However, the same design seems to have been common in France and the Lowlands (Bruna Cat. 155). It may be significant that excepting Ketteringham, Barbara is attested beside a freestanding tower only in the Lynn catchment area.

Cathedral. *im erected and painted, Chapter House. 1444. "Extracts from Account Rolls," 20.

Norwich SPM. al tablet. 15c. Set of female saints. Upper register (L) tower on palm on RH, palm in LH; L & M Cat. 87; part of a *Te Deum* composition. "Four marks to purchase a table of alabaster of nine female saints for St. Peter's church, Norfolk," Ord 94. Found in SPM churchyard.

Norwich, Carrow Priory. *im. *Index Monasticus* 12. 1478 burial by, Rye (1898) xix.

Bawburgh. pg, sIV.A1. c1463–80. Crowned, hair below waist; tower in palm of LH, palm in R.

Cley. pg frag leaded upside down in sIX.A6. 1450–60. Hand holding base of fragmentary tower. See Appendix V.5.

New York, Metropolitan Museum. pg. 1450–60. Tower in LH over draped hand; white mantle over red gown; large letter B set above. Provenance, N Norfolk. For a

matching scene with Mary Magdalene, see below.

Pulham S Mary. pg frag, sII.A2. ?15[4]. Tower (?held in both hands); quatrefoil design on mantle and gown; mantle turned back to create collar. Bell inscr "Ocidus Celi Fac Barbara Crimina Deli."

Ketteringham. pg, E win 2d. 15c. Book in RH, palm in LH; large free standing tower.

Mileham. pg, W win 2a, not *in situ*. 15c. ?Tower in LH (alien glass leaded in this area), palm in RH. W win in conservation in 2000.

Norwich S Peter Parmentergate. *pg. Bl 4:96.

Salle. *pg, E win, S transept. James, *S & N* 165; see Appendix V.5.

Barton Turf. pwd, screen panel, S6. c1440. Tower with turrets in draped RH; mantle held loosely against waist with LH, index finger pointing at tower; gold chapelet; ermine-lined red mantle with upper margin folded back to form a broad collar; single morse; elaborate large foral pattern in damask gown; "*Sancta* barbara"; Constable, il p 213.

N Walsham. pwd, screen panel, S7. c1470. In draped LH a 3-turret tower with flags, door flanked by oculi; palm in RH; very long hair.

N Elmham. pwd, screen panel, S1. 15[3]. Crowned, gold palm in RH, tower on palm of LH, flag flying from top of tower, tall single doorway flanked by 2 oculi; white-lined red mantle over gold damask gown; Duffy fig 68.

Filby. pwd, screen panel, S4. c1471. Crowned; in RH tower with door and 2 oculi, 3 pinnacles with flags; palm in LH; pale mantle over gold damask gown. Paired with Cecilia at N1.

Norwich S James. pwd, screen panel. c1479 (10 mark bequest, Cotton). Clasped book in LH; and tower with 3 turrets, 2 doors; S*ancta* Barbara below. Now paired with Sitha; displayed at S Mary Magdalene.

Thornham. pwd, screen panel, N1. 15[4] (before 1488). Crowned, in LH tower with flag, palm in RH; mantle with ermine collar; lateral scroll with "Martyrio meo deu*m* adoro"; (below) "S*ancta* barbara." Camm color pl LXVII. Restored.

Norwich S Gregory. pwd, screen panel. 15[4]. Tower with 3 turrets in draped LH. Seen only in photograph (UEA); in store NMS.

Ranworth. pwd, N retable, N4. 15[4]. Seated, in draped RH tower with central door, 2 towers on battlement, cross and banner atop central pinnacle; palm in LH; elaborate burlet decorated with large floral ouches, luxuriant hair; for problematic dating see Appendix VI.

Trimingham. pwd, screen panel, S3. c1500. Remains of tower in LH; palm in RH; pink gown, green mantle with morse. This pane and the adjacent one repaired with new wood.

Norwich S James. sc, font stem. 15[3]. At S Mary Magdalene.

Hemblington. sc, font relief, NE face. 15c. Seated, palm in LH, tower in RH (damaged); polychrome restored by Tristram.

Norwich Guildhall? pg frag. 15c. Kent (nd) so identified a female body in a sideless surcoat with ermine (nII). From the position of the hands, I think it more likely to have been part of Assumption.

Walpole S Peter. pwd, screen panel, S6. 16[1]. Palm in LH, in RH tower with tall steeple crowned with cross and banner; unnimbed, burlet.

Beeston S Mary? pwd, screen panel, N4. 16[1]. Tall object in LH; ermine-trimmed gown suggests Barbara rather than Magdalene.

Binham. pwd, screen panel, S10. 16[1]. Tall gold object on palm of LH; long hair, golden burlet.

Denton. pwd, mounted on chest, 6 (reading L to R). 16[1]. RH holding tower against breast; palm in LH; voluminous white mantle; defaced.

Wiggenhall S Mary. pwd, S2. 16[1]. Tower free standing; crowned, leafing through book.

Chs at Norwich: Blackfriars (Harrod [1857] 84) and Guildhall (15c, only the entrance with flanking angels remains); Cistercian nunnery at Marham was dedicated to the Virgin and SS Barbara and Edmund (Knowles & Hadcock).

Guilds at Lynn (Richards 416); Norwich: Greyfriars (1497–1521), Whitefriars (1502–22, Tanner 208); Thetford (1518–9, Dymond 2:357).

Light at S Creake 1491 (Robert Norton, Norf Arch Bk 1, f 173).

L'Estrange (1874) cites 6 bells with inscr "O Virgo [or 'Martir'] Barbara Pro Nobis Deum Exora" and "Ocidus Celi Fac Barbara Crimina Deli."

Barnabas
Apostle, Co-worker of Paul. 11 June.

Diocese. ms, Stowe Breviary, BL Stowe 12, hi, f 252. c1322–5. Apostle robe, both hands raised.

Downham Market. pg, W win 1a. c1300. ¾ profile, holding name scroll in LH; RH raised, palm open. Restored. Evidently part of an apostle set (his liturgical designation); see X.2 *Cathedral*. Original provenance uncertain.

Weybridge Priory. printed calendar, NMS 134.944. 1503. Bp.

Basil

Bp of Caesaria, confessor, and doctor (c330–79). 14 June. See VIII.5.

Benedict

Abbot (c480–c550). 21 March. Benedict, who founded monasteries at Subiaco and Montecassino, established the Rule of the Benedictine Order.

Hulme, S Benet's Abbey. seal. ?date (founded 1019). Abbot seated, blessing with book in RH, pastoral staff in LH, *Index Monasticus* 2; for drawing of frag at British Museum, see Snelling.

— abbot's seal. "A person in a close vest, or tunick, and a gown, part of it to be seen hanging behind him, with a lofty cap issuing out of a coronet, and holding a great broad sword in his RH, wherewith he has pierced the nostrils of a dragon holding a young man by the waist," interpreted as Benedict rescuing young man from dragon; Bl 11:55–6. However, in the drawing of the seal (4:504) the attacker looks very like a Norman knight. The composition may be related to the spandrel reliefs on the Abbey gatehouse which depict (L) armed man with raised sword, (R) lion rampant with forked tail.

Norwich, S Benet's Hospital. seal, *Index Monasticus* 58.

East Anglia. ms, *The South English Legendary*, Bod L Tanner 17, marginal drawing, f 43v. 15[1]. Benedictine habit, holding crozier and clasped book, prominent tonsure.

Eccles. *pg, N chancel. "St. Bennet and this under 'Sancte Benedicte, ora pro nobis'," Bl 1:410. Same invocation on one of the bells (L'Estrange [1874] 15). Antony and Germanus in the same win; see Appendix V.5.

Norwich S Michael-at-Plea. *pwd, screen panel.

"St. Benedict and St. Austin," Bl 4:321.

N Elmham. pwd, screen panel, N2. 15[3]. Abbot in black habit edged in gold, crozier against R shoulder, open book in both hands as if reading, formerly labeled "Sanctus benedict." Today paired with abbot at N1, cozier in RH and open book in LH. These 2 panels were at the W end of the S aisle in the 19c when Carthew (2:539) cited 6 panels "daubed over with paint." Though the screen is difficult to reconstruct there were at least 3 abbots. It is impossible to determine whether the abbot at N1 is Giles or Leonard.

Gt Plumstead. *pwd, screen panel. 15[3]. In voluminous black habit edged in gold; scroll depending from RH; crozier in LH; standing on counterchanged pavement; (below) "Sanctus Benedictus," DT 41:133. By 1859, 4 screen panels detached and hung separately when copied by Winter, *Selection* 2:5; reproduced in Bond (1914) 68. Destroyed by fire 1891.

Horsham S Faith. pwd, pulpit, pane 9 (counterclockwise). 1480. Large tonsure; holding crozier and closed book; voluminous black habit.

Smallburgh. pwd, screen panel, S3. 15[4]. Only the outline remains of saint with crozier; "Benedict," cited in DT 44:62.

Burlingham S Andrew. pwd, screen panel, N4. 16[2] (bequests over 12 years, from 1525 "to making new perke" through 1537 for gilding; screen bears the date 1536). Tonsured, pastoral staff in RH, clasped book in LH; cope over appareled alb, crossed stole; (below) flanked by 2 devils, (L) holding end of crozier; pedestal inscr "Sanctus Benedictus Abbas"; Constable il p 144; Duffy fig 58; drawing in Gunn facing 20.

Norwich. *sc. "The very ancient effigies of St. Benedict in his robes, sitting on a throne . . . now in the gable of the E side of Coslany bridge," Bl 4:298. Destroyed by bomb in WWII.

Weybridge Priory. printed calendar, NMS 134.944. 1503. Hand blessing.

Horning? wdcarv, be niche relief. ?16c. Recumbent youth attacked by 2 snakes (?dragons); Gunn (1852), referring to the screen panel at Burlingham S Andrew, conjectured that this wdcarv was related to the event memorialized in the S Benet Abbey seal.

Cautley dated be 16c, but the work looks suspiciously later.

Linnell cites 3 church dedications: Horning (S Michael in 2 15c wills), *Norwich (see also hospital above), & *Thetford; guild at Castle Acre (Bl 8:353).

Birgitta (Bridget of Sweden)

Widow (1303–73). 8 Oct. Founder of the Brigittine Order, represented in England by Syon Abbey.

Norwich All Saints? pg frag, nII. Late 15c. "[Sancta] Bridgid[a]"; Wdf (1938b) 173.

Sandringham. pg, nII.A3. 16[1]. In wimple and white veil, black upper garment; dove at R shoulder; pen in RH pointing to writing on open book held against breast; "Sancta Brigina"; Keyser (1917) fig 7B.

Horsham S Faith. pwd, screen panel, S1. 1528. Writing, quill in hand, seated before lectern; Deity in nebuly upper left; wearing gold gown with ermine cuffs, wimple and veil; Duffy fig 62; copy of woodcut in *The Dyetary of Ghostly Helthe* (1520), Duffy fig 61.

Blaise

Bp in Armenia and martyr (†4th c). 3 Feb. One of the 10 saints cited by Lydgate as special helpers.

E Anglia. ms, *The South English Legendary*, Bod L Tanner 17, marginal drawing, f 16v. 15[1]. Chasuble and mitre, holding wool comb.

Harpley. pg, W win A9. 15c. Full Mass vestments with crozier, label inscr "Sanctus Blasius episcopus"; paired with Wilfrid.

Sparham. *pg, N win, "Scs blasius," upper part broken, NRO, Rye 17, 3:216.

Norwich, private home, R Carr. *pg. In the bow win of great hall "St. Blase and his comb," Bl 4:436.

Hempstead S Andrew. pwd, screen panel, S5. 15[2] (DP queries early 15c, P & W 1). Bp, cope over alb, crozier in LH, RH ?blessing; no attribute; name below.

Norwich S John de Sepulchre. pwd, screen panel. 15[3–4]. In alb and cope, crozier in LH, carding comb in RH. Winter, *Selection* 1:6.

Haddiscoe? *pwd, screen panel. Drawing shows saint holding a chalice with flames at the top, NRO, Rye 17, 2:182.

Weybridge Priory. printed calendar, NMS 134.944. 1503. Flaming cup on base.

Light at Lessingham, Bl 9:329.

Blyda

Late 11c. Mother of Walstan. No known feast. James cited 2 pwd panels (*S & N* 20), but he identified neither.

Cawston. pg, sX.1a. 15c. Label in patchwork win, "Blida."

N Tuddenham? *pg. Cited by Husenbeth 37.

Norwich S James. pwd, screen panel. c1479. Clasped book in LH, martyr's palm in RH; "Sancta Blida" below. Restored. Now at S Mary Magdalene and paired with Walstan, but both backgrounds are red.

Norwich ?S Peter Parmentergate. *pwd. In a typescript of a lecture, Rye cites a slide of Blyda, though it is not entirely clear that this is the location. NRO Z3F/76.

Martham. burial site. 1522, 10s left to repair the church "where St. Blithe lyeth," Bl 11:175. S aisle dedicated to her.

Boniface IV

Pope 608–15. 8 May. Conferred with Mellitus, bp of London, on matters affecting the English church.

Salle. *pg, nII, light b. c1440. See Appendix V.4 & 5.

Botulf (Botolph)

Abbot (†?680; buried at ?Hadstock, Essex). 17 June. Founded monastery at Icanhoh (Suf) c654 (*Anglo-Saxon Chronicle*). For biographical details see Stevenson.

Wiggenhall S Mary Magdalene. pg, nVI.A2. c1450. Seated; chasuble; crozier in LH, RH blessing; "Sanctus Botulp[h]"; Keyser (1907b), pl 12. Appendix V.5.

Old Buckenham. pg, sV.B2. 1460–80 (King). Abbot, seated with crozier (partial), holding clasped book with RH on lap, frag name "Sanctus [Bot]ulphus"; paired with Leonard; part of ecclesiastics tracery set; **FIGS 31 & 31a**.

Trunch. *sc. c1500. Cited in rector's will, probably statue on N as titular patron.

Foulsham. *im with pilgrimage to it. 1506. Bl 8:208; Hart (1864) 278.

Weybridge Priory. printed calendar, NMS 134.944. 1503. Crozier.

Linnell cites 16 church dedications; Bond (1914) 64 for England.

Chs at Bale (1421, bequest to repair, Bl 9:358); Loddon (in ruins 1538), Scarning (1514), Upwell (*Index Monasticus* 67–9), Tuttington (1499 bequest "to emend window of St. Botolph's ch," C & C).

Guilds at Banningham (Bl 6:330), Barford (Bl 2:485), Grimston (Bl 8:452), Limpenhoe (Bl 7:236), Morley S Botolph (Farnhill), Norwich S Botolph (Farnhill, church demolished 1548, Watkin 1:xvi), Stow Bardolph 1467

(Bl 7:448), Trunch (*Index Monasticus* 74), Upwell (Farnhill), Westwick (Bl 9:82).

Brice

Bp and confessor (†444), successor of Martin of Tours. 13 Nov.

Wiggenhall S Mary Magdalene. pg, nVII.A1. c1450. Bp, seated, LH on breast; "*Sanctus* Britius." Appendix V.5.

Marsham. *pg, N aisle, Bl 6:287.

Brigid of Ireland (Bride)

Virgin, abbess of Kildare (†c525). 1 Feb.

E Anglia. ms, *The South English Legendary*, Bod L Tanner 17, marginal drawing, f 13v. 15[1]. Black habit and veil, white wimple, holding clasped book.

Weybridge Priory. printed calendar, NMS 134.944. 1503. Bust in veil.

Bruno

Confessor (c1032–1101). 6 Oct. Hermit, founder, Carthusian Order.

Wiggenhall S Mary Magdalene. *pg. c1450. Bl 9:170. Appendix V.5.

Callistus (Callixtus)

Pope and martyr (c217–22). 14 Oct.

Wiggenhall S Mary Magdalene. pg, nVII.B1. c1450. Papal tiara and double cross-staff, seated, clasped book held upright on knee; "*Sanctus* Kalixtt"; Keyser (1907b) pl 11. Appendix V.4.

Catherine of Alexandria

Virgin martyr (nd). 25 Nov. Frequently paired with Margaret. One of the 10 saints cited by Lydgate as special helpers.

Narrative

Legend includes a disputation with pagan philosophers, persecution by Emperor Maximinus or Maxentius (so named in *The Golden Legend*), conversion of the Empress and General Prophyry, martyrdom, and translation to Mt Sinai.

Sporle. wp. c1390–1400 (Tristram). 25 framed rectangular scenes in 4 registers along S wall, reading L to R. Jailers dressed in dagged short gowns, sometimes with long-pointed shoes; Emperor and Empress identified by tiara. Unless stated otherwise, the Emperor is typically enthroned to L of scene, often wearing gloves. **1a** Catherine facing and extending RH to Emperor and Empress at palace entrance; 2 figs behind Catherine. **1b** Figs kneeling on either side of central altar, with idol above; (upper R) 2 figs, one with spear; Catherine with raised hand. **1c** Catherine with RH raised, facing Emperor wearing gloves seated with legs crossed and sword drawn in RH; attendant behind Catherine. **1d** 3 philosophers in long robes before Emperor; Catherine behind them with hands joined; (far R) fig. **1e** Emperor with drawn sword in RH; (C) philosophers (in furnace) with executioner above throwing one (into flames); (R) Catherine. **1f** Emperor with attendant; Catherine with attendant behind. **1g** Emperor with drawn sword; Catherine led away by 2 men. **2a** Catherine's head framed in prison win; Porphyry standing before win. **2b** Prison towers and head of Catherine; (above) demi-fig of Christ; (below) Porphyry kneeling with a group of knights, one in ?mitre/tiara. **2c** Catherine, stripped to waist with marks of scourging, standing before Emperor, a jailer beyond her flourishing 3-strand knotted scourge. **2d** Catherine and jailer facing Emperor. **2e–f** [Williams (1956) identified a second artist at this point; DP (P & W 2) suggests dating the completion "several decades later."] (C) flanked by demi-angels with drawn swords, Catherine with frags of wheel and traces of stricken figures; (L) Emperor struck by wheel fragment with blood streaming down face; (R) kneeling Empress. **2g** Emperor with scimitar, Empress being led away by 2 jailers in extravagant head-dresses and short low-belted gowns with maces hanging from belts. **3a** Executioner in elaborate chaperon resting one hand on shoulder of Empress, other raised with sword. **3b** Flanked by conventional trees, Porphyry standing in open grave digging with shovel, headless body of Empress in foreground; (above) hill, moon and stars. **3c–d** Emperor with large scimitar and man with distorted face beside, before him traces of condemned soldiers. **3e** Emperor with courtier beside facing 2 largely disfigured persons (Tristram identified as the condemnation of Porphyry). **3f–g** 4 executioners, scimitars brandished, attacking soldiers in armor and pointed bascinets, striking them to ground. **4a** Catherine before Emperor. **4b** Catherine flanked by

tormentors with distorted faces and elaborate clothing, (R) with large implement, Rouse fig 14. **4c** ?Small nude soul surrounded by devils. **4d** (L) Scene defaced; (R) Catherine led away by jailer in parti-colored gown and hose. **4e** Catherine kneeling and gazing up to angels; behind her, executioner raising scimitar. **4f** Translation to Mt Sinai: (above) sarcophagus with saint's body, attended by 2 angels; (below) 2 angels censing. **4g** (Above) sarcophagus with 3 pilgrims kneeling, one tonsured, one with scrip and staff. Tristram's description (249–50) based on Winter's drawing, NMS B153.235.951, B159.235.951; reproduced in Winter (1872) facing 305; NMR photo in Davidson (1986) fig 7. Rouse (fig 10) reproduces compartments 1e–1g & 2e–2g in color. An amazing amount of detail preserved; according to Williams (33), the most extensive representation in England.

Catfield. wp, S wall above arcade, largely lost. 14³⁻⁴ (DP). Reading E to W: **1** Seated king with 3 philosophers before him, foremost with inscr scroll; ?Empress in doorway. **2** Executioner in fire; 2 men stoking the coals. **3** Catherine surrounded by 4 broken wheels, angel descending with a sword. **4** Catherine naked to waist, about to be executed, the executioner holding her hair away from neck. Only fragmentary details can be seen; the identifications based on DT 27:162-166. Turner (1847c) identified 1 as a Magi scene and 2 as the execution of S Lawrence, but the watercolors do not support such an interpretation. Winter (*Selection* 2:99) said of the saints that only the implements of their torture could be made out.

Cathedral. sc, N cloister bosses. 1425–30. **J2** (C) square altar on which is seated ape-like idol, flanked by (L) king and figs behind and (R) headless fig (?Catherine) both touching altar; behind Catherine figs, incl soldier. (M R James connected the idol to a similar scene from the life of Lawrence; see Lawrence Norwich S Stephen). **J6** Catherine flanked by guards, (far L) executioner and (far R) emperor. **K1** (above) 2 angels, (L) king; (C) Catherine, stripped to waist; (R) broken wheel striking 2 men. James (1911) and Tristram (1937) connected **J2** with Lucy, but it could equally constitute part of this Catherine series.

Individual

Catherine is represented standing with her 2 attributes at either side, the wheel typically resting on the palm of extended hand and sword in the other hand. Unless stated otherwise she is crowned, and the sword is held by the hilt with the point resting on the floor (grounded). Emperor as footstool infrequent (for examples elsewhere in England, see Williams [1956] 24).

Cathedral. *im. Before 1150. See chapels cited below.

Norwich, Carrow Priory. ms, Carrow Psalter, Baltimore, Walters Art Gallery W.34, miniature, 17v. 1250–60. Paired with Margaret.

Norwich Castle. sc, relief, wall, Ch Royal. ?13c. Wheel in RH. It has been conjectured that the 5-scene work (?originally 6) was an altarpiece; Wilkins pl 25; Woodward pl 13. There are a number of other figs (Woodward pl 12); Winter proposed Catherine in prison (*Selection* 2:11).

Cathedral. wp, Ante-Reliquary Ch, vault, E bay. c1300. With Margaret flanking Virgin. (R) LH raised, draped RH holding small wheel. Tristram 230; Caiger-Smith pl VIIIb; Atherton, color pl Va. Separate ch dedicated to Catherine, c1280 (Thurlow 24).

— ch/*im. c1280, ch built; 1363–4 "for making and painting" an image, 20s; Shinners (138) notes a temporary increase in offerings thereafter. "Item, pro factura et pictura ymaginis sancte Katerine, xx. sol," quoted in Shinners 143 fn 33.

Norwich Blackfriars, New House. *im. 14⁴. *Index Monasticus* 38.

Diocese. ms, Stowe Breviary, BL Stowe 12, hi, f 334v. c1322–5.

Norwich S George Colgate. *pcl. 14³. "j pannus depictus lineus cum ymaginibus Sanctarum Marie virginis, Katerine et Margarete," Watkin 1:6.

Merton. pg, nII.light c. c1320–30. Glass heavily restored as S John, eagle in roundel replacing wheel.

Mileham. pg, W win 3a. 1340–50 (Fawcett 1980). Sword pointing to ground in RH; wheel in draped LH; Wdf (1938b) il facing 165.

Cromer. *pg, chancel. 1388. £10 bequest for a 3-light win with Catherine, Christopher, and Mary Magdalene; NCC Harsyk 107 (Cotton, personal communication).

Kimberley. pg, E win 3a. 14c (King). Wheel in RH at shoulder height; gold gown, white mantle with gold trim.

Woodton. pg, tracery, sIII.A1. 14c (S aisle added before 1348). Crown on white veil; wheel in LH resting against her shoulder; RA at waist with index finger pointing up; paired with Margaret.

Thetford Priory 2. pwd, retable. c1335. Paired with Margaret; holding wheel in draped RH, LH at breast; now at Thornham Parva (Suf); *Age of Chivalry* Cat. 564.

Rougham. sc. 14[1-2]. Above W door, in niche R of central crucifixion, wheel in RH, standing on recumbent fig, paired with Margaret; Cotman (1838, 2nd series) 39.

Norwich SPM. al tablet. 15c. Set of female saints (lower register, all queens) grounded sword in LH; L & M Cat. 87.

Provenance unknown. al frag. 15c. Head missing. NMS.

Lt Walsingham. *im. 1442 request for burial before altar (NCC Doke 183, Cotton personal communication); 1510, burial in "new chapel before the image of S Catherine," C & C.

Norwich S Swithin. *im. 1452. Bequest of light before im, Bl 4:252 fn 9.

Alburgh. *im. c1463. Burial by "image of St. Catherine," Bl 5:354.

Gooderstone. *im, S aisle ch, Bl 6:63.

Hingham. *im, light before, Bl 2:423.

Norwich S Edmund. *im, Bl 4:405.

Norwich S Giles. *im and altar, S aisle ch, Bl 4:239.

Norwich S Gregory. *im and light, Bl 4:274.

Swaffham. *im, Bl 6:217, fn 4.

Bedingham. pg frag, nV.A3. 15[1] (King). Frag wheel, sword in LH; alien head and bare feet, both from apostle set.

Salle. pg, sII.C4. c1444. Wheel in draped RH, sword in LH, blade point up; ruby cloak over patterned gown. Formerly with Margaret in E win, S transept (James *S & N* 165); Appendix V.1.

Sustead. pg, sIV.A4. 15[2] . Wheel in draped RH, LH resting on hilt of sword; mantle worn like a shawl; cuff over back of hand. Unidentifiable companion in similar costume at A2, RH on breast, L on book; King conjectures a female martyr set.

Griston. pg, sIV.A3. 15[3]. Wheel on palm of LH, grounded sword in RH; "San*c*ta Katerina" in scroll above head.

Field Dalling. pg, sIV.A5. 15[3]. Wheel in LH; "San*c*ta Katrina." Appendix V.1.

Stody. pg frag, sIV.A5. 1440–50 (King). Wheel in LH, sword in RH, pointed diagonally across body with point at wheel edge. Appendix V.1.

Norwich SPM? pg, E win D8. Mid 15c. Crowned virgin with sword in RH.

Wighton. pg, sIV.A2. 15[3]. Book in RH, grounded sword in L; (R) wheel freestanding; trace of ermine at original shoulder; restored; King fig 4. Appendix V.1.

Bawburgh. pg frag, sV.A4. 1463–80. Sword in RH held diagonally; ermine sideless surcoat.

Guestwick. pg, sV.2b. 15[3]. Wheel on draped RH, sword grounded diagonally; second wheel at 3b.

Pulham S Mary. pg, sII.A6. ?15[4]. Wheel in draped RH, grounded sword in L; ermine-lined mantle. Appendix V.1.

W Harling. pg frag, nIV.A2. 15c. Sword in RH, wheel in LH, arm relaxed; alien angel head; paired with Margaret.

Framingham Earl. pg, nIV, not *in situ*. 15c. Wheel in LH, grounded sword in RH; gown decorated with hexafoils, with vertical row on sleeve; strand of hair hanging over L shoulder.

Ketteringham. pg, E win A7. 15c. Head missing and body patched; wheel in LH, forearm reaching through the wheel; sword in RH held at the medial line of body.

Heacham. pg, nV.B2, probably not *in situ*. 15c. Wheel on palm of RH, LH on hilt of sword; trim of square-necked gown stained yellow, buttons down front; mantle; hair swept back from face.

Rougham. pg, sIV.A4. 15c (Cautley). Crowned, long hair; wheel in draped LH, grounded sword in RH; standing on platform.

Shelton. pg, nII.B1. 15c. Very small object in raised LH; atypical head (in veil), probably a conflation.

Stratton Strawless. pg, nIII.A1. 15c. Long sword held diagonally in RH, wheel probably in raised LH; now patched.

Cathedral. pg, roundel, nX.1d. Erpingham win, late 15c, *ex* Jesus Ch. Catherine with sword grounded on back of emperor, recumbent, crowned, and holding scimitar; (R) wheel.

Caston. pg frags, sV.1a. 15c. Crowned head; hand on frag of spiked wheel; "San*c*ta." Separate fragments leaded in a modern roundel. War damage 1940, windows on the

S side broken; **FIG 32**.

Castle Acre. pg frag, sIV.1a. Wheel.

Hoveton S John. pg frag, nII.2a. Toothed wheel; frag of crowned head.

Pulham S Mary. pg, nVII.A4. 15c. Frag of wheel patched in apostle fig.

N Tuddenham. pg frag, porch, W win 3a, hand with wheel.

Bressingham. *pg, E win, light a, "standing upon a wheel with a sword in her right hand …, left hand upon her breast," paired with S Margaret, NRO, Rye 17, 1:150. These windows survived the 1644 destruction by being moved to the Hall; they were returned to the E win in 1736, Bl 1:69–70. A nimbed crowned head remains in the E win.

Burnham Deepdale. *pg, S porch, W win. Wheel only.

Cringleford. *pg, N win, "holding the wheel," Bl 5:38.

Hoe? *pg, chancel, "half [of] the Saint with a sword in her LH," NRO, Rye 17, 2:258.

Ickburgh. *pg, E win, Bl 2:237; "St. Catherine and another saint," NRO, Rye 17, 2:5.

Narborough. *pg, N aisle, Bl 6:160.

Norwich S Peter Parmentergate. *pg, Bl 4:96.

Poringland. *pg, S chancel, Catherine with wheel, Bl 5:442.

Sharrington. *pg, N win. Frere MSS NRS 1:37. Appendix V.1.

Sparham. *pg, S win, "Sancta Katerina, the figure large and pretty Intire," NRO, Rye 17, 3:216.

Tilney All Saints. *pg, N aisle, Bl 9:80.

Norwich, private home, R Carr. *pg, bow win of great hall, Bl 4:436.

Runhall. *pwd. 1416. "Margaret, widow of Rob. de Berneye, Knt" to be buried "before St. Catherine's altar, to which she gave a picture of St. Catherine," Bl 2:473; "j tablam depict eum historia de sancta Katerina … in manibus Roberti Okyll de Norwic[h]"; the bill was 34s 4d (quoted in Gunn [1869] 14).

N Walsham. pwd, screen panel, N2. c1470. Sword grounded diagonally; wheel in draped LH; belted gown; symmetrically paired with Margaret.

Filby. pwd, screen panel, N3. c1471. In draped LH open book, pages riffled; sword in RH (in unusual position with her palm facing viewer), point of sword resting against small wheel on floor. Symmetrically paired

with Margaret.

Norwich S James. *pwd. c1479. Blomefield (4:424) cited images of Nicholas, Catherine, and John Bapt in the same sentence where he dates the rood loft. Unless these were statues, it seems probable that Catherine and John were painted on the 2 lost panes; the pane with Nicholas is extant.

Foulden. pwd, screen panel, S5. 15[4]. Crowned, frag of toothed wheel in RH; paired with Margaret.

N Tuddenham. pwd, screen panel, S1. 1499–1504. Sword in RH, wheel in LH.

Northwold. plate. 1473. Bequest for "a cuppe silver and gilt standing with a ymage of seint Katerine in the bottom," Williams (1941) 339.

Hingham. sc, Morley Monument, L respond. 15[2–3]. No attribute; mantle fastened with cord; standing on recumbent man (?emperor) holding objects in arm (?tablets), wearing short gown with belt.

Norwich S James. sc, font stem. 15[3]. Standing on emperor, sword in LH. At S Mary Magdalene.

Norwich S Helen. sc, boss (9), S aisle ch. c1480. With name scroll. Together with Margaret, Edmund, and Edward, alternating with the Joys surrounding the central Coronation; see Appendix VII.

Tittleshall? sc, tower niche. 15[3–4]. ?Emperor crouched beneath empty pedestal.

Docking. sc, font stem, N face. 14/15c. Paired with Margaret, wheel in LH, sword in RH; defaced but remains of crown and long hair.

Gt Witchingham. sc, font stem. 15c. Sword & wheel.

Hemblington. sc, font stem. 15c. Sword & wheel.

Hockering. sc, font stem. 15c. Sword in RH, wheel below.

Norwich. seal. nd, "a figure of St. Catherine, inscr "Savncta Caterina," "Extracts" 8:331.

Hardley. wp, N wall. 14[3–4] (P & W 2) or 15[1] (Williams 1956). Probably part of a painting scheme predating the massive Christopher she now abuts; Pevsner 2, fig 40.

Cawston. wdcarv, spandrels of screen door. c1490. (L) Catherine, (R) angel.

Norwich SPM. *banner. 16[1], Hope, 221.

— *bason in blue enamel. 16[1]. Paired with Margaret, Hope, 213.

— *emb cope hood. 16[1], "in the cape sent Kateryn," diverse martyrs on orphreys,

Hope (1901) 197.

Norwich S Stephen. *im. 1523. Bequest for beads to be on the im on "festeful days," Bl 4:154.

Breccles. *im. 16[1]. Light before, Bl 2:27.

Norwich Austin Friars. *im. 1532. Burial before, Bl 4:89.

Sandringham. pg, porch, S1. 16[1]. Closed crown; wheel & sword; at feet emperor with scepter; "S*anc*ta Katerina"; Keyser (1917) fig 12.

Norwich Blackfriars. *pg. 1542–43. "For a new pane of glasse in the east wyndowe in the chappel, with a new ymage of St. Catherine, two shillings," Kirkpatrick (1845) 56.

Walpole S Peter. pwd, screen panel, N1, 16[1]. Unnimbed; small wheel in RH, massive sword in LH; burlet with ouch; ermine collar fastened with large morse; Briggs il p 1013.

Wiggenhall S Mary. pwd, screen panel, S1. 16[1]. Open book in LH; sword; no wheel, but bottom of panel damaged.

Binham. pwd, screen panel, S2. 16[1]. Crowned, long tresses at one side, wheel in RH; Robinson il p 89.

Shipdham. *sc. 1532. "Item payd to the grawer for settyng vp of sent margaret & sent kateryng & for warkmanscep ij s x d"; Galloway & Wasson 82.

Walsoken. sc, font stem. 1544. Wheel in LH; Nichols (1994) pl 2.

Lessingham. pwd, screen door. c1500. Wheel in LH; sword in RH; ermine-lined mantle, wide collar closed with morse; wide ermine hem on gown; NMS. DT 33:165.

Burlingham S Andrew. pwd, screen panel, S4. 16[2]. Wheel at feet, open book with minim writing in RH; sword in LH largely obliterated; rings on hands; below on pedestal "S*anc*ta Katherina *v*irgo."

Babingley. *pwd, screen panel. c1500. Long white veil under crown, sideless surcoat of ermine; wheel at feet, RH probably held sword; DT 53:56-7.

Weybridge Priory. printed calendar, NMS 134.944. 1503. Wheel.

Linnell cites 7 dedications, incl 2 free-standing chapels; Bond (1914) 62 for England. L'Estrange (1874) cited 4 different inscrs among the 9 bells dedicated to Catherine, one a variation of the formulaic Marian text "SUM ROSA PULSATA MUNDI MARIA VOCATA," with "CATHERINA" replacing "MARIA."

Chs at N Barsham (1531, *Index Monasticus* 67), Black-borough Priory (Bl 8.33; the priory was jointly dedicated to the Virgin and S Catherine); Feltwell; Lynn, ch outside E gate, 1382 (Owen 30) (1559–60, Richards 557); Norwich: Cathedral (c1280 with ch of S Michael above); outside the gates, a cell of the priory, later rededicated to S William (Knowles & Hadcock); Carrow Priory (N of chancel, Bl 4:525, Gilchrist & Oliva fig 5); Necton (Ward 297); Shropham (Bl 1:455); Thetford: Thetford Priory 1 (1528/9, Dymond, 2:534), S Peter's (Dymond 2:534 fn); W Walton (chantry chapel of ease, Ward 294).

Altars at Terrington S Clement and Walsoken (Watkin 2:127, 129), Emneth (Williams [1941] 335). Lights at Fakenham (Bl 7:96), S Creake 1451 (John Norton, NCC Aleyn f 74), 1491 (Robert Norton, Norf. Arch. Bk 1, f 173); Stratton Strawless (Harrod [1847] 117).

Catherine of Siena

Virgin (†1380). 29 April. Mystic, Dominican 3rd Order.

Cathedral. *im. 1510, offerings typically 1½d a year, high of 4½d, Beeching 21.

Horsham S Faith. pwd, screen panel, N2. c1528. RH on breast; in LH red heart with gold rays at cardinal points; in elegant cloak; crowned, in gold mantle over red gown with shift visible at neckline. The costume is odd for a Dominican nun, but the rayed heart is her usual attribute. According to Farmer, she so appears on 2 Devonshire screen panels, where she is crowned with thorns.

Cecilia

Virgin martyr (3c). 22 Nov. Typically represented with 2 wreaths of flowers, one on her head (chapelet) and a larger one in one hand. In small representations cinquefoil alternate with what seem to be fleurs-de-lis (in one case clearly leaves), but on the Elmham screen the wreath comprises carefully drawn cinquefoil roses and lilies with intertwined stems, visual evidence for Jacobus de Voragine's roses and lilies so familiar from Chaucer's *Second Nun's Tale*.

Cley. pg, sIX.A8. 1450–60. Flower chapelet on head, cinquefoil alternating with lilies; similar wreath in RH, LA relaxed, hand missing; Appendix V.1.

Norwich SPM. pg frag, E win 6a. Mid 15c. Chapelet of roses in hair; holding palm and wreath of roses; Appendix V.1.

Field Dalling. pg, sIV.A7. 15[3]. Chapelet in hair, wreath in RH consisting of spaced cinquefoils with dots betw; palm in LH; S*anc*ta Cecilia; Appendix V.1.

Pulham S Mary. pg frag, sII.A5. ?15[4]. Wreath of roses in draped LH, clasped book in LH;

Appendix V.1.

Norwich All Saints. pg frag nII.A1. Late 15c. Hand holding wreath, juxtaposed with another hand with book, probably a virgin martyr set.

N Tuddenham. pg frag. 15c. Porch W win 3a. Wreath of cinquefoils on twisted two-strand base.

Diss. pg, frag not in situ, sX.1c. 15c. Nimbed head with chapelet of flowers.

Gillingham. *pg, wreath on head and in hand, sword in LH; Husenbeth 46.

Martham. *pg, Husenbeth 46; perhaps a misidentification.

Sharrington. *pg, N win. Frere MSS, NRS 1:37. Appendix V.1.

N Elmham. pwd, screen panel, S2. 15³. On head large chapelet of white and red cinquefoil roses alternating with lilies; second wreath in RH of identical flowers but on a twisted two-strand base, with lilies extending from strands (Costume Glossary, **FIG c**); Duffy fig 68.

Filby. pwd, screen panel, N1. c1471. Chapelet of alternating white and pink cinquefoil, holding similar wreath in both hands. Paired with Barbara at S4.

Litcham. pwd, screen panel, N3 (damaged). c1500. Chapelet on head seems to match wreath in both hands.

Beeston S Mary. pwd, screen panel, N1. 16¹. Holding wreath of flowers.

Burlingham S Andrew. pwd, screen panel, S2. 16². Palm in LH, wreath in RH, triangular headdress (Costume Glossary, **FIG d**); blood on neck; ermine-lined mantle and collar; rings on hands; on pedestal below "Sancta Cecilia Virgo." A 19c watercolor shows 3 bloody wounds on her neck with 3 rivulets of blood below on her gown; Constable il p 145; Duffy fig 59.

Babingley. *pwd, screen panel. c1500. Luxurious hair, palm in LH, wreath of cinquefoil in RH; DT 53:64.

Church dedication at W Bilney; Bond (1914) 4 for England.

Christina (Christine)

Virgin martyr (?4c). 24 July. One of the 10 saints cited by Lydgate as special helpers.

N Elmham. pwd, screen panel, S8. 15³. Both hands extended, arrows embedded in breast and waist; "Sancta crist" below.

Hingham? *im, light before, Bl 2:423, cited as Christin.

Christina of Markyate (Redburne)

Virgin not a martyr (c1097–c1161). ?5 Dec. Recluse and ultimately a nun. See *Puella Ridibowne*.

Christopher

Martyr. 25 July. One of the 10 saints cited by Lydgate as special helpers. Not always nimbate.

Narrative

Christopher, determined to serve the strongest king, first offered his services to the devil. On finding that the devil was afraid of the cross, he decided to serve Christ. A hermit set him the task of ferrying travelers across a treacherous river. Following the familiar Christ Child episode, Christopher preached Christianity in Lycia, refused to sacrifice to the gods, was imprisoned, and there was tempted by women, whereupon he was shot with arrows and finally beheaded. All the narrative wall paintings are treated in a block at the beginning of this section. All Brindley references are in Ingleby (chart of iconographic details facing 314).

Potter Heigham. wp, E of N door. c1380. Christopher nimbed; painting overlaid with later version of same subject; small ?hermit at immediate L. Much of the detail cited earlier is now lost. Brindley (1924) cited a masted vessel, bridge, and fish; Tristram (237) cited several fish though queried the ship. Lowest section now obscured by vestry.

Hardwick. wp. c1390. Nimbed, mantle fastened with morse; in LH staff raguly with branches at top; Child in mantle held by morse, tripartite colored orb; scene flanked by trees with birds; (lower L) angler; (above ?later addition) "Orate pro anima [mea]." Watercolor (NMS) reproduced in Brindley color pl LVII; some detail now lost.

Witton (near Walsham). *wp N wall. 14c (Minns). Christopher nimbed holding staff raguly; Child in green tunic, cross-fleury nimbus, orb in LH; RH blessing; crab among fish; over N door a small fig, hermit and ch; black letter inscription at base: "Xfor : sci : specie : qienz tue. . . ." Minns pl betw pp 42 & 43. (Text in CB, Fitzwilliam Museum MS 25, f 208: "Xpofer sancti specie quicumqz tuetur / Illo nempe die nulle languore gravetur. . . . ") Description based on Brindley and Minns' watercolor at NNAS.

Moulton S Mary. wp. Late 14c. Head missing,

voluminous red mantle with border, breeches tied at knee, staff in bloom at tip; fish below; Child blessing with RH, no orb; Tristram 224. Brindley recorded hermit, cell, and spectators; traces of hermitage still visible.

Hales. wp, S wall, facing N door. c1400 (Tristram). Curly beard, gown with hanging sleeves; Child on RA, cruciform nimbus, indecipherable object in LH, RH blessing; (L) trace of small hermit with beads.

Hemblington. wp. 15c. (C) Christopher, tree staff in LH, Child on RS; detail of Child lost; Christopher with elaborate belt and string of alternating round and cylindrical beads (cf bandolier elsewhere). Flanked by marginal narratives, scenes roughly laid out in irregular registers delineated by riverine landscape. (L side largely lost) before conversion, (above) remains of large building; (mid) Christopher (frag with staff) meeting 2 devils riding horses; (below) trace of horse. (R) after conversion, 10 scenes of subsequent life, reading from bottom in fluid registers: **1a** Christopher holding staff, black flat cap, meeting 4 soldiers. **1b** 2 soldiers, one with spear, presenting Christopher (red hair and beard) to king on elaborate throne with massive scimitar held point up, flanked by men, one with grounded sword. **2a** Christopher in prison with 2 women tempting him; in anteroom of prison, jailer with staff and massive key. **2b** Christopher, red-haired in hat, brought with the 2 converted women before enthroned king with scimitar. **3a** Execution of women hung by hair from post being elevated by 3 men pulling rope (lower L). **3b** Christopher at post being scourged; (lower R); at edge of painting, indistinct scene. **4a** ?a second scourging scene, fig with hand behind back flanked by 2 men, both in scourging posture; immediately above this scene, seated king as before with scimitar; Christopher, now in long robe standing before king (center L). **4b** Christopher at stake with archers firing, broken arrows on ground; (center) king (R) being struck (badly worn). **5a** executioner; Christopher's body with severed head; (upper L); man kneeling holding arrow, wearing elaborate hat (?Dagarus) (center above). **5b** same fig now with scimitar before base of ?standing cross (?Dagarus

converted). Restored 1937 under Tristram's supervision. **FIG 33** (registers 3–5).

Alburgh. *wp, 2 superimposed paintings. ?14/15c. Christopher in tight-fitting cap, holding mantle with RH, staff in LH, wading W; Child dislocated above RS; crab among fish. Frag flanking scenes in 3 registers (reading L to R): **1** king and queen (of Canaanites) at banqueting table in cutaway dwelling, 2 figs before table, Christopher holding staff turned away; **2** 2 figs in short tunics walking toward each other; **3** 2 figs (Christopher and devil) on either side of base and stem (of market cross), devil represented as king with grotesque face; (R) lower 2 registers: **4** 2 partial figs facing each other, each with staff; **5** partial fig, DT 24:31, "a faithful sketch," 1842; drawing reproduced in Brindley pl LIX.

Irstead. wp, inscr. c1400. Finely modeled Christ; Child on R (faint); frag inscription; lower half cut into by 20c monuments. A 19c copy suggests marginal scenes as well; DT 33:61. Park (P & W 1) identifies a a second tall fig as an earlier Christopher destroyed by a perpendicular win, but the hat is atypical.

Gt Ellingham. wp frag, S wall. 15c. Christopher in ?turban, square-toed shoes, mantle thrown over LS, huge staff in RH, LH raised; walking past wayside cross; remains of (fleeing) devil's horse, rump with pink trapping, long spatulate tail, NMS 212.957, with notes.

Cockthorpe. wp frag. 15c. A framed composition; fish and staff well preserved; (lower L and R) male and female donor, with remains of double row of donor text below; (upper L) crow's nest and masthead of a ship.

Thurton. wp, not directly opposite door. c1500 (P & W 2). Christopher nimbed, holding staff raguly with branches on top; Child in central position, wide collar with double hexafoil morse, holding orb with rising cross and pennon; (below) lamprey, lobster, crab and flat fish, ?mermaid with comb and mirror; (upper L & R) trees. (L) man in buttoned tunic; (R) man in hood with lantern; restorer noted underpainting of earlier head of Christ. Restored 1991. There was an extensive early 14c scheme of wall paintings, a large frag with a standing man

on the wall where the Christopher was painted and frags on the S wall, subjects as yet undetermined.

Fritton. wp. c1506 (donor inscr, Cotton [1987a]). Central Christopher with narrative scenes. Christopher holding staff raguly in leaf, (André recorded the staff as double pronged [1888] 415); parted tunic; Child holding orb with tall cross; fish, incl pike; in background, 3 crosses on 3 hills. Reading R to L: (lower R) Christopher facing king with bandolier (devil), and 2 men with hooked noses, trace of trees; (below C) double cross on ?peninsula/hill, saint facing man [devil] with bandolier of bells over LS and under RA; (lower L) hermitage with bell rope, hermit in front; DT 55:82; Whaite pl 34. In 1995 the wp was in poor condition, retaining few of these details.

Ketteringham. pg, E win 4b. Late 15c. Hermit on bank; Christopher holding blooming staff in both hands, flat cap with brim; voluminous mantle, breeches rolled at knees; an adult-looking Child on shoulders; outline of bank like that at Hemblington.

Cathedral. sc, W cloister bosses, 1425–30. **M7** (L) hermit telling beads; (C) Christopher carrying Child on his RS; (R) hermit telling beads, RH raised; **L7** Christopher being thrown to floor by 2 men before enthroned king with scimitar; woman in doorway.

Langley. wp S wall, E of door. "Collosal . . . also History pieces, I suppose relating to his legend . . . much damaged," Kerrick (1819), BL Add. MS 6756, f 100. Only the upper section remains with inscr scroll, "S[ancte] Cristofere ora. . . ."

Individual

Christopher is typically unnimbed, bearded, wearing a cap or other headdress, mantle, and short gown tucked up over breeches, which are sometimes tied at knees; where lower register is preserved, he usually wades E, the water represented with a variety of fish. He holds a staff in RH and supports the Christ Child on L shoulder or arm. The nimbed Child raises his RH in blessing and in the LH holds an orb with a rising cross. Unless stated otherwise, paintings are on the N wall, usually opposite the S door, and are larger than life-size, *circa* 12 feet tall at Moulton, Paston, and Wickhampton. Fifteenth-century work that cannot be dated more precisely is arranged in alphabetical order. Specific 14c dates are from Tristram unless otherwise stated. Generic descriptions apply unless work identified is fragmentary or stated otherwise.

Norwich Castle. sc, relief, ?part of altar piece, Ch

Royal. ?13c. Child on L shoulder, staff in RH; Woodward pl 13; Winter, *Selection* 2:11.

Norwich Blackfriars, New House. *im, 14⁴. *Index Monasticus* 38.

Halvergate. pg, vIV.A1. 1340–50. Brimmed cap (Costume Glossary, **FIG e**); Child's feet resting on Christopher's arm; fish, eel, crab; *Age of Chivalry* Cat. 34. In 1996 set in separate frame above main altar.

Foulsham. pg, nVII light b. 14c. Soft cap with long point; Child's RH pointing over Christopher's head; in size and design similar to pg at Halvergate.

Cromer. *pg, chancel. 1388. £10 bequest for a 3-light win with Christopher, Catherine, and Mary Magdalene, John Gosselyn, vicar, NCC Harsyk 107 (Cotton, personal communication).

Terrington S Clement. sc, clunch statue. 14⁴. Child (head lost) with elaborate morse and cord tie on robe, prominent feet; Christopher's feet and fish protrude through waves of water; traces of color; Seccombe il facing p 5; Gardner fig 349. Found when buttresses moved at end of 19c. Gardner thought it "too delicately wrought for an external position" (175).

Fring. wp, upper section missing. c1330 (Tristram). Thigh-length coat looped up by belt, breeches tied at knees; water heaped about legs; variety of fish in water; Whaite pl 6.

Burlingham S Edmund. wp frag, S wall. ?c1350 (Tristram). Tunic looped over belt, remains of ?staff and tree; see below for overpainting.

Brisley. wp, S wall, damaged. c1360. Flanked by smaller Andrew (R) and Bartholomew (L). Christopher nimbed, tree staff in RH, knee-length gown belted at waist; fish in lower register, also under the feet of Andrew (eel) and Bartholomew. There are 2 representations in DT 26:113 and 53:202 with the note "Upper part of the painting destroyed through the carelessness of the white washer." The wp has been restored since the watercolors were made. David Park notes existence of other work as yet uncovered (P & W 2). A later Christopher on N wall also recorded in Bl 9:469.

Sedgeford. wp, S aisle, lower part of work covered by monument. c1360. Christopher holding T-headed staff, breeches tied at

knee, soft cap, and mantle lined with vair, wading W; traces of 2 later repaintings, 2 versions of Child at shoulder. According to Tristram impossible to distinguish versions; DT 43:146, 149. Tristram (116) quotes former inscription: "Wyth al thys world in hand / Thy dry staff withouten let / Shall beren leaves in land / Where thou it set"; Whaite pl 8.

Wickhampton. wp, E of N door. c1360 (DP). Possible overpainting of earlier version. Two-pronged staff in LH with remains of green leaf, walking E; cross-nimbed Child on R shoulder; among fish, a conger eel, and a crab; André, [1888] 415.

Babingley. *wp, above main door. c1380. Christopher holding spear; gown buttoned down front, looped over belt, breeches tied at knee; rocks at side of stream, DT 53:77. Tristram (136) queried the spear.

Paston. wp. c1380. Christopher nimbed, with soft cap, luxuriant beard, head turned toward Child; mantle lined with vair, breeches tied at knees; LA destroyed, but hand raised to hold staff; Tristram pl 62; Bardswell (1925) 191.

Crostwight. wp. Late 14c (Brindley 312). Christopher, full face, nimbed, short mantle draped over shoulders; Child in LH; DT 54:108; vestiges of second composition below monument (f 115).

Hockham. wp frag, N wall (not opposite door). Hand holding orb with cross. Size consonant with Christopher; Andrea Kirkham has identified at least 3 levels of painting in this area. See also VI.1 *Last Supper*.

W Somerton. wp frag, S wall betw 3rd win from E and blocked S door (N door principal entry). Late 14c (Tristram). Christopher wading W, staff in RH; Child held on LH. When Cautley saw the church he noted this was the only easily recognizable subject.

Banningham. wp frag. Late 14c. Waves and feet well preserved, head destroyed by clerestory addition.

Lingwood. wp (not opposite S door). 14c. Upper half only, uncovered 1965. Frag of Child on RS, blessing; Christopher with shaggy hair and beard; knobby staff in LH.

Little Melton. wp. 14c. Little decipherable today, partly obscured by organ; Tristram (222) cited breeches tied at knees.

S Pickenham. wp, S wall opposite N door. 14c.

Trunk of body, gown belted at waist; restored 1991.

Swannington. wp frag, S aisle. 14c. An unusual setting against the N side of the S aisle arcade. Breeches tied at knees; ?eeling spade; Sandys watercolor, NMS 1223. B236.235.951. Restored, lower part repainted (DP).

Lt Witchingham. wp frag. 14c. W end of N wall.

Edingthorpe. wp frag. c1400. Helmet-shaped hat, head turned toward Child, staff top in foliage; *900 Years* color il p 73.

Haddiscoe. wp, only upper section preserved. c1400 (Tristram). Saint in peaked cap; Child looking at Christopher; on upper half of orb traces of clouds and trees, DT 30:211. Keyser (1907a, 97) noted that the color was mostly lost, but "the eyes, etc. have been rather unfortunately touched up."

Stow Bardolph. *wp, S wall, painted over earlier S Edmund. c1400 (Brindley 314). Christopher with elaborate curling beard, burlet, and staff raguly; looking up to Child whose cloak billows behind; orb with pennon on cross, RH blessing; on labels proceeding from each: "Parve puer, quis tu? graviorem non tolleravi" and "Non mirans sis tu, nam sum qui cuncta creavi," Dashwood (1852) 137; towers in upper background; Dashwood il betw pp 138 & 139; Esther Reeve watercolor, NMS. The same verse appears in English at Horley (Oxon), James (1929).

Seething. wp, painted over earlier version. c1400. Saint nimbed, in voluminous mantle, breeches tied at knee; staff in bloom at tip; on LA Child extending RH in blessing at level of C's head, orb in LH; Bardswell (1926) il facing 338. Tristram identified a pilgrim's staff with knob at the top (11).

Norwich S Laurence. al frag. 15c. Headless; Child's foot rests on Christopher's LH. Iconography conforms to examples in Cheetham Cat. 21–23. NMS. Perhaps the item is the 1459 bequest of "a St. Christopher and all its appurtenances," Bl 4:296.

Salle. *im, will reference, Robert Aldrych, 1474. Note in 1938 guide book at NMR.

Caston? *im, cited by Barnes (20) with unsubstantiated Bl reference.

Carrow S James. *im at W door of church, Bl 4:524.

Norwich Austin Friars. *im, *Index Monasticus* 43.

Norwich S Gregory. *im and light, Bl 4:274.

Norwich S James. *im, Bl 4:424.

Norwich S John Timberhill. *im and light, Bl 4:128.

Norwich S Laurence. *im and tabernacle, Bl 4:263.

Norwich S Martin-at-Oak (Coslany). *im, Bl 4:485.

Norwich SPH. *im, light before, Bl 4:325.

Swaffham. *im, Bl 6:217 fn 4.

Norfolk ?Besthorpe. ms addition, Bod L Don. d.85, pen drawing f 1v. 1420–30. Voluminous mantle billowing, bandeau on head, leafy branch in LH, looking at Child on RS; Child RH blessing, orb with pennon on cross; (below) fish, incl flat fish. A particularly animated composition; Scott, *Survey* Cat. 39 il no. 171; Pächt & Alexander 803 pl LXXVI.

Diocese. ms, hours. Fitzwilliam Museum 55, miniature, f 134v. c1480. Building on R; James (1895).

Norwich S Leonard's Priory. *pcl. 15c. "j pannus depictus cum Christofere," cited for "camera lecti," Bensly (1895) 204.

Taverham. *pg, nV, light b. c1478 (King). "St. Christopher carrying our Saviour over a river and under him sets an ancient King (Edm[un]d)," NRO, Rye 17, 4:12v. King conjectures a small fig like those at Halvergate and Foulsham placed in this win above Edmund because the win is opposite the S door (1977, 390).

Norwich S George Colegate. *pg. 1499 bequest for a win of S Christopher (C & C).

Pulham S Mary. pg, sIII, eye of tracery. ?15[4]. Staff raguly in LH; mantle windblown to L of composition; trees in landscape.

Denton. pg, roundel (diameter 5¾", Ingleby 65). E win 4a. 15c. Mantle windblown to his R, R knee bent; bandeau on head, staff raguly; looking back at Child; standing mid-calf in river, no fish discernible.

Dunston. pg, sII.1a. 15c. Saint in soft yellow cap, holding staff in both hands; Child in white gown with gold floral pattern; restored.

Langford. *pg, head of N win, Bl 6:22.

Ingworth. *pg frag. Child on LH, large fish below; bare legs attached to an apostle fig probably belonged to Christopher; watercolors done when glass "scattered about the church," DT 33:43.

Poringland. *pg, N win. Christopher "carrying our Saviour over the water," Bl 5:442.

Snetterton. *pg. ?15[3]. Cited as one of series; it is unclear whether "legends with labels" modifies Christopher as well as the other subjects; Bl 1:420.

Stody. *pg. Citation in Frere MSS, NRS 1:37.

Tilney All Saints. *pg, N aisle, "with Jesus on his shoulder," Bl 9:80.

Horsham S Faith. pwd, pulpit panel 4 (counterclockwise). c1480. Standing on pedestal, as do all the pulpit figs, thus no water; gown reaching below mid calf, scalloped hem; supporting Child's leg with LH; Child with large cross-staff on orb.

Hockering. sc, font stem. 15c.

Attleborough. wp, over S door. ?c1450 (N porch c1441, main entry). Frag of Christopher walking E, massive hand; red cloak lined with white; below, tiny woman kneeling with arm extended, ?donor.

Bale. wp, very faint.

Burlingham S Edmund. wp frag. 15c. Flowering staff in LH, cross-nimbed Child on RS; wading E; fish below. A portion of the earlier wp reveals that Christopher's staff was painted exactly on top of the earlier one; Whaite pl 18.

Burnham Overy. wp, nave. 15c (black frame late). Christopher in tunic, trace of mantle; staff raguly in LH, probably with blossom at tip; Child on RS, not supported by saint, holding orb in ?both hands; trace of fish. "Unusually small" (Caiger-Smith); complicated architectual history of N wall; Brindley color pl LVI; restored 1984. A note attached to a 19c watercolor remarks: "It is not improbable that some letters have been covered over at the feet by the black wash," DT 26:190.

— *wp, over chancel door. Saint wearing breeches, staff in LH; Child on RS; the drawing in ?1837 by Mrs Gunn suggests that the wp was in poor condition, DT 26:189.

Caistor S Edmund. wp, S wall (main entrance through N door). Little remains today; in 1924 one could still see Child blessing, Bardswell (1926) 340.

Crostwick. wp, S wall (main entrance through N door). 15c (DP). Mantle draped over shoulders, held with LH; staff raguly in RH; variety of flat fish, lamprey; Child damaged, holding orb in LH; Whaite pl 17.

Thurlton. wp, N wall, but not opposite S door.

15c ("probably late," P & W 2). Staff raguly in full bloom; Christopher looking out at spectator rather than at Child; Child slightly larger than usual, cross-staff with flying pennon; lamprey, lobster, crab, flat fish. Because of narrowness of aisle, the wp could not be seen from the doorway.

Hardley. wp. 15c. Fish below, crane and willow; Pevsner 2 pl 40.

Mundham. wp. Late 15c (DP in P & W 2). Partly hidden by later monument.

Oulton. wp frag. Fish.

Scottow. wp frag within border. 15c. Lower half only, feet surrounded by a variety of fish, eel; walking W.

Weston Longville. wp frag, N wall. ?15c.

Wilby. wp, damaged. Trace of Christopher's LH and red staff in RH.

Yaxham? wp, win splay behind pulpit. Half the upper fig of a nimbed Child, RA raised. If correctly identified, the Child would have been on Christopher's R shoulder.

Drayton. *wp frag, N wall; ?2 subjects. Saint in patterned tunic, no breeches, holding tree staff in full leaf; Child's legs on RS, legs only; landscape above; lower R fig kneeling in prayer before ?female standing in doorway, laying RH on his head. 1850 watercolor by Esther Reeve (DT 54:218) reproduced in Brindley pl LVIII. The subject (lower R) has been identified as the incredulity of Thomas, but the gestures are wrong. It may have originally been part of a narrative series, the fig in the doorway representing the hermit.

Freethorpe. *wp, S wall. Legs and fish; trace of text; frag when recorded in 1849, DT 55:75.

Limpenhoe. *wp (discovered 1854, whitewashed over 1856; walls collapsed in 1881 reconstruction). Christopher looking up at Child, whose right leg is over his shoulder; fish and eels below, DT 56:81.

Norwich S Etheldreda. *wp. Staff in leaf in LH; Child on RS; crab and fish below; N Bolingbroke il facing 343.

Norwich S Giles. *wp, found in 1723. On scraping the walls in preparation for whiting "was discovered a monstrous piece of painting. . . . St. Christopher with our Saviour on his shoulders which is not whited over again and I believe it was at least 4 yards high," Mackerell, BL Add MS 12525, f 66v; see also Bl 4:239.

Stockton. *wp. Inscr asking for prayers for him who "made this christofee," Keyser (1907a) 109.

Ranworth. *wp, S wall. Nimbed, mantle over breeches, wading W holding staff with both hands; Child blessing with both hands (Brindley); remains of scroll (L & R) with illegible writing; DT 42:66, pencil sketch by Lady Palgrave, Elizabeth Turner, 1839.

Walpole S Peter. *wp over S door (Keyser). In 1917 only fish tail and "indications of other objects," Brindley 314.

Wimbotsham. *wp. Christopher in round cap, voluminous mantle, breeches, staff in LH; Child, RH slightly raised, orb in lap; crab; Dashwood & Boutell, il facing p 132; see also DT 48:80–1.

Loddon. *im. 1503. Bequest "to painting image of St. Christopher" (Margaret Davy, NCC Popy 351, Cotton personal communication).

Binham. pwd, screen panel, frag, S9. 16[1]. Nimbed head looking toward tiny head slightly above his head, RH in position consonant with holding staff (identified by James, *S & N* 171).

Norwich SPM. *pyx. 16[1]. A standing pyx with the crucifix on top, "called a gripe is eg w[t] sent x*pist*ofer graven w[t]in the cover," Hope 208.

Unspecified *wp cited by Brindley 312–4.
Aldborough
Arminghall, ?early 16c
Billingford
Brooke (S wall)
Brundall, "small and very late"
Burgh S Peter (S wall)
Fakenham
Garveston
Hockering
Stokesby, "destroyed by chipping and scraping," 1858, *Index Monasticus* 292
Wacton Magna
Wells (S wall), before church fire (1879) "very mutilated"
Westfield, destroyed during restoration, c1897
Wilton S James
Linnell cites 2 church dedications; Bond (1914) 9 for England.
Light at S Creake 1491 (Robert Norton, Norf Arch Bk 1, f 173), Stratton Strawless (Harrod [1847] 117).

Clare

Virgin, not a martyr (1194–1253). 12 Aug. Founder of the Poor Clares.

N **Tuddenham?** pg frag, nIII.A3. 15c. Virgin with staff and chalice with host inscr "ihc"; chalice and host suggest Clare. Wdf (63) conjectured Barbara.

Trimingham. pwd, screen panel, N2. c1500. In wimple and veil, white-lined pink mantle over pink gown; remains of monstrance in RH; clasped book in LH.

Horsham S Faith. pwd, screen panel, N3. 1528. White veil, wimple, brown mantle; closed book in RH; monstrance (damaged) in LH; brown mantle contrasts with black of abbess at N1; otherwise they are dressed identically.

Yarmouth. *im. 1529. Bequest to S Clare's Ch. In this same year there is reference to her guild, and in 1536, request for burial in the ch, Morant (1872) 222, 225.

Original dedication at Stiffkey, Bl 9:252.

Clement

Pope and martyr (†c96), successor to Peter. 23 Nov.

Narrative

Cathedral. sc, N cloister boss. 1427–38. **F2** lamb with golden fleece on rock surrounded by 7 figs; James (1911) connected the boss with a miracle of water found beneath a hill on which a vision of a lamb appeared to Clement. **F8** In tiara, being cast overboard with anchor attached to his neck.

Individual

Terrington S Clement. sc, clunch statue. 14[4]. In full Mass vestments with pallium; gloves, ring (hand detached); RH blessing; LH holding remains of staff; vestments decorated with anchors; frag of anchor at feet; Seccombe il facing p 5. Found when buttresses were moved at end of 19c. Anchors in relief on N aisle battlements and tower. In Seccombe's photograph, the head is missing; one is now displayed, with drooping moustache, without sign of tiara, probably alien.

N **Elmham.** *pwd, screen panel, 15[3]. LA resting on anchor, RH blessing, "*Sanctus* Cleme*n*s." Carthew (2:539) cited on the N of screen a wide panel against the pillar on the N, flanked by 2 narrow ones; on L side, a monk with pastoral crook in LH and open book in RH, obviously a member of the abbot set. See also *Giles* and *Leonard*.

Barnham Broom. pwd, screen panel, N4. 15[4]. Cope over Mass vestments, crozier in LH;

anchor in RH. Paired with a pope almost totally disfigured except for tiara; Duffy fig 80.

Houghton S Giles. pwd, screen panel, S6. 15c. Tiara, double cross-staff over LS; gloved RH blessing; trace of anchor stem lower L (some damage to lower section); name above; defaced.

Trimingham. pwd, screen panel, N3. c1500. Cope over dalmatic; double cross-staff in LH, RH blessing; anchor at lower R corner.

Norwich All Saints. sc, font stem. 1448 (bequest to emend font, C & C). Holding anchor. The font, now at S Julian's, has 8 statues standing on pedestals in identical garments, scalloped collars and flat crowned hats; restored.

Erpingham? sc, font stem. ?Mid 15c. Two figs holding anchors, the second also with flesh-hook (RH); font originally at Norwich S Benedict.

Beeston S Mary. pwd, screen panel, S1. 16[1]. Anchor and lower part of cross-staff; largely disfigured.

Weybridge Priory. printed calendar, NMS 134.944. 1503. Anchor.

Church dedications at Burnham Overy, *Brundall, *Keswich (N Walsham), Norwich (at Fye Bridge and *Conisford), Terrington, Outwell, and some evidence for Lyng. Bond (1914) cited 41 dedications for England. Guild at Burnham Overy (BL 7:28), Outwell (Bl 7:473; 1514, light, Williams [1941] 339).

Cornelius

Pope 251–3 and martyr in persecution of Decius. 14 Sept.

Wiggenhall S Mary Magdalene. pg, nIII.A2. c1450. Wearing mitre, holding double cross-staff in LH, blessing with RH; "*Sanctus* cornelius"; Keyser (1907b) fig 12. Appendix V.4.

Crispin and Crispinian

Martyrs (†c285). 25 Oct, feast introduced 15[1]. Patron of shoemakers.

Yarmouth. Cordwainers' guild. 1525. Morant (1872) 224; cited as Crispin and Crispiana, Bl 11:366.

Cuthbert

Bp of Lindisfarne 685–7 and confessor. 20 March.

E Anglia. ms, *The South English Legendary*, Bod L Tanner 17, marginal drawing, f 42v. 15[1].

In episcopal Mass vestments with mitre and crozier, holding king's head (Oswald).

Wiggenhall S Mary Magdalene. pg, nVII.A1. c1450. Bp, seated, chasuble, holding book; "*Sanctus* Cutb'tus." Appendix V.5.

Weybridge Priory. printed calendar, NMS 134.944. 1503. Bp.

Church dedications at *Thetford and *Norwich (desecrated after 1535, Watkin 1:xvi fn 15).

Cyprian

Bp of Carthage and martyr (c200–58). 14 Sept.

Dersingham. pwd, screen panel, N6. 16[1]. Bp in cope, bleeding wound across neck; clasped book in RH, roll and crozier in LH; Whittingham (church booklet, p 18) identified Cyprian. Williamson (1957) discounted the wound, but it can be clearly seen today and accords with the decollation of Cyprian. See also S Denys on the same screen.

Guild at Lynn (*Index Monasticus* 73; Richards 416).

David of Wales

Bp and confessor (†601/589). 1 March (synodal feast).

Marsham. *pg. "St. David," Bl 6:287–8.

Weybridge Priory. printed calendar, NMS 134.944. 1503. Harp.

Denys (Denis, Dionysius)

Bp, protomartyr, and patron of France (†c250). 9 Oct. One of the 10 saints cited by Lydgate as special helpers.

Diocese. ms, hours, NMS 158.926.4f, hi, f 49 (Lauds, *memoriae*). c1310–20. Bp.

?Paston. *im, gilt. 1464. "Sent Denys," property of John Paston, Gairdner vol 4, no. 563.

Cathedral. sc, N cloister boss, J7. 1425–30. Two registers: (L) mitred in red chasuble, kneeling with hands joined; (above) executioner LH on mitre, RH raised; emperor seated with scepter. (R) Denys, neck bloody, presenting head to monk standing in doorway of elaborate church; Rose (1997) 33.

Hempstead S Andrew. pwd, screen panel, N6. 15[2]. Mitred, in full Mass vestments, crozier in RH, tonsured head in LH; name below; paired with Theobald.

Dersingham. pwd, screen panel, N2. 16[1]. Mitred, in red chasuble, crozier in LH, mitred head in RH.

Weybridge Priory. printed calendar, NMS 134.944. 1503. Elaborate church.

Desiderius

Bp and martyr (c305).

Wiggenhall S Mary Magdalene. pg, nIV.B4. c1450. Bp in Mass vestments with crozier. Appendix V.5.

Dominic

Confessor (c1170–1221). Founder of the Friars Preachers (Blackfriars). 6/4 Aug. Feast in diocese from early 14c (Morgan, L & M Cat. 26). Images of Dominic and Peter Martyr were required in all Dominican churches.

Thetford Priory 2. pwd, retable. c1335. Paired with Peter Martyr, both in Dominican habits (white habit, black mantle); standing, cross-staff in LH; 3 volumes in a case in RH; now at Thornham Parva (Suf); *Age of Chivalry* Cat. 564.

Yarmouth Blackfriars. seal. 14c. (L of Virgin) Dominic with crozier, *BM Cat. of Seals*, 4382; *VCH* pl 3, facing 436. The friary was dedicated to S Dominic.

Norwich Blackfriars, New House. seal. 15c. (C) Fire with book above; flanked (L) by Dominic and a friar and (R) 2 heretics, one in pointed hat. Over Dominic's head 7 stars, and cross fitché near forehead. Blomefield cites the legend from Jacobus de Voragine's *Golden Legend* in which Dominic confronts heretics. Probably the same as the next entry. Reproduced in frontispiece pastedown in Frank Sayer's copy of Blomefield (vol 1) no. 183.

Norwich, Friars Preachers of S John Bapt. seal. 15c. Obverse, "Dominic performing a miracle," *BM Cat. of Seals*, 3774.

Weybridge Priory. printed calendar, NMS 134.944. 1503. Bust in religious habit.

Dorothy

Virgin martyr (†c313). 6 Feb. Characteristic attribute a spray or bouquet of flowers, and/or basket. The fruit cited in the *Golden Legend* is represented only twice. On 2 screens Dorothy, like Cecilia, wears a chapelet of flowers in her hair.

Norwich SPM. *im and light, Bl 4:212.

Ingworth? *pg. Crowned, palm in LH, branch in RH, "painted glass, still remaining in the windows," DT 33:43.

Salle. *pg, E win, S transept. Virgin martyr; James *S & N* 165. Appendix V.1.

N Elmham. pwd, screen panel, S3. 15[3]. Crowned, RH holding mantle and closed book; in LH bouquet of flowers (3 cinquefoil, and 3

nondistinct flowers); Duffy fig 68.

Barnham Broom. pwd, screen panel, S4. 15[4]. Square-necked green gown, sleeves lined with ermine; green burlet with white backing visible through oculi; flowering branch in RH; basket in LH.

N Tuddenham. pwd, screen panel, N5. 1499–1504. Basket of flowers on palm on LH, spray of flowers in LH; ?snood on head.

Diss. *im. 1506. 13s 4d for making image, John Mabely, Ipswich wills 6, 9 (Cotton, personal communication).

Walpole S Peter. pwd, screen panel, S5. 16[1]. Burlet with ouch, unnimbed; palm in RH, basket of flowers in LH; ermine trimmed mantle fastened with single morse.

Trimingham. pwd, screen panel, S2. c1500. Chapelet of flowers in hair; long-stemmed flower in LH; clasped book in RH; for a similar long-stemmed flower, see *Puella Ridibowne*. James (*S & N* 156) identified Cecilia.

Wiggenhall S Mary. pwd, screen panel, N2. 16[1]. Chapelet of flowers in hair, basket of fruit in draped RH.

Denton. pwd, mounted on chest, 2 (reading L to R); defaced. 16[1]. RH raised, palm out; holding basket of flowers betw fingers and thumb of LH; short-sleeved, ¾ length dark tunic with tasseled hem over gold gown with voluminous sleeves; the tassels appear to be threaded on a cord. Head obliterated.

Worstead? *pwd, screen panel. Recorded in the 19c (Camm 272–3), perhaps Philip mistaken for Dorothy.

Babingley. *pwd, screen panel. ?1553–8. Long hair, large buttons down front of gown; palm in LH, basket of fruit in RH; DT 53:72. A second saint with palm in LH, hexafoil flower in RH, staff with pommel in LH; ermine collar, DT 53:68.

Walsoken. sc, font stem. 1544. Basket in RH, spray of flowers in LH.

Dunstan

Archbp of Canterbury (960–88) and confessor. 19 May. Benedictine abbot.

E Anglia. ms, *The South English Legendary*, Bod L Tanner 17, marginal drawing, f 107v. 15[1]. Palium over Benedictine habit, mitre, chalice with one hand, holding devil (cropped) with pincers with the other.

Norwich SPM. pg E win B4. Mid 15c. Archbp.

Beachamwell. *pg, S win, "figures of St. Augustine, and St. Dunstan, the archbishops," Bl 7:296.

Gt Plumstead. *pwd, screen panel. 15[3]. In full archiepiscopal Mass vestments incl gloves, double cross-staff in LH; RH holding devil, perhaps by tail though Winter said "by forceps"; devil defaced, but wings clear; S*anctus* Dunstanus, DT 41:133; Winter, *Selection* 2:5, reproduced in Bond (1914) 68.

Weybridge Priory. printed calendar, NMS 134.944. 1503. Devil with long nose; bp.

Parochial ch at *Saxthorpe (founded before 1313, Ward 306 fn 110).

Edgar

King of England 959–75. Buried at Glastonbury. 8 July.

Norwich SPM. pg, E win C2. Mid 15c. With scepter; inscr name; king set. Appendix V.3.

Edith

There were 3 Anglo-Saxon royal saints named Edith, the nun at Wilton (961–84), Edith of Polesworth (without liturgical evidence), and Edith of Aylesbury, said to have raised S Osyth.

Hingham? *im. Light before "St. Edith or Sythe," Bl 2:423. Edith of Wilton occurs in the calendar of NMS 158.929 4f. Blomefield's option of saints is curious.

Edmund

King of E Anglia martyr (841–69); *cultus* centered at Bury S Edmunds (Suf). 20 Nov; translation 29 April. For S Edmund memorial coinage, see Ridyard 214–6.

Thetford Priory 1. 12/13c. Relic of his coffin "kept miraculously from decay, in which King Edmund the Martyr, many years after his passion was found whole, and looked as if he had been alive," Bl 2:118.

Norwich S Edmund. 14[3]. Shift of S Edmund, "una pars camisie Sancti Edmundi in uno cristall," Watkin 1:7. The roof was decorated with roses and lilies and inscr "S Edmundus, Flos Martirum, velut Rosa, vel lilium," Bl 4:405.

Narrative

Frenze. brass, palimpsest. 15[4]. King seated upright in bed, chest pierced by spear from which hangs money bag; soul with grotesque head departing; hairy bat-winged devil, tongue protruding, talons on feet,

grasping the legs of his departing soul; bed set on raised tile floor. According to Nicholas Rogers the image depicts Edmund coming to provide money demanded by King Sweyn and then killing him, thus freeing the people from paying tribute. John Page-Phillips suggests that the panel came from the shrine at Bury S Edmunds, a replacement after the 1465 fire (Bertram 153 fig 104). For the argument that the scene represents Avarice, see Goodall il p 264. The brass was inaccessible in 1996.

Martyrdom

Defeated by invading Vikings, Edmund refused to deny his faith. He was martyred by being shot with arrows and then beheaded, his head being protected by a wolf. Edmund is typically crowned and thus distinguishable from Sebastian. See also XVI Men.

Norwich, Carrow Priory. ms, Carrow Psalter, Baltimore, Walters Art Gallery W.34, miniature, f 13v. 1250–60.

Saxlingham Nethergate. pg, sII, roundels. Mid 13c. **1a** Edmund (alien head) with hands bound to tree trunk, stripped to waist, 7 arrow shafts protruding from body; remains of man with drawn bow and arrow; **FIG 34 1b** Edmund, crowned, demi-kneeling, head tilted back looking up to white cloud; both hands elevating 3 arrows. Perhaps from Saxlingham Thorpe, King (15) fig 9.

Norwich Brethren de Penitentia. seal of prior. After 1250, "bound to a tree, and pierced with arrows," *BM Cat. of Seals*, 3777.

Norwich Friars of the Sack. seal. Before 1307. Crowned, tied to a tree, his body pierced with arrows, *Index Monasticus* 45. Reproduced in frontispiece pastedown in Frank Sayer's copy of Blomefield (vol 1) no. 187.

Wymondham Priory. seal (second). 14c. (Above) Edmund pierced with arrows, flanked by archers; (below) decapitation; NMS. *BM Cat. of Seals* (4381) cites second seal with ?Virgin. Both scenes also occur on the privy seal of Bury S Edmunds Abbey, *BM Cat. of Seals*, 2801.

Cathedral. sc, E cloister boss B3. c1327–29. 2 wolves; headless man with bow, arrows at belt; Edmund, clean-shaven, halter around neck.

Stow Bardolph. *wp over S door. ?14c. Crowned, crossed hands bound at waist, legs bound beneath knees; and pierced by 11 arrows, flanked by archers drawing bows, (L) with 4 arrows in belt, (R) with 3; archers in pink and blue hose, (R) in large red hat. Partly covered by later wp of S Christopher; Dashwood (1852) il betw pp 138 & 139; DT 60:170; Sandys, NMS 1223.B94,235.951.

Guestwick. *pg, N aisle, main light (King 23). "Danes shooting him &c. and their own King, or leader, falling down dead before him," Bl 8:21. Martin queried "Sebastian or Edmund the King," NRO, Rye 17, 2:150.

Cathedral. sc, N cloister boss H7. 1427–8. (L) men in short gowns with bows; (R) Edmund hands tied behind ?to tree.

Norwich S Laurence. sc, R spandrel, W door. 15³. Crowned, in loin cloth, body pierced by multiple arrows, flanked by archers; wolf's head below.

Norwich S Peter Parmentergate. *pg, N win. 1558. Edmund "naked, with his hands tied his crown on, and his body ful of arrows," Bl 4:98. Perhaps paired with Francis (see below).

Edmund's Head/Wolf

A popular motif on seals of Bury S Edmunds and its abbots, *BM Cat. of Seals*, 2797, 2801, 2803–4, 2807.

Emneth. sc, N chancel. Late 12c. Wolf's head (dedicatory saint).

Cathedral. sc, N cloister boss I7. 1425–30. Headless body with hand resting on head (below) guarded by wolf; flanked by men in chaperons.

Pulham S Mary. sc, porch battlement. 15⁴. Seated wolf with head betw paws.

Walpole S Peter. wdcarv, desk elbow. 15c. Seated wolf with crowned head; 2 examples; ch dedicated to S Edmund; Bond (1910b) il p 12; Anderson (1971) pl 7. Woodwork reset in 17c (E Rose, personal communication).

Gimingham? wdcarv, be. 15c. Winged creature holding head betw paws; fixed to new prayer desk.

Neatishead? wdcarv, be. 15c. Winged creature holding head of a bearded man in its mouth.

Individual

Crowned, usually holding an arrow rather than scepter.

Cathedral. sc, above Prior's Door (R). 1297–1314. Crowned, feet resting on crouching fig with quiver and arrows.

— wp, Ante-Reliquary Ch, vault, N bay. c1300. King, Tristram (230) queried identity.

N Lynn. *im. Before 1389 (Westlake no. 281); 3

candles "brennend a-forn ye seint," T Smith 106.

Diocese. ms, hours, NMS 158.926 4f, hi, f 48v (Lauds, *memoriae*). c1310–20. Holding arrow.

Norwich S Edmund. *pcl, frontal. 14³. "j pannus tinctus pro altari cum ymagine Sancti Edmundi," Watkin 1:7.

Thetford Priory 2. pwd retable. c1335. Paired with John Bapt; standing, crowned, holding arrow in LH; now at Thornham Parva (Suf); *Age of Chivalry* Cat. 564.

Stow Bedon. *wp. 14c. Tristram 27–8.

Oxborough. *brass bell, "on this is the figure of St. Edmund," Bl 6:181. But see L'Estrange (1874).

Norwich S Edmund. *im. 1467. Rector to be buried before feet of im, Williams (1941) 335; Bl 4:405.

Hingham. *im, light before, Bl 2:423.

Norwich S Laurence. *im and tabernacle, S side of main altar, Bl 4:263.

Norwich S Michael-at-Plea. *im, Bl 4:325.

Tilney All Saints. *im, candle before guild image, Firth 177.

Salle. *pg, sIV, light c. c1440. Appendix V.3 & 5.

Martham. pg, nIV.1a. c1450 (C & C). Crowned; scepter in RH; arrow in LH, just below the fletching; short gown, wide belt, fur trimming on gown. Perhaps part of a king set. Taylor (1859b) cited this win in the S aisle.

Stody. pg, nVI.A3. 1440–50 (King). Arrow held diagonally across LS; short tunic, mantle closed with cord, scarlet hose; paired with prophet/patriarch in profile, pointing to Edmund. 4 kings alternating with 4 prophet/patriarchs, all on counterchanged pavement and against 3-dimensional screens. **A1** king in profile facing **A2**; **A5** king with teaching gesture; **A8** in profile facing **A7**. Appendix V.3.

Norwich SPM. pg, E win D7. Mid 15c. With arrow. King set. Appendix V.3.

Denton. pg, roundel, E win 4e, *ex situ*. 15c. Crowned; LH outstretched; in RH 2 arrows; belted white calf-length gown with yellow flowers, white collar over mantle. Roundel broken and mended since original painting was done, circumference reduced; Ingleby 65.

Harpley. pg, W win A5. 15c. Seated; long arrow in RH, head at knee; ermine collar; mantle

over belted gown; paired with Edward in an ecclesiastics set; Appendix V.

Ketteringham. pg, E win, A3. 15c. RH raised; arrow in LH over shoulder; gold figured gown; paired with John Bapt at A6.

N Tuddenham. pg, sIII.A3. 15c. In white gown and ruby mantle, with arrow in LH and scepter in R; at feet scroll inscr "*Sanctus Edemund*'."

Taverham. pg frag, nV. c1478 (King). Feathered angels with texts: **A2** "Miles regis," **A4** "*Pro* sal[ute]," **A5** "Ave rex gentis an[gelorum]," excerpted from the Vespers antiphon, "Ave rex gentis Anglorum: miles Regis angelorum, O Edmunde flos martyrum, velut rosa vel lilium, funde preces ad Dominum pro salute fidelium"; reconstructed by King (1977) 388. A variation of same text was painted on the Fundenhall roodloft ("Ave Rex Gentis Anglorum, Tu Rex Regis Anglorum, O Eadmunde! Flos Martyrum, velud Rosas vel Lilium," Bl 5:174). In the 18c the central light below contained *Edmund "crowned with an arrow in his Right, and a Book in his left hand," NRO, Rye 17, 4:12v.

Provenance uncertain. *pg, E win, S aisle. Saint standing on pedestal, large arrow in RH, breast to navel bare; no crown. The elaborate drawing is on a clean page following an entry for "Wigenhalle S Maries," with an added note "This statue I find portraied and painted in glass . . . is not in Wygenhall S Marys," NRO, Rye 17, 4:161.

Bodham. *pg. Drawing of "king with arrow and sceptre and a bishop with mitre and cross," Frere MSS, NRS 1:10.

Caston. *pg, "St Edmund," NRO, Rye 17, 1:199.

Crownthorpe. *pg, N win. King with arrow in hand; paired with a bishop, NRO, Rye 17, 1:236b.

Marsham. *pg, N aisle, effigy with label, "Sanctus Edmundus Rex", with kneeling man below saying "Sancte Edmunde, ora pro me," Bl 6:287. Appendix V.3.

Merton. *pg, S win, upper end of church. "Edmund, in his princely robes, holding in his left Hand an arrow"; (below) Sir Robert Clifton "with a book before him, and in a scroll from his mouth, 'Sancte Edmund ora pro nobis'," Bl 2:308.

Sparham. *pg, N win, with arrow, NRO, Rye 17, 3:216.

Thwaite? *pg, tracery, seated with orb in LH; copied from Suckling drawing and so identified, DT 46:42. Which Thwaite is not specified.

Hempstead S Andrew. *pwd, screen panel. 15². With arrow. Williamson (1957) cited as loose in 1936. Churchwarden has no knowledge of the fate of this panel. See also *Edward the Confessor*.

Barton Turf. pwd, screen panel, S aisle 2, paired with Henry VI. After 1471. Crowned, forked beard; scepter in RH, arrow held diagonally in LH, head down; ermine collar, ermine-lined mantle; scroll behind head and shoulder: (L) S*anctus* (R) Edmu*n*dus; Duffy fig 76; Camm color pl LVI.

— pwd, screen panel (loose). 15⁴. Closed crown, ermine collar with chain of office, ermine-lined sleeves; arrow in RH, scepter in LH. This panel seems to be by the same artist who worked on the N side of the screen at Ludham. The youthful heads of Edmund and Henry VI are strikingly similar. Provenance uncertain; purchased in Norwich antique shop by the incumbent at Rackheath, who later moved to Barton Turf (Pauline Plummer).

Catfield. pwd, screen panel, S1. 15⁴. Arrow in RH; ermine collar and ermine-lined belted gown with wide ermine hem. Appendix V.3.

Litcham. pwd, screen panel, S2. c1500. Simple crown, 3 arrows in LH, fletching at LS; dark mantle, drawers.

Ludham. pwd, screen panel, N3. c1493. Crown, scepter in RH and arrow in LH; slit ermine collar over ermine-lined mantle, belted gown with wide ermine hem; inscr below "S*ance*:Edmund*us*"; paired with S Edward at S3; Constable il p 214.

Stalham. pwd, screen panel. Late 15c. Head damaged but remains do not suggest crown; short red sleeveless gown, mantle fastened with double morse; arms akimbo, arrow in LH over shoulder, RH holding mantle at belt line; paired with S Edward. In a 19c watercolor (DT 44:161) the 2 kings precede Andrew and a paired archbp; the restoration, hung on the S wall of the chancel, reverses the order of these 2 pairs.

Trimingham. pwd, screen panel, N1. c1500. Crowned; scepter in RH, arrow in LH; pink gown, white-lined mantle, ermine collar

(with tails).

Riddlesworth. pwd, set in modern reredos. ?15c. Originally from Knettishall (Suf); "so thoroughly repainted that no one would identify . . . as medieval," M & R 3.

Acle. sc, statue, SE corner of tower. c1472.

Norwich S Helen. sc, boss, S aisle ch (3). c1480. With name scroll. Paired with Edward.

Hemblington? sc, font relief, SW face. 15c. Seated, scepter in LH, trace of slender object [?arrow] in RH; polychrome restored by Tristram.

Stalham. sc, fig on font stem. 15³. 7 kings, one holding long arrow in RH. Williamson (1961) suggested Kenelm, Edwin, Oswald, Edward the Elder, and Ethelbert, kings found in other sets, but there are no attributes.

Brooke. sc, font stem. 15³.

Downham Market. sc. ?15c. Decapitated, holding 2 arrows, presented to the church in 1886; provenance uncertain.

Wiggenhall S Mary. wdcarv, be, S aisle N9. 15c. Book in one hand, ?arrow in other; paired with S Martin or S Hugh. Bullmore identified paired kings in the nave (N4) as probably Edmund and Edward, but there are no distinguishing attributes.

Emneth. wdcarv, wall post, S1. 15c. Crowned, holding arrow in RH, worn round object in LH.

Norwich S Laurence. *emb. 1501. Bequest of cope with im of Edmund and 2 crossed arrows on pectoral, Bl 4:269.

Norwich SPM. *im, ch of S Nicholas. 1506. A "new tabernacle made," Bl 4:202. See also *Edward the Confessor*.

Outwell. *pg, Beaupré Ch (Bl 7:471). 16¹.

— *pg, N aisle ch, with arrow and scepter, Bl 7:472. 16¹. Almost life-sized; Appendix V.3.

Denton. pwd, mounted on chest, 7 (reading L to R); defaced. 16¹. Crowned; RH holding arrow near head, shaft over shoulder, trace of second arrow head; orb in LH. This may be the same unlabeled Winter watercolor of a damaged screen panel illustrates S Edmund, shown against a cloth of honor, arrow in his RH and an orb on left palm (NMS 73.377.965).

Weybridge Priory. printed calendar, NMS 134.944. 1503. King.

Linnell cites 21 church dedications (9th most popular

dedication); Bond (1914) 61 for England. The Cistercian nunnery at Marham was dedicated to the Virgin and SS Barbara and Edmund (Knowles & Hadcock).
Guilds at Costessey (Bl 2:416), Downham Market (Bl 7:343), Foulden, Hunstanton (Bl 10:328), Ling (Bl 8:252), N Lynn (Farnhill, with second entry), Tilney All Saints (Farnhill).
Chs at Foulden (in Burhall field), Lyng (1558), Hunstanton (13⁴ or 14¹; *Index Monasticus* 67–9); Lynn S Nicholas, joint dedication with Peter (Owen 29, 132), Norwich Prior's ch (Harrod [1857] 301), and Walpole S Peter (Bl 9:118, Ward 297). At Snettisham (1468–1599, Galloway & Wasson 85–95) there were regular processions "to sent Edmund*us*."
Altars at N Wootton (Bl 9:203), Yarmouth (Morant 222). L'Estrange (1874) cites inscr bell at Tivetshall S Margaret, where the word EDMUNDE is cut out, and one at Denton ("EDMUNDE REX SANCTISSIME FAC TECUM SEMPER VIVERE"). "SANCTE EDMUNDE ORA PRO NOBIS" cited at Briston by Bl, Frere MSS, NRS 1:13.

Edmund Rich, of Abingdon

Archbp of Canterbury (1234–40) and confessor. 16 Nov. Shrine at Pontigny.

Fritton. wp, N wall near roodstair entrance. Mid 13c (DP in P & W 2). In flat mitre, green chasuble with white pallium decorated with red crosses, cross-staff in LH; (above) EDMUND.

Diocese. ms, hours, NMS 158.926.4f, hi, f 49v (Lauds, *memoriae*) c1310–20. Cross-staff, no pallium.

— ms, Stowe Breviary, BL Stowe 12, hi, f 329. c1322–25. Archbp.

Walpole S Peter. *pg, N chancel. 1423/25. Bl 9:117; Wdf (179) conjectured a set of archbps and bps; see also *John of Beverley, William of York,* and *Hugh of Lincoln.* See Appendix V.5.

Salle. *pg, sII, light a. c1440. See Appendix V.5.

Wiggenhall S Mary Magdalene. pg, nIV.A5. c1450. Chasuble, no pallium; "S*ancte* edmu*n*d." This win also includes frags of other ecclesiastics: **A1** tippet and green mantle over figured gown (?doctor); **A2** religious habit, with crozier; **A3** religious habit, with crozier; fig in chasuble with staff of ?crozier. These figs were linked with apostle names in the 1924–5 restoration. Appendix V.5.

N Tuddenham. pg, sVI.A2. 15c. Bp in alb and crossed stole, cope, closed book (stamped cover) resting on lap, crozier in LH; below on scroll "S*anctus* Edmu*n*d' epi*scopus*" (label may not belong to fig, Wdf 63).

Weybridge Priory. printed calendar, NMS 134.944. 1503. Two mitres.

Edward the Confessor

King of England (1042–66) and confessor. 5 Jan/13 Oct. Crowned, with attributes of scepter and ring typically held betw thumb and index finger. Shrine (restored 16³) at Westminster Abbey.

Narrative

Lynn. pilgrim badge. 14⁴. "Within a crescent moon . . . king [crowned with scepter in LH] giving his ring in alms to a hair-shirted, barefoot pilgrim [S John]," eagle at his feet; name scroll "S Edwardus" rising vertically betw figs; Spencer (1980) Cat. 80.

Norwich. pilgrim badge. nd. "Imitation finger-ring," Spencer (1980) Cat 81.

Cathedral. sc, N cloister bosses. 1427–8. **G7** Birth: queen in bed, nurse with infant in swaddling clothes; (above R) hand of God pointing from nebuly; (L) king and monk; monk kneeling at nearside of bed; ?serpent; Gardner misidentified as Nativity, fig 505. **G6** at Mass: (L vertical reg) angel, 2 monks, king kneeling before prayer desk with open book; (R) priest saying Mass, cleric with back to altar holding open book. **I3** Mass scene, (L) altar with open book, chalice and corporal, kneeling beside disfigured ?priest; nobleman in dagged collar, pleated tunic and pendant sleeves and sword belt, 2 other figs behind. James conjectured Edward at Mass, but the boss is well removed from Bay G.

Individual

Lynn. pilgrim badges. nd. Crowned head; crowns, Spencer (1980) Cat. 82, 83–6.

Saxlingham Nethergate. pg, nV.1b, tracery light, *ex situ.* c1400. Curly hair and beard, ermine collar; scepter in RH and ring held aloft in LH; provenance uncertain, perhaps from Saxlingham Thorpe (King 25).

Norwich SPM. pg, E win C3. Mid 15c. Crowned, scepter in LH, ring in RH; ermine collar over ermine-lined mantle; belted fur-lined gown; (not part of the king set; see King forthcoming); Wdf pl I.

Harpley. pg, W win A6. 15c. Seated, scepter in LH, ring in RH; ermine collar; belted gown with bag sleeves; facing Edmund.

Heacham. pg, nIV.B2. 15c. Forked beard, scepter in LH, pointing with RH; ermine collar,

dark blue mantle; paired with Olaf. Wdf (180) identified Edward by attribute, but no ring now visible. Appendix V.3.

Swaffham. pg frag, nV.B6. 15c. Hand holding ring.

Marsham. *pg, N aisle, "fine effigies" incl one labeled "Sanctus Edwardus Rex," with donor below, Bl 6:287. Appendix V.3.

Norwich S Peter Parmentergate. *pg, Bl 4:96.

Tilney All Saints. *pg, N aisle, Bl 9:81.

Hempstead S Andrew. *pwd, screen panel. 15². With scepter and ring. Williamson (1957) cited as loose. Churchwarden has no knowledge of whereabouts of the panel.

Barton Turf. pwd, screen panel, S aisle 3. After 1471. Full beard; scepter in RH; ring held betw thumb and index finger of LH; baldric over tunic; ermine-trimmed gown; ermine collar over ermine-lined damask mantle; Constable il p 215; Gunn & Winter fig C; Camm color pl LVII.

Catfield. pwd, screen panel, N8. 15⁴. Scepter in LH over LS, ring held up in RH; ermine collar and lined red mantle.

Barnham Broom. pwd, screen panel, S1. 15⁴. Holding long staff. Tentatively identified by James S & N 141. In the 18c there were "two saints painted on the clerk's seat, one . . . Edward the Confessor," NR0, Rye 17, 1:69. It is unclear whether this was a second painting or a pane of the original screen now restored to S1.

Smallburgh. pwd, screen panel, N2. 15⁴. King in scalloped ermine closed collar over green mantle; scepter in LH, RA held up, 3 fingers visible, index finger and thumb section scratched out; "picture of Edward the Confessor, in his regalia, and his arms," Bl 11:67.

Ludham. pwd, screen panel, S3. c1493. White hair and beard; ermine collar, ermine-lined mantle over belted gown; scepter in RH, ring in extended LH; second artist, name in white without rubrication; paired with Edmund at N3.

Stalham. pwd, screen panel, chancel, S wall. Late 15c. Short beard, open crown; scepter in RH, LH at belt; ermine closed collar over mantle. Paired with Edmund. James (S & N 150) only identified Edmund, citing "another king."

Norwich S Swithin? *pwd, screen panel. 15c. King in demi-profile in belted gown, wide

ermine hem; scepter in RH, scallop shell in LH betw thumb and index finger; DT 40:128. The 1838 watercolor has penciled notes: "Panel of the screen, the only one I have found," "said to represent St. Swithun." This was probably the single painted fig seen by Hart in the vestry (1854, 63). The modeling of the fingers, if not the attribute, suggests Edward.

Norwich S Helen. sc, boss, S aisle ch (7). c1480. With name scroll.

Norwich SPM. *im, ch of the Virgin. 1504 (Bl 4:206). Bequest for burial before im "lately made," Bl 4:214. About this time a new tabernacle was made for S Edmund (see above).

Outwell. pg, sIII.A5. 16¹. Ring in RH, scepter in LH.

— *pg, N aisle chapel. 16¹. With "gold ring in one hand, and a sceptre in the other," Bl 7:472. Appendix V.3.

Burlingham S Andrew. pwd, screen panel, N5. 16². Scepter in RH, ring betw thumb and index finger of LH; ermine-lined mantle and collar, fur-lined mid-calf gown with purse at waist, Tudor shoes; rings on both hands; on pedestal "Sanctus:Edwardus: Rex"; Duffy figs 58, 131.

Denton. pwd, mounted on chest, 8 (reading L to R); defaced. 16¹. Ring held in RH; LH holding mantle.

Repps. *pwd, screen panel. ?1553–8. Book in LH, scepter in RH; DT 59:211.

Weybridge Priory. printed calendar, NMS 134.944. 1503. Holding ring aloft.

Linnell (1962) cites 2 church dedications; Bond (1914) 17 for England.

Edward the Martyr

King of England (975–78) and martyr. 18 March; Translation 20 Oct. While drinking from a cup offered by his stepmother, he was stabbed.

East Anglia. ms, *The South English Legendary*, Bod L Tanner 17, marginal drawing, f 39v. 15¹. Crowned, holding scepter.

Salle. *pg, sIII, light c. c1440. Appendix V.3 & 5.

Guestwick? *pg. "St. Edward the King," cited in win with S Sebastian; NRO, Rye 17, 2:150. Uncertain identification; perhaps Edward the Confessor.

Norwich SPM. pg, E win C3 Mid 15c. Name only; projected by David King (forthcoming) as paired with Alban in the king set.

Appendix V.3.

Stalham? sc, font stem. 15c. Williamson (1961) suggested that one of the kings held a covered cup instead of an orb.

Outwell. pg, sIII.B3. 16[1]. King, chalice and scepter. Appendix V.3.

— pg, nV, light b, N ch. 16[1]. Life-sized king, massive chalice and scepter.

Weybridge Priory. printed calendar, NMS 134.944. 1503. Crowned bust without attribute.

Eleutherius

Pope c175–c189. 16/30 May. According to *Liber Pontificalis* (quoted by Bede), King Lucius requested missionaries for Britain from this pope.

Salle. *pg, nIV, light b. c1440. Appendix V.4 & 5.

Eligius (Eloi, Loy)

Bp of Noyon (558–60) and confessor. 1 Dec; translation 25 June; patron saint of farriers. Eligius appears in an early 14c calendar in BL MS Arundel 83 I.

Cathedral. *altar/im. ?1406. Cited in Shinners 144 fn 46.

S Walsham. *pg. ?15c. Bp with hammer in RH; DT 47:70.

Hempstead S Andrew. pwd, screen panel, S8. 15[2]. Mitred, full Mass vestments; hammer in LH, severed horse's leg in RH. Stolen. Description based on DT 31:141 and 55:235; Constable il p 216.

Potter Heigham. pwd, screen panel, S2. c1501. In Mass vestments, crozier in LH, hammer in RH, below "*Sanctus* loye." S Loy replaces Matthew in what is otherwise a standard 8-pane evangelist/doctor screen.

Weybridge Priory. printed calendar, NMS 134.944. 1503. Hammer (feast of translation).

Altar at Yarmouth, Morant (1872) 222.

Guilds at Norwich All Saints (Bl 4:132), perhaps the same cited 1470–1528 by Tanner (21).

Lights at Stratton Strawless & Wiveton (1487/8) (Harrod [1847] 117).

Elizabeth of Hungary (Thuringia)

Queen (1207–31). 19 Nov. Widowed at 20, driven from court; renowned for abstinence from courtly food and for gifts to the poor.

Norwich SPM pg, E win, 5c. Mid 15c. Nimbed woman in sideless surcoat trimmed with ermine, burlet with cinquefoils, distributing alms to beggars; King Ludwig looks on

from palace; Wdf pl VII. The iconography contrasts significantly with other instances. Details from the iconography of the Works of Mercy reflect the *Golden Legend*, where Jacobus de Voragine catalogues her performance of the Works of Mercy. Wdf noted that Elizabeth belonged to the Third Order of S Francis; for Franciscan donor see King (forthcoming).

Barnham Broom. pwd, screen panel, S6. 15[4]. White veil and wimple, mantle over red dress; loaves of bread in LH; ciborium with rising cross on palm of RH.

Upton. pwd, screen panel, S3. c1500. Nimbed woman in short white veil, holding massive bowl-shaped vessel against breast; LH holding equally massive footed woven basket with bread and an object with a neck (?chicken leg, cf E Harling, Wdf pl XII; Williamson [1957] suggested bottle). Identified by Keyser as Joan of Valois, by Hill as Joanna, Queen of Spain; see *Johanna*; Williamson favored Elizabeth of Hungary.

Wiggenhall S Mary. wdcarv, be, nave. 15c (P & W 2). **S5** Woman in elaborate burlet, 3 loaves of bread in RH. **S4** woman holding ciborium.

Emeria (Hismeria/Ismary)

Sister of S Anne and ancestor of S Servatius; see III *Teaching Virgin to Read* Houghton S Giles and Babingley.

Ermengild

See *Etheldreda*, Norwich SPM.

Erasmus

Bp of Formiae and martyr (c300). 2 June. The blessings of S Erasmus were not unlike those credited to Christopher. Those who prayed every Sunday or offered alms or lights were to be granted 5 gifts: "The firste is he shall have reysonabil gode to his lyvis end; The secunde is that his enimys schal have no power to do hym no bodely harme nor dysese; The iij is, what reysonabil thynge that he woll aske of God and that holy seint ht schall be graunted; The iiij is, that he schall be unbounde of all his tribulacion and dysese; The v is, that in his laste ende he schall have schrift and housill and grete repentaunce and sacramente of annewntinge; and then may he come to that blysse that never hath ende," Trinity Chapel, Cirenester, Turner (1847d).

Martyrdom

Buckenham S Nicholas. al frag (lower section

lost). 15c. Mitred, in drawers, bound on plank, gut protruding from hole in abdomen, being twisted by windlass; (behind plank) man twisting windlass; man in tippet and holding roll in RH; man in pointed hat holding roll in RH; king (Diocletian) holding sword over LS; man turning windlass; L & M Cat. 88; Turner (1847) il facing 243. Found wrapped in sedge beneath chancel floor, now NMS. The composition is very similar to an alabaster at the Society of Antiquaries of London (Duffy fig 65) as well as to the following examples.

NMS. al altarpiece. 15c. Panel 5: mitred, in drawers, bound on trestle table; (C) king with sword on LS, RH raised, flanked by 2 men operating windlass; (below) seated man prodding thigh with flesh hook (also in Society of Antiquaries al). Provenance uncertain. Cheetham (1983) notes the rarity of altarpieces based on martydom; detail fig 50, complete altarpiece figs 46 & 47. See also *Lawrence, Stephen, Thomas Becket*.

E Barsham. *al frag. 15c. Mitred, in drawers, lying on trestle table, upper portion of fig only; W Martin il facing 258.

N Creake. al frag. 15c. Mitred, in drawers, hands behind back, on trestle table; feet bound by rope being pulled by torturer below, bracing legs against a stone; hole in saint's abdomen, trace of windlass; Cheetham Cat. 29.

Individual

Wramplingham. *im. 1470. Bequest "to find a light before the image of St. Erasmus," Bl 2:489.

Hingham. *im, light before, Bl 2:423.

Norwich Austin Friars. *im, *Index Monasticus* 43.

Diocese. ms, hours, CB Fitzwilliam Museum 55, miniature, f 121. After 1471, c1480. Bp with book and windlass.

Norwich S Michael-at-Plea. pwd. 1420–40 (King [1996] 415). (Above) frag demi-angel with cloth of honor (panel cut down); in chasuble with infula on crozier, clasped book held on R palm and forearm; (below L) windlass; paired with archbp against similar cloth of honor; in new retable framed in 1958, Cathedral, S Saviour Ch; L & M Cat. 56; *900 Years* color il p 47. King suggests that the 2 larger panels for Erasmus and an archbishop saint may have formed part of a floor-level parclose screen,

as at Ranworth.

Hempstead S Andrew. pwd, screen panel, S3. 15². In full episcopal Mass vestments, RH pointing to windlass in LH; name destroyed; Constable il p 219.

Bradfield? *pwd, roof of E part of aisle "curiously painted with the history of the saint whose chapels were there," Bl 11:7. Guilds to Erasmus and to Giles.

Buckenham S Nicholas. sc, font bowl. Bp seated with windlass and crozier; Victorian restoration.

Tattersett. wp, S wall. Late medieval (DP in P & W 2). Recumbent with 3 figs behind; partly plastered.

Sandringham. pg. sII.A1. 16¹. Mitred, Mass vestments, crozier in LH; windlass in RH; "S[an]c[t]us Erasm*us*"; Keyser (1917) fig 9A.

Litcham. *im, 1507 will, "lyte afore the image of sent Erasme," Harrod (1847) 259.

Church Dedication: Alby; ch at Sloley (Spurdens).

Guilds at Bradfield (Bl 11:7), Burnham Ulph (Bl 7:32), Burnham Sutton (Bl 7:31), Fulmodeston (Bl 7:90), Kettleston (Bl 7:114), Lynn (*Index Monasticus* 73), Paston, Yarmouth (Bl 11:366; 1497 Morant [1872] 224).

Lights at S Creake (Norf Arch Bk 1, f 173), Fakenham (Bl 7:96), Marsham (Bl 6:287), Outwell (Bl 7:473), Stratton Strawless (Harrod [1847] 117), Swaffham (Williams [1941] 339), Wroxham (Bl 10:478).

Erkenwald

Bp of London (675–93) and confessor. 30 April; Translation 14 Nov (added early 15c to Bod Lib Jones MS 46, a MS with Norwich synodal feasts).

Norwich SPM. pg E win G6. Mid 15c. Bp.

Ethelbert (Æthelbert/Albert)

King of E Angles and martyr (†794). 20 May.

Salle. *pg, nIII, light a. c1440. Appendix V.3 & 5.

Norwich SPM. pg sIV.B8. Mid 15c.

Burnham Norton. *pwd, screen panel, dated inscription, 1458. Above the head of Ethelbert, "Rex Ethelberte, mereamus caelica p. Te," Bl 7:17. Keyser cited as still visible (lxxviii); today remains of donors, the lower portion of 2 bps in appareled albs, dalmatics and chasubles, and partial inscriptions.

Outwell. *pg, N aisle ch. 16¹, "with orb and sceptre," Bl 7:472. Appendix V.3.

Church dedications at Aldby, *Burnham Sutton, *Her-

ringby, Larling, *Mundham, *Norwich (destroyed by fire 1272), *Thetford, Thurton & E Wretham. Bond (1914) cited 16 for England. Cringleford a pilgrimage site; a 1507 will provided for a pilgrimage to S Albert of Cringleford, Hart (1864) 277–9; Cringleford "commonly called St. Albert's chapel" (Bl 5:39).
Chs at Norwich Ethelbert Gate (Bl 4:54, upper story), Cromer (1523 will), & Shipdham (NRO, Rye 134, letter pasted to font fly leaf).
Guilds at Aldby (Bl 6:422), Burnham Sutton (Bl 7:31), Herringby (*Index Monasticus* 72), Paston (Bl 11.59).
Light at S Creake 1491 (Robert Norton, Norf Arch Bk 1, f 173).

Ethelred
See Ailred.

Etheldreda (Æthelthryth/Audrey)
Queen and abbess (†679). 23 June; Translation 17 Oct. Founded double monastery at Ely c673. Generic abbesses tend to be identified as Etheldreda; certainly, she was the most famous in the region. Represented as a crowned abbess, she is indistinguishable from her sister Withburga with E Dereham connections. Where 2 abbesses appear in the same set, I have tentatively identified the one with a book (or the more elaborate one as at Kelling) as Etheldreda. She is so depicted in 12–13c seals from Ely (*BM Cat. of Seals*, 1523, 3109, 3111); in glass in Suf and at All Souls, Oxford (Rickert pl 195); in the painted panels at the Society of Antiquaries, London (Rickert pl 188); in Bod L Bodley Rolls 5; and in pilgrim badges (Spencer [1989] Cat. 206c). See also *Withburga* Oxborough.

Thetford Priory 1. 12/13c. Relics of her coffin "in which she was found eleven years after her death, whole, and as if she had been asleeep," Bl 2:118.

Thetford S Etheldreda. 14³. "j reliquia de Sancta Etheldreda que vocatur Camisia Sancte Etheldrede in una parva cista," Watkin 2:144. 1501 bequest "I will that another man go in pilgrimage for me to Thetford, and offer for me to St. Audry's smock," Martin (1779) 79–80. There were other relics: "'lintheamen quoddam,' called the wymple of St. Etheldrede through which they draw knotted strings or silken threads, which women think good for sore throats; they have also the wymple of St. Audrede, for sore breasts, the comb of the same for headaches, and the rod of Aaron for children troubled with worms, and a ring of St. Ethelred for lying-in women to put on their fingers," *L & P* (1536) 10:143. According to Becon "the Smock of S Audrice . . . was there kept as a great Jewell, and precious Relique. The Virtue of this Smock, was mighty and manifold, but specially in putting away the Toth-ach, and the Swellyng of the Throte," quoted in Bl 2:70. The tumor on S Etheldreda's neck was found miraculously healed when her incorrupt body was exhumed. See Nilssen for the knotted necklaces connected with healing.

Narrative
Terrington S Clement. *pg. 1426. "£10 to reparation of new window with life of S Etheldreda," C & C.

Individual
Crowned abbess with crozier, in wimple and veil.

Norwich SPM. al. 15c. Set of female saints. Upper register, crowned abbess, crozier in RH, large book in LH, ermine collar; flanked by 3 women in similar costume with chapelets in hair. Nelson (1917) and Bensly conjectured her sisters and niece, Withburga, Sexburga and Ermengild (Eormenilda); Bensly (1892) il facing 355 and L & M, Cat. 87. Appendix V.

London/Lynn/Salisbury. pilgrim badge. 14c–late 15c. Crowned abbess, book in RH, ?crozier lost; Mitchiner Cat. 245, Spencer (1990) figs 145–7. Spencer (1980) conjectures that the Lynn finds (Cat. 92–3) may represent the staff that bloomed rather than crozier.

Hingham. *im, light before, Bl 2:423.

Walpole S Peter. *pg, S chancel. 1423/25 (Bl 9:117); Appendix V.5.

Kelling. pg, tracery light set in sIV.2c. c1450 (King 9). Abbess, crowned, pastoral staff in RH; large book with elaborate stamped binding in LH; wimple, head draped with blue mantle, difficult to distinguish where ermine-lined mantle ends and gown begins. Appendix V.3.

Salle. pg, sVII.A2. c1470. Crowned, fluted wimple over chin, crozier in RH. Appendix V.5.

Field Dalling. pg, sVI.A1. 15³. Crowned abbess, crozier in hand; at A5 a displaced book bound as at Kelling. Appendix V.5.

N Tuddenham. pg, sIII.A4. 15c. Crowned, wimple with scalloped edges; crozier in LH; closed book with elaborate binding in RH; same binding design as at Kelling; Duffy fig 71.

Bale? pg frag. 15c. Abbess, hand on crozier (face new).

Fincham. *pg, S aisle, E win, "some abbess or

saint, probably St. Audrey, with her crozier staff, and crowned," Bl 7:356.

Outwell. *pg, N aisle ch, E win, "St. Audrey, with a crosier staff in her hand, and the arms of the see of Ely"; win also included "our Saviour," Bl 7:472.

Stody. *pg. Citation in Frere MSS, NRS 1:37. Appendix V.5.

Norwich S John de Sepulchre. pwd, screen panel. ?15³⁻⁴. Crowned abbess; crozier in RH; clasped book in draped LH; Winter, *Selection* 1:6.

Ranworth. pwd, N retable, N1. 15⁴. Seated, crown over veil, wimple; crozier in RH, open book with writing resting on L knee, held open with LH.

Barnham Broom. pwd, screen panel, S2. 15⁴. Crowned abbess, crozier.

Gateley. pwd, screen panel, N1. 15⁴. Abbess with black mantle over head, wimple; crozier in RH; open book with minim writing in LH; red shoes (Puella Ridibowne is similarly dressed). Name on pedestal, "SANCTA AUDREY"; restored. According to Carthew (2:774) there were traces of words on the book; he also cites a bequest of 6*s* 8*d* to "payntyne of the roodeloft" in 1484. See IV.2 *Visitation*.

Foulden. pwd, screen panel, S3. 15⁴. Crowned abbess, crozier in LH.

Norwich S James. sc, font stem. 15³. Beneath Peter and Paul; crowned abbess with book.

Sandringham. pg, porch S2. 16¹. Crowned abbess; crozier in RH; open book with writing held in LH against breast; "*Sancta* Ethedreda."

N Tuddenham. pwd, screen panel, S3. 1499–1504. Crowned, wimple and veil, crozier in crook of RA, open book held with both hands; Duffy fig 71.

Upton. pwd, screen panel, S2. c1500. Crown over black veil, wimple; crozier in LH, rings on hand; clasped book in RH; voluminous black mantle.

Horsham S Faith. pwd, screen panel, N1. c1528. Crowned, crozier in LH, RH relaxed; wimple across chin; black mantle over gold gown.

Beeston S Mary. pwd, screen panel, N4. 16¹. Black gown, upper and lower sections of crozier, clear trace of open book in LH.

Burlingham S Andrew. pwd, screen panel, S6. 16². Largely obliterated, crown, frag of black habit, crozier. Perhaps paired with Withburga at N3; compare the similar pairing N and S of 2 kings.

Wiggenhall S Germans. wdcarv, be in niche, N2. 16². Crowned abbess, crozier, book in LH. Linnell cites dedications at Norwich (redundant), *Thetford, & *Much Mundham; Bond (1914) 12 for England. Altar at Northwold (1397 bequest of "a silver cup to the altar of St. Etheldred," Bl 2:219); ch at Lynn S Nicholas (Owen 29). L'Estrange (1874) cites an inscr bell at Feltwell and Morley S Botolph, "ETHELDREDA BONA TIBI DANTUR PLURIMA DONA." Guilds at Lynn S Margaret (Bl 8:504) and Shipdham 1525 (Bl 10:248).

Eustace (Eustachius)

Martyr, patron of hunters (nd). 20 Sept. The miracle of the stag with the crucifix betw his horns is found in the lives of both Hubert and Eustace. Without further evidence, it is impossible to distinguish betw them. There is late 13c E Anglian evidence for interest in the life of Eustace (Morgan, *Survey* pt 2, Cat. 182), and Grössinger identified 2 damaged misericords at Ely on basis of illustration in the *Smithfield Decretals* as events in life of S Eustace. There is a lengthy life in the *South English Legendary*. See also *Hubert*.

Castle Acre Priory. pwd, c1320 (Borenius, 1937). 3 pine panels set against architectural background, now at Holkham Hall. 2 scenes: (L panel) frag of miracle while hunting: hind quarters of horse with frag of rider (hand raised, L leg and roweled spur); (R, 2 linked panels) return to wife and children: woman with raised hands; 2 youths in white gowns holding hands, (L) holding woman's gown, (R) looking back; Borenius (1937) pl 29. Borenius thought panels might have been wainscot. We know that the Prior's lodging had a late painted ceiling (Hope [1895a] pl 3). Cf the evidence from Norwich, where Kirkpatrick (38–9) recorded domestic fire damage to historical parts of scripture and legendary stories (?painted wainscot) said to have come from Blackfriars.

Cathedral. sc, N cloister boss K7. 1425–30. (L) squire with horse; Eustace, quiver of arrows under arm, looking at stag (upper L), hands extended in wonder; (below) huntsman with quiver and bow and 2 hounds on lead. *Ch at Gt Plumsted repaired 1460 (Bl 7:240).

Fabian

Pope (236–50) and martyr. 20 Jan.

E Anglia. ms, *The South English Legendary*, Bod L Tanner 17, marginal drawing, f 6. 15[1]. In papal crown, sleeved dalmatic with lined mantle over all (not a cope), with double cross-staff.

Woodbastwick. sc, S porch niche. Only the bottom half of a statue remains, a seated fig in ?vestments. A papal bust was provided by Sir George Gibert Scott during reconstruction.

Weybridge Priory. printed calendar, NMS 134.944. 1503. Nimbed bust without attribute.

Ch dedication at Woodbastwick; evidently the sole English dedication.

Guild to SS Fabian and Sebastian at Lynn (Bl 8:509–10).

Fagan

Archbp (156; date read by Martin).

Salle. *pg, nIV, light c. c1440. Martin provides a drawing with crozier and "ar*che*piscopus. britan," NRO, Rye 17, 3:174; Appendix V.5.

Faith (Foy)

Virgin martyr (?3c, †Agen). 6 Oct. Note the contrast betw representation on early seals and 15c media where she is typically shown with a saw.

Narrative

Horsham S Faith Priory. wp, refectory. c1250, retouched c1440. History of founding of priory. One-register series of scenes set within buildings, very faint: **1 & 2** concealed by alteration; **3** ship taking Robert and Sybil Fitzwalter to France; **4** their capture by mounted bandits; **5** imprisonment; **6** prayer for deliverance; **7** Faith opening cell door; **8** in prayer, before abbot and miraculous image of S Faith (at Conques); **9** return home by ship with 2 monks. Purcell cites a further scene of building the priory (472). Above this register a massive Crucifixion scene with (L) frontal view of queen with scepter, closed crown over white veil draped over shoulders and breast, at one time identified as Faith (but see below *Margaret of Scotland*); Binski (1986) pl LV; Purcell pls I & II; *Age of Chivalry* Cat. 263.

— seal. 1246/56 [1301]. Obverse, saint standing, crowned, holding scepter fleury in RH, flanked by kneeling figures, "one in chains, designed no doubt to represent Robert FitzWalter and Sibill his wife"; reverse, Coronation; Pedrick (1902) 90–1, pl 18, seal 35; *BM Cat. of Seals*, 3292, with variant counterseal 3294 for Prior (1281–93).

Individual

Horsham S Faith Priory. seal. nd. Faith "seated under an arch and crowned; near to the head of the image, a dove, and under the image, the prior on his knees," Bl 10:441.

Norwich S Laurence. *brass, *ex situ*. 1437. In niche above the fig of Prior Langeley (?Horsham S Faith); gridiron in LH, book in draped RH; Cotman (1839) vol 2, pl XCVII. Cotman shows her naked to the waist, but Charles Talbot, who made a drawing in 1793/4, clothes her; the future clergyman was then about 15.

Cley. pg, sIX.A6. 1450–60. Head missing, spine of clasped book in RH; saw with yellow handle held diagonally in LH; Appendix V.1.

Norwich SPM. pg, E win 5f. Mid 15c. Seated on throne, palm in LH, saw in RH; wearing chapelet of quatrefoils (Costume Glossary, FIG h); Wdf pl VIII. Appendix V.1.

S Creake? pg, nVI, not *in situ*. 15c. Label "ffides" at head of tracery; female head, no nimbus.

Horsham S Faith. pwd, pulpit pane 2 (counterclockwise). 1480. Crowned; clasped book in RH, 2-handled saw in LH.

Haveringland. *pwd, screen panel, N2. "S*anc*ta ffides ora," NRO, Rye 17, 2.205.

Marsham. pwd, screen panel, N2. 1503–9. Double-handled green saw held up in LH; RA relaxed, RH holding metal-tipped girdle; awkward restoration of head with flat buff cap. In Winter's watercolor the cap is pink and looks like a snood, NMS 1254.76.94; see DT 56:131 for Winter's comment on pre-1849 restoration. Restored 1939.

Outwell. pg, sIII.C4. 16[1]. Holding saw in RH.

Linnell cites 5 church dedications: Gaywood, Horsham, *Newton S Faith, *Norwich S Faith, Lt Witchingham; Bond (1914) 23 for England.

Guilds at Horsham S Faith (Bl 10:438), Horsford (Bl 10:437).

Ch at Thetford Priory 1 (?Infirmary, Dymond 1:28, 2:371).

Felicianus (Felician)

Bp and martyr (†c297). 9 June with S Primus.

Wiggenhall S Mary Magdalene. pg frag, nIII.B4. c1450. Book in LH; "*Sanctus felicianus.*" Appendix V.5.

Felicissimus

Martyr (†258). 6 Aug. Died in persecution of Valerian with Pope Sixtus and S Lawrence.

Salle. pg, nII.A4. c1440. Dressed as cardinal, holding clasped book. See *Lawrence* and Appendix V.5.

Felix of Dunwich

Bp of the E Angles (630/1–647) and confessor. 8 March.

Cathedral. sc, relief (originally painted and gilded). c1100. Tonsured bp in Mass vestments, LH holding staff, RH blessing; no mitre; originally above Bp's door, now in presbytery; *900 Years* il p 15; P & W 1 fig 8 (but cf Pevsner 1, pl 40b); Fernie pl 27. For identification see Fernie (1993) 83–7 and Franklin (1996) 117–20.

Babingley. *im. 1448. Bequest for pilgrimage to S Felix, Tanner 86.

Ranworth? pwd, N parclose. c1450 (Morgan). Bp in episcopal Mass vestments, paired with Thomas Becket on the S parclose panel. The identity of this bp is problematic, but given the close connection betw Felix and Canterbury, pairing with Thomas would be suitable; Morgan so identifies with a query (L & M Cat.73); Bond (1914) il p 104.

Church dedication and guild at *Babingley (Bl 8:351; Bond (1914) cited 6 for England.

Flitcham may be the site of Felix's church.

Frances of Rome

Widow (1384–1440). 9 Mar. Known for works of mercy, founded community of oblates in Rome; canonized 1608, but might have been known in England because of connections with the English community in Rome.

Sandringham? pg frag, sII.A4. 16[1]. Hand holding basket with loaves of bread being given into hand of woman below; label only, "*Sanc' ffrauncesc' "*; part of a conflated composition (see *Ursula*). So identified by Keyser (1917, fig 5); Wdf (1938b, 173) read as Francis of Assisi probably because of the masculine endings, but similar anomaly appears with S Birgitta.

Francis of Assisi

Confessor (1181–1226). 4 Oct. Founder of Friars Minor (Greyfriars).

Norwich Greyfriars. seal, nd. Francis in door of priory church, *Index Monasticus* 40. Church dedication (Bl 4:108).

Lynn Greyfriars. *im. 1473. For repair of the candelabra hanging "coram ymagine Sancti francisci," Galloway and Wasson 53. In 1512 the guild "ordeynd that John Judd shall finde contenuely the wax lyght before St Fraunces," Owen 324. Guild 1354–1537 (Richards 416); 1454–1536 (Farnhill).

Norwich SPM. pg frag, E win 6e. Mid 15c. Receiving the stigmata, kneeling, one ray striking side where habit rent.

Lt Walsingham? *pg, ?Sii. chancel. Angels with stigmata. According to Woodforde there were 2 pairs of angels "neither feathered nor clothed. Their hands are raised in adoration. The hands of two of them are pierced, blood dropping from the wounds . . . and from wounds in their sides" (144). Destroyed in church fire. Iconography of Francis sometimes includes angels with stigmata.

Hempstead S Andrew. pwd, screen panel, S6. 15[2]. Tonsured, in friar's habit; both hands raised showing stigmata; cross-staff positioned diagonally across saint's body. R section of bottom panel lost, inscr L "*sanctu.*"

Norwich S Peter Parmentergate. *pg, N win. 16[2]. Bl conjectured that Thomas Codd (†1558) represented with Francis belonged to the 3rd Order; Bl 4:98.

Repps. *pwd, screen panel. ?1553–8. In friar's habit with knotted cord, pointing to bleeding stigmata revealed in slit in robe; book in LH, DT 59:214. There is a second panel labeled ?"Francisce," but the script is suspect, and the costume is academic, DT 59: 210; see below *Gregory*.

Weybridge Priory. printed calendar, NMS 134.944. 1503. Bust, religious habit.

Greyfriars dedication at Lynn, Norwich, and Yarmouth (*Index Monasticus* 39–40).

Fursey (Furseus, Fursa)

Abbot (†650). 16 Jan. According to Bede he established a monastery within the castle grounds at Burgh Castle; shrine for head relic at Canterbury. Name recorded in pg at Blythburgh (Wdf 180).

Ch dedication at Aldeby (Bl 8:4).

Gacian (Gation)

Bp of Tours (4c) and confessor. Said to have been a companion of S Denys. 18 Dec.

Cathedral. *im. 1414. Images of Gacian and John of Bridlington, 4s 6d (stone), 26s 8d (making), 8s 10d (painting), Beeching 22.

Guild at Norwich Whitefriars (Kirkpatrick, 176), 1530 (Tanner 208).

George

Martyr, Patron of England (†c309). 23 April. Feast introduced by Synod of Oxford in 1222; after the battle of Agincourt the feast was doubled by Council of London (1415/16). One of the 10 saints cited by Lydgate as special helpers.

Thetford Priory 1. 12/13c. Relic of his body, Bl 2:8.

Cathedral. Guild relic. 1441–2. Silver/gilt angel "deportans brachium sancti Georgii" (gift of John Fastolf), Grace 30.

Narrative

Typically riding on white horse richly caparisoned; George in elaborate armor with bascinet up attacking dragon; princess in the background.

Cathedral. *im and ch. Norwich Guild founded 1385/89: 40s for light and making of im (Westlake no. 296); money left from poor collections "shal gone to ye makynge of ye Image of seint George," T Smith 18. The im was apparently stored after the feast, for there are payments "to the cathedral clerks for taking St. George down from the vault there and putting him up again, 12d," Harrod (1871) 272. c1420 inventory, "2 steyned clothes for the perk and the history (istour) of St George"; 1420–1 account roll, "a dragon, new made, 9s 4d. To John Diggard for pleyng in the dragon, 4d," Hudson & Tingey 2:398. Lancashire (no. 1223) dates the riding 1408–?1553. In 1433 the sign at the George Inn owned by the Guild was painted. The Guild elected "her George, and a man to bere his swerd and be his keruere tofore him"; also a man to carry the banner (Smith 446); in 1420 payments for "playing in the dragon with gunpowder." Guild feast revived 1451/2 (Grace 45). The 1469 inventory cites a scarlet gown for the George "with blow garteryz lyned with grenetartaryn," a cote armor and a "chapelet . . . with an Owche of Copre guylt with þe armes of Seynt George in the

þe myddes" (Grace 32). The princess appears in accounts for 1532, and she and George are provided with gowns from the same velvet in 1537 (Grace 140); in 1545/6 12d bought her shoes and gloves (Galloway 17). For details of the procession, costumes, and payment to those playing the roles of George and Dragon, see Grace 16–18. For a copy of an 18c drawing of Snap the Dragon, see DT 15:11 and also Davidson (1991) 27–28 fig 31. The fraternity's seal and banner also bore S George's im.

Norfolk ?Besthorpe. ms addition, Bod L Don. d.85, pen drawing ff 129v–130. 1420–30. George and dragon, watched by king, queen and princess with lamb on lead; Pächt & Alexander 803 pl LXXVI.

N Tuddenham. pg. c1413 (Marks, King c1415–25). W win, light c. (Above L) George on horseback, lance in RH, raising LH to greet the princess, her hair in a jeweled net, wearing red ermine-lined gown, lamb on lead held in her LH. (Below C) George in full armor raising sword in RH, his broken lance in LH; horse trampling amber-winged dragon with tail ending in grotesque head; (above R) princess with lamb on lead looking on; Wdf pl XVIII, and Marks fig 151.

Lynn. seal, Fraternity of S George the Martyr in the Church of S Margaret. 15c. "The Combat of S George and the Dragon. On the l.h. side, 2 kings, crowned, in a square tower, on the r.h. side a queen, crowned, on a rock, holding a small dog [sic] by a cord," BM Cat. of Seals, 4468. The 2 crowned figs (L) are undoubtedly the queen and king, and the princess has her lamb on a lead. The guild was founded in 1376 "to fynden a Preste to syngen atte autere of Seint George," T Smith 74.

Cathedral. sc, N cloister boss, B7. 1427–8. (L) princess kneeling; (R) George standing on dragon, sword raised above head, thrusting shield into mouth of dragon horse behind.

Witton (near Walsham). *wp N wall. 15[1] (Minns). George on caparisoned horse, long sword raised above head facing dragon; small dragon in cave below; princess with lamb on hill, castle behind, king on parapet. Neither the description nor the engraving in Minns (pl betw 42 & 43) entirely agrees with the watercolors preserved at NNAS.

Norwich S Gregory. wp, W wall of N aisle. Late 15c (DP). (Foreground) George in elaborate armor with red cross on jupon, 3 feathers atop helm, finely detailed saddle decorated with arms, sword in RH raised behind his head; horse, richly caparisoned, trampling on recumbent dragon, broken lance in mouth, with point protruding from throat; 2 other broken lance shafts on ground under horse; dragon's tail wound around horse's L hind leg, 2 small dragons in cave above dragon's head; (upper register) an elaborate walled town, (L) soldier emerging from gate, (C) king and queen at battlements; outside walled town on hill with trees and flock of tiny sheep, princess kneeling, hands joined; large lamb; Kent (1934) color pl facing 167; P & W 1 fig 50. Kent noted that the painting was in poor condition because of improper restoration. The wall painting was under conservation in 1998, with some of the details beautifully revealed. For an assessment of this work as the "finest late medieval wall paintings" in Norfolk "and among the best in England," see DP in P & W 1.

Norwich S John Maddermarket. *wp. In 1934 a painting similar to that at S Gregory's reported "entirely destroyed and not a trace is left" (Kent [1934] 169).

Shouldham Thorpe. *wp. ?Late 15c. (Upper L) castle with crowned fig; George in armor on white horse, sword raised in RH; yellow dragon with long tail and prominent wings; horse caparisoned in pink, DT 44:37.

Fritton. wp, N wall, *circa* 9' wide. 16¹, after 1502 (C & C). (Upper L) fortified castle with king and queen on battlements; (upper R) princess, arms outstretched, and lamb; (C) George on white horse trampling dragon, sword swung high in RH, reins in LH; broken pikes on ground; broken spear head pierces dragon's neck from which blood spurts; elegant horse trappings; jupon over plate armor with pink cross. "Naively overrestored," DP in P & W 2.

Wellingham. pwd, screen panel, N2. c1532. (Background) elaborate landscape with hills, trees, birds, human figs and towers, atmospheric sky; scene flanked by (upper L) king, queen, and 2 courtiers on castle battlements, (upper R) princess kneeling with hands joined, lamb; George in ela-

borate armor, 3 feathers on helm, finely detailed saddle, sword in RH raised behind his head; horse caparisoned in red (faded pink), trampling recumbent dragon, its throat pierced with a broken lance; tiny dragon lower R.

Norwich S George Colegate. sc, L spandrel S porch. 16¹. George partially armed, being ?armed by angels; (L) angel with hands on solleret; (R) angel with hand on gauntlet, angel with hand on massive helm before him; Spencer and Kent fig 16.

Martyrdom

Cathedral. *pcl. 1441–2. "ij pannis depictis pro le perke in ecclesia cathedrali predicta de martirio sancti Georgii," Grace 31.

Individual

George and dragon, as above, but without narrative elements; the horse is rare.

Swannington. sc, relief, tiny square piscina head. Norman. (N face) George, couched spear with banner, attacking dragon (R); (W face) ?George with Norman shield attacking dragon (L, hence 2 dragons "back-to-back").

Norwich Castle. sc, relief, ?part of altar piece, Ch Royal. ?13c. Sword empaled in dragon's mouth; Woodward pl 13.

Elsing. brass. c1347. In apex of arch directly above angels with soul of Sir Hugh Hastings, George on horse thrusting lance into mouth of dragon; shield with arms in LH.

Norwich S George Tombland. *emb lectern cloth. 14³. "Tapicerwerk" with an image, Watkin 1:10.

S Acre. *pg, N clerestory. ?14³⁻⁴. "S[an]c[t]i Georgius," Bl 6:81 (church dedication).

Cley. sc, stop, spandrel, S nave arcade. 14¹ (before 1320, Lindley [1985]). Contrapposto view of warrior in chain mail with split surcoat, sword in scabbard, head twisting over LS, wrestling creature with curled snake tail, trace of wings and grimacing human face, Lindley pl 20.

Lt Witchingham. wp, N wall. c1360. A "large though damaged St. George and the Dragon," DP in P & W 1; dragon tail well preserved.

Banningham. wp in spandrel of N nave arcade. Late 14c. George's head destroyed by clerestory win; fighting on foot, RA thrusting weapon into huge dragon mouth.

Gooderstone. *im, statue, S aisle ch, altar of S George's guild; "large pedestal for its

patron saint," Bl 6:63.

Norwich S George Colegate. *im and tabernacle, Bl 4:470.

Yarmouth. N chancel aisle, *im. "A new east window made in St. George's isle"; "north window at the altar before St. George's image"; also a guild; Morant (1972) 222, 229. The church also owned a relic in 1502, C Palmer 116.

— Charnel House. *im. Guild of St George the Martyr, candles before im, Westlake no. 370.

E Anglia. ms, *The South English Legendary*, Bod L Tanner 17, marginal drawing, f 91v. 15¹. In armor, holding sword in hands; no dragon.

Besthorpe. pg, sVI, frame 3. 15¹ (Dennis King, unpublished notes). Bascinet with visor up, unnimbed; standing on dragon, thrusting spear into mouth; misericord in belt; surcoat argent, a cross *or* rather than traditional red, perhaps to match that of S Michael, with which this work was originally paired.

— pg, sVI, middle frame. 1450–70 (Dennis King). Full plate armor, but instead of bascinet a chapelet in hair; short curly beard; standing on dragon; sword sheathed in LH; thin spear in RH.

N Tuddenham. pg, sVI.A1. 15³ (King). In profile facing R; head in upper foil; helmet with viser up, small buckler and sword on R hip; thrusting spear into dragon's mouth; dragon distributed in 3 foils of quatrefoil, head (R); second head at end of tail (L); George with one foot on body in lower foil; L & M Cat. 77, il (color) p 60.

Ketteringham. pg, E win A1. 15c. LH on hilt of sword in scabbard; RH holds narrow shaft of spear, point up, standing on snarling dragon; misericord, low heavy belt; paired with Michael at A8.

Castle Acre. pg, not *in situ*, reset in sIV.2b. 15c. In embossed armor, standing on platform; RH with spear; shield emblazoned with cross hanging on baldrick against LA; LH resting on belt against hilt of sword; head new; restored.

Shimpling. *pg, S chancel, "his effigies, with his shield, viz. arg. a plain cross gul," Bl 1:156; George also cited on the font; the font does not fit this description.

Outwell. *pg, N aisle ch, E win. Slaying dragon, Bl 7:472.

Stody. *pg. "Probably," King 6.

Hempstead S Andrew. pwd, screen panel, S1. 15². LH holding spear upright, red cross banner attached; dragon below. Name destroyed. The drawing by Kate André (J Lewis André, 1900, facing 218) shows him in atypical clothing, bareheaded and youthful, no dragon; Constable il p 219.

Ranworth. pwd, N parclose. 15³. Standing on blue dragon, L sollerette on tail, R on body; sword raised above head in RH, roughly horizontal; shield in LH; exceptionally elaborate armor and surcote with red cross, multiple wide streamers extending from shoulders, low belt, and burlet on tournament helm; Constable il p 142; Duffy fig 108. Paired with Michael on S parclose. For dating problems, see Appendix VI.

Norwich S John de Sepulchre. pwd, screen panel (monochrome). ?15³⁻⁴. Detailed armor and mantle; hat with one jaunty feather; standing on dragon, spear impaling dragon's mouth; Winter, *Selection* 1:5.

Filby. pwd, screen panel, N2. c1471. Elaborate armor with feathered streamers (?exaggerated dagging) projecting from shoulders; red cross on armor and shield; low belt & burlet on tournament helm; LH holding shield, spear in RH impaling dragon's mouth; André (1900) pl facing 218. Paired with Michael at S3. Cf Ranworth.

Smallburgh. pwd, screen panel, N4. 15⁴. Defaced, feather in center of green headdress with red burlet and white streamers, red cross on jupon, in armor, sword in scabbard, LH resting on hilt; spear in RH piercing dragon's mouth, R foot on dragon.

Elsing. pwd, screen panel, S2. Late 15c. Elaborate armor; wide liripipes, red cross on surcoat and sleeve of LA; LH on hilt of sword, RH holding long staff of banner with red cross.

Thetford. common seal of Monastery of the Benedictine nuns of S George. nd. In armor with shield and misericord, thrusting spear into dragon's mouth, Bl 2:95.

Norwich S Michael Coslany. sc, statue. c1400. Standing on dragon, trace of red coloring on armor cross; ?paired with Michael; "probably" from chantry chapel, L & M Cat. 64. Now NMS.

Norwich All Saints. sc, font, bowl. c1448. Spear impales dragon on which George stands;

paired with Michael on the same panel. Now in S Julian; Gardner fig 524.

Hingham. sc, Morley Monument, R respond. 15^{2-3}. In armor with dragon.

Winterton? sc, spandrels S porch. 15^3. (L) fig largely worn away but sword lifted above head; fig (R) undecipherable.

Saham Toney. sc, spandrels W door. 15^4 (completion of church tower, M & R 3); "large guild held in his honour here, and a chapel, with his sepulchre in it," Bl 2:319.

Colby. sc, relief, spandrel S porch. 15c. Paired with Michael.

Hemblington. sc, font relief, SE face. 15c. Seated on wide bench; feet on recumbent dragon, head missing; polychrome restored by Tristram.

Norwich S George Tombland. sc, S porch boss. 15c. Standing on dragon; other bosses difficult to read; bearded man holding book; bearded man ?fighting animal; Green Man, angels in corner bosses.

Shotesham All Saints. wp. "At E end of S wall, dimly visible remains of a large late medieval figure of St. George, with raised sword as at Fritton," DP in P & W 2.

S Burlingham S Peter. wp frag, S wall. Overlapped by frag Christopher, James *S & N* 142.

Crostwight. *wp frag. Standing on dragon; DT 54:120.

Denver. *wp, NMS 76.94.

Drayton. *wp frag, N wall. Standing on dragon, DT 54:217.

Thurlton. *wp, S wall. "lower part . . . whitewashed over; but the vicar promises to bring it to light again," Keyser (1907a) 100.

Cathedral. wdcarv, misericord, S8. 15^1. George without helm, on horseback, RH raised; remains of dragon below; Rose (1994); G R Remnant 105.

Mattishall. wdcarv, screen spandrel, S3. Mid 15c (C & C). George with cross on shield and scimitar.

N Elmham. wdcarv, screen spandrels over N10. 15^3. (L) shadow of standing male, only raised sword remains in carving; (R) dragon rampant.

Salle. wdcarv, spandrels of screen door. 15^3. Above Ambrose.

Cawston. wdcarv, spandrels of screen door. c1490. (L) George, (R) dragon; also represented in gesso detail; Strange pl XLIV.

Lynn S James, Guild of SS Giles & Julian. wdcarv. Late 15c. Maser with print of S George, Richards 433.

Tivetshall. wdcarv, be, badly worn. 15ex. Dragon confined to one corner.

Gressenhall. wdcarv, screen spandrel, defaced. 15c.

Tuttington. wdcarv, be. 15c.

V & A. wdcarv, stall end. 15c. George on caparisoned horse with sword raised in RH; front hooves of horse directly above open mouth of dragon, tail wrapped about hind leg of horse. Walter Rye conjectured connection with the Norwich guild, and Tracy notes stylistic similarities with the wp at S Gregory, Tracy (1988) Cat. 186, pl 67.

Norwich. pilgrim badge (excavated S Laurence's Lane), foreign. Late 15c/early 16c (Margeson). Paired with a Marian badge; see VIII.5 *Other*.

Marsham. gesso detail, screen panel, N2–3. c1507. Standing on dragon. See Cawston, above.

Lt Walsingham. *im, guild altar in N transept. 1541–5, guild payments for mending and carrying the dragon, Galloway & Wasson 76–7.

Norwich Guildhall. *pg E win, light a. ?16^1. "St. George, with Domine Salvum fac Regem," perhaps arms, Bl 4:329.

Horsham S Faith. pwd, screen panel, N4. c1528. In armor, LH holding sword by hilt, point up.

Bedingham. *wp. 1520. Bequest, "when the church . . . is fully finished . . . myn executores . . . take a warkeman and do draw with colour the image of S George there" (C & C).

W Walton. *wp? 1527. Bequest for a fig "overthwart the high alye," Williams (1941), 338.

Fritton. wdcarv, screen panel spandrels N3 & N4 above Augustine/Jerome. 16^1. (L) dragon; (R) George behind gold leaf-shaped shield, red spear shaft.

Beeston S Mary. wdcarv, screen spandrel, N5–6. 16^1 (C & C). Dragon, second head at end of tail; paired with Michael.

Wymondham. *wdcarv. 1519. "George wt ye horse to ye same ymage of xv hande hye and a dragon wt a beme vowted to sett ye syed ymage horse and dragon upon" to stand in the parochial nave of the abbey church;

Harvey (1975), 158; contract transcribed in Harrod (1871) 271. The guild of the Virgin also provided "spenture and canvas for the giant," with cloths, Harrod 272.

Weybridge Priory. printed calendar, NMS 134.944. 1503. Spear with pennon.

Linnell cites 13 church dedications; Bond (1914) 126 for England.

Germanus (German)

Bp of Auxerre and confessor (†448). 31 July. Emissary to Britain during the Pelagian heresy.

Wiggenhall S Mary Magdalene. pg, nVII.A5. c1450. Bp, seated, cappa clausa and tippet with voluminous white cowl; "Sanctus German[us]." Appendix V.5.

Eccles. *pg, N chancel. "Sanctus Germanus," Bl 1:410. There were originally 3 bells (see *Antony* and *Benedict*); perhaps the third was dedicated to Germanus. Appendix V.5.

Garboldisham. pwd, screen panel, N1. c1500. In episcopal Mass vestments; RH blessing; LH holding crozier; label at either side of head, (L) "Sanctus Germ[anus]," (R) "episc[opus]."

Wiggenhall S Germans? wdcarv, be, nave S1 (L elbow). 15c. Bp. Wilson (P & W 2) cites the series in N aisle depicting his life, but these are surely Victorian. In 1909 the aisles were reseated (Kelly's *Directory*, 1912).

Church dedication at Wiggenhall; ?sole English dedication.

Gervase

See Protase and Gervase.

Gildard

Bp of Rouen and confessor (mid 6c). 8 June. Feast shared with Médard.

Wiggenhall S Mary Magdalene. pg, nV.A2. c1450. Bp. Appendix V.5.

Giles (Egidius)

Abbot (†c710). 1 Sept. Typically in abbatial habit. One of the 10 saints cited by Lydgate as special helpers. Wounded by a king-huntsman while protecting a hind that provided him sustenance; patron of lepers (a leprosarium at Norwich so dedicated), cripples, and nursing mothers. Buried at Pontigny.

Norwich, Hospital of S Giles. seal, Master & Brethren. Late 13c. "Giles, with nimbus,

seated on a chair or throne to the l., with a fawn wounded by an arrow leaping up to him. In the field on the left a tree," *BM Cat. of Seals*, 3779; Pedrick (1902) pl 29; *VCH* pl 3, facing 436; Rawcliffe (fig 17) rightly notes that it is Giles who is wounded rather than the fawn, though see the same confusion at Smallburgh and Sandringham.

— ms, processional, feast of S Giles, BL Add. 57,534, f 123v. Late 14c. Rising out of the O of *Omnis*, an archer drawing bow; Rawcliffe fig 11.

Norwich S Swithin. processional banner. 14³. "ij vexilla processionalia cum ymaginibus Sanctorum Johannis et Egidii," Watkin 1: 17.

Norwich S Giles. *im, Bl 4:239.

Wiggenhall S Mary Magdalene. pg, nVI.A5. c1450. Seated, chasuble, in RH crozier with infula; "Sanctus egid*ius*." Appendix V.5.

Salle. pg, sVII.A1. c1470. Crozier over RS; arrow in L leg; hind resting forelegs against crozier. See Appendix V.5.

Field Dalling. pg, sVI.A7. 15³. Standing with crozier in RH; open book with writing in LH; hind resting forelegs against Giles. Appendix V.5.

Hempstead S Andrew. pwd, screen panel, N8. 15². Benedictine abbot, tonsured, crozier in LH, clasped book in RH; hind at feet; name below. Paired with John of Bridlington.

Gt Plumstead. *pwd, screen pane. 15³. Crozier in LH; in palm of RH open book with rubrication; arrow protruding from habit over R thigh; hind resting forefeet against L knee. In voluminous habit, hood pulled up to tonsured head; "Sanctus Egidius," DT 41: 134. Winter, *Selection* 2:5 reproduced in Bond (1914) 68.

N Elmham. pwd, screen panel, "upper end of N aisle" ("egidu*s*," NRO, Rye 17 2:65v). 15³. The names are now lost. Perhaps the monk now at N1, lower half largely obliterated, originally featured the hind. Carthew cited "a couchant hind at his feet" (2:538).

Smallburgh. pwd, screen panel, S1. 15⁴. In black habit with hood over head, crozier in RH, closed book in LH over mantle; (below R) hind, arrow piercing neck, forelegs resting against Giles.

Bradfield. *pwd. Roof at E of the aisles "curiously painted with the history of the Saints, whose chapels were there," Bl 11:7. Church

dedication and a guild of S Giles (*Index Monasticus*).

Cathedral. sc, N cloister bosses. 1427–8. **H1** (L) king on horseback, man with hawk on wrist and huntsmen; (R) Giles, forelegs of deer at breast; **H2** king kneeling before monk.

— sc, font stem. 15³. Staff in LH, hind leaping.

Norwich, Hospital of S Giles. sc, entrance to chapter house. 15³. At apex of arch, "probably in abbatial robes," Rawcliffe fig 23.

Colby. sc, font bowl. 15c. Seated hind facing Giles kneeling in ¾ profile, purse hanging from belt; axe over shoulder; scroll above hind. Colby had the finger of S Giles in a hand-shaped reliquary (Watkin 2:xcvii).

Sandringham. pg, sII.A5. 16¹. Long staff (crozier) in LH; white hind resting foreleg against staff; arrow piercing its neck; "S[an]c[t]*us* Egedius"; Keyser (1917) fig 11A.

Weybridge Priory. printed calendar, NMS 134.944. 1503. In religious habit, arrow.

Linnell cites 6 church dedications; Bond (1914) 162 for England.

Guilds at Bradfield (Bl 11:7), Colby (Bl 6:423), Houghton S Giles (*Index Monasticus* 73), Lynn (Owen 325), Topcroft (Bl 10:189; Watton (Bl 2:361, former church dedication).

Altars at Cathedral (13⁴, Bl 4:2), Salthouse (Watkin 1:81). L'Estrange (1874, 124) cites an inscr bell at Dickleburgh, "SONITUS EGIDII ASCENDIT AD CULMINA CELI."

Free Ch at Tharston (before 1280, *Index Monasticus* 69) and Topcroft (or S Ethelbert, *Index Monasticus* 69), Ward 300.

Gregory I (the Great)

Pope (590–604) and doctor. 3 Sept. See X.3 *Latin Doctors.*

?Cathedral Priory. ms, Gregory the Great, *Moralia in Job*, CB Emmanuel College 112, hi. c1310–20. (Dedication) Gregory as pope and Leander, both in Mass vestments; (Book 4) Gregory speaking, black monk with open book; James (1904).

E Anglia. ms, *The South English Legendary*, Bod L Tanner 17, marginal drawing, f 29. 15¹. Papal crown, purple cappa clausa, blessing.

Salle. *pg, nIII, light b. c1440. Appendix V.4 & 5.

Norwich S Gregory. sc, boss S porch. c1400. Gregory flanked by 2 figs holding large open book; 2 small figs in front of Gregory; traditionally described as Gregory teaching

music to boys.

Repps. *pwd, screen panel. ?1553–8. Pope, but holding staff with knob instead of cross-staff; name below, DT 59:207. Perhaps the academic labeled Francis was originally one of the Latin Doctors; red pileus, gray gown with voluminous gray over-garment; tippet with attached hood; book in RH; DT 59:210.

Linnell cites 3 church dedications: "Bernham S Gregory 1443, 1444," Heckingham, Norwich; Bond (1914) 132 for England.

Guthlac

Hermit (c673–714). 11 April. Shrine at Crowland Abbey, Lincs.

NMS. pilgrim badge. c1500. Handle from scourge; Spencer (1980) Cat. 117.

Weybridge Priory. printed calendar, NMS 134.944. 1503. Cross on stepped base, ?pot with scourges.

1396 Marham chantry in hermitage of S Guthlac (*Index Monasticus* 69); parochial ch at *Guthlac's Stow (Swaffham); Guild at Swaffham, 1364–1529 (Farnhill).

Hedda of Peterborough

Abbot and martyr (†870). 10 April.

?Cressingham. 16c. Bequest for pilgrimage to S Hede, Tanner 85.

Helen

"Queen" (c250–330). 18 Aug. Mother of Constantine and finder of the True Cross; according to Geoffrey of Monmouth, she was British. She holds a Latin cross unless stated otherwise; for the patriarchal cross, see VI.3 *Cross of Bromholm.* The Ranworth Antiphonal ends with 6 pages of musical settings for the feast of S Helen.

Ranworth. *?pcl. 14³. Banner "cum ymagine Sancte Helene," Watkin 1:36.

Norwich SPM. al tablet. 15c. Crowned, in both hands holding Latin cross with crown of thorns hanging diagonally across bar; Bensly (1892) pl facing 355; L & M Cat. 87. Although the tablet seems to comprise a set of queens, 3 are more properly martyrs (Catharine, Margaret, Ursula), and if the alabaster was part of a *Te Deum* altarpiece this would have been the primary designation. Appendix VIII.

Kelling? pg, tracery light set in sIV.2b. c1450. Crowned; no LH visible; RH pointing L; long hair, white-lined ruby mantle, folded back on shoulder to create collar. King (9)

tentatively identified Helen, suggesting a queen set. Wdf cited a Coronation at Kelling, presumably misled by the queen; her posture, as well as pointing gesture with index finger, however, disqualifies such an identification. Appendix V.3.

Wiggenhall S Mary Magdalene. pg frag, nII.A4c. 1450. Holding cross.

S Creake. pg, nVIII.3c. Mid 15c. Crown over veil; draped RH holding against breast open book with writing; tau cross held diagonally across RS; mantle secured by morse. Probably a statue as well since Robert Norton left money for a light in 1491 (Norf Arch Bk 1, f 173).

Stody. pg frag, sIV.A4. 1440–50 (King). Massive stave in RH; pointed cuff on back of LH. Appendix V.3.

Salle. pg, sVII.A4. c1470. Crown over veil, fluted wimple; massive cross in LH; book in RH. Appendix V.3 & 5.

V & A. pg. 15c. Book in LH, Patriarchal cross in RH. C.348.1937.

No provenance. *pg. 15c. Crowned, holding large cross with LH, book in RH. King Collection, Box 3, NNAS. On the same sheet King has sketched a nimbed queen with query ?S Agnes. She holds a sword in the RH (no LH), probably Catherine. The 2 saints may have been part of a queen set.

Stratton Strawless. *pg, N tracery. 15[4]. Nelson (1913) 154.

Hempstead S Andrew. pwd, screen panel, N2. 15[2]. Only one-third of painting remains; patriarchal cross (with wood grain) in LH; ermine collar; paired with Juliana. There would have been 2 other female saints in the next panel; only a trace of one remains. The badly mutilated dado of the screen originally had 16 scenes, perhaps with returns as well; see *Edward & Edmund*.

Norwich, Hospital of S Giles. pwd/cl. c1462. Bequest of 13*s* 4*d* to paint screen or frontal for altar of S Helen, Rawcliffe 129. A hospital processional includes plainchant for the feast of S Helen.

Norwich S James. pwd, screen panel. c1479. Patriarchal cross held in RH, LH against breast; (below) "S*ancta* elyne"; now at S Mary Magdalene.

Tatterford. pwd, screen panel, now in V & A. 1470–1500. Crowned; holding small book in LH, tau cross in RH; collar over scarlet

mantle, standing on hexagonal pedestal; paired with uncrowned nun in black mantle holding closed book; L & M Cat. 91; Tracy (1988) Cat. 103, color pl 8.

Wolferton. pwd, screen panel, N1 (very poor condition). After 1486 fire. RH raised, LH holding cross-staff; head looks masculine, but all the other saints on N side seem to be feminine. This 12-fig screen is so badly preserved that only 3 female saints can be identified. 3 figs on the S side are male.

Cawston. pwd, screen panel, N2. c1490. Crowned, very long hair; LH holding patriarchal cross diagonally against shoulder; trace of shift beneath neckline of gold damask gown; Strange color pl facing p 84.

Litcham? pwd, screen panel, N7. c1500. Queen holding long wood stave vertically (?cross bar); ermine collar over mantle, ermine-trimmed gown.

Norwich S James. sc, font stem. 15[3]. With cross and book. At S Mary Magadalene.

Eaton. *wp, splays of N win, crowned, with cross-staff and clasped book in LH, in label above "S lena"; Boileau (1864a) il 163.

Wiggenhall S Mary. wdcarv, be nave S7 and S aisle S7 (frag). 15c. With Latin cross.

Upton. pwd, screen panel, S1. c1500. Crown over veil; large cross in RH, clasped book in LH; ermine collar and ermine-lined mantle.

Binham. pwd, screen panel, S12. c1500. Crowned, holding a ?cross in RH; largely disfigured.

Horsham S Faith. pwd, screen panel, N5. c1528. Crowned, holding large wooden cross over RS supported by RH; spine of clasped book in draped LH; mantle secured by morse.

Denton. pwd, mounted on chest, 4 (reading L to R); defaced. 16[1]. RH holding ?patriarchal cross; LH holding mantle; mantle over gown with heart-shaped neckline. Identification difficult because of damage and restoration. There may have been trace of crown and long hair.

Babingley. *pwd, screen panel. ?1553–8. Cross diadem, ermine collar; large cross held by cross bar in both hands, DT 53:69.

Repps. *pwd, screen panel. ?1553–58. Atypical. Crowned, in ermine sideless surcoat; holding portable cross with radiance at topmost finial, DT 59:208. Some of the dubious features reported on this screen may be traceable to the watercolorist.

Linnell cites 6 church dedications for Norfolk:*E Beckham, Gateley, Norwich, Ranworth, Santon; Bond (1914) 135 for England. Norwich church demolished 13c after being appropriated to S Giles, with parish thereafter worshipping at the hospital (Rawliffe 46).

Guilds at E Beckham (Bl 8:87), Gateley (Bl 9:506), Lynn (Owen 325), W Lynn 1359–89 (Farnhill), Swaffham (1473–1522 Farnhill). It is uncertain to what degree Helen was reverenced by guilds dedicated to the Invention of the Cross: Lynn (Farnhill), Upwell (Farnhill), Wormegay (Farnhill). She is mentioned at Lynn in connection with a guild dedicated to the Invention "In ye honour . . . of ye holy crouch yat seinte Eleyne founde" (T Smith 83).

Chs at Belaugh (Bl 6:312), Reedham (M & R 1), Terrington ?S John (Bl 9:121)

Lights at Gateley (Carthew 3:198) & Outwell (Bl 7:473).

Henry VI

King (1422–61, 1470–7). Buried at Chertsey, translated to Windsor 1484, where a major shrine was created; canonization process began 10 years later. Dateable miracles 1480–95. There was a pilgrimage site at S Leonard's outside Norwich. Although it is impossible to determine the purchase site of the badges found in Norfolk, the possibility that they came from the local shrine should be entertained. A collection of prayers and hymns to Henry was added in the late 15c to a Book of Hours (Bod L Jones MS 46) from the first half of the century with Norwich synodal feasts; see L & M Cat. 49.

Narrative

Lynn/Norwich. pilgrim badges. Late 15c. King on horseback, orb in RH, sword of state in L; "perhaps commemorating Henry's return from exile in 1470," Spencer (1980) Cat. 88. Keep with king inside (?imprisonment), Spencer (1980) Cat. 91. For other badges from Windsor, see Mitchiner.

Individual

NMS. pilgrim badge. c1500. "A figure, regally robed and with an orb and sceptre, stands on the lion of England," Spencer (1980) Cat. 87.

Lynn. pilgrim badges. Late 15c. Purses, Spencer (1980) Cat. 89–90.

Provenance uncertain. pilgrim badge, crown badge, CB, King's College Collection.

Norwich S Leonard's Priory. *im, "pilgrims from far and near . . . reported extraordinary cures" at image, Bensly (1895) 193.

Yarmouth. *im. 1484–5. "For painting and gilding the images of St. Wandragesilius, and of King Henry VI., 5s. 2d." Offerings in their chests amounted to £15 12s 9¼d

(Morant [1872] 239, 235). There are also references in 1506 for payment to "thermyte of K. Herry's chapel," as well as a payment in following year to Fr William for "kepyng K. Herry's chapel xiiijs iiijd," Morant, 222 fn 7.

Fakenham. *im, 1492, a light before "good king Henry," Bl 7:96.

Wells. *im. 1495. Bequest for light before "bto henr sexto," Harrod (1847) 119.

Diocese. ms, hours, CB Fitzwilliam Museum 55, miniature, f 141v. After 1471, c1480. Standing with scepter and orb; "flight of black birds behind," Scott, *Survey* Cat. 135.

Gateley. pwd, screen panel, S2. 15⁴. Closed crown; scepter in RH, orb in L; ermine collar on fur-lined mantle, gown with border at hem; name on pedestal below, "REX: HENRECUS VI"; see also DT 55:116.

Barton Turf. pwd, screen panel 1, S aisle. 15⁴. Beardless, closed crown; scepter in LH; orb on palm of RH; ermine collar over ermine lined mantle; wide ermine hem on gown; rubricated scrolls: (L) "Rex Henricus," (R) "Sextus"; Gunn & Winter fig A; Duffy fig 76; Camm color pl LVI.

Ludham. pwd, screen panel, N4. c1493. Nimbed, with closed crown, ermine collar over ermine-lined mantle, gown with wide ermine hem; scepter in RH, orb in L; inscr below "Rex Henricus Sextus"; paired with Walstan S4; Constable il p 214.

Binham. pwd, screen panel, S5. c1500. Crowned, no evidence of halo; ermine collar trimmed in gold; orb in RH, scepter in LH; engorged antelope at feet.

Weasenham All Saints. *pwd. "At the south-east of nave . . . the stone stair case . . .; over the door I saw some years past an old painted board with a portraiture of King Henry VI. painted thereon, in his robes, with the arms of France and England quarterly, and Rex Henricvs Sextvs, with an antelope at his feet," Bl 10:80. I take the description to refer to Weasenham All Saints, though Keyser thought S Peter.

Witton (near Walsham). *wp, N wall. 15⁴. Crown supported by flanking angels; bearing orb and scepter; white antelope gorged, chained and armed at his feet; Minns pl betw 42 & 43.

Ch at Yarmouth (Bl 11:366).

Guild to S Michael and King Henry at Lynn (*Index*

Monasticus 73).
Lights at Horstead (Bl 10:445); S Creake (1505 to "Good King Henry"); 1510, NFK Sparhawk 15 (Cotton personal communication); ?Wells (Harrod [1847] 119), reference perhaps to S Leonard's Priory.

Hilary

Bp of Poitiers and confessor (c315–68). 14 Jan. Known for theological works.
E Anglia. ms, *The South English Legendary*, Bod L Tanner 17, marginal drawing, f 2. 15[1]. In episcopal Mass vestments, mitre & crozier.

Hilary

Pope (461–68).
Wiggenhall S Mary Magdalene. pg, nVII.B.4. c1450. Papal tiara and double cross-staff, chasuble; holding open book with minim writing; "S*anctu*s Hyllari*us*"; Keyser (1907b) pl XI. Appendix V.4.

Hippolytus

Martyr (†235). 13 Aug.
Cathedral. *altar/im. c1330. Name appears with sums totaled of offerings to SS Anne and William; "seems to have been one of the older shrines in the cathedral" (Shinners 143 fn 38); further offerings in 1386 (138). Feast in Benedictine calendars.
Wiggenhall S Mary Magdalene. pg, nVI.B4. c1450. Bp, seated, chasuble, RH blessing; S*anctu*s ipottil*us*. Appendix V.5.

Hubert

Bp (Maastricht and Liège) and confessor (†727). 30 May. Relics translated to abbey at Andage, thereafter known as Saint-Hubert-en-Ardennes. The 15c cult was very popular in the Low Countries (Bruna 150–2). The account of conversion while hunting on Good Friday was borrowed from the life of S Eustace (see above). The following entries are classified here by date since the cult of S Hubert grew in popularity towards the end of the century. For pilgrim badges, see Spencer (1980, 1990) and Mitchiner 1036–8.
Litcham. pwd, screen panel, S6. c1500. Youth in short coat with bow above head (R), both hands raised, looking at stag (above L) with crucifix betw horns; (below L) 2 hounds on a lead.
Dersingham. pwd, screen panel, N4. 16[1]. Clasped book in RH, roll in LH book; animal with long neck lying at feet; Williamson (1957) discounted identification because he saw no cross betw antlers; badly defaced.

Hugh of Lincoln

Bp of Lincoln (1186–1200) and confessor. 17 Nov. Carthusian.
N Tuddenham. pg frag, sIII.A2. 15c. Frags of king and bp. Scroll inscr "S*anctu*s hugo."
Wiggenhall S Mary Magdalene. *pg. "St. Hugh," Bl 9:170. Appendix V.5.
Walpole S Peter. *pg, S chancel. 1423/25. Bl 9:117. Appendix V.5.

Ignatius of Antioch

Bp and martyr (†c107). 1 Feb /17 Dec (see Farmer).
Sandringham. pg, nII.A2. 16[1]. In episcopal vestments; crozier in RH; LH holding ?heart at center of breast; "S[an]c[t]*us* Ignaceus"; Keyser (1917) fig 8A.

Jerome

See XI.3.

Jeron (Hieron)

Martyr (†c856). 17/18 Aug. Worked as missionary in the Low Countries; relics at Noordwijk. Iconography with a falcon well established; see also *Julian the Hospitaler*.
Litcham. pwd, screen panel, S4. c1500. Wearing burlet; falcon in RH, red clasped book in LH; badly damaged, but mantle seems to be hooded.
Oxborough. pwd, screen panel. Late 15c. RH pointing up; hawk on shoulder. The pane is very dark; Keyser queried S Willebrod. Now at E Dereham.
N Tuddenham. pwd, screen panel, N6. 1499–1504. Falcon on LH; dark mantle, Tudor shoes.
Trimingham. pwd, screen panel, S4. c1500. burlet, red mantle; LA extended; falcon on gloved RH.
Haddiscoe? *pwd, screen panel. Martin cited a saint with hawk in LH and leg of bird in RH; NRO Rye 17, 2:181.

Joan (Johanna) of Valois

Queen (1464–1505). 4 Feb. Deposed, marriage annulled 1498; known for works of mercy, special devotion to the wounds of Christ, founded Order of the Annunciades. See also *Elizabeth of Hungary*.
Norwich S James. pwd, screen panel. c1479. Chalice filled with wine in RH; basket filled with loaves of bread in LH; "S*anct*a Iohan*n*a" below. The screen date and name are obviously at odds; perhaps the names

were a late addition. Williamson (1957) favored Elizabeth of Hungary. See *Agnes* for a similar problem with the label.

Eaton. *wp, splays of N win. Crown above LH, in label above "Johanna tolerably legible"; identified by Husenbeth; Boileau (1864a) il 163. The offset crown might suggest her rejection as queen.

John I

Pope (523–26). 18 May.

Salle. *pg, sII, light b. c1440. Appendix V.4 & 5.

John of Beverley

Bp of York (706–17) and confessor. 7 May. Retired to the monastery he founded at Beverley (†721). His office, approved for use in England in 1416, was included in a missal (London Guildhall Library, Muniment Room MS 515) probably of Norwich origin, c1420–30; Scott, *Survey* Cat. 46.

Walpole S Peter. *pg, N chancel. c1423–5. "St. John, of Beverly," Bl 9:117. Wdf (179) conjectured a set of archbps & bps. Appendix V.5.

John of Bridlington

Canon Regular, Prior of S Mary, Bridlington (†1379, canonized 1401). 21 Oct. Henry V attributed his victory at Agincourt to John of Bridlington and John of Beverley, both Yorkshire saints.

Cathedral. *im painted. 1414. Bracket with name found in 1889, Hope & Bensly 121.

Hempstead S Andrew. pwd, screen panel frag, N7. 15². Habited like the paired Giles, cross-staff in RH, holding ?book in LH; Williamson (1957) thought a fish, but splay of the hand suggests a book.

John Schorne

Master John Schorne was Rector at N Marston, Buckinghamshire (†1314). Shrine at N Marston; c1480 translated to S George, Windsor.

Gateley. pwd, screen panel, S4. 15⁴. Pointing with RH to devil with black horns in long boot held in LH; black pileus, large-sleeved red garment with fur lining, white-lined red scarf, L side depending over shoulder, R fastened by what seems to be a button, identical to that worn by a bachelor-in-law on a brass at E Raynham; name on pedestal below, "MAGISTER:IOHS:SCHORN"; DT 55: 118, 119; Duffy fig 72.

Cawston. pwd, screen panel, S8. 1492–1504

(Cotton). Nimbed, wearing black pileus; RH raised in blessing; devil in boot in LH (largely defaced); red gown, academic hood lined with black; defaced, bottom section destroyed by rot.

Suffield. pwd, screen panel, S3. c1524. Tonsured; LA extented, hand squeezing devil from very long boot; RH pointing to devil at top, held in extended LH; academic hood, mantle open at RS. Perhaps copied from pilgrimage badge design; see Spencer (1990) fig 165.

John the Baptist

Unless stated otherwise, John is barefoot and bare-legged; he points with his RH to the Agnus Dei lying on closed book (sometimes clasped) held on his LA; lamb with cross-staff with pennon (resurrection standard). Sometimes the Agnus Dei is charged on a disc held in LH. Although typically wearing a camelskin garment with hairy or shaggy surface, on apostle screens John is often dressed like an apostle (see X.1). All documentary citations below specify John Bapt. See also X.3 *John Evangelist and John Baptist.*

Pentney. seal, prior of Austin Canons' Priory of the Trinity, S Mary, and S Mary Magdalene. 13c. *BM Cat.of Seals*, 3821.

Cathedral. seal, William Middleton (1278–88). Flanking bp (L) holding Agnus Dei "on a plaque"; (R) ?Lawrence with gridiron, *BM Cat.of Seals*, 2030. At the vigil of John the Baptist's feast, choir boys began the liturgy; Dodwell (1996) 236. S Luke's chapel original dedication.

— sc, above Prior's door (L). c1297–1314. In camelskin garment; feet resting on recumbent man; arms missing, no Agnus Dei; Fernie pl 55.

Lynn S James. *im, 1372–89. Guild candle "brennyng a-forn ye ymage of seint Johan . . . on sundayes and oyere holydayis, qwil yat seruice is in doynge," T Smith 79; Westlake no. 252.

Fincham S Martin. *im. 1379. Guild provided candle before im, Westlake no. 233.

Wiggenhall S Mary Magdalene? *im. 1387. Guild of S John Bapt Cranborn (?Crabhous), 3 candles before im, Westlake no. 360; but see X.4 *John Evangelist.*

Diocese. ms, hours, NMS 158.926.4f, hi, f 45 (Lauds, *memoriae*). c1310–20. Bust, one shoulder bare; Agnus Dei without staff.

Mileham. pg, W win 3b. 1340–50. No obvious skin garment; charged disc; Wdf (1938b)

165. Church dedication.

Norwich S John de Sepulchre. *?pcl.14[3]. Banner, Watkin 1:22.

Kimberley. pg, E win 4b. Mid 14c. Holding disk charged with Agnus Dei, scroll in hand inscr, "[Ag]nus dei qui"; gown with stylized fur tufts.

Foulsham. pg frag, sIII.A4. 14c. Hand holding charged disk.

Thetford Priory 2. pwd, retable. c1335. Paired with Edmund; charged disc in LH; now at Thornham Parva, Suf; *Age of Chivalry* Cat. 564.

Thetford. seal-die. 14c. John in camelskin with Agnus Dei, inscr "SANCTA IOHANNES ORA PRO ME," Margeson (1985).

Heacham. wp, S face of SW pier at crossing. c1340. Charged disc in draped LH; Tristram 179 pl 55b.

Irstead. sc, font stem. Late 14c (Cautley). Camel's legs depend from garment.

Diocese. ms, missal, Bod L Hatton 1, hi, f 158v. 14[4]. Seated, hairshirt beneath mantle; open book with 2 clasps; trees and hill.

Seething. wp, N wall, E end, frag. 14c. Rough hair, long beard; lower body obscure; Tristram (245) queried identification.

Boughton. See X.3.

W Harling. *im. 15[3]. Will request to be buried "before Seynt Jon"; guild to John Bapt, Bl 1:303.

Elsing. *im. 1489. Bequest "to the peynting of the tabernacle of seynt John Bapte, ij cumbe of malte," Harrod (1847) 118.

Carbrooke. *im. 15c. N aisle chapel "dedicated to S John the Baptist, whose Altar and Image were in it," Bl 2:334.

N Creake Abbey. *im, *Index Monasticus* 22.

Hingham. *im, light before, Bl 2:423.

Lakenham. *im. Guild "held before a remarkable image of the Baptist, which stood in the chancel," Bl 4:522. Church dedication (with All Saints).

Litcham. *im and guild, Puddy 49.

Norwich Blackfriars. *im. After 1307, new church dedicated to John Bapt.

Norwich S Edmund. *im, Bl 4:405.

Norwich S Giles. *im, Bl 4:239.

Norwich S James. *im, Bl 4:424.

Norwich S Martin-at-Oak (Coslany). *im, Bl 4:485.

Norwich S Mary Coslany. *im, Bl 4:490.

Norwich S Michael Coslany. *im in Ramsey's chantry, Bl 4:500.

Norwich SPH. *im, burial before, Bl 4:333.

Runcton. *im. Guild provided candles to burn "time without memory," Westlake no. 319.

Swaffham. *im, light before, Bl 6:217 fn 4.

Yarmouth. *im, guild to provide light before, Westlake no. 376 (see also Guilds below). Also a ch in the graveyard, Morant (1872) 235.

Diocese. ms, Wollaton Antiphonal, Nottingham U Library 250, hi, f 339v. c1430. Scott, *Survey* Cat. 69.

Ringland. pg, NIV.1b. c1466. Camelskin garment, with camels's head below; knotted sash; lamb lost but part of book and pennon; "Ecce Angus dei" recorded in sketch in George King Collection, Box 3, NNAS.

Norwich Guildhall. pg, E win 1d, probably from S Barbara Ch. Mid 15c. John in camelskin garment tied with sash, camel's head betw feet, scroll inscr "Ecce agnus Dei." Wdf (142) indicates the scene was originally flanked by the demi-angels with scrolls inscr **A4** "Fuit homo [missus a Deo, cui nomen]" and **A1** "Erat Iohannes."

Norwich SPH. pg frag, E win 5b. 15[3]. Hand holding book with Agnus Dei.

Ketteringham. pg, E win A6. 15c. Nimbed lamb on huge codex resting on R palm; trace of camelskin beneath conventional mantle.

N Tuddenham. pg, nIV.A1. 15c. Holding scroll inscr "Agnus dei" but no lamb; white mantle over skin tunic with camel's head hanging betw feet. M Q Smith, without documentation, cited a lost sequence on his life, but Wdf 62 cites only this scene without further comment.

Norwich SPM. pg, E win 4c. Mid 15c. With Agnus Dei.

Oxburgh Hall. pg. 15c. Charged disc.

Diss. pg frag, sX.2c. 15c. LH at waist, index finger pointing up; bare legs, camelskin garment.

Alderford. *pg, "in camels hair with an Agnus Dei," NRO, Rye 17, 1:14. Church dedication.

Brandiston. *pg, S win. "Johns head and Agnus Dei in left hand, Ecce Agnus Dei out of his mouth," NRO, Rye 17, 1:140.

Ingworth? *pg frag. Bare legs, one hand raised, other with closed book, DT 33:43.

Tilney All Saints. *pg, N aisle, Bl 9:81.

Watlington. *pg, N aisle, Bl 7:483.

Norwich, private home, R Carr. *pg. Bl recorded im of John "in his garment of camel's hair," in the bow win of great hall, (4:436).

Norwich S James. *pwd, screen panel. c1479. Bl 4:424. See *Catherine*.

Ranworth. pwd, N retable. 15⁴. N2 John with Agnus Dei on open book resting on L knee, lamb resting forelegs on camelskin garment; N3 John, incomplete; against cloth of honor held by demi-angels; Duffy (1997) fig 8.3. Plummer (293) noted traces of an original archbp at N2, converted to John when N3 covered with "some carved structure, tabernacle or image housing."

Hingham. sc, Morley Monument, R respond. 15²⁻³. John in camelskin garment, with wallet.

Ditchingham. sc, statue, W door, S niche. ?15⁴. Both arms relaxed at waistline; apostle mantle over camelskin tunic, triangular corner of hide betw legs; ?originally holding Agnus Dei; face & hands restored. It is hard to reconcile what remains today with the 18c description: "Two images one of our Saviour the other of the Virgin Mary at the west end of the steple," NRO, Rye 17, 2:35; M & R il 2:32.

Langley Common. *sc, face of cross shaft, DT 33:152.

Hellington. *sc, "just sufficient sculpture" to identify John the Bapt," Manning (1859) 198. Church dedication.

Provenance unknown. pwd, screen panel. c1500. In apostle gown; heavily restored; now at Rainthorpe Hall.

Worstead. pwd, parclose screen, S aisle, 3. 15³. Agnus Dei on open book resting on L forearm. Since the N ch was dedicated to John, it seems likely that this panel paired with Stephen would have formed a N aisle screen together with Lawrence and Sixtus when the new apostle screen was provided in the last quarter of the century; see X.2.

Norwich S Gregory. pwd, screen panel; in storage NMS.

Trimingham. pwd, screen panel; see *James Major*.

Matlaske. reliquary, gold with black enamel. Late 15c. L of central crucifix, apostle mantle; now NMS; Young pl 3.

Weston Longville. wp, See X.3 *John Evangelist*

and John Baptist.

Witton. *wp, N wall, within niche. Late 15c (Minns). Camelskin garment; Minns pl betw 42 & 43.

Lynn S Nicholas? wdcarv, be, roundel on poppy head. 15c. Bearded, seated, LH on closed book, RH on large sheep; camelskin garment, camel's head betw legs; atypical design.

Wiggenhall S Mary. pwd, screen, S4. 16¹. In camelskin gown, red tabard.

Burlingham S Andrew. pwd, screen panel, S1. 16². Agnus Dei standing on book resting on L forearm and palm; (directly above) scroll inscr "ecce agnus"; length of fabric draped over L shoulder; shaggy camelskin tunic (no sleeves); name on pedestal; Constable il p 145; Duffy fig 59.

Norwich SPM. *im in ch, Bl 4:212. 1511–23, a 2-story tabernacle for gilded im; will references in Woodman (1995) 292.

Linnell cites 30 churches dedicated to John, incl 5 in Norwich; Bond (1914) 496 for England. References to S John without specification are extensive in wills and antiquarian records, and many undoubtedly refer to the Baptist. He was an enormously popular saint.

Chs were common in non-dedicatory churches, e.g., Barney (1496, C & C); Banningham (1518, C & C); Carrow (Gilchrist and Oliva fig 5); Earlham (Bl 4:514); Lynn S Margaret (Owen 149); Norwich Blackfriars ("Report for 1949," map facing 90). At Lynn there was a hospital with a ch dedicated to him (13c–1545) which was the site of Sawtry's recantation, Beloe (1899) 76.

Altars at Ashill, 1458 request for burial before the altar and bequest for new win by the altar (Bl 2:349); Colton (Bl 2:420); Deopham (E end of N aisle, Bl 2:494); Docking, 1415 bequest to glaze a win by his altar (C & C); will request to be buried before his altar (Bl 10:368, titular saint); Northwold, 1435, bequest of "silver cup to the altar of St. John Baptist" (Bl 2:220); Long Stratton (guild as well, Bl 5:192); Stalham (Rye 3, 3:203).

Farnhill cites 125 guilds, incl one dedicated to S John Baptist de Rollesby at Yarmouth, Bl 11:366. The guild at Bressingham was particularly wealthy because of extensive pardons (Bl 1:49); bell inscr "SANCTE JOHANNES ORA PRO NOBIS." L'Estrange (1874, 13, 106) believed that the large number of bells inscr Johannes were for the Baptist, though only 4 are so specified: "MUNERE BAPTISTE BENEDICTUS SIT CHORUS ESTE" at 3 and "I AM MAD IN NAME OF SEN ION BAPTIST" at Alderford (church dedication).

Julian of Le Mans

Bp and confessor (?4c). 27 Jan. His *cultus* received encouragement from Henry II.

Wiggenhall S Mary Magdalene. pg, nV.A3.

c1450. Bp in chasuble "*Sanctu*s Julian*us*."
Appendix V.5.

Julian of Norwich

Mystic and anchoress at Norwich (†c1443).
Norwich. pilgrim badges. 15c. Julian nimbed,
seated or standing before lectern; with head
of deity above; bust of nun; 3 badges depict
her at the window of her cell, Mitchiner
Cat. 572–5.

Julian the Confessor

Confessor (nd). ?Jan feast. Identity uncertain. *The South
English Legendary* identifies him as confessor, known
for his preaching and miracles. The identification as
king and confessor in Blomefield is curious. The *Acta
Sanctorum* provide a lengthy life for Julian and his wife
Basalissa with a feast of 9 Jan., but they were martyrs.
E Anglia. ms, *The South English Legendary*, Bod
L Tanner 17, marginal drawing, f 11v. 15[1].
With book, preaching; prophet hat, toga-
like garment, leggings.
Norwich S Julian. *im, "in a niche in the wall of
the church, in the churchyard"; burial in
churchyard of Julian "King and Confessor,"
Bl 4:80.
Linnell (1962, 20) argues that the Norwich parish
church was dedicated to Julian of Brioude (28 Aug).

Julian the Hospitaler

29 Jan. In most MSS of *The South English Legendary*
his life immediately follows that of Julian the
Confessor. His legendary life is entirely devoted to good
deeds after inadvertently killing his parents; he had been
warned by a hart.
Thetford. 12[1]. Hospital dedicated to SS Mary and
Julian founded for travelers and pilgrims
(Knowles and Hadcock). Ch dedicated to
Julian "stood in the yard," Bl 2:9.
Hingham. *im, light before, Bl 2:423.
E Anglia. ms, *The South English Legendary*,
Bod L Tanner 17, marginal drawing, f 12.
15[1]. Praying, in plate armor; helm and
blood-stained sword on ground.
Suffield. pwd, screen panel. S4. c1524. Hawk on
gauntlet in LH, armor covered with black
mantle forming hood over ?helmet; RH
lifting mantle from R leg. Winter and Wil-
liamson identified Jeron, but James (*S & N*
158) and, more recently, David Park iden-
tify Julian.
Lynn S James, Guild of SS Giles & Julian.
wdcarv. Late 15c. Maser with S Julian and
a hart in the bottom (Richards 433).

Guild and altar to SS Giles and Julian at Lynn S James,
1535 (Bayfield 322)—a particularly wealthy guild, see
Richards 422–36. Bond (1914) cited 7 dedications for
England.

Juliana

Virgin martyr (early 4c). 16 Feb. The female saint with
a devil (or dragon) on a chain or lead is identified by
label twice as Juliana and once as Martha. Juliana's cult
is attested as early as Bede's Martyrology
E Anglia. ms, *The South English Legendary*,
Bod L Tanner 17, marginal drawing, f 22.
15[1]. With open book.
Martham? pg, nIV.3a. c1450. RH raised holding
chain with demon attached. Appendix V.1.
Wighton? pg, sIV.A3. 15[3]. RH raised, LH hold-
ing chain to which greenish demon at-
tached; restored; King fig 4. Appendix V.1.
Field Dalling? pg frag, sVI.A8. 15[3]. "A male
saint, the upper part of whose figure is lost,
holding a red dragon on a yellow lead,"
tentatively identified by Wdf as Sylvester
(179). The dragon is now very difficult to
see, but I see nothing essentially male about
the frag fig; the hand holding a ceinture is
particularly graceful. There is an abbess at
A1, but neither Juliana nor Martha classi-
fied as an ecclesiastic.
Hempstead S Andrew. pwd, screen panel, N1.
15[2]. Birch raised in LH, RH holding rope
tied around neck of demon; demon lying on
back; name below; paired with Helen. In
1845 this pane was "with several other
panels built into the Clerk's desk; they have
been cut into pieces, and much mutilated,"
DT 31:138.
N Elmham. pwd, screen panel, S5. 15[3]. LH
raised, palm out, RH holding triple-linked
chain with demon attached lower R; name
below.
Litcham? pwd, screen panel, N4. c1500.
Crowned, ermine collar; lower R traces of
demon.
Dersingham. pwd, screen panel, N5. 16[1].
Scourge in LH; RH holding demon by long
cord.

Kenelm (Cynhelm/Cenelm)

Boy king of Mercia and martyr (†812 or 821). 17 July.
There is a lengthy life in *The South English Legendary*.
The Stowe Breviary provides Kenelm's feast with a
generic bearded king's head whereas he should be
represented beardless.
Norwich SPM. pg E win E1. Mid 15c. Name

only; king set. Appendix V.3.

Marsham. *pg, N aisle, "fine effigies" incl one with label, "Sanctus Kenelmus Rex," female donor below, Bl 6:287.

Swaffham. *im, Bl 6:217 fn 4.

Lambert

Bp at Maastricht and martyr (c635–c705). 17 Sept. Patron of Liège.

Wiggenhall S Mary Magdalene. pg, nVI.A3. c1450. Bp, seated, chasuble, name scroll in RH; "Sanct*us* lambert." Appendix V.5.

Taverham? sc, font stem. 15c (?Victorian). Cautley so identified a priest with generic palm.

Weybridge Priory. printed calendar, NMS 134.944. 1503. Bp.

Laudus (Lo/Laud)

Bp of Coutance and confessor (6c). 22 Sept.

Cathedral. *altar or im. 1363. Sacrist's roll, offerings 9*s* 8*d*, Shinners 138.

Wiggenhall S Mary Magdalene. pg, nVI.A1. c1450. Bp, seated, cope, roll in LH, book in RH; "*Sanctus* laud'." Appendix V. 5.

Lawrence

Deacon and martyr (†258). 10 Aug. Martyred in the persecution of Valerius shortly after Sixtus.

Narrative

See also *Catherine* Catfield.

Diocese. ms, hours, NMS 158.926.4f, hi, f 47v (Lauds, *memoriae*). c.1310–20.

— ms, Stowe Breviary, BL Stowe 12, hi, f 292. c1322–5. On gridiron, (L above) man with bellows, (R above) man prodding Lawrence with fork.

Norwich S Stephen. sc, boss, N porch. Mid 14c. (L) fig seated with object in LH, (C) devil with massive vaned wings, on pillar; (R) Lawrence standing with hand extended. Paired with martyrdom of Stephen.

Shotesham All Saints. frag wp. c1360 (DP in P & W 2). Martyr lying with feet and wrists bound (hands joined), and flames lapping feet. (Above) a woman with beatific expression (early 16c, DP).

NMS. al altarpiece. 15c. Panel **3**: in drawers, chained to gridiron over fire, scroll issuing from mouth; 2 torturers, one piercing leg with spear; (far R) emperor with sword; (below) 2 men one with bellows, one stoking with pitchfork. Panel **7**: holding book

and gridiron; symmetrically paired with Stephen. Provenance uncertain. For details see Cheetham (1983) figs 49, 51.

Cathedral. sc, N cloister bosses. 1425–30. **I2** Men carrying faggots, (C) ?Lawrence kneeling; **I5** (C) Naked, being roasted on gridiron; fire stoked below by man with poker and man with ?bellows; (above) enthroned king flanked with courtiers and other figs. Stephen at **J5**.

Norwich S Laurence. sc, spandrel, W door. 15³. On gridiron, (below) man setting fire, man poking fire with rod, man using bellows; (above L) man in crown holding handle of gridiron, (R) youth with sword; drawing in Frank Sayer's copy of Blomefield, vol 2, facing 671.

Harpley. *pg. "In the uppermost window but one, of the north aisle, was the history of St. Laurence, painted on the glass, as appears from some frags, and the insignia of the saint, a grid-iron, or," Bl 8:458.

Individual

Dressed in deacon's vestments, dalmatic over alb with amice (only exceptional detail cited); prominent tonsure; gridiron attribute.

Norwich. seal, William Middleton (1278–8). "St. [Lawrence with a gridiron] on the r," *BM Cat. of Seals*, 2030.

Norwich S Laurence. *emb frontal for high altar. 14³. "Item j pannus de saye pulverizatus cum rosis albis et ymagine Sancti Laurencii stante in medio eiusdem panni enbrauded albi coloris cum custodiis de velvett nigri coloris pulverizatis cum stellis de auro," Watkin 1:16. See also entry for 1501.

Stowe. seal. 14c. Standing with gridiron; fig kneeling R; seal matrix inscr "S Laurencii de Stowe"; see Knowles and Hadcock; on loan NMS.

Cathedral. wp Ante-Reliquary Ch, vault, N bay. c1300. Deacon; Tristram (230) queried Stephen.

NMS. al. See *Narrative*, above.

Hingham. *im, light before, Bl 2:423.

Norwich S Laurence. *im and tabernacle, Bl 4:263.

Tilney S Lawrence. *im. Guild provided lights throughout the year, Westlake no. 333.

Salle. pg, nII.A3. c1440. "S*anctus*. Laurentius, Card*inal*," clasped book in LH; in cardinal dress. According to the *Golden Legend* Lawrence was an archdeacon. Popes at an

early stage were elected by archdeacons, forerunners of the cardinals. Felicissimus, another cardinal in this set, died in the same persecution with Lawrence. Appendix V.5.

Diss? pg frag, sX.2b. 15c. Deacon with ?gridiron in raised RH.

Harpley. pg, W win C1. 15c. Seated; in fringed dalmatic, prominent tonsure; holding huge clasped book and what seems to be a stave (?handle of gridiron); titular saint; paired with Stephen; Appendix V.

N Tuddenham. pg, sV.A2. 15c. In appareled alb, dalmatic with central vertical orphrey and gold fringe; gridiron and clasped book.

Sparham. *pg, S win, "Sanctus Laurenci[us]," NRO, Rye 17, 3:215; Appendix V.6.

Poringland. *pg, S win, Bl 5:442.

Hempstead S Andrew. pwd, screen panel, S4. 15². RH on breast, LH with gridiron; blue dalmatic with parti-colored fringe; name below; paired with Stephen; Constable il p 219.

Worstead. pwd, screen panel, N aisle 3. 15³. Fringed dalmatic over appareled alb, gridiron and closed book with 2 loose clasps; paired with archbp (see *Sixtus*).

Ranworth. pwd, S parclose screen. c1479 (see *George* Ranworth). Dalmatic with parti-colored fringe; gridiron resting on ground supported by LH; clasped book on palm of RH; paired with Stephen. Bond (1914) il p 112.

Ludham. pwd, screen panel, S5. c1493. Gold dalmatic, epaulette on shoulder; gridrion & book "Sanctus Laurentius"; paired with Stephen at N2; Duffy fig 73.

Smallburgh. pwd, screen panel, S2. 15⁴. Green dalmatic, parti-colored fringe; gridiron in RH, holding small bag by throat in RH.

Harpley. sc. frag of seated fig on church battlement, W end of aisle roof. 15¹ (P & W 2).

Norwich All Saints. sc, font stem. c1448. RH on breast, LH with gridiron; restored, now at S Julian.

Watlington. sc, font stem. 15³. With chemise-sac and gridiron; paired with prophet fig.

Hemblington. sc, font stem. 15c. With maniple, gridiron, and book.

Norwich S Laurence. *emb. 1501. Bequest for high altar cloth with Lawrence in the middle; cope with Lawrence, on pectoral a gridiron, Bl 3:269.

Norwich Whitefriars. *im, *Index Monasticus* 42;

S side of the church, 1510, Kirkpatrick (1845) 176.

Norwich Austin Friars. *im, *Index Monasticus* 43; 1512, Kirkpatrick (1845) 147.

Walsingham Priory. *im. *Valor Ecclesiasticus* reported £8 9s 1½d. Ch near the holy wells, Harrod (1857) 165. The ch had its own collection of relics; Spencer (1998) thinks it likely that some pilgrim badges came from this site (Cat. 153).

Pulham S Mary. pg, roundel eye of nIV, *ex situ*. 16c.?Maniple on LA; gridiron in LH, flanked by trees and plants. ?English.

Outwell. pg, sIII.B5. 16¹. Gridiron in RH, book in LH.

Wiggenhall S Mary. wdcarv, be, N aisle S4 and S aisle S4. 16¹/15c. In each case paired with Stephen.

Weybridge Priory. printed calendar, NMS 134.944. 1503. Holding gridiron.

Linnell cites 14 church dedications for Norfolk; Bond (1914) 239 for England.

Chs at Alburgh (Bl 5:354), Ereswell (Bl 6:175), Haveringland (14⁴ *Index Monasticus* 67), Tilney (free chantry ch; for extensive inventory, see Ward 296), Wiggenhall S Mary Magdalene.

Guilds at Beeston S Lawrence (Bl 11:16), Ingworth (Bl 6:369), Hanworth (Bl 9:402), Harpley (Bl 7:458), Lynn (Richards 416), Stody (Bl 9:442), Wymondham 1461–1524 (Farnhill).

Lawrence of Canterbury (Laurentius)

Archbp of Canterbury (c604–19). 3 Feb.

Salle. *pg, nII, light c. c1440. Appendix V.5.

Wiggenhall S Mary Magdalene? *pg, "Sanctus Laurencius," NRO, Rye 17, 3:55. Cited next to Nicholas, NRO, Rye 123, p 199. Given the sets of bps and archbps at Wiggenhall, this was probably the archbp of Canterbury who succeeded Augustine. Appendix V.5.

Lazarus

Brother of Martha and Mary (usually identified with Mary Magdalene at this time). 17 Dec. See also V.4 *Miracles*.

Thetford Priory 1. 12/13c. Pieces of his clothes and sepulcher, Bl 2:118.

Thornham. pwd, screen panel, S7. 15⁴ (before 1488). Forked graying beard, downcast eyes; mantle on LS, held at opposite side by LH; pink chaperon with gold trim and ouch rising above brow; gold design on black

damask gown; vertical scroll to his L: "*Per me mu*l*ti* [cre]didderu*nt in* I*h*es*u*m"; name below, Lazarus paired with Mary Magdalene. Restored.

Leger (Leodegarius)

Bp of Autun and martyr (c619–679). 2 Oct. Relics preserved at Ebreuil.

Thetford Priory 1. 12/13c. Relic, Bl 2:118.

Cathedral. *im. 1390. Sacrist's roll (Shinners 139). Relic in casket with others (1234, Beeching 17).

Field Dalling. pg, sVI.A3. 15³. Bp in episcopal Mass vestments; short flesh hook in LH; tentative identification, Wdf 179.

Harpley. pg, W win E1. 15c. Bp in Mass vestments with crozier; book with 2 clasps, spine resting in R palm; label, "Leodgari*us*, ep*iscopus*"; paired with Thomas Becket.

Horsham S Faith. pwd, screen panel, N6. c1528. In full Mass vestments, crozier in LH; augur in RH; augur handle and tip obscured by chasuble border.

Weybridge Priory. printed calendar, NMS 134.944. 1503. Bp.

Guild at Heacham (Bl 10:312).

Light at S Creake 1491 (Robert Norton, Norf Arch Bk 1, f 173).

Leo I (the Great)

Pope (440–61) and doctor. 11 April.

Wiggenhall S Mary Magdalene. *pg, N aisle. 1450. "St. Leo," pope, Bl 9:170. Appendix V.5.

Leonard

Abbot (?6c). 6 Nov. According to his legend, he was a hermit and, later, founder of the abbey of Noblac. Patron of prisoners. Shrine and relics at S Leonard de Noblac, on pilgrimage route to Compostela. A badge from this shrine found in London (Mitchiner Cat. 1023). Bod L Jones MS 46 with Norwich synodal feasts ranks the feast of S Leonard in red with 9 lessons; for additional prayers see L & M Cat. 49.

Narrative

Norwich S Leonard's Priory. ?pwd. 1490. For painting the miracles of Leonard, 3*s* 9*d*, NRO, DCN 2/3/90; Dodwell (1996) 254.

Individual

In monk's habit (black or dark blue), sometimes with abbatial crozier, holding manacles.

Norwich S Leonard's Priory. *im. c1100. Built to house monks while priory being con-

structed, later a dependency; Knowles & Hadcock.

Thetford Priory 1. 12c/13c. Relic, Bl 2:118.

Lynn S James. *im. 1371–89 (Westlake no. 260). Guild candle "a-forn þe ymage of seynt leonard," T Smith 49.

Norwich S Leonard's Priory. *im. c1422. Jeweled statue, "in pectore sancti leonardi sunt iiij anuli positi in modum crucis . . . sub gutture . . . j parvum broche incinctum undique diversis petris," also 10 rings on fingers, and "j cappa . . . ornata serico" Bensly (1895) 198, 201. Mid 14c, annual offerings at his altar approximately £25. Offerings rose to £43 in 1454–5, Dodwell (1996) 254. Pilgrimage site.

— pilgrim badges. 15c. Manacles hanging from RH, variously mitred, with crozier, in chasuble with pallium/cross; Mitchiner Cat. 566–71; see also Peter M Jones, il in "Pilgrim Badges," *King's Parade*, Spring 1998. I am grateful to Martial Rose for calling this badge to my attention.

Wells-next-Sea. *im. 1495. Bequest for light before, Harrod (1847) 119.

Old Buckenham. pg, sV.B3. 15³. Abbot, manacles hanging from RH, holding book with 2 fingers interleaved; crozier in LH; "L[e]onard*us*"; paired with Botulf, part of ecclesiastics tracery set. **FIGS 31 & 31a.**

N Tuddenham. pg, sIII.A1. 15c. Crozier in LH, manacles in RH; habit with identical cowl design at Horsham S Faith; paired with abbess Etheldreda.

Sparham. *pg. 15⁴. Nelson (1913).

Hempstead S Andrew. pwd, screen panel, S7. 15². Half lost when adjacent panel stolen; manacles in RH; part of name below; Constable il p 216.

Norwich S John Maddermarket. pwd, screen panel, now at V & A. 15³. Crozier in RH, manacles in LH; L & M Cat. 74; Rickert pl 189; "much repainted," Rickert, 250, fn 17; Tracy Cat. 100, color pl 6.

N Elmham. *pwd, screen panel. 15³. Leonard's name cited next to Egidius's; NRO, Rye 17, 2:65v. Abbot set; Appendix V.5.

Horsham S Faith. pwd, pulpit, pane 10. 1480. Rectangular linked chain hanging from RH, crozier in LH; dressed as if paired with S Benedict.

Gressenhall. pwd, screen panel, S aisle, not *in situ*, originally N1 paired with Antony at

S4. 15³⁻⁴. Crozier in RH, lower edges of voluminous sleeves typical of a religious habit; no trace of chains, "Sanctus Leonardus."

Cathedral. sc, font stem. 15³. Manacles in RH, staff in LH.

Norwich S James. sc, font bowl. 15³. Paired with ?William. At S Mary Magdalene.

Hemblington. sc. font stem. 15c. Hood pulled over head; crozier and manacles.

Buckenham S Nicholas. sc, font panel. 15c. Cope, stole over alb, staff in LH and chain in RH. ?Victorian recut.

Beeston. pwd, screen panel, S6. 16¹ (C & C). Links of chain; largely disfigured.

Sandringham. pg, nII.A6. 16¹. Dalmatic over appareled alb, maniple over LA; open book with writing & rubrication in LH against chest; manacles in RH with rings at either end; "S[an]c[t]us leonardus"; Keyser (1917) fig 6A.

Wiggenhall S Mary. wdcarv, be niche, nave N1. 16¹. Chains in LH, book in RH; James *S & N* il p 212

— ? wdcarv, be shoulder, nave S8. Early 15c (P & W 2). In alb. Paired with ?James Maj.

Weybridge Priory. printed calendar, NMS 134.944. 1503. Holding manacles.

Linnell cites only 2 dedications; Bond (1914) cites 239 for England.

Guild at Mundford (church dedication, *Index Monasticus* 73).

Longinus

See *William of Norwich*.

Louis IX

King of France (1214–70) and confessor. 25 Aug.

Salle. *pg, sII, light c. c1440. Appendix V.3 & 5.

Litcham? pwd, screen panel, S8. c1500. Crowned, thorns in RH; badly damaged.

Foxley? *pwd, screen panel. Keyser cited S Louis and the Latin Doctors (see XI.3); the screen is now covered with dark paint.

Stalham. sc, font stem. 15³. Holding crown of thorns and staff for tightening it.

Altar at Yarmouth, Morant (1872) 222.

Guild at Lynn (*Index Monasticus* 73).

Lucius

King (c179); see *Eleutherius*. 3 Dec. Supposedly the first Christian ruler in the world, he appears in genealogical rolls of the kings of England, e.g. Bod L Bodley

Rolls 10, membr. 4, col. 1.

Salle. *pg, nIV, light a. c1440. Appendix V.3 & 5.

Lucy

Virgin martyr (†304). 13 Dec. Knife/sword instrument of martyrdom.

Narrative

Cathedral? sc, N cloister boss, I8. (L) cross-legged king seated on throne; (C) ?pedestal ?with idol; (below pedestal) 2 kneeling men; (above) 4 men in loose gowns (?monks), (R) man holding hat, one with ?hammer, men pulling on cords or chains. James (1911) and Tristram (1937) identified the tortures of Lucy, who could not be dragged by chains.

Individual

Wendling Abbey. Foot relic, *VCH* 422.

Cley? pg, sIX.A5. 1450–60. Palm in LH, trace of knife hilt at throat. The fig is patched where one would expect to find a lamb, so the saint may have been Agnes.

Guestwick. pg frag sV.1b. 15³. Part of chin and chest; dagger in chest with blood flowing; **FIG 20**. Identified by King (23).

Stody. *pg. Citation in Frere MSS NRS 1:37.

Marsham. *pg, N aisle, "portraiture . . . of St. Lucia," Bl 6:287.

Horsham S Faith. pwd, screen panel, S6. 1528. Holding mantle in LH, in RH a heart with gold flames rising; chapelet of beads with rhombus at center of brow at hairline; name below has been interpreted as Anna, but Martin cited inscr "Sancta Lucia"; NRO, Rye 17, 2:266.

Weybridge Priory. printed calendar, NMS 134.944. 1503. Fish.

Luke

Evangelist. 18 Oct. See XI.2.

Norwich. ms, Bible, Bod L Auct. D.4.8, hi, f 609v. 1190–1250; 14c Priory pressmark. (Acts) apostles dictating to Luke.

Diocese. ms, Stowe Breviary, BL Stowe 12, hi, f 314v. c1322–5. Seated, writing, ox below. Sandler, *Survey* Cat. 79.

Cathedral. ch, "an ancient gild called St. Luke's gild, kept at the altar here," Bl 4:8. The chair belonging to the guild borrowed for the reception of Elizabeth Woodville must have been exceptional (Harrod 1859b).

Margaret of Antioch

Virgin martyr (nd). 20 July. Often paired with Catherine; one of 10 saints cited by Lydgate as special helpers.

Narrative

Lived as a shepherdess until taken to court of Olybrius, whom she refused to marry. Refusing to deny her faith, Margaret was subjected to a variety of tortures, incl being swallowed by a dragon.

Limpenhoe. *wp, framed, N wall. c1390. Reading W to E: **1** Margaret seated spinning, holding distaff; man in cloak with dagged collar approaching on horseback, ring in RH. **2** Margaret standing before prefect seated on raised platform, guard grasping her arm; second man with scourge, DT 56:73. **3** Man with peaked hood holding rod; 2 executioners casting Margaret head first into cauldron from which 2 birds fly. **4** Executioners with brands flanking Margaret; gibbet in background, DT 56:74. **5** Torturer grasping Margaret's hair with LH, raising scourge in RH; torturer in dagged hip-length gown, low ornamented belt, hood with dagged gorge, long liripipe, & pointed shoes; (above) large bird with outspread wings. **6** Missing scene. **7** Executioner with sword in RH, severed head in LH, bird flying upward; Margaret kneeling with hands raised; behind executioner a group of figs supporting bodies of 2 men. **8** Margaret in tomb; 3 figs at head, and priest with open book at feet, 2 figs behind, DT 56:75. Tristram's description based on copies by Winter; Husenbeth's notes in DT 56:69–70. Walls collapsed in 1881 reconstruction.

N Tuddenham. pg. c1415–25 (Marks). **W win a** (L) Margaret seated, a chapelet of twisted sprays of oak leaves in her hair; spinning thread from distaff to depending spindle, surrounded by sheep; (above) scroll inscr "Miserere d*omi*ne an*ime* mee'." (R) Man holding ring in one hand, lance & pennon in the other; issuing from his mouth scroll inscr "Veni d*omi*ne loquere meo"; her reply, "C*om*paco non potest esse"; Wdf pl XVI, Marks fig 152. **W win b** (L) Olybrius, closed crown and scimitar in chased scabbard hanging from a strap decorated with bells, clutching at Margaret's white overgarment with his RH. Margaret, chapelet in hair, in a blue diapered gown and chasuble-shaped overgarment decorated with flowers (same design at Heacham), raising RH and clutching overgarment with LH. Scrolls rising vertically, from Olybrius "Et quo gen*ere* es libera a*n*cilla," from Margaret "libera no*n* solum sed xp*isti*ana." Behind Olybrius a man in green tunic and yellow hat, his LH on hilt of sword; behind Margaret the squire, and 2 other men, one with a mace; Wdf pl XVII. Dislocated frags in porch: **W win 1–2a** horses with trappings, 2 hounds on a lead. A particularly nice horse's head, probably from the same scene, is leaded in **sV**. It is likely that bits of text in the porch win at Welborne belonged to this history of Margaret; Wdf 58. **W win tracery** frags, **A** Olybrius seated, with scepter, one leg folded over the other; **B** head of squire, a hand holding a ring, bells. **nV.A1** Crowned Olybrius seated; before him a squire in elaborate clothing; 2 hands resting on Olybrius's LS; **A3** nude fig, Margaret "about to be plunged into a cauldron," Wdf 62; **A4** Margaret being scourged, kneeling and naked to waist, her hair twisted around a horizontal post.

Heydon. *pg, S aisle. "A man on horseback Ite festinanter et apprehendite illam. Hic Margarita flagellatur et per crines suspendatur. She says, Speravi in te Domine, non confundar in eternum. Hic Margareta decollatur, &c.," Bl 6:253 fn 4.

Swannington. sc, high relief, S porch spandrels. 1452–78 (bequests C & C). (W) angel in nebuly; Margaret rising from recumbent dragon; (E) execution: (far L) fig touching Margaret's veil; along curved edge of spandrel Margaret's prone body, veiled head detached from body; (R) soldier with sword at side; flushwork at base of porch entry "S MARGARETA."

Individual

Crowned, standing on or in front of a dragon, his head at one side and tail at the other. Holding cross-staff, in RH, unless stated otherwise, which pierces dragon's mouth or throat. The way in which Margaret's voluminous gown spreads at the hem line may suggest emergence from dragon. Generic details should be presumed unless a fragment; only variations are cited.

Lynn, Benedictine Priory. seal. 13c. Beneath an arch "richly carved and crocketed . . . upheld by 2 elaborately worked pinnacled and crocketed towers, each having 3 stories of windows," Margaret emerging from the

belly of a dragon, clasped book held by spine in draped LH; in RH cross-staff impaling dragon's mouth at one side; dragon's tail ending in second head with long tongue reaching almost to book height; "SUB. MARGARETA. TERITUR. DRACO. STAT. CRVCE. LETA," Pedrick (1902) 90–2, pl 1. See also *BM Cat. of Seals*, 2088.

Lynn. common seal, reverse. 13c. *BM Cat. of Seals*, 5149; Pedrick (1904) pl 1. Privy seal of mayoralty, 15c, same composition, *BM Cat. of Seals*, 5152; Pedrick, pl 36. 16c town records cite a processional dragon, and the town minstrels wore collars of dragon heads, branches of silver, and enameled scutcheons (Galloway & Wasson).

Cathedral. Ch cited c1280 (Thurlow).*im. 1363. 20*s* "pro factura et pictura ymaginis," Shinners 143 fn 33.

— wp, Ante-Reliquary Ch, vault, E bay. c1300. Paired with Catherine, flanking Virgin and Child; (L) standing on dragon, palm in RH, cross-staff in LH; white gown and green mantle, veiled, no crown; above head "S: MARG . . . ," Tristram 230; Caiger-Smith pl VIIIb; Atherton, color pl Va.

Clenchwarton. *im. 1378. Guild provided torch to burn during service before im, Westlake no. 228.

Diocese. ms, hours, NMS 158.926.4f, hi, f 51 (Lauds, *memoriae*). c1310–20.

— ms, Stowe Breviary, BL Stowe 12, hi, f 274v. c1322–5.

Merton. pg, nII.light b. 1320–30. Standing on dragon, cross-staff in LH, not piercing dragon's mouth; restored, new head. See *Catherine*.

Mileham. pg, W win 3c. 1340–50. Standing on dragon, book in LH; Wdf (1938b).

Kimberley. pg, E win 2b. 14⁴. Crowned but no halo; hair falling over LS; standing in front of dragon; staff in LH impaling dragon's mouth; King fig 28.

Woodton. pg, sIII.A2. 14c (S aisle added before 1348). Crown over white veil; standing on dragon; mantle held at thigh level in LH; paired with Catherine.

Thetford Priory 2. pwd, retable. c1335. Clasped book in RH; cross-staff in LH; paired with Catherine. Now at Thornham Parva (Suf); *Age of Chivalry* Cat. 564.

Lynn Whitefriars. seal. 14c. (L) Virgin standing with Child; (R) Margaret piercing dragon's

head with cross-staff; *VCH* pl 3, facing 436.

Rougham. sc, 14¹⁻². Above W door, in niche L of central Crucifixion, spearing dragon; paired with Catherine; Cotman (1838) pl XXXIX.

Catfield? *wp, S wall. 14³⁻⁴. DT 27:167. The theme on the S wall seems to have been martyrdom, with Catherine's preceding this scene. It is thus likely that the crowned fig with cross-staff rising from the belly of a monster with a hellmouth was Margaret rather than a resurrection as identified in the drawing.

Heydon. wp frag, S aisle ch. Late 14c (DP). Crowned, hair in 2 plaits; trace of ?staff in LH; cut into by later monument.

Norwich SPM. al tablet. 15c. (Lower register) set of female saints: standing behind dragon, thrusting tau cross with both hands into dragon's mouth; Bensly (1892) pl facing 355; L & M Cat. 87.

Norwich Austin Friars. *im, *Index Monasticus* 43; Kirkpatrick (1845, 147) cites 1415 as date.

Paston. *im. 1419. Clement Paston left 6 pounds of wax for light before, Richmond 13.

Salle. *im, N aisle. John Rightwys (†1475) desired to be buried before her image, 1938 guide book (NMR).

Gooderstone. *im and light, Bl 6:63.

Norwich S Gregory. *im, Bl 4:274.

Norwich S Margaret. *im, Bl 4:474. With plague depopulation "principal image of St. Margaret was carried to St. George's," Bl 4:474.

Swaffham. *im, Bl 6:217 fn 4.

Weasenham S Peter. pg, nVI, not *in situ*. 15² (1437 bequest for 2 windows, C & C). Partially open book (fine binding details), supported in crook of L thumb and fingers; voluminous white mantle obscuring dragon's green body, head at one side, tail at other; M & R il 3:149.

Salle. pg, sII.C3, not *in situ*. c1444. Standing on dragon; RH holding book with double clasps; cross-staff piercing laterally the jaw of grimacing dragon and impaled in lower neck, blood spouting; details from colored drawing in King Collection, Box 3, NNAS. Appendix V.1

Martham. pg, nIV.1c. c1450. Ermine-lined mantle; clasped book in LH; standing on dragon. Appendix V.1

— pg, sV.1c. Book in LH; staff (largely new)

in RH; ?alien head.

Stody. pg frag, sIV.A2. 1440–50 (King). Cross-staff held diagonally in RH; closed book on palm of LH. Dragon recorded earlier but now missing. Appendix V.1.

Mileham. pg, W win 2c, not *in situ*. 1460–80 (Wdf). Strand of hair along her R shoulder and arm; standing on dragon, cross-staff impaling dragon's mouth with point piercing throat; clasped book in LH; Wdf (1938b) interpreted Margaret as pregnant, pl facing 167.

Framingham Earl. pg, tower win, not *in situ*. 15c. Standing on dragon; in relaxed LH closed book held at lower edge of binding; mantle over gown with coin design.

W Harling. pg, nIV.A1. 15c. Standing on dragon; cross-staff in LH held diagonally, piercing dragon's mouth; alien head (?Paul); paired with Catherine.

Heacham. pg, nV.B3, not *in situ*. 15c. Hair falling at sides of both arms; cross-staff held diagonally in LH, piercing dragon's head; clasped book in draped RH.

Ketteringham. pg, E win A2. 15c. Waist-length hair; clasped book in draped LH; mantle turned back to create collar; paired with Catherine at A7.

Stratton S Michael. pg, nIII.A2. 15c. Clasped book in draped RH; LH holding cross-staff diagonally. The dragon would have occupied the space filled with alien lower gown. Margaret wounding the dragon cited in a N chancel win, NRO, Rye 17, 3:229.

Alderford. *pg, a kneeling fig with Margaret above, NRO, Rye 17 1:15v.

Brandiston. *pg, N win, "crowned and a dragon under feet which she pierceth with a spear," NRO, Rye 17, 1:140v.

Bressingham. *pg, E win, light b, "standing upon a dragon wounding it with her left hand and in her right hand a book"; paired with S Catherine, NRO, Rye 17, 1:150.

Cringleford. *pg, E win. Margaret paired with John Bapt, with knight kneeling below with scroll inscr, "Mere de paradyis pry[ez] pour moy a no . . . ," sketch in NRO, Rye 17, 1:229v. No Marian scene recorded in this win.

Garveston? *pg, steeple win, Margaret or Michael, broken, NRO, Rye 17, 2:138.

Marsham. *pg, N aisle, "standing on a dragon," Bl 6:287. Appendix V.1.

Gt Massingham. *pg. Cross-staff held diagonally; clasped book in draped RH; DT:63. N ch perhaps dedicated to Margaret.

Norwich, private home, R Carr. *pg, bow win of great hall, Bl 4:436.

Norwich S Peter Parmentergate. *pg, Bl 4:96.

E Rudham. *pg? With spear and "dragon (red) on the screen chapel East Window [*sic*]," NRO, Rye 17, 3:157.

Sharrington. *pg, N win. Frere MSS NRS 1:37. Appendix V.1.

Norwich Michael-at-Plea. pwd. 1420–40 (King [1996] 415). Against gold diapered gesso ground. Elaborate cross-staff piercing dragon's throat, red tongue protruding from dragon's mouth; red-bound book in draped LH; sideless surcoat trimmed in ermine and fastened at the hip with a massive morse, mantle fastened by double morse; L & M Cat. 57. Now in Cathedral vestry.

N Walsham. pwd, screen panel, S9. c1470. Standing on dragon; belted gown, holding mantle with LH.

Filby. pwd, screen panel, S2. c1471. Standing on dragon; holding ermine-lined mantle with LH. Paired with Catherine at N3.

Gressenhall. *pwd, screen panel. 15³⁻⁴. Originally S1 paired with Michael at N4, "S*ancta* Marg*are*t," NRO, Rye 17, 2:173.

Foulden. pwd, screen panel, S6. 15⁴. Book in LH, cross-staff held diagonally. The ermine hem of her gown spreads across the bottom of the scene. No sign of dragon.

Ranworth. pwd, S retable, S4. 15⁴. Seated, gown falling over dragon; LH holding cross-staff diagonally, piercing dragon's mouth; open book with loose clasp in draped RH. The other 3 saints of the retable are also seated; Duffy fig 74.

Haveringland. *pwd, screen panel, N1. "S*ancta* Ma[r]gareta," NRO, Rye 17, 2:205.

Felbrigg. enamelled paten. 1480–1500/15¹ (Oman). Standing ?on/behind dragon; closed book in draped LH; Pevsner 1 fig 39a; Oman pl 36d; Manning pl facing 85.

Lynn. seal, Mayoralty. 15c. Beneath a canopy "supported by 2 carved side towers," standing on dragon, book in LH; Pedrick (1904) 93, pl 45.

Rushforth College. seal, *Index Monasticus* 50.

Hingham. sc, Morley Monument, L respond. 15²⁻³.

Norwich S Helen. sc, boss, S aisle ch (5). c1480.

With name scroll.

Norwich S James. sc, font stem. 15[3]. At S Mary Magdalene.

Norwich S Margaret. sc, spandrels N porch. Very dirty, no details clear; paired with cleric in religious habit.

Hemblington. sc, font stem. 15c. Book in draped LH.

Docking. sc, font stem, N face. 14/15c. Head missing but remains of crown and hair; in LH a long stave ending in a rectangular mass (?dragon's head); paired with Catherine.

Hockering. sc, font stem. 15c. Crowned, standing on dragon, cross-staff in RH; paired with Catherine.

Wiggenhall S Mary. wdcarv frag, be shoulder, nave S6. 15c.

Walpole S Peter. *im. 1504. Bequest for "gilding of Seint Margaret xxvjs. viijd.," Williams (1941) 338.

Upton. *im. 1511. Vicar's request for burial in the chancel before the im to which he bequeathed an embroidered "kercher" and new vestment "de le velvet," Hill 118.

Norwich S Stephen. *im. 1523. Alice Carre willed that her beads deck im on her feasts, Bl 4:154.

Sandringham. pg, nII.A4. 16[1]. Crowned, long hair; cross-staff in both hands; standing on dragon; "S*ancta* Margaret," Keyser (1917) fig 7A.

Worthing. *pg. 1535. Bequest for mending win (Richard Joye, NFK Gedney 69, Cotton personal communication).

Lessingham. *pwd, screen door. c1500. Crowned; in RH cross-staff piercing dragon's mouth; large open book in draped LH with writing held face out; ermine-trimmed gown and mantle, DT 33:163. Williamson (1957) found only 3 doors loose in the vestry, so this pane had already disappeared by that date.

Walpole S Peter. pwd, screen panel, N3. 16[1]. Burlet with single ouch, unnimbed; clasped book in LH; emerging from dragon; cross-staff piercing dragon's mouth, Briggs, il p 1013.

Wiggenhall S Mary. pwd, screen panel, N3. 16[1]. LH thrusting cross-staff into dragon's mouth.

Babingley. *pwd, screen panel. c1500. In demi-profile; cross-staff held diagonally, not im-

paling dragon, DT 53:74.

Repps. *pwd, screen panel. ?1553–8. Atypical, knobbed staff piercing dragon, palm in LH, wide ermine collar, no crown, DT 59:215.

Norwich SPM. *plate. 16[1]. Basin in blue enamel, with Catherine; Hope (1901) 213.

Shipdham. *sc. 1532. See *Catherine*.

Walsoken. sc, font stem. 1544. Cross-staff in LH impaled in dragon's mouth.

Norwich S Helen. wdcarv, be. c1519–32. Crowned and with hands joined, no attribute; (L) dragon's head at shoulder height, (R) tail at elbow height. Margaret emerging from the belly of the dragon; P & W fig 55; Rawcliffe fig 33.

Linnell cites 58 church dedications in Norfolk; Bond (1914) 261 for England. Farnhill cites 58 guilds. L'Estrange (1874) cites some 16 bells, the most common inscr being "FAC MARGARETA NOBIS HEC MUNERA LETA."

Ch at Hilbury; "At this day it is called by the neighboring people, the PILGRIM chapel" because it was on the route to Walsingham, Bl 6:118. Ch & relic at Yarmouth (1502), C Palmer 116. Mitchiner assigned a pilgrim badge found in London to Lynn S Margaret (Cat 551); Spencer (1990 Cat. 121) prefers Ketsby (Lincs). Altars at Aylsham (1368, Watkin 1:63), Wymondham (Bl 2:523, for location see Woodward pl 30).

Margaret of Hoveton (Hulme)

Martyr (†1170). 22 May. Young girl martyred at Hoveton S John; buried under high altar at S Benet's Abbey (*Index Monasticus* 2).

Pilgrimage site at Hoveton, Hart, 278.

Pilgrimage site at Horstead, Bl 10:445; Hart, 277. Linnell thinks that Horstead was involved in the *cultus* of this Margaret rather than Margaret of Antioch.

Margaret of Scotland

Queen of Scotland (1046–93). 16 Nov. Descendant of Anglo-Saxon royalty, Margaret was known for her piety.

Horsham S Faith Priory. wp frag. Mid 13c. (L of Crucifixion) queen, crown over veil, once identified as "almost certainly . . . St Faith herself"; since then David Park has entertained the suggestion that the flanking king and queen are Henry I, king during the Fitzwalter pilgrimage to Conques, and Margaret of Scotland, canonized in 1251, P & W 1; Purcell pl I; *Age of Chivalry* Cat. 263.

Letheringsett. Service book, see Watkin 2:xli.

Hardley is said locally to be dedicated to Margaret of Scotland.

Mark

Evangelist. 25 April.

E Anglia. ms, *The South English Legendary*, Bod L Tanner 17, marginal drawing, f 92v. Disheveled hair, holding open book, standing on lion; Pächt & Alexander 861 pl XXXII.

Martha

Virgin. 29 July. Sister of Lazarus and Mary of Bethany. One of 10 saints cited by Lydgate as special helpers. Both Martha and Juliana have the same attribute, a devil or devil on a chain or lead.

N Elmham? *pwd, screen panel. 15³. NRO, Rye 17 2:65v. Cited next to *Mary Magdalene. Martin also cites Juliana betw Sitha and Petronilla, her present position.

Horsham S Faith. pwd, screen panel, S5. c1528. Palm in LH, lead (?girdle) in RH, dragon defaced; chapelet in hair; "*Sancta* Martha"; the label, no longer visible, cited in NRO, Rye 17, 2:166.

Martin of Tours

Bp and confessor (c316–97). 11 Nov. His relics and pilgrimage site were at Tours. For grading of feast at Thetford 1, see Sandler, *Survey* Cat. 108; the monks had taken possession of their new priory on the feast of S Martin.

Narrative

Cathedral. sc, N cloister boss, J3. 1425–30. On horseback dividing cloak (sword lost) which he holds over beggar (R). In background are mounted figs in religious habits.

Thompson. seal, secular college, S Mary and All Saints. 14c. "Martin dividing his cloak with a beggar," *BM Cat. of Seals*, 4164; *VCH* pl 3, facing 436. Altar in ch, *Index Monasticus* 51. Parish dedication.

Individual

Diocese. ms, Stowe Breviary, BL Stowe 12, hi, f 324. c1322–5. Bp.

Cathedral. wp. Ante-Reliquary Ch, vault, S bay. c1300. Paired with Richard of Chichester, flanking Nicholas. E of central fig, frag of mitred head and crozier, (above) "S: MARTINVS," Tristram 230.

Norwich S Martin-at-Oak (Coslany). *im, Bl 4:485.

Harpley. pg, W win D5. 15c. Episcopal Mass vestments, crozier; "Martin e*piscopus*"; paired with Vincent. Appendix V.5.

N Tuddenham. pg, porch, E win light a. 15c. Mitre, red chasuble, appareled alb, tasseled gloves, crozier in LH; RH blessing; name at base of pedestal, "*Sanctus* martin*us*," Wdf (1935) il facing 226. See also *Nicholas.*

Marsham. *pg, N aisle, Bl 6:287.

Gt Plumstead. *pwd, screen panel. 15³. Bp in Mass vestments, ?trace of almuce, elegant gloves; crozier held diagonally on LS; RH with open book, pages lined; "*Sanctus* Martinus," DT 41:134; Winter (*Selection* 2:5) reproduced in Bond (1914) 69.

Norwich S James. pwd, screen panel. c1479. Bp in Mass vestments; crozier in LH, RH blessing. Now displayed at S Mary Magdalene.

Smallburgh. pwd, loose screen panel, mounted on wall. 15⁴. Defaced archbp in full Mass vestments; name at base, "Marti[n]*us*."

Wiggenhall S Mary? wdcarv, be S aisle, N9. Early 15c. Headless cleric in chasuble, goose beside; paired with S Edmund. Bullmore conjectured S Hugh if the animal is a swan.

Linnell cites 17 church dedications in Norfolk, incl 3 in Norwich; Bond (1914) 173 for England.

Guilds at New Buckenham (Bl 1:397), Hindringham (Bl 9:230), Thompson (*Index Monasticus*).

Mary Magdalene

22 July. In medieval literature a composite of 3 biblical figs. Represented with luxurious hair, she holds an ointment jar. In glass frags it may be difficult to distinguish the jar from Barbara's tower; see *Barbara* Cley.

Wiggenhall S Mary Magdalene. *im, light to burn before patron of guild. c1389. Firth 177.

Diocese. ms, hours, NMS 158.926.4f, hi, f 51 (Lauds, *memoriae*). c1310–20.

— ms, Stowe Breviary, BL Stowe 12, hi, f 276v. c1322–5. Book in LH, jar in RH.

Norwich, Hospital of S Mary Magdalene. *pcl. 14³. Lectern cloth with the image of Mary Magdalene; Watkin 1:33; earliest leprosarium in Norwich.

V & A. pg. c1320. Standing, hands clasped with fingers interlaced; demi-profile; no ointment jar. V & A notes cite the glass as from Norwich or vicinity. See X.4 *Matthew.*

Cromer. *pg, chancel. 1388. £10 bequest for a 3-light win with Christopher, Catherine, and Mary Magdalene; NCC Harsyk 107 (Cotton, personal communication).

Lynn, Hospital of S Mary Magdalene. seal. nd (founded 1145). Ointment box in RH, palm

in LH, flanked by keys saltire and arms of Trinity, *Index Monasticus* 54.

Irstead. sc, font stem. 14c. Luxurious hair.

Lynn, Benedictine Priory. *im. 1440. The Priory of SS Mary Magdalene, Margaret, and the virgin saints recorded 52*s* 6*d* in offerings to images, *Index Monasticus* 5.

Norwich SPM. *im and light, Bl 4:212.

Swaffham. *im, Bl 6:217 fn 4.

Stody. pg frag, sIV.A3. 1440–50 (King). Hand holding strand of hair. Appendix V.2.

E Harling. pg, E win 2a. 1463–80 (King). Hair cascading over RS to below hip length; holding strand of yellow hair in RH at waist level; massive jar resting on L forearm steadied by hand; ermine-lined mantle fastened with double morse; ermine hem of gown.

Field Dalling. pg, sIV.A3. 15³. Long strand of hair in RH; jar in draped LH. Appendix V.2.

Glasgow Burrell Collection. pg, rectangular panel *circa* 14" x 10". 15³. Strand of hair falling over LS to hip; massive jar resting on ?book held on palm of RH; gold-bordered white mantle over red gown; standing in a meadow; majuscule "M" above head; Marks 198 and fig 168; Wells (1965) Cat. 72. Provenance, N Norfolk; a paired Barbara in the New York Metropolitan Museum.

Pulham S Mary. pg, sII.A1. ?15⁴. Strand of hair in RH; top of massive jar in head segment; mantle turned back to create collar. Appendix V.2.

Burnham Deepdale. pg, tower patchwork win. Late 15c. RH pointing to jar in crook of draped LA; atypical jar, cylindrical with bands; button knob.

Martham? pg, sv.1a. Holding a tress of hair and in draped RH attribute; the self-contained segment is now a chalice; Dixon restoration. She has also been identified as Barbara, although there is no other Norfolk evidence for such an attribute; perhaps better classified as a generic virgin, presumably from the same win that originally held Petronilla, Juliana, and Margaret. This glass exemplifies persistent difficulties at Martham occasioned by restoration history.

Wiggenhall S Mary Magdalene. *pg, E win, "formerly . . . effigies of St. Mary Magdalene," Bl 9:170.

N Walsham. pwd, screen panel, S8. c1470. Holding strand of hair in LH, veil slipping from back of head; elaborate jar on palm of RH.

N Elmham. *pwd, screen panel. 15³. NRO, Rye 17, 2:65v. Cited betw *Martha & Barbara.

Thornham. pwd, screen panel, S8. 15⁴ (before 1488). Strand of reddish hair in LH; elaborate jar on palm of RH; ermine-lined mantle; inscr vertical scroll: "Tulerunt d[omi]n*u*m meum" (John 20:13); name below; paired with Lazarus. Restored.

Ludham. pwd, screen panel, N1. c1493. Luxuriant hair; jar in LH supported with R; same costume as paired female saint, Apollonia; (below) "Maria Magdalena."

Oxborough. pwd, screen panel frag. 15⁴. With jar, half the pane lost; now at E Dereham.

Hingham. sc, Morley Monument, L respond. 15²⁻³. Long hair; no clear attribute; so identified by James (*S & N* 141).

Norwich S James. sc, font stem. 15³. Crowned (as are all the women on the stem). At S Mary Magdalene.

Docking? sc, font stem. 15c. Williamson (1961) queried damaged fig.

Hemblington. sc, font stem. 15c. Long strand of hair in RH, remains of jar in LH.

Norwich S Mary Coslany. *im (in Marian ch, Bl 4:490). 1505. Bequest to "make glass window by Mary Magdalene on S side," C & C.

Lessingham. pwd, panel from screen door. c1500. Holding strand of hair in LH; jar in RH; ermine-trimmed gown and mantle; burlet with flower decoration; details from DT 33:166; the pane is badly disfigured; NMS.

Walpole S Peter? pwd, screen panel, S4. 16¹. Unnimbed, hair less luxurious than that of other female saints on screen; jeweled burlet, ermine-trimmed mantle fastened with single morse; holding flask-shaped bell (?jar with knob mistaken for ring-shaped handle of bell).

Garboldisham. pwd, screen panel, N3. c1500. Long strand of hair; jar in LH; label at either side of head, (L) "*sanc*ta maria" (R) "magdelena"; defaced.

Binham. pwd, screen panel, S6. c1500. Luxuriant hair; trace of gold jar in LH. (James suggested Mary of Egypt, *S & N* 171.)

Wiggenhall S Mary. pwd, screen panel, N1. 16¹.

Luxurious hair, jar in LH.

Weybridge Priory. printed calendar, NMS 134.944. 1503. Long hair; vessel.

Walsoken. sc, font stem. 1544. With jar.

Babingley? *pwd, screen panel.?1553–8. Luxuriant hair, jar in RH; (L) dove at head level as in the Annunciation; scroll in LH inscr "Recor—beate virg," DT 53:67. Keyser seems to have identified this saint as Bridget (Birgitta). This is not the only problematic pane at Babingley.

Repps. *pwd, screen panel. ?1553–8. Ointment jar in RH, holding lock of hair with LH, DT 59:212. Probably by the same artist as the preceding entry.

Wiggenhall S Mary. wdcarv, be niche, nave N5. 16[1]. Triangular headdress (similar shape worn by Cecilia, Burlingham S Andrew); LH resting atop jar in RH; Gardner fig 542.

Linnell cites 8 church dedications in Norfolk; Bond (1914) 187 for England. The Hospital at Thetford held a major fair on July 22 (Dymond 1:45). L'Estrange (1874) cited 11 bells, with 2 inscrs about evenly divided: "DONA REPENDE PIA ROGO MAGDALENE" and "O MAGDALENA DUC NOS AD GAUDIA PLENA."

Altar at Norwich S Stephen, 1368 (Watkin 1:20), 1498 bequest of 20s, jointly dedicated to S John (Bl 2:153).

Mary of Egypt

?5c. 2 April. Hermit in desert; her legend attributes an early life of prostitution in Alexandria to her before her conversion.

E Anglia. ms, *The South English Legendary*, Bod L Tanner 17, marginal drawing, f 85. 15[1]. Fully clothed, full-length hair, holding 3 loaves; Scott, *Survey* Cat. 45; Pächt & Alexander 861 pl LXXXII. Mary also appears in MSS with E Anglian connections: a calendar of a psalter of uncertain provenance (Herdringen, Fürstenbergische Bibliothek MS 8, Sandler, *Survey* Cat. 81) but decorated by the same hand that illuminated the All Souls Psalter (Sandler Cat. 82) whose calendar suggests an E Anglian destination. The calendar of Fürstenbergische Bibliothek MS 8 contains a number of other saints typical in the Norwich diocese.

Guestwick? pg frag sV.1b. 15[3]. Bare foot protruding under from full-length waving hair. Second frag, a hand holding a lock of hair; **FIG 20**.

Weybridge Priory. printed calendar, NMS 134.944. 1503. Naked bust.

Matilda

Identity uncertain; possibly Mercian abbess (†c700), Mechtilde of Hackeborn, Mechtilde of Magdeburg (both 13c German mystics).

Lynn. Guild. 1371. Owen, 326.

Maurice

Martyr (†c287). 22 Sept. Soldier-saint who refused to take part in killing of Christians.

Yarmouth. 1502. Relic of "St. Maurick, in copper," Bl 11:367; C Palmer 116.

Wellingham. pwd, screen panel, N1. c1532. Paired with Sebastian. Youth with green burlet with 2 ouches; elaborate armor with mantle and ermine collar, and chain of office over shoulders; holding sword & spear, both point up; standing on recumbent man wearing chain of office; "*Sanctus* Ma . . ." on scroll at stem of pedestal. Despite the lack of agreement on the identification of this saint, the pairing with Sebastian suggests that he was an early martyr and that the recumbent fig was the persecuting emperor. Like Catherine, who is similarly represented, Maurice refused the commands of the emperor. The chain of office corresponds with his role as military leader. Although the first 2 letters of his name seem clear today, Martin did not identify him, citing merely "a Knt armed cap a pied with a sword . . . spear . . . & king under his feet," NRO, Rye 17, 4:85. Nicholas Rogers has suggested Mercurius, rather than Maurice.

Church dedication at Briningham (S Mary in 1505, Linnell); Bond (1914) 8 for England.

Médard

Bp of Vermandois and confessor (c470–c560). 8 June.

Wiggenhall S Mary Magdalene. pg, nV.A1. c1450. In figured gown with sword over shoulder; name misplaced. Appendix V.5.

Unique church dedication at Little Bytham in S Lincolnshire (Cotton personal communication).

Michael

Archangel. 29 Sept. In battle with devil as dragon; armor or surcoat emblazoned with gold cross. Often paired with S George. For weighing of souls, see IX.3.

Norwich S Michael Tombland. *im. c1100. Stone cross marking the spot where demolished ch had stood, Bl 4:117; "in eius summitate ymaginum S. Michaelis pul-

cherrimam," *Registrum primum*, quoted by Stewart 22.

Norwich Austin Friars. seal. 13c. Michael in combat, *BM Cat. of Seals*, 3771; mid-14c, *Index Monasticus* 43; *VCH* pl 3 facing 436; see also Manship pl 1.1.

Aylsham. sc, spandrels of piscina. Late 13c. Church dedication.

Wormegay. *im. 14c. Painted niche E wall, curtains hanging from rings; stone stool hacked off; church dedication.

Norwich Blackfriars New House. *im. 14⁴. *Index Monasticus* 38.

Diocese. ms, hours, NMS 158.926.4f, hi, f 45 (Lauds *memoriae*). c1310–20. Generic angel.

— ms, Stowe Breviary, BL Stowe 12, hi, f 305. c1322–5. No wings, standing on dragon, piercing with lance.

Ryston? sc, niche S porch (14c). "A cinquefoiled niche with figure," P & W 2. Garment with tight sleeves, double skirt; crowned; sword grounded, no dragon. Although well covered with lichen, the atypical composition suggests that the statue may not be medieval. Church dedication.

Crostwight. *wp, pier S side of chancel screen. Late 14c. Michael and Satan, DT 54:120.

Norwich S Michael-at-Plea. *im, "a hanging branch of lights burning before St. Michael"; burial before im; Bl 4:325, 327.

Hingham. *im, light before, Bl 2:423.

Lt Poringland. *im. "In the Chancel in the usual place for *imago principalis*," Bl 5:445; church demolished.

Shipdham. *im, tabernacle cited, Bl 10:248.

Besthorpe. pg, sVI, not *in situ*. 15¹ (Dennis King, unpublished notes). In contrapposto; surcoat with cross fleury; knight's girdle with misericord, armor hinge at R elbow; shield in LH, RA raised; dragon's tail wrapped round L leg; **FIG 19**. Originally paired with George. Atypical features: Roman nose, prominent toes.

Ketteringham. pg, E win A8. 15c. Standing on dragon, thrusting spear through muzzle of dragon; amber feathered legs; upper body lost; paired with George at A1.

Sparham. *pg, S win, "Sanct*us* Micael . . . much broken," NRO, Rye 17, 3:216.

Outwell. *pg, N aisle E win, "with the triangular emblem of the Trinity on his breast," Bl 7:472. Probably paired with George.

Ranworth. pwd, screen panel, S parclose. 15³. Bare feet and legs, feathered upper legs, RH raised with sword over head, LH holding shield; standing on seven-headed dragon attacking shield, 2 heads falling, another neck headless; over breastplate long white-lined mantle with ermine collar, diadem with rising flowers; long white sash wound at hips with one floating end superimposed on dragon tail (no head); paired with George. Constable il pp 142, 143 (good view of entire parclose screen); Duffy fig 109; P & W 1 fig 49; Robinson color il betw 126 & 127.

Gressenhall. pwd, screen panel, S aisle, not *in situ*. 15³⁻⁴. Double set of wings; sword in LH raised above head, remains of shield; standing barefoot on dragon, tail-head with tongue protruding; drops of blood falling from dragon's neck. Originally N4, NRO, Rye 17, 2:173.

Norwich. seal, Thomas Mark, Archdeacon of Norfolk (1459–76). Michael and dragon. *BM Cat. of Seals*, 2113

— seal, Archdeaconry of Norfolk. 1494 and 1589. *BM Cat. of Seals*, 2114–5.

— seal, Commissary of the Archdeacon? nd. *BM Cat. of Seals*, 2112.

Norwich All Saints. sc, font bowl. c1448 (C & C). Standing on dragon, sword impaling dragon; paired with George on the same panel; Gardner fig 524; now at S Julian.

Gt Cressingham. sc, niche S porch. 15² (C & C). Damaged, but armor and wings still distinguishable; standing on pedestal; crowned M and sword in flushwork; church dedication.

Hingham. sc, Morley Monument. 15²⁻³. R respond, so identified by James, *S & N* 141. George also on R respond.

Colby. sc, relief. 15c. Spandrel S porch, paired with George.

Hockering. sc, font stem. 15c. Standing on dragon impaled with his spear; restored.

Reepham. sc, boundary? cross. 15c. Paired with Andrew.

Gt Ellingham. wp frag, S wall win jamb. 15c.

Wells-next-Sea. *wp. 15c. 2 sets of wings; ermine collar with double morse over armor emblazoned with red cross, large sword over RS, DT 49179; same pattern at Worstead.

Worstead. *wp. 15c. 2 sets of wings; ermine

collar with double morse over armor emblazoned with red cross, shield similarly emblazoned; huge scimitar in RH over RS, DT 49:55. The red cross suggests George rather than Michael, but the figs at Wells-next-Sea and Worstead are winged. "The walls were covered with paintings," destroyed 1838, Keyser.

Norwich S Peter Parmentergate. ?wdcarv/pwd. "On the screens is St. Michael and the dragon," Bl 4:96.

Cathedral. wdcarv, misericord, N11. 15[1]. 3 sets of wings, barefoot, attacking 7-headed dragon, with sword swung behind his head; Rose (1994).

Emneth. wdcarv, wall post, S4. 15c. Thrusting spear into dragon with both hands.

Cawston. gesso, screen mullion, c1490–1510. Same mold used at Aylsham and Marsham, Strange 82.

Aylsham. gesso, screen mullion. c1500.

Marsham. gesso, pwd, screen mullion. c1503–9.

Foulsham. *im. 1532. Bequest to paint tabernacle (Cecily Hawe, Bacon f 180, Cotton personal communication).

Sandringham. pg, nII.A1. 16[1]. Cross diadem on head; shield in LH, RH in gauntlet, driving cross-staff into mouth of dragon; dragon grasping leg with claws; "S[an]c[t]*us* Michaell," Keyser (1917) fig 8B.

Binham. pwd, screen panel, S1. c1500. Crowned, red armor with white cross, spear held diagonally in both hands, piercing dragon lower L; trace of wings; Robinson il p 89. Plummer has identified the face as the work of the same artist who did S Ambrose at Cawston.

Norwich Michael-at-Plea. sc, spandrels S porch. 16[1]. Badly worn.

Foulsham. *sc. 1532. Bequest to paint S Michael's tabernacle (Bacon f 180, Cotton personal communication).

Shotesham All Saints. wp, N wall. ?16[1]. Very faint.

Aylsham. wdcarv, screen spandrel, N8. c1500. Feathered, in chest armor, with sword and shield; dragon with ravening mouth; above Peter, DT 24:141.

Norwich S Peter Parmentergate. wdcarv, screen. ?16c. Spandrels N side.

Linnell cites 43 church dedications in Norfolk; Bond (1914) 686 for England.

Chs in Cathedral Chapter House (Fernie & Whittingham 1972), Lynn S Margaret (before 1314, Owen 131); ch and altar Norwich S Helen (Rawcliffe 129).

Lights at S Creake 1491 (Robert Norton, Norf Arch Bk 1, f 173), Stratton Strawless (Harrod [1847] 117).

Nicholas

Bp of Myra and confessor (4c). 6 Dec. A popular saint with numerous chs dedicated to him incl ones at the Cathedral Priory (?infirmary chapel) and Norwich Castle; some without trace like that in the N transept of the college of S Mary in the Fields, others with survivals of parclose screens inscribed with N (Castle Acre). Yarmouth had a relic of "the oil of St. Nicholas" (Bl 11:367).

Narrative

Diocese. ms, Stowe Breviary, BL Stowe 12, hi, f 225. c1322–5. *Tres Clerici*: bp blessing 3 boys in tub.

N Lopham? *pg, S win, chancel. nd, "a bishop, in his pontificalibus, is represented as dead, lying alone," Bl 1:233; titular saint.

Ingham. *pwd, retable, 4 miracles in 3 panels. c1390. **1** *Tres Clerici*, upper register: (above L) innkeeper and wife at inn door welcoming 3 tonsured youths, 2 carrying large bags; (R), 3 youths in bed, their clothing hung on rack; all bleeding from cuts in heads, innkeeper's wife standing by bed, rod (?knife) in hand, innkeeper with raised axe. Lower register (bottom missing when drawings made): (L) innkeeper and wife at inn door, innkeeper with bone in hand, Nicholas, crozier in LH, extending RH to innkeeper; (R) Nicholas, crozier in LH, RH on breast before 3 clerks standing in pickling tub. **2** *Consecration of Nicholas and Miracle of the Bath.* Upper register: (C) 2 bishops in Mass vestments, each with attendant cleric, flanking Nicholas similarly vested with hands at breast, seated on wide throne; (L) bp placing mitre on his head; (R) woman in veil observing consecration, both hands raised; (L) woman, veil now on her shoulders, holding hair at both sides of face (distress over child forgotten in the bath); lower register: (upper L) in blue nebuly bust of Nicholas with RH raised; (below L) figs (?devils) beside bath set over fire; mother lifting child from bath; (R) youth in fashionable dress with LA raised (in testimony of miracle); mother seated, nursing child. **3** Upper register: *Dowries* (upper L), 3 angels in nebuly, (below) tonsured cleric in alb, closed book in RH,

crozier in L; Nicholas in full Mass vest-
ments standing at doorway with open box
of gold coins from which he showers 10 on
foremost of 3 maidens within the house; in
bed shrouded mother (eyes closed), and
husband (naked) sitting up with hands
joined. Lower register: *Rescue at Sea* (L)
tonsured cleric in surplice with open book
in LH, crozier in RH; frag of Nicholas,
mitred and in Mass vestments; (far R) 4
heads, broken mast of ship with demon in
rigging (C and lower section of panel
missing). Park (1988) il p 134; Lee-Warner
betw 208–9. NMS 134.944. B92.235.951,
B100.235.951, B93.235.mm951.

Potter Heigham. wp, N aisle. c1380. *Tres Clerici*
second register (C), small figs in tub,
praying with hands upraised, (R) trace of
fig with nimbus, hand above tub; Tristram
237; church dedication.

Rushall. *wp. 14c. Consecration of Nicholas,
"perhaps part of a 'history' of the saint,"
Keyser; "two bishops consecrating a third
in a church; a female figure at the side"
(?Miracle of the Bath), letters S. N. above,
"Extracts" 6:381.

Cathedral. sc, N cloister bosses. 1427–8. **G2**
Miracle of the Bath: (below) child in tub,
mother beside; (above) Consecration of
Nicholas: bp seated on throne, flanked by 2
clerics, **FIG 35**. **G8** Rescue at Sea: devils
above and below storm-tossed ship, 4 men
kneeling in prayer in boat, Nicholas at
prow.

Individual

Yarmouth. seal, municipal. 13c. Archbp seated,
blessing, crozier in LH, *BM Cat. of Seals*,
5533–4; flanked by censing angels,
Manship pl 1.1. Parish dedication.

Norwich Blackfriars, New House. *im, 14[4].
Index Monasticus 38.

Diocese. ms, hours, NMS 158.926.4f, hi, f 50
(Lauds, *memoriae*). c1310–20. Bp.

Cathedral. wp, Ante-Reliquary Ch, vault, S bay.
c1300. Central fig flanked by Martin and
Richard of Chichester. Frag only, nimbed
mitred head (?unbearded) and crozier,
Tristram pl 12a; inscription above "S:
Nichs." It is likely that the recorded relic of
Nicholas was housed in this chapel; Beech-
ing 16.

Diss. *im. 15[1]. Guild built separate ch, Bl 1:32-3;
legacy for tabernacle, Bl 1:21.

Norwich SPM. *im, N transept. 1445. Bequest of
£10 to glaze the E win over S Nicholas'
altar, "by which the image of that saint was
placed," Bl 4:204. Chantry established
1328.

Needham. *im. 1469. New tabernacle for S
Nicholas altar, Bl 5:384.

Norwich S Helen. *im, Lady ch. 15[4]. Also a
second picture, Rawcliffe 131.

Upton. *im. 1479 and 1505. Bequests for the "re-
pair of the image and tabernacle of St.
Nicholas, Bishop," and "paynting and gild-
ing of the tabernacle," cited in Hill 114,
116.

Norwich S Peter Parmentergate. *im. 1499.
Bequest of "scarlet gown, and cloth for a
robe," Bl 4:93.

Caston. *im, light before, Bl 2:282.

Fundenhall. *im. Guild held "before his image,"
Bl 5:174.

Gooderstone. *im and light, Bl 6:63.

Hingham. *im. Light before; altar dedication, Bl
2:423.

Norwich S Andrew. *im with tabernacle, Bl
4:305.

Norwich S James. *im, Bl 4:424.

Norwich S Laurence. *im and tabernacle, Bl
4:263.

Norwich S Michael-at-Plea. *im, Bl 4:325.

Norwich SPH. *im, light before, Bl 4:325.

Norwich, Brakendale. *im. 1428 (*Index Monas-
ticus* 70). Parochial ch "on a hill, which was
much frequented by fishermen and water-
men, who used to come hither to offer to
good St. Nicholas, their patron saint, to
whose honour this ch was dedicated," Bl
4:223.

Swaffham. *im, Bl 6:217 fn 4. In 1517 the Guild
of S Nicholas contributed to the repair of
the E win in the steeple; Rix 32.

Tacolneston. *im, "new tabernacle for St. Nicho-
las altar," Bl 5:384.

Tibenham. *im. Will reference to S Nicholas of
Tibenham, Tanner 86; in 1506 bequest for
paving ch; C & C.

W Acre. *im. Bequest for pilgrimage, Hart,
277–8.

N Tuddenham. pg frag, porch, W win, light b.
15c. "[San]c*tus*:nicolau." Perhaps an ec-
clesiastics set; see Martin.

Brandiston. *pg, "in a window of the chancel,
the figure of St. Nicholas [blessing, crozier
in LH] under it a woman kneeling, in a

scarlet gown, and a girdle of gold with this label: 'Serve Dei Nicholae, mei Christo memor esto'," Bl 8:197; details and woman sketched in NRO, Rye 17, 1:140. Church dedication.

Caston. *pg, "St Nicholaus," NRO, Rye 17, 1:199.

Hoe. *pg, chancel, NRO, Rye 17, 2:257.

Stody. *pg. Citation in Frere MSS NRS 1:37.

Norwich Guildhall. *pg, nII. Name only remains. Kent notes (n.d., 14) that parish clerks assembled every Dec 6 at S Barbara's Ch for a special Mass. He connects a frag of scribes sitting at a table with the original win.

Norwich S James. pwd, screen panel. c1479. Bp in Mass vestments; crozier in RH; "Sanctus nicholas" below. Now on display at S Mary Magdalene.

Lynn S Nicholas. sc, W front, so identified in M & R 3. In 1997 this statue was missing. A 19c watercolor of the W front shows no statue (Patricia Midgley, personal communication.)

Gressenhall. seal, College of S Nicholas (Secular Canons). nd. Nicholas as bp, *Index Monasticus* 48.

Eccles. *wp,"formerly painted on walls," Bl 1:410.

Lynn S Nicholas. wdcarv, roundel in poppyhead. c1419. Against a radiance and nebuly, nimbed bp seated; (R) ?tub; Pevsner 2, pl 33b.

Old Buckenham. *im. c1505. Richard Towler buried before, Bl 1:397.

Litcham. *im. 1507 will, light before image, Harrod (1847) 259.

Norwich SPM. *emb pall. 16¹. Hope (1901) 193.

Gt Witchingham. *cope. 1556. S Nicholas cope, crimson velvet with gold images, Bl 8:310.

Weybridge Priory. printed calendar, NMS 134.944. 1503. Bp.

Linnell cites 29 church dedications in Norfolk; Bond (1914) 437 for England. L'Estrange (1874) cites 4 inscr bells.

Altars at Cawston, Field Dalling; Lynn: S James (Richards 416), S Margaret (Owen 126); Middleton; Norwich: Cathedral, 1298 (Kirkpatrick, 1816, 44); S Saviour, ch and altar; burial before, 1372 (BL 4:445); S Stephen (Watkin 1:52, 1:85, 2:121, 1:3, 1:20). Ridlington (NRO Rye 3:264); Stow Bedon, 1505 "to make a glass window by S Nicholas altar" (C & C). Lights at Ashmanhaugh, Buckenham S Nicholas (Bl 7:215), S Creake 1451 (John Norton, NCC Aleyn f 74),

1491 (Robert Norton, Norf Arch Bk 1, f 173), Freethorpe (Bl 7:232), Horsford (Bl 7:437), Lessingham (Bl 9:329), Norwich S Peter Southgate (Hale 23), Outwell (Bl 7:473), Stratton Strawless (Harrod [1847] 117). Nuns at Shouldham held an annual fair at Stoke Ferry on the feast of Nicholas (Gilchrist & Oliva 28).

Boy Bishop

For an account of boy bishop celebration at the Cathedral, see Bl 4:41.

Norwich SPM. vestments for the boy bishop. 14³. See above for the ch of S Nicholas. 4 copes and "una mitra magni precij cum baculo pastorali," altar cloths and 4 riddels; Watkin 1:3. Perhaps the same copes cited in the next century: "iiij copis for Childern of corse vorke chekerd of reed & wight . . . cope for the boy that is the bushope paned yelow & blew," with matching vestment for the priest, Hope (1901) 200, 204, 239.

Norwich S George Tombland. 14³. 2 copes "pro pueris," Watkin, 1:10.

Thetford Priory 1. The register has a number of 16¹ costs related to the boy bishop but without specification (Dymond *passim* and Galloway & Wasson 105–13).

Nicholas

Pope 858–67.

Wiggenhall S Mary Magdalene. *pg, "In the east window is the broken effigies of St. Nicholas the Pope on his throne," Bl 9:140. "Sancte Nicholaus" cited without comment on medium or site, NRO, Rye 17, 3:55; Appendix V.4.

Nicomedes

Martyr at Rome (nd). 1 June.

Dunston. pg frag, sIII.1a. c1450. Beardless youth in appareled amice; frag of instrument of martyrdom (spikes set in triangular head on stave); head (perhaps from SPM) and fragment of instrument of martyrdom set in new composition.

Weybridge Priory. printed calendar, NMS 134.944. 1503. Bludgeon on end of stave.

Olaf (Olave)

King of Norway and martyr (995–1030). 29 July. Olaf appears in calendars and litanies from the early 14c in Norwich MSS (see Sandler, *Survey* Cat. 47, 108). For the typical loaf held by Olaf, see Cheetham Cat. 74. The loaf (Appendix V, **FIG v**) is the most common attribute in Norfolk, although the battle axe is also found and appears in the seal for Priory of S Olave (Suf).

Norwich, Carrow Priory. ms, Carrow Psalter, Baltimore, Walters Art Gallery W.34, hi, f 42. 1250–60. 6 medallions with the life of saint: Olaf instructed by angel; miraculous sailing through rock; death; priest maimed; priest healed by Olaf; Olaf seated; Morgan, *Survey* pt 2, Cat. 118 il no. 105.

Lyng. emb orphrey frag. c1480. King with scepter and battle axe, DT 33:188.

Wiggenhall S Mary Magdalene. pg, nIII.A5. c1450. Composite male fig, hand holding loaf of bread.

Heacham. pg, nIV.B3. 15c. Crowned, forked beard; halberd in LH; large round loaf in palm of RH; see *Edward*.

Hoveton S John. pg frag, nII, light b. 15c. A graceful hand holding 3 loaves, garment with large gold star; shape of loaf like that at Barton Turf.

Stockton? pg frag, sII, light b. 15c. Head missing, in ermine-lined mantle, large round object in RH, atypical loaf, Keyser (1907a) pl XXI.

Barton Turf. pwd, screen panel, S aisle 4. After 1471. Parted beard; docked bread (?2 loaves) in RH; halberd in LH; ermine collar over ermine-lined mantle; scroll inscr "*Sanctus* Holofius," Constable il p 215; Gunn & Winter fig D; Camm color pl LVII. S Olave's bridge is visible from the hill on which the church is built.

Catfield. pwd, screen panel, N6. 15^4. Halberd in LH, RH raised, gold stylized leaf (?scepter finial) betw fingers; gold belt hung from hip, ermine collar, ermine-lined mantle.

Stalham? sc, font stem. 15c. Williamson (1961) identified a battle axe held by king, "possibly St. Olaf."

Outwell. pg, sIII.B2. 16^1. Loaf in LH, scepter in RH.

Babingley. *pwd, screen panel. ?1553–8. ?Battle axe in RH; ?large loaf in LH, DT 53:66.

Linnell cites 3 church dedications; a parochial ch at Methwold; Norwich S Olave Colegate consolidated to S George Colegate in 1546 and demolished (Bl 4:475); S Olave in Conisford added to S Peter Southgate before 1345. Bond (1914) cited 13 dedications for England. Ch (S Toly, Bl 11:366) and altar at Yarmouth; offerings noted for 1384–5, Morant (1872) 222, 231. Guild at Norwich S Olave (*Index Monasticus* 73); Tanner (210) cites one without site specification (1490–1516).

Osith (Osyth)

Martyr, Anglo-Saxon princess (†c700). 7 Oct. Founded a convent at Chich, Essex.

Fakenham? light, Bl 7:96. Taylor conjectured Sythe (*Index Monasticus* 72) and Farnhill so identifies the guild citation (Sitha). Neither names (see Sutcliffe) nor attributes mutually exclusive, a key being used for both (see Spencer [1980] Cat. 118), and Osith is represented with beads (and rock) in the Heller Hours, possibly made for an E Anglian patron, Scott, *Survey* Cat. 126. A number of other female saints popular in Norfolk appear in the MS, incl Barbara, Dorothy, and Ursula. For litany citation, see Sandler, *Survey* Cat. 47.

Oswald

King of Bernicia and martyr (†642). 5 Aug.

Norwich SPM. pg, E win E7. Mid 15. Sword over shoulder; name inscr; king set; see King, forthcoming.

Horsham S Faith. pwd, screen panel, N2. c1528. Crowned, scepter in LH; clasped book held by spine in RH; ermine collar, cuffs, and gown lining; gown mid-calf and slit like a dalmatic; red stockings; "*Sanctus* Oswald*us*," NRO, Rye 17, 2:266.

Oswin

King of Deira (644–51) and martyr. 20 Aug.

Norwich SPM. pg, E win E1. Mid 15. Bearded; name in B7; king set; see King, forthcoming.

Paul the Hermit

Norwich hospital dedicated to S Paul the Apostle and S Paul the Hermit (Bl 4:430).

Peter Martyr (Peter of Verona)

Dominican martyr (1205–52). 29 April. Convert from Catharism. Images of Peter Martyr and Dominic were required in all Dominican churches.

Thetford Priory 2. pwd, retable. c1335. Paired with Dominic; both in Dominican habits; cross-staff in LH, book in RH; dagger on head; blood from chest wound staining habit; now at Thornham Parva (Suf); *Age of Chivalry* Cat. 564.

Norwich Blackfriars. *im. 1466. Kirkpatrick (1845) 38.

E Anglia. ms, *The South English Legendary*, Bod

L Tanner 17, marginal drawing, f 93v. 15[1]. Dominican habit, belt and scapular, ?book box suspended from belt by looped cord, holding bloody sword and clasped book; dagger piercing chest, head wounded and bleeding.

Old Buckenham. pg, sVI.B3. 15[3]. Dominican habit; large sword held by hilt, resting against RS; thin staff in LH; short dagger plunged into side under scapular, drops of blood; blood stain on head; dark mantle and tippet over white habit.

Threxton. pg, nIII.2b. 15c. "S petr' de meleni [Milan]," label only; provenance uncertain; **FIG 36**.

Petronilla (Petronella, Pernele)

Virgin martyr (nd). 31 May. Popularly believed to be the daughter of S Peter. Identified by key(s), typically held with the wards up.

Cathedral. 1234, relic in casket (Beeching 17). 1386, first donations recorded, continued intermittently (Shinners 138). 1404, im painted, 5s 6d, "Extracts from Account-Rolls" 208.

Stratton Strawless. *im. Cited as pilgrimage site (Pernele) in will, Bl 10:445; 1490, light (Harrod [1847] 117).

Martham. *pg tracery, S aisle. c1450. In RH 2 small keys on a string, wards down; clasped book in LH; white mantle over damask gown. "In the other top compartments are also portions of female saints"; when the drawing was made, Margaret was next to Petronilla, DT 59:150. Appendix V.1.

Cley. pg, sIX.A4. 1450–60. LH holding a key by handle; RA across breast. Appendix V.1.

Sharrington. *pg, N win. Frere MSS, NRS 1:37. Appendix V.1.

N Elmham. pwd, screen panel, S6. 15[3]. Large key in RH, clasped book in draped LH; damask gown, distinctive gold braid with clasp at neckline of mantle (2); name below.

Litcham. pwd, screen panel, N6. c1500. LH with key, book in RH.

Smallburgh. pwd, screen panel, hung on N wall. 15[4]. RH with palm; LH with key; burlet with 3 ouches, ermine surcoat.

Trimingham. pwd, screen panel, S1. c1500. LH with key, clasped book in RH; burlet, mantle with morse.

Weybridge Priory. printed calendar, NMS 134.944. 1503. Nimbed bust of female holding key.

Altar at Yarmouth, Morant (1872) 222.

Prosdecimus (Prosedocimus)

Protobp of Padua and confessor (c103). 7 Nov.

Wiggenhall S Mary Magdalene. pg, nVI.A4. c1450. In chasuble, mitre, name scroll in hand. Appendix V.5.

Protase and Gervase

Proto-martyrs of Milan (nd). 19 June. Unique English dedication at Lt Plumstead (Bond, 1914).

Puella Ridibowne (Ridebourne)

Identity uncertain (James *S & N* 21), as is the site for pilgrimage. Tanner (85) conjectures Redbourne in Lincolnshire or Hertfordshire, and Farmer suggests Puella is Christina of Markyate. Gregory Clerk, mayor of Norwich 1505/14, left a bequest for pilgrimage to Our Lady of Redybone (NKF Batman 84, Cotton personal communication).

Gateley. pwd, screen panel, N4. 15[4]. Nun with open book in one hand, spray of flowers in other; wimple, black mantle over gown (same costume worn by Etheldreda at N1); name on pedestal, "SANCTA:PUELLA:RIÐI-BOWNE." For a similar spray of flowers, see *Dorothy* Trimingham.

Hackford. *im. In 1516 Giles Clerk of Hackford left 4d for a light to "the good maide Redybowe" (NFK Bateman 84, Cotton, personal communication).

Babingley? pwd, screen panel. ?1553–8. Holding spray; DT 53:65.

Redybone ch at Cromer (1509 will of Henry Bacon of Thurgarton, Cotton personal communication).

Quirinus

Identity uncertain; perhaps the martyr venerated in Normandy. 11 October in Benedictine calendars. Perhaps the martyr Quirinus of Neuss (Spencer, 1990).

Norwich Blackfriars, New House. *im. 14[4]. *Index Monasticus* 38. Kirkpatrick (1845, 38) also cited 1505.

Radegund

Queen and abbess at Poitiers (518–87). 13 Aug. Her convent was a scholarly center.

Coxford Priory. Ch dedication, 1463, *Index Monasticus* 22.

Guilds at E Rudham (appropriated to Coxford prioress, Bl 7:157); Coxford Priory.

Remigius

Bp of Reims and confessor (†533). 1 Oct.

Dunston. pg, sII.2a. 14c. Flat mitre, full Mass vestments, LH raised; (above) "S Remigi"; (lower R) donor in blue habit and white wimple, hands raised, Lady Margery de Creke, originally with scroll reading "Priures Flxtune"; restored. Martin's drawing shows the bp blessing with RH, crozier in LH, NRO, Rye 17, 2:53.

Linnell cites church dedications at Dunston, Hethersett, Roydon, Seething (jointly with S Margaret), and *Testerton (Bl 7:200); guilds at Hethersett (*Index Monasticus* 72) and Testerton.

Richard Caister

†1420. Vicar of Sedgeford (1397) and Norwich S Stephen (1402–20), where his tomb became a place of pilgrimage (Bl 4:147); known as Caister the Good. For his hymn see *Index of Middle English Verse* 1727.

Lynn. pilgrim badge. After 1420. Caister in academic dress, preaching in wine-stem pulpit, dove at ear, "surrounded by the inscription *Mr. Cast of Norwiche*," Spencer (1980) Cat. 110. An identical complete badge found at old London Bridge; also found at Salisbury (Spencer [1990] Cat. 96), one version showing Caister within an R framework (1990 Cat. 97, and 1998 Cat. 209d).

Lynn/London/Salisbury. pilgrim badge. After 1420. Frag of preacher with dove, God the Father above; inscr "*soli deo honor* [et amor et gloria]," Spencer (1980) Cat. 111. The same badge has been found at London (Mitchiner, Cat. 576) and Salisbury (Spencer [1990] Cat. 93–5). Spencer (1990) connects the motto with possible Cathedral Priory sponsorship of the Norwich shrine (Cat. 97); see 1998 (Cat 209) for summary of badge types.

Richard of Chichester (Wych)

Bp of Chichester (1245–53)) and confessor (b. 1197). 3 April.

Cathedral. wp frag. Ante-Reliquary Ch, vault, S bay. c1300. Paired with Martin, both flanking Nicholas. Nimbed mitred head; crozier in LH, RH blessing; foot and lower part of alb and chasuble; blue drapery. Inscr above "S: RICHARDUS: CICES . . . ," Tristram pl 12b.

Norwich All Saints. pg, nII.A6. Late 15c. Scroll inscr "*Sanctus* Rich."

Robert of Bury St Edmunds

Boy (1171–81) purportedly killed by Jews. Unofficial cult.

Norwich SPM. *im, ch of S Anne. 1526 (burial before). There were "pilgrimages sometimes made to St. Robert here," Bl 4:207; will references in Woodman (1995).

Erpingham. *pwd, screen panel. "12 images painted, the last on the south side hath a child over it, to which it is praying in these words, 'Sancte Roberte Succurre mihi Pie'," Bl 6:412. Keyser cites "St. Robert Confessor, and other Saints," presumably based on Husenbeth's identification (1882, 181).

Roch

Confessor, hermit (c1330–c1380). 16 Aug. Shown with plague sore on thigh. Lessingham, Stalham, and N Tuddenham were in areas with endemic disease (Gottfried, Map 2).

S Acre. *pg, N clerestory. ?14^{3-4}. "S[an]c[t]us Rochus," Bl 6:81. When described, the feet of Roch were preserved.

S Lopham? wdcarv, be. 15^{3-4}. Gardner (1955) 37.

Stalham. pwd, screen panel, chancel, S wall. Late 15c. L stocking rolled to knee exposing thigh and long wound, gown held back by LH; staff in RH; small purse suspended on a cord over LS. In the 19c paired with a *Resurrection, DT 44:163.

N Tuddenham. pwd, screen panel, S4. 1499–1504. RH holding short gown to reveal wound on L leg; staff in LH, pilgrim's hat at back; knee-high boots; Duffy fig 71.

Horsham S Faith. pwd, screen panel, N4. 1528. Beardless, prominent mantle, RH extended; variously identified, but Martin cited name now lost, "*Sanctus* Rochus," NRO Rye 17, 2:266.

Wellingham. *pwd, screen panel. c1532, "a pilgrim with a pouch & staff on his hat [*sic*] R . . . & worms on his R thigh with an angel holding away his garment & exposing the worms, etc.," NRO, Rye 17, 4.83; paired with S Antony.

Lessingham. pwd, screen, N1. c1555. Seated; helmet-like hat; mantle secured with 3 buttons at L side; staff in RH; small fig in white (angel) pointing to nearly obliterated leg; L & M Cat. 92; now NMS. The painting is on paper pasted over a mutilated ori-

ginal apostle. The 1555 plague in Norfolk supports the argument that the new work was a Marian attempt to restore the defaced screen.

Little Massingham. *im. 1518 "I bequeth to the chirche of Litell Massynghm an Image of Seynt Roke," Harrod (1847) 269.

Ch at Walsoken (1512, *Index Monasticus* 69).

Rodiburt
Identity uncertain.
Marsham. light, Bl 6:287.

Romanus
Bp of Rouen (630–c640) and confessor. 23 Oct.
Wiggenhall S Mary Magdalene. pg, nVI.5. c1450. Bp, seated, cope; book in LH, name scroll in RH; "S romanus"; Appendix V.5.

Samson (Sampson)
Bp of Dol in Brittany and confessor (†565). Welsh by birth, he was especially remembered in Cornwall. 28 July.
Wiggenhall S Mary Magdalene. pg, nVII.A4. c1450. Bp, seated, chasuble; crozier in RH, book in LH; "Sanctus Samson'," Keyser (1907b) pl XI; Appendix V.5.

Scholastica
Virgin, first Benedictine nun, sister of Benedict (†c543). 10 Feb.
E Anglia. *The South English Legendary*, Bod L Tanner 17, marginal drawing, f 21. 15[1]. Benedictine habit, holding book, telling beads.
Wiggenhall S Mary? pwd, screen panel, N4. 16[1]. Black veil, wimple, red mantle, identification suggested by Keyser (1907b). But she may equally well be one of the other nuns represented elsewhere.
Erpingham? sc, font bowl panel. ?Mid 15c. Nun seated on wide bench, holding scroll. Heavily remodeled, opposite fig identified as Benedict; font originally at Norwich S Benedict.

Sebastian
Martyr (†late 3c). 18 Dec. During persecution of Diocletian, he was ordered to be put to death by being shot with arrows; he recovered and was clubbed to death. Plague saint.
E Anglia. ms, *The South English Legendary*, Bod L Tanner 17, marginal drawing, f 6v. 15[1].

Sebastian (no wounds) in mitre, being untied from stake by Irene, pile of arrows beside.
Guestwick. *pg, NRO, Rye 17, 2:150. Perhaps a martyr set; see *Edward Martyr*.
Poringland. *pg, N win, "Sebastian holding an arrow," Bl 5:442.
Colney. sc, font bowl, W face. 15c. Ankles bound, hands behind back, wearing loincloth; pierced by one arrow in the chest and 6 arrows below; head defaced; female (?donor) in veil kneeling R on cushion.
N Tuddenham. pwd, screen panel, S2. 1499–1504 (bequests, C & C). Arrow in RH, sword in LH; flat Tudor cap; long mantle, red hose.
Wellingham. pwd, screen panel, N1. c1532. Youth, in gold loin cloth with hands behind back; multiple arrows piercing flesh with blood flowing from wounds; "Sanctus Sebastianus" on scroll at stem of pedestal.
Binham. pwd, screen panel, S16. c1500. Youth with dark band in hair, in armor; holding 3 arrows.
Weybridge Priory. printed calendar, NMS 134.944. 1503. Without attribute.

Sexburga
Queen and abbess (679–700). 6 July. Succeeded her sister Etheldreda as abbess at Ely. A characteristic E Anglian saint in Norwich diocese calendars; see Sandler, *Survey* Cat. 1, 51.
Norwich SPM? al. 15c. Set of female saints; see *Etheldreda* SPM.
Kelling? See *Withburga* and Appendix V.3.
Walpole S Peter. *pg, S chancel. 1423/25. "Sexburga with a palm branch," Bl 9:117. Appendix V.3.

Sitha (Scytha, Sythe, Zita)
Virgin not a martyr (1218–72). 27 April. Young domestic servant of Lucca, typically represented holding beads in one hand and keys and/or purse in the other. Status indicated by white apron. See Sutcliffe for the development of her cult.
Cathedral. *altar/im. 1363 sacrist roll, offering of £2 6s 4½d, Shinners 138; ?ch paved in 1398, Bl 4:13. 1466 (post fire) candlesticks purchased for the Pietà and Sitha ("de ymagines compassionis et Sancte Sithe," compotus roll quoted in Steward 43.
Hingham. *im. Light before "St. Edith or Sythe," Bl 2:423.

Emneth. pg, nVIII.A2. 15[3-4]. Veiled, 4 keys hanging, holding massive 4-decade set of beads ending in tasseled large bead. No sign of apron, and a rather more elaborate gown and mantle than typical.

Guestwick? pg frag, sV.4b. 15[3]. Skirt with apron.

Sharrington. *pg, N win. Frere MSS, NRS 1:37. Appendix V.1.

Barton Turf. pwd, screen panel, N2. c1440 (Morgan, L & M Cat. 72). Beads over L wrist, purse and set of keys in RH; short veil, fur-lined mantle, belted gown over long dark undergarment, white apron, paired with Apollonia; (above) "*Sancta* Citha"; Constable il p 211; Duffy fig 60.

N Elmham. pwd, screen panel, S4. 15[3]. Short white veil lying over shoulders; beads in extended RH, LH holding key ring, keys hanging from waist; white apron, mantle fastened at neck with double clasp; name below.

Norwich S James. pwd, screen panel. c1479. Beads in elevated RH; keys and purse hanging from belt; white apron; (below) "*Sancta* Sitha." Now paired with S Barbara; displayed at S Mary Magdalene.

Wolferton. pwd, screen panel, N2. After 1486. Wimple and ?veil, apron, beads.

Litcham. pwd, screen panel, N1. c1500. Beads in RH, trace of key ring in LH; white veil falling on shoulders, white apron.

Provenance unknown. *pwd. A screen frag recorded in the possession of the Rev. James Bulwer, *The East Anglian; or Notes and Queries* 3 (1869): 291.

Norwich S James. sc, font stem. 15[3]. Closed book in RH; keys hanging from belt. At S Mary Magdalene.

Docking. sc, font stem, E face, worn. 15c. Church notes and M & R identify Agatha, but what they interpret as forceps might also be part of key ring. Since this female also holds beads, characteristic of Sitha, she is so identified.

Binham. pwd, screen panel, S15. c1500. Wimple and veil; beads and trace of ?purse; white apron.

Denton. pwd, mounted on chest, 5 (reading L to R); defaced. 16[1]. Beads in RH, LH relaxed; long sash draped diagonally from RS, ending in tassels; square-necked, short-sleeved, ¾-length tunic over gown, similar to but simpler than the costumes worn by Agnes

and Dorothy in the same series.

Guilds at Fakenham (Bl 7:96) and Lynn 1377 (Westlake no. 267).

Lights at Marsham (Bl 6:287), E Harling (15[4]), Stratton Strawless (1490, Harrod [1847] 117).

See also IV.2 *Visitation* Cley.

Sixtus II

Pope (257–8) and martyr in the persecution of Valerian. 6 Aug.

Wiggenhall S Mary Magdalene. pg, nVII.A3. c1450. Bp, seated, cope, book in LH; "*Sanctus* Sixtus." Appendix V.4.

Worstead. pwd, screen panel, N aisle, 4. 15[3]. Archbp in full Mass vestments (no pallium), cross-staff in LH, RH with rings raised in blessing; paired with Lawrence (so identified by Camm 273). Both Sixtus and Lawrence suffered martyrdom in the same persecution. They may also have been paired at Smallburgh if the badly damaged prelate inscr as a martyr is taken to be Sixtus.

Stephen

Deacon and proto-martyr (†c35); see Acts of the Apostles 6:8–15 & 7:1–60. 26 Dec.

Narrative

Diocese. ms, Stowe Breviary, BL Stowe 12, hi, f 20v. c1322–5. Kneeling, being stoned by man with additional stones held in drape at waist.

Catfield. wp, arcade spandrel of S aisle. 14[3-4] (DP). Dalmatic with appareled alb; kneeling, hands joined; flanked by 2 executioners hurling stones, (L) with stones in LH in readiness; 2 stones on Stephen's head; executioners in short tunics and hats.

Norwich S Stephen. sc, boss, N porch. Mid 14c. Stephen kneeling, flanked by 2 executioners raising stones above their heads, leg positions similar to those in flagellation scenes. Paired with atypical scene for Lawrence.

NMS. al altarpiece. 15c. Panel **1**: standing, book in RH 3 stones in LH, stone on top of head; maniple; symmetrically paired with Lawrence at the other extreme of the altarpiece. Panel **2**: (above) hand of God; Stephen kneeling, hands joined, scroll (originally with inscription) issuing from hands; flanked by 4 executioners hurling stones, 2 stones on Stephen's head; (L) fig in ?pleated chaperon (symmetrically paired with the emperor in the execution of Law-

rence). Provenance uncertain. For details see Cheetham (1983) fig 48. See also *Lawrence.*

Cathedral. sc, N cloister boss J5. 1425–30. (Above R) in nebuly Deity with orb; (above L) head of ?Christ; (L) enthroned fig in white collar over long gown, man with sword; Stephen kneeling; (R) 2 men, one with stone in raised hand, the other with 5 stones in fold of garment at waist; (below) Saul holding cloak.

Gressenhall. sc, affixed to chancel wall. 15c. (Below L) Saul with garment, (above) man with 2 stones in crook of LA, RA raised (hand missing); (C) Stephen kneeling in profile, hands joined; vertical scroll above; pile of rocks before him; (R) soldier in armor, sword in scabbard standing in doorway.

Norwich, Hospital of S Stephen. seal. 16c. "Stoning of St. Stephen," *BM Cat. of Seals*, 3783; drawing in DT 16:166.

Individual

Dressed in deacon's vestments, dalmatic over alb with amice (only exeptional detail cited); short hair with prominent tonsure. On 4 screens represented with a humeral veil draped over right shoulder and hand, probably signifying Stephen's diaconal order. Elsewhere Stephen typically holds a stone, so perhaps the veil is meant to suggest the instrument of martyrdom so covered.

Cathedral. relics, 4 pieces. 1234 (Beeching 17). The current Jesus ch was formerly dedicated to S Stephen and All Martyrs. Offerings were still being made in the 1330s (Shinners 135 & fn 5).

NMS. al. See *Narrative* above.

Diocese. ms, hours, NMS 158.926.4f, hi, f 47 (Lauds, *memoriae*). c1310–20. Holding stones.

Norwich SPM. pg frag, E win 5b. Mid 15c. Palm in RH, stone in LH.

Harpley. pg, W win C6. 15c. Seated, clasped book in palm of LH, stone in RH; paired with Lawrence; Appendix V.6.

Heacham. pg, sV.B3. 15c. Clasped book in RH; yellow stones in palm of LH; stylized flowers on blue dalmatic, fringe on sleeves as well as on sides of dalmatic; maniple on LA.

Sparham. *pg, S win, "Sanctus Stephanus good figure . . . Stones in lap," NRO, Rye 17, 3:215; win also contained Lawrence and Vincent; Appendix V.6.

Hempstead S Andrew. pwd, screen panel, S3.

15². Stones (?3) in RH, closed book in LH; blue dalmatic with parti-colored fringe; paired with Lawrence; Constable il p 219.

Ranworth. pwd, N parclose panel. 15³. Open book (damaged) held on L wrist with fingers supporting cover; no stones discernible; dalmatic with parti-colored fringe; humeral veil over RS and RH; paired with Lawrence on S parclose screen. Bond (1914) il p 55.

Worstead. pwd, screen panel S aisle 4. 15³. Clasped book in LH, R side damaged; humeral veil on RS and RH. For likely original order, see *John the Baptist.*

Ludham. pwd, screen panel, N2. c1493. 3 stones in RH, LH relaxed at waist; trace of epaulette at shouders, alb with large apparels; (below) "*Sanctus: Stephanus*"; paired with Lawrence at S5.

Smallburgh. pwd, screen panel, N3. 15⁴. Closed book in LH; dalmatic, humeral veil over RS, held loosely in RH; Lawrence on S side.

Barton Turf. pwd, screen panel (loose). 15⁴. Holding 3 stones; fringed dalmatic; for provenance see *Henry VI* Barton Turf.

Hempton. seal, Austin Priory of S Stephen. 1449. Nimbed, "holding 3 stones or loaves in a cloth on the r. arm, in the l.h. a bag, betw. 2 long candles on candlesticks," *BM Cat. of Seals*, 3266; *Index Monasticus* 23.

Upton. sc, font stem. 15¹. Holding stone in each hand.

Watlington. sc, font stem. 15³. Holding chemise-sac and stones; paired with prophet.

Hemblington. sc, font stem. 15c. Maniple; stones in LH, palm in RH.

Walpole S Peter. *im. 1504. Bequest for gilding, Williams (1941), 338.

Sandringham. pg, sII.A3. 16¹. Stones held in both hands; stone on tonsured head; "S[an]c[t]*us* Stephan*us*"; Keyser (1917) fig 10A.

Outwell. pg, sIII.B7. 16¹. 3 stones in RH, book in LH.

Horsham S Faith. pwd, pulpit pane 8 (anti-clockwise). 1528. Clasped black book on L palm; stones lying on R forearm; fringed dalmatic; humeral veil over RS; Cautley il p 141. By same hand as panel painter (DP).

Weybridge Priory. printed calendar, NMS 134.944. 1503. Stone on head.

Walsoken. sc, font stem. 1544. Holding stones.

Wiggenhall S Mary. wdcarv, be, N aisle S4; S aisle S5. 16[1]/15c. In each case paired with Lawrence.

Linnell cites dedications at *Hempton and Norwich; Bond (1914) 46 for England.

Swithun (Swithin)

Bp of Winchester (852–62) and confessor. 2 July. Noted for his charity and his church building.

Wiggenhall S Mary Magdalene. pg, nV.A5. c1450. Name damaged, "[?]thun"; now with archbp; Appendix V.5. See *Sixtus* for another misplaced label; Keyser (1907b) pl XII.

Norwich S Swithin. *pwd. 1460. Bequest of "a picture of St. Swithin," Bl 4:255. An 1838 watercolor of a king has a penciled note: "said to represent St. Swithun," DT 40:128. See *Edward* Norwich S Swithin.

Linnell cites church dedications at Ashmanhaugh, Bintry, Frettenham, and Norwich, to which can be added Langetot Manor (Bl 8:199); Bond (1914) 58 for England.

Light at Marsham (Bl 6:287).

Sylvester I (Silvester)

Pope (314–35) and confessor. 31 Dec. He is said to have received the document called the "Donation of Constantine" (now known to be a later forgery) from the emperor.

Salle. *pg, sIII, light b. c1440. Appendix V.4 & 5.

Wiggenhall S Mary Magdalene. pg, nIV.B2. c1450. Pope, double cross-staff; *Sanctus* sylvester. Appendix V.4.

Houghton S Giles. pwd, screen panel, S5. 15[4]. Pope, double cross-staff over LS; RH blessing; (lower R) small woman in blue mantle and white veil with scroll inscr "Silvestere *sancte* me tua salva prece"; defaced.

Weybridge Priory. printed calendar, NMS 134.944. 1503. Pope.

Theobald of Bec

Archbp of Canterbury (1139–61) and confessor. He was patron of S Paul's Hospital in Norwich (Rawcliffe 1995). (Other candidates suggested are Theobald of Provins, hermit and priest [†1066], 30 June/1 July; or Theobald of Vauz-de-Cernay, monk, 1 June.)

Cathedral. *im. 1390. Sacrist's roll, Shinners, 139.

Hempstead S Andrew. pwd, screen panel, N5. 15[2]. Bp in full Mass vestments, crozier in LH, RH blessing; name below; paired with

Denys.

Hautbois. *im. 1507. Bequest for pilgrimage to S Tebbald of Hobbies, Hart (1864) 277, 279.

Lakenham. *im, "an image of St. Theobald, or Tebald, much frequented by pilgrims," Bl 4:522. Gregory Clerk, twice Norwich mayor, requested a pilgrimage to S Tebald, site unspecified; Tanner 85.

Norwich S Peter Parmentergate. *pg. Bl 4:96. 1440 bequest to repair ruined ch in church at Thursford.

Theodore of Canterbury

Archbp (668–90). 19 Sept. In 1234 the Cathedral lent a relic of a Theodore (probably the Archbp of Canterbury) along with a number of others in a casket to Henry III (Beeching 17).

Thomas Becket (Thomas of Canterbury)

Archbp of Canterbury (1162–70) and martyr. 29 Dec; Translation 7 July. Following his death his *cultus* spread rapidly. At Wymondham a ch was founded 1184 (rebuilt 14c); guild established 1187 (Farnhill).

Narrative

Stratton Strawless. al. c1390. Lower register: (L) bp in cope and mitre holding outstretched hand of Thomas (C) in voluminous outer garment, holding crozier (head damaged); fig in similar garment reading from book. Upper register: 4 clerics (C) holding cross-staff and blessing Thomas; (R) 2 holding open book; L & M Cat. 61; now NMS.

Lynn. pilgrim badge. ?14c. "Ampulla in the form of a ship with four occupants and an aperture in the forecastle" which probably "contained a drop of Canterbury's life-giving water and was made for the Feast of the Return of St. Thomas," Spencer (1980) Cat. 79. At the V & A a ship figures in "Thomas landing at Sandwich," Cheetham Cat. 84. In 1384/5 the town records cited payment for "ludentibus interludium Sancti Thome Martiris," Galloway & Wasson 38; Lancashire no. 806.

Cathedral. sc, N cloister bosses. 1427–8. **H3** (L) 4 knights, 3 with weapons; (R) Thomas in red tippet over white gown, Grim in monk's habit, with cross. **H5** (L) angel, Grim (as before) Thomas kneeling before (R) dressed altar, (above) 4 knights with 2 leering, bateared devils at shoulders. **H8** 7 monks, each with hands joined, standing behind recum-

bent body of Thomas in red chasuble, head resting at foot of altar; 3 knights in helmets. **I1** Thomas in full regalia lying in tomb, officiating priest in alb and crossed stole and monks behind. **H6** Henry II kneeling at shrine, naked except for drawers, crown on ground; (L) courtiers holding his clothes; being scourged by layman at shrine; attending monks, *900 Years* color il p 39; Anderson (1971) fig 71. See also *Giles* Cathedral.

Norwich SPM. *emb. 16[1]. Cope with "orpheras golde brodered werke of the life of sent Thomas of Canterbury"; hood, S Peter; Hope (1901) 196.

Martyrdom

Crown of head cleft with sword, chalice on altar; +/- Grim the cross-bearer, and 3 knights. Tristram (26) noted that the martyrdom is recorded in 10–12 churches in the fourteenth century. For general treatment see Borenius (1929).

Norwich, Carrow Priory. ms, Carrow Psalter, Baltimore, Walters Art Gallery W.34, miniature, f 15v. 1250–60.

Diocese. ms, Stowe Breviary, BL Stowe 12, hi. c1322–5. Ff 27v martyrdom; 270 (Translation) vested body in tomb, attended by bp and clerics

Norwich Diocese. ms, hours, NMS 158.926.4f, hi, f 48 (Lauds, *memoriae*). c1310-20. Sword severing crown of head.

Eaton. *wp S wall betw windows S6 and S7. c1370 (DP). (L) small building with altar, Grim the cross-bearer behind; Thomas kneeling, before altar, hands joined, mitre on floor; (R) 4 knights, "RH and most of the arms of 2 foremost lost," third with drops of blood at his feet, "fourth with LH on hilt of sheathed sword"; 2 and 4 with shields; Tristram 167; Boileau (1864a) color il p 165; drawing of S wall, 163. Boileau's illustration seems to be based on a water color by Walter Hagreen (1860) in the King Collection, NNAS, Box 4. However, in Hagreen's work there is no blood on the ground, nor does the second knight hold a shield.

Burlingham S Edmund. wp, S wall chancel. Late 14c (DP). (L) tree in background; within church, altar with chalice & host; Grim the cross-bearer at altar corner; Thomas in chasuble with pallium, kneeling before altar, hands outstretched, mitre on ground; (behind) 4 knights in elaborate armor: one

with dagger in LH, thrusting sword in RH into head; Le Bret (identified by arms), severing part of scalp, drops of blood on sword; Fitzurse (identified by arms), battle axe in RH, LH on dagger hilt; 4th knight drawing sword from scabbard; (far R) tree; Tristram 145; Morant (1859) il facing 185; André (1888) 409. Much of this detail, clear in 1925 ("Report 1925" 84), is difficult to see today, though the general outline of the composition is well preserved.

Easton. *wp. 14c. Drawings of soldiers exhibited in 1861, work subsequently whitewashed. Thomas covered with cement-like substance that made it unrecoverable, "Proceedings," 269.

Yarmouth? *wp, N chancel, Keyser queried the murder of "Thomas à Becket," but the reproduction in C Palmer (facing 119) makes this identification unlikely (see II.4 *David*). There were lights to S Thomas in the 14c, 8 "on the perch in the chancel [probably N transept] of S Thomas of Canterbury," Morant (1872) 223–4.

Burgh S Peter. *wp, "knights on galloping horses, and a sanctuary and altar"; reported obliterated but sketched, "Extracts" 7: 374. I have not been able to locate the sketch.

Hingham. *wp. "I am authentically informed that at Hingham [a wp of martyrdom] lately existed, but has been covered over," Boileau (1864a) 166–7.

NMS. al altarpiece. 15c. Panel 5: (C) Thomas kneeling before altar, chalice covered with corporal; mitre on floor; cross-bearer at far side of altar; (above) 4 knights, 2 striking head with swords. For details see Cheetham (1983) fig 49.

Lynn. pilgrim badges. 14–15c. Mitred head, Spencer (1980) Cat. 70–74.

— pilgrim badges. 14[4]–15[1]. Sword. Spencer (1980) Cat. 76.

— pilgrim badge frag, "headless figure of St. Thomas and the legs of the leading knight," Spencer (1980) Cat. 77.

Hoe? *pg, N aisle, "Somebody killing a saint . . . & several kneeling persons," at each corner of the pane a capital T. Although the T is suggestive, the tiny drawing does not look particularly like the martyrdom of Thomas; perhaps it represents the funeral; NRO, Rye 17, 2:258. This must be the same scene described in Bl 10:50, "A person lying as

dead on an altar tomb, and 5 priests as praying by him."

Wellingham. *pwd, S side. "Martyrdom," NRO, Rye 17, 4:85.

Burnham Market. sc, relief, tower. 15ex. (Reading clockwise) **W1** Thomas facing altar; **W2** murderers approaching.

Foulsham. *wp? 1526. Bequest of one pound of wax "to be burned in the worshipp of Seynt Thomas buyfor [before] his martyrdom" (NCH Randes 139, Cotton personal communication).

Norwich SPM. *emb. 16^1, "a vestment complet of grene cloth of tissue wt orpheras of brodery worke gold ymagery of the mart[ir]dome of sent Thomas of Cantorbury," Hope (1901), 203. See also cope above.

Norwich. ?*medium. 1484–5. A guild "gave a famous picture of the history of Bishop Becket" to a chapel dedicated to the Translation on the hill E of Norwich near that of S William, Bl 4:426; *Index Monasticus* 70.

Individual

Unless stated otherwise, Thomas is dressed in archiepiscopal vestments, the double cross-staff resting in the LH or against the LS and the RH blessing. Only variations, incl particularly good vestment detail, are cited below. Generic archbps are typically identified as Thomas Becket, but strictly speaking, unless named, there is no way to distinguish Thomas from any other archbp. I have included such extant examples labeling them ¤, but I have excluded the numerous documentary citations of "Thomas" unspecified. Such conservatism means that this section under-represents the most famous of English martyrs.

Lynn. *im. 1272. Light before im at Matins, Mass, Vespers and lamp to burn at night, Westlake no. 269.

¤**Cathedral.** wp, Ante-Reliquary Ch, vault, N bay. c1300. (C) "perhaps St. Thomas of Canterbury," Tristram 230.

Heacham. *im. 1359. Guild provided candles to burn before im, Westlake no. 234.

Lynn S Nicholas. *im. 1376, guild to maintain light before "þe holy martir seynt Thomas of Cauntirburye," T Smith 47.

N Lynn. *pastoral staff. 14^3. Watkin 2:123.

Salle. *im. 1480. Thomas Ryghtwys, burial before image of S Thomas the Martyr, cited in a 1938 guide (NMR).

Norwich S Gregory. *im in niche, S aisle ch dedicated to Thomas Becket, and its altar to SS Thomas and Anne, Bl 4:273.

Spixworth. *im and ch, Bl 10:456.

Swaffham. *im, light before, Bl 6:217 fn 4.

Weston Longville. *im of S Thomas martyr, Bl 8:291.

Walsingham Priory. *im. Ordered in will of Henry VII to be set before our Lady of Walsingham, Bl 9:279.

Salle. *pg, sIII, light a. c1440. Appendix V.5.

— pg, sVI.A1, not *in situ*. c1444. Fine costume detail, incl fringe on pallium; donor Thomas Briggs and 2 wives at A2, 5, & 6.

Norwich SPM. pg, E win D1. Mid 15c. Archbp, "S' Thom'."

Harpley. pg, W win E4. 15c. LH raised; cross-hatched ?win; (below) "Thomas archi*episcopus*"; paired with S Leger.

¤**Stratton Strawless.** pg frag, patchwork win 3b. 15c. Mitred head, scroll inscr "Thoma," perhaps not part of same composition.

¤**N Tuddenham.** pg, sII.A2. 15c. Particularly nice gloves; see *Sixtus*.

Norwich S John de Sepulchre. *pg, "for makinge of a glasse wyndow wherein Thomas Beckett was, xixs. viijd," Boileau (1864b) 373.

¤**Norwich S Michael-at-Plea.** pwd. 1420–40 (King [1966] 415). (Above) frag demi-angel above cloth of honor (panel cut down); (below) in chasuble with pallium, infula on cross-staff; paired with Erasmus; for ils see *Erasmus* above.

Ranworth. pwd, S parclose panel. 15^3. Cross-staff over LS; open book on palm of RH, pages interleaved with LH; exceptionally good vestment detail, pallium clearly a separate article of clothing lying atop chasuble orphreys, T on chasuble and alb apparel; 4 rings on RH, one on LH; paired with bp on N parclose; L & M color il p 59. See *Felix*.

Attleborough. pwd, screen panel (retable) S1. 15^3. Pallium with crosses. "According to old Tradition . . . said to be the portrait of Thomas A-Bekitt," DT 53:33; one of the donors was Thomas Cove, rector 1424–6.

Horsham S Faith. pwd, pulpit, pane 3 (counterclockwise). 1480. Pallium decorated with crosses; heavy fringe on dalmatic, colors alternating red/yellow/green; according to Cautley the pane was labeled S Thomas of Canterbury.

¤**Sparham.** pwd, screen panel, now in N aisle; 1480 (DP). Cross decoration on pallium.

¤**Litcham.** pwd, screen panel, S1. c1500. Archbp

in cope over Mass vestments; double cross-staff in RH, closed book in LH. Puddy (51) recorded traces of lettering at base.

¤**Oxborough**. pwd, screen panel, N1. 15⁴. Now at E Dereham.

¤**Stalham**. pwd, screen panel, chancel, S wall. Late 15c.

Cathedral. *sc, 1427. 117s for im, incl painting and decorating with precious stones; Beeching 22; see also Bl 4:30.

¤**Cathedral**. sc, font stem. 15³.

¤**Gt Witchingham**. sc, font stem. 15⁴.

¤**Hemblington**. sc, font relief, E face. 15c. Archbp seated on bench; polychrome restored by Tristram.

¤**N Walsham**. *im & *emb altar cloth. 1502. Bequest for "a cloth of red fyn worsted with braunches of gold sett ther upon, to hang before ye seyd auter, and in ye mydd of ye cloth an Image of seynt Thomas," Williams [1941] 339. The ch appears in a will of 1459 with bequest to glaze a win (C & C).

¤**Beeston S Mary**. pwd, screen panel, S2. 16¹. Archbp largely disfigured.

¤**Edgefield**. *pwd, screen panel, frag. 16¹ (donor scenes in parclose dated 1526). Williamson (1957) cited a loose panel "a Bp, with head defaced, possibly St. Thomas of Canterbury"; stolen 1977.

Burlingham S Andrew. pwd, screen panel, N6. 16². Elaborate fringe on dalmatic and tunicle with stole visible below against appareled alb, largely disfigured whereas other panel figs only defaced; "*Sanctus Thomas*" on pedestal below; Duffy figs 58, 131.

Weybridge Priory. printed calendar, NMS 134.944. 1503. Cross (July 7, Translation); ?bp (Ages of the World).

Linnell cites 5 church dedications in Norfolk, 3 of which were parochial chs; Bond (1914) 80 for England. Hospital at Beck. The Augustinian priory at Bromehill, dedicated to Thomas the Martyr, owned a 5-day fair held at the feast of the Translation (Dymond 1:89n). Farnhill cites 19 guilds of S Thomas Martyr. In the 1371 list of guilds contributing to the repair of dikes in Lynn, donations were made by one dedicated to the Translation (Owen 325; see also T Smith 80). Outside of Norwich a ch dedicated to the Translation with "a famous picture of the history of Bishop Becket," Bl 4:426.

Altars cited at Blakeney (Linnell 14), Cawston (14³, Watkin 1.52), Upton, Wymondham (Bl 2:523).

Lights at S Creake 1491 (Robert Norton, Norf Arch Bk 1, f 173), Stratton Strawless (Harrod [1847] 117).

Chs at Bromehill (Bond [1914] 201). Shipdham (1487, indulgence for repairs to ch and roads, Bl 10:248-9), Fakenham (burial 1494, Bl 7:96), Foxley (decorative paint remains), Norwich: Blackfriars (Harrod [1857] 94); S Mary Coslany (Bl 4:490); Tilney, Keswick (free ch, *Index Monasticus* 69), Wymondham (in the middle of town, Bl 2:507 and 523). W Acre or Custhorpe, a cell of W Acre Priory, dedicated to S Thomas and a pilgrimage site on route to Walsingham; Taylor queried a cult image with relics (*Index Monasticus* 27). A 1480 will provides for a pilgrimage to S Thomas of W Acre, Hart (1864) 277.

Uncumber (Wilgefortis)

Virgin martyr (nd). 20 July. Purportedly a Portuguese princess who grew a beard to avoid marriage; crucified by her father. According to Thomas More the patroness of women wishing to disencumber themselves of husbands. The sword of Winfarthing similarly served "unto the shortning of a married mans life, if that the wyfe which was weary of her husband, would set a candle before the Swerd every Sunday, for the space of a whole yeare, no Sunday excepted," Becon as quoted in Bl 1:184.

Norwich S Giles. *im, Bl 4:239.

Norwich S James. *im. 1528. Burial before im of S Uncombre, Bl 4:425.

Norwich S Peter Parmentergate. *im. 1552-3 inventory: "two of maide Uncumbres best Cotes"; "a Cote of Maide Uncumber of redde silk," Harrod (1859a) 118. The im must surely have been disposed of before the inventory, but the gowns remained.

Worstead. pwd, S8, pane not *in situ*. 1512 (inscr). Crowned, nimbed, beard; tied to cross at hands and feet; mantle draped over shoulders, loin cloth (description based on watercolor by Mrs Gunn c1832-4; Camm pl LIX). Restored with long gown with belt and depending pomander. Considerable disagreement about identification; see Camm (278-81) for restoration history.

Light at Bunwell (1504, John Hyonyng, NCC Ryxe 77, Cotton personal communication).

Urban I

Pope (230-5) and martyr. 25 May.

Salle. *pg, sIV, light b. c1440. Appendix V.4 & 5.

Ursula and Companions

Virgin martyr (?4c). 21 Oct. Typically crowned, carrying arrow(s) in one hand and sometimes a book in the other. She is represented sheltering the 11,000 virgins within the folds of her cloak at Litcham and Barnham

Broom. Virgins represented by 9 busts in veils in the Stowe Breviary (f 315v).

Norwich SPM. al tablet, 15c. Set of female saints (lower register, all queens). Holding large closed book and arrow in LH; L & M Cat. 87.

Burnham Deepdale. pg, nVIII.2a. 15⁴. Crowned; 3 arrows in LH; against her breast, RH supporting open book with writing and gold flourishing.

Norwich S John de Sepulchre. pwd, screen panel. ?15³⁻⁴. Hip length hair; long arrow held diagonally in RH; clasped book in draped LH; wide ?ermine-hemmed gown; burlet with 3 ouches rising, Winter, *Selection* 2:5.

Wolferton. pwd, screen panel, N4. After 1486. Long hair; arrow in RH.

Litcham. pwd, screen panel, N8. c1500. ?Burlet; ermine sideless surcoat and collar over dark mantle; arrows in each hand; maidens beneath mantle, 5 clustered (R) and 6 (L) (11 for 11,000 virgins) .

Barnham Broom. pwd, screen panel, S3. 15⁴. Crowned; ermine-trimmed mantle; 3 arrows in LH; RH drawing mantle aside; virgins clustering at either side within shelter of ermine-trimmed mantle; on wine-stem pedestal.

Sandringham. pg frag, sII.A4. 16¹. Crowned; in crook of RA 3 arrows, fingers interleaved in book; Keyser (1917) fig 10B.

Outwell. pg, sIII.A9. 16¹. Arrow in RH.

Babingley. *pwd, screen panel. ?1553–8. White veil and wimple, gray cloak; RH pointing to long arrow in LH, DT 53:73.

Repps. *pwd, screen panel. ?1553–8. White veil and wimple, gray gown, holding arrow and book; by the same artist as the preceding entry, DT 59:206.

Valentine

Martyr at Rome (3c). 14 Feb.

Hingham. *im, light before, Bl 2:423.

E Anglia. ms, *The South English Legendary*, Bod L Tanner 17, marginal drawing, f 21v. 15¹. Exotic hat, shaggy beard, holding book.

Weybridge Priory. printed calendar, NMS 134.944. 1503. Nimbed bird. (It was believed that birds began mating on the feast of S Valentine.)

Vedast

Bp of Arras and confessor (499–539). 6 Feb. Famous for restoring religion to his diocese.

Norwich S Vedast. *im. 1384. Principal im repaired (Bl 4:104); altarpiece restored by painter (King [1996] 413). In 1256–6 anchoresses at church (Gilchrist & Oliva 99). Church destroyed 1540 (Watkin 1:xvi). According to Blomefield the church was commonly called S Faith's (4:105).

Veronica

The woman who wiped the face of Christ during the Way of the Cross.

Diocese. ms, hours, CB Fitzwilliam Museum 55, miniature, f 122v. After 1471, c1480. Cloth with face imprinted, held at top by hands; Scott, *Survey* Cat. 135, il no. 492.

N Creake. pwd, screen panel, not *in situ*; panel formerly on organ case, newly reset in altarpiece in N aisle ch. 16c. In both hands holding white cloth impressed with face of Christ; green ?burlet, wimple, mantle over red gown. A curious companion for 3 Cardinal Virtues (see XIII.4); Williamson (1957) identified Mercy.

Babingley. *pwd, screen panel. ?1553–8. Crowned, long hair; barb, dalmatic-length tunic over red gown, mantle; holding white cloth in both hands, eyelids half closed, as if looking down; cloth blank, DT 53:60. Keyser (1917) seems to have identified as Etheldreda.

Victor

Pope (189–99) and martyr. 8 May.

Wiggenhall S Mary Magdalene? pg, nIV.B1. c1450. Bp in Mass vestments, books in LH; (below) name; Appendix V.4. Given the large number of popes in these windows, this is probably Pope Victor. Cotton and Tricker suggested Victor of Troyes.

Vincent of Saragossa

Deacon and proto-martyr of Spain (†304). 22 Jan. Typically with Stephen and Lawrence, he always appears in deacon's vestment.

Thetford Priory 1. 12/13c. Relic, Bl 2:118.

E Anglia. ms, *The South English Legendary*, Bod L Tanner 17, marginal drawing, f 9. 15¹. Holding book, standing on mat rolled at end.

Harpley. pg, W win D1. 15c. Seated with palm in RH; closed book in LH; paired with Martin; Appendix V.6.

Salle. *pg. "Vincent with flesh-hook (now moved)," cited in same win as Etheldreda, Giles, and Helena, James *S & N* 165. James's original notes were probably made in 1884 before the extensive restoration of 1912. Appendix V.6.

Sparham. *pg, S win, "Sanctus Vicencius," drawing of flesh-hook, NRO, Rye 17, 3: 215; the win also contained Lawrence and Stephen; Appendix V.6.

Watlington. sc, font stem. 15³. Chemise-sac in RH, flesh hook in LH; paired with prophet.

Cathedral. *sc. nd. Image bracket, with "Sanctus Vincentius" label readable in 1916 (Beeching 7).

Sandringham. pg, nII.A5. 16¹. Maniple; clasped book in LH; long, toothed saw in RH; "S[an]c[t]us Vincencius"; Keyser (1917) fig 6B.

Weybridge Priory. printed calendar, NMS 134.944. 1503. Sword.

Walstan of Bawburgh

†1016. Son of a prince, Walstan devoted his life to farm service. Typically unnimbed, Walstan is usually crowned; his attribute is a characteristic Norfolk scythe. Invoked for fevers (a holy well in neighboring farmyard) and by people and beasts who had lost their genitals, a feature that fueled Bale's satiric wit. At height of popularity 6 chantry priests served altar in the N ch at the shrine in Bawburgh. Although no liturgical evidence has survived, farmers came to the shrine on 30 May to have their animals blessed, probably a local adaptation of Rogation blessings. Norfolk and Suffolk wills document pilgrimage interest (Cotton, personal communication).

Norwich S James. pwd, screen panel. c1479 (Bl 4:424). No crown, scythe in RH; barefoot; name below. Now paired with Blyda, but both backgrounds are red. Displayed at S Mary Magdalene.

Sparham. pwd, screen panel, now in N aisle, c1480 (DP). Crowned; scythe in RH; scepter in LH; 2 oxen at feet; ermine collar, belted gown with wide ermine hem, ermine-lined mantle; Borenius & Tristram (1927) pl 81; Camm pl LXI.

Litcham. pwd, screen panel, S5. c1500. Crowned and nimbed; scepter in LH; scythe in RH, blade up; ermine collar over belted ermine-lined gown with wide ermine hem.

Ludham. pwd, screen panel, S4. c1493. Crowned, dark hair and short beard; scythe in LH, cross-staff in RH; ermine collar; "Sanctus Walstanus" in white without rubrication (second artist); paired with Henry VI, N4; Duffy fig 81.

Barnham Broom. pwd, screen panel, N5. 15⁴. Head largely disfigured; scythe in LH; 2 miniature oxen at either side; long belted gown, wide white collar and turned back cuffs; Duffy fig 80.

Foulden. pwd, screen panel, S4. 15⁴. Scythe in LH; orb with foliated cross in RH; (below R) clear antlers of animal.

Haddiscoe. *pwd, screen panel, saint with scythe; NRO, Rye 17, 2:181.

Norwich All Saints? sc, font stem. c1448. M & R 2 identified a fig with branch as Walstan; font now at S Julian.

Binham. pwd, screen panel, S11. c1500. Crowned, clear remains of scythe.

Beeston S Mary. pwd, screen panel, S3. 16¹. Frag of scythe at upper RS; wide ermine hem on gown; major disfigurement.

Denton. pwd, mounted on chest, 9 (reading L to R); defaced. 16¹. Scythe in RH over shoulder; LH extended but cut off by framework; ermine collar over voluminous red gown.

Burlingham S Andrew. pwd, screen panel, S3. 16². Crowned and nimbed; scythe in LH; short ermine-lined mantle and collar, fur-lined mid-calf gown, purse hanging from belt; rings on both hands. "sanctus: Walstanus:rex" on pedestal; Duffy fig 79.

Outwell. pg, sIII.B4. 16¹. Crowned; scythe in LH, scepter in RH.

Linnell cites 2 dedications, Bawburgh parochial ch and Bawburgh joined with S Mary, with a 1505 will citing only Walstan.

Wandrede (Wandregesilius, Wandrille)

Abbot of Fontenelle in Normandy (c600–68). 22 July. after separating by mutual consent from his wife so that they both might devote themselves to chastity, he became a monk.

Bixley. *im. 1478. "Item, I wyll have a man to go a pilgrimage to St. Wandrede of Biskeley," Bl 5:450, fn 8. Margaret East (1484) made a similar request (reg. *Norfolk Arch.* wills 4:338). Sole church dedication in England.

Yarmouth. *im. 1484–5. 5s 2d for "painting and gilding"; see *Henry VI*. Listed as "fforinsa"

with expenses for the free standing ch of
John Bapt; Morant (1872) 239.

Wilfrid I

Bp of York (669–78, 686–91) and confessor. 12 Oct.
He defended the Roman date for Easter at the Council
of Whitby (663/4), was chosen bp of York, but deposed
in favor of Chad; reinstated 686.

Harpley. pg, W win A2. 15c. In Mass vestments,
holding double cross-staff, no sign of
pallium on voluminous blue chasuble; label
at feet, "Wilfrid arch*iepiscopus*"; paired
with Blaise. Appendix V.5.

William of Norwich

Apprentice skinner from Haveringland, purportedly
crucified in 1144 at Thorpe Wood. Blame was placed
on the Jewish community. 26 March. For veneration at
the Cathedral, see Shinners.

Narrative

Provenance unknown? pg, ?tracery light. 1460–
80. Woman (William's mother opposed his
going to Norwich) directly behind young
boy in long gown, penner at waist, holding
sack over RS; man in tall hat directly
behind boy; now at V & A. It has been
conjectured that the man is a messenger of
the Jews luring the child away, though the
costume in not convincing. David King
points out that the scene bears resemblance
to the departure of Benedict for Rome,
though he does not rule out the former
identification; L & Morgan Cat. 93; An-
derson (1964) pl 1; Archer, color pl 19.

Haveringland. *pg, westernmost win N side, 1.
"a man on horse back met by an old
Hermite (I think) at the bottom of which
pane is this inscription Hic in Iane ducit
ip*sum* in sacco ad silvam & ip*sum*
abscondit; 2. divers monks have digyd up a
naked corps. Hic per revela*c*ionem monar-
chi S*anc*te Trinitatis ip*sum* inveniunt; the
body laid in a fine coffin or shrine, a Monk
& divers cripples kneeling by it; 3. and
some monks about it setting on a cover
adorned with much old fashioned spired
work compartments etc. Hic *in* tumba
humatus est p*er* monarchos; In another a
Priest (I think) sitting with an open book
lying upon his knees, a man kneeling before
him, an other standing & another kneeling
behind with an incircled head Hic examinat
est coram. . . . In another a man kneeling

having a dagger by his side; lookes some-
thing ghastly, an old man on horseback
takes him by the hand, another turning his
head away as affrighted. Another pane hath
a youth with an incircled head drinking out
of a cup: a woman standing by & lower an
old man," all defaced, NRO, Rye 17, 2:202.
The scene has been identified with William
in part because of his connection with
Haveringland; one bell there read "S*ANCTE*
W*ILLE* M*ARTIR* O*RA* P*RO* N*OBIS*," L'Es-
trange (1874) 83.

Loddon. pwd, screen panel, N1. c1500. Nimbed
youth crucified in grove of 3 trees; cross bar
supported by 2 tree trunks raguly; one leg
and hand tied to trees, one leg and hand
nailed; flanked by executioners (3 L, 2 R),
all with prominent noses and leering faces:
(R) man in hose plunging dagger into
William's side, collecting blood in bowl;
second man with dagger over RS; below
"S*anctus* wylelm"; *900 Years* color il p 32.
Some details may have been restored based
on Thomas of Monmouth.

Individual

Cathedral. shrine. 1154, body translated to ch of
S Stephen and All Martyrs (current Jesus
ch). 1325 restoration: "In C and 40 leaves
of gold . . . 6s.8d. In CCC and ½ silver 11d.
In 12 lbs. white lead, vermilion and or-
fraiment 2s. 2d. In oil for painting 10d" as
well as stipend and food for Simon the
Painter and groom for 9 weeks, Saunders,
111. There was also an altar dedicated to
William elsewhere; c1426 relics translated
again, probably to S William's altar (Shin-
ners 143, fn 24).

— *im. It is conjectured that the smaller of the
2 niches flanking the pulpitum door was
designed for the saint's image (Vallance
[1947] 43–4). In 1376 the pelters formed a
guild in honor of the Trinity, Virgin, and
"seynt William ye holy Innocent and digne
marter." Procession of members led by "a
knaue chyld, innocent . . . tokenynge of ye
gloryous marter." On the Saturday after the
feast of Peter and Paul, they offered 2
flowered candles before the tomb, T Smith
29–30.

Lynn S Margaret. *im. 1383. Guild of young
scholars "to mayntene and kepen an ymage
of seynt Wylyam, standyying in a taber-
nakle," T Smith 51; see also Shinners 137.

Norwich S John Maddermarket. pwd, screen
panel, now at V & A. 15³. Standing youth,
mantle over gown; 3 nails in RH, hammer
in LH; 3 nails protruding from crown of
head exuding blood; L & M Cat. 74; "much
repainted," Rickert 250 fn 17; Tracy Cat.
101, color pl 5. The head nails are probably
not original; see also *Agatha*.

Norwich S James. pwd, screen panel. c1479.
Youthful face, short hair, barefoot; long
dagger in RH; name excised. Now at S
Mary Magdalene; Jessop & James pl 5.

Litcham. pwd, screen panel, S7. c1500. Youth
holding knife in RH, 3 nails in L; mantle
turned back to create collar.

Norwich S James? sc, font bowl. 15³. Fig hold-
ing a dagger or short knife (paired with S
Leonard); most of the heads on the bowl
have been restored. At S Mary Magadalene.
Duplication of screen pane; also duplicated,
SS Barbara, Helen, and Sitha.

Norwich S Michael Coslany. *im, light before
(Bl 4:499); 1511 burial in ch of S William
"which is now in buyldyng in the north
syde," C & C.

Norwich SPM. *pcl, banner. 16¹. Hope (1901)
221.

Worstead. pwd, screen panel, S7. 1512 (inscr).
Nimbed youth with crown of thorns; huge
codex under RA; 2 nails in LH; breast
pierced by dagger (short sword); bloody
wounds in R foot and on L ankle; thigh-
length gown with 2 gesso buttons at neck.
In 1832 this panel was betw Jude (N7) and
Uncumber (N8); Camm 273–8, color pl
LIX; Jessop & James pl 3; *VCH* pl VII;
restored.

Suffield? *pwd, screen panel ?S5. c1524. Knife
and 3 nails in RH, scourge in LH; wearing
flat hat on narrow band, ermine collar over
green mantle lined with white, dark pink
gown, purse with metal fittings hanging
from belt; NMS Todd IV.16, where the fig
is next to Jeron. The ermine collar suggests
S Louis but the hat is at odds with such an
identification. The screen panels have been
rearranged since Winter made his drawings.
Guild at Norwich, S Michael-at-Thorne (Bl 4:135);
?Whitefriars, 1397–1436, 1521 (Tanner 210).

William of York

Archbp of York (1143–47; restored 1153; †1154) and
confessor. 8 June. *Cultus* centered at York Minster.

Walpole S Peter. *pg, S chancel. 1423/25. Bl
9:117. Appendix V.5.

Norwich SPM. pg F, win G5. Mid 15c. Archbp;
name inscr.

Garboldisham. pwd, screen panel, N2. c1500.
RH blessing; cross-staff in LH; red chasu-
ble over green dalmatic, reverse of color in
paired S Germanus; label at head height (L)
"Sancte Wille," (R) illegible.

Winwaloy (Winwaloe)

British Abbot (6c), shrine at Mounstrol. 3 March. Found
in Norwich calendars (see Sandler, *Survey* Cat. 79, 82).
Norwich parish rededicated to S Catherine, 1349 de-
populated by plague, thereafter attached to Carrow; ch
demolished 16c (Watkin 1:xv). Priory dedication at
Wereham (1199–1336, when granted to W Dereham
Abbey, for which relation see Bl 6:180); horse fair in
honor of Winwaloe at Wereham (Dymond 2:374, 619).

Wistan (Wynstan)

Mercian Prince and martyr (†850). Grandson of Wiglaf
of Mercia. 1 June.

Norwich SPM. pg, E win D4. Young king, iden-
tified by David King (forthcoming), paired
with Kenelm in king set. Appendix V.3.

Withburga

Virgin (†c743). Virgin. 17 March; translation 8 July.
Sister of Etheldreda, solitary at Holkham, later founded
Benedictine nunnery at E Dereham, where she was
buried (subsequently translated to Ely). She and her
convent at one time were fed miraculously with the milk
of 2 does. Miraculous spring in churchyard (14c
substructure). See also *Etheldreda* Norwich. Farmer
mistakenly cites 6 screens in Norfolk.

Salle. *pg, sVII.A2. c1470. Cited by King (1979)
in same win with Etheldreda. Appendix
V.5.

Kelling. pg, tracery light, sIV.2a, not *in situ*.
c1450 (King 9). Crowned abbess; crozier in
LH; in relaxed RH clasped thin book with
stamped binding; ermine-lined mantle,
wimple over chin. Though royal, not a
queen; perhaps Sexburga.

Walpole S Peter? *pg, S chancel. 1423–5. Bl
9:117, cited as S Cuthburga (founder and
abbess of Wimborne). Appendix V.5.

Wood Dalling. *pg, N win. NRO, Rye 17, 2:17.

Oxborough. pwd, screen panel. 15⁴. Abbess with
crozier in RH and book in draped LH.
Panel now at E Dereham. Keyser and James
(*S & N* 191) identified both Etheldreda and
Withburga at Oxborough. It is unclear

which abbess the remaining pane represents. In a photo taken before the collapse of the tower at Oxborough, a female saint is shown next to the screen opening; no halo, short white veil; RH raised, palm out; clasped book in LH; mantle turned back to form collar. Blomefield gives no details of screen at Oxborough, saying only it was "curiously painted" (6:184).

Barnham Broom. pwd, screen panel, S4. 15[4]. Crowned abbess; church on R palm; leaping doe at L; ermine-lined mantle, white wimple; on wine-stem pedestal.

Norwich ?S Peter Parmentergate? *pwd. In a typescript of a lecture, Rye cites a slide of a panel that included the name "northburga," NRO MS Z3F/76.

Dersingham? pwd, screen panel, N3. 16[1]. Crowned, long hair; scepter in LH; ?palm in RH; gown with looped sash; animal at feet. The animal could be a lamb as well as a doe, but the crown and scepter are better suited to Withburga than to Agnes.

Burlingham S Andrew. pwd, screen panel, N3. 16[2]. Crowned, holding cruciform church on palm of LH; (below) 2 does; ermine-lined mantle; elaborate cincture; ring on LH; on pedestal "S*a*ncta Withburga V*i*rgo"; Constable il p 144; Duffy fig 58; drawing in Gunn (facing 21) shows a label for the church reading "Ecclis de Est Derhm," still legible today. A transept ch formerly de-

dicated to S Withburga, Bl 10:211.
Dedications at Holkham, Hoe (Launditch Hundred, current dedication S Andrew); *parochial ch E Dereham Guilds at Holkham (Bl 9:244), E Dereham (Bl 10:212).

Wulfstan (Wulstan)

Bp of Worcester (1062–95). 19 Jan. Benedictine; initiated regular visitation of diocese.

Cathedral. *wp, S aisle within arcading. 13c/early 14c. Bp receiving crozier from Edward the Confessor, inscription above, "S*ANCTU*S W*V*LSTANVS." Park & Howard conjecture the miracle of Wulfstan retrieving his crozier from the tomb of the Confessor (Park [1994] 162–6; Park & Howard [1996] 381–3). In 1234 the Cathedral lent a relic along with a number of others in a casket to Henry III (Beeching 17). Park & Howard color pl IV.

E Anglia. ms, *The South English Legendary*, Bod L Tanner 17, marginal drawing, f 3. 15[1]. In mitre, with cross-staff.

Hingham. *im, light before Wulstan, Bl 2:423.

Texts connected with saints:

Norwich SPH. pg, nV, head of lights b and d. "[Simil]e est regnu*m* celoru*m*" (antiphon or responsory for vigil of the feast of virgins); "Gaude*nt* i*n* ce[lis]" (antiphon for the vigil of the feast of martyrs and feast of relics), Wdf 139.

XIII. PASTORALIA

1. The Creed

This section begins with screens because they provide the best evidence for the distribution of the articles of the Creed, fragments of which can be used to identify apostles in other media. Apostle descriptions cited in X.1 obtain here. Where there are no names or attributes, identification is based on the established order of the articles of the Creed. Disarranged panels are cited in Creed order. See also X.1 Trunch (1502) where Peter alone has a Creed sentence. Traces of texts are evidence for a complete set.

a. Creed Sets

For texts and order of the Articles, see Appendix IV.1, Table 2.

Mattishall. pwd. c1453 (bequest to roodloft and screen, Cotton). Apostles facing each other, 2 to a pane, names below; Creed texts read from bottom up; no symbols unless cited; donor, Simon Baxter. **S1** Peter and Andrew, scrolls in LH: Peter, large key in RH held diagonally towards Andrew, text 1a; Andrew, large cross saltire behind, text 2. **S2** James Maj and John: James Maj, shell in RH, scroll in LH, text 3; John, RH, scroll depending, raised in blessing towards chalice in LH, text 4; Duffy, figs 31 & 32. See also IV.2 *Annunciation*. **S3** Thomas and James Min: Thomas, text 5; James Min, text 6 (reading top down). **N1** Philip and Bartholomew: Philip holding text 7 in both hands; Bartholomew, both hands raised, text 8. **N2** "Matheus" and Simon: Matthew, text 9a in LH; Simon, LH pointing toward text 9b and 10. **N3** Jude and "Matthias": Jude ["Judas tade"] holding text 11. Matthias, RH on breast, LH holding mantle, text 12 horizontal above his head. Elaborate gesso backgrounds and awkward attempts at contrapposto. Covered with brown paint until the middle of the 19c.

Salle. pwd. 15³. Vestiges of Creed texts in fascia of molding above. **N5** Thomas in profile, spear in LH, text 5. **N6** James Min in demi-profile, fuller's bat in crook of LA, text 6. **S1** Philip, cross botony in both hands, text 7. **S2** Bartholomew, ?knife, text 8. The rest of the screen was never painted; it is likely that the other apostles were represented on return screens. Counterchanged background colors operate N to S incl the door panels

with Latin Doctors (XI.3).

Ringland. pwd. 15⁴. Looping text scrolls read from top to bottom. **N4** Peter in papal tiara, appareled alb and amice, cope over fringed dalmatic, 2 huge keys and cross-staff in LH. Text 1: scroll above head, "Credo" (backwards as if scroll twisted); "In deum . . . terre" on depending scroll. **N3** Andrew, small cross saltire in LH, text 2. **S1** John, palm in RH, text 3. **S2** James Maj, staff in LH, suspended wallet with scallop shell thereon, text 4. **S3** Thomas, spear, text 5. **S4** James Min, bat in RH, text 6. (Pane hung on N wall) Philip, woven basket with 3 loaves in RH, scroll in LH, text 7. **N1** Jude, unrigged boat in both hands, text 11. **N2** Matthew, ?money bag in LH, text 12. Duffy fig 141. A 1945 photo (NMR) shows the screen at the W end. In 1877 when the roof was seriously decayed, the screen was described with "paintings of saints barbarously mutilated" ("Report," *NA* 8:ii). When Williamson did his survey, the panels were in a "dilapidated frame of an old screen, leaning against the west wall." Nothing is known of the missing Creed panes (texts 8–10), but the chancel opening is too small for twelve panels; perhaps there were screen returns like those posited for Salle. On the other hand, there is a parish tradition that the screen was not original with the church. Stylistically related to Weston Longville, which may account for the ascription of text 12 to Matthew.

Weston Longville. pwd. c1500 (donor [†1492] inscr on dado rail, Cotton). Names in register below feet; Creed texts read top to bottom, scrolls swirling diagonally across apostle. **N1** Peter, key in RH, chemise-sac held by LH, text 1. **N2** Andrew, large cross saltire in RH, clasped book in LH, text 2. **S1** John, chalice in RH, palm in LH, text 3. **S2** James Maj, hat with shell, staff in RH, with wallet attached (decorated with shell), clasped book in LH, text 4. **S3** Thomas, spear in LH, clasped book in RH, text 5. **S4** James Min, bat in LH, clasped book in RH, text 6. **S5** Philip, basket of loaves in RH, clasped book in LH, text 7. **S6** Bartholomew, knife in LH, clasped book on palm of

R, text 8. **N6** "Matthia," square in RH, text 9. **N5** Jude, oar in RH, boat in LH, text 10. **N3** Simon, large fish, text 11. **N4** "Mathee," halberd in RH, clasped book in RH, text 12. Particularly elegant scrollwork, probably from the same workshop that produced the Ringland screen, but heavily restored; Duffy fig 29 (N side).

Gooderstone. pwd. 1490–1520 (King in L & M, 58); rood sollar repaired 1446. Apostles against cloth of honor held by demi-angels; Creed texts are on scrolls arched over heads; names on molding above. **N1** Peter in profile facing Andrew, white hair with prominent tonsure, red mantle worn toga style; key in LH, RH pointing to end of extended scroll, text 1 continuing into unextended part of the scroll. **N2** Andrew supporting large cross saltire with LH, text 2; Constable il p 147 (Peter and Andrew). **N3** James Maj, RH holding staff with large wallet attached, on palm of LH open book with chemise binding, rubricated minim writing, text 3. **N4** John, RH blessing and resting on rim of chalice with serpent, text 4; Constable il p 146 (John and James). **N5** Thomas, spear in LH, chemise-sac in RH, text 5. **N6** James Min, bat in RH, in LH open book with writing, in chemise binding, text 6. **S1** Philip, 3 loaves resting on LH, text 7, largely worn. **S2** Bartholomew, knife in LH, closed book on palm of LH, text 8. **S3** Simon, 2 fish on draped LH, small scroll in RH, text 9. **S4** Jude, rigged boat in LH, RH raised, text 10. **S5** "Matheus," halberd in LH, RH raised, text 11. **S6** "Matthias," short square in RH resting against R shoulder, clasped book in LH, text 12. N3 and N4 il in Briggs 1004. In 19c 8 figs painted over, and 4 concealed by pews. Only the badly disfigured doctors on the doors were visible.

Wickmere. pwd, frags of 4 articles. 15^{3-4}. **N1–4** constituent scenes missing. **N5** texts 9b and ?10. **N6** Andrew with short cross saltire, trace of text scroll above head and in LH. **S1** apostle with ?spear, text badly faded, beginning "Et" (?text 8). **S2** fragments of 2 apostles, first with text 9a. **S4–6** constituent scenes missing. In very poor condition. Donor panels in modern pulpit, probably from demolished screen at Wolterton S Margaret.

Thetford S Cuthbert. *pwd. "Upon the screen dividing the nave from the chancel were painted the twelve apostles," Martin (1779) 83.

Thetford S Peter. *pwd. 16^1. 1503 bequest of "£5 to new paint the screens . . . viz. the Apostles with the Creed in labels from their mouth," Bl 2:62. The figs had been "whited over" when Martin recorded the screen (1779, 66). C & C record a 1500 bequest of 40*s* to paint the roodloft.

Terrington S Clement. pwd. 1635. Renaissance borders with antique masks, animal masks, fruit, and birds; Our Father and Apostles Creed, no commandments. The same motifs decorate the monument to Ralf Hare (1624) at Stow Bardolph.

Elsing. pg. c1375 ("may well be earlier and part of the original mid-century glazing scheme," King 21). **sII.1–3b** Matthew in atypical costume, badly corroded scroll in LH. **sIII.1–3a** Jude with scroll, "carnis resurrectionem" (restored boat), Jude. **1–3b** apostle with scroll in LH, "inde ventur*is* judic[are]," Philip with fuller's bat. Attributes new. P & W 2 fig 47.

Glasgow Burrell Collection. pg. 14c. Composite, remains of Creed sentences 2–4: (C) "nost*rum*" text 2; (R) "natus ex maria" text 3; and (L) "pass*us* su[b]" text 4; **FIG 37**. Text 3 is integral to the central fig of John with chalice in RH, palm in LH. Provenance Costessey Hall. Patricia Collins notes that the tracing paint in the texts is from separate sources and conjectures that the panel is a 19c assembly.

Bedingham. pg, E win N aisle, frag tracery set in central light. 15^{1-2} (King). (L) James Min "Ascendit ad . . ."; Thomas, frag of spear head "[t]ercia die resur[rexit]"; (R) Philip with wicker basket of five loaves, scroll depending from LH, "Inde venturus." Catherine in the same win has been fitted out with the bare feet and head of an apostle.

S Creake. pg frags, N aisle. c1451. 2 sets, one larger (represented by James Min) and one smaller (represented by Andrew, James Maj and text fragments); the 2 sets are distinguished by the composition of the Creed scrolls. **nVIII.3a** James Maj with atypical hat, staff, buckled wallet strap, wallet very high under LA, inscr scroll largely illegible. Andrew with cross saltire and text 2. **nX.2b**

James Min standing with closed book, scroll arising from shoulder, text 6; name on label. 1a frag texts: texts 7, 9a, and 11.

Bale. pg frag, sV.3c. 1450–80. Philip holding clasped book in RH, long hair, heavily bearded; scroll "est iudicare v[ivos . . .]," text 7; Duffy fig 30.

Norwich S Michael-at-Plea. pg, E win. not *in situ*. 1460–80. Head of main light b. "[Et in Ihesu]m Christ*u*m fili[um eius unicum dominum nostrum]," text 2; **A2** "Pass*us* sub [Pontio Pil]ato, crucifix*us*, mortu[us et sepultus]," text 4; quatrefoil at head of tracery, hand holding scallop shell; Wdf (1938b) il facing 174.

N Tuddenham. pg, *ex situ*. 15³⁻⁴. There are at least 2 Creed sets in glass, one tracery, the other from main lights. Porch E win: **1b** text 4 "qui co*n*cept'"; **4b** "Petrus" without border; porch W win: **4a** "vitam" text 12; light b, frag large fig, James Maj, wallet with flap affixed to short stick, whelk and scallop shells attached to wallet, wearing galoshes; "Iacob maio" in black border in same segments with galoshes; **4b** "et i" ?text 2; **FIG 38**. **nVI.A4** John, text 4 "sub . . . m[ortuus]," on vertical scroll to R of beardless apostle with closed book in LH. "Jacobe" on scroll, no border. **nVI.A1** "*Sanctu*s: thomas" on scroll with gold border. **nV.A2** "surrec" on scroll (Wdf pl XX). **sV.A3** Matthias in blue gown and white mantle, with scroll supported by both hands, text 12, at feet scroll inscr "Matthias." The glass can only be dated stylistically because the origin is unknown (Wdf 55).

Ringland. *pg, S aisle, E win, main lights. ?15³ (extensive glazing in this period). Under Crucifixion Type 1, 3 apostles (Peter, Andrew, James Maj) with texts cited in looped scrolls forming arches; portion of text 1b "o*m*ipotente*m* creatore*m*"; text 2 "Et in Ihesu*m* xpi*stum* filium eius unicum dominum nostru*m*"; text 3 "Qui co*n*ceptus est de Spirit*u* S*a*ncto natus ex Maria virgine." S win, Thomas with text 7, "Inde ve*n*turus est Iudicare vivos et mortuos"; SW win, bust of Jude flanked by "[Carn]is" and "resurreci-onem." Elsewhere text 7 is always given to Philip. The E win was the gift of the guild of SS Peter and Paul. Perhaps the large head of S John cited in the chancel be-

longed to this composition, NRO, Rye 17, 3:142v–143.

Thetford S Peter. *pg, N aisle win. c1483 (glazing bequest, Martin [1779] 65). "The Apostles were neatly painted on them, each having a sentence of the Creed issuing from his mouth," Bl 2:63.

Norwich All Saints. pg frags, nII. Late 15c. 2 sets, one Creedal, perhaps the other with attributes only. **A1** "carnis resur." **A2** "*Sanctu*s Paulus" on scroll; ?apostle with book. **A3** ?apostle. **A4** John, clasped book in LH, RH blessing; James Min with club, scroll inscr "Iacob." **A5** frag Simon with fish; Jude with boat. **A6** Jude with boat; scroll inscr "Judas." Frags of a number of inscr scrolls; Wdf (1936) il facing 173.

V & A. pg. 15c. Apostles on counterchanged black and white pavement, text scrolls above heads. Peter, crossed keys on closed book, text 1; John with chalice and palm, text 4; Thomas with text 5. V & A C.334–7/1937.

Marsham. *pg, S aisle, "Apostles with the Creed in labels from their mouths," Bl 6:287.

Snetterton. *pg. ?15³. "The windows contain . . . the Apostles, each bearing a sentence of the Creed in a label from his mouth," Bl 1:419.

Tilney All Saints. *pg, N aisle. "Apostles, with labels of Creed"; distributed in 2 windows, Bl 9:80–1.

Sparham. *pg, N nave, easternmost win. Nimbed lay fig in short red garment with purse, holding flaying knife; lateral label "Credo in unum deum," DT 44:126.

N Creake. *wdcarv, chancel. c1490. Before 1877 restoration, one of 12 figs with scrolls "among the rafter-feet" bore the inscr "Inde venturus est," and 6 of the original 14 wall post figs remained, incl Matthew and John (Compton, 208–9). Subsequent restoration has further confused the evidence; bearded figs may be remains of prophets. Compton suggested 2 sets of apostles. A good example of Victorian recreation of damaged medieval work.

Brooke. *wp, W wall. Reformation. Creed written in red and black in 11 narrow parallel columns, extending width of church, Beal 63. See section 3 for earlier wp on this wall.

b. Apostle/Prophet Sets

The pairing of apostles and prophets was particularly common in small-scale work inhospitable to text citation. Where Old Testament passages are preserved, there is only limited uniformity in ascription; see Appendix IV.2.

?Wiggenhall S Germans. ms, Howard Psalter, BL Arundel 83 I, full page miniature, f 12. c1310–20. "Duodecim articuli fidei." In 4 columns named prophets and apostles paired with texts inscr (see Appendix IV.2), scrolls reaching to the central column where each article is illustrated: Father blessing, orb in LH; Son displaying wounds; Nativity; Crucifixion Type 1; Resurrection; Ascension; Christ displaying wounds flanked by angels with instruments of the Passion; Pentecost; 3 figs in white; cleric birching monk; Resurrection of the Dead; Coronation of the Virgin. No attributes for the last four apostles, nor for Jas Min; John holds a palm; the other apostles with customary attributes.

Diocese. ms, Corpus Christi Psalter, CCCC 53, miniatures. 14[1]. Ff 7 Jeremiah and Peter; 8v–9 Andrew and David, Isaiah and "Ja[c]obus" [Maj]; 10v–11 Daniel and John, Osee and Thomas; 12v–13 Amos and "Jacobus maior" [error for Min], Joel and Philip; 14v–15 Aggeus and Bartholomew, Matthew and Sophonias; 16v–17 Malachi and Simon, Zachariah and Thadeus; 18v Abdias and Matthias. See Sandler, *Survey* Cat. 66 for the complex arrangement of these miniatures with the Joys, Flagellation, Carrying of the Cross, Crucifixion, S Christopher, Christ in Majesty, and James & John Baptist.

Lynn S Margaret. brass (Flemish). Adam de Walsokne (†1349) and wife. Paired prophets and apostles in lateral and central niches. Badly worn. (Reading L to R) Peter, John, Paul; Andrew, James Min, James Maj; Bartholomew, apostle with halberd, apostle with sword; Jude, Philip (cross bottony), and Thomas; Cameron (1983) 300. Apostle/prophet pairing was common on merchant brasses, Cameron (1980) 152, 159, pls 42d & 43c (prophets).

Oxborough. pg. 1390. On the N side of the chancel "Apostles with labels of Creed," in 18c Peter and John Bapt remaining," Bl 6:183, 186; 2 frag apostles without scrolls remain at **nII.A3 & 4**. Prophets, wearing

soft hats, looping scrolls. **sII.A2** prophet, scroll with damaged name in RH, "patrem invocavit *dominus* celu*m* & tra . . ." (Jeremiah 3:19; 32:17); Bl cited "Moses, In principium erat Verbum &c. Gen. 1 ch. 1a"; no such text remains. **A3** prophet with "Numquit ego qui alios parere facio" (Is. 66:9). **A5** Isaiah, scroll in LH, "Ecce virgo concipiet et pariet filium" (7:14), name at head of scroll. **A6** Baruch, scroll in RH, "Hic est Deus noster & non estimabitur alius" (3:36), name at end of scroll. **nIII.A3** Aggeus [no name] "Sp[i]r[itus] m[eu]s erit in m[edio] . . . vestri" (Aggeus 2:6), Bl 6:185. Texts reconstructed from frag inscr; Appendix IV.2; Aggeus's hat, IV.3 **FIG t**.

Field Dalling. pg, nIV. 15[3]. 3 prophets with names in lower register, 3 apostles with names in upper register, attribute in one hand and frag inscr text in the other: **A1** Abraham, apostle head, "qui fecisti." **A2** "Osee" in prophet hat, "O mors ero mors tua," restored. **A3** "Ysaias" ?apostle head, "Ecce virgo concipiet." **A4** Peter, key in LH, text 1 in RH. **A5** Andrew, cross saltire against chest, text 2 in LH. **A6** James Maj, staff in LH, text 3. Extensive restoration. Appendix IV.2.

Guestwick? pg frag. 15[3]. **sVII.4b** apostle with teaching gesture. **sV.4b** heavily bearded head with prophet hat.

Norwich SPH. pg frags, E win. 15[3]. **1a** apostle and prophet. **2a** James Maj and Simon, James with whelk shells sewn to fur coat. **3–4a** John. **1c** apostle. **2c** apostle paired with Bartholomew.

Heydon. *pg. "St. Peter, Bartholomew, Matthew, Simon and Jude, and Osias in the north window"; "O mors," cited in Bl 6:253.

Poringland. *pwd, screen. 15[4]. Robert Peresson, rector 1472/3–90, "built the seats in the chancel, and the screens, and painted them neatly with the twelve Apostles, each having a sentence of the Creed in labels from their mouths; . . . other effigies . . . : 1, Moses, with yellow horns holding the law, 'In principio creavit Deus Celum et Terra.' 2, St. Peter with the first Article of the Creed. 3, A person crowned, and this: 'Dominus dixit ad me Filius meus es Tu' [David, Ps 2:7]. 4, An Angel 'Ecce Virgo concipiet et Pariet Filium' [Isaiah 7:14]. 5, 'Ero mors tua O mors mortus tuus ero

inferne' [Osee 13:14]. 7, 'Spiritus meus erit in medio Vestri, nolite timere' [Aggeus 2:6]. 8, 'In Ecclesiam Populi Dei, convenerunt Populi Judei' [Judgcs 20:2]. 9, 'Cum odio habueris diruitur Domine Deus Israel' [Malachi 2:16]. 10, 'Suscitabo Filios tuos Syon' [Zechariah 9:13]. 11, 'Ego do vobis viam et Vite et Mortis' [Jeremiah 21:8]. 12 . . ." (Bl 5:440). Only 10 prophet texts are cited, sentences 6 & 9 missing; see Appendix IV.2. Mackerell thought the prophets "the effigies of 12 saints," BL Add MS 12526, f 118. Goddard Johnson c1840 noted that the screen had been dismantled about 15 years earlier and was then "in a cottage garden . . . exposed to the weather ever since cutting down," 1:96.

Salthouse. pwd, screen. 1513 (date inscr, Cotton). 8 paired apostles and prophets. **N1** apostle with ?tau cross in his LH. **N2** prophet turned slightly to paired apostle, green mantle lined with ermine, holding small scroll. **N3** prophet pointing to Thomas. **N4** Thomas, spear in LH, chemise-sac in RH. **N5** prophet in profile facing John. **N6** John. **N7** ?Peter, largely disfigured, attribute scraped away. **N8** prophet turned slightly to ?Peter, ?scroll in RH. **S1** Andrew with diminutive cross saltire in LH, open book on draped palm of RH. **S2** prophet in dark mantle and hood, holding chaperon in LH, RH raised toward Andrew. **S3** James Maj, pointed staff held diagonally in LH, trace of wallet on strap, sleeveless surcoat. **S4** prophet in contrapposto facing James Maj, LH holding scroll that extends over head, voluminous garment over gown, Tudor shoes, long scarf depending from LS and draped around R hip. **S5** James Min, closed book in LH, no text scroll. **S6** prophet pointing to scroll in RH, slit sleeves, calf-length belted coat with embroidery at edge, white stockings and Tudor shoes. **S7** ?Simon with boat. **S8** prophet with RH raised, slit sleeves, black ?ermine-lined coat, hitched under LA over short square-necked gown, Tudor shoes. Prophets at N3, 5, 8 and S2, 4, 6 and ?Peter with looped "text" scrolls above or behind heads. Horizontal scrolls above heads N except N3 and S except 5 & 6. No texts preserved except "pro animabus" and date at S3 & 4. Parclose screen: frag names below in crude

black letter, horizontal scrolls above with undeciphered texts: **1** Matthew (name disfigured) holding clasped book in RH, halberd in LH. **2** "Sof[on]ias Propheta," RH pointing up, LH hitched in belt; ?ermine-lined mantle and collar over calf-length gown with split hem, heavy boots. **3** "S[anctus] thadeus" (sic) holding fish in both hands, mantle turned back to create collar, a brown purse hanging at waist. **4** "Daniel Propheta," RH pointing to scroll above, holding purse in LH, a flat-crowned hat, loose surcoat with slit sleeves over a knee-length gown, Tudor shoes. Restored 1931. See Appendix IV.2.

2. The Commandments

Surlingham. *pg, S win. 2 "broken effigies, one of a false witness, and under him, 'Testis iniquus.' In a label this, 'Ne Jures vana per ipsum.' The other hath the word 'Mechus' under him, and this in a label, 'Tuos venerare Parentes'," Bl 5:467.

Griston? *pg, N win, "priest in pulpit preaching to a large congregation, with this in labels, 'Nos predicamur Christus Crucifixum' And this: 'Nonne est hic qui expugnabat?' Some of his audience with 'Jesus' from mouths, some are kneeling, and others prostrate; this is perfect, and is a curious painting," Bl 2:294. Perhaps related to continental scenes for the Commandments.

Brooke. wp, S wall. ?16c (Protestant). 2 tablets painted over earlier wp, Beal 65. See also section 3.

Commandment Tables

Most of the early Commandment boards, like those beneath the Elizabethan arms at Tivetshall, are unornamented. Those with Moses and Aaron—e.g., at Woodrising and Caister (1688)—generally postdate the Subject List. Thomas Martin's reference to Moses and Aaron at Downham Market "painted by old Brook" (NRO, Rye 17, 2:37v) suggests 18c work. There are, however, two instances deserving mention, the free-standing flat manikins of Moses and Aaron from Gorleston (now NMS) and the reredos at Colby. One authority has dated the former c1630, though the date is disputed. I have included the fine example preserved at Colby because the priestly costume corresponds in detail with that found in 15c English manuscripts of Nicholas de Lyra's *Tabula*. Unless restored, the commandment boards are often very dark and difficult to interpret.

Shipdham. pwd. 1630. 2-tablet design with orna-

mented border; tetragrammaton in apex; Cautley il p 104; "originally part of painted tympanum," Pevsner 2.

Gt Snoring. pwd. c1640 (DP). (C) Commandments flanked at extremes by full-length fig with arms extended towards the commandments, (L) nimbed (restored to look like Christ) standing on dragon with long protruding red tongue; (R) head backlighted, in simple belted gown. In roundels flanking tables evangelists writing at tables with inscr label below: (L above) Matthew with angel behind leaning towards him; "Death"; (L below) Luke with ox in foreground; "Hell"; (R above) Mark, lion in foreground, "Judgment"; (R below) John, "Heaven." Cautley's "faint" figs, whom he thought to be Moses and Aaron, are no longer faint but restored out of character.

Colby S Giles. pwd. Late 17c (Pevsner 1). (L) Moses, bald, bearded, mantle over gown, holding tablets of Law in RH; Exodus XX at top of tablets, laws numbered i–v and vi–x; (R) Aaron holding thurible, bearded, wearing oriental hat, breastplate, with layered gowns of gold, green, and white; dalmatic trimmed with beads (?pomegranates). The backgrounds are decorated with pyramids and palm trees. See P & W 1 for provenance.

Diss. pwd. ?17c. Central tablets flanked by (L) Moses in red belted gown with draped mantle and white undergarment, staff in RH, LH resting on tablet; (R) Aaron, turban, breastplate, bells at hem of tunicle, RH resting on tablet, LH holding thurible; restored.

Moulton S Michael. pwd, tower arch. ?17c. (Above Creed L) Ark on Mt Ararat, (C) IHS in radiance, (R) waters. Demi-figs above boards, (L) Moses pointing to commandments; Aaron in priestly vestments, incl mitre and breastplate. Commandments moved from chancel in 1736/7 (churchwarden accounts). Cited by M & R (3) but not by Cautley or Wilson. The work is very dirty and hung in a dark corner of a redundant church.

3. The Deadly Sins and Others

Unless stated otherwise, the sins are represented by men.

Cathedral. sc, boss, Bp Salmon's porch. 14[1].

Lust: "a devil perched behind a male and female holding hands," Sekules 202. Whittingham (1979, 365) identified gossips, but that would entail 2 females. The boss is very dirty and ill lit; porch restoration is planned.

Brooke. *wp, S wall, frag when recorded. c1400. Horizontal registers, each in an arched compartment above a hellmouth, wearing tight cote-hardie ending in scallops at upper thighs, belt at hips. Pride (Vanity) youth with round mirror in RH, comb in L, head bound with filet, elaborately striped gown, buttoned from neck to belt (Ingleby pl VII). Anger with curling short hair and short beard, contorted brow, plunging 2 knives into breast, blood drops falling into hellmouth (Ingleby pl V). Avarice with a tasseled purse in each hand glancing towards RH (Ingleby pl VI). Gluttony ?vomiting, bent over cask containing flames; (L & R) 2 other vessels (Ingleby pl III; see also DT 53:228). (Above) ?Socordia ?bear with white belt and girt with sword in scabbard walking on hind legs dragging a youth by tied ankles (Ingleby pl VIII). Perhaps a different subject since Beal (68) noted it was non-contiguuous with the other 4 scenes. Discovered in 1849, whitewashed; all except Gluttony il in Beal. See also *Fraudulent Alewife.*

Catfield. *wp, frieze of N nave arcade betw 1st and 2nd arches. 14[3–4] (DP). Tree of Vices, perpendicular branches of tree dragon's body ending in mouth where fig stands next to a devil; names in scrolls above each sin. Reading down: (L) large fig blowing trumpet; "avaritia" sitting in mouth of dragon, man counting money on a board; "ira" stabbing breast with dagger; "socordia," devil with hand drawing man's head to rest on his shoulder. (Opposite R, largely destroyed) "Invidia." (C) demi-figs emerging from branches, heads tied to long vertical chain being pulled by 2 devils standing in hellmouth below, king falling head-first therein. Winter described the devils as bufoons in paper crowns, but one crown may be a fool's cap (*Selections* 2:11); Turner (1847c) il facing 133. Interesting correspondence from Husenbeth and Turner in DT 27:151–53.

Crostwight. wp, N wall, L of door, *circa* 9' x 4'.

Late 14c. Tree of Vices, each fig in small hellmouth at branch end (dragons with wings), root rising from large hellmouth. Defaced fig at the apex (?Pride). Reading down L: Lust, man with hand on woman's breast. Sloth, woman leaning head on palm of hand, remains of inscr scroll. Reading down R: Gluttony holding a cup. Avarice with a money bag in each hand. Anger, RH raised and LH at hip; (below L) devil, (C) 3 figs in flames; Tristram 160; DT 54:111. Generally well-preserved, but details in watercolors no longer observeable. Turner (1849) il betw pp 252 & 253.

Reepham S Mary? *wp. A photo of a damaged drawing suggests a possible tree of vices; two heads with "Luxuria" above. Penciled note, "Found in 1910 betw clerestory windows," NMR.

Brumstead. *wp. "Deadly Sins" reported destroyed in 1865, "Extracts" 7:355.

East Anglia. ms, CB UL Gg.4.27(1), Geoffrey Chaucer, *Canterbury Tales* (Parson's Tale), miniatures with names inscr. c1420–30. Ff 416 Envy as young man with sword, riding a dog, holding lead and bone, paired with Charity (names inscr); 432 Gluttony as obese young man holding bird by lead and "luring it with worm or entrail," riding bear, paired with Abstinence; 433 Lechery as woman with chained lock on wrist holding sparrow, paired with Chastity. The rarity of illustrated paired vices and virtues is noted by Scott, *Survey* Cat 43, who illustrates Envy and Charity (il no. 182).

Norwich S Leonard's Priory. *pcl. 145[2–3]. "Item pannus pictus de vij peccatis," Bensly (1895) 218.

Lynn S Nicholas. wdcarv, roundel in poppyhead. c1419. Naked man riding backwards on horse (punishment for sexual misconduct), Gardner fig 537. For an ape riding backwards in the early 14c Peterborough Psalter, see Mellinkoff 170, fig 10.

Wiggenhall S Mary? wdcarv, be nave S10. Early 15c. ?Avarice, box, fig with ?purse; ?Lust, 2 headless figs, one naked.

N Elmham? wdcarv. screen spandrel N6. 15[3]. Man with long dagged sleeve riding pig.

Cathedral. wdcarv, misericord. 15[4]. **N16** Anger in lay costume riding on boar, drawing sword (Grössinger pl 191). **N18** Gluttony, (L) pitcher on stand, (C) fat man on sow,

drinking from flagon, liquid spilling down chest, ?mazer strapped to chest (P & W 1 pl 56), supporters, mermen; Rose (1994).

— wdcarv, misericord elbow rests, 2 sets. 15[4]. Seated men with attributes: **S14** ?Pride, dagged garment, extravagant hat; **S15** Gluttony holding wine-skin/bottle; **S16** Lust, thighs and legs exposed; **N16 & N26** Avarice holding bag; **N24** Gluttony holding jug. Demi-figs in hellmouth without attributes: **S30 & N19** in armor; **S31** bald, elaborate clothing; **N23, 27, 28** in variety of hats; **N25** no hat; Rose (1994).

Thornham. wdcarv, be. 15c. Each in hellmouth: Sloth seated on bench with head resting on RH, beads held slackly in LH. Anger in short gown, jaunty hat, holding dagger at his breast, Gardner (1955) pl 19.4. Gluttony seated on bench holding huge beaker to his mouth. See section 5 below.

Watlington. wdcarv, be. 15c. Sloth in chaperon resting his head on hand, beads in other hand. Avarice seated with an open box [money chest]. Anger drawing a sword.

Forncett S Peter? wdcarv, be. ?16[1]. N3 (reading from W). Man with money chest and animal (devil) betw legs (upper section new). Cautley conjectured that a woman "in a sentry box" (doorway of house) might have represented incontinence, but this fig is paired with visiting the sick; Cautley il p 149. 1857 restoration confined largely to upper bodies. See below section 5.

Pulham Market. wdcarv, be, chancel. ?Gluttony.

Wiggenhall S Germans. wdcarv, be, nave L/R shoulder of poppyheads. c1500. (L) each sin carved within hellmouth, paired with angel (R) pointing at the sin. **S2** ?Sloth, decapitated kneeling fig. **S3** Anger with ?knife in breast. **S4** with sword betw legs. **S5** Avarice seated holding 2 money bags in LH, one in R, cylindrical chest betw legs (Duffy fig 27). **S6** Gluttony seated, LH pouring from flagon into large bowl in RH (James, *S & N* il p 213; Gardner [1955] pl 19.3). **S7** Lust, couple embracing (Duffy fig 26). Although there are 7 benches, S1 is not part of the series. Jenkins, color il p 482.

Bressingham. wdcarv, be. 16[2]. Sin paired with seated fig. Avarice in 2-buttoned tunic sitting before a chest. Gluttony with distended belly. See section 5 below.

Northwold? pg. 16c. The rector "sitting alone,

(as great as Epicurus himself) at a table well furnished with meat and drink," Bl 2:216. Martin drew a hand holding a bread knife above loaves of bread, a second hand holding a bowl, (above) a covered chalice and ?cut bread; "when whole the Representation of a Jolly Priest with the inscription 'Epulari et gaudere oportet' over his head." Martin also cited diverse sorts of fowl and the word "*Fortitudo*" in a round piece Intire," NRO, Rye 17, 3:98. Perhaps an emblem.

There is evidence for the 16c vice play at Norwich, where in 1546 the Queen's players produced an interlude, "whose matter being the market of Myscheffe," (Galloway 20; Lancashire no. 1230), and at Wymondham in 1538/9, where the Watch and Play Society paid for a vice cap as well as 4*s* "for blew and red bokehm for ij vice cots" (Carthew [1884] 146, Galloway & Wasson 129, and Lancashire no. 1550).

Other Sins
Simony
Cathedral. wp, 3 roundels, S aisle, 4th bay, cll90–1200. Herbert de Losinga in appareled alb handing money to agent for the simonical purchase of the See; Losinga as bp repenting; Norwich Cathedral (purportedly built in penance for his sin, but see Harper-Bill 282); Park (1994) color pls 14–15; Atherton, color pl IV.

— sc, boss, Bp Salmon's porch. 14[1], "a mason and courtier in a net tussling over a church," Whittingham (1979) 365. It is impossible to verify this description in the present condition of the boss. Further specification must await restoration.

?Cathedral Priory. ms, Gregory the Great, *Moralia in Job*, CB Emmanuel College 112, hi. c1310–20. (Book XI) Layman seated with purse facing man wearing coif and gloves; (below) 2 men falling into hellmouth; (border) large fig of Gregory as pope in Mass vestments pointing to scene; James (1904). Sandler queries 2 misers, *Survey* Cat. 45 il no. 103.

Swearing
Heydon. *pg, N aisle. 12 sentences in scrolls and a lamentation, "many young swearers, drunkards, dice-players, and other profligate liers, with a representation of hell, and such sinners as those in its flames," Bl 5:253. "The Figure of our Saviour speaking

to sinners," with text cited, NRO, Rye 17, 2:210v. Wdf reconstructs the win on the basis of antiquarian descriptions and corresponding wall paintings elsewhere. The composition comprised a series of young men swearing in rhymed couplets by the limbs of Christ, "Be Goddys hert . . . blod . . . body . . . sowle . . . armys . . . sydys . . . nie [knee] . . . feet" with a lamentation and perhaps a central Pietà; for reconstructed texts, see Wdf 183–4. A frag in a private collection of a man in balloon hat and 3 dice on palm of RH may have come from this win or one like it (Dennis King, copy of letter in Heydon church).

Gossiping (Jangling)
Typically a devil (Tutivillus) or devils drawing the heads of women together to encourage gossiping. Tutivillus is the recording demon who writes down words wrongly spoken or uttered during Mass. See *Age of Chivalry* Cat. 557 and fig 13. In Norfolk beads play a prominent role in these scenes—the women are neglecting their prayers for gossip. See Tristram 108–12.

Colton. wp, W wall, *circa* 2'9" x 3'3". 14[3-4] (Tristram). 2 women on bench, leaning towards each other, holding hands, beads in unclasped hands; flanked by devils standing on ends of bench who press their heads together. (Above) devil with one foot on each of the women's heads, arms akimbo, tail depending betw women. 3 text scrolls with apparently meaningless successions of letters, 2 extending from central devil, the third from L devil.

Lt Melton. wp, N wall. 14[3-4] (Tristram). 2 women on bench, heads together, holding beads in R hands, inclining to each other; L arms at breasts; Tristram's flanking devils no longer visible.

Seething. wp. S wall, E end. 14c (Tristram). 2 women seated on bench, L with beads in RH and small devil below ?running away with second set of beads; large devil behind with hands on women's heads (for a similar scene in Cambridgeshire, see Rouse fig 78; (L) meaningless succession of letters.

Stokesby. *wp, W of N door. 14c. 2 veiled women on bench in gowns buttoned in front, clasping R with L hands, heads bent together; (R) woman resting RH on shoulder of companion; on outermost shoulders "beetle-like creatures" (Husenbeth called them cockroaches); (above) a large shaggy-

headed horned devil with bat's wings outspread (for the same treatment elsewhere, see Grössinger pl 14); (far L) 2 devils, one standing above the bench, horned with big ears, a pointed object in RH; small bearded devil seated on the bench; (far R) veiled woman seated on bench holding beads betw her knees, hellmouth beside. Description based on Winter's 1858 watercolor, NMS B.147.235.951 ("Inside Norfolk Churches," exhibit, Norwich Castle Museum, 24 Sept 1994–3 Sept 1995), but see also Tristram (110), who read "insects" for "beetle-like creatures" and conjectured witchcraft. For Husenbeth's mistaken interpretation, see Taylor (1859a) 292–3.

Eaton. wp, above S door to church addition. ?Early 15c. 2 women, heads together; kneeling behind bench, one with beads; flanked by devils, (L) with curling tail, (R) large devil leaning over woman with foot on hem of her skirt.

Crostwight. *wp, above N door. ?15c. (C) 2 women with angels standing behind trestle bench; (L) large fig (devil) in fool's cap; remains of other figs. The angels seem to have their arms around the women, for which see Mrs Gunn's watercolor, DT 54:113; Turner (1849) il betw 252 & 253. Perhaps iconography of this scene incorporated a contest betw good and bad angels in 15c illustrated prayers to the guardian angel and in penance scenes (6b). See Tristram (112) for witchcraft query. Adjacent scenes, tree of vices and Christopher.

S Walsham. wdcarv, be. 15c. Woman with beads kneeling at prayer stool with second woman "almost enveloping her." Peter Meredith calls the scene "Interrupted Prayer"; I am grateful for being permitted to see a copy of his work on the bench ends at S Walsham.

Fraudulent Alewife

Cathedral. sc, nave boss, N7. 15³. Devil pushing soul in wheelbarrow, woman holding flagon aloft riding on his shoulders; Rose (1997) 114.

Brooke. *wp, W wall, c6' x 7'. c1400. Woman with purse at waist, holding vessel with flaming liquid in LH, in RH bung of cask; on trestles over flames cask with flames rising; (above) issuing from flames nimbed angel with outstretched arms; Ingleby pl IV; Beal, facing 68. The angel troubled Tris-

tram ("evidently misunderstood," 144); perhaps it should have been a demon as in the Chester Whitsun cycle.

4. Virtues

East Anglia. ms, Geoffrey Chaucer, *Canterbury Tales*, Parson's Tale, CB UL Gg.4.27(1), miniatures. c1420–30. Paired with Vices (see above). Ff 416 Charity nimbed, crowned, holding winged, flaming heart; 432 Abstinence crowned, nimbed, holding covered ?water pitcher and ?stalk; 433 Chastity with cross-staff standing on ?dragon; Scott, *Survey* Cat. 43, il no. 182 (Charity). Scott notes the relationship of Chastity to S Margaret; cf also below where Fortitude is based on the iconography of Barbara.

Four Cardinal Virtues

Women representing Prudence, Justice, Temperance, Fortitude; see also IV.1.

V & A. pg roundel. 15⁴. Justice, luxurious hair, burlet with 7 ouches; sword in LH, scales in LH. V & A ac.181–1934. Almost certainly part of a set.

N Creake. pwd, 4 screen panels. 16¹. Temperance, woman with long hair pouring water from pitcher in RH into bowl in LH; ?burlet, square-necked red fitted gown with layered/slashed sleeves; (below) "Temperancia." Justice (badly damaged) woman in square-necked gown, sword point up in RH, on palm of LH globe inscr with scales (?originally Catherine). Fortitude, woman with long hair, barb under chin and over large ?burlet (Costume Glossary, **FIG f**); RH holding mantle, LH at back of tower reaching from floor to head height; (below) "Fortitudo" (?originally Barbara). Over the years the panels have been attached to a vestment press, organ case, most recently reconstituted as an altarpiece in N aisle chapel. See also XII *Veronica*.

Norwich S Andrew. 1556. Pageant for mayor's installation incl the 4 virtues "with an orator all having speeches," Lancashire no. 1234.

Tittleshall. al. 17². Monument to Sir Edward Coke: 4 reclining women: (L of broken pediment) Justice with small scroll in LH; Prudence with snake encircling LA. (R) Temperance resting empty water vase on L thigh; Fortitude, bare-breasted, with RA encircling broken column.

Buxton. *pg. "Justice with her equal balanced scales," Bl 5:447

5. Corporal Works of Mercy

While identification of sets is relatively straightforward, individual works are only cited when evidence is strong. The "Worker" is typically a woman. When Works cluster geographically, as they do in Wickhampton and Moulton S Mary, it is tempting to hypothesize that the double figs on the benchends at Tivetshall may be remains of scenes better preserved in the same medium at Forncett S Peter.

Wickhampton. wp, N wall. c1360 (DP). In 2 registers, 8 scenes framed in canopied arcades (each *circa* 4'x 6'), originally with inscr scrolls, none decipherable. Reading from L to R, upper register: Feeding the Hungry: (R) veiled woman extending RH to pilgrim with staff; scrolls. Giving Drink to the Thirsty: (R) woman with ?crown giving cup to man with staff. Clothing the Naked, (R) woman in wimple and veil extending garment to cover man in drawers, nude to waist; man bending to draw garment over head. Receiving the Stranger: (R) woman receiving a man walking with 2 sticks. Lower register: Relieving Prisoners: (R) woman in hooded cloak bending over clasping hand of a bearded prisoner in short red tunic seated in stocks, scroll above his head; James conjectured she was putting money into his hand. Visiting the Sick: woman visiting man sitting up in bed. Burying the Dead: in sepulcher corpse in shroud decorated with cross formy, cleric in alb standing at head of sepulcher in alb holding open book, priest in the center with an aspergillum, grave-digger with spade at the foot. Christ standing, fully clothed, holding Resurrection banner, remains of lateral text. The curious eighth scene was identified by Tristram as "Christ blessing." Some details in Tristram (264) are not in Reeve's watercolors, nor are they discernible today. Same workshop as wp at Moulton, James (Ingleby) pls XXVI–XXXIII.

Moulton S Mary. wp S wall. c1360 (DP). If the existing canopies can be taken as scene-defining, there were originally 11 scenes in one register on the S wall. (The relationship betw the Works and the other scenes is unclear.) Three have been cut away by win S6, with just the canopies remaining above,

and the first scene is cut into by the embrasure of S5. The extant 8 scenes are framed in arcades and have scrolls with indecipherable traces of writing. Reading from E: ?Giving Food to the Hungry: woman extending RH. Giving Drink to the Thirsty: woman in gown with long sleeves, funnel-shaped cuffs (bombard), and liripipes, holding scroll and extending bowl; pilgrim with scrip and staff accepting bowl with RH (Batcock pl 47). Clothing the Naked: woman extending large garment with red lining, helping to clothe man in drawers tied at waist who grasps the hem of garment in both hands (same cartoon as at Wickhampton) (Tristram pl 29b; Caiger-Smith pl XIX mislabeled Little Melton), 3 scenes lacking. Priest in cope holding LH against open book held by clerk in alb. Nimbed Christ with scroll (cf Wickhampton). Relieving Prisoners: man seated in stocks, woman extending hand to him. Burying the Dead: 2 figs standing beside bier, one with aspergillum in RH; cross on shroud. Remains of fig and canopy. Same workshop as at Wickhampton.

Potter Heigham. wp, S aisle. c1360. Works arranged U-shaped around a life-sized woman occupying the upper ⅔ of central space, facing E, RH raised, LH holding building with doorway in which stands a man holding a staff. The woman performing the Works is veiled and wears a sideless surcoat. Reading counterclockwise from the topmost register: (L) Feeding the Hungry, inscr "hunger": woman placing bowl and loaf in hands of man with forked beard. Veiled head ?Giving Drink to the Thirsty. ?Clothing the Naked, hand extended; frag fig. (C base) Relieving Prisoners: man with shaggy hair and long forked beard seated on rush mat, wrists shackled and feet in stocks; woman placing money in his hand. (R) Sheltering the Homeless: veiled woman in doorway grasping wrist of pilgrim (for his hat see Costume Glossary, **FIG g**) and taking his staff; (above) scroll inscr "herb' ?have. . . ." Visiting the Sick: veiled woman feeding man in bed with spoon from bowl, his RH on striped blanket, LH on bare breast; inscr above, probably decipherable with proper light (Tristram pl 64a; Pevsner 1 pl 40a). Burying the Dead: woman point-

ing LH, giving coin to priest in Mass vestments; (upper R) fig with processional cross; inscr above, probably decipherable with proper light. The remaining inscriptions are extensive and deserve transcription. In 1961 Eve Baker conjectured an adjacent set of Deadly Sins covered by limewash.

Edingthorpe. wp, N wall. c1400, retouched after 1937. Tree with 3 lateral branches creating eight sections; only R side preserved. Reading from base: ? Heads only. ?Relieving Prisoners: woman, LH on breast, RH extended and dropping object into extended hand. Sheltering the Homeless: 2 figs clasping hands, Tristram suggested "the Fourth Work." Unidentified work: 2 small figs with raised hands, facing a *Manus Dei* or "the right hand of a figure of Christ . . . originally above the adjacent window," Tristram 167.

Catfield. *wp, N wall. 14^{3-4} (DP). Traces of burial of the dead, DT 27:154. Betw 2nd and 3rd arches, contiguous with sacraments; Caiger-Smith (54) without further comment cites Works.

Cathedral, Visitors' Centre. pg frags. 15^{3-4}. Giving Drink to the Thirsty: woman with pitcher, LH in greeting gesture; house in background. Relieving Prisoners: man with purse putting coins into hand of prisoner standing at top of jail building with chain over shoulder. ?Visiting the Sick: head of man in coif. Burying the Dead: 2 hands laying out shrouded corpse; hand holding book with minim writing; 2 clerics in surplices (segments leaded separately). Angel in feathers with scroll "For your good deeds Heaven shall be." King conjectured a Suffolk origin (1996, 426).

Guestwick. pg frag. 15^3. Extensive glass still *in situ* in 18c. sVII.1b Visiting the Sick: man in bed, head on pillow, bedclothes chest high: "In a window of the S isle is the portraiture of a physician administering physick to a person sick in bed, and this, 'In sicknes I pyne—Trost in God, and here is medicine'." *Clothing the Naked: "Also a person naked, and, 'For colde I quake'; also a woman bringing things, 'Have here clothes and warm to make'," Bl 8:219. Martin cites "ffor Cold we quake/ have here Clothys & warm to make." *Feeding the

Hungry: "Lo ȝe to fedyn / I am redy / ffor hunger / be gredy," NRO, Rye 17, 2:150v. The patchwork win also preserves a number of fragments, possibly part of the Works— bare feet, a head in a straw hat, a priest in a chasuble with RH blessing, and a bearded head in close white veil cradled in LH, eyes with intense expression. David King (23) suggests that extant grotesque heads may also come from this series.

Brandiston. *pg, S win, next the porch. 15c. Visiting the Sick: "Ful seek i pine. mac mirthe lo medicine." Feeding the Hungry: "Ye to fedin lo me." Relieving Prisoners: "Dotȝ don yeze"; and texts "dedis" and "to wynne," NRO, Rye 17, 1:140. See also IX.3. This scene was misread as the "history of the Good Samaritan," Bl 8:197; see Wfd 194.

Lammas. *pg, N win. 15c. Feeding the Hungry: (1st pane) "The Hungry Man says, 'For Hunger Gredy,' The Virgin answers, 'Thee to Fede, lo me nogh reedy'." Clothing the Naked: "The Naked calls out, 'For Cold I Qua[k,]' The Virgin answers, 'Doo on a Cloth the Warme withall'." Giving Drink to the Thirsty: "The Thirsty saith, 'For Thirst I Cleve,' The Virgin says, 'Have Drynk for the Lord that ye Leve'." Sheltering the Homeless: "The Stranger cries, 'Hostel, I Crave,' She replies, 'Come wery in and you shall have'," Bl 6:291–2. Part of a Last Judgment scene; woman performing the Works misidentified as the Virgin.

Oxborough. *pg, ?E win, N aisle. Visiting the Sick: "in a pannel are the remains of one lying sick in a bed, and another administering something to her relief in a cup," Bl 6:183–4.

Quidenham. *pg. 15c. Visiting Sick/Prisoner, "effigies of the Virgin holding a wafer, on which is this, 'Hi Visite ye'," Bl 1:336. Wdf suggested a coin. In Martin's drawing the woman is crowned, and the words are immediately below the coin, NRO, Rye 17, 3:118v.

Thornham. *wp. James in 1899 remembered a man in stocks over S door, *S & N* 205.

Coltishall. *wp, N wall. Burial "probably intended to represent the Seventh Act of Mercy," Keyser.

Feltwell S Mary. wdcarv, be, nave aisle. 15[4] (?1494, P & W 2). Numbered from W. **S5** ?Sheltering the Homeless: fig with purse at waist standing before doorway with outstretched arm; in doorway a second fig; Gardner (1955) pl 18.1. **S6** Feeding the Hungry: fig with round loaf in each hand; fig with loaf in one hand and beads in other. **N3** Burying the Dead: 3 figs, one with thurible, standing above shrouded corpse; Gardner (1955) pl 22.5. **N4** Relieving Prisoners: face in prison win, portcullis on side of prison, disfigured worker standing before win. **N5** ?Clothing the Naked: naked fig on all fours, atypical posture.

Wilton. wdcarv, be. 15c. ?Feeding/Giving Drink: woman in doorway of house greeting a standing fig, her arms in a position consonant with giving. ?Sheltering the Homeless: worn fig in doorway of house; man holding ?chaperon over shoulder. ?Visiting the Sick: bed clothes as at Blythborough (Suf). If Sloth, as Duffy argues, there may have been a Works/Sins set at Wilton. Cautley conjectured that the house scenes represented the sin of incontinence.

Pulham Market. wdcarv, be, chancel. 15c. ?Clothing the Naked: fig kneeling before layman. Burying the Dead: shrouded corpse on bier.

Forncett S Peter. wdcarv, be. ?16[1]. Reading from W. **N4** Visiting the Sick: woman in door of house, fig standing beside person abed. **S5** Burying the Dead: woman standing beside fig on bier. See also section 3.

Bressingham. wdcarv, be, S side nave. 16[2]. Each paired with seated fig. Reading from E. Feeding the Hungry: 2 standing figs with basket betw them. Clothing the Naked: (L) frag kneeling fig; (R) standing fig with clothing folded over arm. Unidentified, 2 seated figs. Burying the Dead: 2 figs standing behind draped bier with shrouded corpse. Sheltering the Homeless: 2 figs, one with staff. Relieving Prisoners: man entering prison, the walls of which are incised to look like stone, 2 win slots.

Other Related Scenes

Aslacton. *pg, chancel. A swaddled infant in cradle, supposedly a foundling raised by and named for the parish. Aslac became a standard bearer to Edward III; Bl 5:180–1.

Morley S Botolph. *pwd, top of screen back.

c1480. Rector with name over head shown, (C) "parsonage-house, with the word 'Rectoria' over it," apparently drawings of his two churches, S Botolph and S Peter, and "on one side, he is represented in a priest's habit, giving alms to the lame, blind, and poor, and on the other side in a shepherd's habit, looking after a flock of sheep," surely one of the more curious works cited in Bl 2:477.

Watton. wdcarv. 1639. Poor box in shape of standing man holding purse, inscr "Remember the Poore," Cautley il p 152.

6. The Sacraments and Liturgical Ceremonies

For variations from standard Sacrament iconography described below, see Nichols (1994) Gazetteer.

Baptism: Priest immersing infant in font with godparents flanking the scene; often with cleric holding service book.

Confirmation: Bp in mitre and tippet over gown anointing infant presented by godparents; often multiple confirmands.

Eucharist: Priest elevating host or chalice at dressed altar, often with flanking clerics sometimes with sacring torch or ringing bell; sometimes with lay people. See below for other representations.

Penance: Priest, often wearing chaperon, laying hand on head of penitent; sometimes with good or bad angel; other penitents, sometimes fingering beads. For chaperon, see Nichols 1986.

Orders: Bp in varying vestments laying hand on head of ordinand.

Matrimony: The priest standing betw bride and groom whose right hands are linked (handfasting); typically an attendant holding the service book and male and female witnesses flanking the scene. See also IV.2 *Marriage of Mary and Joseph.*

Extreme Unction: *Moriens* in bed, being anointed by priest; often wife at bedside.

a. Individual Sacraments

Additional representations of the Eucharist are listed separately at the end of this section.

Norwich, Carrow Priory. ms, Carrow Psalter, Baltimore, Walters Art Gallery W.34, hi, f 178 (Ps 97). 1250–60. Elevation of Host.

Ranworth. ms, Ranworth Antiphonal, S Helen's Church, hi, f 107v. 1460–80. Eucharist (feast of Corpus Christi): elevation of Host, priest flanked by 2 Premonstratensians lifting edges of chasuble; altar with 2 candles and riddles; Nichols (1994) pl 66. The habits lend support for a Langley Ab-

bey provenance.

N Tuddenham. pg, nVI.A4. 15c. Penance: priest in alb, stole, and hood, birch in RH resting LH on head of kneeling penitent; above on scroll, "Confide fili remittut[r tibi pecc]ata tua," Wdf pl XIX.

Tilney All Saints? *pg, ?N aisle. ?Penance: "a person on his knees . . . a priest standing by him," Bl 9:81.

Stratton S Michael. *pg, S chancel win. ?Extreme Unction/Burial: "a censer and a broken figure (seemingly) of a Dead or sick person under it much broken," NRO, Rye 17, 3:229.

Wiggenhall S Germans. wdcarv, be. c1500. Both sacraments paired with standing men, pointing E (cf angels on S side). **N1** (E side) Penance, priest seated, wearing stole; hand on head of kneeling penitent (absolution). **N2** (E side) Matrimony, priest wearing stole and clerk with open book facing man and woman, each with hands joined in prayer, no handfasting; Gardner (1955) pl 15.2. Tempting as it is to posit a set of sacraments to balance the Deadly Sins on the S, the rest of the N benches are dominated by seated men with rolls or books paired with animals.

In addition to the elevation during the Mass, the Eucharist is also represented by adoration, communion, incl viaticum (communion of the dying), and widespread occurrence of arms of the sacrament (selective citation only).

Adoration

Diocese. ms, missal, Bod L Hatton 1, hi, f 120v. 14⁴. Feast of Corpus Christi: two clerics in copes swinging censors before curtained altar with a gold monstrance; copes held back by two clerics in albs; Scott, *Survey* Cat. 5, il no. 20.

— ms, Wollaton Antiphonal, Nottingham U Library 250, hi, f 170v. c1430. Cleric with monstrance flanked by acolytes; Scott, *Survey* Cat. 69, il no. 279.

Cathedral. *im. 15³⁻⁴. Angel lowered from the roof on the feast of Corpus Christi. In the nave vault at J4 there is an aperture *circa* 2 feet in diameter instead of a boss; the central boss in bay J represents the Last Supper. Costs appear in the sacrist rolls sporadically betw 1452 and 1487. Woodman (1996, 188) argues that a hiatus betw 1452 and 1462 supports his contention that

the nave was out of operation because the vaulting was being done then and not after the 1463 fire as usually claimed.

Burgh-next-Aylsham. sc, font bowl relief. 15⁴. Monstrance on draped lateral altar; man in tippet kneeling with hands joined. 8th scene of a 7-Sacrament font.

Bread of Angels

Gressenhall. wdcarv, screen tracery above Gregory and Michael. 15⁴. In spandrels 2 angels censing; main tracery, 2 angels in albs demi-kneeling, holding betw them a chalice with surmounted host.

Upwell. *pwd, screen, "an altar with the cup and wafer, supported by 2 bishops [?angels]," Bl 7:466.

Communion/Viaticum

East Anglia, ?Norfolk. ms, Guillaume Deguileville, *Pilgrimage of the Soul*, New York Public Library, Spencer 19, miniature, f 7. c1430. Adaption of viaticum: Dreamer in bed with vision of Dame Prayer with chalice and host and Dame Misericord burying his body. Scott, *Survey* Cat. 74 il no. 291.

Norwich SPH. *pg, N side of altar. 15⁴. A "priest in purple performs the ceremony, and by him is the host; by the bed's side appears the face of the evil angel, which cannot approach him," Bl 4:330. Priest (Rector Thomas Andrew) remaining in E win 2b described as kneeling before a city in the clouds and "at prayers at an altar, his crown . . . shaven."

Gayton Thorpe. sc, font bowl relief. 15³. Priest in crossed stole before woman kneeling at houseling cloth; second cleric offering houseling cup to kneeling man.

Suffield. wdcarv, pwd, screen spandrel. c1524. Parody of viaticum: bird placing round object in mouth of fox lying at an angle, paired with pig in doctor's cowl examining jordan. Viaticum represents the Eucharist in 7-Sacrament glass at Doddiscombsleigh (Devon) and Crudwell (Wilts).

b. Complete Sets

Catfield. *wp. 14³⁻⁴ (DP). N wall, betw 3rd and fourth arches, Works, in 2 registers: (above) next to Baptism, 3 missing scenes; (below) Penance, Matrimony, Extreme Unction, and also Crucifixion in 2 registers.

When the watercolors were made, the subjects were damaged and faint, DT 27:155–8.

Norwich S Clement. *pcl. 1489. "Margaret late wife of William Blofield, and widow of Roger Greyve, who gave a stained cloth of the seven sacraments . . . and many gifts to our Lady's altar," Bl 4:461.

Costessey? *pg. 1504. 20*s* to glaze win with Seven Sacraments, C & C. The will actually cites "holy things," the Creed sentence *sanctorum communionem* sometimes interpreted as the sacraments. New windows provided in 1886 (E Rose, personal communication).

Fonts

7 Sacraments carved in relief on the faces of octagonal baptismal fonts; the most common subjects for the 8th face were the Crucifixion or Baptism of Christ. Detailed description in Nichols (1994); all pl citations to this work. Unless stated otherwise Cautley's illustrations are general views.

Norwich SPM? Obliterated. The 1463 will of John Cawston specifies the font or some more necessary work. David King thinks it unlikely that the money would have been spent on the font since the roof was not yet leaded (1473 bequest). Except that the general design is very like that of the 7-Sacrament font at Blythborough (Suf), there is no evidence for assuming the destroyed figure work represented the seven sacraments, but the 1463 date is significant, for Cawston's specification reflects the interest in funding new fonts in Norwich churches during the third quarter of the century.

Cathedral. 1460–70 (Cathedral inventory). Nichols pls 53 (Penance, good angel [Nichols 234], second penitent), 90 (Extreme Unction).

Brooke. c1466/8. Cautley 136; Nichols pl 92 (Extreme Unction).

E Dereham. c1468; Cautley 134; Gardner fig 525; Nichols pls 4 (Penance [good and bad angel], Eucharist, Confirmation), 49 (Confirmation), 56 (Penance, detail, bad angel), 63 (Eucharist, detail), 77 (Matrimony, bride and groom at L of priest), 91 (Extreme Unction).

Marsham. c1470. Cautley 134; Nichols pls 57 (Penance, good and bad angel), 82 (Extreme Unction).

Martham. c1470.

W Lynn. c1470. Nichols pls 47 (Confirmation), 67 (Orders).

Salle. 15³. Full set il in Cautley 137; Nichols pls 64 (Eucharist, sacring torch and bell), 80 (Matrimony, bride and groom at L of priest), 83 (Extreme Unction), 88 (Penance). The same model for Penance is used at Cley and is found in Bod L Douce 131 (f 126), a MS stylistically connected with E Anglian MSS but without certain provenance; Sandler, *Survey* Cat. 106 pt 1:29–30 & il no. 269.

S Creake. 15³. Reliefs largely obliterated.

Binham. 15³.

Cley. 15³. Nichols pls 37 (Baptism), 45 (Confirmation), 71 (Orders, ordinands prostrate), 78 (Matrimony, bride and groom at L of priest), 84 (Extreme Unction), 89 (Penance).

Gayton Thorpe. 15³. See above *Communion*.

Seething. c1473. Cautley 136. Font related to that at Sloley.

Sloley. 15⁴. Cautley 135 (Confirmation) & 136.

Loddon. 1487. Largely obliterated; Nichols pl 6.

Burgh-next-Aylsham. 15⁴. Nichols pl 76 (Matrimony).

Earsham. Before 1490.

Gt Witchingham. 15ᵉˣ. Nichols pl 60 (Eucharist, altar under canopy, sacring torch and bell).

Gresham. c1500. Complete set in Bond (1985) il 160–1; Nichols pls 36 (Baptism), 42 (Confirmation), 62 (Eucharist, with laypeople), 69 (Orders), 74 (Matrimony, bride and groom at L of priest).

Alderford. 16¹. Nichols pls 41 (Confirmation), 52 (Penance detail, bad angel with meathook). The 1518 will of the John Baker, rector of S John Maddermarket, left 20*s* to the reparation of the font (Tanner 237). Baker seems to have had special devotion to John Bapt (dedication, Alderford) since he owned an al tablet of his head (Tanner 338).

Lt Walsingham. 16¹. Bond (1985) color il facing 306; Nichols pl 38 (Baptism), 43 (Confirmation), 58 (Eucharist), 75 (Matrimony), 87 (Extreme Unction & Penance).

Walpole S Peter? 1532.

Wendling. Before 1536. Nichols pl 44 (Confirmation).

Walsoken. 1544. Nichols pl 2 (Extreme Unction).

Chamfer Symbols on 7-Sacrament Fonts

On the chamfers of 4 fonts are carved symbols of the

sacraments originally above (for reorientation of the bowl at Brooke, see Nichols 1994, 72). The complete set at Salle is reproduced in Cautley (137).

Baptism: soul (Burgh); chrismatory (Salle); ?candle (Binham), a massive paschal candle (Cathedral).

Confirmation: mitre (Salle), Trinity arms (Burgh); ?crown (Binham).

Eucharist: altar stone (Salle, Nichols pl 64); chalice (Burgh, ?Binham) with Host (Cathedral); paschal plate with superimposed object (Brooke with reorientation; cf Orders at Norwich).

Penance: open book (Cathedral, Brooke with reorientation); birch (Salle, Burgh, and ?Binham).

Matrimony: fretted instrument (Binham, Salle [Nichols pl 80], Montagu identified gittern at Salle); book (Burgh); ?pall (Cathedral).

Orders: chrismatory (Binham, Burgh); chalice (Salle, Brooke with reorientation, Nichols 267–8 fn 25, pl 5); paschal plate with superimposed vessel (Cathedral).

Extreme Unction: chrismatory (Burgh), shroud (Cathedral, Nichols pl 90); soul in cloth (Binham, Salle).

c. Eucharistic Symbols

With the exception of the Pelican Vulning, post-Reformation citations are rare—e.g., 4 figs holding loaf, wine glass, cross and purse on the 17c communion rail at W Winch.

Chalice with Host

Commonly associated with Instruments of Passion on roofs, sometimes angels holding chalice only; see also XIV.2. Three chalices with superimposed hosts are known as the Arms of Sacrament. The following citations are selective, suggesting only the range of media.

Dunston. stone mold for badges, found in churchyard. nd. Chalice, IHC on base and on host within chalice, host surrounded with rays; inscr on chalice bowl "Hic est Calix," Spencer (1980) Cat. 109.

Barton Turf. pg frag, nIV.2a. 15c. Host on chalice.

Wretton. pg frag, win by pulpit. M & R 3.

Easton. *pg, E win. "Gul. 3 chalices Or. on each a Wafer Arg," Bl 2:397.

Ringland. *pg, "gules, three cups, or, at the top of each" a wafer, Bl 8:254.

Hackford. *pg, S win, Bl 2:497. Also on font panel.

Framingham Earl. sc, font, hosts inscr with crosses.

Saxlingham Nethergate. sc, font.

Shelton. sc, font, no hosts.

Shotesham All Saints. sc, font.

N Creake. wdcarv, nave, S3. 15c.

Outwell. wdcarv, angel, S aisle. 15c.

Thornham. wdcarv, be. 15³⁻⁴. Framed in a tabernacle, probably meant as arms of the sacrament; Gardner (1955) pl 25.5.

Norwich S Laurence. *image of Jesus, and the sacrament in the chancel," Bl 2:263; the nature of the image is unclear; "the sacrament" is probably the arms of the sacrament.

Blood of Christ

Cathedral. ?medium. 1427. 3s 4d. "pro factura et pictura de lez story sanguinis xpi in Anglic," "Extracts from Account-Rolls" 208. The subject is tantalizingly imprecise.

Lynn. pilgrim badge from Wilsnack. After 1383. 3 hosts connected triangularly, bearing, respectively, Flagellation, Crucifixion, and Resurrection, Spencer (1980) Cat. 102 Wilsnack was a popular Continental shrine centered on hosts with marks of blood, miraculously saved from fire. Spencer (1998 Cat. 263) notes that vermillion traces remain on many badges. See also X.1 *Lynn* All Saints.

Vine and Grapes

These figure in a number of bosses in the Cathedral cloister, some probably with eucharistic import.

N Elmham. wdcarv, altar. 1622. Grapes and vine leaves; inscr "Vera Vitis Chris'."

Pelican in Piety (*Vulning*)

Pelican pricking breast with beak to feed young on its blood. The image seems to have been one of the few that persisted after the Reformation. Unless stated otherwise, woodcarvings are 15c.

Blickling. sc, corner of piscina. ?14c. Head missing, 3 nestlings, one sucking at breast.

Yarmouth. *wdcarv, boss. ?14c. DT 62:40. A large number of subjects appear in the boss engravings in C Palmer pls 1 & 2. Though they do not look medieval, a handful correspond to those provided by DT.

Cathedral. latten lectern. 1380–1420. Pelican's outstretched wings forming bookrest; no young, base with 1841 replacements.

Fakenham. brass. 1428 (Henry Keys, rector). Roundels at corners of stone; Cotman (1838) pl VIII; only 2 remain (see X.4 *Peter*).

Colby S Giles. pg, E win, eye of tracery. Pricking breast, 4 drops of blood, nestling looking up, beak open. If *in situ*, a Crucifixion be-

low (King 17).

Gt Ryburgh. *pg, S win, S transept, NRO, Rye 17, 3:162v.

Cathedral. sc, N cloister boss, B6. 1427–8. Within wreath of oak leaves. The vault also includes 2 Emmaus bosses (B5 and 8).

— sc, spandrel, W front. 15². Paired with ox with scroll.

E Harling. sc, cusp of ogee arch, Harling Monument. 15². 5 nestlings.

Mattishall? sc, N porch capital. c1445–53. M & R 2.

Barney. sc, font bowl. 15c. Piercing breast with long beak; 4 nestlings, beaks lifted to receive drops of blood; ?recut.

Walpole S Peter. sc, boss, S porch. Late 15c.

Cathedral. wp, S face reliquary arch. 1416–25. Within shield, blood visible; personal seal of Bp Wakering.

Morston. wdcarv, screen spandrel, N1. c1480. Above John with chalice.

Braydeston. wdcarv, screen spandrel. c1489 (bequest to "new perke," C & C). 3 nestlings below, 2 with beaks lifted; reset in modern screen S1.

Cathedral. wdcarv, misericord, N12. 15⁴. With pelicans in supporters, Rose (1994) 59.

Brandon Parva. wdcarv, roof boss, now on side of organ, M & R 2.

Norwich S Gregory. wdcarv, roof boss.

Walpole S Peter. wdcarv, misericord; **FIG 39**.

Carbrooke. wdcarv, be. Head missing.

Cley. wdcarv, be.

Forncett S Peter. wdcarv, be. ?5 nestlings looking up; head of pelican restored.

Holme Hale. wdcarv, be. Head broken, 3 nestlings.

S Lopham. wdcarv, be. Small birds at feet.

Salle. wdcarv, stall arm rest. c1470. 2 nestlings; pelican repaired.

Thornham. wdcarv, be. 3 nestlings, one with beak at breast.

Wilton. wdcarv, be. 2 nestlings; Gardner (1955) pl 25.4; ?Victorian.

S Acre. wdcarv. Finial of font cover; restored.

N Walsham. wdcarv. Finial of font cover, Bond (1985) il p 283.

Norwich SPM. *emb, cope hood. 16¹. Hope (1901) 198.

Cathedral. sc, N and S transepts, stops. 16¹.

Suffield. wdcarv, screen spandrel. c1524. Head damaged, nestlings below; paired with a raptor seizing a rabbit, second rabbit hiding

in warren below.

Cathedral. seal, John Jegon (1608–18). Pelican in piety at head of cross on stepped pedestal; *BM Cat. of Seals*, 2059.

Wiggenhall S Mary. wdcarv, font cover. 1625.

Watlington. wdcarv, font cover. 1620. Restored.

Saham Toney. wdcarv, font cover. 1632. No young; with texts. Found in rectory cellar, restored 19c.

The last 4 items are hallmarks.

Surlingham. chalice. 1637. Hopper (1910) 274.

Swannington. chalice. 1639. Hopper (1917) 232.

Lammas. chalice. 1640. Hopper (1910) 188.

Wacton. paten. 1641. Hopper (1904) 50.

d. Other Liturgical Rites

Cathedral Priory. ms, Ormesby Psalter, Bod L Douce 366, bas-de-page f 131. 14¹. Betrothal.

Starston. *wp, N wall tomb recess. Early 14c. Deathbed scene in 2 horizontal registers: (below) ?bier with corpse covered by pall; behind (C) woman in crown, crespine, and barbette, sideless surcoat, hands joined; woman veiled, book in LH, lifting RH to inclined head; women flanked by (R) clerics and laymen, (L) 4 men, incl priest in chasuble, and cleric with scroll inscr "PRECOR TE MARIA," scroll lying on cuboid altar, beside altar crucifixion tablet; (above) 2 demi-angels emerging from clouds holding soul standing in cloth; Phipson il facing 301; Tristram pl 56a.

W Dereham Priory. *ms. (Lowest of 3 registers) abbot lying in coffin with pastoral cross; large number of clerics, 2 flanking the scene with candles, one holding cross-staff, another the service book; (R) 3 clerics in copes, one holding pastoral staff, a document being exchanged, DT 28:190–2.

Norwich, Carrow Priory. ms, Carrow Psalter, Madrid, Biblioteca Nacional 6422, hi, f 113 v (Ps 97). 1250–60. 3 clerics singing at lectern. Ps 97 (*Canticum novum*) is typically so historiated; see next 6 entries.

Cathedral Priory. ms, Psalter, Lambeth Palace 368, hi, f 79v (Ps 97). c1270–80. 3 clerics singing at lectern, Morgan, *Survey* pt 2 Cat. 181 il no. 392.

?Wiggenhall S Germans. ms, Howard Psalter, BL Arundel 83 I, hi, f 63v (Ps 97). c1310–20. Clerics before lectern with noted scroll of music; hybrid musicians below

with psaltery and gittern.

Bromholm Priory. ms, Bromholm Psalter, Bod L Ashmole 1523, hi, 116v (Ps 97). c1310 (ff 1–168v). (Above) Creator flanked by animals; (below) clerics chanting, David conducting; two scenes divided by bust of king with two trumpets, Sandler, *Survey* Cat. 44 il no. 101.

Diocese. ms, Stowe Breviary, BL Stowe 12, f 195 (Ps 97). c1322–5. 3 clerics standing before lectern with noted music.

— ms, psalter, CB UL Dd.12.67, hi, f 103v (Ps 97). c1400. Clerics before lectern.

Cathedral Priory. ms, Ormesby Psalter, Bod L Douce 366, hi, f 128 (Ps 97). 14[1]. Clerics chanting, Deity in nebuly above, kneeling monk, Sandler, *Survey* Cat. 43 il pt 1 frontispiece.

Ranworth. ms, Ranworth Antiphonal, S Helen's Church, hi. 1460–80. Ff 128v (Dedication of a Church) bp with crozier and 5 clerics; 157 (Ps 97) cleric with hand on head of boy in alb; 6 clerics at lectern holding sheet with notation ("Sanctus").

Diocese. ms, Wollaton Antiphonal, Nottingham U Library 250, hi, f 350. c1430. Bp blessing relics, bones in dish.

Upton. sc. 15c (Cautley thought 14c). Well-preserved statues around the font stem; woman holding swaddled infant, man and woman with beads; a bp flanked by two angels in albs, each holding a candle, a deacon with book. The font stem was at one time separate from the bowl and the background surfaces have been restored.

Docking. sc, font stem. W and S faces. 15c. 2 women (one with candle) holding infants, woman with small child; ?paraliturgy, cf Upton. Williamson (1961) queried SS Emeria and Servatius, Anne and Virgin, Elizabeth and John, but there are no identifying features to support this interpretation.

In contrast to earlier emphasis on morbidity, recent studies of late medieval mortuary art have emphasized the positive hope of resurrection. Badham notes that figures face E, are casting off their shrouds, or stand on grass. At Norwich S Andrew in the Ch of Our Lady of Grace there is a brass (originally for 7 female children) with a child standing on a mead. Trees and grass also occur in the burial scenes in the life of S Catherine at Sporle (3b, 4f & g). For general survey see Pevsner and Wilson 1:70–2, 113–6 (also in vol. 2). One atypical monument deserves notice. At Saxlingham only Mirabel Heydon (†1593) and a Bible remain from the curious structure erected by Sir Christopher Heydon: "kneeling under an arch and over her a pyramid rises near the height of the chancel, adorned with many hieroglyphical figures, after the manner and taste of the Egyptians," Bl 9:435. See also IX.3.

1. Commendation of Souls

The soul, represented as small naked body, with hands joined, stands within a grave cloth held at either end by an angel.

Elsing. brass. c1347. Directly above Sir Hugh Hastings, 2 angels holding soul with cloth; *Age of Chivalry* Cat. 678. Two angels in albs also support the pillow under his head.

Ingham. sc, W face of du Bois tomb. Mid 14c. Flanking Trinity, angels with souls in cloth.

Rougham. sc under image bracket. 14c. Angel holding cloth in both hands, soul with hands joined.

Cathedral. sc, W cloister boss, M8a. 1425–30. Angels holding soul of Bp Wakering in cloth; Bp seated below, flanked by 2 angels. Wakering (†1425) bequeathed money for completion of the cloister.

— sc, frag of table tomb. c1439. Angel holding soul in arm; angel censing; angel blowing trumpet; cleric with candle on candlestick; Borg & Franklin Cat 46; Thurlow & Whittingham facing 504. See also XI.1 S Walsham.

— wdcarv, misericord, elbow rest, S5. 15[1]. Demi-angel on nebuly holding soul in cloth; Rose (1994) 13.

Outwell. wdcarv, hammer beam angel, S aisle. 15c.

Norwich S Gregory. emb pall. 1517 (bequest). Black worsted with applied embroidery, 2 rows of 5 demi-angels in nebuly, each carrying a soul in a cloth, once inscr, "Pray for the soul of Ihon Reede and Agnes his wyff"; L & M Cat. 99. See also XV.6g *Dolphin.*

2. Chalice Brasses

A chalice typically with the Host suspended above, sometimes inscr ihs/ihc. Ever since Macklin and Druitt, commentators have noted that chalice brasses are characteristic of Norfolk. The chalice, Host, and sometimes paten also appear with effigy in Mass vestments, e.g., at Upwell (1428, 1435), Wiveton (1512), Hickling (1521), Brisley, with a rayed inscr Host (1531), and Cley (1520, Druitt pl facing 105). Following is list of datable chalice brasses; for further citations see Linnell, *TMBS* 8 (1951): 356–65; 9 (1952): 76–9; 12 (1955): 168–9.

Norwich, SPM, 1479 (matrix), Gough 2.
Salle, 1482 (matrix).
S Walsham, 1485.
Poringland, 1490, Gough 2.
Barton Turf, 1497 (matrix).
Crostwight, 1497 (matrix).
Norwich S Giles, 1499; il Farrer (1890) facing 46.
Strumpshaw, 1500 (matrix).
Trunch, 1500 (matrix).
S Walsham, 1500.
Colney, 1502.
Hedenham, 1502 (rector).
Sloley, 1503.
Guestwick, 1504.
Bylaugh, 1508, Bertram (1996) fig 69.
Buxton, 1508 (vicar).
Colby, 1508.
Bintry, 1510, Bertram (1996) fig 74.
Wood Dalling, 1510.
Surlingham, 1513.
Norwich S Michael Coslany, c1515 (matrix).
Taverham, 1515.
Salthouse, 1519; il Farrer (1890) facing 46.
N Walsham, 1519 and c1520 (chaplain).
Old Buckenham, 1520.
Sloley, 1520.
Lt Walsingham, c1520, veiled chalice with host, Druitt il facing 101.
Attlebridge, c1525 (vicar).
Bawburgh, 1531, held by thumbs issuing from clouds, (vicar).
Hindolveston, 1531 (matrix).
Northwold, 1531 (matrix).
Lt Walsingham, 1532 (matrix).
Walpole S Peter 1537 (matrix).
Burlingham S Edmund, 1540.
Fakenham, Henry Newman, rector of Pensthorpe, chalice brass circled with Latin text, DT 29:165.
*Hockering, loose, NRO, Rye 17, 2:222v.

3. Cadavers and *Memento Mori*

The text *Hodie mihi cras tibi* (see below, section 4) appears in a variety of English translations: on the brass of a rector at Wells-next-Sea (1499), "Have need man of my dredful doom / Swyhe shaal be thyn it is no nay / Perchaunce to the it schal come this day / That yesterday to me is come," NRO, Rye 17, 4:89v. The formulaic nature of the text continues into the 17c: at Toft Monks (1607), "as I was so be yee: as I am ye shall be"; at the Cathedral (4th bay S aisle, monument for Thomas Gooding) ". . . As you are now even so was I / And as I am so shal you be."

Sparham. pwd, 2 screen panels. 1480 (DP). **1** Shrouded skeleton rising from chest tomb to the right of a font; inscr scrolls, betw font and raised cover "De utero"; depending from font cover to the shoulder of the skeleton "Fuisse*m* qu*asi* no*n* essem"; R of the skeleton "*tr*ansla*tus* ad tumu*l*um : iob 10" ("I should have been as if I was not, translated to the grave," Job 10:19). **2** (L) man in cloak and hat with jaunty feather, RH holding remains of a funeral torch with frags of "sic transit gloria mundi"; LH extended with scroll inscr "Nat*us* homo muliere brevi de te*m*p[or]e parvo" ("Man is born of a woman for but a brief, short time"); (R) woman in pink gown with black dots, wide cuffs, holding bouquet of flowers in her RH, overhead scroll inscr "Nu*n*c est nu*n*c no*n* quasi flos qui cresett in arvo" ("Now he is, now he is not, like the flower that blooms in the field"; cf Job 14:1–2); Duffy fig 114; Camm [Ingleby] color pl 60.

Ditchingham. wdcarv, screen (largely Victorian). Skeleton, crown over shroud, with scroll in RH, DT 39:44, copied from Suckling, *Antique and Armorial Collections*, 1821.

Shroud Brasses

Extant shroud brasses range over 200 years, though they are uncommon in the seventeenth century. Indents without dates are not cited. Swaddled infants are also carved on bench ends, e.g., at Binham and Sheringham (Cox [1917] il p 129; Gardner [1955] pl 20.4), perhpas memorials.

Infants

Rougham. 1505, 1510, 2 chrisom infants, M & R il 3:103.

Blickling. 1512, Anne Asteley, holding swaddled twins in arms; Latin inscr dates parturition on the feast of S Agapitus, Martyr.

Ketteringham. c1530.

Wiggenhall S Mary. c1624, al tomb, Sir Henry Kervil; chrisom infant.

Adults

The shroud may be tied at the head and feet, enveloping the entire body, open to reveal only the face, or open over the torso to reveal the skeleton, with the shroud providing a modesty shield over the lower trunk, in which case the hands are commonly joined or crossed on the breast. The opening of the shroud evokes the resurrection of the body. Only significant variations cited.

Family groups

1468. Brampton, Robt. and Isabel Brampton; grass under feet, as well as under image of the Virgin and Child above; Farrer (1890) il facing 12. Badham cites as an example of hopeful funeral imagery (1996) fig 27. For other examples, see Farrer il facing 31 & 102.

1499. Aylsham, Rich. Howard and Cecilia, with detailed spinal column and worm on head.

1505. Kirby Bedon, Wm. Dussyng and wife, legs visible, DT 33:121.

1505. Cley, John Symondes and Agnes standing on grass, shrouds open; 8 children below with names, oriented E (i.e., toward the resurrection); text oriented W "Now thus" (3 times per column); Bertram (1996) fig 67.

1515. Norwich S Michael Coslany, Hen. Scolows and wife.

1546. Loddon, Sir Thos. Sampson and wife.

1649. Dunston, 2 wives of Clere Talbot, inscr and shields cut in stone.

Single Brasses

1452. Norwich S Lawrence, Thos. Childes.

?1454. Salle, John Brigg, open shroud, grass at feet, verse below concludes "so shall ye be a nother day," Gough 3: pl 37:5; full quotation in Macklin 211–3.

c1495. Gt Fransham, ?Cicely Legg.

1505. Bawburgh, Thos. Tyvard [Tyard], S.T.B. Tonsured, wrists crossed over breast, lower legs and feet free of shroud.

1507. Aylsham, Thos. Wymer.

c1520. Fincham, a woman.

c1520. Frenze, "Pray for þe sowle of your charite of Thomas Hobson to þe trynyte."

c1540. Wiveton, entire male skeleton, Linnell (1952) il p 13.

1588. Norwich S Michael-at-Plea, Barbara Ferrer.

Heart Brasses/Incised Stones

These do not necessarily indicate heart-burial. The design typically comprises a heart, sometimes held by 2 hands, with 3 text scrolls rising above at angles. The most common text is Job 19:25–6, with liturgical variants from the Office of the Dead (Badham 449–50): "Credo quod redemptor meus vivit," "De terra surrecturus sum," and "In carne meo videbo salvatorem meus." The *Credo quod* text also appears in effigies without heart, e.g., at Kimberley, where ""Credo . . . vivit" is the scroll from the mouth of John Wodehous (†1465) and "Et in carne mea . . . Salvatorem meum"

from his wife's, Bl 2:549 (DT 10:110–11). For 5 Norwich examples, see Greenwood & Norris (1976) 85. The text occurs in other mortuary contexts, e.g., the Fountain brass at Salle (c1453). Unless stated otherwise, the medium is brass.

Stratton Strawless. sc. 13c. Wimpled woman holding heart at her breast.

E Tuddenham. sc. Late 13c (armor). Knight with heart in hands.

Wickhampton. sc. Early 14c (Cautley). Sir William Gerbygge holding heart in hands.

Walsoken. sc, N aisle. c1350 (P & W 2). 2 hands holding heart, now whitewashed.

Norwich S Michael Coslany. *emb. ?15c. "The carpet at the altar formerly belonged to the altar of the north chapel [John Bapt], . . . and there are several angels with labels, on which, '. . . Credo quod Redemptor meus vivit. Mortui venite ad Judicium'," Bl 4:498. Perhaps originally a pall.

Kirby Bedon. c1405. No name, 3 scrolls, heart inscr with "Credo quod"; the redemptor clause is at head of the brass; il Farrer facing 46.

Ormesby S Margaret. c1440. Woman in headdress with plain cauls, loose mantle falling from shoulders with ties depending to hips; hands holding heart against breast; appropriated for Alice Clere, 1538, with heart encircled with black letter text "Erth my body I give to the / on my soule Ihesu have mercy," Druitt, 259; il Buzza 2:96; Bertram (1996) fig 102.

— 1446. Robert Clere. 3 rising scrolls with traditional texts; drawing in NRO, Rye 17, 2:103v.

Fincham. Mid 15c. 2 pairs of hands with hearts and scrolls, *TMBS* (1991) "Portfolio of Small Plates" pl 2b.

Wiggenhall S Mary. c1450. Sir Robt. Kervile, atypical brass. Heart central with curved scrolls at 4 corners, (above) "orate," (below) "de Wignale" and "Eadmundi Kervile," DT 48:59; only 2 of the labels now remain.

Helhoughton. c1440. Wm Stapleton and wife, 2 arms rising out of nebuly, heart inscr "Credo quod"; forearms with "ecce in pulvere"; "de terra."

S Acre. 1454. Sir Roger Harsyk and wife Alice. Matrices only, heart and scrolls clear. 1888 in possession of churchwarden: text Ps. 31:5, "In man[us tuas redemisti me] domine commen[do spiritum] meum re[demisti me]

d[omine deus veritatis]," palimpset with c1400 civilian head, Macklin (1907) 207.

Loddon. 1462. Dionysius Willys, heart held by hands, Macklin (1907) 207; in 1995 covered by taped carpet.

Merton. 1474. Alice Fincham, 2 hands holding a heart "upon which the word 'Credo'," only 2 scrolls, "Credo quod Redemptor meus vivit" and "Et in novissimo Die Surrect . . . Salvatorem meum," Bl 2:308.

Itteringham. 1481. Macklin (1907) 207; "O bone ihesu" text, NRO, Rye 17, 3:9.

Brancaster. 1485. Text only, Wm. Cotyng, rector, with text "qui hic nunc in puluere domit expectans adventum Redemtoris sui," Macklin, 1907, 207.

Attlebridge. 1486. Heart lost, Macklin (1907) 207.

Martham. 1487. Robt. Alen, priest, copy of lost original; enamel heart engraved with "Post tenebras spero luce: laus deo meo," Macklin (1907) 207.

Fakenham. c1500. 4 double hearts at the corners of a stone, inscr "Jhesu mercy" and "Ladi help," Macklin (1907) 207; Mackerell cites the same text in glass at Freethorpe (BL Add MS 12526, f 65v).

Norwich SPH. 1597. Mackerell cites texts (BL Add 12525, f 226).

Trunch. 1522–1. Heart inscr "munda me domine" 3rd scroll, "in terra vivencium," Norwich work, *TMBS* (1988) "Portfolio of Small Plates," pl 5.

Ranworth. 1540. Name lost; 3 rectangular inscr labels arranged above heart.

Ludham. 1633. Grace White, Macklin (1907) 207.

Worstead. Indent only.

Variation

Lynn S Nicholas. brass. c1400. 3 registers reading from bottom: massive tree, with (1) prayer for Thome Watyrdeyn & Alicie "consortis sui" at base; (2) linked hearts on tree trunk with linked quatrefoils (L) "ubi" and (R) "ibi"; (3) in scroll reading (L to R) "vera sunt gaudia nostra fixa sunt corda"; drawing in NRO, Rye 17, 3:5; *TMBS* (1987) "Portfolio of Small Plates" pl 1.

Death as Skeleton

Norwich S Michael-at-Plea. brass. 1452.

Burnham Market. sc, relief, tower, N face. 15ex. (Reading L to R) skeleton; king; Adam and

Eve; decapitation of John Bapt.

Lt Barningham. wdcarv. 1640. 18" high skeleton with scythe in LH and hour glass in RH standing atop pew end, shroud caught at head with top knot; English version of *cras tibi* text, "As you are nowe even so was I," M & R il 1:61. Reported stolen, 1995.

S Acre. al monument. c1634. On wall skeleton with hour glass, woman with wreath; on tomb chest below Sir Edward Barkham and wife, exceptionally good male and female costume, he robed as Lord Mayor.

Skull/Crossbones

Cathedral. wp, Prior Bozoun's chantry. c1480. 3 skulls, and inscr "morieris, morieris, morieris," and a now vanished text cited by Chittings, "O tu qui transis vir aut mulier puer ansis Respice picturas aspices, lege, cerne figuras Et memor esto tui, sic bene disce mori," quoted in Finch, 482 fn 38.

Lynn S Nicholas. Snelling Monument. 1623. (C) Kneeling husband and wife; (above) a winged, crowned death's head in wreath; wings and crown gilded, green wreath.

Moulton S Mary. Anguish Monument. 1628. Edmund holding skull.

Norwich S Peter Parmentergate. Brass. 1630.

Spixworth. Peck Monument. 1635. Effigies in shrouds; on pediment putti and skulls.

Stratton Strawless. Thomas Marsham Monument. 1638. (Below) charnel-house with gravedigger's tools.

S Acre. Barkham monument. c1634. Skull betw 2 pillows at edge of monument, facing W; another at feet; charnel-house niche betw 2 groups of kneeling children.

— sc. After 1634. Death's head set as keystone of porch arch.

Colkirk. sc. 1639. Gaping skull, "Hodie mihi cras tibi."

Besthorpe. Sir William Drury Monument. 1639. One of 3 children kneeling at the feet of recumbent father holds skull.

Hour Glass and Scythe

Bexwell. memorial tablet. 1581. Henry Bexwell, M & R 3.

4. Three Living and Three Dead

Les Trois Vifs et les Trois Morts. Typically life-sized or larger, commonly on N wall. There are approximately 30 14c examples in England (Park, *Age of Chivalry*) of which one-third are in Norfolk. The kings are elaborately dressed (see XIII.3 *Pride*), sometimes repre-

senting the 3 stages of life. The warning texts of the 3 Dead are now largely lost, but Heydon's *Swiche schul ye be* epitomizes the messages borne by the skeletons. The same sentiment, *Hodie mihi cras tibi*, is common on brasses.

Limpenhoe *wp, N wall. c1340. "Partially concealed by the St. Margaret scenes," Tristram 192.

Lt Witchingham. wp, damaged, flanking tower arch. c1360 (DP). (L) well preserved shoe; (R) skeleton legs and feet.

Paston. wp, N wall. c1370. 3 skeletons (one very faint) with indecipherable black letter inscr above. 2 kings, hair curled at chin level and forked beards, 2nd in "hip-length cote-hardie buttoned down centre, adorned with stripes and roundels," his RH extended to skeletons and head turned away, hawk on LH. Attendant with cord around neck and raised RA with object (Tristram 234 anachronistically thought ?bugle) or ?leashes (E Carleton Williams, 1942); Tristram pl 63a; Bardswell il betw 190 & 191; Williams reproduced Tristram's drawings as pls 6 & 7; in 1940 he found the skeletons "almost indistinguishable."

Wickhampton. wp, N wall. c1360 (DP). Figs larger than life-size, each with scroll above head; scenes demarcated by trees. Reading L to R: 3 skeletons, easternmost raising LH towards king; first 2 kings bearded, (1) looking towards and holding (2) by wrist; (3) beardless, holding hawk with jesses in gloved LH, RA extended to nearest companion to whom he looks. (Below and smaller scale) a huntsman bearded and capped, with parti-colored pourpoint and counterchanged hose, with 2 leashed hounds straining after rabbit escaping westward. Possible association with 3 Ages of Man (Tristram 263–4); James [in Ingleby] pl 2; Storck fig 1.C facing 250.

Two wps in adjacent parishes should be noted:

Gorleston. wp. c1380, N wall. "Two foremost Kings bearded men in flowing red cloaks, red stockings, shoes with diaper pattern, and gauntlets, the third a youth crowned with flowing yellow hair, in embroidered yellow cloak, red gipon, flesh-coloured hose, and gauntlets," Tristram 175; E Carleton Williams (1942, 39) notes that the scene is set in a "flowery meadow"; Storck, il facing 314

Belton. wp. c1400. 3 kings on horseback each

with scroll; "I can well remember the inscribed scrolls about the three kings when they were perfectly legible. (1) O benedicite. (2) O marvelous syte is that I see. (3) I wyl fle," Cautley, *Suffolk* 195. André (1888, 418) cited (1) "[Away] wyl I fle," (2) "O marvellous stytte ys that I se" (3) "O benedicite what want ye." See also E Carleton Williams (1942) 36–7, 39; Storck fig 1.E facing 150.

Haddiscoe. wp, N wall. 14c. 2 crowned heads and ?hawk on R king's hand; part of one skeleton. Tristram (176) recorded the work on the S wall.

Heydon. wp, N wall. 14c. Partly destroyed by 15c windows and later monuments. 2 crowned kings, one with hawk on extended hand, pinched waists, low-belted pourpoints; 2 skeletons with text above in red, "Swiche schul ye be."

Northwold. wp frag N wall. 14c. Good remains of 2 skeletons; arm holding hawk with jesses.

Seething. wp, above N door. 14c. Partly destroyed by win. Skeleton; tree; 3 crowned kings in low-belted pourpoints, pointed shoes (red hose on kings 1 and 3, white on 2), "one holding a lure, on which a hawk is perched" (Bardswell 339); tree, traces of attendant overpainted by Christopher; (below) a hare heading W, Tristram 245.

Ditchingham. *wp, N nave. 14c. (L) 3 kings, (R) 3 crowned skeletons, with worms. 3 kings with drooping moustaches and beards, 1 and 3 in ermine collars, 1 and 2 with scepters over RS, 3 with battle axe over LS. Trees in background, birds in air by kings. Inscr scrolls; above king 3 "My ares [heirs]"; above skeletons the label "So were we" (Storck, 317). According to Storck (256, fn 13) the subject was connected with the Last Judgment. Cited by Williams (1942) 39. Watercolor attributed to F. Sandys, NMS 1223.B 52.235.951; Storck fig 1.D facing 150.

Stokesby. *wp, S wall. Horseman in cap and tiara; at his feet a hare and 2 hounds; horse tied to one behind by traces; Taylor (1859a) 291; E Carleton Williams (1942) 40. According to Storck (256, fn 12) the subject was connected with the Deadly Sins (N wall).

Wymondham. *wp, S wall triforium, "in a lower

compartment, three skeletons or emaciated human figures, above them a cloud, and in it three other figures, 'fat, and well liking'." In the next compartment "a figure on horseback, having on his head a triple crown, beneath him a wood with wild beasts, hare, hound," Woodward 290. According to Storck (256 fn 13), the subject was connected with the Last Judgment.

5. Dance of Death

Norwich S Andrew. pg, sVIII, light c, not *in situ*. 16¹. Death clasping gloved hand of bp/abbot in full Mass vestments, mitre, and crozier; G King (1914) il facing 286; Marks fig 67. Marks dates the glass late 15c or early 16c, but see above II. *Abraham and Isaac*. Originally part of a multi-scene composition, incl an emperor, pope, cardinal, carpenter, "and other mechanick trades"; damaged when seen by Kirkpatrick.

6. 17c Monument Detail

There are a number of fine monuments in the county by Nicholas Stone (1617–c1640) and his workshop. See P & W 113–6.

Oxnead. Sir Clement Paston Monument, 1597. Lying on a woven rush mat with end rolled into pillow for head. Wife kneeling in profile on face of tomb. Nicholas Stone monument for Lady Katherine Paston, bust on pedestal. 1629.

Emneth. Hewer Monument, Nicholas Stone. 1617. Recumbent effigies.

Norwich S John Maddermarket. Sotherton Monument. 17¹. Flanking pilasters with Peace (a maiden), Vanity (cherub), Glory (maiden), Labor (man).

Norwich S Andrew. Suckling Monument. 17¹. (Upper face) fire rising from an urn, (inscr above) "Sparisco"; bird escaping from cage, (inscr above) "sciolta; (lower W and E ends) ship sinking with text "sin Viento Soy Nada"; grove of trees, some felled, bones, flowers with text "Ny croissons ny tombons ensemble." Sir John and Lady Suckling lie on a slab supported by 4 skulls. For detailed description, see Bl 4:308-9.

Narborough. Spellman Monument. 17¹. Sir Clement Spellman and wife resting on elbows; infant in long gown with ruching around neck, reclining laterally on pillow beneath a cradle canopy.

Paston. 2 Paston monuments, Nicholas Stone. 1629. Katherine Knevet Paston, semi-reclining, RA resting on embroidered pillow, lace-edged shroud draped at periphery of elegant gown; 2 reclining allegorical figs on pediment; inscr ". . . and lyeth here intombed expecting a Joyful Resurrection." Sir Edmund Paston (1632): urn. "The contrast between the severity of the one and the ebullience of the other is startling," P & W 1.

Stratton Strawless. Marsham Monument. 1638. Sir Thomas Marsham reclining on one elbow, looking into the distance; shroud draped negligently; "an early case of this attitude in England and certainly the first in Norfolk," P & W 1. Text below "Hic Requiescit in spe resurrectionis ad vitam aeternam corpvs Thomae Marsham . . ." (see also Skull).

Cathedral. wp, pulpitum. 1622. Above effigy of William Inglott (Cathedral organist), 2 choir members with bay wreaths, song book, and hourglass; (above) in strapwork, skulls and Fame blowing trumpet; Finch 470, fig 178.

XV. Miscellaneous

1. Occupations
a. Labors/Occupations of the Months

In 1443 in Norwich a procession of men "disguised as the twelve months and Lenten (clad in herrings' skins, and followed by his horse, trapped with oyster shell)," Lancashire no. 1224. The assignment of labors to specific months is not uniform; note in particular the contrast betw April in early and late work, when Continental influence can be seen in domestic glass. Comparative table in Anderson (1955) Appendix 2.

Burnham Deepdale. sc, font relief, 3 sides of bowl. Early 12c. (Above) frieze of foliage and lions; (below) men primarily in profile; reading R to L. (N face) Jan, man seated with drinking horn; Feb, man seated, warming feet at fire; March, man digging; April, man pruning; Bond (1985) il p 190. (E) May, tall plant, fig beside a banner (?Rogation procession/"beating the bounds"); June, man weeding with ?falcastrum; July, man mowing with scythe; Aug, man binding sheaves; Gardner fig 105; Bond (1985) 190; Robinson color il betw 126 & 127. (S) Sept, man threshing with flail; Oct, man pouring into a container (grain into a mill/wine into a barrel); Nov, man killing a pig; Dec, 4 figs at table feasting; occasional Latin names of months. (W) "conventional designs" (Cautley), "Trees of Life (Pevsner 2).

Warham All Saints. sc, font relief. 12c. ?Jan, man (profile) seated. According to Pevsner 1, the font originally had the labors of the months and a tree of life, but the scenes are difficult to decipher and include an animal musician.

Diocese. ms, calendar, Corpus Christi Psalter, CCCC 53. 14[1]. Ff 1–6v, Jan, 3-faced man drinking at table. Feb, man seated by fire hooking meat from pot. March, man pruning. April, man riding with hawk. May, girl on grass with flowers in each hand. June, man mowing. July, man reaping. Aug, man threshing. Sept, one fig with stick and basket on back, another treading. Oct, man sowing from barrel-like container. Nov, man beating oak tree for pig. Dec, man butchering pig. James (1912).

East Anglia. wdcarv, misericords. Late 14c. Aug, 2 scenes: man and woman binding sheaves; sheaves being loaded on horse-drawn cart.

Sept, two men flailing wheat; fabulous hybrids as supporters; now at V & A; Tracy (1988) Cat. 69–72 pls 21–2, 24; Bond (1910a). Originally thought to have come from Lynn S Nicholas (see H. Clifford Smith, V & A Cat. 62–4, discussion in Tracy).

Norwich S Michael Coslany. Parsonage. pg roundels. c1450–60 (Marks). Feb, man in armchair, beaver hat over hood, one shoe removed, warming hands and foot at open grate with pot simmering; towel hanging from rack, jug and plate on mantle (Marks color pl XXIV); Wells (1965) Cat. 127. Aug, man on ladder picking fruit; sack on ground (so identified by Wdf, V & A cite Nov). Sept, young man, brow bound with scarf, cutting grapes with knife, two-handled woven basket filled with bunches (Wdf pl XXXIV). Oct, man sowing, seed basket hung diagonally from shoulder, pouch hanging from belt. Aug and Oct in L & M Cat. 96 a & b. In 1841 at parsonage; now divided betw the Burrell Collection (Feb) and the V & A (Aug, Sept, Oct); for two French roundels from the same site, see Wdf 158.

Norwich S Martin-at-Palace. *pg roundels. Late 15c. Aug, woman reaping. Oct, man sowing, patched hose, knife at side, seed basket hung diagonally from shoulder; yellow hose patched. See Wdf (152) for Winter drawings.

Norwich, ?private dwelling. pg roundels. Late 15c. Jan, king feasting before elaborately set table. Feb, man seated, warming hands at fire. March, man pruning, cuttings tied in bundles. April, man in fur-lined garment entering house during hail shower (Wdf pl XXXIII). July, man mowing, fork and rake beside. Aug, woman reaping with serrated sickle, ewer and lunch napkin beside (Wdf pl XXXII). Sept, within enclosure young man plucking bunches of grapes and putting them into two-handled woven basket on stool (Wdf pl XXXII). ?Month, woman bathing, looking from behind enclosing curtain. Formerly at Marsham and Brandiston Hall; for details and provenance, see Wdf 150–2 and P & W 1.

Provenance uncertain. pg, quarries. c1480. July, man in straw hat, parti-colored tunic, boots, mowing. Aug, man in fur hat with jewel, picking fruit from ladder; basket and sword attached to belt; basket of fruit on ground, other trees in background; Wdf 154; drawings in G King Collection, NNAS, Box 1.

Glasgow Burrell Collection. pg, roundel. 15[4]. Sept/Nov snaring birds: boy kneeling at cage holding decoy; (background) corner of wall and wattle fence; Wells (1965) Cat. 112.

Norwich Castle Museum. pg roundel. Late 15c. Oct, man in brimmed hat, sowing; rectangular seed basket suspended at waist, wearing laced short black boots; provenance uncertain.

Norwich S George Tombland. pg roundel. Late 15c. April, man in fur-lined gown hurrying into house to avoid rain and hail shower; Wdf pl XXXIII.

Besthorpe. pg frags, 2 roundels, not *in situ*. Late 15c. **sVI.4b** April, long-haired man entering building, looking over LS. **sVI.2b** Nov, man in blue tunic, conical hat, axe lifted to stun animal (only part of head remains); Wdf pl XXXV. Wdf (154) conjectured that a frag with 2 ewers came from a feasting scene.

Denton. pg roundel, sIII, head of light, not *in situ*. Late 15c. Scene set indoors, win and door in background; (L) ox; (R) man in yellow tunic, white apron with pocket, massive axe lifted over shoulder, Ingleby pl 12.

Foulsham. pg, Flemish roundel, SE win of chancel. Late 15c. Man harrowing a field; man teaching dog to beg, Wdf 156.

Gt Witchingham Hall. pg roundel. Late 15c. April, (inscr) young man and woman holding flowers; Wdf 157.

Forncett S Peter. wdcarv, be. ?16[1]. 3 benchends with paired labors on shoulders. (Reading from W) **S1** man with stalk in leaf (cf Burnham Deepdale). **S2** man with flail and tied sheaf of wheat, man with seed basket. **S3** butcher aiming axe at animal, man with loaves. **N2** man with scythe, man tying stalk of wheat. 1857 restoration largely confined to the tops of figures.

Shimpling? wdcarv, be. In 1733 names of the months Jan –June legible with initial letters missing, NRO, Rye 17, 3:199v. M & R

conjecture that the lost figs on the arms represented the labors.

Weybridge Priory. reverse of woodblock calendar, NMS 134.944. 1503. Names in Latin. Jan, warming before fire. Feb, digging. March, pruning. April, harrowing. May, holding flowers. June, shearing sheep. July, mowing. Aug, gathering grain into sheaves. Sept, threshing. Oct, sowing. Nov, killing pig. Dec, feasting. For provenance, see Wdf 160.

b. Musicians/Musical Instruments

Identification of stringed instruments is complicated by medium. Tracery lights, for example, restrict the artist to predetermined shapes of limited size. Frontal views make it impossible to determine the nature of underbody of the instrument, flat for a citole or convex for the small member of the lute family variously called mandora/gittern. Since authorities have not always agreed on the names for stringed instruments, I have adopted the system used by Remnant (1999). When evidence is weak, I merely indicate whether stringed instruments are plucked or bowed. Documentary records from 1370 through the 16c cite payments to gittern players, harpers, fiddlers, bagpipers, zither and trumpet players. See also Appendix I.3.

Lay Musicians

Diocese. ms, Bromholm Psalter, Bod L Ashmole 1523, hi, f 99 (Ps 80). c1310 (ff 1–168v). (Above) Son; (below) cleric in alb holding open book; lay musicians with pipe and tabor, psaltery, fiddle, and trumpet; Pächt & Alexander 537 pl LII; L & M Cat. 22, color il. Ps 80 is sometimes illustrated with clerics playing bells; see Morgan, *Survey* pt 2 Cat. 181.

?Wiggenhall S Germans. ms, Howard Psalter, BL Arundel 83 I, hi, f 55v (Ps 80). c1310–20. King playing bells. See also *Animal/ Hybrid musicians*.

?Diocese. ms, psalter, Oxford, All Souls College 7, f 7, border for Ps 1. c1320–30. Lay musicians with trumpet, fiddle, and gittern; Sandler, *Survey* Cat. 82 il no. 209.

Lynn S Margaret. brasses (Flemish). 1349. Minstrels with ?rattle & tambourine, bent horn, fiddle, ?shawm; Cameron pls 40c, 44c. 1364. Minstrels with fiddle, ?rebec, shawm, and trumpets; Cameron pl 49b, Dennison fig llc; this brass also represents feasting (?Peacock Feast in honor of Edward III).

Cathedral Priory. ms, Ormesby Psalter, Bod L

Douce 366, hi, f 128 (Ps 97). 14^1. Clerics chanting, Deity in nebuly above, kneeling monk; Sandler, *Survey* Cat. 43, frontispiece.

Thetford. lead alloy fig. 14^{1-2}. In hood, wearing long gown, plucking strings with long plectrum in RH; rectangular with curved neck, animal-head terminal; Margeson 325 fig 2 identified as a gittern; pl I reproduces a MS illumination of a lay musician in short gown playing similar instrument (marginal illumination, *Statuta Angliae* 14^{1-2}).

Cley. sc, stops, nave S arcade spandrel. 14^1, before 1320 (Lindley, 1985). **S4** youth in contrapposto; head turned over RS; curling hair, flat hat, red gown; LH holding fiddle by pegboard. **S5** musician playing pipe and striking tabor, L leg raised as if walking. S aisle. 15^2. **N4** musician with legs drawn up, plucking a narrow rectangular instrument.

Cathedral. sc, cloister bosses. S walk (1323–9). **D7** man in coif and hood with holly-shaped citole; bareheaded fig with fiddle; both riding grotesque beasts; Fernie pl 57. **K6** man with fiddle, sidesaddle on beast with female head; man blowing trumpet, barefoot, astride hybrid beast with female head in cowl. E walk 1327–9. **C4 2** musicians in short gowns, one striking tabor; other barefoot with puffed cheeks blowing pipe. N walk (1427–8) **A3** flanking women riding on men (see also section 6) musicians with (L) bent horn (R), ?shawm. These bosses are probably allegorical, representing sinful rather than edifying qualities of music.

Ranworth. ms, Ranworth Antiphonal, S Helen's Church, hi, f 154v (Ps 80). 1460–80. 5 musicians playing organ, bells, harp, bent trumpet, and horn; "Extracts" 18: il facing xxxvi.

Besthorpe. pg, sVI, restored panels hung separately. c1450. Second panel of middle light; both musicians richly dressed in fur-trimmed gowns; (L) blue hat and belt, murry gown with full sleeves, green hose, pointed black shoes; playing fretted 6-string lute; (R) large purple hat, blue hose, red gown with full sleeves, small dagger and pouch at belt; playing rebec; both musicians pluck/ bow with L hands. Dennis King conjectured from the shape of frags that the work might have been originally designed for a lay site (unpublished notes); M Remnant (1986) pl 126.

Ketteringham. pg, E win. 1e. 15c. Queen playing psaltery; A. Rose, fig 19.

Glasgow Burrell Collection. pg frag. 15c. Composite, head of queen with double morse at neckline (Patricia Collins suggests from a Virgin enthroned); central torso with lute and plectrum, wearing a gown with flower pattern. The panel also includes wings, and frag of an ?apparelled alb. Wells, Cat. 97 (45/67).

Warham S Mary Magdalene. pg frag, nIV.2b, *ex situ*. 14^1/15c. In rhombus, a lay musician plucking citole (identified by A Rose). At 1a fig in alb and amice bowing fiddle with LH; at 1c similarly vested fig from same set playing pipe and tabor; probably angels.

Cathedral. sc nave boss. 15^2. Bay F: Israelites celebrating defeat of Pharaoh, **8** with lute & harp; **9** with trumpet & ?shawm; Rose (1997) 73.

Wymondham. sc, stop, N aisle. Mid 15c (Pevsner 2). **S7** layman in chaperon, short beard, with bagpipes. **N7** layman in high-necked gown with four buttons, short beard and moustache with 4-stringed small instrument, ?plectrum; Montagu cited 2 lutes with a third on hammerbeam roof.

Methwold. sc, stop, nave. 15c. **N3** hooded fig playing bagpipes. **S4** angel with mandora/ gittern.

Seething. wp, S wall. Man playing harp; other obscure remains.

Thurgarton. wdcarv, be. 15c. Seated man with lute (3 strings). Man playing bagpipes (lion on adjacent shoulder seems to be listening).

Tuttington. wdcarv, be. 15c. Man with lute. Man with pipe and tabor.

Dickleburgh. wdcarv, screen, N2. 15c. Man in hooded garment playing double shawm (Montagu).

Wickmere. wdcarv, be. c1500. Man in flat hat, coat with slit sleeves, legs crossed, playing lute with LH.

Quidenham. *wdcarv, stalls, "two persons playing on violin," NRO Rye 17 3:118v.

Ranworth. *wdcarv, be. Man in soft hat and gown open at throat playing fiddle at chin; woman in veil and filet holding stringed instrument; in 1840 "broken and pulled down and lying in pieces on the floor," DT 42:72, 73.

Animal/Hybrid Musicians

Warham All Saints. sc, font relief. 12c. Rabbit

playing a harp.

?Wiggenhall S Germans. ms, Howard Psalter, BL Arundel 83 I, bas-de-pages. c1310–20. Ff 33v (Ps 38) hybrid musicians; 55v (Ps 80) hybrid and human musicians with organ, drum; hybrid trumpeters in frame.

?Diocese. ms, psalter, Oxford, All Souls College 7, f 7, border for Ps 1. c1320–30. Hybrid with organ.

?Thetford Priory 1. ms, Cluniac Psalter, Yale, Beinecke 417, f 7, bas-de-page. c1320–30. Hybrid and human musicians.

Ringland. pg, sV, roundel. c1310–25. Centaur in hood and jacket playing fiddle; dog below; M & R il 2:116; King 19, fig 7; M Remnant (1986) pl 74.

Cathedral. pg, Erpingham Win, nX.1c. 1330–40. Hybrid with bagpipe.

Denton. pg, E win, light 2, roundels. 15c. Bird playing trumpet. Bird playing harp.

Suffield. wdcarv, screen spandrels, N5. 15c. Pig on barrel playing harp; 3 pigs dancing, feeding trough below.

Wiggenhall S Germans. wdcarv, be N3. c1500. Bear playing ?shawm.

c. Other Occupations
Organized alphabetically by occupation.

Carpenters

Cathedral. sc, nave bosses. 15³. **B4** Carpenter (Noah) planing with broadaxe, Rose (1997) 41. **C1** stone carver with set of chisels lying on open ?case, square hanging from tree branch; short gown, long apron.

Lynn S Nicholas. wdcarv, misericord. c1419. (L) 2 apprentices carving; (C) "master-carver seated at his bench, . . . dog at feet, designing with the aid of dividers and square"; (R) apprentice bringing jug; saw and gouge on supporters; Tracy Cat. 78 pl 30; Bond (1910a) 96.

Clerics/Monks

Lynn St Nicholas. wdcarv, misericord. c1419. Cleric in habit (?Benedictine), kneeling betw chair and desk with open book, prayer scroll in joined hands; (L) supporter, eagle with scroll in beak enclosed in twisted ribbon forming B; perhaps donor of misericords, Tracy Cat. 74 pl 26.

Cathedral. wdcarv, misericord, S6. 15¹. Richard Courtenay (bp 1413–15) in Benedictine habit, reading; supporters (L) shepherd tending sheep; (R) 2 scholars before books,

2 others; (above) monk preparing meal. Supporters probably meant to represent pastoral duties (Courtenay was Chancellor of Oxford); Rose (1994); Tracy (1990) pl 98.

Farm Workers

Cathedral. sc, N cloister boss K6. 1425–30. Woman in wimple and hat riding, holding infant; 4 men walking beside, one with pitchfork.

Tuttington. wdcarv, be. 15c. Woman sitting before churn; woman with basket and pig.

Fools
See also II *David.*

Norwich, Carrow Priory. ms, Carrow Psalter, Baltimore, Walters Art Gallery W.34, hi, f 113 (Ps 51). 1250–60. Fool eating a loaf.

Bromholm Priory. ms, Bromholm Psalter, Bod L Ashmole 1523, hi, f 66 (Ps 52). c1310 (ff 1–168v). Fool with bladder disputing with wise man; *manus dei* above. Pächt & Alexander 537, pl LII.

?Wiggenhall S Germans. ms, Howard Psalter, BL Arundel 83 I, miniature, f 40v (Ps 52). c1310–20). King with sword, fool with bladder on stick.

Hunters

Cathedral. sc, capital, 12c. Archer with quiver at back, using feet to draw longbow. ?Wounded archer with bow in hand. Man spearing large animal, ?deer; Borg & Franklin Cat 5. For other bowmen, see I.3 *Lamech* and *Esau.*

— sc, capital, 12c. Man holding dog by collar; dog attacking deer; Borg & Franklin Cat 7.

Reedham. 2 tiles, c1300. Falconer on horseback, relief detail lost, Rogerson il p 381.

?Wiggenhall S Germans. ms, Howard Psalter, BL Arundel 83 I, bas-de-pages. c1310–20. Ff 14 (Ps 1) woodland scene, incl hidden hunter with owl, deer, squirrel, rabbit, and birds; 26v (Ps 26) hybrid hunting, shooting at rabbit.

Lynn. plate, enameled cup. c1340. Animals, figures hunting, hawking; 12 women, one with longbow, 2 with hawk; 9 men; dogs, hares, and foxes at foot of cup; *Age of Chivalry* Cat. 541; L & M Cat. 35, color il p 22; restored. Rare survival of secular plate.

Ingham. *wp, wall above tomb of Sir Oliver de Ingham, whose effigy lies on bed of rocks. c1343. (L) huntsman in green pourpoint

and hood in grove of trees, holding horn to mouth, staff in hand; frags of animals; (R) archer in buttoned pourpoint holding long bow; effigy angled as if turning away from hunting scene, DT 33:14. Weever (817) gives further details: "He being a great travailer, lyth upon a Roke, beholding the Sunne, and Moone, and starres, all very lively set forth in mettall, beholding the face of the earth: about the Tombe, twenty and foure mourners." For Stothard's engraving (55–6) see Martindale pl 17. Keyser thought S Hubert hunting; for a classical interpretation, see Martindale (1989b), who cites a similar effigy at Reepham.

Burlingham S Edmund, private dwelling. wp. 16^1. Discovered 1991, "series of hunting scenes, and executed in a semi-grisaille palette" (DP in P & W 1): boar; stag hunt, hounds, hedgehog. I am grateful to Andrea Kirkham for details on this and the following two entries.

Lt Walsingham, private dwelling. wp on chimney beam. 16^1. Stag hunt, huntsman blowing horn, hounds, stag with arrow embedded in side, "a rare survival of early secular decoration," DP in P & W 1; decorative motifs with foliage above.

Shipdham, private dwelling. wp. 17c. Hunting scene, dogs with birds in mouth, fish; fruit trees, fig tree (labeled in English).

Cathedral. wdcarv, misericord, N5. 15^1. Bearded huntsman with quiver of arrows, blowing horn; (L) stag confronted by 2 hounds; supporters (L) stag, (R) 2 stags; Rose (1994).

Thurgarton. wdcarv, be. 15c. ?Hunter (on one shoulder) moving toward fighting dogs (on adjacent shoulder).

Tuttington. wdcarv, be. 15c. Man with gnarled club over shoulder and sack in hand.

Brinton. wdcarv, be. c1544 (westernmost be inscr). Man in boots walking, carrying musket.

Millers

Lynn S Margaret. brass of Adam de Walsokne (†1349). Post mill in lowest register.

Cathedral. sc, W cloister boss, A7. 15^1. Mill with miller at door; woman astride horse with sack of grain; man before granary with sack.

Thornham. wdcarv, be elbow rests. 15^{3-4}. Post mill. Simon Miller (†1464) and son John (†1488) were major benefactors of the church; Gardner (1955) pl 25.6.

Pedlars

Swaffham. wdcarv, be built into stalls. Early 16c (Wilson, P & W 2). Pedlar and dog with muzzle and chain. Swaffham pedlar and wife, both holding beads and standing at shop stall (thought to be John Chapman and wife, donors of N aisle), Duffy fig 126.

Mileham. pg frag, sII.1a. 15c. 2 packhorses, one with paniers followed by man and woman. Originally inscr "Thomas broun peddar"; "broun" remains, Wdf (1938) 171–2, il facing 172.

Seamen/Ships

Lynn S Nicholas. wdcarv, stall end. c1419. 2-masted vessel, "square-rigged on the main mast and lateen-rigged on the mizen"; sails furled, "pennons on the ends of the main yard, on top of the mast and bowsprit"; forecastle, fighting tops, shields of knights on after castle; details include "main stay, shrouds and ratlines, lifts, sheets, gaskets, bowlines, rudder," and "a sheave of darts in main fighting top"; sun shining from beneath clouds; 6 stars and crescent moon; fishes and crab in sea, Tracy (1988) Cat. 158 pl 55. Second stall end: "single-masted vessel showing fore and after-castles, fighting top, parral, yard with square sail, sheets, and rudder"; 2 fenders at sides of hull; man on board; 3 dried fish in register below, Tracy (1988) Cat. 159 pl 56.

Thornham. wdcarv, be elbow rests. 15^3. Sailboat with rudder; Platt 133 fig 107. Anderson (1971) cited "scratched drawings" of ships at Blakeney, Cley, Salthouse, and Wiveton (217).

Beeston Regis. brass. 1526. Seaman's whistle, Badham 422.

Shepherds

Wilton. wdcarv, be. 15c. Shepherd and flock; Cautley also identified shepherd's dog and a slain wolf; M & R il 3:166.

Shingham. wdcarv, be. 15c. Shepherd and dog, Wilson, P & W 2.

Teacher

Cathedral. wdcarv, misericord, S25. 15^4. Teacher chastising pupil laid over his lap; flanked by two children with books; Rose (1994); Pevsner 1 pl 34.

Tumblers

Cathedral. sc, capital. 12c. Borg & Franklin, Cat. 17.

— sc, E cloister boss F6. 14^1. Tumbler, in long

gown with gloves; Rose (1997) 19.

Wood Dalling. sc, stop, now set in S wall, W end. ?14c. Contortionist.

Cathedral. wdcarv, misericord, elbow rests N11 and N3. 15c. ?Tumbler/contortionist, Rose (1994).

Methwold. sc, capital, nave, S5. 15c. Contortionist.

Wrestlers

Cathedral. wdcarv, misericord, S16. 15⁴. 2 wrestlers, detailed costume; supporters (L) boar; (R) engorged swan; Rose (1994).

Hockham. wdcarv, be. 15c. 2 wrestlers kneeling chest to chest, heads thrown back.

Watchmen

Watlington. wdcarv, be. 15c. ?Watchman ringing bell (2 examples).

2. Wheel of Fortune

Barton Bendish S Mary. wp, S wall. c1330 (DP in P & W 2). Large wheel; trace of female standing behind, slightly off center; undecipherable remains along wheel edge at 12:00 & 3:00; under wheel, a well-preserved bier. There is no consensus about the identity of this subject, but the position of the woman corresponds to that of Fortune elsewhere, and the other remains are consonant with the falling kings. The same composition appears in the Douai Psalter (Gorleston, Suf); see Sandler, *Survey* Cat 105 il no. 273. Keyser, Cautley, and Mortlock & Roberts queried a Catherine sequence; Park "presumably a morality subject" (P & W 2).

Catfield. *wp, N wall, above last arch. 14³⁻⁴ (DP). Fortune crowned, turning wheel; around perimeter [FORT]UNA ROTA; (L) king falling saying "Regnavi," (below king prone "[no]n regno," DT 27:150.

Norwich SPM. *emb. 16¹. Corporas case, "an old one of brodery worke gold of the wheel of fortune," Hope (1901) 214.

3. Three Ages of Man

See also IV.2 *Magi.*

Walpole S Peter. wdcarv, stall finial. 15c. Gardner fig 538.

4. Wodewose
(Wodehouse, Wildman)

Shaggy hair-covered man with club over shoulder;

sometimes shown in combat. For Wodehouse arms, see M & R il 2:68. Common on stems of fonts 15¹⁻². An inventory of play expenses from Wymondham (1537/8) cites "ijd. to a man gadderyng moss to aray a woodhouse," Galloway & Wasson 129.

Lynn S Margaret. brass of Adam de Walsokne. †1349. Wodewose attacked by lion beneath feet; Cameron pl 37b.

— brass of Robert Braunche. †1364. Wodewose attacking griffin beneath feet; Cameron pl 37c.

Hapton. sc, chancel arch. c1310 (P & W 2).

Cathedral. sc, E cloister boss. 14¹. F7. As atlas fig for rib.

Acle. sc, font stem. 1410. Wodewoses ~ lions. Drawing in Williamson (1961) pl 2.4.

Lt Cressingham. *sc, spandrels of W door. Early 15c. (R) man in armor; (L) wild man, head of man couped in RH, ragged staff in LH, Bl 6:114.

Dickleburgh. sc, font stem. 15¹. Wodewoses ~ lions; M & R il 2:30.

Ludham. sc, font stem. 15¹. Male with club and shield; female with club, long hair, one breast clearly visible.

Happisburgh. sc, font stem. 15¹. Wodewoses ~ lions; Bond (1985) color il facing 322.

New Buckenham. sc, font stem. 15¹. Wodewoses ~ lions.

Wymondham. sc, font stem. 15¹. Wodewoses ~ lions (larger scale than wodewose).

Norwich S Peter Parmentergate. *sc, font stem. Cited in N Spencer. Church now deconsecrated.

Cawston. sc, relief, S transept piscina spandrels. 15¹⁻². Wodewose and dragon (donors' arms).

Potter Heigham. sc, niche over S porch. 15c. Found in graveyard; ?originally from porch pinnacle; "rustic demi-figure," Pevsner 2.

Pulham S Mary. sc, S porch pinnacle. 15c. Seated, legs crossed, club over shoulder.

Salle. sc, N porch pinnacle. 15c.

Cley. sc, buttress pinnacles. Ellis (288) cited 3 but only 2 qualify; the third is not a wodewose.

Hilborough. sc, W door spandrels. 15c. (R) "a savage or wild man, bearing in his right hand the head of a man couped, and in his left hand a ragged staff," Bl 6:114; cf description in M & R 3:64.

Cathedral. wdcarv, misericord. 15¹. S7 2 wodewoses fighting each other, holding clubs

and tearing at beard and hair respectively, Druce pl 7.1; Rose (1994). **S11** wodewose with club raised, holding two lions on chain; scroll with "War Foli: wat"; supporters (L) wodewose struggling with animal ?dog/lion, (R) 2 sheep; Rose (1994). 15^4. **N31** wodewose with club in RH, looped rope in LH tied to neck of lion on which he sits cross-legged; supporters, eagle (L) preening, (R) ?eating; Rose (1994).

Aylsham. wdcarv, roof boss. Early 15c.

Felmingham. wdcarv, originally from screen 15c. Incorporated into pulpit, but in 1848 "nailed up in the pews, or lying loose on the floor," DT 55:22.

N Walsham. wdcarv, misericord. 15c. Twisted club over his LS; L supporter, wyvern, Grössinger, frontispiece.

Norfolk. wdcarv, probably from wall post, perhaps from a domestic building. ?15c. Full fig, no club, leaves at waistline. NMS.

Yarmouth? *wdcarv, bosses. 15c. Hairy man with club; riding a lion, DT 62:33, 39.

5. Green Man

Face surrounded by leaves (sometimes hawthorn). Authors use this term to identify a wide variety of faces; the selected examples cited below can be either benign or menacing (cf Cathedral misericords S20 and N24, Rose [1994]).

Hapton. sc, chancel arch. c1310 (P & W 2).

Lt Dunham? sc, stop, W arch betw chancel and aisle. ?14c. ?short beard, 2 horns, 3 leaves growing out of a stem at either side of neck; defaced. Carthew (2:676) thought a bull's or ram's head, but despite the horns the head looks human.

Burnham Norton Friary Gatehouse? sc, boss. 14c. Wide-eyed, animal ears, open mouth, boss surrounded with foliage.

Cathedral. sc, cloister bosses. 14^1. E walk **C2**, **D2**, **M5** (Rose [1997] 9); S walk **C6**. 15^1. W walk **A2**. N walk **C4** (2 branches proceeding from open mouth), **K3**.

Thompson. sc, sedilia. 14c. 3 green men.

Weston Longville. sc, sedilia. 14c. 2 small heads, one with lolling tongue.

Lynn S Margaret. wdcarv, misericord. c1370–80. 2 multi-leaved oak branches proceeding from each side of mouth, Colling, 1:71.

Scottow. sc. c1400. S porch, central boss.

Ashill. sc, font chamfer. 15c. Leaves coming out of mouth.

Colby. sc, font chamfer. 15c.

Moulton S Michael. sc, S porch spandrel. 15c. Branches coming from both sides of mouth; leaves in opposite spandrel.

Salle. sc, parvise chapel bosses. 15c. 4 green men, part of Coronation design; see Appendix I.3, Diagram 3.

Yarmouth. *wdcarv, boss. ?15c. In mitre, tongue protruding, DT 62:37.

Cathedral. wdcarv, misericord. 15^4. **S20** Face with leaves extending from eyebrows and above and below mouth, Colling 1:87. **N24** leaves extending from mouth and betw eyebrows; small pomegranates with leaves; teeth delineated, cross-eyed; Rose (1994), Tracy (1990) pl 100d. Elbow rests **S13** & **S14** leaves extending from mouth; Rose (1994).

Swaffham. wdcarv, roof brace. c1485. Haward (1999) il 4SLE.

Gissing. wdcarv, roof brace. $15^{3–4}$. Rudimentary foliate head with protruding tongue; Haward (1999) il 3SLW; Haward cites 2 examples.

Cawston. wdcarv, nave boss. 15c.

Felmingham. wdcarv, originally from screen. 15c. In 1848 "nailed up in the pews, or lying loose on the floor," DT 55:22.

Wilton S James. wdcarv, spandrels of screen, facing E. 15c. Head with leaves protruding from mouth, one each in opposite spandrels; screen "much renewed," Pevsner 2.

Aylsham. *wdcarv, misericord. DT 24:140.

6. Other

a. Degrees of undress

Men

Cley. sc, stop, S aisle N2. 15^2. Man in hood, scratching exposed buttocks, drinking from ?flagon; Tracy (1987) pl 72b. A damaged fig at N1 probably belongs to the same genre.

Cathedral. sc, E cloister bosses. 1316–27. **A2** Boy with bare back, shown from the rear. **F7** Head of man, animal head at hip, ?defecating, Fernie 179.

— wdcarv. elbow rests. 15^4. **N12** man in dagged hood grasping buttocks; **N20** man in pointed shoes grasping buttocks; Rose (1994).

Wymondham. wdcarv. N aisle roof bracket,

naked fig kneeling, prominent belly, pendulant breasts, grotesque head.

Women

Cathedral. sc, cloister bosses. 14[1]. E walk **D4** Woman beating man caught stealing washing; Rose (1997) 12; *900 Years* color il p 37. 15[1]. N walk **A3** 2 women in fools caps wielding wicker truncheons, riding on backs of men; flanked by musicians with (L) bent horn (R) ?shawm.

b. Literary Works

Cathedral Priory. ms, BodL Canon misc. 110, f 123. c1400. Martianus Capella, Marriage of Mercury and Philology.

East Anglia, ?Norfolk. ms, Geoffrey Chaucer, *Canterbury Tales*, CB UL Gg.4.27(1), miniatures. c1420–30. Reeve, Cook, Wife of Bath, Pardoner, Monk, Manciple; strong orthographic evidence for Norfolk; Scott, *Survey* Cat. 43 il no. 181 (Cook). Before mutilation the MS would have had 31–35 miniatures.

— ms, Guillaume Deguileville, *Pilgrimage of the Soul*, New York Public Library, Spencer 19. c1430. 26 miniatures illustrating the narrative; Scott, *Survey* Cat. 74.

— ms, Sir John Mandeville's Travels, BL Harley 3954. c1430. Extensive miniatures, dialect of scribe possibly Norfolk; Scott, *Survey* Cat. 70B, il nos. 272–4.

Cathedral. wdcarv, misericord S30. 15[4]. Marcolf, solver of riddle. Man in a net (neither dressed nor naked), holding hare in LH (a gift that is no gift—it will escape when presented), riding a stag with only one foot on ground (neither riding nor walking); Rose (1994). For the same subject at Worcester (c1379), see *Age of Chivalry* Cat. 536; at Beverley, Grössinger pl 147.

Norwich S Peter Parmentergate. *wdcarv, misericord. Late 15c. Portcullis trapping Sir Yvain's horse, Bond (1910a) 77.

Norwich Guildhall. *pg, New Council Chamber. 1535. Otanes, corrupt judge, flayed alive by Cambyses: (above) "Lette alle Men se, stedfast you be, / Justyce doe ye, or els loke, you fle"; (below) "You that sittyst now in Place, / See hange before thy Face, / Thy own Faders Skyn, / For Falshod; this ded he wyn," Bl 4:229. Wdf conjectured the glass may have come from abroad with English texts provided locally, or may have

been local Flemish work (198).

c. Nine Worthies

Robert Reynes included 9 couplets on the Worthies in his commonplace book (*IMEV* 3666), perhaps a record of a local pageant (Louis 436–7).

Norwich Greyfriars. *pcl. 1483. Gift from local vintner, stained cloth "with the 9 worthies," Bl 4:110.

Marsham. pg, sIV, lights a & c. 15c. Judas Maccabeus in armor, feather atop helmet, RH holding spear with banner, LH on hip, embroidered on surcoat edges "[IVD]AS MAKABIAS OFMIWORTHYNESS: EFTHE WOL WEOTLORDE," at neckline "IUSDASMA"; David with crown above burlet, ermine collar and hem on cote-armure; harp in RH, sceptre in LH. Glass restored to Marsham in 1966 from Bolwick Hall; for its complex provenance see Wdf 151–2.

Norwich, domestic dwelling, Sir John Fastolf's city house. *pg. In large N win 10 "effigies of great warriours and chiefs, as David, Sampson, Hercules, &c. holding bows, swords, halberds, &c. ornaments suitable to the taste of so great a warriour as Sir John was," Bl 4:436.

Blickling Hall. *wdcarv, staircase. 1627. Hector, David, Godfrey of Boulogne, Alexander, and Joshua (P & W 1).

d. Classical Figures

See also *Hybrids*.

Hercules

Mattishall. wdcarv, screen spandels N3. c1453 (C & C). (L) lion; (R) Hercules with club raised. On the N there are 3 sets of men engaged in battle with animals, incl a lion, and an armed man above Matthias and Simon; on the S there are 2 animals above the first pane, the Annunciation above the second, and a man with scimitar and dragon above the third.

Norwich S Peter Parmentergate. *wdcarv, misericord. Hercules with club, holding chained lion, Hart (1849) 238.

Blickling Hall. sc, statue. c1640. Hercules by Nicholas Stone, originally at Oxnead.

Others

Arranged chronologically within media.

Larling. bone plaque. c800. She-wolf nursing twins; also wyvern and cockatrice.

Cathedral. sc, 3 capitals. 12c. ?Circe holding

bucket and rod facing other figs in short gowns; seated archer discharging 3 arrows, ?Odysseus; fig emerging from vine, ?Dionysius; Franklin (1996) il pp 126–33; for an earlier interpretation of the capitals see Borg and Franklin Cat. 1.

Norwich Castle. sc, capitals & voussoir on doorway to Bigod Tower. 12c. ?Pegasus, Heslop (1994) fig 13; ?Meleager killing the boar of Aetolia, figs 12 & 14.

Cathedral. seal, ?Everard or ?William Turbus, bp. 12c. Apollo in midst of beasts with legend "[A]VE:M*ARIA*:GRAC[IA:PLENA]," Hope (1887) 290.

Langley Abbey. seal, Simon de Middleham, Abbot. 1260. Mercury (bust) with filet, *BM Catalogue of Seals*, 3402; Erwood fig 3.5

W Acre Priory. seal. 13c (second seal). Reverse, imperial bust with hair tied with filet, *BM Catalogue Seals*, 4296. For use of gemstones in seals, see Henig & Heslop.

Norwich. seal, reuse of intaglio-stone 1 BCE. c1300. Satyr walking, Henig and Heslop pl 1.1.

Lynn S Nicholas. wdcarv, roundel on poppy head. c1419. Satyr seated, long tail, holding pig over back by hind legs, small church at bottom; far R a tiny bp with crozier (?Nicholas), and a tiny man with hands joined.

Cathedral. wdcarv, misericord N28. 15[4]. Janus head, (L) benign profile (R) menacing profile; supporters with similar expressions; Rose (1994); G L Remnant (108) and Rose suggest Deceit.

e. Atlas Figures

Man with foreshortened arms and agonized expression supporting an arch or roof post; for discussion in misericords, see Grössinger (1997). Some may have represented contortionists (see also section 1c, above).

Cathedral. sc, capital. 12c. Crouching man in short tunic; Borg & Franklin Cat. 14.

Snettisham. sc, stop. c1330. Crouching man in hood, animal feet; Tracy, (1987) pl 73a.

Cley. sc, stop, S aisle N3. c1330. Man contorted, one arm twisted around head.

Letheringsett. sc, stop, NW arch of aisle. 14c. Man resting his hands on his knees with feet turned back, bearing the weight on his back; ?contortionist.

Walpole S Peter. sc, relief, exterior, corner of chancel and N aisle. 14[3–4]. Standing fig with

arms raised as if to support stair turret above. Local legend has it that this is Hickathrift, fenland giant, whose grave is claimed at two different parishes.

Lynn S Margaret. wdcarv, misericord. c1370–80. Bearded fig supporting rest with one arm (2 examples).

?East Anglia. wdcarv, misericord. 15c. Naked fig sleeping, supporting seat on back, head against LH in a traditional posture of sloth; "said to have come from E Anglia," Smith V&A Cat. 71; now V&A W.25-1911; Tracy (1988) Cat. 68 pl 20. A witty combination of atlas and Sloth.

Norwich S Gregory. wdcarv, misericord. 15c. Man squatting, hands on knees.

Ranworth. wdcarv, misericord. 15c. Crouching man.

Giants

The function of 2 giants in the pageant for Queen Elizabeth Woodville's Norwich visit in 1469 is unclear from the records. A wood and canvas giant worked by wires figured in a 1538/9 play at Wymondham, Galloway & Wasson 129; Carthew (1884) 146; Lancashire no. 1550.

f. Exotic Combatants

Screen spandrels were popular sites for human/animal conflict. Men sometimes wear exotic headgear and often wield a scimitar.

Norwich Ethelbert Gate. sc, spandrels, 1316–7. (L below) lion; (above) bearded man in profile holding shield, engaged in battle with (R) dragon with menacing teeth; (below) crested bird with tail ?basilisk. Frag dragon extant, Tracy (1987) pl 68; details in Borg & Franklin Cat. 36. Sekules (1996, 201–2) argues the triumphalist nature of the sculpture in reaction to the 1272 conflict betw town and priory.

Hulme, S Benet's Abbey. sc, spandrels of gatehouse doorway. Late 14c. (L) man in armor with sword and ?shield; (R) lion rampant (perhaps heraldic). Sekules thinks this may be a copy of scene on the Ethelbert Gate (Borg & Franklin 34).

Hemsby. *sc, boss. 15c. Man in belted short tunic, holding bird in LH, club in raised RH, DT 31:115. Perhaps originally in the upper room of the S porch.

Hilborough. sc, W porch spandrels. 15c. (L) fig with scimitar; (R) wodewose.

N Elmham. wdcarv, screen spandrel N8. 15[3]. 2 men in exotic headgear, dagged sleeves,

each with scimitar raised.

Morston. wdcarv, screen spandrel S3–4. c1480. Demi-fig in red holding massive scimitar, head missing; dragon wing and tail in the next spandrel.

Salle. wdcarv, misericords. c1470. 2 heads in exotic turbans.

E Harling. wdcarv, stall arm rest. 15c. Holding scimitar and tiny ?shield, knotted filet around head; dragon on opposing arm rest; repaired.

Suffield. wdcarv, screen spandrel N3. 16[1]. (L) ?wyvern breathing fire; (R) barefoot fig in exotic headdress holding club in both hands.

g. Animals

No attempt has been made to catalog the amazing array of animals in Norfolk, in part because identifications are fraught with private interpretation. One viewer's seahorse is another's wolf! Even Bond (1908) would not commit himself to distinguishing the head of a cat from a wolf on Norman fonts (192–3), and other experts sensibly take cover with the generic term "beast." The following section is highly selective, particularly for bench ends, and includes only a few heraldic animals for general interest. Unless stated otherwise, a 15c date may be presumed. Quite realistic animals also feature in the robes painted by the Damask Workshop; for a summary, see Briggs 1001. Manuscript margins are particularly rich in animals; for an index of 15c animals in E Anglian manuscripts in the Bodleian Library, see Nichols *et al., Index of Images.*

Antelope

See also *Cervidae.* The yale with projecting tusks is an heraldic animal with spots. It seems to have been popular with woodcarvers in Norfolk, without necessary heraldic significance, Tracy (1988) Cat. 161.

Walpole S Peter? sc, boss S porch. c1435. Bicorn.

Lynn S Nicholas. wdcarv, be. c1419. Engorged, Tracy (1988) Cat. 161 pl 58. Identified by some as an ibex. Now at the V & A.

Cathedral. wdcarv, misericord S32, 15[4]. Rose (1994).

Wiggenhall S German. wdcarv, be. Tracy (1988) fig 35.

Feltwell. wdcarv, be. Tracy (1988) Cat. 161.

Lt Fransham. wdcarv, be. Bicorn with tail.

Walpole S Peter. wdcarv, be. Anderson (1955) 191.

Watlington. wdcarv, be.

Ape (Monkey)

?Wiggenhall S Germans. ms, Howard Psalter,

BL MS Arundel 83 I, f 40v, bas-de-page. c1310–20. An ape and owl.

Cathedral. sc, N cloister boss, D3. 1427–8. Peering from branches, observing small animal.

Cley. sc, boss S porch. 15[1]. 2 apes birching a boy.

Cathedral. wdcarv, misericords. 15[4]. **N14** Ape riding backwards on ?dog, holding its tail and birching it; supporters, apes (L) with ?toothache. **N27** (R) Ape pushing wheelbarrow, being birched by ape balanced on wheelbarrow; (L) ape with hand on wheel of barrow; supporters, wyvern with human face. **S18**. ?Ape in hood with fool's peak, playing dog like bagpipes, flanked by dog and ape with birch, animal heads in warren holes below; supporters (L) bear chained to clog, playing pipe; (R) bear; Grössinger pl 146. For similar subject with a fox instead of dog, see Varty fig 123. All in Rose (1994).

Dickleburgh. wdcarv, screen, N2. 15c. Man in chaperon and ape about to eat acorn. In the spandrels and cusps of geometric designs in this 4-panel screen is a wide range of heads (angel, human, grotesque, and animal), some whimsical but others relatively naturalistic. One panel obscured by church furniture.

Fakenham. *wdcarv, misericord. In cap holding jordan, DT 55:11.

Frenze. wdcarv, be.

Grimston. wdcarv, stalls in chancel.

Norwich S Peter Parmentergate. *wdcarv, stalls/misericords. 2 monkeys in monastic dress, playing bagpipes, Hart (1949) 238; Bl 4:96. Bl cites a number of satiric representations of monks. Stalls were provided in the church for a college of priests living in an adjacent building, formerly home to the Pied Friars.

Salle. wdcarv, stall arm rest. Climbing down.

Stibbard. wdcarv, be. Cowled, with prominent penis.

Wymondham. wdcarv, N aisle roof bracket.

Yarmouth. *wdcarv, boss. In cap, holding jordan, purse at belt, DT 62:39.

Bear

There are some two dozen references to bearwards in the Thetford Priory records (Dymond); similar citations occur in records for Yarmouth, Hickling, and Hunstanton (Galloway & Wasson, 13, 18, 20). Guild records at

Wymondham for 1509/10 record 1*d* payment "to a Berward pleynge with the ape," Galloway & Wasson 123. See also animal musicians.

Cathedral. sc, capital. 12c. Man wrestling ?bear; another animal on adjoining face of capital; Borg & Franklin Cat. 8.

— sc, S cloister boss A1. 14[1]. Bear and cubs.

Walpole S Peter. sc, boss, S axis S porch. c1435. Muzzled and chained, eating a vine.

Crostwick. sc, tower arch stops. Heads.

Denton. sc, boss N porch. Muzzled, Cave (1948).

Stalham. sc, E end N aisle.

Cathedral. wdcarv, misericord S9. 15[1]. Collared bear fighting lion; supporters (L) bear with collar and chain, seated; (R) squirrel eating nut, Rose (1994).

Aylsham. *wdcarv, misericord. Man with club raguly and shield attacking bear with club. A large number of fighting scenes were recorded in the 19c (DT 24:134–136, 138), four remain in a Victorian altarpiece (G L Remnant).

Holme Hale. wdcarv, be, arm niche. Muzzled, standing at ragged staff. Unusual style of benchend, "unique in my experience," Cautley; see p 147 for general view.

N Elmham. wdcarv, be, elbow rest. Haltered and chained to post.

Tottington. wdcarv, be. Haltered, fur incised; now at Rockland S Peter.

Wimbotsham. wdcarv, be. Muzzled; Dashwood and Boutell 135. Other wdcarv by James Ratee, 1854 (P & W 2).

Yarmouth. *wdcarv, boss. Bear fighting monkey, DT 62:33.

Brinton. wdcarv, be. c1544. Chained.

Coxford Priory. *emb. 1536–37. Dissolution inventory, "an olde cope of bawdekyn with beres hedds wrought in yt xij d," Walcott 244.

Birds

See also specific birds.

Cathedral. sc, capital. 12c. Confronted birds pecking at forelegs; Borg & Franklin Cat. 16; see also Cat. 11 & 18.

Walpole S Peter. sc, boss, central axis S porch. c1435. Eating a vine.

Ingham. ms, Michael de Massa, *On the Passion of Our Lord*, Bod L Bodley 758, marginal miniature, f 87. 1405. Parrot with scroll in beak, inscr "I hope" and "I woulde wel"; blackbird, "In domino confido" and "In wel

to be War." Also a Trinitarian friar (probably Ralph de Medylton).

Necton. wdcarv, roof. c1450. Bird on nest, Haward (1999) il 4NW.

Aylsham. wdcarv, screen spandrel S1. Paired herbivore (eating flower pod) and carnivore (eating snake).

Dickleburgh. wdcarv, screen. Hooded demi-fig holding 2 birds, Colling 1:18.

E Harling. wdcarv, stall, chancel. Repaired.

Thornham. wdcarv, be. Bird standing over barrel, rebus for Hopton.

Boar

?Norwich. pg, roundel, c1340. ?Badge for DeVere; Cresswell & King 437, il facing 436.

Walpole S Peter. sc, boss S porch. Eating grapes. 1435. See Ps 80.

Beeston S Mary. wdcarv, screen spandrel S2. 16[1]. Mauling man.

Suffield? wdcarv, screen spandred N6. 16[1]. Engorged, lion's tail, but clear tusk.

Bull

Cathedral. wdcarv, misericord, S26. Taurus, Rose (1994); Tracy (1990) pl 101.

Butterfly

Norwich SPM. *emb alb. 14[3–4]. "Item unum album cum paururis de rubeo velvet pulverizat[um] cum Boterfleyes de auro," Hope (1901) 235.

Camel

For 2 references to a man traveling with a camel through Thetford, see Dymond 2:390, 463.

Walpole S Peter. wdcarv, stall; M & R il 3:145.

Cat

Castle Rising? sc, Norman font. Commonly so identified; better classified as animal masks.

Cley. wdcarv, be, Gardner (1955).

Dickleburgh. wdcarv, screen. 15c. Cat with kittens nursing, one kitten in mouth.

Sheringham. wdcarv, be. Cat with kitten (?mouse) in mouth; Gardner [1955] 39 queries Manx cat; Cox (1916) 129.

Wiggenhall S Germans. wdcarv, be. Gardner (1955).

Cervidae

See also II.1 *Cathedral* & XV.1.c *Hunters*.

Shimpling. tiles. 14c. Running stags, probably Bawsey tiles.

Norwich. seal, Walter Lyherd, bp 1446–72, privy seal. 1454. A hart lying in water, *BM Catalogue Seals*, 2056; Bl 3:539. Rebus also used in stops at the Cathedral.

Necton. wdcarv, roof. c1450. Haward (1999) il 6SE.

Lynn S Nicholas. wdcarv, misericord. c1419. Stag pursused by hounds; hunting horn and crossbow on supporters; rabbit in burrow, Grössinger pl 8; Tracy (1988) Cat. 76 pl 28. Lynn Museum, on loan from V & A.

Cawston. wdcarv, misericord. Stag, G L Remnant 100.

Hockering. wdcarv, be. 16c. Stag and deerhound, P & W 2.

Cock

See also *Fox* and VI.3 *Instruments of the Passion*.

Cathedral Priory. ms, Ormesby Psalter, Bod L Douce 366, hi, f 128 border. 14^1. 2 cocks confronting each other; Sandler, *Survey* Cat. 43, pt 1 frontispiece.

Cathedral. sc, W cloister boss C6. 1420–1. 2 fighting.

Baconsthorpe. wp, E end of S arcade, with inscr text.

Dog

According to Cave, particularly common in roof bosses, but in Norfolk they are popular on bench ends. Particularly fine examples are found on the Thorpe alabaster tomb at Ashwellthorpe (c1417), on the brass for the wife of Sir John Curson (†1471) at Bylaugh, and formerly on the Stapleton Monument (c1466) at Ingham, where he was named Jakke (Jokke). For trivialization of Psalm 91 in mortuary design, see Badham 456. For hunting hounds, see XV.1.c.

?Diocese. ms, psalter, Oxford, All Souls College 7, bas-de-page, f 7. c1320–30. Dog chasing rabbit, Sandler, *Survey* Cat. 82 il no. 209.

Kenninghall. sc, door jamb. ?c1300 (P & W 2); others have interpreted a lion.

Cathedral. sc, cloister bosses.14^1. E walk **E8**, dog amidst vines and grapes; S walk **B7** barefoot man, LH on dog; lion. 15^1. W walk **B3** 2 dogs fighting.

Shernborne. brass. Dog with collar of bells looking up, Cotman etching, DT 43:191.

Walpole S Peter. sc, bosses S porch. 1435. (S axis) gnawing a ?bone; (N) eating a rabbit.

— sc, recess vaults flanking E win. P & W 2.

Necton. wdcarv, roof. c1450. Haward (1999) il 4SE.

Cathedral. wdcarv, misericords. 15^4. **S33** man being attacked by three dogs, defending with long staff. **N29** 2 dogs fighting, standing on hind legs; ?seated ape betw them; Rose (1994).

Cawston. wdcarv, be. c1460 (bequest for seating).

Aylsham. *wdcarv, be. Dog with raised paw; engorged hart, DT 24:144.

Castle Acre. wdcarv, be. Dogs with collar and chains.

Dickleburgh. wdcarv, screen, S1. ?Dog with rabbit in mouth.

Gt Massingham. wdcarv, be. Woman holding dog by tail, M & R 3.

Irsread. wdcarv, be.

Stibbard. wdcarv, be. Dog on elaborate chain.

Stockton. wdcarv, be. Talbot hounds.

Brinton. wdcarv, be. c1544.

Hockering. wdcarv, be. 16c. Pair of hounds, P & W 2.

Dolphin

The dolphin appears in textiles donated by families in fishery trades.

Norwich SPM. *emb cope. 14$^{3–4}$. Powdered with dolphins, Hope (1901) 235.

Norwich S Gregory. emb pall. 1517 (bequest). 2 rows of dolphins, each swallowing a fish, L & M Cat. 99. Fishmonger John Reede bequeathed pall "of Black worstede powdered with Anngells and dolfins of golde," Bl 4:284. NMS.

Salle. wdcarv, misericord. c1470. Pair leaping from waves, G L Remnant 111.

Scottow. wdcarv. 17c (Cautley) or 18c (Pevsner 1). 4 inverted dophins supporting central column on font cover; polychromed.

Eagle

The spread eagle was commonplace in embroidery patterns and also used for stenciled ceilings. There are a number of eagle arm rests at Harpley. See also II.1 *Cathedral*.

Shotesham S Mary. brick panel. 2 spread eagles at head of piscina, with other animals. The work may reflect bookbinding styles, e.g., alternating animal stamps as found on the cover of Bod L MS. Lat.th.e.7.

Gt Bircham. emb cope, converted to altar frontal.

c1480. Spread eagles and fleur-de-lis; engraving in DT 53:158; L & M Cat. 100; NMS.

Norwich S Helen. pwd, chancel ceiling. c1383. 152 eagles from the arms of Anne of Bohemia (royal visit 1383); Rawcliffe pl 28.

Redenhall. pwd, N aisle. Spread eagles, Winter, *Selection* 1:6.

Walpole S Peter. sc, boss S porch. c1435.

E Anglia. wdcarv, misericord. Late 14c. Displayed eagle with bird supporters, Tracy (1988) Cat. 71 pl 23. Originally thought to have come from Lynn S Nicholas (see H. Clifford Smith, V & A Cat. 67); discussion in Tracy.

Necton. wdcarv, roof. c1450. Haward (1999) il 4SW.

Cathedral. wdcarv, misericord. 15^4. S13 attacking lamb and bird, talons well preserved; **N10** perched eagle preening; **S33** elbow rest, eagle with two heads; Rose (1994).

Castle Acre. wdcarv, misericord, G L Remnant 100.

Lt Fransham. wdcarv, stalls.

Watlington. wdcarv, be.

Walpole S Peter. wdcarv, misericord, G L Remnant 112.

Elephant

Marsham. pg, quarry, set in nVI.

Elephant & Castle

Lillian Randall (1966) cites elephant and castle as a common feature of manuscript marginal decoration.

S Lopham. wdcarv, be. c1460. Badge of Beaumont family, which held manor, Gardner (1955) pl 26.2.

Holme Hale. wdcarv, be, arm recess.

Thurgarton. wdcarv, be, Cautley 148; Gardner (1955) pl 26.3.

Tuttington. wdcarv, be. Face peeping out of castle, M & R il 1:100.

Burlingham S Edmund. wdcarv, be. ?16^1. Elephant on haunches; opposite shoulders, ?bear/boar following, Cautley 148; Gardner (1955) pl 26.4.

Falcon

See *Raptor* and XII *Jeron*.

Fish

See also II.1 *Cathedral* & XII *Christopher*.

Grimston. wdcarv. be.

Watlington. wdcarv, be.

Fox

Cathedral Priory. ms, Ormesby Psalter, Bod L Douce 366, bas-de-page f 89. 14^1. "Riddle of the fox, the lamb and the cabbages," Sandler, *Survey* Cat. 43.

Outwell. *pg. "In the S window of the chancel there was formerly this antique piece of painting, A matron in a white robe and blue mantle, on her knees, betw four men; at her feet, a fox [Renard] hanging on a tree, wounded in the neck with two arrows, behind and before two monkies with bows, shooting at the fox," Bl 7:472.

Ringland. *pg, N aisle. c1310–25. Fox in habit, reading open book with minim writing, riding backwards on fantastic animal; sketch in G King Collection, Box 3, NNAS. Wdf (72) identified as a rabbit rather than fox.

Fox Stealing Goose/Cock

Fox often identifiable by tail.

Chedgrave. *pwd. 14^4. Wooden tabernacle decorated with goose and fox, NRO, Rye MS 17, 2:211.

Cathedral. sc E cloister boss B6. 14^1. Fox with cock in mouth, fox-cub; **FIG 40**. Probably the scene cited by Varty (140) as dog seizing a fox who seizes a cock.

Cley. sc roof boss, S porch 15^1. Woman chasing fox with distaff, Varty fig 44. For this subject at Ely (1339–41), see Grössinger (1997) pl 7.

Walpole S Peter. sc, boss S porch. 1435. Goose on back.

Wymondham. sc, stop, N aisle. Goose on back.

Necton. wdcarv, roof. c1450. Goose in mouth; Haward (1999) il 2SW; Platt 133 fig 106.

Cathedral. wdcarv, misericord S27. 15^4. Grimacing woman in apron chasing fox with distaff; fox with goose in mouth; (L) pig (?dog) with snout in pot; Rose (1994).

Brisley. wdcarv, be. Goose in mouth.

Dickleburgh. wdcarv, screen. Colling 1:18.

Grimston. wdcarv, be. Goose in mouth.

Norwich S Peter Parmentergate. *wdcarv, misericord. Dressed like monk, pilgrim staff, enticing chickens and seizing them; Hart [1849] 238.

Ringland. wdcarv, be. In pulpit preaching, with

two geese under his hood.

Stanfield. wdcarv, be. Goose in mouth.

Thornham. wdcarv, wicket door, S porch. (L) fox preaching to geese; (R) fox with goose in mouth. Varty (143) cites two pulpit scenes in benches, one with goose in hood; Gardner (1955) pl 21.4.

Tuttington. wdcarv, be. Woman with distaff (damaged) attacking fox trying to steal goose from basket; Varty fig 43.

Beeston S Mary. wdcarv, screen spandrel S2. 16[1]. Goose in mouth.

Burlingham S Edmund. wdcarv, be.?16[1]. Goose on back; damaged.

Brinton. wdcarv, be. c1544. ?Fox carrying off a goose.

Frog

Cathedral. sc, W cloister boss G5. 15[1]. Emerging from dragon's mouth (see IX.4 *Apocalypse*).

Cawston. wdcarv, be. Being swallowed by dragon; Gardner (1955) pl 22.4; Anderson (1971) thought a man (154).

Goose

See *Fox* and XII *Martin* Wiggenhall S Mary.

Goat

Lynn S Nicholas. wdcarv, be. c1419. Face missing, Tracy (1988) Cat. 176; see also Cat. 181.

Litcham? wdcarv, misericord, G L Remnant 103.

Hare

See also *Rabbit*.

Cathedral Priory. ms, Ormesby Psalter, Bod L Douce 366, border, f 128. 14[1]. (Below) 2 hares attacking dog with sword and club; (above) 2 cocks, Sandler, *Survey* Cat. 43, pt 1 frontispiece. Also hi, f 128 border frame. 2 rabbits.

W Wretham. *pg S chancel win, "an hare riding on a grayhound, with a bow and quiver hanging at its back, and a bugle horn by its side," Bl 1:470.

Attlebridge. seal die. 14c. Hare with horn astride hound. For other examples of 'sohou' (hunting-cry) seals from other sites, see Margeson (1985).

Norwich S Peter Parmentergate. *wdcarv, stall. 2 hares eating grapes, Bl 4:96.

Hart

See *Cervidae*.

Hawk

See *Raptor*.

Horse

See also XII *George & Margaret*.

Kenninghall. sc, door jamb. ?c1300 (P & W 2).

Cathedral. sc, cloister bosss. 14[1]. E walk **B4** 2 men fighting on horseback. S walk **D4** woman falling head first from horse (perhaps allegorical).

Walpole S Peter. sc, boss S porch. 1435. Holding ?bit in mouth.

N Tuddenham. pg sV, eye of tracery. Porch, W win, S light, excellent fragments with trappings.

Blakeney. pg, nVII.5c. Head.

Cley. wdcarv, be. Horse with bridle.

Colton. wdcarv, be. Horse biting tail.

Lt Fransham? wdcarv, be. A very long muzzle. A number of the armrest carvings have been reset.

S Acre. wdcarv, be. Saddled animal, head missing.

Suffield. wdcarv, screen spandrel, N6.

Leopard

Lynn S Nicholas. wdcarv, misericord. c1419. Engorged and chained; barrel in R supporter; Tracy (1988) Cat. 73 pl 25.

Lion, Lioness

As early as the Norman font at Burnham Deepdale, lions were carved on font bowls and stems. For lion seal dies, see Margeson (1985). Some authors automatically connect lions with S Mark, but unless there is evidence of other tetramorphic symbols, I have not done so.

Norwich S Gregory. metal door knocker (?Flemish). 14c. Lion devouring man (only head visible); P & W 1 fig 25; ?sanctuary knocker, perhaps allegorical; now NMS. There are 2 identical designs in Yorkshire (Robinson il p 25; Jenkins, color il, xxxiii) and one at Durham ("Extracts" 18:xiii).

Cley. sc, stop, spandrel of nave arcade, S3. c1330. Lion gnawing on bone. In size and artistry, this lion is unlike any other in Norfolk.

Cathedral. sc, cloister bosses. 14[1]. E walk rich in lions, incl **B1** lion eating acorns; **B8** lions fighting; **D1** 3 lions, one eating grapes, one

with protruding tongue; **D8** lion with cubs. S walk, **B4** man fighting 2 ?lions; **B1, D3.** N walk, 1427–8. **I4** 2 lions, protruding tongue, paw at head, probably supporters for blank shield.

Norwich, Bp Salmon's Porch. sc, boss. 14^{1-2} after 1318. Lions fighting, Tracy (1987) pl 69.

Shotesham S Mary. brick panel; perhaps a leopard.

?Arminghall Hall. *tablet, above door. Lion pulling man from horseback, DT 24:37; Cotman (1838) pl LIX. For further detail, see Lindley.

Lynn S Nicholas. wdcarv, misericord. c1419. Crouching; Tracy (1988) Cat. 77 pl 29.

Cathedral. wdcarv, misericords. 15^1. **N6** Nude man attacked by (L) wyvern, (below) dragon, and (R) lion; man, holding one paw of lion, rests LH on head of dragon. Despite the menace, the man's expression is placid; perhaps allegorical in meaning. 15^4. **S17** 2 men fighting lion; supporters, wyverns. **S28** man, nude except for loin cloth, with club, holding lion by chain (damaged); supporters, lions. **S29** ?Leo. **N23** lion being attacked by wyvern, Rose (1994).

Castle Acre. wdcarv, be.

S Acre. wdcarv, be.

Dunston. wdcarv, rood screen arch. Lion and dragon attacking each other.

Lt Fransham. wdcarv, be.

E Harling. wdcarv, stall, repaired.

S Lopham. wdcarv, be. With ?cub in mouth.

Thornham. wdcarv, be.

Thurgarton. wdcarv, be, on W shoulder as if creeping up on man playing bagpipes on E shoulder.

Gt Walsingham. wdcarv, be. Lion sejeant, crowned.

Brinton. wdcarv, be. 1544. Man sitting astride a seated lion.

Owl

Cley. sc, S porch. 15^1. Owl with mouse in beak.

Cathedral. sc, cloister bosses. 15^1. S walk **L6** owl mobbed by 5 starlings. 1427–8. N walk **B4** in pear tree; **C7** in pear tree with mouse in beak.

— wdcarv, be, misericord. 15^4. **S21** owl in grapevine being attacked by surrounding birds; allegorial meaning uncertain; supporters, eagle attacking bird. **N17** flanked

by small birds in foliage; supporters, 2 birds, Rose (1994).

Lt Barningham. wdcarv, be.

Suffield. wdcarv, be, screen spandrel S4.

Yarmouth. *wdcarv, boss, N aisle, DT 62:42.

Pheasant

Norwich SPM. emb cope orphreys. 16^1. Powdered with pheasants, Hope (1901) 199.

Pig

Wood Norton. sc, chancel stop. Pig sticking out tongue.

Dickleburgh. wdcarv, screen, N2.

Suffield. wdcarv, screen spandrels. **N4** Pig physician, wearing black tippet and hood, seated on stool, observing jordan. **N5** (L) Pig sitting on barrel playing harp for (R) three dancing pigs. The order of the panels below has changed since Winter made his copies.

Grimston. wdcarv, be. Man in stocks with pig (?sheep) over shoulders.

Rabbit

Ranworth. pwd, screen S1. Fabric design in Peter's gown. Eagle on back of rabbit.

Necton. wdcarv, roof. c1450. Haward (1999) il 6NE.

Beeston Regis. wdcarv, stall shoulder. Seated rabbit; Bond (1910b) il p 119.

Dickleburgh. wdcarv, screen, S1. Bearded man in hat holding 2 rabbits.

Gt Walsingham. wdcarv, be.

Raptor

See also XII *Jeron.*

Langley Abbey. sc, boss, "hawk grasping a wild duck," Erwood 91.

Cathedral. choir staff canopy. c1420. Hawks with jesses; Bond (1910b) 48.

Felmingham. wdcarv. Hawk now in 19c pulpit, perhaps from screen, M & R 1.

Lynn S Nicholas. wdcarv, misericord. c1419. Raptor siezing rabbit, others looking out of warren. Lynn Museum, on loan from V & A; Tracy (1988) Cat. 75 pl 27.

Suffield. wdcarv, screen spandrel S3. (L) Raptor attacking rabbit, other rabbit in warren below. (R) Pelican in her piety.

Salamander

Sculthorpe? sc, font relief, Bond (1985) 185.

Hethersett. sc, porch capitals, P & W 2.

N Elmham. sc W porch, arch of inner portal, P & W 2.

Serpent/Snake

See also II.2.

Runhall. iron work on door. Mid 12c (P & W 2).

Cathedral. sc, capital. 12c. Serpent attacking large animal; on second face, ?dog holding man betw forelegs, Borg & Franklin Cat. 6.

Hautbois. sc, base of Norman font (19c bowl). 12c. Winged serpents entwined.

Erpingham. wdcarv, be. Bird with snake in mouth.

Burlingham S Edmund. wdcarv, be. ?16[1]. Snake crawling up bench shoulder, mouth open, tongue protruding; dog on opposite shoulder.

Norwich S Stephen. wdcarv, misericord. 16c. "Entwined serpent or asp," G L Remnant 104.

Sheep

Common in Old Testament scenes and Nativity; see also section 1c *Other Occupations.*

W Harling. pg, sIII, eye of tracery.

Long Stratton? pg frag, E win, 4a. Segment of body and 2 hands holding a sheep. Perhaps from a Nativity scene.

Cathedral. sc, N cloister boss. 1427–8. **A6** Ram in vines; **A4** 2 men fighting, mounted respectively on ram and lion.

Walpole S Peter. sc, boss S porch; boss in passage beneath chancel.

Squirrel

E Harling. pg, E win, B1. Red squirrel with nut; Lovell badge (Wdf 54).

E Tuddenham. sc, moulding stop, vestry win (exterior). Eating a nut.

Harpley. wdcarv, be.

Salle. wdcarv, stall arm rest. Eating fruit.

Gt Walsingham. wdcarv, be.

Stag

See *Cervidae.*

Stork/Crane

Old Buckenham. brass. c1500. Stork with scroll (Pevsner 2).

Thornham. wdcarv, be. Waterbird (double-headed) preening.

Swan

See also II.1 *Cathedral.*

Shotesham S Mary. brick panel.

Cathedral. sc W cloister boss B8. 15[1]. Caught in tendrils.

Ranworth. pwd, screen S1. Fabric design in Paul's gown, dogs attacking swan.

Norwich, Holme Street. pwd. 1467. Hospital inn sign painted, Rawcliffe 60.

Cley. wdcarv, be.

Dickleburgh. wdcarv, screen, N2. Swan eating fish.

Salle. wdcarv, stall arm rest.

Swanton Morley. wdcarv door, part of rebus, with barrel (tun); restored. Chancel wall-posts, M & R 2.

Tigress

Wiggenhall S Germans. wdcarv, be. With mirror, Anderson (1971) 152.

Wolf

Shernborne? sc, font, "creature with square head . . . may be a wolf," Bond (1985) 183 & frontispiece. Bond also so identified the heads at Toftrees (il p 193) and S Wootton (il p 192).

Woodpecker

Grimston. wdcarv, stall.

Mythical Animals

Dragons range from the flamboyant beasts in the paintings of S George and S Michael through the tiny examples carved on the spandrels of rood screens or in stone. They lent themselves to circular compositions on the supporters for misericords or bosses. It is not always easy (or possible) to distinguish a dragon (4 legs) from a wyvern (2 legs).

Cathedral. sc, capital. 12c. Wingless dragons interlaced with foliage, bands of beading on bodies; confronted dragons; Borg & Franklin Cat. 3 & 15; see also dragon on relief of S Felix (see XII, above).

Shotesham S Mary. metalwork. c1200. On S door "a small plate for the ring decorated with a pair of winged dragons," P & W 2.

Ellingham. sc, part of wall-shaft. 13c. Head down.

Reedham. sc, stop, priest's door to S chapel. c1300. E Rose, NMR report.

Cathedral Priory. ms, Ormesby Psalter, Bod L Douce 366, bas-de-page, f 128 (Ps 97). 14[1]. Knight fighting 5-headed dragon, one head on ground, another falling; Sandler, *Survey* Cat. 43, pt 1 frontispiece. Dragons were popular in 14c borders.

Norwich Whitefriars. sc, Arminghall Arch. c1330. Eating grapes, Lindley pl 19; for details see XII *Barbara.*

Cathedral. sc, E cloister bosses. 14[1]. A number of dragons in the E walk incl **B2**, **C3** (Rose [1996] fig 123), **E4**, **L5**, **M7**; sometimes being attacked as at **E6** & **F3** where a young man grasps the dragon with LH, thrusting sword in RH into mouth (Rose [1997] 16), and **A1** where a barefoot man is locked in combat, thrusting shield into dragon's mouth and sword into head.

Strumpshaw. sc, piscina. 14c. Tiny dragon in foliage.

Thornage. *pg. 15c. Curled tail, vaned wing, ruby tongue and eye (drawing, NMS 27.B273.235.951).

Cathedral. sc, W cloister boss A7a. 1415–6. Dragon and lion fighting.

— sc, N cloister bosses. 1427–28. **D4** 2 dragons under hawthorn leaves; **D6** dragon fighting lion.

Cawston. sc, spandrel W door. 15[1]. Paired with wodewose; same pairing on piscina (reflecting arms of major donors).

Walpole S Peter. sc, boss S porch. 1435. Biting tail.

Attleborough. wdcarv, be arm rest. Engorged hybrid dragon/bird, wearing cockle shell on breast.

Aylsham. wdcarv, 3 misericords, since built into Victorian reredos. c1470. Man with sword fighting dragon; bearded man with club and shield fighting a hybrid; a man fighting a griffin with a club. A 4th misercord with man protruding tongue, G L Remnant 99; Whittingham noted similarities to post-1472 misericords at the Cathedral.

— wdcarv, screen spandrel S3. Paired with fabulous beast.

Blakeney. wdcarv, misericord. Flying dragon, G L Remnant 100.

Cathedral. wdcarv, misericord. **S2** dragon with single horn in forehead fighting lion; **S5**, dragon; Rose (1994).

Felmingham. wdcarv. Now in 19c pulpit, perhaps from screen, M & R 1.

Gimingham. wdcarv, be. Now attached to prayer desk.

E Harling. wdcarv, stall. Repaired.

E Lexham. wdcarv, misericord, said to have come from Castle Acre Priory, now built into a chair; dragon with wings, G L Remnant 102.

Norwich SPH. wdcarv, square boss, originally from porch. 1497.

Salle. stall arm rest. Long tail wrapped around neck.

Sheringham. wdcarv, relief on rood loft spandrels, paired with hybrid, crane head and feline body.

Thurlton. wdcarv, screen spandrel.

Tuttington. wdcarv, be. Recumbent man with hand in dragon's mouth.

N Walsham. wdcarv, be arm rest, DT 47:47.

Swaffham. wdcarv, hammerbeam roof brace, Haward (1999) il 2SMW.

Lynn S Margaret. wdcarv, moon dial. 1603. High tide indicated by dragon pointer; restored.

Wyvern

Cathedral. misericords. 15[4]. **S31**, **N25**, **S14** (center and supporters); **S17** (supporters); Rose (1994).

Thurgarton? be.

N Walsham. misericord (L supporter). 15c. G L Remnant 109.

Hybrids

These combine human and animal forms or 2 or more animal forms. For the riot of the hybrids in E Anglian manuscripts, see Sandler, *Survey*, in particular Cat. 43, 47, 48, 51. Allegorical interpretation varies. A description in *Fasciculus Morum* in the section on Sloth calls attention to "aliquas ymagines que dicentur babewynes." "For all the world they seem to be like those images called babewynes . . . which painters depict on walls. Some of them they paint with a human face and the body of a lion, others with a man's face and the body of an ass, and others again with a human head and the hind part of a bear, and so on" (Wenzel 514–5).

Blemya
Man with face in chest.

E Anglia. ms, BL Harley 3954, Mandeville's Travels. c1430. Incl cyclops and blemyae; Scott, *Survey* Cat. 70B, il no. 273.

E Anglia. wdcarv, misericord. Late 14c. Supporters, Tracy (1988) Cat. 69 pl 21.

Cathedral. wdcarv, misericord, S30. 14[4]. Supporters, Blemyae with daggers; Rose

Centaur

Cathedral. sc, Bay 8. 14c. Spandrels of blocked doorway leading to preaching yard.

Cockatrice (Basilisk)

Lynn S Nicholas. wdcarv, be. c1419. Tracy (1988) Cat. 162 pl 59.

Grimston. wdcarv, be.

Sheringham. wdcarv, be. Anderson (1971) 248.

Griffin

Quadruped, hindquarters of lion, otherwise eagle.

Cawston. embossed leather chalice case. 1373–82. Not heraldic. See *Age of Chivalry* Cat. 115.

Cathedral. sc, W cloister boss C3. 15[1]. Overcoming a knight in armor.

— sc, nave boss, B16. 15[3].

— wdcarv, misericord S22. 15[4]. Knight attacking griffin with lamb in claws; Rose (1994); Bond (1910a, 150) identified the knight as S George.

Aylsham. wdcarv, misericord. c1470. Now built into reredos; man fighting dragon.

?Lynn S Nicholas. wdcarv, be. c1419. Tracy (1988) Cat. 180.

Felmingham. wdcarv. Now in pulpit; in 1849 "nailed up in the pews, or lying loose on the floor," DT 55:22.

Harpley. wdcarv, be.

Quidenham. *wdcarv, stalls, NRO. Rye 17, 3:118v.

Watlington. wdcarv, be.

Harpy

Lynn S Nicholas. wdcarv, be. c1419. Tracy (1988) Cat. 173.

Winged ?Reptile

Gateley. wdcarv, be. Cited as caterpillar, P & W 2; M & R il 3:48.

Manticora

Winged, lion's tail, bird's feet, head of man.

Lynn S Nicholas. wdcarv, be. c1419. Bearded, wearing coif; Tracy (1988) Cat. 163 pl 60.

Cawston. wdcarv, nave roof. I am grateful to Tony Sims for calling my attention to this item.

Mermaid/Merman

A 1540 Norwich pageant was called the *Moremayd*, as was another for the Coronation triumph of Edward VI in 1547.

Cathedral. sc, capital. 12c. Fish tail, ?mermaid harping; Borg & Franklin Cat. 17.

?Norfolk. ?emb. 1498 will of Anne Harling. "To Thomas Fyncham a rounde bedde of silk with marmeydens"; "To Margarete Bardewell, my nece, a rounde bedde with marmaydens," *Testamenta Eboracensia*, ed. James Raine, Jr. 4:153.

Wighton. sc, porch, keystone of the W win. c1494.

Cathedral. wdcarv, misericord, N9. 15[1]. Suckling a lion; mirror hanging from a conch; supporters, dolphins swallowing fish ("their young," G L Remnant pl 8c); Bond (1910a) il p 11; Rose (1994).

Norwich S Peter Parmentergate. *wdcarv, stall. Merman with bason and comb; 2 dolphins and mermaid suckling merboy, Bl 4:96.

Attleborough. wdcarv, misericord, arm rest. Comb in one hand, ?flower in other, long tail wound about lower body.

— wdcarv, misericord, arm rest, fish in hand, ?merman.

Cley. wdcarv, be.

Felmingham. *wdcarv. Holding a mirror; in 1849 "nailed up in the pews, or lying loose on the floor;" DT 55:22.

Grimston. wdcarv, stall.

Hockham. wdcarv, be. With mirror.

Quidenham. *wdcarv, stalls, "merman & mermaid," NRO, Rye 17, 3:118v.

Sheringham. wdcarv, be.

Wiggenhall S Mary. wdcarv frag, be, N aisle N3; Bullmore (328) no. 8E.

Unicorn

Marsham. pg, quarry set in nVI.

Aylsham? wdcarv, screen spandrel N6. Paired with ?eagle.

Felmingham. *wdcarv. In 1849 "nailed up in the pews, or lying loose on the floor," DT 55:22.

Various

A particularly rich category in manuscript tradition.

Cathedral. wdcarv, misericord. Furry animal, long tail, in collar; digital font paws and rear cloven hooves; Rose (1994).

E Anglia. wdcarv, misericord. Late 14c. Supporters; Tracy (1988) Cat. 70 (pygmies) & 72 (bird and human), pls 22, 24.

Lynn S Nicholas. wdcarv, be. c1419. There are a number of hybrids, all cited by Tracy (1988), incl human hooded head and shoulders, hooved feet (Cat. 160 pl 57), an animal biting its tail (Cat. 178 pl 65).

Top left: (1994); Tracy (1988) fig 18.

XVI. Unidentified Subjects

Part XVI cites a handful of the unidentified compositions in the hope that others more knowledgeable than I may be able to identify the subjects: it ignores minor fragments I consider utterly unidentifiable. Where I have found reasonable grounds for assigning a subject, I have cited the material with a query in the appropriate sections above.

Women

There are two exquisite unnimbed female heads (not donors), one in the E win of the N aisle at S Creake, another in a museum win at Pulham S Mary Magdalene.

Hoveton S John. pg, nII.1b.15c *ex situ* (David King). Queen with long hair, hand on short sword at breast height; apprehensive expression. A second frag immediately below this scene represents a man with a similar expression and both hands raised as if to protect himself. For a queen stabbing herself as an illustration of Ps 52, see Scott, *Survey* Table I.

Foulsham. pg, sIII.A1 (small scale). 15c. Enthroned, crown over veil, hand extended, LH holding finial of throne; bust only.

Litcham. pwd, screen N2. Woman holding short crook over shoulder. Puddy tentatively identified Margaret of Scotland, crowned with scepter, but I find no clear evidence for a crown and though the object held is scepter length, it terminates in what looks like a shepherd's crook.

Men

Morningthorpe. *pg, N chancel. Demi-kneeling knight, helm down; (L) retainer holding horse; NRO, Rye 17, 3:80v.

Guestwick. pg, sv.1b. Man's head in a finely detailed straw hat, porcine nose, and small beard. **FIG 20**.

Norwich S Gregory. sc, boss S porch. (C) man in loincloth flanked by ?executioners.

E Rudham. sc. 2 lay figures with hats seated on bench, (L) with open book on lap, DT 43:47.

Stanfield. sc. Atop buttresses of porch roof remains of two kneeling nude figs.

Billingford S Leonard. wp frag, S wall. A large rectangular composition. (Upper R) a large building with architectural detail, 3 standing figs, and a fig in doorway; frag of second building below. The building seems too elaborate for a Works scene; it is tempting to conjecture details from a life of S Leonard.

Lynn S Nicholas. wdcarv, roundel on poppy head, obverse of the satyr roundel. c1419. (L & C) large animal with long tail; (R) seated man with RH raised ?in wonder; (C above) ledge/table with 2 jordan-shaped vessels. Perhaps this is the scene Gardner (1955) tentatively identified as S Giles.

Morston. wdcarv, N2, divided spandrel above Matthew. (L) fig in white gown and gold mantle (?alb and cope) turned toward (R) wounded man in gold mantle jamming an ?arrow through the mullion. One is tempted to look for a relationship between the carvings and the subjects painted below since there is a pelican vulning above John, but the other subjects are less clear. Above Luke a feathered angel in armor with arms crossed is paired with a large white animal with a tail (?ox), but there is an eagle above Mark. At S3 a flower is paired with man with a massive scimitar.

Norwich SPM. font, painted panel. A preaching scene with pulpit, probably wine-stem (not a baptismal font as Fryer claimed). Blomefield noted that the font was painted (4:204), and printed guides persistently assume the bowl was originally painted rather than carved. The physical evidence, however, indicates figure sculpture (Nichols 1994). The defaced panels were filed smooth and then painted, a simple and inexpensive way of replacing mutilated sculpture. Too little evidence remains to identify the subject—perhaps John Bapt, who appears commonly on fonts, and preaches from a pulpit on a transept boss at the Cathedral. Alternatively, the church dedication to Peter and Paul may be suggestive. Peter preaches from a pulpit in the E window.

Men and Women

Crostwight. *wp frag, N wall (corner of E wall), frag. 14c. Man in wide parted collar and woman with bags on heads as on journey, DT 54:109, 116. It is unclear what relationship this scene could have had to the exist-

ing Passion/Ascension wall paintings, which largely occupy the N wall. Perhaps the scene is related to the *Speculum humanae salvationis* "Release from Israel," ch. 30. The German illustration printed in Avril Henry's edition of a Middle English manuscript shows a woman with a bag on her head very much like that at Crostwight. However, I know of no English instance. On the E wall there were 3 scenes of an unnimbed king, holding a chalice (N side), with a battle standard and praying (S side), DT 54:116, 117; perhaps Abraham and Melchisedech.

Cawston. pg frag of man, sX.2b. Winter's watercolor records 2 intact tracery lights: (L) a man in chaperon and short fur-lined gown holding hand extended with handkerchief to (R) 3 aristocratically dressed women (NMS B329.235.951).

Site Unknown. pg. A nimbed girl in sideless surcoat pointing; 6 laymen, one pointing; king with elaborate bird hat on a closed crown The hat is worth noticing since the same design appears in the curious illustration of William of Nassington's *Speculum vitae*, Bod L Hatton 18 (see *Index of Images*, Fascicle II). G. King collection (Box 2, NNAS) contains a number of drawings of glass without site notation.

Clerics

Haddiscoe. sc, in niche above S door. Norman. Bare-headed ?bishop seated on massive chair (?throne), in chasuble over dalmatic, both arms raised, hands holding identical knobbed objects; Keyser thought short scepters and believed the scene represented Christ. (Above) an undefined mass; Keyser "the dextera Dei emerging from a cloud" (1907) 98. None of the early representations suggest the *manus Dei*; see Martin (NRO, Rye 17, 2:181, f 23), Kerrick (BL Add MS 6758, f 23), and Cotman (1818) pl XXXIX. Kerrick's drawing looks more like a cloud than what we see today. "Considering the rarity of Norman sculpture in Norfolk, this figure deserves to be better known," P & W 2.

Bedingham. *sc, boss *ex situ*. Fig in ?habit pointing to badly deteriorated fig kneeling with staff, set against a carefully delineated segmented background (too large to be a

wing, ?wall).

Watlington. sc, font stem. On the 8-figured font stem Stephen, Lawrence, and Vincent (with flesh hook) occur with a fourth cleric in alb holding a book in one hand and Roman cross in the other. There seems no convenient deacon to pair with Vincent; in the otherwise symmetrical composition at Harpley he is paired with "Martin ep*iscopus*."

Besthorpe. pg. Head and shoulders in amice, remarkable stubble on chin. Dennis King conjectured a prophet.

Castle Rising. *pg. Barefoot, bearded, tonsured saint holding yellow tool by handle, ?hammer, DT 42:199.

Morality Subjects

Some of the bench ends at Wiggenhall S Mary may be allegorical; see Bullmore 328–9.

Bawburgh. wp W wall, S side, 2 registers. (Above) 2 figs who seem to be embracing; (below) large male fig with hand raised. Likely that the scene is extended on the other side of the arch. Extensive inscr text above lower scene. The text and the lower fig suggests the Works of Mercy, but the upper fig seems more likely to represent lust. Further determination seems impossible until the text is deciphered and the wall more extensively investigated. I am grateful to Andrea Kirkham for this information.

Lynn S Nicholas. wdcarv, roundel in poppyhead. ?c1419. Man rising out of a whorled shell, fish and waves below: (L) scroll; (R) plant designs; naked man riding backwards on horse. Grössinger cites naked figures rising from shells as supporters at Lincoln Cathedral (il 118).

Cathedral. wdcarv, misericord, N30, c1480. Clothed man (hood, tippet, buttoned tunic) rising out of whorled shell; sword brandished in RH, saddle in LH; supporters, grotesque animal with ravening mouth; Rose (1994). Whittingham identified as pilgrim.

S Peter Parmentergate. *wdcarv, stall. "A monk with his beads, holding a cart-saddle issuing from a welk-shell, between two sea-monsters," Bl 4:96.

Elm (Cambs, near Wisbech). wdcarv. 1480–90. Hybrid in a hat rising out of a whorled shell, Haward (1999) il 8SMW.

Judgment Scene

Norwich. brick, c1530. (L) 2 men, woman with hands bound before her; (R) man in antique clothing accuses her (RH raised, fingers splayed); second man; judge in oriental hat seated in elaborate chair. Borg & Franklin Cat. 54. Probably the accusation of a virtuous woman; a second brick depicts Judith.

Other

N Tuddenham. pg frag, porch. 2 sheaves of wheat and a hand parting one of them—perhaps from the Miracle of the Cornfield in a narrative window of the Flight into Egypt (cf Hedington wp, Bod L MS Top. Oxon a.21, ff 13–15).

Glossary of Specialized Terms

hands joined: hands, palm and fingers, pressed together and extended, gesture of supplication.

jordan: flask used for examining urine, attribute of physician.

misericord: hinged seat, in chancel of church or in cathedral choir; dagger (for *coup de grace*).

perk: common Norfolk term for rood screen.

pulpitum: the screen dividing nave from chancel.

tau orb: an orb modeled on the tau map, divided into 3 compartments, sometimes inscr with water (sea), air (clouds), and earth (plants).

Costume Glossary

Terms for articles of dress vary from author to author, and hence quoted descriptions, especially from antiquarian accounts, in the Subject List should be read with caution. A number of French nouns are taken from Ann van Buren's extensive glossary in her forthcoming book *Dress and Costume in Late Medieval Art*, but these have been adjusted to usage in East Anglian antiquarian sources. Although her work is based on Continental dress, the quotations are often English; even when not attested in the *MED*, it is not unlikely that French terms were in use.

academic: pileus, tippet, cappa clausa (**FIG 28**).

alb: a long white vestment worn with a girdle (rarely depicted but creating a blouson effect); worn by angels and liturgical ministers of all ranks under outer vestments; when worn by priests also with amice.

amice: rectangular piece of linen worn over the shoulders under the alb, sometimes suggested by gathering at neckline; when reinforced with an apparel, it often looks like a modern collar (**FIG 3**).

almuce: (ME *amice*; see van Buren) a fur stole worn by clerics as part of choir dress, often with two strips of fur depending in front; worn by Latin Doctors. A good example in brass with stole and almuce over a surplice at Gt Cressingham (John Aborfield †1518).

apparel: embroidered cloth sewn at points of wear on the alb and amice (**FIG 3**).

bandeau: a broad band of cloth tied around the head and forehead; cf *filet*.

barret: a hat with upturned brim, the typical Tudor hat, often with a split brim probably developed from the barret.

burlet: a ring, probably of wicker, typically covered with cloth, sometimes in contrasting colors and fabrics; decorated by massive jewels (see *ouch*) or small ornamental mounts or pins. Worn by angels (Appendix I.1, **FIG j**), female saints, and as support for the chaperon (burlet-chaperon, Appendix IV.3, **FIG p**). See van Buren for ME and French quotations.

cappa clausa: a long outer garment with narrow arm slits, worn by academics and the Latin Doctors (**FIG 28**).

chapeau: a hat with low crown (heraldic term).

chapelet: a circlet headdress, sometimes a plain band, probably tablet-woven, but often with ornamental flower-mounts or jewels (**Fig h**). In France there were women known as *chapeliers de fleurs* (Egan 294). It is not always possible to distinguish real flowers from ornamental ones.

chaperon: headdress worn by laymen and priests; characterized by a long hanging strip of cloth (liripipe) worn a variety of ways, wrapped around the crown or hanging over the shoulder. Confessors seem to have worn the chaperon as a means of preserving privacy in confession (Nichols 1986).

chasuble: a sleeveless elliptical over-vestment worn by the priest at Mass.

coif: a close-fitting linen cap with or without ties, worn tied under the chin by lawyers.

collar: (1) a necklace; (2) a wide attachment to garment, sometimes falling over shoulders (but see tippet below). Royal collars are sometimes scalloped or slashed at the hems (for illustrations see Rose [1990] 143, 155); sometimes the collar has no front opening (suggesting that it was a separate garment), a detail not consistently cited in the entries.

cope: a full-length semi-circular non-Eucharistic vestment, closed at the neckline with a morse, the vertical edges and vestigial hood typically decorated by embroidered orphreys.

crozier: staff shaped like a shepherd's crook, the mark of office for bishops and abbots; archbishops carry a cross-staff; pope, double cross-staff. A 1705 drawing of *glass at Wood Bastwick ("broken to

pieces" in 1707) shows an abbot holding a particularly fine crozier with an elaborately braided infula (DT 2:45–6). Wood Bastwick was appropriated to S Benet's Abbey.

dalmatic: a wide-sleeved vestment slit at the sides, often with parti-colored fringe; identifying vestment of a deacon; also worn by bishops under chasuble.

filet: a thin band, sometimes ornamented, tied around the brow.

frontal: length of cloth, usually embroidered, covering the vertical face of an altar; in this corpus commonly created from old vestments.

houpelande (slop): an outer garment.

humeral veil (sudarium): a rectangular piece of light-weight cloth draped over the shoulders and hands of a deacon holding sacred vessels; always white in cited representations.

maniple: a narrow strip of cloth sometimes with fringed ends, worn hanging over the forearm, worn by clerics above rank of deacon as part of vestment set.

mantle: a long outer garment open in the font without hood.

mitre: headdress with double peaks front and back, sometimes with infulae (lappets depending to the shoulders), identifying a bishop or mitred abbot. The older form of a flat mitre with peaks worn over the ears is rare (13c examples at Ellingham and Fritton); in 15c typically used as headdress of Old Testament priests.

morse: an ornamented clasp used to secure a mantle or cope at the neckline.

orle: in heraldic costume, a burlet worn over helmet, though the term seems not to be attested before the 16c. The *MED* does cite *urlis* as a participle of *ourlen*, to trim. See burlet.

orphrey: embroidered or woven strip of cloth sewn on vestments.

ouch: jewelled pin, typically worn on headdresses (**FIG j**, & Appendix IV.3, **FIG p**).

a. Jewish hat. Houghton St. Giles

pallium: a Y-shaped stole worn over a chasuble by archbishops.

pileus: a cap worn by academics and the Latin Doctors; Yslyngton (STP), Druitt pl facing 105.

religious habit: tippet and hood, scapula over gown; color essential to distinguish one religious order from another.

robes of office: brasses as well as 17c monuments preserve a wide range of detail, e.g., William Norwich, Mayor with his mantle secured with 3 buttons on the R shoulder (†1463, brass, S George Colegate); Robert Brasyer, Mayor 1510 (brass, Norwich S Stephen); Sir Edmund Reve (†1647), Judge of Common Pleas (monument, Long Stratton), and Sir Edward Markham (†1634), Mayor of London (monument, S Acre). Druitt (106–7) thought a buttoned scarf might have been a clerical substitute for hood and tippet. John Yslyngton, STP, wears such a scarf at Cley.

scapula (scapular): a length of cloth with an aperture for the head, worn tabard-style over the shoulders, characteristic of the religious habit.

stole: a narrow strip of cloth, identifying a deacon when hung diagonally across one shoulder to opposite waist and a priest when crossed over the breast.

tiara: triple crown worn by pope, emperor, empress; also by Deity.

tippet: an elbow-length bell-shaped closed cape (**FIG 28**) probably with attached hood, though not shown in frontal views; worn by unvested bishops, academics (ancestor of the modern academic "hood"), the Latin Doctors, and angels. The cardinal's tippet was typically fur (Hunter figs 5 & 8); Jerome is so represented in at least four instances. The angels at Barton Turf provide a tippet style show (Appendix I.1, **FIGS l–o**).

tire: see *burlet*.

Tudor shoes: square-toed with strap across instep.

b. St. Apollonia's headdress. Lessingham.

c. St. Cecilia's wreath of roses and lilies. North Elmham.

f. Fortitude's headdress. North Ceake.

d. St. Cecilia's headdress. Burlingham St. Andrew.

g. Pilgrim's hat. Potter Heigham

e. St. Christopher's hat. Halvergate.

h. Typical chapelet. St. Faith, St. Peter Mancroft.

The Antiquaries

By Barbara Green

PEOPLE studying many aspects of Norfolk's history owe a great debt to the antiquaries of the seventeenth and eighteenth centuries. Their collections of original documents, copies, notes and observations are invaluable sources, while Francis Blomefield's *An Essay towards a Topographical History of the County of Norfolk* (henceforth *History*) is still the major history of the county and the starting point for many historians. Most of Blomefield's contemporaries published little in their lifetimes, but their material was a source for their successors in the nineteenth and twentieth centuries who published some of it or used it in a variety of books and papers. The present listing will concentrate on some of these antiquaries, most of whom are linked to the production of Blomefield's *History*.

Peter Le Neve (1661–1729) of Great Witchingham was born in London. His interest in genealogy and manorial history began at an early age, and by 1689 he had begun to compile calendars of documents relating to Norfolk in public records. He became Rouge Croix Pursuivant at the College of Arms in 1690 and in 1704 Norroy King at Arms. He was a great collector and amassed a library of original documents, calendars of records, and miscellaneous notes. He planned to publish a history of Norfolk. He was acquainted with a number of other Norfolk antiquaries, in particular Thomas Tanner, John Kirkpatrick, and Thomas Martin. Some of Le Neve's Norfolk material is now in the Gough Collection at the Bodleian Library; more is in the Norfolk Record Office.

Thomas Tanner (1674–1735) was born in Wiltshire and in 1690 became a chapel or bible clerk of Queen's College, Oxford. Here he began antiquarian research and in 1695 published *Notitia Monastica*, which brought him to the notice of the Bishop of Norwich, whose daughter he later married. In 1698 he became private chaplain to the bishop, then in 1701 Chancellor of the Norwich diocese and Archdeacon of Norfolk in 1721. He had wide interests including Norfolk ecclesiastical history. He encouraged and helped Blomefield with his *History* project even after he became

Bishop of St. Asaph in Wales in 1732.

John Kirkpatrick (?1685–1728) was the son of Thomas, probably a Scottish cattle drover and grazier, who married and settled in Norfolk. John became a linen merchant in Norwich in partnership with John Custance and a freeman of the city in 1711. He had accumulated much material towards a history of Norwich, and had exchanged copies of manuscripts and notes with Thomas Tanner and, in particular, Peter Le Neve. He left his collection of manuscripts, printed books, notes and coins to his brother Thomas for eventual deposit in a library in Norwich. Since he was a good draughtsman, his sketches provide an invaluable record of Norwich buildings in the early eighteenth century. Unfortunately, in the early nineteenth century his collection was dispersed. Some of his works were published by local antiquaries of the period (see Bibliography). Kirkpatrick's topographical material and his records of the contemporary scene are an invaluable source for twentieth-century archaeologists and historians.

Benjamin Mackerell († 1738) was the second son of an alderman of Norwich and a contemporary with Kirkpatrick. He became librarian of Norwich Public Library, founded in 1608 for the use of visiting preachers. In 1732 he published a New Catalogue of the library. He also acted as an assistant to Peter Le Neve. His considerable interest in Norfolk history resulted in a history of King's Lynn, published in 1738, and manuscript surveys of Norwich and Norfolk churches (British Library Add. MSS. 9370, 12,525–26, 23,011).

Thomas Martin (1697–1771), born in Thetford, was a key figure in the antiquarian circle. He, like the majority of this circle, developed an early interest in antiquities, particularly those of Thetford. When Peter Le Neve visited Thetford, he found the person best able to satisfy his curiosity about local antiquities was the schoolboy Thomas Martin. Much against his wishes Martin was articled to his brother, a Thetford lawyer. In about 1720 he set up a practice in Palgrave, Suffolk, and in 1734 bought an estate there, where he lived

until his death. He was a jovial man, fond of food and drink, and it was said "His thirst after antiquities was a great as his thirst after liquors." He was an avid collector and built up a large collection of printed books, manuscripts, deeds, other papers and notes, and antiquities. His collection was enlarged after the death of Peter Le Neve. Le Neve had intended that his Norfolk and Suffolk collections should be placed in a library in Norwich and he appointed Tanner and Martin as executors. They disagreed about the deposition of the collection. Then Tanner left Norwich for St. Asaph, whereupon Martin spent a great deal of time at Great Witchingham sorting Le Neve's collections. His wife having recently died, Martin married Le Neve's widow and removed the collection to Palgrave. His library was available to local antiquaries, including Blomefield. In later life he fell into debt and was forced to sell parts of his collections. After his death, much of the remainder, including the Le Neve collection, was bought by John Worth of Diss, who began to sell it off. Some of Martin's material is now in the Norfolk Record Office.

Francis Blomefield (1705–52) as a schoolboy traveled around local churches and recorded details. He continued his antiquarian studies when at Gonville and Caius College, Cambridge, where he was ordained priest in 1729. He became, briefly, rector of Hargham and then rector of Fersfield, his father having purchased the living for him. Blomefield, continuing his antiquarian studies, collected material for his projected *History*, in which he was much encouraged by Thomas Tanner and able to gain access to Martin's library as well as, importantly, Le Neve's collection. He had met Martin while at Cambridge, and Fersfield is only a few miles from Palgrave. Blomefield supplemented the information from Le Neve's records with his own observations. However, after a serious illness, he had to curtail his travels, so instead, using a standard questionnaire, he wrote to local clergy seeking further information about their churches. Other local antiquaries also helped, including Anthony Norris and the Walsingham physician Edmund Newdigate. Because of the difficulty of finding a suitable printer and publisher, Blomefield decided to carry out the work himself and set up a printing press in an outbuilding at his home. The *History*, with parishes classified by hundreds, was brought out in parts, with the completion of the first folio volume in

1739. Volume 2, covering Norwich, was not completed until 1745. Work began on the third volume, but Blomefield died of smallpox before completing it. Blomefield had failed to cost the volumes properly and left many debts. Thomas Martin as his literary executor had to sort out the Le Neve material from Blomefield's own papers, and he bought Blomefield's manuscripts.

Charles Parkin (1689–1765), rector of Oxborough, agreed to prepare some of the parish entries for publication in Blomefield's *History* as he was already working on the area of West Norfolk. He agreed to finish the *History* after Blomefield's untimely death, but it is uncertain how far he got before he himself died. Following Parkin's death, the material was bought by William Whittingham, a bookseller of King's Lynn, who published the remainder between 1769 and 1775.

Anthony Norris (1711–86) of Barton Turf, Norfolk, was educated at Norwich Grammar School and Gonville and Caius College, Cambridge, and was called to the bar in 1735. He was particularly interested in East Norfolk and worked on a history of the area (unpublished). He made available to Francis Blomefield his large collection of genealogical and church notes. His son, John, who had also been at Cambridge, died aged 24. Anthony Norris left his genealogical material to his son's Cambridge friend, John Fenn.

John Fenn (1739–94) developed his antiquarian interest while a child (it is said as early as age five). He went to Gonville and Caius College, Cambridge, where he became friends with John Norris and John Frere, whose sister Fenn married. Fenn lived in East Dereham, where he acquired a reputation as an antiquary. William Whittingham obtained his help in editing some of the text for the final volumes of Blomefield's *History*. Fenn, a friend of Thomas Martin, also helped Worth to sort and catalogue the surviving part of Martin's collections. Fenn acquired by gift and purchase some of this material, including part of the Le Neve collection. When Fenn died, he left his antiquarian collection to John and William Frere. Both collections were disposed of by the Frere family in the nineteenth century. A large part of this material was left to the Norfolk and Norwich Archaeological Society. This is now on deposit in the Norfolk Record Office. A report prepared by Paul Rutledge for the Royal Commission on

Historical Monuments is available at the Norfolk Record Office

The Artists

In the nineteenth century there was a growing interest in collecting prints and water-colors of local antiquarian subjects, some of which were intended to illustrate copies of Blomefield's *History*. Foremost among the local artists were C. J. W. Winter (whose drawings were used extensively in the preparation of the present Subject List), Esther Reeve, F. Sandys, M. E. Cotman, and H. Ninham. Members of families collecting these illustrations—e.g., the Rev. James Bulwer and the Rolfe family—also produced watercolors. The Rev. S. C. E. Neville-Rolfe organized a group of water-colorists, had a special coach constructed to store their materials, and transported the artists from church to church over a period of ten years. Without these indefatigable efforts we would have a much poorer understanding of the iconography of the fifteenth century. Some artists produced multiple copies of the same picture for several collectors as illustrations for Blomefield's *History*. The Neville-Rolfe Blomefield (33 volumes) is in the Local Studies Library; the Todd Blomefield (unbound) at the Castle Museum, and the Dawson Turner at the British Library. The illustrations for the Supplement to Blomefield's *Norfolk* were drawn from the Neville-Rolfe collection, which in 1929 was in the possession of the publisher Clement Ingleby but is now split between several owners. Dawson Turner's collection, comprising two separate collections, was purchased by the British Library in 1859. Illustrated folio volumes can be found in various collections, but no detailed work has yet been done on grangerized Blomefield volumes.

The watercolors, valuable as they are as a record of now lost work, pose their own problems in interpretation. While working on a catalogue of Bronze Age metalwork in the Norwich Castle Museum, this writer compared some of the nineteenth century discoveries with the contemporary illustrations in the Museum's collections. In quite a number of cases the owner and find spot of works were given differently on each of the watercolors and on the actual item. It is uncertain when or who labeled the illustrations. Similar discrepancies are found in the Dawson Turner material. To date it has not been possible to check all the illustrations in the Museum's Art Collections (see Bibliography below).

BIBLIOGRAPHY

Dictionary of National Biography.

Fenn, J. "Memoirs of the Life of Thomas Martin, Gent, F.A.S. of Palgrave in Suffolk," *Norfolk Archaeology* 5 (1904): 233–60.

Hepworth, P. "Supplementing Blomefield," *Norfolk Archaeology A* 31 (1957): 427–34.

Johnson, F. "John Kirkpatrick, antiquary," *Norfolk Archaeology A* 23 (1929): 285–304.

Le Neve-Foster P. *The Le Neves of Norfolk: A Family History.* Sudbury, Suffolk, 1969.

Rutledge, P. *Report on the Frere Collection of Antiquaries' Papers in the Norfolk Record Office*, with an introduction by A. Smith. 1999.

Serpell, M. F. "Sir John Fenn, his Friends and the Paston Letters," *Antiquaries Journal* 63 (1983): 95–121.

Smith, H., and R. Virgoe. "Norfolk." In C. R. J. Currie and C. P. Lewis, eds., *A Guide to English County Histories.* Stroud, Gloucester: Sutton, 1994.

Stoker, D. A., ed. *The Correspondence of the Rev. Francis Blomefield (1705–52).* Norfolk Record Society, 1992.

A number of unpublished lists and catalogues in the Norfolk Record Office will be of interest in identifying the whereabouts of the surviving antiquarian collections.

ANGELS are ubiquitous in Norfolk churches. They appear in all media, preeminently in the famous hammerbeam roofs where they commonly hold liturgical furnishings (**FIG 41**) or the instruments of the Passion, and in glass where exquisite costume detail is preserved. Angel musicians appear often at the heads of lights and in tracery, as do censing angels, typically in albs paired L & R, with triple-chained thuribles swung high into the upper point of the tapered light. Where they flank an empty eye, as at West Barsham, it is likely that the head of the Deity originally occupied the apex. Angels as supporters of shields appear in glass and sometimes on misericords, and are particularly common in stone relief, e.g., on baptismal fonts, often on the bowl chamfer, and on funerary monuments, e.g., at Hingham, where there are four on each side of the bide turrets of the Morley Monument.

1. Costume

Angels are dressed either as members of the heavenly court (with diadems and/or ermine) or as participants in the heavenly liturgy. Although artists were sometimes more fanciful than realistic when depicting liturgical dress, details of courtly dress once thought fanciful, e.g., pendant leaves, have since been documented by archaeological evidence. It must be allowed, however, that artists allowed themselves a fair amount of freedom with detail.

Angels in Liturgical Dress

The alb is the most common vestment (**FIGS 3, 31**). The albs, however, are less uniform than the earthly model and sometimes have relatively full sleeves, cuffs (golden ones at Old Buckenham and Salle), or non-apparel facings. A *Visitatio* angel at the Cathedral (**FIG 18**) has the sleeves turned back (one size did not fit all) with a folded amice at the neckline. At Barton Turf the Guardian Angel wears a slit alb, revealing a feathered leg, and the neckline has a circular facing. Celestial custom seems to have favored variety over uniformity. On the Ranworth retable the demi-angel angel above Margaret wears an amice and perhaps a very short-sleeved dalmatic but no alb. Above Mary Salome the angel wears an alb, amice, and what appears to be a dalmatic but with a crossed stole. Of all the angels, Gabriel is the most elaborately dressed, commonly in alb or vested as a deacon, but sometimes wearing a cope. At Bale he appears in two variations of liturgical vestment as well as wearing a toga-style mantle (see IV *Annunciation*). Though Gabriel is largely disfigured in the wall painting at Norwich St. Gregory, the garments are spectacular, a blue-lined red mantle spreading out to suggest the wind created by his sudden appearance.

Order angels wear liturgical dress less frequently than generic angels. At Barton Turf, only two orders are vested, the Guardian Angel (whose alb is startling enough to disqualify it) and the Domination with tiara, a chasuble with orphrey worn over a dalmatic, and stiffly appareled amice. At Salle the Archangel wears an alb and what was probably meant to be a dalmatic.

Feathered Angels with Other Items of Dress

Most frequently angels are represented in feathered garments, with or without other articles of clothing. When carved in wood (e.g., the roof angels at Cawston) or in stone (e.g., spandrel reliefs at Salle), the feathers are overlapping leaves, sometimes with diagonal "quilling." The tights end just above the ankles or at the knees, with bare legs and feet below (note the foot with a wing tip at the top of **FIG 20**). In glass the feathers are given far more elaborate attention, and they sometimes depend liripipe-fashion from the back of the elbow. The "skirts" Woodforde cites resemble the classic ballerina garment in a range of colors—murrey, red, or blue—and need to be distinguished from the wavy nebuly found with demi-angels. The V-shaped collar decorated with depending oak leaves worn by an angel at the Victoria and Albert Museum (Wdf pl XXXI) is strikingly similar to one worn by Potestates at Barton Turf. Tin-coated sheet-iron leaves were apparently a popular form of accessory (Egan 192 & pl 3). They also decorate the sleeves of the curious porcine-faced man at St. Peter Mancroft (Wdf pl XXXVII) whom David King identifies as a caricature of Richard III.

Armor and Belt (Kinght's Girdle)

The Order Potestates is always shown in armor. At Barton Turf he wears full armor, while the Archangel is so dressed but without bascinet.

(Gabriel as archangel is also shown in armor in a series of related Annunciations on porch spandrels). Elsewhere angels wear only parts of body armor or the knight's girdle (commonly seen on monuments, e.g., William de Kerdiston at Reepham, Martindale [1989b] pl 18; Gardner fig 419). These belts, often with misericord attached (**FIG 19**), were ornamented with metallic mounts fixed into the leather. There is an amazing variety of mount patterns: cylinders of small diameter (South Creake), coin design (Wighton); square floral mounts (Blakeney; for similar designs found in London, see Egan fig 14). Belts are also decorated with fixed (Cawston) or hanging bells (Barton Turf and Shimpling); for bells ordered for a belt for Richard II, see Egan 336. The belts may be worn directly over feathered tights (Remnant [1986] pl 125) or over a skirt (Wdf pl XXXI).

Headdress

Diadems are the most common headdress worn by all angels (**FIG i**). Typically a central

i. Diadem. Guardian Angel. Barton Turf.

cross rises above the brow (**FIG 8**), rarely as at Wighton, in the rear as well. The crosses take a variety of forms from plain to fleury. Burlets provided enormous versatility because all sorts of decorations could be attached. They are sometimes covered with tiny petals or feathers. An Order angel at St. Peter Hungate wears such a headdress, as do harping angels at East Barsham and Martham and an angel with a bent trumpet in the Burrell Collection. (One also appears in the caricature of Richard III at St. Peter Mancroft; Wdf pl XXXVII). The angels on the Barton Turf screen wear a wide range of burlets variously decorated: with a spectacular mass of pink petals

(**FIG j**, Cherub); with tiny oak leaves and three floral ouches (Archangel); with white petals and ouch, the burlet worn over the helmet (Potestates); and wound with white cloth supporting a crown (Principatus). Finally, modified barrets are worn by the Virtue at Barton Turf, by Order angels at Harpley (**FIG 42**) and East Harling, and possibly by clerestory angels at South Creake.

Tippets/Collars

It is not always easy to distinguish a tippet from a wide collar, but the garments commonly worn by feathered angels are clearly distinct articles of clothing. They may be ermine (as at Shimpling, Remnant [1986] pl 140) or embroidered (Guestwick), or made of a figured fabric (St. Peter Hungate, Remnant pl 125). At Barton Turf the red-feathered Principatus wears over a long mantle a figured tippet with white-lined hood (**FIGS k & l**). The Throne wears a plain white tippet bound in gold with a rolled fabric at the neckline, as does the blue-feathered Virtue (**FIG m**). Tippet hems are cut in a number of ways: solid; with an inverted V at the center, often finished with a jeweled morse (e.g., the demi-angel holding the cloth of honor for St. Ethel-

j. Petaled Burlet with Ouch. Cherub, Barton Turf.

dreda at Ranworth); with large inverted V's at either side (the Cherub and Seraph at Barton Turf, **FIG n**); or with a series of small inverted V indentations. The conflation of liturgical garment with royal collar, e.g., the albs with wide ermine collars as at Knapton (**FIG o**; Haward 116–19), is only one example of the artistic freedom evident in angel costume.

k. Feathered Principatus. Barton Turf.

l. Tippet (detail). Principatus. Barton Turf.

m. Tippet and Scarf. Virtue, Barton Turf.

n. Tippet with Ouches. Cherub, Barton Turf.

o. Ermine Tippet. Knapton.

Knotted Scarves

There is a long and wide-spread tradition in English art of angels wearing a scarf around the neck with tails depending in front or looped in a central knot at the neck or breast or around the hips. Angels on wheels embroidered on an English cope (c1280) wear a collar-like scarf, with the looped knot in front (Christie, Cat. 51 pls 46–47). Gabriel at York Minster wears a short scarf.

Rushforth thought the angels' neck scarf at Great Malvern to be "a mark of dignity" (*Medieval Christian Imagery* 210), but the scarf worn by the Cherub there is shorter than the typical East Anglian scarf and closed with a jewel rather than knotted. For two styles of the short scarf, see Marks ([1993] fig 69) one in Beauchamp Chapel at Warwick and the other, Norwich work, at Buckden, Cambs. A surviving angel from Coventry Cathedral wears a scarf just like the Buckden

angel (Crewe fig 46). The earliest example in glass in Norfolk is at Southrepps (14c). In the 15c a number of higher Order angels wear variations of the scarf (Banningham, Colby St. Giles, West Dereham, Narborough, Norwich St. Peter Hungate, West Rudham, and North Tuddenham). At Ranworth a demi-angel holding the cloth of honor for Barbara has the twisted scarf crossing over his breast and tied around the waist. A variation of the sash is worn at the hips below Michael's armor, its long ends flying in the air. Two of the angels on the screen at Barton Turf also wear a twisted scarf-like sash around their hips, the Cherub with it knotted in front. A painted glass angel with two sets of wings has elaborate tassels at the end of the sash knotted at the hip (Wdf pl XXXI). In all these instances, clothing provided, as it did for mortals, distinctive hierarchical status.

2. Order Angels

According to the schema in *The Celestial Hierarchy* ascribed to Dionysius the Areopagite and popularized in the *Golden Legend*, the nine choirs of angels were divided into three hierarchies: the Seraphim, Cherubim, and Thrones were solely concerned with the Almighty; the Dominations, Virtues, and Powers with the universe, and the last three orders, the Principalities, Archangels, and Angels, directly with humankind. One would expect three sets of wings for the three highest orders, two sets for the second hierarchy, and one for the last. The distinction, however, does not seem to have been observed consistently. The only complete set of named Order angels in Norfolk is the well-preserved screen at Barton Turf. There the Seraph, Cherub, and Throne have six wings each, the Domination, Virtue, and Power four wings, but in the lowest order the Principality and Angel also have four wings while only the Archangel has the expected two. (Gabriel also sometimes has two sets of wings, though a single set was more common). It is, of course, difficult to determine the number of wings in small bits of glass, though it is usually possible to distinguish multiple sets. Thus the angels at Blakeney with two sets and the generic scepter (nVII.A5 & 6) are probably Order angels. Although the fragmentary state of most glass makes it unwise to hypothesize, it seems likely that many artists were content to suggest a range of hierarchies by varying the number of wings and elaborate costume (see above) rather than specify

individual orders of angels. Although now decimated, the angels in the north clerestory at East Harling still show a wide range of clothing.

Architectural design rather than theology dictated the number of angels in a glass composition. The overwhelming majority of angels are preserved in tracery lights, rarely providing a multiple of nine. (East Harling with its 54 lights was a notable exception.) At Harpley the five main lights accommodated ten angels, while at Salle each Order was duplicated. Even where it was possible to use triads, as in the Cathedral alabaster, the carver preferred an asymmetrical pattern (Bensly [1892] il facing 353). The pairing of two angels in armor in the middle of the central register provides a striking focus for the composition. It is this effect rather than theological nicety that concerned the alabasterman.

In Norfolk as elsewhere, angel attributes are various and rarely mutually exclusive. Although there are wheels in Ezekiel's description of the chariot supported by Cherubim, and although this order is so represented at Southwold (Suf), Norfolk churches provide no unambiguous evidence for such identification, though Woodforde may be right that isolated angels on wheels came from Order sets (see also I.4.b, Howard Psalter). The one easily recognized angel is Powers, in armor chastising the devil in chains, a distinctive East Anglian representation. Aside from the eye-covered feathers of the Cherubim, red glass associated with the Seraphim, the throne with Thrones, most of the attributes occur too seldom to be used for identification. Take the book, for example, a single vehicle for two different tenors, the book of deeds (held by the Archangel calling humanity to judgment as at Salle), and the book of mysteries held by an angel with eye-covered feathers at West Dereham. Similar evidence seems to obtain at Wiggenhall St. Mary Magdalene. If we identify the angel with book as a Cherub, then one must assume that the label (below) "Sy" is all that remains of a lost Seraph. However, there is documentary evidence that a red-feathered Seraph at Martham once held an open book (DT 35:44); today only fragments of red feathers remain leaded in a number of places in window sV. The book, then, cannot of itself be used to distinguish Seraph from Cherub. Costume is equally nondistinctive since four different orders appear in armor. Thus unless names accompany angels, it is not usually possible to identify a specific order with surety, and unless the glass is *in situ* it is

unwise to attach a name uncritically to an adjacent angel. Once the Suffolk Subject List is complete, we will have a more extensive understanding of East Anglian angelology.

3. Angel Musicians

This section cites angel musicians not entered in the main subject list and specifies instruments for those cited as part of another subject, typically divine or Marian, particularly the Coronation (see below, Salle Parvise, Diagram 3, for typical range of instruments). (For the identification of instruments see XV.1.b.) Angel musicians appear in all media but predominate in painted glass where they survive at the heads of lights and in tracery. In the magnificent hammerbeam roofs, they may function either as the hammer itself (true) or attached thereto (false). The citation of instruments below is selective rather than exhaustive; costume is not noted unless of special interest. Paired instruments are not usually cross-listed. All dates are 15c (largely 15^3) unless stated otherwise. All M Rose citations are illustrations.

Singing Angels
Angels bearing scroll texts (see I.4.a) may have been intended to represent angelic song.

N Tuddenham. pg, porch, E win 3b; 2 angels singing from a book on lectern; Cowen il p 157; A Rose fig 12.

Shelton. pg, E win, B2. Angel with an open book

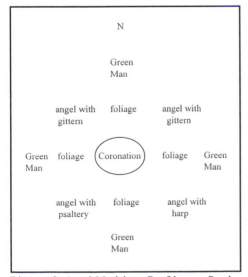

Diagram 3. Angel Musicians. Roof bosses, Parvise Chapel, Salle.

?singing; part of a series, see *bagpipes, harp, organ*, and *psaltery*.

String Instruments: Bowed
Crwth
Upton. sc, font chamfer. Rectangular, held on shoulder; identified by Hill (56); other angel musicians on the chamfer.

Fiddle, fidel, vielle
This instrument is rarely held under the chin.

Carleton Rode. pg. 13^4. Win blocked by organ case, clear fiddle visible from exterior.

Lynn S Margaret. brass. c1364. Cameron pl 45a; see I.2 *Trinity*.

Kimberley. pg, E win, 4c. 14^4. 2 angels holding fiddles under chins against LS.

Attleborough. pg, W win tracery C1. 14^3. Instrument held vertically. Heavily restored.

Dersingham. pg frag set in sX.A5. Held vertically.

Norwich SPH. pg, W win A4. Paired with bagpipes; see VIII.3 *Coronation*.

Norwich S Andrew. *pg. Demi-fig with nebuly, cited by G King (1914) 289. The patchwork panel now in light b of sVIII has a number of angel frags, but many of the instruments cited by King have since disappeared.

Pulham S Mary. *pg, E win, "persons playing upon violins and other musical instruments on either side" (of ?Peter), Bl 5:395.

Saxlingham Nethergate. pg, nV.1a, not *in situ*. In quatrefoil, fiddle on RS; paired with angel plucking gittern with curved neck (1c); Remnant (1986) pl 116.

Warham S Mary Magdalene. pg, nIV.1a. Played with LH.

Cathedral. sc, W cloister bosses. Christ enthroned flanked by musicians; K3 (R) fiddle, lute, psaltery; (L) harp; K8 (L) fiddle, psaltery, (R) harp, small lute. M Rose (1999).

Pulham S Mary. sc relief; see IV.2 *Annunciation*.

Knapton. wdcarv, S2. Held vertically. All angel musicians are in the second rank, wearing cross diadems and albs with ermine collars; Remnant (1986) pl 140; Haward (1999) color il 2SL.

Yarmouth. *wdcarv, boss, DT 62:41.

Rebec
Lynn S Margaret. brass for Robert Braunche

(†1364) and wives.

Cockthorpe. pg, W win, *ex situ*. 15c. Angel in feathered tights, playing five-stringed rebec with LH; 2 sound holes; A Rose fig 6.

Crostwight. *pg, DT 54:128.

Cathedral. wdcarv, misericord, N8. (R supporter) bow ?broken; M Rose (1994).

Symphony

Happisburgh. sc, font bowl. Very small with incised quatrefoil, 2 bridges and four strings. Identified by Montagu.

String Instruments: Plucked
Harp

Commonplace in pg:

Attleborough. pg, W win tracery C3. 14^3.

Bale. pg, sV.2c, petaled burlet; A Rose fig 8.

Banningham. pg, sV.3a, not *in situ.*

E Barsham. pg, n.III. 2 sets of wings, feathered; see IV.2 *Visitation.*

Blakeney. pg, nVII.A4. Standing on platform.

Cawston. pg, sX, lights b & c. Angel frags, best harpist in 3c. A Rose figs 3 (Irish harp) & 4.

S Creake. pg, nVIII.A2 & 5. Demi-figs in albs on nebuly with radiance below. Gothic harp; A Rose.

Denton. pg, E win, lights 1 & 5; paired with gittern. Gothic harp; A Rose.

W Dereham. pg, W win 2, 2b.

Downham Market. pg, W win, 2b. Alien head.

N Elmham. pg, E win, clerestory A2.

Emneth. See IV.2 *Annunciation.*

Fincham. pg, nII tracery. Gothic harp; A Rose.

Flordon (Rainthorpe Hall). pg. 3 harping angels in albs.

Guestwick. pg, sV.1b. Gothic harp; A Rose.

Hassingham. pg, N and S chancel tracery; paired with lute; restored.

Hindringham. pg frag, sIII.A4 and eyelets. See A Rose.

Ketteringham. pg, E win, tracery extremes. Paired with lute.

Langley. pg, E win.

Letheringsett. pg frag, sIII.1a, not *in situ.*

Martham. pg, nIV.A1 & 2 and head of lights a & b; sV.A1 & 5 and transom light b. Angels in albs; A Rose cites 9 examples.

Gt Massingham. *pg, DT 35:62.

Mulbarton. pg, sIII, head of light b; paired with lute in light a; *ex* Martham.

Norwich S Andrew. pg frags, sVIII.1 & 3b. 3

angels in unusual costume, tight yellow sleeves with wide-sleeved gown over.

Norwich S John Timberhill. pg, sIV, above central light.

Norwich SPM. pg, E win 7e, D5 & G10.

Norwich, Carrow Priory. pg. Irish harp; A Rose.

Oxborough. *See* I.4.

Salle. pg, sVII.B6. Feathered angel, 2 sets of wings; paired with gittern at B1.

Shelton. pg, nII.A1. An 1850 watercolor shows as tracery light, cited in top of E win of N aisle, DT 60:85.

Shimpling. sIV.A1 & 4. Feathered with ermine tippet; A Rose fig 9.

Gt Snoring. pg, nII.A3. Gothic harp; A Rose.

Swannington. W win 1, A2.

Trunch. pg, NII.A3 & 4, NIV.A4. ¾ figures in albs on nebuly. See also *Lute.*

Warham S Mary Magdalene. pg, nIV.2c. Harp only.

Weston Longville. pg, sIV.A5. Paired with gittern; restored. Irish harp; A Rose.

V & A. pg. c1460–80. Feathered angels with 2 sets of wings, harpist in tunic, and knight's belt; also fiddler; L & M Cat. 79a & 79b; Wfd pl XXXI. Norwich glass of uncertain provenance.

Brockdish. sc, chancel corbel, retained in Victorian restoration, E Rose, NMR notes.

Cathedral. sc Bauchun Ch boss 45; see Appendix II, Diagram 5.

Salle. sc, N parvise ch boss; see Diagram 3.

Haddiscoe. sc, font. Williamson (1961) pl III.4.

Happisburgh. sc, font bowl.

Terrington S Clement. sc, label stops, nave arcade; other angels with organ, lute, and ?horn (Montagu, "indeterminate").

Burlingham S Andrew. wdcarv, hammerbeam roof N4. Demi-angel on nebuly, paired with lute at S4, 5 strings with C-holes (Montagu).

Cawston. wdcarv, wall-plate angel, paired with 5-string lute.

N Creake. wdcarv, hammerbeam roof S9, paired with organ at N9.

Knapton. wdcarv, hammerbeam roof S6, paired with organ at N6; Haward (1999) il 6SL.

Swaffham. wdcarv, cornice; cited by Montagu.

Lute

Cawston. pg frag, sX. A Rose cites 6 examples, figs 3 & 8.

S Creake. pg, nVIII A3 & 4; demi figs in albs on

nebuly with radiance below. A Rose queries gittern at A3.

Field Dalling. pg, sV.B2.

Hindringham. pg, sIII.A2. Frag of 2 lutes with plectra; well preserved feathered angel with blue nebuly around hips and damask tippet, plectrum in LH.

Irstead. pg, E Win. In alb and tippet with small lute, alien head.

Martham. pg, nIV.A5 & 6 and sV.A2 & 6. In albs, with plectra. Instrument frags in sV.B1.

Mulbarton. pg, sIII, head of light a. 4-stringed instrument with plectrum; *ex* Martham.

Norwich S Andrew. *pg, G King (1914) 289.

Norwich SPM. pg, E win 7b, c, e. A Rose cites 10 examples.

Salle. pg, E win, head of light e; restored.

Saxlingham Nethergate. pg frag; see A Rose.

Shimpling. pg, sIV.A2 and at A3. An elliptical instrument with flat back (also at nV). Feathered with skirts and bells; A Rose fig 10.

N Tuddenham. pg, sII.A1 & 4. On nebuly, one with amber, other with blue mantle, using plectrum.

Trunch. pg, NII.A1 & NIV.A1. ¾ angels in alb, on nebuly; with plectra; drawing in Goodrich 32.

V & A. pg. Diadem with finial, tunic over feathers, belt with bells; Norwich glass of uncertain provenance; Archer, color il 15.

Lt Walsingham. pg, nII.3–5.

Warham S Mary Magdalene. pg frags, nIV.1b. 2 angels from a set, one plucking with plectrum in RH, the other in LH; A Rose fig 13.

Gt Witchingham Hall. pg. Standing angel, feathered legs, short patterned gown with bag sleeves, wide ermine collar; plectrum in RH; **FIG 43**. Now NMS.

Norwich S Gregory. sc, identified by Williamson; font encased in wood in 1999.

Pulham S Mary. sc, relief; see IV.2 *Annunciation*.

Knapton. wdcarv, hammerbeam roof S8. 6 tuning pegs; Montagu.

Lynn S Nicholas. wdcarv, between tie-beams S5 & N4; Montagu figs 9 &11 (with different nave numbering system).

Swaffham. wdcarv, double hammerbeam roof N & S4. All angel musicians in the upper rank; Haward (1999) il p 147.

Citole

Warham S Mary Magdalene. See XV.1.b.

Castle Acre Priory, Prior's Lodge. sc. ?Angel. Identified by Montagu.

Attleborough. pg, W win, C5. 14³. A Rose conjectures citole.

Mandora/Gittern

Lynn S Margaret. brass. c1364. Identified by Cameron 158.

Norwich, Carrow Priory. pg. 1370–90 (A Rose). A Rose fig 15.

Bale. pg, sV.2a. Flat back, carved grotesque head at neck; angel in petalled burlet; A Rose fig 7; he cites 3 examples in lights a & c.

Blakeney. pg, nVII.A2. Feathered angel with cross diadem, 2 sets of wings, standing on platform.

Cawston. pg, X light b. A Rose fig 5.

Crostwight. *pg, 5 strings, elliptical, flat back, DT 54:128.

N Elmham. pg, E win clerestory A5, chancel arch. Hand with plectrum in A2.

Letheringsett. pg, sIII.b2, not *in situ*. Feathered with ermine tippet.

Mulbarton. pg, sIII, head of light a. 4-stringed instrument with plectrum.

Norwich SPH. pg frag, E win 2c. Small hand with plectrum, probably an angel.

Sustead. pg, sV.A4. 3 strings over sound hole and bridge, plectrum in LH. A Rose queries ?lute.

Wiggenhall S Mary Magdalene. Costume doubtful, may be lay musicians.

Wighton. pg, W win (S). 4 feathered angels in tippets with cowl neckline, each with 2 sets of wings; with plectra.

Crostwight. *pg. 8-strings, round with flat back, with plectrum, DT 54:129.

Norwich S John Timberhill. pg, sIV, above central light. Round with flat back; paired with harp.

Shotesham S Mary. pg, nII.2b.

Gt Snoring. pg, nII.A2. Round with flat back.

Sprowston. pg frag, sV, light b. Feathered angel with ermine tippet, plectrum in LH; round with flat back; provenance uncertain.

Cathedral. sc, Bauchun Ch boss 39. 2 angels with 4-stringed instrument. Appendix II, Diagram 5.

Salle. See Diagram 3.

Brockdish. sc, chancel corbel, retained in Victorian restoration; E Rose, NMR notes. Pro-

nounced incurvation.

Felbrigg. sc, nave wall-post stop.

Upton. sc, font bowl and chamfer.

Haddiscoe. sc, font bowl. 2 panels, 4 strings and ornate scroll; Montagu.

Happisburgh. sc, font bowl, 2 panels. 4 strings; Bond (1985) color il 7, facing 322.

Hilborough. wdcarv, hammerbeam, N4; restored.

Lynn S Nicholas. wdcarv, N12 & S11, angels between tie-beams; Montagu figs 8 & 13 (with different nave numbering system).

Psaltery

Lynn S Margaret. brass. c1364. Cameron, pl 45b.

Barnham Deepdale. pg frag, nVII.3a. Hand plucking; see A Rose.

N Elmham. pg, nIX central tracery. 14c. Angel seated, murrey gown, white mantle, green wings; psaltery with three sound holes, quatrefoils and cinqfoil; A Rose fig 1.

Cawston. pg, sX. 4 angels in patchwork, one playing with both hands (1a), three supporting instrument with one hand, playing with other (1c and 3c); A Rose figs 2–3.

Castle Acre. pg frag, sIV.2c; not *in situ*.

Norwich Guildhall. pg frag, nII.

Norwich SPM. pg; instrument only; A Rose.

Oxborough. See I.4.b.

Shelton. pg, E win, B1. See A Rose.

Shimpling. pg, Wdf 143; not in the church in 1997.

Welborne. pg frag, porch E win 3a. Related to glass bought by the rector at N Tuddenham.

Weston Longville. pg, sV, eye of tracery.

Cathedral. sc, W cloister boss M4; see also *Fiddle*.

— sc, Bauchun Ch boss 38 (Coronation vault); see Appendix II, Diagram 5.

Brockdish. sc, chancel corbel, retained in Victorian restoration, E Rose, NMR notes.

Salle. sc, N parvise ch boss; see Diagram 3.

Cathedral. wdcarv, misericord, N8. L supporter; M Rose (1994).

Lynn S Nicholas. wdcarv, N3, between tie beam. Montagu fig 10 (different nave numbering system).

Tromba Marina

Lynn S Nicholas. wdcarv, between tie-beams, S6 and N11. A long instrument with crook-shaped flourish at upper end, held midway by one hand and apparently plucked in lower register by a second hand.

String Instruments: Struck
Dulcimer

Stratton Strawless. pg, nII, eye of tracery. Early 16c. Angel holding long thin mallets in both hands.

Percussion
Cymbals

Norwich SPM. pg, E win 7f.

Griston. pg, flanking sIV tracery.

Nakers

Norwich, Carrow Priory. pg. 1370–90. A Rose fig 16.

Upton. sc, font bowl. 2 nakers, identified by Montagu fig 112; music book with 4-line stave, M & R 1.

Tabor (and Pipe)

Norwich S Andrew. pg, sVIII.1b, tabor only.

Warham S Mary Magdalene. pg, nIV.1c; Pevsner 1 pl 56; A Rose fig 14.

Yarmouth. *wdcarv, boss, DT 62:41.

Tamborine

Lynn S Nicholas? wdcarv, N9, angel between tie-beams. Holding large round disk, ?tabor/tamborine.

Wind Instruments
Bagpipes

Typical instrument of shepherds; also used by angels.

Norwich Guildhall. pg nII, feathered, 2 sets of wings, ?amice and tippet open at shoulder; Crewe fig 47.

Norwich SPH. pg, see VIII.3.

Oxborough. pg; see I.4.b.

Shelton. pg, E win, B6.

Sustead. pg, sV.A6, headless fig in capacious apostle mantle with gold border over white garment; bag decorated with star-fish flower; lovely lion-head at throat of bag. King identifies musician as an angel (bare foot); A Rose fig 18.

Yarmouth. *wdcarv, roof boss, DT 62:41.

Organ

Used in N-Town Assumption (Rastall 365) and in the Norwich Grocers' play of the Fall (Rastall 74).

Lynn S Margaret. brass (c1364). Cameron pl

45a; see I.2.

Norwich, Carrow Priory. pg. 1370–90. Portative organ; A Rose fig 17.

Cawston. pg, frag sX. Portative organ; A Rose.

Fincham. pg, nII.A3. Portative organ; A Rose.

Oxborough. pg; see I.4.b.

Shelton. pg, E win B5. Portative organ; A Rose.

Cathedral. sc Bauchun Ch boss 38 (Coronation vault), 9-pipe organ; see Appendix II, Diagram 5.

Knapton. wdcarv, hammerbeam roof N6.

S Creake. wdcarv, hammerbeam roof N9.

N Creake. wdcarv, hammerbeam roof N9.

Pipe

Norwich S Andrew. pg. One demi-angel with pipe, G King (1914) 289.

Norwich S Stephen. pg. Pipe/recorder; A Rose.

Brockdish. sc, chancel corbel, retained in Victorian restoration; E Rose, NMR notes.

Shawm

E Barsham. pg, nIII. See IV.2 *Annunciation*.

Burnham Deepdale. pg frag, nVII.4b.

Cawston. pg frags, sX, lights a, b, c. A Rose cites 4 examples, fig 4.

Guestwick. pg, sVII.3b.

Norwich S Andrew. pg, sVIII.1b.

Pulham S Mary? sc relief, see IV.2 *Annunciation*.

Knapton. wdcarv, N5, *Te Deum* roof. M & R il 1:57; Haward (1999) il 5NL. Used to accompany *Te Deum*, Rastall 92–4.

Burlingham S Andrew. wdcarv, hammerbeam roof N6 and S6. Demi-angel on nebuly; tuning vents, Montagu fig 95.

Norwich SPH. wdcarv, boss.

Outwell. wdcarv, wall-plate. Tenor shawm (bombard). Identified by Montagu, "clear duplicate little finger hole, finger on either reed or flared cupped pirouette" (113).

Swaffham. wdcarv, double hammerbeam roof S8 and N8, tenor shawm; Montagu's treble shawm is probably at S6.

Recorder

Lynn S Nicholas. wdcarv, angels between tiebeams. S9 tenor recorder, Montagu fig 12; S10 angel holding hands in position to play a wind instrument (lost).

Trumpet

Cathedral. sc, S cloister bosses. 1327–9. H1, 2, 5, 8; I1; K5. W cloister boss. 1425–30. K6. All in M Rose (1999).

— sc, Bauchun Ch boss 27. 2 angels playing trumpets (Coronation vault); see Appendix II, Diagram 5.

Pulham S Mary. sc relief, see IV.2 *Annunciation*.

Bent (Folded) Trumpet

Glasgow Burrell Collection. pg. Feathered angel in damask tippet, low belt with bells, petaled burlet; Wells (1965) Cat. 89. Another angel from the same set, no instrument, Cat. 91. Norwich glass, provenance unknown.

Pulham Market. pwd. Angels with long S-shaped trumpets. The ceiling was also decorated, censing angels and monograms, DT 59:93–8; for details in 1889, see Fox 73.

Burlingham S Andrew. wdcarv, hammerbeam roof N2 and ?S2. S-shaped trumpet, Montagu fig 122.

Swaffham. wdcarv, double hammerbeam roof S & N10.

Appendix II. The Cathedral Bosses

The Cathedral boasts four major sets of historiated bosses: those in the nave, traditionally dated after the 1463 fire, though Woodman (187) has recently argued for the preceding decade; the Bauchun Chapel bosses c1475; the transept bosses from the Nykke episcopacy following the 1509 fire in the south transept; and the historiated cloister bosses begun in the first quarter of the fourteenth century and only finished 100 years later. A fifth set, Goldwell's 135 presbytery bosses, including 97 gold wells, has only two historiations, the Virgin crowned and the Pity of the Father.

Such a rich collection of the bosses has attracted considerable interest since the nineteenth century, but unfortunately many of the major publications are not readily available. For the nave there is Dean Goulburn, whose massive folio illustrated all the bosses; for the transepts, C. P. J. Cave, who drew on W. T. Bensly's notes; for the Bauchun Chapel, the indefatigable M. R. James; and for the cloister, James and E. W. Tristram. In the 1980s A. B. Whittingham produced a small illustrated guide, but it was largely confined to local audiences. More recently Martial Rose has described all the bosses in detail, and I am heavily indebted to his unpublished typescript in the Dean and Chapter Library. His monograph *Stories in Stone* is accompanied by splendid color photographs by Julia Hedgecoe. More recently he has published all the Apocalypse bosses in color. A CD-Rom version of the historiated bosses is now available at the Cathedral. As is only to be expected with such complex material, interpretations of unusual scenes have varied. I have drawn on all the published descriptions and worked from Hedgecoe's color slides in the Dean and Chapter Library. In the interest of economy I have not noted where I diverge from published identifications, though I sometimes cite scriptural texts to provide a basis for my interpretations. Much work remains to be done.

1. Nave Bosses

The 14 bays of the nave are equally divided between the Old and New Testaments. The bosses have been numbered by a variety of systems, but currently the bays are designated from E to W with a capital letter, and each boss is numbered within its bay (**Diagram 4**). The subjects of the

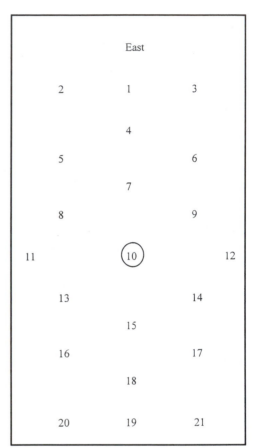

Diagram 4. Bay numbering. Norwich Cathedral nave bosses.

bays move chronologically from Creation in the first bay (A) to Noah (B), Abraham and Isaac (C), Jacob (D), Joseph (E), Moses (F), and David (G). The next seven bays are devoted to the New Testament beginning at H and ending with N. Individual incidents may be restricted to one or two bosses, e.g., the Tower of Babel (C1 & 4), or extend to as many as five as with Samson (F17 & 18, G 1–3). It is not uncommon for key figures to link two bays, Cain (A & B), Rebekah (C & D), Joseph (E & F), Samson (F & G), Solomon (G & H). Jacob, for example, is a leading character is the deception of Isaac (C) as well as the principal actor in the next bay; similarly, Joseph figures both as the central figure and as a type of Christ in bay E, but also as the link between the land of Canaan and Egypt, the setting for the succeeding

story of Moses (F). Samson as Judge links the transitional period between the Exodus and the period of Kings, and Solomon links the Old Testament to the New. The central boss in each bay represents a central event, e.g., the Fall (A10), the Sacrifice of Isaac (C10), the Nativity (H10), the Last Judgment (N10). The narrative patterns in the bosses are complex and sometimes at odds with modern linear reading habits. A colon draws attention to the interrelationship of multiple scenes (sometimes as many as five or six bosses per subject). In this example the colon indicates that bosses 9 and 10 constitute the Nativity scene. "Nativity: **9** angel with scroll reading "Gloria in . . ."; **10** nimbed, nude Infant in manger, 2 animals above; Joseph with cane; Virgin."

2. Transepts

The 150 historiated bosses in the N and S transepts are numbered separately. Cave's system moves from cathedral wall to central crossing numbering the bosses sequentially in the western, central, and eastern ranges. I have simplified his four digits (STC1) to the last two. A sample entry reads:

Cathedral. sc, S transept bosses. 16[1]. **C1** Standing before dressed altar, Joseph, Mary holding Child. **C7** Joseph, Virgin holding swaddled Infant; priest with book standing before altar; **E7** Joseph; Virgin as before; altar with priest behind.

C1 and C7 are in the central range, E7 in the eastern. The transept bosses have been generally maligned for inferior workmanship and repetition, but the latter charge fails once we perceive that biblical stories are here expanded—the action is being presented in slow motion, frame by frame. In the N transept bosses the animal bearing the Virgin and Child to Egypt progresses from C21, with four feet firmly planted on the ground, to E20 where he is walking. Similarly, the account of the Magi is spread over 13 bosses in all three ranges. Six concern Herod and their encounter with him, four their approach to Bethlehem, two their finding of the Child, and one their departure. The seemingly identical bosses at W16 and C16 are actually subtly different in time frame. In C16 the Magi approach the holy family; they are standing and all three are crowned; in W16 the first has removed his crown and is kneeling, while the second points to the star. W16 reproduces the classic adoration iconography. The N transept also provides three distinct iconographical tradi

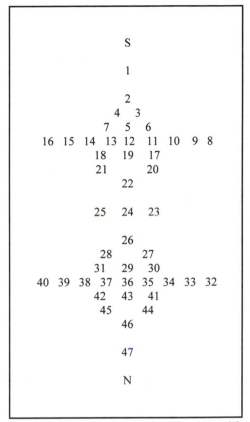

Diagram 5. Boss numbering, Bauchun Chapel, Norwich Cathedral.

tions of the Nativity, the standard manger scene, the Brigittine Nativity, and the scene with Mary in bed holding the Infant.

3. The Bauchun Chapel

The 47 bosses in the Bauchun Chapel are distributed in two vaults. The central bosses are the Assumption and Coronation with a number of ancillary angel musicians, but the chapel is better known for the accused queen story represented in surrounding bosses, which have drawn the interest of literary scholars looking for parallels with Chaucer's *Man of Law's Tale*. The bosses, which were first published by M. R. James (1908), are numbered sequentially (**Diagram 5**). Though small, the reproductions are reasonably intelligible. The most detailed descriptions are those by Martial Rose (typescript, Dean and Chapter Library), based in part on Julia Hedgecoe's color slides. Frances Barasch used an earlier set of color slides, copies of which are at the University of

East Anglia. Barasch has argued that the plots represented in the bosses derive from multiple sources. To make a very complicated story short, there are two plots, one concerning relations between the Empress and Emperor, and one the relations between the Empress and the lord Heros. The Empress is falsely accused in each of the plots. Interpretations of individual bosses vary significantly, but costume can be used to help identify characters. The Empress, for example, regularly wears a triple-crown, and male and female attendants wear a variety of distinctive clothing. Following is a rough correlation of boss numbers to plot; plain text represents the interpretations of Barasch and Rose; italicized from James.

> marriage 17
> Emperor's departure/*?return of Emperor* 19
> Emperor's brother's attempted seduction 3
> Empress accused/*farewell scene* 13
> arraignment of Empress 20 & 21
> plans for execution 6 & 18
> Plots 1 and 2 linked by the salvation of Empress by Heros 24
> *?Empress brought to wife of Knight* 23
> Empress assigned care of Heros' son 25 & 33
> murder of child by Heros' brother 22
> arraignment of Empress 42
> banishment to island 29
> vision of virgin and discovery of herb 28 & 7
> release from island 44
> healing scenes 4, 11 (*healing of Knight's brother*)
> reconciliation with Emperor 26 & 46
> death of the Empress/*healing of leprous brother* 5

Noting duplication of scenes, Barasch found no rational placement of the individual bosses. James was equally critical and concluded that "their order is mere disorder" (6), a criticism he also made of the transept bosses. As with the transepts, it is unwise to reply on modern habits of reading chronologically ordered plots; it would be wiser to look for a different organizing principle at work.

4. Cloister Bosses
See also Appendix III.

The cloister bosses, like those in the nave, have been numbered by a variety of systems. C. J. W. Winter, who drew all the bosses, numbered them consecutively 1–386. M. R. James used Winter's drawings, but he sensibly followed Bensly's suggestion and numbered bosses within each bay, designating each walk by Roman numerals. The system has been further simplified by Martial Rose, and it is that system that I use here (**Diagram 6**). As in the nave, the central boss in each bay represents a central event, e.g., in the N walk, the Sealing of the Tomb (A5), the Meal at Emmaus (B5), the Ascension (C5), Pentecost (D5), and Coronation (E5). The central bosses in succeeding bays in the north walk focus on martyrdom, including Herod's Feast, Murder of Thomas Becket, and execution of Lawrence and Stephen. Related subjects are sometimes situated in contiguous bays along the garth and inner walls, e.g., the four evangelists at boss 7 in bays B–E (east walk), the story of the Merchant of Constantinople at 7 in bays I–K (S walk), or the Annunciation and Visitation at boss 4 in bays I and J (south walk). The cloister is best known for its representation of the Apocalypse in 102 bosses (Appendix III). The vaulting of ten bays on the south walk was complete by 1330. Cut off by the Black Death, work was not to recommence for another half century when a 1411/12 bequest sparked a major campaign to complete the work (Woodman 172). Recent Courtauld examination of the bosses found no evidence of the original polychromy, but the contrast between the palette used by Tristram (1935–8) with that of Campbell Smith (1980s) exemplifies a startling contrast in restoration styles. When interpreting the bosses, it is preferable to rely on gesture rather than on facial expression, which can be subtly manipulated by a restorer.

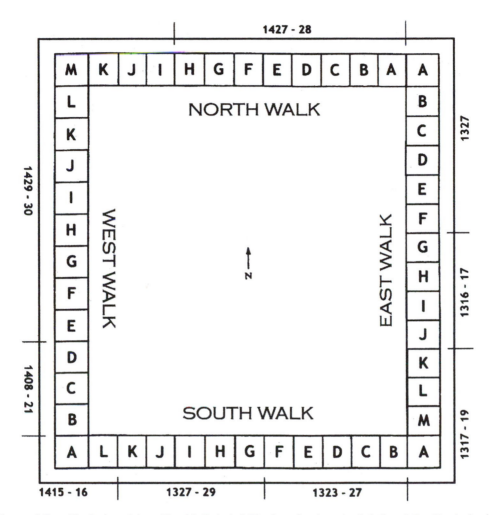

1427 - 28

M	K	J	I	H	G	F	E	D	C	B	A	A

NORTH WALK

WEST WALK

EAST WALK

SOUTH WALK

1429 - 30

1408 - 21

1327

1316 - 17

1317 - 19

1415 - 16 **1327 - 29** **1323 - 27**

Diagram 6. Boss Numbering, cloister, Norwich Cathedral. The date of each section is indicated. Bay Numbering is indicated in the diagram below.

GARTH

```
        4
        3
8       5    2    1
        6
        7
```

WALL

III. The Apocalypse Bosses

It is to be hoped that the recent photographic campaign in the cloisters will spark renewed research in the Apocalypse iconography represented in the bosses. They pose challenging problems, not least the difficulty of aligning boss to text. In Apocalypse manuscripts illustrations move linearly, whereas boss scenes are arranged around the central boss (5) of a vault, a privileging that raises interpretive questions. A second critical question concerns the models used in the first and second building campaigns, a new Apocalypse exemplar having been requested in 1346. The two manuscripts cited in the table included in this appendix have been selected because of possible East Anglian provenance. M. R. James argued a Peterborough provenance for the Dublin Apocalypse (Trinity College MS. 64), though Lucy Sandler (*Survey* 1986) has noted more cautiously that it can only be ascribed to a Benedictine house. There is general agreement that it stemmed from the same workshop that produced the Ormesby and Bromholm psalters and the Emmanuel College *Moralia in Job*. The French prose Apocalypse (BL Royal MS. 19.B.XV) is of uncertain provenance, but Nigel Morgan in the catalogue of the 1973 Norwich exhibition of East Anglian Art specifically drew attention to parallels between its iconography and that of the bosses. Still, however interesting the parallels, it is clear that neither manuscript was an exemplar for the model used in the cloisters.

The table summarizes the standard subjects represented in the three witnesses. In general the titles conform to those used in Sandler's tables (1986), but in a few cases I have cited Morgan's titles for the more elaborately illuminated texts of the thirteenth century (*Survey* 1988). Chapter and verse citation in general follow modern convention. Subjects missing in all three witnesses have been omitted in the table. Of special interest are the number of instances in which the bosses are more detailed than either manuscript, particularly in the west walk. It thus seems likely that the exemplar in use was related to a tradition deriving from the more extensively illustrated thirteenth-century manuscripts classified in Morgan's tables rather than from the later texts surveyed by Sandler. Chapter 19 is a case in point. Verses 1–10 are illustrated by one illumination in the French Apocalypse, by two in the Dublin Apocalypse (the Judgment of the Harlot is part of a preceding illustration), but by five bosses. K1 & 6 seem to have no parallels in either manuscript. The details on page LVIII of the Dublin Apocalypse (19:1–9a) include the Deity in mandorla, blessing and holding a book, flanked above by tetramorphic symbols and below by the elders adoring. At the far right the crowned bride holds a chalice and banner. Excepting the bride, these same details occupy the central boss of bay K. Boss K3 illustrates the final phrase of this text ("Et dixit mihi: Scribe," 9a) and K8 corresponds to the next Dublin illustration, John prostrate at the feet of the Deity ("Et cecidi ante pedes eius, ut adorarem eum," 19:10). Similar amplification obtains for chapter 17, provided with two illustrations in each manuscript in contrast to ten bosses, though admittedly some are difficult to assign to specific texts. The Dublin Apocalypse assigns verses 3–19 to one crowded page (the text is often abbreviated in other manuscripts), and Morgan's table provides only one subject between 17:6 and the next chapter, the Beast going to Perdition. Eight of the bosses, predominantly in bay I, seem to explicate 17:7, "the mystery of the woman and of the beast." Probably the source of the boss amplification is to be found in a gloss rather than in the scriptural text itself.

Table 1 **Apocalypse Subjects**	Norwich Cathedral South Walk	London, BL MS Roy 19.B.XV folio	Dublin Trinity Coll MS 64 (K.4.31) folio
S Paul (commentary)		1	
Angel Standing (1:1)	A5		
John Preaching (1:13)	B2	1v	
John on Patmos (1:9)	B8	2v	?lost
Angel with Trumpet (1:10)	B3		
Vision of Christ with Sword (1:12)	B5	2	?lost
Angel Orders Letters (1:11)	C1	3	
Door Opened in Heaven (4:1)	C2	5v	
John Climbs Ladder (4:1)			
Christ & 24 Elders (4:7)	C5	6	III
Lamb and 24 Elders (4:8-11)	D1		
Christ and the Book (5:1-3)	D2	7v	IIII
John Weeps (5:4-5)			V
Lamb Takes the Book (5:6-7)	D5	8	VI
Adoration of the Lamb (5:8-14)	E1	9	
1st Seal: White Horse (6:1-2)	E2	9v(a)	VII
2nd Seal: Red Horse (6:3-4)	E5	9v(b)	VIII
3rd Seal: Black Horse (6:5-6)	E8	10	IX
4th Seal: Pale Horse (6:7-8)	F1	10v	X
5th Seal: Souls under Altar (6:9-11)	F2	11	XI
6th Seal: Earthquake (6:12-17)	F5	11v	XII
Four Winds (7:1)	G1	12	XIII
Angel with Seal (7:2-3)	G2		
Adoration of God and Lamb (7:9-12)	G5	12v	XIIII
John and an Elder (7:13-14)	G8	13	
7th Seal: Trumpets Distributed (8:1-2)	H1	13v	XV
Censing the Altar (8:3-4)			XVI
Incense Cast on Earth (8:5)			XVII
1st Trumpet (8:7)	H2	14	XVIII
2nd Trumpet (8:8-9)	H5	14v	XIX
3rd Trumpet (8:10-11)	H8	15(a)	XX
4th Trumpet (8:12)	I1	15(b)	XXI
Voice of the Eagle (8:13)			XXII
5th Trumpet (9:1)	I2	15v	XXIII
Locusts (9:2-12)			
6th Trumpet (9:13-15)	I5	16	XXIIII
Army of Horsemen (9:16-21)	J5	16v	XXV
Angel and Book (10:1-7)	I8	17	XXVI
John Takes the Book (10:8-11)	J2	17v, 18	
John Measures Temple (11:1-2)	J8	18v	XXVII
2 Witnesses (11:3-6)	K1	19	XXVIII

Death of Witnesses (11:7-10)	K2	20	XXIX
Ascension of Witnesses (11:11-14)			XXX
7th Trumpet (11:15-17)	K5	20	XXXI
Woman Clothed in Sun (12:1-2)	K8	20v	XXXII
Dragon & Woman (12:3-6)	L1	21	XXXIII
War in Heaven (12:7-8)	L5	21v	XXXIIII
	West Walk		
Dragon Cast out (12:9)	A4		
Angel Proclaims Salvation (12:10)		22	
Wings Given to Woman (12:14)	A5	22v	XXXV
Dragon Casting Water (12:15-16)			
Beast from the Sea (13:1)	B1	23	
Beast like a Leopard (13:2)	B2		
Worship of Beast (13:4)	B5	23v	XXXVI
War of Beast and Saints (13:7-10)			XXXVII
False Prophet Calls down Fire (13:13)	C1	24v	XXXVIII
Mark of the Beast (13:16-18)			XXXIX
Lamb on Mt Sion (14:1-5)		25	XL
Angel & Everlasting Gospel (14:6-7)	C5	26	XLI
Angel Predicts Fall of Babylon (14:8)	D1	26v	
Son of Man Reaping (14:14-16)	D5	27	XLII
Vintage I (14:17-18)	E1	27v	XLIII
Vintage II (14:19-20)			XLIIII
7 Angels (15:1)	E2	28	XLV
Harpers, Sea of Glass & Fire (15:2-4)	E5		
Song of Moses (15:3)	E6		
Fear of the Lord (15:4)	E3		
Temple Opened in Heaven (15:5)	E8	28v	XLVI
Distribution of Vials (15:7)			
1st Vial (16:2)	F1	29	XLVII
2nd Vial (16:3)	F2	29v	
3rd Vial (16:4)	F5 & F8		XLVIII
Judgment Praised (16:5-7)	F6		
4th Vial (16:8)	F3	30(a)	XLVIX
5th Vial (16:10)	G1	30(b)	
6th Vial (16:12)	G2		L
Frogs (16:13)	G5	30v	
Gathering of Forces (16:15)	G3		
Beatus qui vigilat (16:15)	H3		

Armageddon (16:16)	G6		
7th Vial (16:17)	G8		
Earthquake (16:18-19)	H1	31v	LI
Plague of Hail (16:21)	H2		
Harlot on the Waters (17:1-2)		32	LII
Ten Crowns (17:3b)	H6		
Harlot on Beast (17:3-4)	H5	32	LIII
Harlot Drunk (17:5-6)	H8	32v	
Mystery of the Woman (17:7)	I1		
Beast Emerges from Abyss (17:8a)	I2		
Names not in Book of Life (17:8b)	I3		
Kings Fallen (17:10)	I8		
Beast that Was and Is Not (17:11a)	I5		
Beast to Perdition (17:llb)	I6		
Ten Kings (17:12)	J1		
Fall of Babylon 1 (18:1-3)	J2	34	LIIII
Fall of Babylon 2 (18:4)		34v	
Lament of Kings (18:9-10)	J5		LV
Lament of Merchants (18:11-16)	J6		
Lament of Shipmasters (18:17-20)	J3		LVI
Angel & Millstone (18:21-23)	J8	35v	LVII
Blood of the Prophets (18:24)	K1		
Great Voice (19:1)	K6		
Judgment of the Harlot (19:2)	K2		LVI
Triumph in Heaven (19:4-6)	K5	36	LVIII
John Bidden to Write (19:9)	K3		
John Kneels to Angel (19:10)	K8		LIX
Armies of Heaven (19:11-16)	L1	37	LX
Angel Summons Birds (19:17-18)	L2	37v	LXI
Battle with Army of Beast (19:19)	L5	38	LXII
False Prophet and Beast (19:20)	L6		
Defeat (19:21)	L3		LXIII
Dragon Bound & Imprisoned (20:1-3)	L8	38v	LXIIII
lst Resurrection (20:4-5)	L4	39	LXV
Loosing of Satan (20:7)	M1		LXVI
Siege of Holy City (20:8)	M2		LXVII
Satan Cast Down (20:9)			LXVIII
Last Judgment 1 (20:11-13)	M5	40	LXIX
Last Judgment 2 (20:12a)	M3		
Casting into Hell (20:14)	M6		LXX

1. Creed Screens

The consistent allocation of the Creed articles or sentences in English manuscript tradition (**Table 2**) is reflected in only seven of the first eight articles (**Table 3**) on Norfolk screens. Of the final four sentences only Mattishall conforms to the manuscript norm of Matthew, Simon, Jude, and Matthias. The variation of article 3 instead of 4 for John attested at Weston Longville and Ringland also appears in glass at the Burrell Collection. Creed glass is too fragmentary to provide more than supplementary evidence (**Table 4**), but it should be noted that the same variation is well attested in incunabula (Bühler).

The apostles are arranged in the order of their articles (L to R) at Gooderstone, but not on the other Creed screens. Clearly the panels must have been removed and disarranged at Mattishall where the first six articles are on the south, but the second six begin at N1. We can presume that the present north and south sections have been reversed and hypothesize that the screen originally was ordered as at Gooderstone. The counterchanging of background colors supports such a textual order. The incomplete Ringland screen is less easy to sort out. It has texts 3–6 reading in order L to R on the south, and texts 1–2 reading R to L on the north followed by 11 and 12. Philip's pane is hung on the wall, and the other three apostles are missing. The most obvious disarrangement appears at Weston Longville where the woodwork is designed in four sets of three. Peter and Andrew with the first two sentences of the Creed are followed in sequence by apostles with sentences 11, 12, 10, and 9. Whoever mounted the panels was guided by background counterchanging, maintaining a red/green variation. It is easy to identify the source of the problem, if less easy to sympathize with the restorer's solution, for if the last six panels were mounted in the correct sequence of sentences, the counterchanging breaks down.

7	8	9	10	11	12
green	red	red	green	green	red
		(Matthias)			(Matthew)

The problem is clearly traceable to the original work. The assignment of articles is also odd since

Matthew is assigned the last sentence (12), whereas at Mattishall and Gooderstone it is given to Matthias, the norm for English manuscripts. Even if we reassigned the halberd (12) and square (9) to Matthias and Matthew, the color problem remains.

Table 2
Creed Articles:
Assignments in 5 English Manuscripts‡

In Creed compositions (screens and glass) the numbers correspond to the numbered articles (sentences) below.

1. Credo in Deum Patrem omnipotentem creatorem coeli et terrae — Peter
2. Et in Jesum Christum Filium eius unicum Dominum nostrum — Andrew
3. Qui conceptus est de Spiritu Sancto natus ex Maria virgine — James Major°
4. Passus sub Pontio Pilato, crucifixus mortuus et sepultus — John
5. Descendit ad inferna, tertia die resurrexit a mortuis — Thomas
6. Ascendit ad celos, sedet ad dexteram Dei Patris omnipotentis — James Minor°
7. Inde venturus judicare vivos et mortuos — Philip
8. Et in Spiritum sanctum — Bartholomew
9. Sanctam Ecclesiam catholicam, sanctorum communionem — Matthew
10. Remissionem peccatorum — Simon
11. Carnis resurrectionem — Thadeus
12. Vitam aeternam, Amen. — Matthias

‡BL Arundel 83 I, Sandler, *Survey* Cat. 38. 14[1]. (Norfolk provenance)
Queen Mary Psalter, Sandler, *Survey* Cat. 56. 14[1].
Corpus Christi Psalter, Sandler, *Survey* Cat. 66 (Norwich Diocese). 14[1].
Taymouth Hours, Sandler, *Survey* Cat. 98. 14[2].
Sherborne Missal, Scott, *Survey* Cat. 9. 14[ex].
°Corpus Christi Psalter ascribes Article 3 to "Jacobus," Taymouth to "Jacobus aps"; both ascribe Article 6 to "Jacobus Maior."

Table 3
Creed Screens

Mattishall	Gooderstone	Weston Longville	Ringland	Salle	Wickmere
name +attribute	name/ attribute	name/ attribute	name/ attribute	name/ attribute	attribute/ text
1 Peter+	Peter	Peter	Peter	o	o
2 Andrew+	Andrew	Andrew	Andrew	o	Andrew
3 Jas Maj+	Jas Maj	John	John	o	o
4 John +	John	Jas Maj	Jas Maj	o	o
5 Thomas	Thomas	Thomas	Thomas	Thomas	?spear
6 Jas Min	Jas Min	Jas Min	Jas Min	Jas Min	o
7 Philip	Philip	Philip	Philip	Philip	o cross
8. Barth	Barth	Barth	o	Barth	o
9a Matthew	{ Simon	{ Matthias square	o	o	text frag
9b					text frag
10 { Simon	Jude	Jude	o	o	text frag
11 Jude	Matthew halberd	Simon	Jude	o	o
12 Matthias	Matthias square	Matthew halberd	Matthew ?money bag	o	o

Numbers = Creed Articles (**Table 2**)
Identifications by name and/or attribute; attributes typical unless stated otherwise.
o = no evidence

2. Apostle/Prophet Sets

The pairing of prophets and apostles has a robust history in English manuscript art where the messianic texts of the Old Law are balanced with their fulfillment in the articles of the Apostles Creed. In the remarkable full-page table of the twelve Articles of Faith in Arundel 83 I, the prophetic and apostolic texts are linked by a central column of tiny miniatures illustrating each Creed article (see XIII.1.b). Though the page design varies with manuscript, there is typically some kind of engagement between the paired prophet and apostle. Whether juxtaposed opposite each other on facing pages (Corpus Christi Psalter and Taymouth Hours) or paired at the head of each calendar page (Sherborne Missal), prophet and apostle seem to be engaged in dialogue. This dialogic is reproduced in the

Table 4
Creed Glass

*Ringland	Bed'ham	S Creake	N Tud'ham	Field D	Burrell Coll.	Various
1 Peter			name only	Peter		
2 Andrew		Andrew	frag	Andrew	frag	*Nor SM* frag
3 James Maj		James Maj	James Maj	James Maj	John	
4			John		frag	*Nor SM* frag
5	Thomas		frag/name			
6	James Min	James Min			*Elsing*	*Bale* Philip
7 Thomas	Philip	frag			Philip	
9a		frag			Matthew (?text)	
11 Jude		frag			Jude	*Nor SS* frag
12			Matthias			

Numbers = Creed articles (see Table 2, above). Because of the fragmentary nature of these compositions, generalizations are hazardous without a careful inventory of the state of the glass and the extent of restoration (see individual entries, XIII.1). Definitive conclusions must await publication of the *Corpus Vitrearum* volume for Norfolk.

*Lost, based on NRO Rye 17 3:143; *Nor SM*=St. Michael-at-Plea, Norwich; *Nor SS*=All Saints, Norwich; frag= fragmentary text only. See also XIII, glass at V & A.

late screen at Salthouse, the most complete example of prophet/apostle iconography in Norfolk. The figures are drawn in pairs, either slightly facing or pointing to each other. Zachariah holds his scroll with one hand raised; Ezekiel and Sophonias point to their scrolls; Amos and Osee are posed with teaching gestures. The same gestures predominate on the well-preserved prophet screen at Thornham.

Although the ascription of sentences to the prophets is by no means uniform in either English or Continental work (for English glass, see Caviness and Mezey), English manuscripts fall into two distinct groups, here cited as Traditions 1 and 2 (**Table 5**; see **Table 6** for the texts). Both traditions are found in Norfolk. The Thornham screen is pivotal for our understanding of these traditions because the prophets are named and have legible texts. The screen thus provides a useful control.

Except for sentences 2, 3, and 5, which are uniform across a wide range of instances, the Poringland sentences are significantly different from Tradition 1, but close enough to two other manuscripts to define a second tradition. Four of the cited texts correspond to sentences 4, 8, 10, and 11 in the Taymouth Hours and Corpus Christi Psalter, an instructive correspondence given the diocesan provenance of the Corpus Christi Psalter. We are dependent on Blomefield for a description of the Poringland screen (Bl 5:440). Though only Peter is cited specifically vis-à-vis the prophets, the description includes "twelve Apostles, each having a sentence of the Creed in labels from their mouths" as well as "twelve other effigies of prophets."

"1, Moses, with yellow horns holding the law, 'In principio creavit Deus Celum et Terra'

Table 5

MS Tradition 1				MS Tradition 2		
Thornham Screen	QMPs	Ar 83 I	Sherb Missal	CCPs	TayH	Poringland Screen*
1 Jeremiah	+	+	+	+	+	Moses Gen. 1:1
2 David	+	+	+	+	+	+
3 Isaiah	+	+	+	+	+	+
4 Zachariah	+	+	Dan 9:26	+	+	+
5 Osee	+	+	+	+	+	+
6 Amos	+	+	+	+	+	o
7 Sophonias	+	+	+	Joel 3:12	+	o
8 Joel 2:28	+	+	+	Aggeus 2:6	+ [ascr Ez]	+
9 Micah	+	+	+	Soph 2:15	+	Judg 20:1
10 Malachi	+	+	+	Mal 2:16	+	+
11 Daniel	+	+	Zach 9:13	+	+	+
12 Ezekiel	+	+	+	Abdias 1:21	+	Jer 21:8

+ = same text as that cited left. See **Table 6** for texts.
QMPs = Queen Mary Psalter, Sandler, *Survey* Cat. 56. 1310–20.
Ar 83 I = Arundel 83 I (Norfolk Provenance), Sandler, *Survey* Cat. 38. c.1308.
Sherb Missal = Sherborne Missal, Scott, *Survey* Cat. 9. 1396–1407.
CCPs = Corpus Christi Psalter (Norwich Diocese), Sandler, *Survey* Cat. 66. 1304–21.
TayHours = Taymouth Hours, Sandler, *Survey* Cat. 98. 1325–35.

[Gen 1:1]. 2, St. Peter with the first Article of the Creed. 3, A person crowned, and this 'Dominus dixit ad me Filius meus es Tu' [David Ps 2:7]. 4, An Angel 'Ecce Virgo concipiet et Pariet Filium' [Isaiah 7:14]. 5, 'Post lxx hebdomadas occidetur Christus Dominus' [Dan 9:26.] 6, 'Ero mors tua O mors tuus ero inferne' [Osee 13:13]. 7, 'Spiritus meus erit in medio Vestri, nolite timere' [Aggeus 2:6]. 8, 'In Ecclesiam Populi Dei, convenerunt Populi Judei' [Judges 20:1]. 9, 'Cum odio habueris diruitur Domine Deus Israel' [Malachi 2:16]. 10, 'Suscitabo Filios tuos Syon' [Zachariah 9:13]. 11, 'Ego do vobis viam et Vite et Mortis' [Jeremiah 21:8]. 12, [missing]," Bl 5:440.

Jeremiah is usually assigned the first sentence and paired with Peter. At Poringland, however, Moses is paired with Peter and given the opening verse in Genesis, the same text assigned to Moses at Oxborough. Jeremiah is instead cited with a sentence that is unique in the Norfolk corpus. The text from Judges is also

unique. Presumably it is the ninth sentence since it follows Aggeus 2:6, which is sentence 8 in Tradition 2. Because the sentence distribution for the apostles is well established (**Table 2**), it is possible to reconstruct the original pattern. In addition to Peter being paired with Moses, Andrew would have been paired with David, the "crowned person" (sentence 2), James Major with Isaiah [the angel?] (3), John with Daniel (4), Thomas with Osee (5), Bartholomew with Aggeus (8), Matthew with ?Sophonias with a text from Judges (9), Simon with Malachi (10), Jude with Zachariah (11), and Matthias with Jeremiah (12). If the lost panel also corresponded with the Peterborough/Taymouth distribution, the sixth sentences would have been given to James Minor and Amos, the seventh to Philip and Joel.

The late apostle/prophet screen at Salthouse unfortunately lacks texts, or ones that can be deciphered with the naked eye. What seems to be a mistake (Jude is given Simon's fish, and

Simon, Jude's boat) suggests that the complex plan of this screen overtaxed the makers. The screen may have been painted in a relatively short period since there were two donations in 1510, and a donor text on the south side dates the screen 1513. Nevertheless, even with limited data it is possible to reconstruct part of the texts. Eight paired apostles and prophets figure on the main screen, two others on a parclose screen. (There must have been a second parclose screen, either lost, or perhaps only planned and never executed.) Only two prophets on the parclose screen have names, and only one of the paired apostles: Daniel paired with Thadeus (Jude), and Sophonias with an apostle holding a halberd. These data reveal interesting textual correspondences. Daniel, paired with Jude, appears elsewhere with sentence 11 (Ezekiel 37:12) in Tradition 1 as well as in the Fairford windows. He is given the same text on the Thornham screen. Tradition 2 can also be invoked, for Sophonias is assigned sentence 9 in the Corpus Christi Psalter and Taymouth Hours and paired with Matthew, precisely what is suggested here by the halberd, a preferred attribute for Matthew in Norfolk (Appendix IV.4). Since the central screen alternates sentences north and south (see XIII), it is likely that the two parclose screens were also so designed, the extant panels preserving Sophonias and Matthew (sentence 9) and Daniel and Jude (sentence 11) and the lost screen sentences 10 and 12. If Tradition 2 was followed, Malachi would have paired with Simon and Abdias with Matthias; if Tradition 1, Ezekiel would have replaced Abdias. Limited though it is, the Salthouse screen documents a mixed tradition.

This diversity is further evidenced by prophet glass, although it is more difficult to deal with because of its fragmentary nature. Only five prophets remain of the early apostle/prophet set at Oxborough (XIII). Two texts are unattested elsewhere in Norfolk, Baruch's "Hic est deus noster . . ." (3:35) and an unidentified prophet with "Numquit ego qui alios parere facio" (Is. 66:9). Isaiah appears with his accustomed sentence, and Aggeus with sentence 8 corresponds to Tradition 2. The fifth prophet, with damaged name, has Jeremiah's traditional text; it is not immediately obvious how this was rationalized with the lost Moses. The Griston glass is also problematic. It preserves four figures with names and texts. Three are clearly

rooted in the prophet tradition, with standard texts for David and Isaiah (sentences 2 and 3) and Jeremiah with the opening words of his book "Verba Jeremie" (1:1). The fourth figure is Noah with "Ecce adducam aquas dilu[vii] super terram" (Gen 6:17). Although the term prophet was not restricted to the major and minor prophets, witness the alabaster table now at Norwich St. Stephen, Noah's text is difficult to assign to a two-testament scheme. The Griston glass has thus been classified as a prophet/patriarch set (see also Salle, II.6). On the other hand, Abraham figures at Field Dalling with a fragmentary text "fecisti," perhaps sentence 1, along with Isaiah and Osee with their usual texts. The restored window arranges the prophets with three extant apostles Peter, Andrew, and James Major with accustomed sentences. The most tantalizing glass is preserved at Bale, a prophet set from the second half of the fourteenth-century and the earliest example of prophet texts in the Subject List. Had more been preserved, we would be in a much better position to understand the development of prophet iconography in Norfolk. Daniel appears with sentence 4 (9:26), which we have already met in Tradition 2. The second Bale prophet has a text unrecorded elsewhere to my knowledge. "Ascendit reptans manibus et pedibus" (1Sam 14:13) suggests sentence 6. We can only project that the Bale glass has survived from a complete prophet/apostle set, but because of the complicated restoration history of this glass we do not even know how much was original with the church.

Table 6
Prophet Articles
in 5 English Manuscripts‡

Wording and spelling vary in sources and from standard Vulgate editions. Spelling here conforms to earlier Subject Lists with the exception of Aggeus (Haggai), Abdias (Obadiah), Osee (Hosea), and Sophonias (Zepheniah), which are retained in medieval form. Where text source differs from ascription, it is in brackets. It was not uncommon for texts to be misascribed, such patterns defining different traditions.

Articles

1. Jeremiah 3:19/32:17 Patrem invocabis me dicit dominus /qui terram fecit et condidit

celos.

2. David Ps. 2:7 Filius meus es tu hodie genui te.

3. Isaiah 7:14 Ecce virgo concipiet et pariet filium.

4. Zachariah 12:10 Aspicient omnes ad me quem confixerunt.

Daniel 9:26 Post hebdomades lxii [sexaginta] occidetur.

5. Osee 13:14 O mors ero mors tua morsus tuus ero inferne.

6. Amos 9:6 Qui edificat in celo ascensionem suam.

7. Sophonias [Malachi 3:5] Ascendam ad vos in iudicio.

Joel 3:12 In vallem Iosophat iudicabit omnes gentes.

8. Joel 2:28 Effundam spiritum meum super omnem carnem.

Aggeus 2:6 Spiritus meus erit in medio vestri nolite timere.

9. Micah [Sophonias 3:9] Invocabunt omnes in nomen domini.

Sophonias 2:15 Hec est civitas gloriosa que dicit.

10. Malachi [Micah 7 :19] Deponet dominus omnes iniquitates nostras.

Malachi 2:16 Cum odeo habueris dimitte.

11. Daniel [Ezekiel 37:12] Educam vos de sepuchris vestris.

Zachariah 9:13 Suscitabo filios tuos.

12. Ezekiel [Daniel 12:2] Evigilabunt omnes alii ad vitam alii ad opprobrium.

Abdias 1:21 Et erit regnum domini [Amen].

‡BL Arundel 83 I (Norfolk Provenance)
Queen Mary Psalter
Corpus Christi Psalter (Norwich Diocese)
Taymouth Hours
Sherborne Missal

Norfolk *Unica*

Bale: 1 Sam 14:13 Ascendit reptans manibus et pedibus

Field Dalling? Jeremiah 3:19 [Ecce tu]fecisti [caelum et terram]

Oxborough: Isaiah 66:9 Numquit ego qui alios parere facio

Baruch 3:35 Hic est Deus noster

Poringland: Judges 20:1 In Ecclesiam Populi Dei, convenerunt populi Judei

Jeremiah 21.8 Ecce ego do coram vobis viam vitae.

3. Prophet Hats

The two 14c prophets at Bale wear no hats. In the 15c prophet hats, instantly recognizable but protean in shape, function as a kind of Old Testament livery. The hats are sometimes soft, perhaps turbans at Griston. At Salle the patriarchs wear hoods, while Elijah wears a blue chaperon, a type of hat also worn in the Thornham screen as well as by at least three of the prophets in the Norwich alabaster. The Thornham hats deserve special attention. It is not surprising that the workshop that took such interest in damask designs was equally inventive with hats. No two prophet hats are alike, though Lazarus (paired with St. Mary Magdalene) wears a chaperon like Sophonias. The loose cloth, pink for Lazarus, blue for Sophonias, is in each case trimmed with a wide band of gold trim. Sophonias's chaperon is the more elaborate because the supporting burlet rises in a peak, drawing attention to the central ouch (**FIG p**).

p. Burlet-chaperon, Sophonias. Thornham screen.

Isaiah's hat is damaged, but it is notable for two wide tasseled streamers attached to the sides. The other prophets at Thornham all wear hats that suggest the fine art of sizing and blocking. Daniel's hat is a soft-crowned dark blue with a turned-up front brim in contrasting lighter color. Brims are commonly turned back to create such color contrasts, and ouches abound. Osee has seven on his hat. Jeremiah's red hat with a rounded soft crown is topped with an ouch, and the cylindrical brim supports three. Ezekiel also wears a red hat, but it has a dome-like crown, not unlike that worn by the Emperor John Paleologus (Newton fig 19). The brim is edged in gold, pointed and scalloped in front, turned up in front to reveal a green lining finished with a central ouch (**FIG q**). The hat with the most elaborate brim is worn by Zachariah. Again it is

q. Prophet hat, Ezekiel. Thornham screen.

r. Prophet hat, Joel. Thornham screen.

s. Hat with burlet. Micah. Thornham screen.

t. Prophet hat, Aggeus. Painted glass, Oxborough.

turned up to show the contrasting lining, but its scalloped edges end in rising quatrefoils, perhaps pins fixed into the circumference. Micah and Joel both wear hats with well defined

blocked crowns. Joel's hat is pink with a contrasting blue brim, turned up both in the back and in front with the typical ouch. The crown is covered by a soft fabric with fullness at the center ending in tiny knobs (**FIG r**). The crown of Micah's dark chapeau suggests blocking; a white burlet fits over the crown, like an orle on a bascinet, with ouch in front. The brim is turned down over forehead but jauntily up in back (**FIG s**). Zachariah wears a massive white burlet surmounted by an ouch; at the rear a long white streamer depends, providing useful evidence about the dressing of a burlet. The frame was covered by winding a fine fabric around it, in this case with the ends tied into a single knot and left hanging. (Similar evidence for this draping can be found in Flemish painting.) The same sort of burlet (without streamer) is worn by the Principatus at Barton Turf as well as by the bride at the Marriage Feast of Cana at East Harling (Wdf pl XII).

It is sometimes claimed that the blockbook versions of the *Biblia Pauperum* were influential in Norfolk, but a comparison of the Thornham hats with those described by Avril Henry (Appendix B) shows no such influence. The rounded rather bulbous crown on Zachariah's hat in the blockbook (d10) is the same as Jeremiah's, but the brims are totally different. Micah's massive burlet (b1) rather carelessly draped with cloth is only related to Zachariah's in size; the two are draped quite differently. The similarities probably stem from contemporary hat styles. No matter how you wrap a burlet, it is still going to look like one. The ouches so prominent at Thornham appear only on Solomon's hat worn for quotations from Proverbs and Wisdom (g4), and they are very modest ones. (A more interesting question is the influence of Continental art on the blockbooks: David's hat with the nodding brim worn whenever he appears as Psalmist [a4] is clearly the same hat worn by Claus Sluter's Zachariah [Newton fig 24]). Unfortunately, Norfolk preserves too few prophets to provide evidence to warrant generalizations except to note that two prophets at Oxborough (**FIG t**) wear the same style hat worn by Nicodemus (or Joseph of Arimathea) in a painted panel of the Entombment (*Age of Chivalry* Cat. 712). The same hat appears in the Pepys Model Book, where the artist shows the back with a pointed brim matching the front (Scott, *Survey* il no. 43). Like the pointed hats worn by the Jewish women on

the Houghton St Giles screen (Costume Glossary, **FIG a**), all such headdress identified the wearers as Jewish actors in the sacred history represented within the parish church.

4. Apostle Attributes

With the exceptions of Matthew and Matthias, the attributes assigned to the apostles in Norfolk parochial art are generally uniform. Variations in Norfolk may be the rule elsewhere, for which see Caviness and Cameron (1983). (Cameron's remarks on Norfolk must be disregarded where they are based on Husenbeth's misidentifications.)

Philip: Cross/Halberd

Philip is consistently represented with loaves, sometimes held in his hand but more commonly in a woven basket (**FIG u**). He appears with a cross in nine uncontested instances (five with likely Continental influence). On the Salle Creed screen Philip bears text 7 (the uniform allocation on Creed screens and in English manuscripts) and a cross botony. He is named and given a tau cross at Norwich St. Helen. Since there is no evidence for assigning the cross to another apostle, it is reasonable to assume that even where remains are fragmentary (e.g., at Kimberley and Salthouse) an apostle figure with a cross should be identified as Philip. The types of crosses vary, a plain cross in the Weybridge printed calendar, a tau cross on screens at Salthouse and Aylsham and in stone work at Norwich (St. Helen, All Saints, and St. James), and the well-preserved cross botony at Salle. The Continental preference for a cross is seen in the Flemish Walsokne brass at Lynn, where Philip also holds a cross botony. It is probable that Continental influence accounts for the preference of a cross in Norwich as well as on the puzzling Worstead screen, where an anomalous twelfth apostle, who should be Matthias, holds a processional cross. It should be noted, however, that on the screen at Southwold (Suffolk) Philip has both a basket and a Roman cross. The halberd is attested only in Fitzwilliam MS. 55 (c1480), unless one explains what looks like a forked stick on the Stalham font as a restoration of a broken short halberd.

Simon and Jude: Oar

The typical identifying attributes are for Simon a fish (or fishes), sometimes astonishingly realistic, and an unrigged boat for Jude. Cameron notes this preference as a peculiar East Anglian characteristic. The attributes are reversed on the apostle/prophet screen at Salthouse since the apostle with a fish is identified in a restored name below as "Sa thadeus." A similar problem obtains at Norwich St. Helen, where Simon has the boat and the apostle with a fish is named Matthias, surely another error for Jude since one would expect Paul to have replaced Matthias, not Jude. In Fitzwilliam Museum MS. 55, Jude is shown with both boat and oar, and both attributes occur at Weston Longville, where Jude is named. He holds only an oar on the Aylsham screen and on the Stalham font (not paired with the apostle holding a fish). The oar can be assigned to Simon on the font from Norwich All Saints (paired with an apostle holding boat) and the screens at Cawston and Redenhall. The oar's triangular blade is pointed down at All Saints and Stalham, but up at Aylsham and Cawston.

Simon and James Minor: Saw

The saw is assigned unequivocally to Simon only at Beeston Regis, which has been heavily restored. Bench end apostles with saws at Great Walsingham and Wiggenhall cannot be identified because the sets of apostles are partial. The anomalous font from Norwich All Saints pairs James Major with an apostle with a saw who by elimination must be James Minor; on the related font at St James the two Jameses (with usual attributes) are also paired. An apostle figure with a saw is included among the fourteen wallposts at West Lynn (not Simon or James Minor, who are identified by normal attribute),

u. Typical basket held by St. Philip.

perhaps Matthias. Cameron noted only one instance in Tournai brasses where the saw was associated with Simon.

Matthew and Matthias

Matthew and Matthias are the two apostles most resistant to identification from attribute only. They are difficult to assign in apostle screens where there are no names or where Paul is included in a twwelve-figure set and one apostle must be eliminated. One would expect Matthias to dropped since he was the last to be chosen and assigned text 12 of the Creed (**Table 2**) as well as last in the Litany order. However, four Creed screens maintain no such pattern. Matthias is assigned the last article in only two of the screens (**Table 3**); in the other two the article is given to Matthew. Furthermore, in twelve-figure screens including Paul, it is by no means certain which of the two apostles is dropped. The related apostle screens at Ranworth and Hunstanton, both with names, are a case in point. Both were produced by the same workshop at approximately the same time. The twelfth apostle holds a sword as an attribute, but is named "Mathias" at Hunstanton and "Mathee" at Ranworth where the names are in the vocative case and one would expect "Mathia" for Matthias. Oddly, the same double e spelling occurs in the Tanner manuscript of *The South English Legendary* written beside the marginal drawing of St. Matthias (Pächt & Alexander 861 pl LXXXII). Indeed, the various manuscripts of the *Legendary* preserve a number of interesting orthographic variations. One user of the Corpus Christi manuscript (CCCC 145) was sufficiently disturbed by the ending of "Mathie apostoli" in the margin of the life of Matthias to correct the spelling to "Mathia." Artists unfamiliar with Latin might be expected to muddle the spelling of case endings rather than stems, and that is exactly what seems to have happened at Tunstead (twelve apostles including Paul) where "Mathiee" represents the stem for Mathias, but the vocative for Matthew. A straightforward error is preserved on the Evangelist screen now at North Tuddenham where the name written below Matthew is Matthias.

Even with these difficulties, however, it is possible to argue for reasonable consistency of attributes. At Weston Longville and Gooderstone, where the two apostles are named and hold attributes, the halberd belongs to Matthew and the square to Matthias. The arrangement of the apostles at Irstead supports this identification, and in three glass sets (Great Massingham, Pulham St. Mary, and Stody) and on the screen at Swanton Abbot two apostles are given the square and halberd respectively. It is, therefore, attractive to assume that when there are twelve apostles with attributes including a halberd and square, these designate Matthew and Matthias respectively. There is, however, one instance, in addition to the problematic Tunstead, where the halberd must be assigned to Matthias, for at Cawston Matthew has a collecting vessel. Matthew is also identified by a money bag on five screens and in apostle sets on two roofs. At Ringland the disfigured object in the hand of the apostle with the last sentence may be a purse; this text is also ascribed to Matthew at the related Weston Longville.

A third attribute, a sword, is less easy to assign exclusively. The sword appears as a non-Pauline attribute in six apostle screens. At Ranworth and Hunstanton the twelfth apostle holds a sword. The other four screens include both sword and halberd. The early and late screens at Castle Acre and Beeston Regis have both sword and halberd (halberd head at Beeston). The two anomalous sixteen-figure fonts in Norwich pose a similar problem. At All Saints the pairs in question are Thomas and an apostle with a sword, and Philip (with tau cross) and an apostle with a halberd. The figure with a sword must be the otherwise missing Bartholomew, so Matthew can be assigned the expected halberd. At St. James the two apostles paired with sword and halberd must be Matthew and Matthias. Given the relationships between the two fonts, I am inclined to assign the halberd to Matthew. At Blofield if we assign the halberd to Matthew, then Matthias is identified by a short axe. A long axe is his attribute in Fitzwilliam MS. 55. It is hardly surprising that an expendable apostle had variable attributes, nor that the similarity in names and unfamiliar case endings might confuse a painter working in less than ideal lighting.

Appendix V. Liturgical Estates: Sets of Saints

THE DIURNAL liturgy of the sanctoral cycle was simplified by the designation of common texts for specific classes of saints, sometimes with subdivisions, e.g., for one apostle as opposed to more than one (to accommodate shared feasts). Though collects might vary, the same proper Mass texts as well as appointed psalms could be used for all virgin martyrs, all bishop martyrs, etc. The same pattern also informs the organization of the litany with its apostles, martyrs, confessors, doctors, virgins and widows, classes that might be called liturgical estates. These estates are represented in the 13c vault of the Ante-Reliquary Chapel at the Cathedral (male and female martyrs, apostles, and confessors) as well as in the 15c alabaster tablet at St. Peter Mancroft comprising five holy women (not martyrs) and four virgin martyrs. Pairs of saints on rood screens are also drawn from liturgical classes, e.g., at Ludham, virgin martyrs, deacon martyrs, royal martyrs, royal confessors, and the four Latin Doctors. Sets of saints could be found in most media, from grand schemes on the walls to small scale embroidery on vestment orphreys, but the focus in this appendix will be on glass.

1. Female Saints: Virgin Martyrs

Virgin martyrs are typically nimbed, and long flowing hair identifies their virginity. They typically wear a loose mantle over a gown. The men or boys who represented sixteen virgin martyrs in a pageant for Queen Elizabeth Woodville's visit to Norwich wore mantles with hoods (Harrod [1859b] 35). In addition to individual attributes, the virgin martyrs are commonly shown with closed books symbolizing not only their refusal to deny the Word of God but also their skill in defending the Gospel; one only needs to think of Cecilia's eloquent preaching in *The Golden Legend*. Not all virgin saints can be identified since many lack attributes. This lack and the fragmentary nature of much glass means that the Subject List cites only a fraction of the virgins that once existed.

Martyr sets (see below) were particularly popular in tracery lights. M. R. James recorded four martyrs in the east window of the south transept at Salle, only two of which have survived

and are now differently situated. It seems likely that where two survive, as at Sustead and Heacham, they are what remains of a complete set. St. Peter Mancroft must have had a fine set of martyrs in the main lights, but only Faith (5f) is preserved entire, with a fragmentary Cecilia (6a). Though it is possible that singular occurrences may be unique survivals of a set, e.g. Agatha at Norwich St. Peter Hungate (based on the same cartoon as at Cley), I have excluded them from this discussion. I have also excluded the commonly paired Catherine and Margaret unless they are clearly part of a larger set. Without careful study of the leading and restoration records, it is hazardous to draw any very firm conclusions about who belonged to which set. Much of the glass, as at Martham, is not *in situ*, and although we know there was a set of eight saints in one window at Cley (sIX), the identity of two is unsure. Cley, one of a group of parishes in the section of Norfolk that escaped the 17c wave of iconoclasm, is remarkable in that Agatha, Agnes (or Lucy), and Cecilia correspond to three of the martyrs memorialized in the Canon of the Mass—"Agatha, Lucy, Agnes, Cecilia, Anastasia."

Painted glass tracery sets sometimes include a generic martyr with a palm in one hand and a book in the other. Where the women in the set correspond to the saints of the Canon, the generic martyr may have been intended for St. Anastasia. The correspondence raises the possibility that she may be an otherwise unidentified saint at Cley (sIX.A3), Field Dalling (sIV.A2), and Wighton (sIV.A1, King fig 4). King has noted that the figures at Cley and Wighton are based on the same cartoon, the saint holding what may be sword or stake. At Field Dalling the generic virgin holds a book and a palm. The figure identified as Anastasia at All Souls College, Oxford, carries a closed book. Woodforde (178) thought it curious that Dorothy did not appear in the glass virgin martyr sets, but if the canonical martyrs formed the core of some sets, her exclusion does not seem strange at all. More interesting is the inclusion of other non-canonical saints. Juliana, Petronilla, and Barbara appear in three sets, Apollonia and Faith feature in two. Probably the patterns have been so disturbed by loss that no firm conclusion

can be drawn, except for the well-documented popularity of Catherine and Margaret.

Cley	Wighton	Field D	Martham
?Agnes		Agnes	
Agatha	Agatha		
?Anast	?Anast	?Anast	
Apoll	Catherine	Catherine	
?Barbara			
Cecilia		Cecilia	
Faith	Juliana	?Juliana	Juliana
?Lucy			Margaret
Petronilla			*Petronilla

Pulham	Marsham	Salle	Sharrington
*Agatha?	*Agatha	*Barbara	*Apollonia
Barbara	*Lucy	Catherine	*Catherine
Catherine	*Margaret	Margaret	*Cecilia
Cecilia		*Dorothy	*Margaret
			*Petronilla
			*Sitha

Stody	Guestwick	Norwich SPM
Catherine	Catherine	Cecilia
*Lucy	Lucy	Faith
Margaret		

Virgin martyrs were also popular on screens. Barbara is attested on thirteen or perhaps fifteen screens, Catherine on twelve or perhaps fourteen, Margaret on thirteen, seven of which are paired with Catherine, Apollonia on ten, Dorothy and Agnes each on eight or perhaps nine, Ursula on five, Juliana and Petronilla each on four, Cecilia on four or five, Faith on three, Agatha on two or three, Lucy on one or two. On screens they are typically paired with representatives of other liturgical classes, e.g., deacon martyrs or holy women. There are only two extensive virgin martyr sets, the north side at Litcham (including an abbess) and the south at North Elmham, with a smaller set originally on the doors at Lessingham (including Mary Magdalene). In general the screens were more eclectic than glass, sometimes concentrating male saints on one side and female on the other, but also mixing them in no observable pattern.

Holy Women Not Martyrs

The virgin martyr sets sometimes include other female saints, in particular Mary Magdalene. She appears in sets at Field Dalling, Pulham St. Mary, Stody, and perhaps Martham and Cley (where the tiny fragment leaded in one of the tracery lights might be Magdalene's ointment jar rather than the base of Barbara's tower). At Stody there was probably a mixed set; Helen and Mary Magdalene are now in the same window with Margaret and Catherine, but an antiquarian source adds an abbess and Lucy to the list. Magdalene was also paired with Barbara in the beautiful pair of rectangular panels now preserved separately, Magdalene at the Burrell Collection in Glasgow and Barbara at the New York Metropolitan Museum of Art. Women saints also appear as abbesses and queens (see below). Martyrdom or royalty would seem to have been the normal paths to sanctity. The one exception is the servant Sitha, a virgin not a martyr, who was particularly popular on screens. She appears in the sets of women saints at North Elmham and Litcham. At Barton Turf she is paired with the virgin martyr Apollonia. Glass remains are minor and inconclusive.

2. Male Saints

With male saints the liturgical estates of martyr and confessor intersect with a range of hierarchical estates. Kings might be confessors (notably Edward the Confessor) or martyrs (Edmund and Edward Martyr), and genealogical rolls regularly so indicate. The popular pairing of Edward the Confessor and Edmund Martyr is a case in point. Popes and arch/bishops might be confessors, doctors, or martyrs. At Marsham one window contained at least four confessor bishops (there were "many other saints and confessors," Bl 6:287). At Harpley, where the labels distinguish archbishop from bishop, the two archbishops are identified by liturgical class, one a confessor (Wilfrid) and the other (Thomas) a martyr. Liturgical estate was the principle governing the organization of the west window.

Harpley, West Window, outermost registers

Leger	Thomas
bp martyr	**archbp martyr**
Vincent	Martin
martyr	**confessor**
Lawrence	Stephen
deacon martyr	**deacon martyr**

Wilfrid	Jas Min	Edmund	Edward	John	Blaise
archbp conf	**ap**	**mart**	**conf**	**ap**	**bp mar**

Liturgical estate operates elsewhere as well. At

Salle of six popes two are martyrs, and martyr kings dominate as they do at St. Peter Mancroft. When large-scale glazing schemes assigned estates to different windows, the martyr windows were typically female. Perhaps male martyrs balanced the abbot confessors in the tracery lights at Old Buckenham, though only Peter Martyr remains. These distinctions were commonly cited in calendars and also noted in guild records, e.g., "þe Noble confessour seynt Antony," "þe holy confessour seynt Leonard" (T. Smith 45, 49).

The focus below is on individual estates, but mixed sets were also common. Crown and scepter, papal tiara, pallium, cross-staff, crozier, and mitre make generic identification possible, even for damaged and fragmentary scenes, but there are only a handful of unequivocal attributes to identify individual kings, popes, and archbishops or bishops. Luckily, painted glass sometimes included names without which we could never have predicted the unusual array of saints and historical figures memorialized in Norfolk.

3. Monarchs (Kings, Queens)

Medieval interest in history is well documented and ranges from the chronological lists of kings in genealogical rolls to sculptural programs like those on the west front of Lincoln Cathedral (Gardner fig 444) or on the pulpitum at Canterbury newly faced at the turn of the fifteenth century. Sets of kings also figured in dramatic production, e.g. in the pageant for Henry V's entry into London following the victory at Agincourt which included a dozen "kings of the English succession" as well as the apostles and "martyrs and confessors" (Lancashire no. 920). Norfolk reflects the same historical interest, for sets of kings were painted on screens and glass and even carved on font stems, where damage makes identification particularly difficult. Elaborate painted glass schemes seem to have provided names, at least if the sets at Salle and St. Peter Mancroft can be taken as exemplary. Names were essential for obscure sainted kings with no established attributes. Only Olaf and the paired Edmund and Edward are regularly identifiable by attribute (**FIG v**). Pairing was common, par-

v. Loaves, attribute of St. Olaf.

ticularly on screens. Isolated kings (e.g., at Stockton) may have belonged originally to sets, and there may have been a king set at Martham, but the discussion here is limited to "sets" of three or more extant kings. The painted glass set at St. Peter Mancroft comprises seven named Anglo-Saxon kings as well as evidence of at least three others. (For the original site and order of the windows as well as historical implications, see David King, forthcoming.) A remarkable glazing program in the Salle chancel included kings, popes and archbishops. Fortunately recorded by Martin in the eighteenth century and further elucidated by M. R. James (Parsons 62–4) and David King (1979), this lost glass will figure in each of the following three sections.

The screen at Catfield has sixteen monarchs (including one queen), composed as pairs, each king turning slightly toward the other. Although only four can be identified by attribute, the order may well have been chronological on the north side since Athelstan is at N3, Olaf at N6, and Edward the Confessor at N8. If so, it would be possible to conjecture which kings might have completed the sequence. Only Edmund is identifiable on the south side; he is paired with Edward in the place of honor flanking the chancel door. None of the kings is nimbed, not even the recognizable saints, an omission that suggests a focus on kingship *per se*. The inclusion of *rex* in glass labels achieves the same effect. It is probably not accidental that sets of English kings appeared repeatedly in Norfolk glass in a period that saw the deposition and reinstatement of Henry VI, a king well represented in Norfolk art. The sets should properly be seen against the background of genealogical rolls, i.e., not just sets but records of historical succession.

It is more difficult to document queen sets, with the possible exception of Kelling (if Sexburga [see XII] instead of Withburga). Neither do we know who the three empresses were who figured in the Norwich pageant for Elizabeth Woodville. Etheldreda and Helen seem to have been included with sets of women saints, as one would expect if liturgical classes are privileged, though they are paired as queens next to two virgin martyrs on the screen at Upton. Kings also appear in sets and include popes, arch/bishops and abbots/abbesses, rulers of both the body politic and spiritual. Probably Giles, Etheldreda, Withburga, and Helen, all at one time in the same window at Salle, comprised such a set.

Painted Glass
Norfolk St. Peter Mancroft
Cited in approximate chronological order (see King, forthcoming):
Alban
Oswald
Oswin
Ethelbert
Kenelm
Wystan
Edmund
Athelstan (if the son of Edward the Elder)
Edgar
Edward Martyr

Salle Set 1, see below	Kelling
*Lucius (unique)	?Helen
*Ethelbert	Etheldreda
*Edmund	?Sexburga
*Edward Martyr	
*Louis IX	

Marsham	Stody	Heacham
*Kenelm		
*Edmund	Edmund	Olaf
*Edward	3 generic kings	?Edward
	[See II.6]	2 generic kings

Outwell

Beaupré Chapel	North Chapel
*Edmund	*Edmund
Edward the Confessor	*Edward the Confessor
Edward Martyr	Edward Martyr
Olaf	*Ethelbert
Walstan	

4. Popes

Even where defaced, a pope can be identified by the outline of a triple crown (papal tiara) or a double cross-staff. On painted screens popes appear in pairs, e.g., at Houghton St. Giles the martyr popes Clement and Sylvester. At Barnham Broom the popular Clement stands next to a largely disfigured pope and at Beeston St. Mary with a disfigured archbishop. There are interesting collections of popes in glass at Salle and Wiggenhall St. Mary Magdalene, both mixed sets including kings and (arch)bishops. At Salle three of the six popes had or were believed to have had special connections with England (Eleutherius, Gregory, and Boniface). Four of the popes are unique citations; Gregory and Sylvester appear

elsewhere. King has suggested that Salle's complex scheme had political overtones and that the iconography was probably selected by the rector Master William Wode. The collection at Wiggenhall is more eclectic and idiosyncratic than that at Salle. Excepting Sylvester all the popes are unique. The five-window scheme with a total of fifty tracery openings includes an equally idiosyncratic set of early popes, prelates and martyrs.

Salle
*painted glass originally in the chancel (King [1979] 335; Parsons 62–8). Set 1, see below.
Eleutherius
Urban I
Sylvester I
John I
Gregory
Boniface IV

Wiggenhall St. Mary Magdalene
?Victor
Callistus
Cornelius
Sixtus II
Sylvester I
Leo I (the Great)
Hilary
Nicholas I

5. Arch/bishops and Abbots/Abbesses

As with monarchs, there are isolated arch/bishops that may have come from sets (e.g., a fine archbishop at Besthorpe, one at West Tofts, two bishops and fragments at Guestwick). The font stem at the Cathedral (*ex situ* St. Mary-in-the-Marsh) balances four bishops with four monks wearing the distinctive wide-sleeved habit (only SS. Leonard and Giles are identifiable by emblem), a parity not always reflected in the history of the Cathedral and Priory. Woodforde (179–80) cites a number of examples in glass, to which can be added the lost abbots at Eccles. Commonly these saints are generic without names or attributes, e.g., the set of six at Great Cressingham (nIX), one archbishop identified by pallium (A5), an abbot (A3), and four bishops (one with a king's head). At Wiggenhall St. Mary Magdalene, where names do not match figures (e.g., apostle names attached to abbots), we know that the original sets were much more extensive than the extant glass. In panel painting, a fine set of abbot/bishops comprising Benedict, Dunstan,

Giles, and Martin survived at Great Plumstead until a disastrous fire in 1891, and a similar set remains at Smallburgh including Benedict, Giles, Martin, Antony, and two other figures with croziers; the screen also features Lawrence and Stephen. A set may have existed at Garboldisham All Saints, but only two figures remain, Germanus and William of York. Leonard, commonly dressed in Benedictine habit, was included with Benedict, Giles, and another Benedictine at North Elmham and with Antony in the fragmentary screen at Gressenhall. The three royal Anglo-Saxon ab-besses figure in what was probably a *Te Deum* alabaster tablet and once accompanied a set of English archbishops at Walpole St. Peter. On the screens Etheldreda is typically represented with abbatial status; at Norwich St. John Sepulchre she is paired with the bishop Blaise, at Barnham Broom and Burlingham St. Andrew with With-burga. At North Tuddenham a tracery abbess is paired with St. Leonard Abbot. Elsewhere Ethel-dreda typically appears in sets of holy women.

The most notable set of archbishops is at Salle where they appeared with kings and popes in six triads (see below). David King (1979) noted that although York Minster provided the model, the York archbishops were replaced by Canter-bury. Five are well-known archbishops of Canter-bury, and it is likely that the British archbishop Fagan is so classified in some source. A second set of male saints is partially preserved, including prophets, patriarchs, and three early saints dressed as cardinals. North Tuddenham also preserves evidence of a king/bishop set (Edmund, Hugh, and Edmund Rich, with three additional arch/bishops unnamed, perhaps one figure belonging to Hugh).

(Arch)bishops/Abbots/Abbesses/ Archdeacons in Painted Glass

Total index citations for rare saints cited in parentheses

Salle

(Set 1 See below)	(Set 2)	(Set 3 Mixed)
*Fagan (1)	Patriarchs	Etheldreda
*Aug of Cant	Prophets	*Withburga
*Lawr of Cant (2)	Asterius (1)	Giles
*Alphege (2)	Felicissimus (1)	[Helen]
*Thomas Becket	Lawrence	[*Vincent]
*Edmund Rich		

Marsham **Field Dalling**
*Brice (2) Etheldreda
*Ethelred (Ailred) (1) Giles
*David (2) Leger
*Martin unidentified bp

Norwich SPM **Harpley**
Dunstan Blaise, with Wilfrid
Erkenwald (1) Leger, with Tho Becket
Thomas Becket Martin, with deacon
William of York

N Tuddenham **Walpole S Peter**
Edmund Rich *Edmund Rich *Etheldreda
Hugh of Linc (3) Hugh of Linc (3) *Sexburga
Leonard *Wm of Yk (3) *Withburga
abbess *John of Bev (1)
+ 3 unnamed figs

Wiggenhall St. Mary Magdalene **Stody**
Unique Citations (Total Citations) *Nicholas
Aldhelm Botulf (4) *3 other bps
Bruno Brice (2) *abbess
Desiderius Cuthbert (2) **Eccles**
Felicianus Germanus (3) *Anthony
Gildard Egidius (19) *Germanus
Julian of Le Mans Hippolytus (mart, 2) *Benedict
Médard Hugh of Lincoln (3)
Prosdecimus Lambert (3)
Romanus Laudus (2)
Samson Lawrence of Canterbury (2)
 ?Swithun (2)

Old Buckenham
Botulf
Leonard
*probably a third light

Unlike the female saints, who are widely represented, the male saints are less popular; set membership is often the only citation in the Sub-ject List or one of two. Wiggenhall and Salle are classic examples, but the pattern is more per-vasive. At Marsham, where the glass survived into the 18c (Bl 9:117), only Martin appears com-monly elsewhere; Kenelm, Brice, and David each have only two citations, and Ethelred (Ailred) is unique. The lights recorded there include a Rodi-bert (unique in the subject list), perhaps Rigobert, an archbishop of Reims, who like Thomas Becket (cited in the same list) suffered from royal inter-ference. Hugh of Lincoln and Germanus appear only in sets, and William of York in two out of the three citations. The sole citation for John of Beverley is in the set at Walpole St. Peter (Bl 9:117). The iconographic program of the chancel windows there, however, is not entirely clear. Woodforde drew attention to the English archbishops and abbesses, but the windows also

included St. Alban and St. John the Evangelist. Alban, proto-martyr of England, features in a king set at St. Peter Mancroft.

Salle: *Set 1, opposing main lights in chancel

Kings	Popes	Archbishops of Canterbury
nIV Lucius	Eleutherius	Fagan‡
nIII Ethelbert	Gregory	Augustine
nII ?	Boniface IV	Lawrence
sIV Edm Martyr	Urban I	Alphege
sIII Edw Martyr	Sylvester I	Thomas
sII Louis IX	John I	Edmund Rich

‡*British Archbishop*

The chronological patterns are striking, the sets moving in strict chronological order with the exception of Lawrence and Augustine, probably arranged so that Augustine would stand next to Gregory. The earliest figures are situated in the westernmost light (nIV and sIV), the most recent in the easternmost (nII and sII). Liturgical classification operates within lights. All the saints on the south side are martyrs except in sII, where all are confessors (non-martyrs predominate on the north). Although it would be difficult to reconstruct the order at Wiggenhall St. Mary Magdalene, it seems likely that chronology as well as liturgical classification would have played a part in the overall scheme.

6. Deacons

Stephen the proto-martyr and Lawrence are common pairs. They stand next to each other on the screen at Hempstead and are balanced symmetrically at Ludham and Ranworth as they once must have been at Smallburgh. It is likely the pairing was more common than extant work documents, particularly in glass: where one saint is preserved, the other may have been lost. At Sandringham Stephen and Vincent appear on opposite sides of the nave. Vincent, a supposed cousin of Lawrence, appears with the pair in two glass sets (see below). At Watlington a fourth unidentified deacon completes the pattern on the font stem.

Sparham	**Harpley**
*Lawrence	Lawrence
*Stephen	Stephen
*Vincent	Vincent

APPENDIX VI. PAINTED PANELS: FROM ALTARPIECE TO SCREEN

THE EARLIEST extant altarpiece is the retable and altar frontal from the Dominican Priory in Thetford c1335, now divided between the Musée National du Moyen Age in Paris (formerly Cluny Museum) and Thornham Parva, Suffolk (Binsky, Norton, and Park). We know of other early work, now lost: in 1289 the Cathedral Priory refectorer spent 4s 6d on a painted tablet for St. Etheldreda's (DCN 1/8/1); in 1346 8s for a painted "tabula" for the high altar at St. John Timberhill; in the following year 1s 3d for another (DCN 1/10/5 and 1/10/6, Cotton, personal communication); and in 1384 the altarpiece at St. Vedast's was being restored (King [1996] 413). The Ingham St. Nicholas altarpiece (c1390), fortunately recorded in the last century, has also disappeared. Four other altarpieces, all Passion subjects, remain in whole or in part: the relatively intact Despenser Retable made for the high altar at the Cathedral (1382–3); two Passion scenes from St. Michael-at-Plea (1380–90) now at the Cathedral; two panels with Norwich provenance (1400–10), perhaps from the parish church of St. Saviour, now at the Fitzwilliam Museum; and one now at Ipswich (1390–1400) (L & M Cat. 51, 52, 54; *Age of Chivalry* Cat. 712). All of this work has been variously dated within a range of thirty years. The high quality suggests the sort of expense that could only be afforded by wealthy donors.

In the fifteenth century painted panels move from the altar to the rood screen and from Norwich into rural parishes. Unlike the high altar, the rood screen was easily visible to the parishioners, its subjects selected and paid for by those same men and women. Today ninety parishes either preserve rood screens with saints or other sacred subjects painted on the dado or can cite evidence for specific subjects once so painted. For another two dozen screens there are maddeningly vague references, e.g., for Little Rainham "Several Saints painted on skreen" or for Rockland St. Peter "four defaced Saints on skreen" (NRO, Rye 17, 3:121, 146). Although a handful of the Norfolk screens were at one time dated in the first quarter of the century (King in L & M 45), the tendency lately is revise those dates upwards. Two-thirds of the extant screens have some sort of documentary dating, but yet it is not easy to date

the panel painting precisely. Because screens were created in stages (built in workshops, then the numbered parts reconstructed on site before the painting was done *in situ*), bequest dates need to be linked to this process. Unfortunately, the often vague language of bequests does not make that possible. Only a handful of wills refer specifically to the "painting of the panes." At best, then, testamentary dates are suggestive rather than definitive. Painting and gilding might be completed within as few as ten years or as many as forty. A case in point is the late screen bearing the date 1536 at Burlingham St. Andrew but with six bequests ranging from 1525 "to making new perke" to 1537 for the final "gilding." Even the word 'new' is relatively imprecise—how long had the new perk been a-building? Still, 1525 does provide a useful anchor date. Not all screens were completed as quickly as Burlingham St. Andrew's. At Tunstead bequests for painting range over twenty years, with the perke being described as "new" in 1470. The remarkably well documented Cawston rood screen took even longer to complete, some forty-five years, if the 1460 bequest of 10 marks 13s 4d to the roodloft signals the beginning of the project (a mark was valued at two-thirds of a pound). A 1490 bequest paid for painting the north side, and there were further painting bequests in 1492 and 1494, with four marks provided in 1504 for one pane. The bequest for a four-mark pane provides a benchmark for the cost of a screen in the first decade of the sixteenth century. Elaborate gesso effects, as at Cawston, Aylsham, or Loddon, account for increased cost; simpler screens could have been contracted more economically. One wonders whether cruder screens were so for financial reasons or whether they turned out to be bad bargains for the money.

The piecemeal patronage at Cawston can be posited in other instances where more than one artist painted the panels, e.g., at Aylsham, Walpole St. Peter, Trunch, and Ludham. Eamon Duffy (1997) has argued that such patronage probably reflects the hierarchy of parish social structure. He conjectures that at Ludham John Salmon's wife Lucy initiated the gift on his death in 1486, with other donations recorded in 1487, 1490, 1491, 1492, 1506, and 1508. The date inscribed on the screen is 1493; presumably the

later small donations went for minor details of completion. Such piecemeal funding, however, did not mean haphazard organization. At Cawston a decision must have already been taken to represent the twelve apostles before painting began. The first artist painted Agnes, Helen, and six apostles on the north as well as the two first apostles on the south. A second artist was paid to paint the Latin Doctors on the doors, and a third painted the remaining apostles on parchment, which was then affixed to the screen. The division of labor is even more curious at Ludham, especially since the bequests are concentrated within six years. A mediocre painter did the first four panes on the south, perhaps the initial work: Gregory, Jerome, Edward the Confessor, and Walstan. A more gifted artist produced the two last panes on the south and the six figures on the north; these included Augustine, Ambrose, Edmund, and Henry VI. Whatever the sequence of work, the decision to represent two Latin Doctors and two English kings committed the second painter to complete the series. This also throws light on the failed pattern at Potter Heigham. Someone, presumably a donor, could and did feel free to ignore pattern, preferring a favored saint (Eligius) over the fourth evangelist.

Where testamentary evidence fails, dating is typically based on stylistic criteria, with predictable differences of opinion. One of the most interesting puzzles concerns a number of screens using the same stencils and cartoons. The work is unmistakable: striking designs on fabrics (an eagle on John's gown at Ranworth), "spider-web" haloes, distinctive counterchanged geometric pattern on the pavement (**FIG w**), as well as similarities in posture and modeling. I have called this "shop," for want of a better name, the Damask Workshop. Pauline Plummer (1979) has conjectured that the distinctive fabrics may have been based on silk from Lucca. Similar designs were used on the Barton Turf screen, though the work is stylistically distinct from the other screens

w. Pavement, Damask Workshop.

dated over a forty- or fifty-year period. Plummer, who has conserved most of the screens in Norfolk, described the workshop in an article on the Ranworth rood screen, attributing at least ten screens in Norfolk and northern Suffolk to this shop. Ranworth has been variously dated in the 1430s (Tudor-Craig), c1450 (Morgan), and the 1470s or 1480s (Wilson). The issue is complicated there because three different elements need dating: the rood screen itself, the retables for the north side altar (the south has a 1479 bequest), and the par close screens. The joinery links the screen to that at Attleborough, one of whose donors died in 1446, so a mid-century date is reasonable for the woodwork. Since the principal screen would have been completed before the side altars, a date before the end of the third quarter of the century must be assumed. Plummer thinks it possible that Ranworth was the work of two different generations. She divides workshop screens stylistically into two groups, the first (and earlier) comprising Ranworth, Hunstanton, and North Walsham, and the second at North Elmham, Filby, and Norwich St. James. Four of the screens have testamentary evidence: North Elmham 1457 (to making the pulpitum, *terminus a quo*; Filby 1471 (pulpitum); Norwich St. James 1479 (to paint screen); and Thornham 1488 (donor inscription). The Thornham date is a *terminus ad quem* because there is no bequest in the donor's will (†1488).

Recently John Mitchell has identified direct copying of Continental models at Worstead and cited influence at Aylsham, Cawston, and Marsham. His lavishly illustrated article arrived too late for the plates to be cited in the Subject List.

Appendix VII. Christocentric Sequences: The Joys and Sorrows of the Virgin

THE JOYS OF MARY, variously numbered as five, seven, fifteen, and even twenty five, were celebrated in literature as well as in art. Latin and French texts were widespread (Wilmart 326–36), and John Lydgate wrote two poems, one on the Fifteen Joys (MacCracken no. 50, *IMEV* 553) and one on the Fifteen Joys and Sorrows (MacCracken no. 51, *IMEV* 447, though the printed text cites only fourteen). The Five Joys comprise the Annunciation, Nativity, Resurrection, Ascension, and Assumption/Coronation. The Ascension is sometimes omitted in verse with the Assumption and Coronation cited as separate joys (*IMEV* 2171). The five Joys became seven by adding the Epiphany and Pentecost, though other choices were possible. Morgan (1994, 232) noted that the Seven Joys were rare before the 15c in England (for Sorrows, see Martindale 1989b), the Five and Fifteen being more common. There are no unequivocal examples of the Seven Joys in Norfolk art, but the Five Joys are preserved in a wall painting at Seething, painted wood at Loddon, and preeminently in a series of porch roof bosses at Attleborough, Denton, Hemsby, Hethersett, and Wymondham as well as in the roof bosses in St. Helen's chapel at St. Giles's Hospital, Norwich, where they alternate with paired kings and virgin martyrs. There is also documentary evidence for lost embroidery and painted cloth as well as glass. A fine set is preserved at Saxlingham Nethergate.

The Fifteen Joys are less uniform than the Five. Lydgate's two poems have only nine events in common (**Table 7**). Such textual variations were probably common. The incipit for "Blessed lady, O Pryncesse of mercy" (MacCracken, no 50) identifies the poem as a translation from French, and it is instructive to compare it with an Anglo-Norman poem copied in an early 14c manuscript owned in Norfolk in the fifteenth century (Escorial Library MS. Q II 6; Sandler, *Survey* Cat. 80). Lydgate's source excluded early events from the life of the Virgin and preferred the First Stirrings, the Feeding of the Five Thousand, and the Compassion. In "Atween mydnyght and the fressh morwe gray," however, Lydgate includes apocryphal events from the early life of the Virgin, all events dramatized in the N-Town Marian plays.

Perhaps the best example of the Fifteen Joys in Norfolk is the east window at East Harling.

Twelve of its fifteen scenes are traditional Joys with three drawn from the Passion sequences. Similar mixed sequences are featured in glass at St. Peter Mancroft and in the nave bosses at the Cathedral. The combination of joys and sorrows raises the question of whether such cycles should be treated as Christocentric or Marian. The Flight into Egypt, for example, could be classified as either a sorrow (at threat of death) or a joy (at deliverance). Indeed, all the events of the Infancy cycle can be viewed from two points of view, as events in the life of Jesus or as reactions of Mary to those events. The Presentation of Christ/Purification of the Virgin is a case in point, the same event given two names. Lydgate highlights this difference by treating the Presentation as a Joy in first poem and the Purification in the second as a Sorrow. He cites the "hye Ioye and consolacyon" the Virgin had when she made "a presentacyone" of her Son and Simeon "Withe bothe hys armes hym lowly did enbrace" (no. 50, ll. 101, 103, 105). In contrast, Simeon's prophecy is described as a sharp sorrow: "The dool remembryd whan thu were purifyed . . . the trouble thu feltist of that language" (no 51, ll. 206, 209).

One way to understand these complex sequences is to see them against the manuscript tradition of Infancy and Passion cycles, in short through a Christocentric focus. The traditional illustrations for the eight Hours of the Virgin were almost exclusively drawn from the Infancy: Annunciation, Visitation, Nativity, Shepherds, Magi, Presentation, Flight, and Coronation, all events included in the Fifteen Joys. (In some cases the Massacre of Innocents replaced the Coronation.) Michael Orr has demonstrated how the Infancy Cycle became linked with the Passion Cycle in manuscripts that combined the Hours of the Virgin with the Hours of the Cross. The tendency to interleave the two hours each with separate illustrations or to illustrate them with one mixed set is reflected in much of the parochial art in Norfolk. It is probably not accidental that the best examples of these expanded cycles are found in Norwich or in grand churches like Salle, Martham, and East Harling precisely where manuscript influence can be documented or reasonably projected. At the Cathedral the Joys are concentrated in bays H and M of the nave, the Sorrows in bays J, K, and L. Because the bosses in bay I focus on the public life of Jesus, it is theologically more

accurate to describe the focus of these six bays as Christocentric rather than Marian. On the other hand, the focus at St. Peter Mancroft is more properly Marian, for in addition to traditional Joys and five events from the Passion cycle, scenes (see VIII.2) are drawn from apocryphal events at the end of the Virgin's life treated in *The Golden Legend*, a work owned by the parish (David King,

forthcoming). The contrast between St. Peter Mancroft and the Cathedral could not be more marked, the Virgin playing a central role in a devotionally conceived sequence in the great market church as opposed to a supporting role in a grand theological scheme at the Cathedral beginning with Creation and ending with the Last Judgment.

Table 7
Joys and Sorrows of the Virgin

W Dereham Pr Sandler, *Survey* Cat. 80	Lydgate no. 50	Lydgate no. 51	East Harling cf St. Peter Mancroft
Golden Gate			
Education of Virgin		Presentation	
Suitors of Virgin		Angel Service	
Annunciation	+	+	+
Visitation	+	+	+
Angel and Joseph		Proof of Virginity	
	First Stirring‡		
Nativity	+	+	+
	Shepherds	Shepherds & Magi	Shepherds
Adoration of Magi	+		+
		Flight to Egypt	
Presentation	+		+
Christ & Doctors	+	+	+
Wedding at Cana	+	+	+
	Feeding 5000‡		
	Compassion‡		
Resurrection	+	+	+
Ascension	+	+	+
	Pentecost		Pentecost
		Gift of Palm	
Assumption		Apostles Assembly	
Coronation	Cor & Assump	+	+
		Marrriage	
		False Accusations	
		Flight to Egypt	
		Simeon's Prophecy	
		Loss in Temple	
		Called "Woman"	
			Betrayal
		Christ's Arrest	
		Separation	
		Missing Christ	
		Crucifixion	+
		Last Words	
		Death of Christ	
		Deposition	+
		Burial	

+=Same item as at left
‡Typical in French texts

APPENDIX VIII. *TE DEUM*

THE *TE DEUM* was sung at the end of Matins on feast days and Sundays outside of Lent and Advent, and also in times of calamity (Connelly 15). Its verses address the principal estates of the heavenly kingdom: angels ("Tibi omnes angeli"), apostles ("Te gloriosus apostolorum chorus") prophets ("Te prophetarum laudabilis numerus"), martyrs ("Te martyrum candidatus laudat exercitus"), and others ("sancta confitetur ecclesia"), a hierarchy parallel to the liturgical estates represented in Nofolk art. *Te Deum* verses figured in a number of compositions (I.3), but the estates themselves were also represented in alabaster (Cheetham 1984). Although no alabaster altarpiece survives intact in Norfolk, there is strong evidence that one existed in Norwich. Preserved today are four tables without text citation. The one at the Cathedral comprises Order angels; the one formerly on display at St. Peter Hungate, apostles; at St. Stephen, prophets; and at St. Peter Mancroft, women (including four martyrs). Norwich provenance is firmly established for all four tables. By 1892 when Nelson wrote his article, three of the four were in their current sites. The Cathedral inventory for the Order angel table, originally at the Bishop's Palace, cites its provenance as untraced. The apostle tablet (Norfolk Museums Service) was in the possession of a Minor Canon at the Cathedral in 1892 (Nelson) but came from the collection of R. A. Phipson, a well-known Norwich architect involved in restoration. St. Peter Mancroft alone has documentary evidence, an undated will citation of "Four marks to purchase a table of alabaster of nine female saints for St. Peter's church, Norfolk" (Ord, 94), certainly the same tablet unearthed in the graveyard in the eighteenth century and passed through the hands of a Norwich physician before being given to the church. It was in the church by 1745 and is today on display in the side chapel formerly dedicated to St. Nicholas. This mosaic of evidence supports an argument for a *Te Deum* altarpiece in Norwich. The series of tables would have been arranged around a central scene, the Majesty as at Saffron Walden, the Trinity as at Genoa (Nelson, 114–5), or the Crucifixion. Given the importance of the Crucifix Trinity at the Cathedral, and the extensive devotion to the Trinity documented at St. Peter Mancroft, it is attractive to hypothesize such a central scene for the Norwich altarpiece. In the remarkable inventory of vestments at St. Peter Mancroft were two copes with the Trinity and orphreys with apostles and virgins on one, and apostles and prophets on the other (Hope [1901] 196–7).

The second type of *Te Deum* composition focuses on its text. Unless the accidents of preservation are badly skewed, this composition was favored in glass and woodwork, typically with angels holding scrolls on which lines of text are painted. It is possible that Order angels preserved in glass may have functioned in these compositions rather than in hierarchies since the *Te Deum* cites "angeli," "universae potestates" as well as cherubim and seraphim. Extant glass is fragmentary, but G. King made a drawing of what must have been a fine main light at Ringland. The Crucifix Trinity is central with angels in the surrounding border. King's drawing is damaged around the edges, but two small angels hold scrolls inscribed with the opening verses: "Te deum laudam*us* te dominu*m con*fite[mur]; and "Te ete[rnu]m p[atrem]." Further texts were recorded in the eighteenth century (NRO, Rye 17, 3:142–3, and Rye 6, 2:368). Texts are also preserved at East Harling and in Norfolk glass in the Burrell Collection.

The *Te Deum* also appears in woodwork, either carved or painted. In addition to fragmentary remains, the magnificent Knapton roof incorporates text and figures, apostles and representative prophets, martyrs, and other members of Holy Church. Although details have been obscured by damage and restoration, the original plan is clear. Demi-angels with inscribed *Te Deum* scrolls are situated on opposing hammerbeams on the upper range. The angel at S3 sings "Te deum" while the one at N3 responds "Laudamus"; similarly at N5 and S5, "Te Dominum" and "Confitemur." "Amen" is at S10. An angel in the second rank with a scroll inscribed "Majes[tatis]" breaks the pattern, joining the angel musicians there who accompany the *Te Deum* on organ, shawm, harp, lute, and fiddle and eight angels with instruments of the Passion giving glory to the Son ("tu devicto mortis aculeo aperuisti"). The wallpost figures, although very dark and badly worn, probably included all twelve apostles as well as prophets. Elias and Jonas are at N3 and S3, though Matthew and one prophet also appear in the topmost rank. The original plan may have been for the angel at the foot of the wallpost to

carry the attribute of the figure above, the relationship having been lost. These angels, already missing in the eighteenth century, were replaced in the 1882 restoration. We know that in 1890 the roof was covered in yellow with figures picked out in red, green, and white (Fox 71). More recently restored in 1932, the roof deserves the sort of careful study only possible from a scaffold in order to determine the full extent of restoration.

SELECTED BIBLIOGRAPHY

Unpublished Sources

Abbreviations

Arch J	*The Archaeological Journal*
EDAM	Early Drama, Art, and Music
EETS	Early English Text Society
HMSO	Her Majesty's Sationery Office
JBAA	*Journal of the British Archaeological Association*
JBSMG	*Journal of the British Society of Master Glass Painters*
NA	*Norfolk Archaeology*
NARG	*Norfolk Archaeology Rescue Group News*
TMBS	*Transactions of the Monumental Brass Society*
VCH	Victoria County History

I. Unpublished Materials

Cambridge, Fitzwilliam Museum, MS. 55. Book of Hours, etc.

Cambridge, University Library, MS. Dd.12.67. Book of Hours.

London, British Library, Add. MSS. 6738, 6756, 6758. Thomas Kerrich. Original Notebooks.

— Add. MS. 9370. Benjamin Mackerell. An Account of the Parish Church of St. Peter Mancroft in the City of Norwich. 1736.

— Add. MS. 12,525. Benjamin Mackerell. The Monumental Inscriptions, Fenestral and Other Arms in the Parish Churches of Norwich. 1723.

— Add. MS. 12,526. Benjamin Mackerell. Norfolk Churches. n.d.

— Add. MS. 23,011. Benjamin Mackerell. A Brief Historical Account of S Peters of Mancroft Church in the City of Norwich. 1736.

— Add. MSS. 23,013–23,062. The first eleven volumes are a large-paper copy of the second edition of Blomefield's *History* (see below). The Norwich volumes (23,015–16) have additional plates and drawings. 23,024–62 are described as A Collection of Engravings, Etchings, and Original Deeds Formed towards the Illustration of a Copy of Blomefield's History of Norfolk in the Library of Dawson Turner, Esq. Vols. 24–52 comprise the first series; 53–62 a second series of additional drawings. Both series

are alphabetically arranged. Cited as DT + last two digits, e.g., DT 58 is BL Add. MS. 23,058. See Hepworth for a description of the entire collection.

— Arundel MS. 83 I. Howard Psalter.

— Royal MS. 19.B.XV. Apocalypse.

— Stowe MS. 12. Stowe Breviary.

Norwich Cathedral, Dean and Chapter Library. W. T. Bensly, Typescript notes on the Transept Bosses, 1893.

— Courtauld Institute of Art [*et al.*]. "The Polychromy of the Norwich Cathedral Cloister Bosses," A Report for the Dean and Chapter, December 1992.

— Helen Howard, "The Ante-Reliquary Chapel, Norwich Cathedral: Scientific examination of the wall paintings," Conservation of Wall Painting Department, Courtauld Institute of Art, March 1995.

— Martial Rose, "Norwich Cathedral Roof Bosses," 2 vols., typescript. 1997.

— Norwich Cathedral Inventory, Concise Catalogue. 1999.

Norwich, Garsett House. Charles Sugden Talbot, Collectanea Sepulchralia, 2 notebooks of drawings of brasses.

Norwich, Norwich Museums and Archaeology Service. *Individual holdings classified below by site.*

— Bridewell Museum, MS. 158.926/4c. Psalter.

— — MS. 158.926/4f. Book of Hours.

— — Weybridge Calendar, 134.944.

— Castle Museum, MS. 1993.196. Helmingham Breviary.

— Department of Prints and Drawings. Todd Blomefield (unbound).

Norwich, Local Studies Library, Public Library. The Neville-Rolfe Blomefield, 33 vols.

Norwich, Public Library, MS. TC 27/1. Berengaudus, *In Apocalypsim*.

Norfolk Record Office (Norwich). Frere MSS. C.3.8 & C.3.9.

— Goddard Johnson, Notes on Blomefield, c1840. 2 vols. bound together. Vol. 1 paginated with numbers entered sporadically; vol. 2 largely numbered with intermittent pagination.

— Rye MS. 3. Anthony Norris. History of E. and W. Flegg, Happesburg, Tunstead and part of N Erpingham.

— Rye MS. 6. Anthony Norris. History and Antiquities of Diverse Towns.

— Rye MS. 17. Collection of Church Notes by Thomas Martin and Others. 7 vols. Hand-dated 1782. Citations to Martin are to this work unless stated otherwise.

— Rye MS. 123. Thomas Martin of Palgrave, notebook.

— Rye MS. 134. Walter Rye. Collections for a History of Shipden and Cromer.

— DN/ADR/27/14. Various papers regarding St. John de Sepulchre (compiled by Major Patrick King).

Oxford, Bodleian Library. MS. Bodley 316. Ranulf Higden, *Polychronicon*.

— MS. Bodley 758. Michael de Massa, *On the Passion of Our Lord*.

— Bodley Rolls 5. Genealogy of the Kings of England.

— Bodley Rolls 10. Lines of Descent from Noah, Genealogy of the Kings of England.

— MS. Don. d.85. Offices and Prayers.

— MS. Gough Norfolk 2, 4–13, 15, 22–23. Blomefield collections.

— MS. Gough Norfolk 30, 34–39. La Neve collections.

— MS. Hatton 1. Missal, Use of Sarum.

— MS. Hatton 18. William of Nasington, *Speculum vitae*.

— MS. Jones 46. Book of Hours.

— MS. Lat.th.e 7. *Sermones domincales.*

— MS. Liturg. 153. Psalter.

— MS. Tanner 17. *The South English Legendary.*

— MS. Tanner 407. Robert Reynes, Commonplace Book.

— MS. Top. Oxon a.1.17.

Paine, Stephen. Wall Painting Conservation Report, St. Nicholas, Potter Heigham, Norfolk, August 1996.

Perry, Mark. Wall Painting Conservation Record St. Gregory's Church, Pottergate, Norwich, Norfolk. June, 1999.

Ranworth, St. Helen's Church. Antiphonal.

II. Published Sources

The bibliography does not include all sources checked in the preparation of the Subject List. Much information is repeated in pamphlets and ephemeral publications difficult to access except in specialized collections. I have cited only major works or those in which I first accessed information.

Alexander, Jonathan. "The Pulpit with the Four Doctors at St. James's, Castle Acre, Nor-folk." In Rogers (1994), 198–206.

_____ and Paul Binski, eds. *Age of Chivalry: Art in Plantagenet England 1200–1400*. London: Weidenfeld and Nicolson, 1987.

Alford, Lady M. *Needlework as Art*. London: Sampson Low, Marston, Searle, and Rivington, 1886.

Anderson, M. D. *Drama and Imagery in English Medieval Churches*. Cambridge: Cambridge University Press, 1963.

_____. *History and Imagery in British Churches*. London: John Murray, 1971.

_____. *The Imagery of British Churches*. London: John Murray, 1955.

_____. *A Saint at Stake: The Strange Death of William of Norwich 1144*. London: Faber and Faber, 1964.

André, J. Lewis. "Female Head-dresses Exemplified by Norfolk Brasses," *NA* 14 (1901): 241–62.

_____. "Mural and Other Paintings in English Churches," *Arch J* 45 (1888): 400–21.

_____. "St. George the Martyr in Legend, Ceremonies, Art, Etc.," *Arch J* 57 (1900): 204–23.

Andrews, Phil. "St. George's Nunnery, Thetford," *NA* 41 (1993): 427–40.

Archer, Michael. *An Introduction to English Stained Glass*. London: HMSO, 1985.

Astley, J. H. Dukinfield. "A Group of Norman Fonts in North-West Norfolk," *NA* 16 (1905): 97–116.

_____. *Two Norfolk Villages*. Norwich: Goose, 1901.

Atherton, Ian, *et al. Norwich Cathedral: Church, City and Diocese, 1906–1996*. London: Hambledon Press, 1996. Cited as Atherton.

Atkin, M. W. "A 14th-Century Pewter Chalice and Paten from Carrow Priory, Norwich," *NA* 36 (1983): 374–79.

Badham, Sally. "Status and Salvation: The Design of English Brasses and Incised Slabs," *TMBS* 15 (1996): 413–65.

Baines, Anthony. "Fifteenth Century Instruments in Tinctoris's *De inventione et usu musicae*," *Galpin Society Journal* 3 (March 1950): 19–25.

Baker, Eve. "The Adoration of the Magi at Shelfanger Church, Norfolk," *NA* 34 (1966): 90–91.

Bardswell, Monica. "Some Recent Discoveries in Paston." *NA* 22 (1925): 190–93.

_____. "Wall Paintings Recently Uncovered at

Seething and Caistor by Norwich," *NA* 22 (1926): 338–40.

Barasch, F. K. "Norwich Cathedral: The Bauchun Chapel Legend of the Accused Queen," *EDAM Review* 15 (Spring 1993): 63–75.

Barnes, John S. *A History of Caston, Norfolk*. Orpington, Kent: John S. Barnes, 1974.

Batcock, Neil. *The Ruined and Disused Churches of Norfolk*. East Anglian Archeology Report 51. Norwich: Norfolk Archaeological Unit, 1991.

Bately, John. "Recent Discoveries on the Site of Grey Friars, Great Yarmouth," *NA* 13 (1898): 21–32.

Bayfield, T. G. "A Descriptive Catalogue of the Seals of the Bishops of Norwich," *NA* 1 (1847): 305–23.

Beal, William. "Letter . . . to Dawson Turner . . . Descriptive of Certain Mural Paintings," *NA* 3 (1852): 62–70.

Beeching, D. C. *Chapels and Altars of Norwich Cathedral*. Norwich: Goose and Son, 1916.

Beloe, Edward Milligen, "A Cemetery Cross of the 'Blackfriars' at Lynn," *NA* 9 (1880): 346–58.

_____. *Our Borough: Our Churches (King's Lynn, Norfolk)*. Cambridge: Macmillan and Bowes, 1899.

Bensly, W. T. "On Some Sculptured Alabaster Panels in Norwich," *NA* 11 (1892): 352–58.

_____. "St.. Leonard's Priory, Norwich," *NA* 12 (1895): 190–227.

Bertram, Jerome, ed. *Monumental Brasses as Art and History*. Stroud: Alan Sutton, 1996.

_____. "Orate Pro Anima: Some Aspects of Medieval Devotion Illustrated on Brasses," *TMBS* 13 (1983): 321–42.

Binski, Paul. "The Coronation of the Virgin on the Hastings Brass at Elsing, Norfolk," *Church Monuments* 1 (1985): 1–9.

_____. *The Painted Chamber at Westminster*. Society of Antiquaries, Occasional Paper, n.s. 9. London, 1986.

Birch, C. G. R. "On Certain Brasses at Necton and Great Cressinghamn," *NA* 12 (1895): 298–303.

Birch, W. de G. *Catalogue of Seals in the Department of Manuscripts in the British Museum*. Vols. 1, 2, 5. London: Longmans, 1887, 1892, 1898. Cited as *BM Cat. of Seals*; seals cited by catalogue number.

Blomefield, Francis (with continuation by C. Parkin *et al.*). *An Essay Towards a Topographical History of the County of Norfolk*. 11 vols. London, 1805–10.

Boileau, John P. "Notes on Some Mural Paintings Recently Discovered in Eaton Church," *NA* 6 (1864a): 161–70.

_____. "Returns of Church Goods in the Churches of the City of Norwich," *NA* 6 (1864b): 360–78.

Bolingbroke, Leonard. "The Reformation in a Norfolk Parish," *NA* 13 (1896): 199–216.

Bolingbroke, N. "Mural Painting of St. Christopher at St. Etheldred's Church, Norwich," *NA* 9 (1880): 343–45.

Bond, Francis. *Dedications and Patron Saints of English Churches*. London: Oxford University Press, 1914.

_____. *Fonts and Font Covers*. 1908; reprint, London: Waterstone, 1985.

_____. *Wood Carving in English Churches*. I. *Misericords* (a); II. *Stalls* (b). London: Oxford University Press, 1910.

_____ and Dom Bede Camm. *Roodscreens and Roodlofts*. London: 1909.

Bonner. "Alabaster Fragments from East Rudham Church," *Norfolk Archaeology* 8 (1879): 328–29.

Borenius, Tancred. "The Iconography of St. Thomas of Canterbury," *Archaeologia* 79 (1929): 29–55.

_____. "Medieval Paintings from Castle Acre Priory," *Antiquaries Journal* 17 (1937): 115–21.

Borenius, Tancred, and E. W. Tristram. *English Medieval Painting*. Paris: Pegasus Press, 1927.

Borg, Alan, Jill Franklin, *et al. Medieval Sculpture from Norwich Cathedral*, Catalogue. Norwich: Sainsbury Centre for Visual Arts, 1980.

Bradfer-Lawrence, H. L., ed. "Calendar of Frere MSS.: Hundred of Holt." *Norfolk Record Society* 1 (1931): 3–40.

Brandon, Raphael and J. Arthur. *Parish Churches*. London: George Bell, 1848.

Briggs, O. M. "Some Painted Screens of Norfolk," *Royal Institute of British Architects Journal*, 3rd ser. 41 (1933–34): 997–1015.

Brindley, H. H. "Notes on Mural Paintings of St. Christopher in English Churches," *Antiquaries Journal* 4 (1924): 227–40.

_____. "Saint Christopher." In Ingleby, 299–314. References to Brindley are to this source unless stated otherwise.

Britton, John. *The History and Antiquities of the See and Cathedral Church of Norwich.* London, 1816

Brown, Sir Thomas. *Repertorium: or, Some Account of the Tombs and Monuments in the Cathedral Church of Norwich in 1680,* in *Posthumus Works.* London, 1712.

Bryant, Thomas Hugh. *The Churches of Norfolk.* Norwich: Norfolk and Norwich Archaeological Association, 1898–1915.

Bruna, Denis. *Enseignes de Pélerinage et Enseignes Profanes.* Paris: Editions de la Reunion des musées nationaux, 1996.

Bühler, Curt F. "The Apostles and the Creed," *Speculum* 28 (1953): 335–39.

Bullmore, William R. "Notes on the Architecture and Wood-carving of the Church of St. Mary the Virgin, Wiggenhall," *NA* 19 (1917): 314–32.

Bulwer, James. "Notices of the Church at Wells," *NA* 5 (1859): 81–88.

Buzza, David Thomas. "English Female Costume 1400–1485 as Represented on Monumental Brasses and Brass Rubbings," 2 vols. Ph.D diss., University of Minnesota, 1986.

Caiger-Smith, A. *English Medieval Mural Paintings.* Oxford: Clarendon Press, 1963.

Camm, Bede. "Some Norfolk Rood-Screens." In Ingleby, 237–95.

Cameron, H. K. "Attributes of the Apostles on the Tournai School of Brasses," *TMBS* 13 (1983): 283–303.

_____."The Fourteenth-Century Flemish Brasses at King's Lynn," *Arch J* 136 (1980 [for 1979]): 151–72. References to Cameron are to this work unless stated otherwise.

Cardwell, Edward. *Documentary Annals of the Reformation of the Church of England.* Oxford: Oxford University Press, 1894.

Carter, E. H. *Studies in Norwich Cathedral History.* Norwich: Jarrold and Sons, 1935.

Carthew, G. A. "Extracts from Papers in the Church Chest of Wymondham, *NA* 9 (1884):121–52, 240–74.

_____. *The Hundred of Launditch and the Deanery of Brisley,* 3 pts. Norwich: Miller and Leavins, 1877–79.

_____. "North Creake Abbey," *NA* 7 (1872): 153–68.

_____. *Proceedings of the Society of Antiquaries,* 2nd ser., 3 (1867): 386–90.

Cattermole, Paul. *Church Bells and Bell-Ringing: A Norfolk Profile.* Woodbridge: Boydell Press, 1990.

_____. "St. Margaret's Church, Hardley, Norfolk," *NARG* 34 (1983): 15–20.

_____ and Simon Cotton. "Medieval Parish Church Building in Norfolk," *NA* 38 (1983b): 235–79. Cited as C & C.

_____ and Simon Cotton. "Martham Church Redated—Murphy's Law at Work," *NARG* 33 (1983a): 20–21.

Cautley, H. Munro. *Norfolk Churches.* 1949; reprint Ipswich: Boydell Press, 1979.

_____. *Suffolk Churches and Their Treasures,* 5th ed. Woodbridge: Boydell Press, 1982.

Cave, C. P. J. *Roof Bosses in Medieval Churches: An Aspect of Gothic Sculpture.* Cambridge: Cambridge University Press, 1948.

_____. "The Roof Bosses in the Chancel of Salle Church," *NA* 25 (1935): 368–72.

_____. "The Roof Bosses in the Transepts of Norwich Cathedral Church," *Archaeologia* 83 (1933): 45–65.

Caviness, M. H. "The Stained Glass from the Chapel of Hampton Court," *The Walpole Society* 42 (1968–70): 56–60.

Chadd, David. "The Medieval Customary." In Atherton, 314–22.

Cheetham, Francis. *English Medieval Alabasters: With a Catalogue of the Collection in the Victoria and Albert Museum.* Oxford: Phaidon, 1984. Cited as Cheetham.

_____. "A Fifteenth-Century English Alabaster Altarpiece in Norwich Castle Museum," *Burlington Magazine* 125 (June 1983): 356–59.

_____. *Medieval English Alabaster Carvings in the Castle Museum Nottingham.* 1962; reprint Nottingham: Art Galleries and Museums Committee, 1973.

_____. "Medieval English Alabaster Figure of St. Paul," *NA* 35 (1970): 143–44.

Christie, A. G. I. *English Medieval Embroidery.* Oxford: Clarendon Press, 1938.

Clark, H. O. "An Eighteenth-Century Record of Norfolk Sepulchral Brasses," *NA* 16 (1936): 85–102.

Cole, William. *A Catalogue of Netherlandish and North European Roundels in Britain.* Corpus Vitrearum Medii Aevi, Great Britain, Summary Catalogue 1. Oxford: Oxford University Press, 1993.

Colling, James. *Gothic Ornament,* 2 vols. London: George Hall, 1848–53. All references are to illustrations.

Compton, C. H. "Creake, Norfolk: Its Abbey and Churches," *JBAA* 46 (1890): 201–20.

Connelly, Joseph. *Hymns of the Roman Liturgy.* Westminster, Maryland: Newman Press, 1957.

Constable, W. G. "Some East Anglian Rood Screen Paintings," *Connoisseur* 84 (1929): 141–47 (Ranworth, North Burlingham), 211–13 (Hempstead, Ludham).

Cooper, Trevor, ed. *The Journal of William Dowsing.* Woodbridge: Boydell Press, 2001.

Cotman, John Sell. *Engravings of Sepulchral Brasses in Norfolk and Suffolk,* 2 vols. London, 1839. Vol. 2 in 2 pts. (1838) with separate title page, *Engravings of Sepulchral Brasses in Suffolk.* 2nd ed. with additional plates, incomplete portfolio at Dean and Chapter Library, Norwich Cathedral.

_____. *A Series of Etchings Illustrative of the Architectural Antiquities of Norfolk.* London: Longman, 1816–18.

_____. *Specimens of Architectural Remains in Various Counties in England, but Principally in Norfolk.* London: Henry Bohn, 1838.

_____. *Specimens of Norman and Gothic Remains in the County of Norfolk.* London, 1838.

Cotton, Simon. "Building the Late Mediaeval Church," *NARG* 16 (1979): 10–16.

_____. "Clutching at Straws: Mediaeval Churchbuilding Revisited Yet Again," NARG 31 (1982): 1–7.

_____. "Indulgences for Building Norfolk Churches," *NARG* 51 (1987b): 11–16.

_____. "Mediaeval Rood Screens in Norfolk—Their Construction and Painting Dates," *NA* 40 (1987): 44–54. Cited as Cotton.

_____. "The Medieval Church's Development," *NARG* 44 (1986): 1–11.

_____. "Nice Things in Small Packages," *NARG* 49 (1987a): 8–14.

_____. "On the Coexistence of Curvilinear and Perpendicular," *NARG* 32 (1983): 1–8.

_____. "Some Norfolk Medieval Architects," *NARG* 40 (1985) ll–18.

_____. "South of the Border," *NARG* 38 (1984): 9–12.

_____. "Tradition and Authority in Churchbuilding," *NARG* 26 (1981): 8–13.

_____ and Richard Fawcett. "Further Aspects of Mediaeval Churchbuilding," *NARG* 28 (1982): 5–14.

_____ and Roy Tricker. "St. Mary Magdalene Wiggenhall, A Brief Guide." N.p., n.d.

Cowen, Painton. *A Guide to Stained Glass in England.* London: Michael Joseph, 1985.

Cox, J. Charles. *Bench-Ends in English Churches.* London: Oxford University Press, 1916.

_____. *Churchwardens' Accounts from the Fourteenth to the End of the Fifteenth Century.* London: Methuen, 1913.

_____. *County Churches, Norfolk,* 2 vols. London: George Allen, 1911.

_____. *The Parish Registers of England.* 1910; reprint Totowa, N.J.: Rowman and Littlefield, 1974.

_____ and A. Harvey. *English Church Furniture.* London: Methuen, 1907.

Cozens-Hardy, B. "Norfolk Crosses," *NA* 25 (1932–34): 297–336.

Cresswell, I., and Dennis G. King. "A Fourteenth-Century Glass Roundel," *NA* 34 (1968): 437.

Crewe, Sarah. *Stained Glass in England: 1180–1540.* London: HMSO, 1987.

Crossley, F. H. *English Church Craftmanship.* London: B. T. Batsford, 1941.

Dashwood, George Henry. "Mural Paintings in the Church of Stow Bardolph," *NA* 3 (1852): 134–39.

_____. "Notes on the Gaswell Pedigree," *NA* 5 (1859): 277-286.

_____ and C. Boutell. "Notes on the Parish and Church of Wimbotsham," *NA* 2 (1849): 127–48.

Davidson, Clifford. "The Anti-Visual Prejudice" and "The Devil's Guts." In *Iconoclasm vs. Art and Drama,* ed. Clifford Davidson and Ann Eljenholm Nichols, 33–46, 92–144. EDAM Monograph Series 11. Kalamazoo: Medieval Institute Publications, 1989.

_____. *Illustrations of the Stage and Acting in England to 1580.* EDAM Monograph Ser. 16. Kalamazoo: Medieval Institute Publications, 1991.

_____, ed. *Material Culture and Medieval Drama.* EDAM Monograph Ser. 25. Kalamazoo: Medieval Institute Publications, 1999.

_____, ed. *The Saint Play in Medieval Europe.* EDAM Monograph Series 8. Kalamazoo: Medieval Institute Publications, 1986.

_____ and Jennifer Alexander. *The Early Art of*

Coventry, Stratford-upon-Avon, Warwick, and Lesser Sites in Warwickshire. EDAM Reference Series 4. Kalamazoo: Medieval Institute Publications, 1985.

_____ and David E. O'Connor. *York Art*, EDAM Reference Series 1. Kalamazoo: Medieval Institute Publications, 1978.

Dennison, Lynda. "The Artistic Context of Fourteenth Century Flemish Brasses," *TMBS* 14 (1986): 1–38.

Dickinson, Francis H., ed. *Missale ad usum insignis et praeclarae ecclesiae Sarum*. 1861–83; reprint Farnborough, 1969.

Dodwell, Barbara. "The Monastic Community." In Atherton, 231–54. Cited as Dodwell 1996.

_____. "William Bauchun and his Connection with the Cathedral Priory at Norwich," *NA* 36 (1975): 111–18.

Druce, G. C. "The Elephant in Medieval Legend and Art," *Arch J*, 76 (1919): 1–73.

_____. "Some Abnormal and Composite Human Forms in English Church Architecture," *Arch J* 72 (1915): 135–86.

Druitt, Herbert. *A Manual of Costume as Illustrated on Brasses*. London: De la More Press, 1906.

Duffy, Eamon. "The Parish, Piety, and Patronage in Late Medieval East Anglia: The Evidence of Rood Screens." In *The Parish in English Life 1400–1600*, ed., Katherine L. French *et al.*, 133–162. Manchester: Manchester University Press, 1997.

_____. *Saints and Sinners: A History of the Popes*. New Haven: Yale University Press, 1997.

_____. *The Stripping of the Altars: Traditional Religion in England 1400–1580*. New Haven: Yale University Press, 1992.

Dymond, David. *The Register of Thetford Priory*, pt. 1 (1482–1517), pt. 2 (1518–40). Records of Social and Economic History 24–25. Oxford: Oxford University Press, 1995–96. Also published as Norfolk Record Society, 59–60.

East Anglian Archaeology Report, no. 15. Excavations in Norwich 1971–1978. Norwich: Norwich Survey, 1982.

_____, No. 18. The Archaeology of Witton, near North Walsham. Norwich: Norfolk Archaeological Unit, 1983.

_____, No. 26. Excavations in Norwich 1971–1978, Part 2. Norwich: The Norwich Survey, 1985.

Ecclesiologist's Guide to the Deaneries of Brisley, Hingham, and Breccles, The, pt. 1. London, n.d.

Egan, Geoff, Frances Pritchard, *et al. Dress Accessories c1150–c1450*. Medieval Finds from Excavations in London 3. London: HMSO, 1991.

Ellis, H. D. "The Wodewose in East Anglian Church Decoration," *Suffolk Institute of Archaeology and Natural History* 14 (1912): 287–93.

Erwood, F. C. Elliston, "The Premonstratensian Abbey of Langley," *NA* 21 (1923): 175, 186–88.

Eve, Julian. *A History of Horsham St. Faith Norfolk*. Norwich: J. R. Eve, 1994.

_____. *Saints and the Painted Rood-Screens of North East Norfolk*. Norwich: Hussey and Knights, 1997.

Evans, H. F. Owen. "The Holy Trinity on Brasses," *TMBS* 13 (1982): 208–23.

_____. "The Penner and Inkhorn on Brasses and Incised Slabs," *TMBS* 11 (1971): 128–35.

"Extracts from the Account-Rolls of Norwich Priory: Illustrative of Painting, Pigments, &c," *Proceedings of the Archaeological Institute, Norwich, 1846*. London, 1851.

"Extracts from Proceedings and General Meetings," *NA* 6 (1860–64): 379–87; 7 (1865–72): 349–74; 8 (1874–79): 326–41; 18 (1911–14): i–lxiii. Cited as "Extracts."

Falkner, T. Felton. "Notes on the Sculptured Parapet on the Tower of St. Mary's Church, Burnham Market," *NA* 17 (1910): 277–83.

Farmer, David. *Oxford Dictionary of Saints*, 4th ed. Oxford: Oxford University Press, 1997.

Farnhill, Kenneth Scott. "Gilds and the Parish Community in Late Medieval East Anglia, c. 1470–1550." Cambridge University, Ph.D. Thesis, 1998.

Farrer, Edmund. *A List of Monumental Brasses Remaining in the County of Norfolk*. Norwich: Goose, 1890.

_____. *A List of Monumental Brasses Remaining in the County of Suffolk*. Norwich: Goose, 1903.

Fawcett, Richard. "A Group of Churches by the Architect of Great Walsingham," *NA* 37 (1980): 277–93.

_____. "The Influence of the Gothic Parts of the Cathedral on Church Building in Norfolk." In Atherton, 210–27. Cited as Fawcett

1996.

Fernie, Eric. *An Architectural History of Norwich Cathedral*. Oxford: Clarendon Press, 1993.

_____ and A. B. Whittingham. *The Early Communar and Pitancer Rolls of Norwich Cathedral Priory with an Account of the Building of the Cloister*. Norfolk Record Society 41. 1972.

Finch, Jonathan. "The Monuments." In Atherton, 467–93.

Firth, Catherine B. "Village Gilds of Norfolk in the Fifteenth Century," *NA* 18 (1914): 161–203.

Fitch, Robert. "Seal of the Benedictine Nunnery at Carrow," *NA* 1 (1847): 252–54.

Fox, G. E. "Notes on Painted Screens and Roofs in Norfolk," *Arch J* 47 (1890): 65–77.

Franklin, Jill A. "The Romanesque Cloister Sculpture at Norwich Cathedral Priory." In Thompson, 56–70.

_____. "The Romanesque Sculpture." In Atherton, 116–35. Cited as Franklin 1996.

Franks, A. W. "Communication on the Cawston Leather Case," *Proceedings of the Society of Antiquaries*, 2nd ser. 14 (1892): 246–54.

Fryde, E. B. *et al. Handbook of British Chronology*, 3rd ed. Cambridge: Cambridge University Press, 1986.

Galloway, David. *Norwich 1540–1642*. Records of Early English Drama. Toronto: University of Toronto Press, 1984.

_____ and John Wasson. *Records of Plays and Players in Norfolk and Suffolk 1330–1642*. Malone Society Collections 11. Oxford, 1980–81.

Gairdner, James. *The Paston Letters A.D. 1422–1509*, 6 vols. London: Chatto and Windus, 1904.

Gardner, Arthur. "The East Anglian Bench-End Menagerie," *JBAA*, 3rd Ser. 18 (1955): 33–41.

_____. *English Medieval Sculpture*. 1935 [*A Handbook of English Medieval Sculpture*]; reprint Cambridge: Cambridge University Press, 1951. All references to Gardner are to the 1951 edition unless stated otherwise.

Gibson, Gail McMurray. *The Theater of Devotion: East Anglian Drama and Society in the Late Middle Ages*. Chicago: University of Chicago Press, 1989.

Gilchrist, Roberta, and Marilyn Oliva. *Religious Women in Medieval East Anglia*. Norwich: Centre of East Anglian Studies, 1993.

Gillett, H. M. Walsingham: *The History of a Famous Shrine*. London: Burns, Oates, and Washbourne, 1950.

_____. "Walsingham Centenary," *Westminster Cathedral Chronicle* 4 (1961): 100–02.

Goodall, John A. "Death and the Impenitent Avaricious King: A Unique Brass Discovered at Frenze, Norfolk," *Apollo*, n.s. 126 (Oct. 1987): 264–66.

Goodrich, Percival J. *The Story of Trunch*. Cambridge: [distributed by] Cambridge University Press , 1939.

Gordon, James D. "The Articles of the Creed and the Apostles," *Speculum* 40 (1965): 634–40.

Gottfried, Robert S. *Epidemic Disease in Fifteenth Century England*. New Brunswick: Rutgers University Press, 1978.

Gough, Richard. *Sepulchral Monuments in Great Britain*, 2 vols. in 3. 1786–96.

Goulburn, E. M. *The Ancient Sculptures in the Roof of Norwich Cathedral*. London, 1876.

_____. "The Confessio or Relic Chapel: An Ancient Chamber in Norwich Cathedral, on the North Side of the Presbytery," *NA* 9 (1884): 275–81.

Grace, Mary, ed. *Records of the Gild of St. George in Norwich, 1389–1547*. Norfolk Record Society 9. 1937.

Green, A. "Romsey Painted Wooden Reredos; with a Short Account of St. Armel," *Arch J* 90 (1934): 306–14.

Green, Barbara. *Norwich Castle: A Fortress for Nine Centuries*. Norwich: Jarrold, 1966.

Green, Charles. "Excavations at Walsingham Priory, Norfolk, 1961," *Arch J* 125 (1969): 257–90.

Greenwood, Roger. "Lost Brasses in Attlebridge and Norfolk," *TMBS* 13 (1983): 347–49.

_____ and Malcolm Norris. *The Brasses of Norfolk Churches*. Holt: Norfolk Churches Trust, 1976.

Grössinger, Christa. *The World Upside-Down: English Misericords*. London: Harvey Miller, 1997,

Gunn, J. *Illustrations of the Rood-screen at Barton Turf*. Norwich: Norfolk and Norwich Archaeological Society, 1869. C. J. W. Winter drawings with notes by Gunn.

_____. "Screen at North Burlingham," *NA* 3 (1852): 19–23. [Letter to Henry Harrod and Richard Hart dated 1849.] Preceding (betw 18 & 19) "A Synopsis of the Paintings upon

Some of the Rood-Screens in the County of Norfolk."

Hale, Richard. *The Churches of King Street Norwich.* Norwich: King Street Publications, 1999.

Harford, Dundas. *A Norwich Parish 500 Years Ago.* Norwich: Frank H. Goose, n.d. [?1905].

Harper-Bill, Christopher. "The Medieval Church and the Wider World." In Atherton, 281–313.

Hart, Richard. *The Antiquities of Norfolk: A Lecture.* Norwich: Charles Muskett, 1844.

_____. "Catalogue of the Emblems of Saints," *Arch J* 1 (1845): 53–63.

_____. *Illustrations of the Rood-screen at Fritton.* Norwich: Norfolk and Norwich Archaeological Society, 1872. C. J. W. Winter drawings with notes by Hart.

_____. "On Misereres with An Especial Reference to those in Norwich Cathedral," *NA* 2 (1849): 234–52.

_____. "The Shrines and Pilgrimages of the County of Norfolk," *NA* 6 (1864): 277–94.

Harrod, Henry. "Extracts from Early Norfolk Wills," *NA* 1 (1847): 111–38, 255–72.

_____. *Gleanings among the Castles and Convents of Norfolk.* Norwich: C. Musket, 1857.

_____. "Goods and Ornaments of Norwich Churches in the Fourteenth Century," *NA* 5 (1859a): 89–121.

_____. "Queen Elizabeth Woodville's Visit to Norwich in 1469," *NA* 5 (1859b): 32–37.

_____. "Some Particulars Relating to the History of the Abbey Church of Wymondham in Norfolk," *Archaeologia* 43 (1871): 264–72.

Harvey, Anthony, and Richard Mortimer. *The Funeral Effigies of Westminster Abbey.* Woodbridge: Boydell Press, 1994.

Harvey, John. *Medieval Craftsmen.* London: B. T. Batsford, 1975.

_____. *The Perpendicular Style.* London: B. T. Batsford, 1978.

Haslam, A. *St. Nicholas' Parish Church, Dersingham, Norfolk.* Dersingham, 1993. Church booklet.

Haward, Birkin. *Nineteenth Century Stained Glass: Gazetteer.* Norwich: George Book and Centre of East Anglian Studies, 1984.

_____. *Suffolk Medieval Church Roof Carvings.* Ipswich: Suffolk Institute of Archaeology and History, 1999.

Hayes, Rosemary. "The 'Private Life' of a Late Medieval Bishop: William Alnwick, Bishop of Norwich and Lincoln." In Rogers, 1–18.

Henig, Martin and T. A. Heslop. "Three Thirteenth-Century Seal Matrices with Intaglio Stones in the Castle Museum, Norwich," *NA* 39 (1986): 305–09.

Henry, Avril, ed. *Biblia Pauperum.* Aldershot: Scolar Press, 1987.

_____, ed. *The Mirour of Mens Saluacioune.* Philadelphia: University of Pennsylvania Press, 1987. Middle English translation of *Speculum humanae salvationis.*

Hepworth, P. "Supplementing Blomefield," *Norfolk Archaeology* A 23 (1929): 285–304.

Heslop, T. A. "The Easter Sepulchre in Norwich Cathedral: Ritual, Transience, and Archaeology." In *Echoes Mainly Musical from Norwich and Around,* ed. Christopher Smith, 17–20. Norwich: Solen Press, 1994.

_____. "The Medieval Conventual Seals." In Atherton, 443–50. Cited as Heslop 1996.

_____. *Norwich Castle Keep: Romanesque Architecture and Social Context.* Norwich: Centre for East Anglian Studies, 1994.

Hill, Percival Oakley. *History of Upton, Norfolk.* Norwich: H. Goose, 1891.

Hope, W. H. St. John. "Castle Acre Priory," *NA* 12 (1895a): 105–57.

_____. "Inventories of the Parish Church of St. Peter Mancroft, Norwich," *NA* 14 (1901): 153–240.

_____. "On a Painted Table or Reredos of the Fourteenth Century, in the Cathedral Church of Norwich," *NA* 13 (1897): 293–314.

_____. "On the Sculptured Alabaster Tablets Called St. John's Heads," *Archaeologia* 52 (1890): 669–708.

_____. "Seals of English Bishops," *Proceedings of the Society of Antiquaries of London,* 2nd ser. 11 (1885–87): 271–306. Cited as Hope (1887).

_____. "Municipal Seals," *Proceedings of the Society of Antiquaries of London,* 2nd ser. 15 (1895b): 434–55.

_____. *Windsor Castle, An Architectural History.* London, 1913.

_____ and W. T. Bensly. "Recent Discoveries in the Cathedral Church of Norwich," *NA* 14 (1901): 105–27.

_____ and T. M. Fallow, "English Medieval Chalices and Patens," *Arch J* 43 (1886):

137–61, 364–402.

_____ and Edward S. Prior. *Illustrated Catalogue of the Exibition of English Medieval Alabaster Work Held in the Rooms of the Society of Antiquaries 26th May to 30th June 1910*. Oxford: Horace Hart, 1913.

Hopper, Edmund C., C. R. Manning, H. S. Radcliffe, and John H. Walter. "Church Plate in Norfolk," *NA* 9 (1884): 68–113; 10 (1888): 66–116; 15 (1902): 44–50; 16 (1907): 31–38, 153–68, 240–66; 17 (1910): 165–92, 263–76; 18 (1914): 23–45, 261–82; 19 (1917): 185–96, 221–37, 310–30; 20 (1921): 22–30, 150–57, 257–72; 21 (1926): 37–51, 143–51, 310–30; 22 (1926): 1–16, 133–46, 260–91; 23 (1929):19–50, 221–40, 341–60; 24 (1930–34):18–31, 262–89.

Hoskins, Edgar. *Horae Beatae Mariae Virginis or Sarum and York Primers*. London: Longmans, Green, 1901.

Hotblack, John T. "The Church of St. Mary Coslany," *NA* 17 (1910): 31–41.

Hudson, Anne. *The Premature Revolution: Wycliffite Texts and Lollard History*. Oxford: Clarendon Press, 1988.

Hudson, William, and John Cottingham Tingey. *The Records of the City of Norwich*. 2 vols. Norwich: Jarrold and Sons, 1906–10.

Hunter, John. "Who is Jan van Eyck's 'Cardinal Nicolo Albergati'?," *Art Bulletin* 75 (1992): 207–18.

Husenbeth, F. C. *Emblems of Saints*, ed. Augustus Jessopp. Norwich: Norfolk and Norwich Archaeological Society, 1882.

_____. "Mural Paintings in Norwich Cathedral," *NA* 6 (1864): 272–76.

_____. "On Some Mural Paintings Discovered in Limpenhoe Church, Norfolk," *NA* 5 (1859): 221–25.

Index Monasticus; *see* R. C. Taylor.

Ingleby, Clement, "Denton and Its Glass," in following entry, 47–69.

_____, ed. *A Supplement to Blomefield's Norfolk*, introd. Christopher Hussey. London: Clement Ingleby, 1929. Plates cited as numbered, not as corrected in the errata sheet. Cited as Ingleby. References are to this edition unless stated otherwise.

Jacobus de Voragine. *The Golden Legend of the Saints as Englished by William Caxton*. 7 vols. Reprint London: J. M. Dent, 1973.

James, Montague Rhodes. *The Apocalypse in Art*. London: Oxford University Press, 1931.

_____. *A Descriptive Catalogue of the Manuscripts in the Fitzwilliam Museum*. Cambridge: Cambridge University Press, 1895.

_____. *A Descriptive Catalogue of the Manuscripts in the Library of Corpus Christi College*. Cambridge: Cambridge University Press, 1912.

_____. ed. *The Dublin Apocalypse*. Cambridge: Roxburghe Club, 1933.

_____. "Legends of SS. Anne and Anastasia," *Proceedings of the Cambridge Antiquarian Society* 9 (1899): 194–204.

_____. "Lives of St. Walstan," *NA* 19 (1917): 238–67.

_____. "On the Wall Paintings in Willingham Church," *Proceedings of the Cambridge Antiquarian Society* 9 (1899): 96–101.

_____. Review of H. C. Whaite, *St. Christopher in English Mediaeval Wall painting*. *Antiquaries Journal* 10 (1929) 75–76.

_____. *The Sculptured Bosses in the Cloisters of Norwich Cathedral*. Illustrated by C. J. W. Winter. Norwich: Norfolk and Norwich Archaeological Society, 1911.

_____. *The Sculptured Bosses in the Roof of the Bauchun Chapel of Our Lady of Pity in Norwich Cathedral*. Norwich, 1908.

_____. *Suffolk and Norfolk*. 1930; reprint Bury St. Edmunds: Alastair Press, 1987. Cited as *S & N*.

_____. "The Wall Paintings in Brooke Church.." In Ingleby, 14–25.

_____. "The Wall Paintings at Wickhampton Church." In Ingleby, 123–42.

_____. *The Western Manuscripts in the Library of Emmanuel College: A Descriptive Catalogue*. Cambridge: Cambridge University Press, 1912.

Jenkins, Simon. *England's Thousand Best Churches*. London: Allen Lane, Penguin Press, 1999.

Jessopp, Augustus, ed. *Visitations of the Diocese of Norwich, A.D. 1492–1532*. Camden Society, n.s. 43. London, 1888.

_____ and Montague Rhodes James. *The Life and Miracles of St. William of Norwich by Thomas of Monmouth*. Cambridge: Cambridge University Press, 1896.

Jones, Mrs. Herbert. "Notes on Harpley Church," *NA* 8 (1879): 17–38.

_____. "Notes on Sculthorpe Church," *NA* 7 (1872): 321–40

Kelly, E. R., ed. *Kelly's Directory of*

Cambridgeshire, Norfolk and Suffolk. London: Kelly, 1883, 1888, 1900, 1904, 1912, 1937. Published under a variety of titles.

Kent, Ernest A. "The Mural Painted of St. George in St. Gregory's Church, Norwich," *NA* 25 (1934): 167–69.

_____. *Norwich Guildhall: The Fabric and the Ancient Stained Glass.* Norwich: Jarrold and Sons, n.d.

_____. "Proceedings of the Congress," *JBAA* n.s. 31 (1926): 15–16, 83–85.

_____. "The Seasons in Domestic Glass," *JBSMG* 5 (1933): 19–24.

Ker, N. J., and A. J. Piper. *Medieval Manuscripts in British Libraries,* 4 vols. Oxford: Oxford University Press, 1969–92.

Ketton-Cremer, R. W. "The Heydon Monument at Saxlingham," *NA* 34 (1966): 85.

Keyser, C. E. "A Day's Excursion among the Churches of South-East Norfolk," *Arch J* 64 (1907a): 91–109.

_____. *A List of Buildings in Great Britain having Mural and other Painted Decorations, of Dates Prior to the Latter Part of the Sixteenth Century,* 3rd ed. London: Eyre and Spottiswoode, 1883. References to Keyser are to this work unless stated otherwise.

_____. "Notes on some Fifteenth-century Glass in the Church of Wiggenhall St. Mary Magdalene," *NA* 16 (1907b): 306–19.

_____. "Some Notes on Ancient Stained Glass in Sandringham Church, Norfolk," *NA* 19 (1917): 122–32. In addition to detailed reproductions, full views of windows, figs 4–5.

King, David J. "An Antiphon to St. Edmund in Taverham Church," *NA* 36 (1977): 387–91.

_____. "The Panel Paintings and Stained Glass." In Atherton, 410–30. Cited as King 1996.

_____. "Salle Church—The Glazing." In "Report" (1979), 333–35. Cited as King (1979).

_____. *Stained Glass Tours Around Norfolk Churches.* Fakenham: Norfolk Society, 1974. References to David King are to this work unless stated otherwise.

King, Donald, and Santina Levey. *The Victoria and Albert Museum's Textile Collection: Embroidery in Britain from 1200 to 1750.* New York: Abbeville Press, 1993.

King, George A. "On the Ancient Stained Glass Still Remaining in the Church of St. Peter Hungate, Norwich," *NA* 16 (1907): 205–18.

_____. "The Pre-Reformation Painted Glass at St. Andrew's Church, Norwich," *NA* 18 (1914): 283–94.

Kirkpatrick, John. *History of the Religious Orders and Communities and the Hospitals and Castles of Norwich* [c.1725]. Yarmouth, 1845.

Knowles, David, and R. Neville Hadcock. *Medieval Religious Houses, England and Wales.* London: Longmans, Green, 1953.

Koldewey, A. M. "Pilgrim Badges Painted in Manuscripts: A North Netherlandish Example." In *Masters and Miniatures: Proceedings of the Congress on Medieval Manuscript Illumination in the Northern Netherlands (1989),* 211–18. Doornspijk, Netherlands: Davaco, 1991.

Laird, Marshall. *English Misericords.* London: John Murray, 1986.

Lancashire, Ian. *Dramatic Texts and Records of Britain : A Chronological Topography to 1558.* Toronto and Buffalo: University of Toronto Press, 1984.

Lasko, P., and N. J. Morgan, eds. *Medieval Art in East Anglia, 1300–1520.* Norwich: Jarrold and Sons, 1973.

Layard, Nina Frances. "Notes on some English Paxes, Including an Example Recently Found in Ipswich," *Arch J* 61 (1904): 120–30.

Lee-Warner, James. "The Stapletons of Ingham," *NA* 8 (1879): 183–221.

L'Estrange, J. *Church Bells of Norfolk.* Norwich, 1874.

_____. "Church Goods of St. Andrew and St. Mary Coslany, Norwich," *NA* 7 (1871): 45–78.

_____. "Mural Paintings at West Somerton Church," *NA* 7 (1872): 256–59.

Letters and Papers, Foreign and Domestic, of the Reign of Henry VIII, ed. J. S. Brewer, J. Gairdner, and R. H. Brodie. Vols. 2, 10, and 11. 1887. Rpt. Vadus: Kraus, 1965.

Lindley, Phillip Graham. "The 'Arminghall Arch' and Contemporary Sculpture in Norwich," *NA* 40 (1987): 19–43.

Linnell, C. L. S. "The Commonplace Book of Robert Reynys of Acle," *NA* 32 (1959): 111–28.

_____. *Norfolk Church Dedications.* Borthwick Institute of Historical Research, St. An-

thony's Hall Publication 21. York, 1962. References to Linnell are to this work unless stated otherwise.

_____. *South Creake Church*. Suffolk: Home Words, 1955. Church guide.

_____. "Wiveton, Norfolk," *TMBS* 9 (1952): 12–14.

Long, Edward T. "Recently Discovered Wall Paintings in England," *Burlington Magazine* 76 (1940): 124–28, 156–61.

Louis, Cameron; *see* Reyes, Robert.

Lydgate, John. *The Minor Poems*. Ed. Henry Noble MacCracken. EETS, e.s. 107. 1911; reprint London: Oxford University Press, 1962.

Mackerell, Benjamin. *The History and Antiquities of the . . . Corporation of King's Lynn in Norfolk*. London, 1738.

Macklin, Herbert W. *The Brasses of England*. London: Methuen, 1907.

_____. *Monumental Brasses*, rev. ed., ed. Charles Oman, 1953.

Mannship, Henry. *The History of Great Yarmouth*, ed. Charles John Palmer. Great Yarmouth: Louis Alfred Meall, 1854.

Manning, C. R. M. "Ancient Lecterns," *NA* 7 (1872a): 122–27.

_____. "Coins Found at Diss," *NA* 7 (1871): 341–48.

_____. "Elsing Church," *NA* 6 (1864a): 200–12.

_____. "Illustrations of Church Plate in Norfolk," *NA* 13 (1898): 233–40.

_____. "Medieval Patens in Norfolk," *NA* 12 (1895): 85–99.

_____. "A Monumental Brass, Discovered under the Pews in St. Stephen's Church, Norwich," *NA* 6 (1864b): 295–99.

_____. "Notes on the Architecture of Hellington Church," *NA* 5 (1859): 195–96.

_____. "Wickhampton Church," *NA* 7 (1872b): 1–8.

Margeson, Sue. "A Medieval Musician from Near Thetford," *NA* 40 (1989): 325–26.

_____. "14th-Century Seal-Dies from Norfolk," *NA* 39 (1985): 218–20.

Marks, Richard. *Stained Glass in England during the Middle Ages*. Toronto: University of Toronto Press, 1993.

Marks, Richard, and Nigel Morgan. *The Golden Age of English Manuscript Painting 1200–1500*. London: Book Club Associates, 1981.

Martin, A. R. *Franciscan Architecture in England*. Manchester: Manchester University Press, 1937.

Martin, Thomas. *The History of the Town of Thetford*. London: J. Nichols, 1779.

Martin, W. "Some Fragments of Sculptured Stone Found in a Barn at East Barsham, Norfolk," *NA* 11 (1892): 257–58.

Martindale, Andrew. "The Aswellthorpe Triptych." In *Early Tudor England: Proceedings of the 1987 Harlaxton Symposium*, ed. Daniel Williams, 107–23. Woodbridge: Boydell Press, 1989a.

_____. "The Knights and the Bed of Stones: A Learned Confusion of the Fourteenth Century," *JBAA* 142 (1989b): 66–74.

Martin-Jones, S. "Notes on the Roof of the Nave of All Saints' Church, Necton," *NA* 17 (1910): 159–64.

McAleer, J. Philip. "The Façade of Norwich Cathedral: The Nineteenth-Century Restorations," *NA* 41 (1993): 381–99.

McCulloh, John M. "Jewish Ritual Murder: William of Norwich, Thomas of Monmouth, and the Early Dissemination of the Myth," *Speculum* 72 (1997): 698–40.

Mellinkoff, Ruth. "Riding Backwards: Theme of Humiliation and Symbol of Evil," *Viator* 4 (1973): 153–77.

Messent, C. J. W. *The City Churches of Norwich*. Norwich: H. W. Hunt, 1932.

_____. *The Parish Churches of Norfolk and Norwich*. Norwich: H. W. Hunt, 1936.

Mezey, Nicole. "Creed and Prophets Series in the Visual Arts, with a Note on Examples in York," *EDAM Newsletter* 2 (Nov. 1979): 7–10.

Milburn, R. L. P. *Saints and Their Emblems in English Churches*. London: Oxford University Press, 1949.

Millican, Percy. *A History of Horstead and Stanninghall Norfolk*. Norwich, 1937.

Minns, G. W. W. "Notice of Mural Paintings at Witton," *NA* 6 (1864): 42–49.

Mitchell, John. "Painting in East Anglia around 1500: The Continental Connection." In *England and the Continent in the Middle Ages: Studies in Memory of Andrew Martindale*, Proceedings of the 1996 Harlaxton Symposium, ed. John Mitchell. Stamford: Shaun Tyas, 2000.

Mitchiner, Michael. *Medieval Pilgrim and Secular Badges*. London: Hawkins, 1986.

Montagu, Jeremy, and Gwen Montagu. *Minstrels*

and Angels: Carvings of Musicians in Medieval English Churches. Berkeley: Fallen Leaf Press, 1998.

Moore, Andrew W. *Dutch and Flemish Painting in Norfolk: A History of Taste and Influence, Fashion and Collecting.* London: HMSO, 1988.

Morant, A. W. "Mural Painting Discovered at Burlingham St. Edmund, Norfolk," *NA* 5 (1859): 185–87.

———. "Notices of the Church of St. Nicholas, Great Yarmouth," *NA* 7 (1872): 215–48.

——— and J. L'Estrange. "Notices of the Church at Randworth," *NA* 7 (1872): 178–211.

Morgan, Nigel. "The Coronation of the Virgin by the Trinity and Other Texts and Images of the Glorification of Mary in Fifteenth-Century England." In Rogers, 223–41. Cited as Morgan 1994.

———. *Early Gothic Manuscripts,* pt. 1, 1190–1250; pt. 2, 1250–1285. A Survey of Manuscripts Illuminated in the British Isles, 4. London: Harvey Miller, 1982–88. Cited as Morgan, *Survey.*

Mottram, A. S. "An Enamelled Bronze Armlet from Southacre," *NA* 34 (1968): 253–58.

Mortlock, D. P. *The Popular Guide to Suffolk Churches,* no. 1, West Suffolk; no. 2 Central Suffolk. Cambridge: Acorn Editions, 1988–90.

——— and C. V. Roberts. *The Popular Guide to Norfolk Churches,* no. 1, North-East Norfolk; no. 2 Norwich, Central and South Norfolk; no. 3 West and South-West Norfolk. Dereham and Cambridge: Acorn Editions, 1981–85. Cited as M & R.

Muskett, Charles. *Remains of Antiquity in Norwich.* Norwich, 1843.

Nelson, Philip. *Ancient Painted Glass in England: 1170–1500.* London: Methuen, 1913.

———. "Some Further Examples of English Medieval Alabaster Tables," *Arch J* 74 (1917): 106–21.

———. "Some Unpublished English Medieval Alabaster Carvings," *Arch J* 77 (1920): 213–25.

Newton, Stella Mary. *Renaissance Theatre Costume.* New York: Theatre Arts Books, 1975.

Nichols, Ann Eljenholm. "The Etiquette of Pre-Reformation Penance in East Anglia," *Sixteenth Century Journal* 17 (1986): 145–63.

———. *Seeable Signs: The Iconography of the Seven Sacraments, 1350–1544.* Wood-bridge: Boydell Press, 1994. Cited as Nichols.

——— et al. *An Index of Images in English Manuscripts from the Time of Chaucer to Henry VII c.1380–1509,* gen. ed. Kathleen L. Scott. Fascicle 1. London: Harvey Miller, 2000. Cited as *Index of Images.*

Nilson, Ben. *Cathedral Shrines of Medieval England.* Woodbridge: Boydell Press, 1999.

900 Years, Norwich Cathedral and Diocese. ed. Jim Wilson. Norwich: Jarrold, 1996.

Norton, Christopher, David Park, and Paul Binski. *Dominican Painting in East Anglia: The Thornham Parva Retable and the Musée de Cluny Frontal.* Woodbridge: Boydell Press, 1987.

Norwich, Archdeaconry of. *Inventory of Church Goods temp. Edward III,* ed. Aelred Watkin. Norfolk Record Society 19, pts. 1–2. 1947–48. Cited as Watkin.

Ogden, Dunbar H. "Costumes and Vestments for the Medieval Music Drama." In Davidson (1999), 17–57.

Oman, Charles. *English Church Plate 597–1830.* London: Oxford University Press, 1957.

Ord, Craven. "Description of a Carving in the Church of Long Melford," *Archaeologia* 12 (1796): 93–95.

Orr, Michael T. "Illustration as Preface and Postscript in the Hours of the Virgin of Trinity College MS. B. 11.7," *Gesta* 34 (1995): 162–76.

Owen, D. M. *The Making of King's Lynn: A Documentary Survey.* Records of Social and Economic History, n.s. 9. London: Oxford University Press, 1984.

Pächt, Otto, and J. J. G. Alexander. *Illuminated Manuscripts in the Bodleian Library, Oxford,* III: *British, Irish, and Icelandic Schools.* Oxford: Clarendon Press, 1973.

Palmer, Barbara. *The Early Art of the West Riding of Yorkshire.* EDAM Reference Series 6. Kalamazoo: Medieval Institute Publications, 1990.

Palmer, Charles John. *The History of Great Yarmouth Designed as a Continuation of Manship's History of that Town.* Great Yarmouth: Louis Alfred Meall, 1856. Cited as C. Palmer.

Park, David. "A Lost Fourteenth-Century Altarpiece from Ingham, Norfolk," *Burlington Magazine* 130 (1988): 132–36.

———. "Simony and Sanctity: Herbert Losinga,

St. Wulfstan of Worcester and Wall-paintings in Norwich Cathedral." In *Studies in Medieval Art and Architecture*, ed. David Buckton and T. A. Heslop, 157–70. Stroud: Alan Sutton, 1994.

_____ and Helen Howard. "The Medieval Polychromy." In Atherton, 379–409.

Parsons, W. L. E. Salle. *The Story of a Norfolk Parish, Its Church, Its Manor and People*. Norwich: Jarrold and Sons, 1937.

Past Masters and Present Delights, The Churches Conservation Trust Review and Report, 1999–2000. London: Churches Conservation Trust, n.d.

Pedrick, G. *Borough Seals of the Gothic Period*. London: J. M. Dent, 1904.

_____. *Monastic Seals of the XIIIth Century*. London: De la More Press, 1902.

Pevsner, Nikolaus. *North-East Norfolk and Norwich*. The Buildings of England. Harmondsworth: Penguin Books, 1962. Cited as Pevsner 1.

_____. *North-West and South Norfolk*. The Buildings of England. Harmondsworth: Penguin Books, 1962. Cited as Pevsner 2.

_____ and Bill Wilson. *Norfolk 1: Norwich and North-East*, 2nd ed. The Buildings of England. London: Penguin Books, 1997. Cited as Pevsner & Wilson 1. Material from the original 1962 edition cited as Pevsner 1 to distinguish it from the new information.

_____ and Bill Wilson. *Norfolk 2: North-West and South*, 2nd ed. London: Penguin Books, 1999. Cited as Pevsner & Wilson 2. Material from 1962 edition cited as Pevsner 2 to distinguish it from the new information.

Pfaff, R. W. *New Liturgical Feasts in Later Medieval England*. Oxford: Clarendon Press, 1970.

Phipson, R. M. "Notes on Starston Church, and a Mural Painting Lately Discovered There," *NA* 7 (1871): 300–02.

Piponnier, Françoise, and Perrine Mane. *Dress in the Middle Ages*, trans. Caroline Beamish. New Haven: Yale University Press, 1997.

Platt, Colin. *The Parish Churches of Medieval England*. London: Secker and Warburg, 1981.

Plummer, Pauline. "The Ranworth Rood Screen." In "Report" 1979, 292–95.

_____. "Restoration of a Retable in Norwich Cathedral," *Studies in Conservation* 4

(1959): 106–15.

Pocknee, C. E. *Cross and Crucifix in Christian Worship and Decoration*. London: A. R. Mowbray, 1962.

"Portfolio of Small Plates," *TMBS* 14, pt. 2 (1987); pt. 3 (1988); pt. 6 (1991).

Potter, R. "A Topographical Account of Tottington, in Norfolk," *Gentleman's Magazine* 89 (1819): 114.

Prideaux, Edith K. "Carvings of Medieval Musical Instruments in Exeter Cathedral Church," *Arch J*, 2nd ser. 62 (1915): 1–36.

Prior, Edward, and Arthur Gardner. *An Account of Medieval Figure Sculpture in England*. Cambridge: Cambridge University Press, 1912.

"Proceedings . . . of the Archaeological Institute," *Arch J* 18 (1861): 268–69.

Purcell, Donovan. "The Priory of Horsham St. Faith and its Wallpaintings," *NA* 35 (1973): 469–73.

Puddy, Eric. *Litcham*. Dereham: G. Arthur Coleby, n.d.

Rastall, Richard. *The Heaven Singing: Music in Early English Religious Drama*. Cambridge: D. S. Brewer, 1996.

Rawcliffe, Carole. *The Hospitals of Medieval Norwich*, Studies in East Anglian History 2. Norwich: Centre of East Anglian Studies, 1995.

_____. *Medicine for the Soul: The Life, Death and Resurrection of an English Medieval Hospital*. Stroud: Sutton, 1999.

Remnant, G. L. *A Catalogue of Misericords in Great Britain*. Oxford: Clarendon Press, 1969.

Remnant, Mary. *English Bowed Instruments from Anglo-Saxon to Tudor Times*. Oxford: Clarendon Press, 1986.

_____. "Gittern in English Medieval Art," *Galpin Society Journal* 18 (1965): 104–09.

_____. "Musical Instruments in Early English Drama." In Davidson (1999), 141–94.

_____. "Rebec, Fiddle, and Crowd in England," *Proceedings of the Royal Musical Association* 95 (1969): 15–27.

_____. "Rebec, Fiddle, and Crowd in England: Some Further Observations," *Proceedings of the Royal Musical Association* 96 (1970): 149–51.

_____. "Use of Frets on Rebecs and Medieval Fiddles," *Galpin Society Journal* 21 (1968): 146–51.

"Report for 1861," NA 6:i–v; "Report for 1877," NA 8:i–ii

"Report of the Congress of the British Archaeological Association, 1925," JBBA n.s. 31 (1925): 3–114.

"Report of the Summer Meeting of the Royal Archaeological Institute at Norwich in 1949," Arch J 106 (1951): 51–115. Cited as "Report" 1949.

"Report of the Summer Meeting of the Royal Archaeological Institute at Norwich in 1979," Arch J 137 (1980): 280–368. Cited as "Report" 1979.

Reynes, Robert. The Commonplace Book of Robert Reynes of Acle: An Edition of Tanner MS 407, ed. Cameron Louis. New York: Garland, 1980.

Richards, William. The History of Lynn. Vol. 1. Lynn: W. G. Writtingham, 1812.

Richmond, Colin. The Paston Family in the Fifteenth Century. Cambridge University Press, 1990.

Ridyard, Susan J. The Royal Saints of Anglo-Saxon England. Cambridge: Cambridge University Press, 1988.

Rickert, Margaret. Painting in Britain: The Middle Ages, 2nd ed. Harmondsworth: Penguin Books, 1965.

Rix, W. B. The Pride of Swaffham. N.p., n.d.

Robinson, John Martin. Treasures of the English Churches. London: Sinclair-Stevenson, 1995.

Rogers, Nicholas, ed. England in the Fifteenth Century, Proceedings of the 1992 Harlaxton Symposium. Harlaxton Medieval Studies 4. Stamford: Paul Watkins, 1994.

Rogerson, Andrew, et al. "Medieval Floor Tiles from St. John the Baptist's Church, Reedham," NA 38 (1983): 380–83.

Rose, Adrian. "Angel Musicians in the Medieval Stained Glass of Norfolk Churches," Early Music 29 (2001): 186–217.

Rose, Edwin J. "Recent Discoveries at Crostwick St. Peter," NA 39 (1985): 192–202.

Rose, Martial. The Misericords of Norwich Cathedral. Dereham: Larks Press, 1994. All references are to photographs organized by misericord number.

——. The Norwich Apocalypse: The Cycle of Vault Carvings in the Cloisters of Norwich Cathedral. Norwich: Centre of East Anglian Studies, 1999. Boss illustrations are organized sequentially by walks.

——. "Salome's Sword Dance: A Note on a Roof Boss in the Vault in the South Transept of Norwich Cathedral," EDAM Review 18 (1995): 1–7.

——. "The Vault Bosses." In Atherton, 363–79. Cited as Rose 1996.

—— and Julia Hedgecoe. Stories in Stone. London: Herbert Press, 1997. Unless stated otherwise, all references to this work are to illustrations cited by page number.

Rushforth, Gordon McN. Medieval Christian Imagery. Oxford: Clarendon Press, 1936.

Rye, Walter. Carrow Abbey; Otherwise Carrow Priory. Norwich: Goose, 1889.

——. "The Guilds of Lynn Regis," The Norfolk Antiquarian Miscellany 1 (1877): 153–83.

——. History of the Parish of Earlham. Norwich: Roberts, 1917.

——. History of the Parish of Eaton. Norwich: Roberts, 1917.

——. History of the Parish of Heigham. Norwich: Roberts, 1917.

——. History of the Parish of Hellesdon. Norwich: Roberts, 1917.

——. An Index of Norfolk Pedigrees. Norwich, 1896.

——. An Index of Norfolk Topography. London: Longmans, Green, 1881.

——. "Norfolk Church Goods," NA 7 (1872): 20–44.

Rouse, E. Clive. Medieval Wall Paintings. Haverfordwest, Dyfed: Shire Publications, 1991.

Sandler, Lucy Freeman. Gothic Manuscripts: 1285–1385, 2 pts. A Survey of Manuscripts Illuminated in the British Isles, 5. London and Oxford: Harvey Miller and Oxford University Press, 1986. Cited as Sandler, Survey.

——. The Peterborough Psalter in Brussels and Other Fenland Manuscripts. London: Harvey Miller, 1974.

——. The Psalter of Robert de Lisle in the British Library. London: Harvey Miller, 1983.

Saunders, H. W. An Introduction to the Obedientiary and Manor Rolls of Norwich Cathedral Priory. Norwich. Jarrold and Sons, 1930.

Scott, Kathleen L. "The Illustration and Decoration of the Register of the Fraternity of the Holy Trinity at Luton Church, 1475–1546." In A. S. G. Edwards, Vincent Gillespie, and Ralph Hanna, eds., The English

Medieval Book: Studies in Memory of Jeremy Griffiths, 155–83. London: The British Library, 2000.

_____. *Later Gothic Manuscripts, 1390–1490*, 2 pts. A Survey of Manuscripts Illiminated in the British Isles, 6. London: Harvey Miller, 1997. Cited as Scott, *Survey*.

Seccombe, J. T. "The Church at Terrington St. Clement," *NA* 12 (1895):1–12.

"Screen in St. Mary's Church, Attleborough, Norfolk, The," *JBAS*, n.s. 37 (1932): 184–89.

Sekules, Veronica. "The Gothic Sculpture." In Atherton, 197–209.

Sheingorn, Pamela. *The Easter Sepulchre in England*. EDAM Reference Series 5. Kalamazoo: Medieval Institute Publications, 1987.

Selection of Illustrations of Norfolk, A. See Winter, C. J. W.

Shinners, John R. "The Veneration of Saints at Norwich Cathedral in the Fourteenth Century," *NA* 40 (1988): 133–45.

Simpson, W. S. "On Pilgrimage to Bromholm in Norfolk," *JBAA* 30 (1874): 52–61.

Sims, Tony. "Aspects of Heraldry and Patronage." In Atherton, 451–66.

Smith, H. Clifford. *Catalogue of English Furniture and Woodwork, Victoria and Albert Museum Department of Woodwork*, vol 1. London: HMSO, 1923. Cited as V & A Cat.

Smith, M. Q. "The Roof Bosses of Norwich Cathedral, and their Relation to the Medieval Drama of the City," *NA* 32 (1961): 12–26.

Smith, Toulmin. *English Gilds*. EETS, o.s. 40. London: N. Trübner, 1870. Cited as T. Smith.

Snelling, J. M. *St. Benet's Abbey*, rev. ed., ed. W. F. Edwards. Hunstanton: Witley Press, n.d.

Southern, S. "Fresco discovered at Elsing Norfolk," *East Anglian Notes and Queries* 1 (1864): 100–01.

Spencer, B. *Medieval Pilgrim Badges from Norfolk*. Norfolk Museum Services, 1980. References are to this source unless stated otherwise.

_____. *Pilgrim Souvenirs and Secular Badges*. London: HMSO, 1998.

_____. *Salisbury Museum Medieval Catalogue*, pt. 2: *Pilgrim Souvenirs and Secular Badges*. Salisbury: Salisbury and South Wiltshire Museum, 1990.

Spencer, Noel, and Arnold Kent. *The Old Churches of Norwich*. Norwich: Jarrold, 1970.

Spurdens, William Tylney. "Particulars of the Hundred of Tunstead," *NA* 3 (1852): 80–96.

Stallard, A. D. *The Transcript of the Churchwardens' Accounts of the Parish of Tilney All Saints, Norfolk 1443–1589*. London: Mitchell Hughes and Clarke, 1922.

Stevenson, Francis Seymour. "St. Botolph (Botwuf) and Iken," *Proceedings of the Suffolk Institute of Archaeology and Natural History* 18 (1924): 29–52.

Stewart, D. J. "Notes on Norwich Cathedral," *Arch J* 32 (1875): 16–47, 155–87.

Stoker, David A., ed. *The Correspondence of the Reverend Francis Blomefield (1705–52)*. Norfolk Record Society 55. 1992.

Storck, Willy F. "Aspects of Death in English Art and Poetry," *Burlington Magazine* 21 (1912): 249–56, 314–19.

Stothard, C. A. *The Monumental Effigies of Great Britain*. London: J. M. M'Creery, 1811–13 (17 plates); London, 1917.

Strange, Edward F. "Rood Screen of Cawston Church," *Walpole Society* 2 (1912–13): 81–87.

Sutcliffe, Sebastian. "The Cult of St. Sitha in England: An Introduction," *Nottingham Medieval Studies* 37 (1933): 83–89.

Sutton, A. F., and Livia Visser-Fuchs. *The Hours of Richard III*. Stroud: Alan Sutton, 1990.

Sutton, Denys. "English Medieval Paintings Newly Discovered in Norfolk," *Apollo*, n.s., 111 (June 1980): 464–65.

Tanner, Norman P. *The Church in Late Medieval Norwich 1370–1532*. Studies and Texts 66. Toronto: Pontifical Institute of Mediaeval Studies, 1984. Citations to Tanner are to this work unless stated otherwise.

_____. *Heresy Trials in the Diocese of Norwich, 1428–31*. Camden Society, 4th ser. 20. London: Royal Historical Society, 1977.

Taylor, E. S. "Notices, Historical and Topographical, of the Parish of Stokesby, Norfolk, Deanery of Flegg; With Some Account of the Mural Paintings Discovered in the Parish Church," *NA* 5 (1859a): 287–96.

_____. "Notices of the Church of Martham, Norfolk, Previous to Its Restoration in 1856," *NA* 5 (1859b): 168–79.

Taylor, R. C. *Index Monasticus; or, the Abbeys and Other Monasteries Alien Priories, Friaries, Colleges, Collegiate Churches and*

Hospitals with their Dependencies formerly established in the Diocese of Norwich and the Ancient Kingdom of East Anglia. London: 1821. Cited as *Index Monasticus.*

Thompson, F. H., ed. *Studies in Medieval Sculpture.* Society of Antiquaries, Occasional Papers, n.s. 3. London, 1983.

Thurlow, Gilbert. "The Bauchun Chapel Roof." Friends of Norwich Cathedral Annual Report, 1966.

_____. *Norwich Cathedral.* Norwich, 1972.

_____ and A. B. Whittingham. "An Incised Grave-slab," *NA* 35 (1973): 503–04.

Tomlinson, Harold. "Some Norfolk Fonts." In Ingleby, 207–36.

Tracy, Charles. *English Gothic Choir-Stalls, 1200–1400.* Woodbridge: Boydell Press, 1987.

_____. *English Gothic Choir-Stalls 1400–1540.* Woodbridge: Boydell Press, 1990.

_____. *English Medieval Furniture and Woodwork.* London: Victoria and Albert Museum, 1988. All items so cited are either at the V & A or on loan to the King's Lynn Museum.

Trench, Edwin J. "The Church at St. James Great Ellingham," *NA* 22 (1926): 34–49.

Tristram, E. W. "The Cloister Bosses Norwich Cathedral." Friends of the Cathedral Church of Norwich, Annual Report, 1935 (East Walk, 6–13); 1936 (North Walk, 6–21); 1937 (North walk cont'd, East Walk, 21–49).

_____. *English Wall Painting of the Fourteenth Century.* London: Routledge and Kegan Paul, 1955. References are to this work unless stated otherwise.

_____. *English Medieval Wall Painting: The Thirteenth Century.* Oxford: Oxford University Press, 1950.

_____. *English Medieval Wall Painting: The Twelfth Century.* Oxford: Oxford University Press, 1944.

_____. "The Wall Painting at Horsham St. Faith Near Norwich," *NA* 22 (1926): 257–59.

Tudor-Craig, Pamela. "Medieval Panel Paintings from Norwich, St Michael at Plea," *Burlington Magazine* 98 (1956): 333–34.

Turner, Dawson. "Drawings by Mrs. Gunn of Mural Paintings in Crostwight Church," *NA* 2 (1849): 352–62.

_____. "Letter . . . transmitting A Crucifix and Alabaster Tablet," *NA* 1 (1847a): 243–50.

_____. "A Second Letter . . . upon the Subject of the Crucifix and Tablet representing the Martyrdom of St. Erasmus," *NA* 1 (1847b): 300–04.

_____. "Mural Paintings in Catfield Church," *NA* 1 (1847c): 133–39.

_____. "Return of Church Goods in Nine Churches Within the County of Norfolk," *NA* 1 (1847d): 73–90.

Vallance, Aymer. *English Church Screens.* London: B. T. Batsford, 1936.

_____. *Greater English Church Screens.* London: B. T. Batsford, 1947.

V & A Catalogue. See Smith, H. Clifford.

Varty, Kenneth. *Reynard the Fox: A Study of the Fox in Medieval English Art.* New York: Humanities Press, 1967.

_____. "Reynard the Fox and the Smithfield Decretals," *Journal of the Warburg and Courtauld Institutes* 26 (1963): 347–54.

The Vernon Manuscript: A Facsimile of Bodleian Library, Oxford, MS. Eng. Poet. a.1. Cambridge: D. S. Brewer, 1987.

The Victoria History of the County of Norfolk, ed. William Page. Vol. 2. 1906; reprint Folkstone: William Dawson and Sons, 1975. Cited as *VCH.*

Wagner, Anthony R., and J. G. Mann. "A Fifteenth-Century Description of the Brass of Sir Hugh Hastings at Elsing, Norfolk," *Antiquaries Journal* 19 (1939): 421–28.

Walcott, Mackenzie E. C. "Inventories and Valuations of Religious Houses at the Time of the Dissolution, from the Public Record Office," *Archaeologia* 43 (1871): 201–49.

Waller, J. G. "On the Retable of Norwich Cathedral and Paintings in St. Michael-at-Plea," *NA* 13 (1898): 315–42.

Walter, John H. F; *see* Hopper, Edmund, *et al.*

Walters, H. B., *et al.* "Inventories of Norfolk Church Goods (1552)," *NA* 26 (1936–38): 245–70; 27 (1938–41): 97–144, 263–89; 28 (1942–44): 7–22, 89–106, 133–80; 30 (1947–52): 75–87, 160–67, 213–19, 370–78; 31 (1955–57) 200–09, 233–98; 33 (1962–65) 63–85, 216–35, 457–90.

Ward, Wendy. "The Chantry Certificates of Norfolk: Towards a Partial Reconstruction," *NA* 43 (1999): 287–306.

Warner, James Lee. "Walsingham Priory, A Memoir," *Arch J* 13 (1856): 115–33.

Watkin, Aelred; *see* Norwich, Archdeaconry of.

Waterton, Edmund. *Pietas Mariana Britannica.*

London: St. Joseph's Catholic Library, 1879.

Weever, John. *Ancient Funerall Monuments within the United Monarchie of Great Britaine.* London, 1631.

Wells, W. *Stained and Painted Heraldic Glass, Burrell Collection Glasgow.* Glasgow: Glasgow Art Gallery and Museum, 1962.

_____. *Stained and Painted Glass. Burrell Collection.* Glasgow: Glasgow Art Gallery and Museum, 1965.

Wenzel, Siegfried, ed. *Fasciculus Morum.* University Park: Pennsylvania State University Press, 1989.

Westlake, H. F. *The Parish Gilds of Mediaeval England.* London: Society for Promoting Christian Knowledge, 1919. References to Westlake are to this work unless stated otherwise.

_____. "The Parish Gilds of the Later Fourteenth Century," *Transactions of the St. Paul's Ecclesiological Society* 88 (1919): 99–110.

Whaite, H. C. *St. Christopher in English Medieval Wall Painting.* London: Ernest Benn, 1929.

White, C. H. Evelyn. "The Seals of the Cathedral Church of Norwich," *East Anglian Notes and Queries,* n.s. 8 (1900): 369–73; 9 (1901): 1–6.

White, William. *History, Gazetteer and Directory of Norfolk.* London, 1836, 1839, 1842, 1845, 1864, 1854, 1883. Succeeded by *Kelly's Directory.*

Whittingham, A. B. "Bishop's Palace Norwich." In "Report 1979," 365–68.

_____. "Dersingham Church Guide." N.p, n.d.

_____. "Elsing Church." In "Report" 1979, 318.

_____. "The Erpingham Retable or Reredos in Norwich Cathedral," *NA* 39 (1985): 202–06.

_____. *Norwich Cathedral Bosses and Misericords.* Norwich: Jarrold and Sons, 1981.

_____. "The Ramsey Family of Norwich." In "Report" 1979, 285–89.

_____. "The Stalls of Norwich Cathedral." Friends of Norwich Cathedral, *Annual Report,* 1948, 115–31.

_____ et al. "Horsham St Faith's Priory." In "Report 1979," 323-25.

_____ and Barbara Green, "The White Swan Inn, St. Peter's Street, Norwich," *NA* 39 (1987): 38–50.

Wilkins, William, "An Essay towards a History of the *Venta Icenorum* of the Romans and of Norwich Castle," *Archaeologia* 12 (1796): 132–80.

Williams, E. Carleton. "Mural Paintings of St. Catherine in England," *JBBA,* 3rd Ser. 19 (1956): 20–33.

_____. "Mural Paintings of the Three Living and the Three Dead in England," *JBAA,* 3rd Ser. 7 (1942): 31–40.

Williams, J. F. "The Brasses of Norwich Cathedral," *TMBS* 9 (1960): 366–74.

_____. "The Brasses of St. Margaret's Church, Norwich," *TMBS* 9 (1954): 118–25.

_____. "Some Norfolk Churches and their Old-Time Benefactors," *NA* 27 (1941): 333–44.

Williamson, W. W. "Notes on Some Fonts," *NA* 32 (1961): 247–60.

_____. "Saints on Norfolk Roodscreens and Pulpits," *NA* 31 (1957): 299–346. Cited as Williamson.

Wilmart, André. *Auteurs spirituels et textes dévots du moyen âge latin.* Paris: Librairie Blond et Gay, 1932.

Wilson, Christopher. "The Original Setting of the Apostle and Prophet Figures from St. Mary's Abbey, York." In Thompson, 100–21.

Winter, C. J. W. "Discovery of a Mural Painting in the Church of Sporle," *NA* 7 (1872): 303–08.

_____. *Illustrations of the Rood-Screen at Randworth.* Norwich: Norfolk and Norwich Archaeological Society, 1867.

_____. *A Selection of Illustrations of Norfolk and Norwich Antiquities.* 2 vols. Norwich, 1885–88. (Originally 22 fascicles published in 2 vols; only the notes are paginated. Woodforde refers to the paginated two-volume bound set, which is now very difficult to find.) Cited as *Selection.*

Woodforde, Christopher. "Foreign Stained and Painted Glass in Norfolk," *NA* 26 (1938a): 73–84.

_____. "Further Notes on Ancient Glass in Norfolk and Suffolk," *JBSMG* 5 (1933a): 57–68.

_____. *The Norwich School of Glass-Painting in the Fifteenth Century.* London: Oxford University Press, 1950. Unless stated otherwise, references to Woodforde (abbreviated Wfd) are to this work.

_____. "The Medieval Glass in the Churches of St. John the Baptist, Mileham, and All

Saints and St. Michael-at-Plea, Norwich," *NA* 26 (1938b): 164–77.

———. "The Medieval Glass in Elsing Church, Norfolk," *JBSMG* 4 (1932a): 134–36.

———. *The Medieval Glass of St. Peter Mancroft, Norwich*. Norwich: Goose and Son, 1935a.

———. "Medieval Glass Restored to Cawston Church," *NA* 25 (1935b): 138–39.

———. "The Medieval Painted Glass in North Tuddenham Church, Norfolk," *NA* 25 (1935c): 220–26.

———. "The Medieval Stained Glass in East Harling and North Tuddenham Churches, Norfolk," *JBBA*, 3rd Ser. 5 (1940):1–32.

———. "Painted Glass in Saxlingham Nethergate Church, Norfolk," *JBSMG* 5 (1934): 163–39.

———. "Schools of Glass-Painting in King's Lynn and Norwich in the Middle Ages," *JBSMG* 5 (1933b): 4–18.

———. *Stained Glass in Somerset 1250–1830*. 1946; reprint Bath: Kingsmead Reprints, 1970.

Woodman, Francis. "The Gothic Campaigns." In Atherton, 158–96. Cited as Woodman 1996.

———. "The Rebuilding of St. Peter Mancroft." In *East Anglian Studies: Essays Presented to J. C. Barringer*, ed. Adam Longcroft and Richard Joby, 290–95. Norwich: University of East Anglia, 1995.

Woodward, S. "An Account of Some Discoveries made in Excavating the Foundations of Wymondham Abbey," *Archaeologia* 26 (1863): 287–99.

———. *The History and Antiquities of Norwich Castle*. Norwich: Charles Muskett, 1847.

Wormald, Francis. "The Rood of Bromholm," *Journal of the Warburg Institute* 1 (1937–38): 31–45.

Wright, Laurence. "The Medieval Gittern and Citole: A case of mistaken identity," *Galpin Society Journal* 30 (1977): 8–42.

Yates Thompson, H. *Facsimiles in Photogravure of Six Pages from a Psalter Written and Illuminated about 1325 A.D. for a Member of the St. Omer Family in Norfolk*. London: Chiswick Press, 1900.

Young, Rachel M. R. *Guide to the St. Peter Hungate Church Museum*. 1967; reprint Norfolk Museums Service, 1975.

The Norfolk Subject List is restricted to the pre-1835 county boundary. Norfolk parishes outside that boundary, e.g., Gorleston, will be included in the Suffolk Subject List. Except for manuscripts, sites are places of origin (for current location see main entries). Manuscripts are listed by library holding. The general principles cited in the Guide for Users obtain. Sites are alphabetized to privilege geographic proximity—e.g., North and South Creake are alphabetized under C. Norwich parishes are presented in a separate block. Entries cited as consecutive may include a number of separate citations. Information not classified by medium is cited at the head of each entry. For abbreviations, see pages 15–16.

351

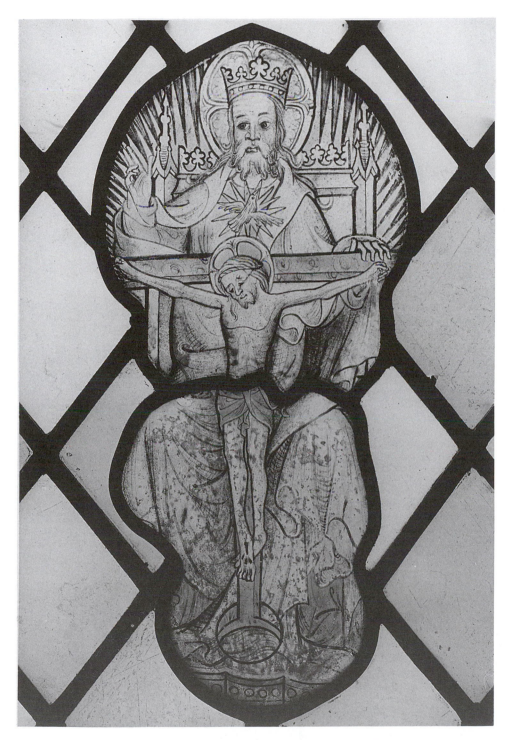

1. Crucifix Trinity. Painted glass, St. Ethelbert, Thurton. By kind permission of G. King and Son.

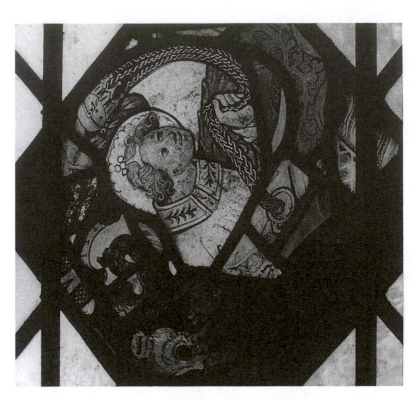

3. Angel Thurifer. St. Mary Magdalene, Warham.

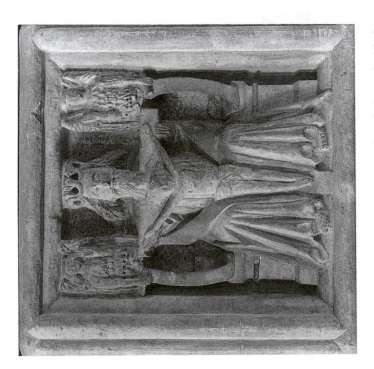

2. Crucifix Trinity, with Angels. Baptismal font, St. Mary the Virgin, Stalham. © Crown Copyright. National Monuments Record.

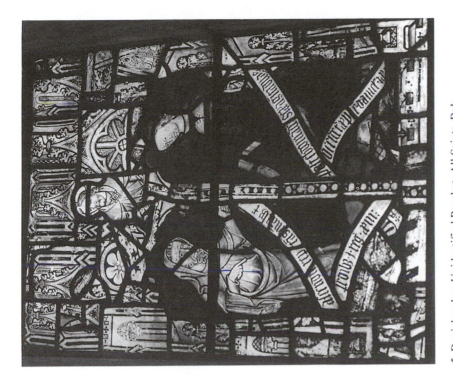

5. Daniel and an Unidentified Prophet. All Saints. Bale.

4. Angel of the Expulsion (left). Adam and Eve leaving Eden, and above them the Serpent. Rood screen spandrel. St. Peter. Brooke. © Crown Copyright. National Monuments Record.

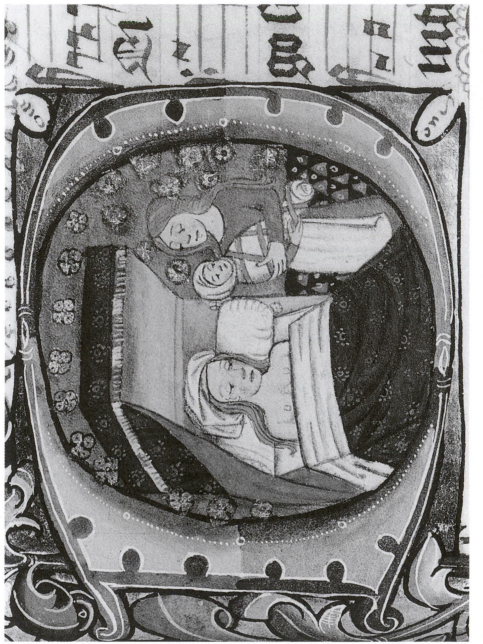

6. The Nativity of the Virgin. Manuscript illumination. Ranworth Antiphoner. By kind permission of the School of World Art Studies. University of East Anglia.

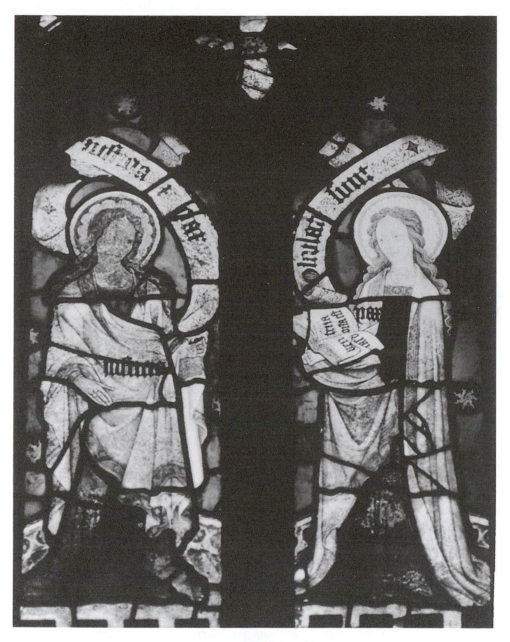

7. Parliament of Heaven, Justice and Peace. Painted glass (heavily restored). SS. Peter and Paul, Salle. By kind permission of David King.

9. Virgin, from Annunciation. Sculpture, *ex situ*. St. Michael-at-Plea, Norwich. By kind permission of the Norfolk Museums and Archaeology Service.

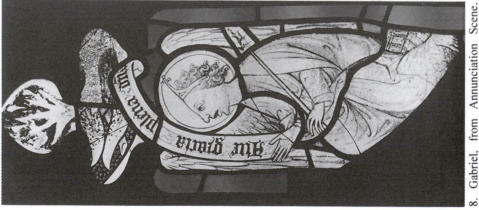

8. Gabriel, from Annunciation Scene. Painted glass, St. Mary, Shelton. © Crown Copyright. National Monuments Record.

10. Adoration of the Magi. Wall painting. Holy Trinity, Hockham. By kind permission of Andrea Kirkham.

11. Flagellation. Wall painting. St. Faith, Little Witchingham. Churches Conservation Trust.

12. Image of Pity. Manuscript illumination, Norwich Castle Museum MS. 158.926.4c. Courtesy of the Conway Library, Courtauld Institute; with kind permission of the Norfolk Museums and Archaeology Services.

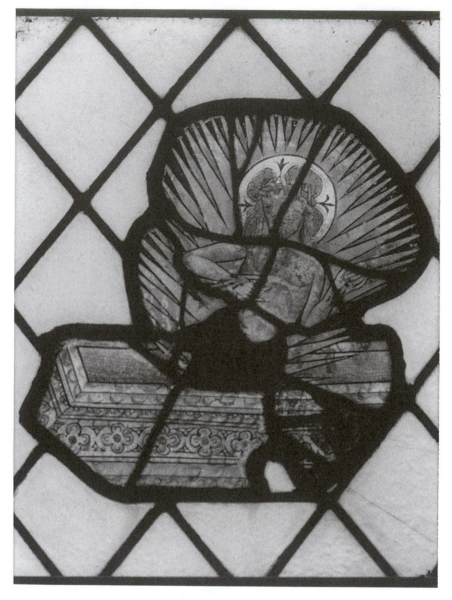

13. Image of Pity. Painted glass, St. Nicholas, Blakeney.

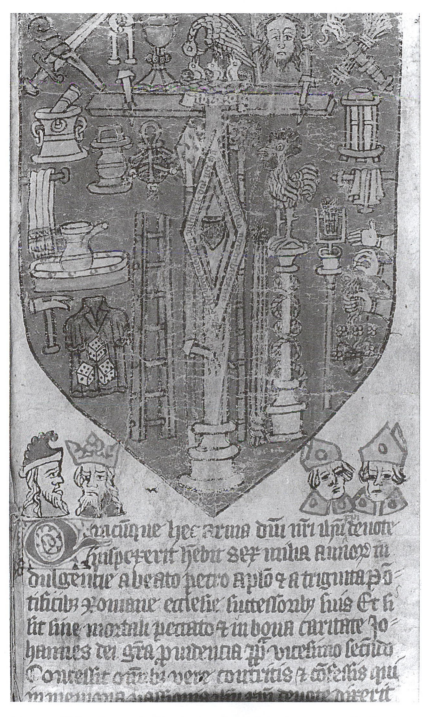

14. Arma Christi. Manuscript illumination. Norwich Castle Museum, MS. 158.926.4c. Courtesy of the Conway Library, Courtauld Institute. By kind permission of the Norfolk Museums and Archaeology Services.

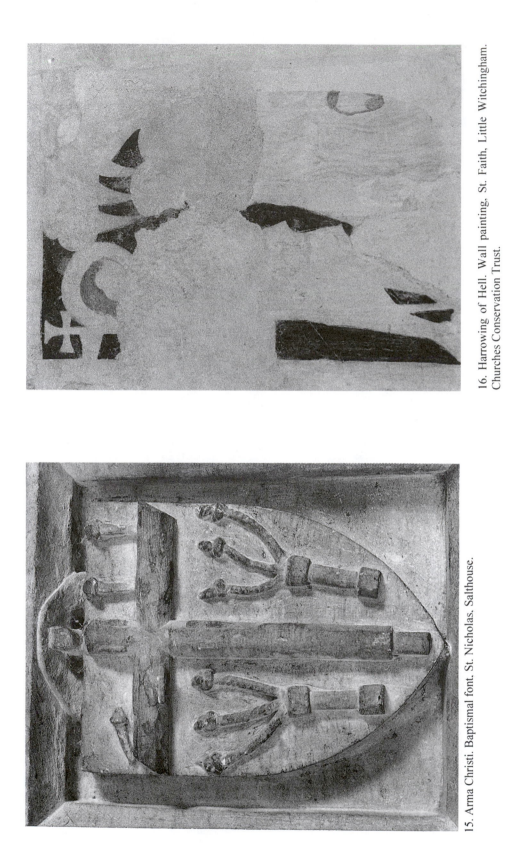

16. Harrowing of Hell. Wall painting. St. Faith, Little Witchingham. Churches Conservation Trust.

15. Arma Christi. Baptismal font. St. Nicholas, Salthouse.

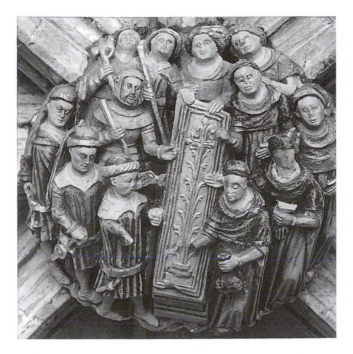

17. Sealing of the Tomb. North Cloister boss, Norwich Cathedral. By kind permission of the Dean and Chapter.

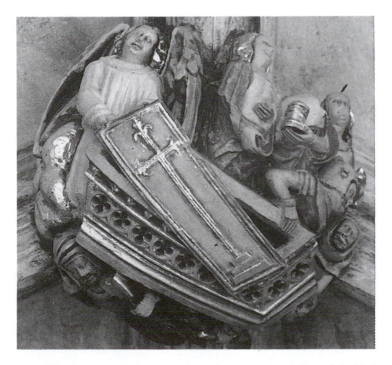

18. Visit to the Sepulcher. North Cloister boss, Norwich Cathedral. By kind permission of the Dean and Chapter.

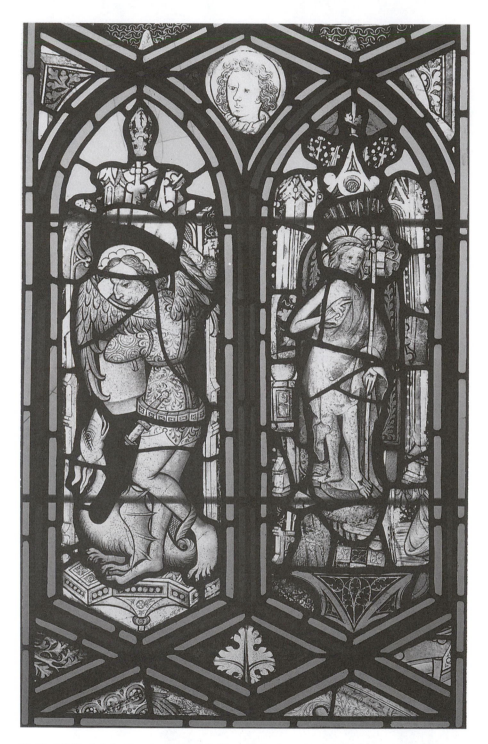

19. St. Michael defeating the dragon (left), and the Resurrection (right). Painted glass, All Saints, Besthorpe. By kind permission of G. King and Son.

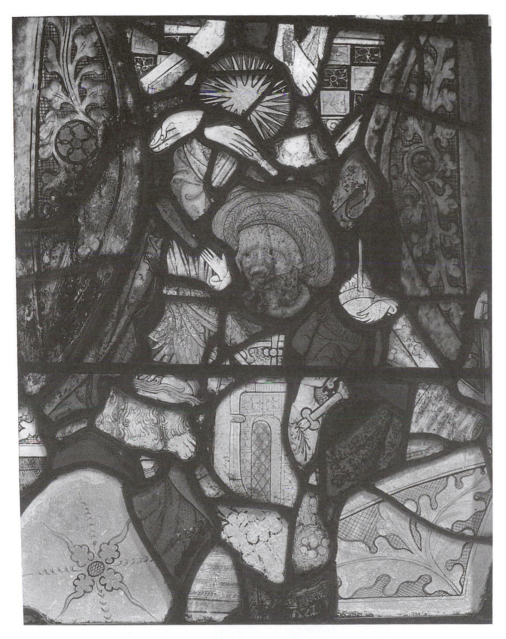

20. A typical patchwork window, with glass from at least eight different subjects. St. Peter, Guestwick.

21. Coronation of the Virgin. Roof boss, St. Mary, Worstead.

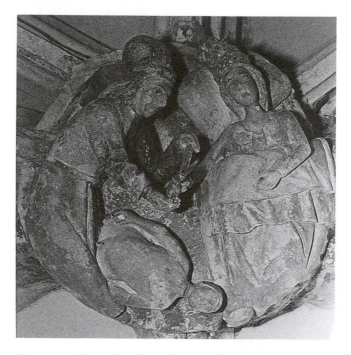

22. Accused Queen. Roof boss, Bauchun Chapel, Norwich Cathedral. By kind permission of the Dean and Chapter and the Eastern Daily Press.

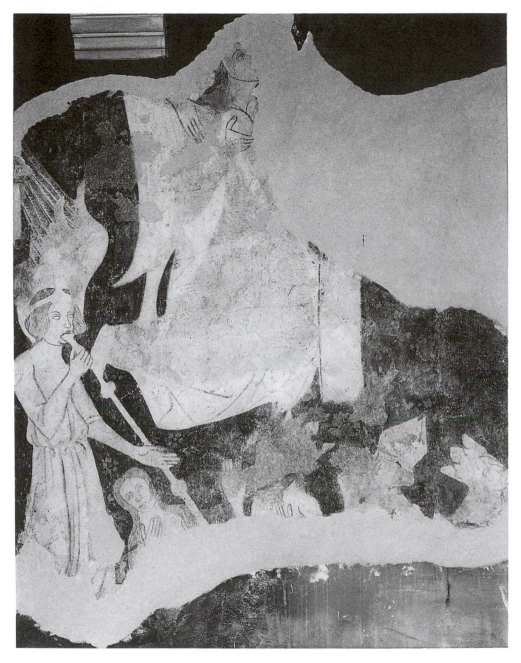

23. The Last Judgment. Wall painting, S. Mary, West Somerton. ©Crown Copyright. National Monuments Record.

24. St. Andrew (left) and St. Jerome (right). Rood screen, *ex situ* All Saints, Lessingham. By kind permission of the Norfolk Museums and Archaeology Service.

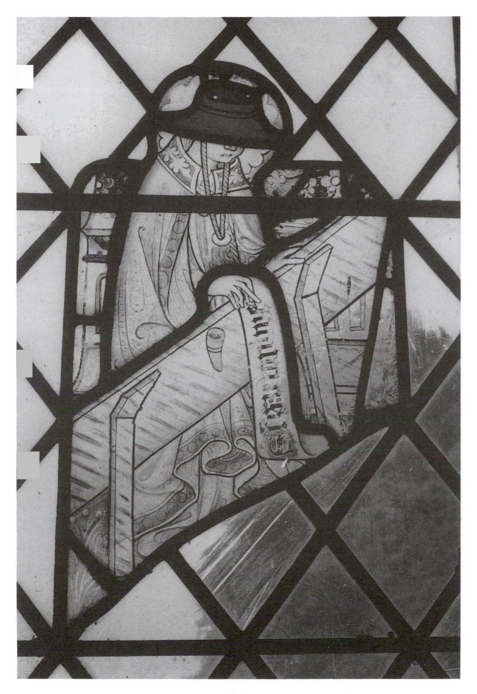

25. St. Jerome. Painted glass, St. Mary the Virgin, Saxlingham Nethergate.

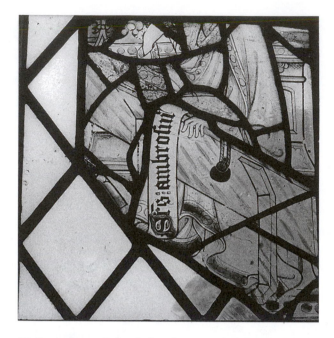

26. St. Ambrose. Painted glass fragment, St. Mary the Virgin, Saxlingham Nethergate.

27. St. Gregory with scroll inscribed "Felix Culpa." Rood screen, All Saints, Weasingham.

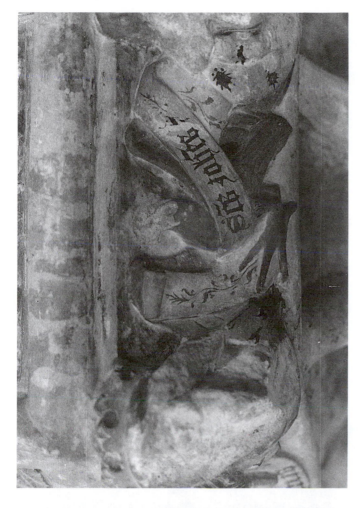

29. St. John's Eagle. Baptismal font chamfer, Assumption of the Blessed Virgin, Great Witchingham.

28. Doctor as Academic. Base of font *ex situ* St. Mary-in-the-Marsh. Norwich Cathedral. By kind permission of the Dean and Chapter.

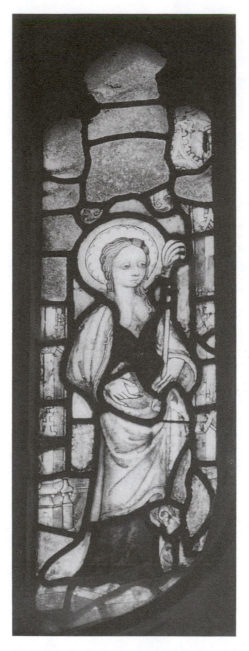

30. St. Agatha. Painted glass, Cley.

31. SS. Botulf and Leonard and angels. Painted glass. All Saints. Old Buckenham.

31a. Detail showing SS. Botulf and Leonard. Painted glass, All Saints, Old Buckenham.

32. St. Catherine's Wheel. Painted glass, Invention of the Holy Cross, Caston.

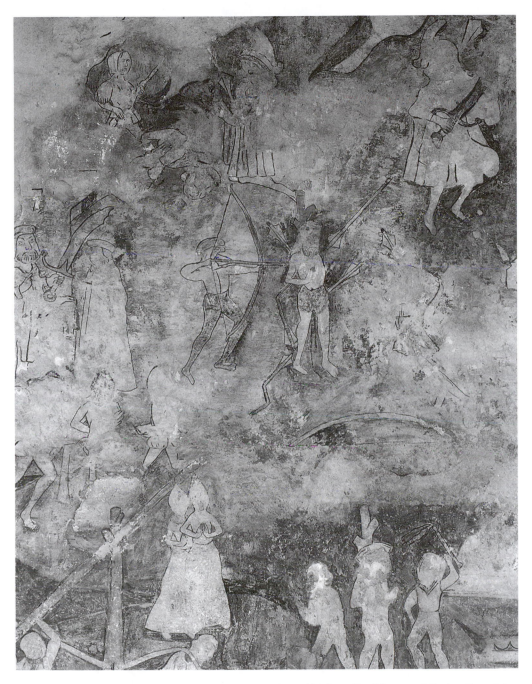

33. Scenes from the life of St. Christopher. Wall painting, All Saints, Hemblington. ©Crown Copyright. National Monuments Record.

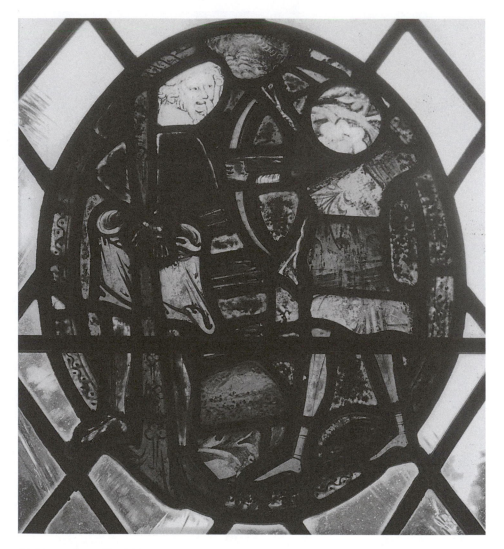

34. Martyrdom of St. Edmund. Painted glass roundel, St. Mary the Virgin, Saxlingham Nethergate.

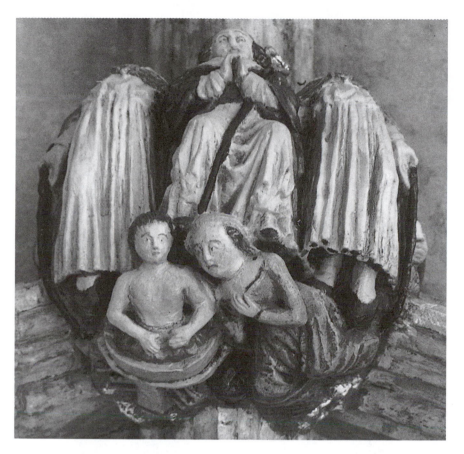

35. St. Nicholas, Miracle of the Bath. North Cloister boss, Norwich Cathedral. By kind permission of the Dean and Chapter.

36. St. Peter Martyr (name on scroll). Painted glass fragment, All Saints, Threxton.

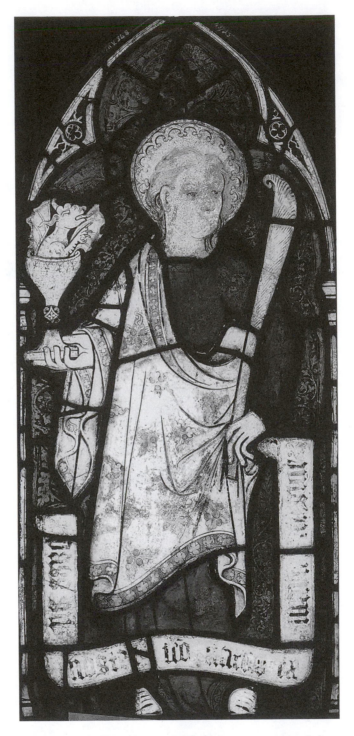

37. St. John and Creed texts. Painted glass, composite window.
Burrell Collection. By kind permission of Glasgow Museums.

38. St. James Major. Painted glass, St. Mary, North Tud-
denham.

39. Pelican in Piety. Misericord, St. Peter, Walpole.

40. Fox Stealing a Cock. East Cloister boss, Norwich Cathedral. By kind permission of the Dean and Chapter.

42. Above: Order Angel with Scepter. Painted glass, St. Lawrence, Harpley.

41. At left: Angel with Chrismatory, before restoration. Wood carving, St. Mary, South Creake. © Crown Copyright. National Monuments Record.

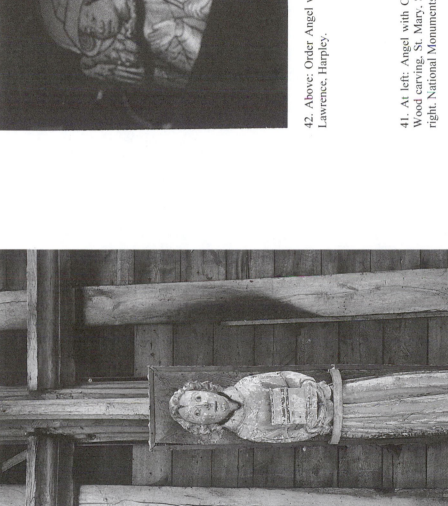

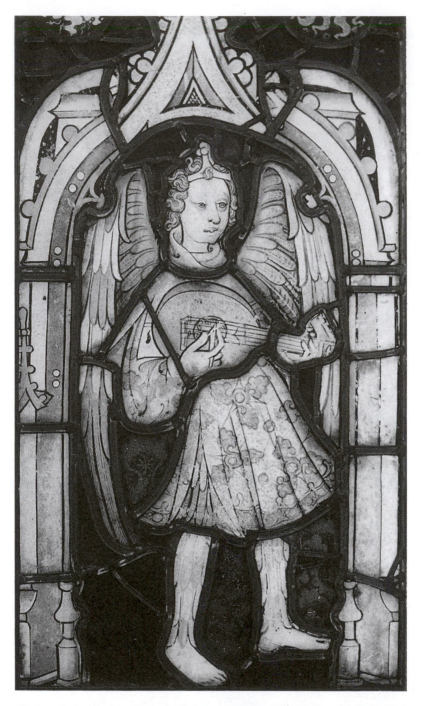

43. Angel playing lute. Painted glass, *ex situ* Great Witchingham Hall. By kind permission of the Norfolk Museums and Archaeology Service.